Natalie Lettner
Translated by Jeff Crowder

Maria Lassnig The Biography

Maria
Lassnig
The
Biography

I didn't become human
until I learned to handle brushes and paint.[1]

Introduction

Maria Lassnig always opted for art. This, in addition to her extraordinary talent, was why, despite the most unfavorable circumstances, she succeeded in becoming one of the most important artists of the twentieth and early twenty-first centuries. Quite a few men proposed marriage to her, especially in her younger years, but she declined them all. She feared having to neglect the most important thing in life to her: art. A beloved man once even delivered her an explicit ultimatum: If you give up painting, I'll marry you. This attempt at blackmail followed a quarrel. He was jealous—another man was in the game. In order to get the ultimate proof of love from Lassnig, he demanded she renounce what he knew was more important to her than anything else. Later, he regretted his ultimatum, realized the enormity of it all, and apologized.[2]

Lassnig was not the only woman who was faced with this dilemma of career or love—quite the contrary. Even into the 1970s, this was the rule rather than the exception. The average man assumed the woman he married would give up her job to take care of the household and look after the children. No wonder many women decided against their own careers. Forgoing love and family is, after all, a great sacrifice. This was possible for Lassnig because art always took utmost priority for her and because her childhood experiences made her generally distrust interpersonal relationships. Opting for the difficult yet only possible choice—committing herself to art—thus became easier. Still, she suffered her whole life from loneliness and the subjective feeling that she had never really been loved unconditionally. Male artists were hardly confronted with this choice. Usually they had partners or wives who backed them up, took care of everyday practicalities, and provided them with a cozy retreat from the brutal cage fight of the art world.

Lassnig's path was not strewn with roses. She had to fight hard and persistently for her successes. The obstacles were numerous, starting with her gender. Men, to this day, still have it easier in the art world, and it is hard to imagine the difficulties women of her generation had to face. A few years before her death, Lassnig wrote in her journal: "Strong women (really strong women) … are a nuisance for strong men."[3] Lassnig called herself a feminist but hated it when her art was associated with something specifically feminine. She found it discriminatory and derogatory to be labeled a "female artist" rather than an "artist." She refused to be pigeonholed in the female artist category. For her, this was synonymous with not being taken seriously. She did not want to be compared with other female artists but with the most successful of her craft, and these were usually men: "What does Baselitz think of me, what about Richter? What does Lucian Freud say about my work?"[4]

On top of this, she had to deal with her roots, having grown up in the poorest circumstances. This biography tells the amazing story of a woman who

was born as an illegitimate child in one of the most rural areas of Austria and developed into a cosmopolitan avant-garde artist. In her first thirty years of life, she lived through four political systems, Austria's First Republic, the Austro-Fascist corporate state,[5] National Socialism, and the Second Republic. For the next thirty years, she lived and worked as an artist in four major cities, including the world art capitals of Paris and New York. Only in 1980 after Austrian Minister of Science Hertha Firnberg had appointed the sixty-year-old Lassnig as the first woman professor of painting in Austria—Lassnig was avant-garde in this, too—did her career gain momentum. What followed was her participation in many of the most important art biennials, prizes, exhibitions, and honors. For the first time in her life, she did not have to watch every penny. Despite this, she never got the feeling that she had fully arrived. Her whole life she felt undernoticed, underrecognized, not taken seriously. At eighty-one, a time when she was getting a lot of attention, she noted: "I was never in there, was always just in front of the door; now still in front of the door without ever having been in there but already outside again with my back to the door."[6] This eternal dissatisfaction forced her time and again to reinvent herself, to try new things, to never rest on her laurels. This biography tells the story of her self-empowerment.

What distinguished Lassnig was her extreme form of high sensitivity, which was a blessing and a curse at the same time. She was all too aware of this. In 1944 she wrote, "I feel like a fragile apothecary's scale being used to weigh sacks of flour."[7] Lassnig reacted seismographically to both mental and physical stimuli: wars, environmental destruction, and the suffering of animals made her cry—"automatically," she stressed—and could cause her physical pain. She was amazed how tough others were. "All people here are sewn into thick-quilted eiderdowns, where they do not hear how the world is doing, how it howls with pain, cold and hunger, blind with rage. But I have no skin. All my nerves are exposed ... In some places deep inside the body, there are nerve caves, nesting places for birds with long beaks."[8] Her sensitivity to noise and odor often made hell of her living and working conditions. Sometimes even earplugs did not help. Her body was always present. She often felt pain somewhere—in her liver, lungs or heart, wherever.

At the same time, it was precisely her highly sensitive nature that enabled her to develop her own bodily avant-garde painting style. Not only did she perceive everything with her eyes, she also captured it with her entire body. In the course of her artistic life, she developed her own terminology, such as Introspective Experiences, Body Feelings, Body Sensations, and Body Awareness.

Although her oversensitive body was often a great burden to her, her artistic handling of it seldom had anything masochistic or maudlin about it. Quite the contrary, she combined the highest sensitivity with (often wicked) wit—a

striking and rare combination. Her own comments on this were quite ambivalent. She herself was responsible for the role of pain and great emotion in her work being sometimes overemphasized—she spoke of "love, death and oppression"[9] as her big themes and described her way of working as "paining the painting into form."[10] However, with other statements she emphasized that she was only concerned with very concrete, simple body perceptions, not with the "big" feelings. She described her first idea for Body Awareness paintings as follows: "It was in my studio in Klagenfurt. I was sitting in a chair and felt it pressing against me. I still have the drawings where I depicted the sitting sensation. The hardest thing is to really concentrate on the sensation while drawing. Not drawing a buttocks because you know what it looks like, but drawing the buttocks sensation."[11]

Lassnig repeatedly advised looking at her work if you wanted to know something about her. In fact, her animated films—especially *Selfportrait, Couples, Palmistry*, and, above all, the *Maria Lassnig Kantate (The Ballad of Maria Lassnig)*—as well as her paintings and drawings, contain numerous references to her life story. She was self-focused, but not a vain artist, who explored and portrayed herself in countless self-portraits. And if she presented herself as a lemon, Headness, dumpling, ear, monster, phallus, mushroom, prophet, animal, jam jar, Native American girl, female Laocoön, warrioress, rich shepherdess, frog princess, or alpine cow, then that had something to do with her biography and her current living conditions.

Nevertheless, Lassnig played with the idea of a biography or an autobiography, as fragmentary records from her memories and journal entries make clear: "Whether I could simply tell my life story, probably I could, but where would I start? Which tracks to take? Without just whining and moaning because I consider myself an unlucky duck, what method should I choose?"[12] Even though she couldn't bring herself to finally take the narrative of her life into her own hands, she felt the desire to do so, especially in the last two decades of her life. Her journal entries and memoir notes are important sources for this biography.

In Max Frisch's *Gantenbein* from 1964, his protagonist says, "Sooner or later every person invents a story that fits his life, I say, or a whole series of stories."[13] Without a doubt, this fits Lassnig, who time and again in her interviews expressed similar but varied and sometimes contradictory anecdotes, an indication of her complex, exciting, and also conflicted personality—"You're different every day, you're different every minute, almost every second."[14]

Indeed, self-invention played an important role; her entire existence as an artist was a great, courageous self-invention. Despite enormous external resistance, many setbacks, and disappointments, she was persistently determined to not let herself be stopped from leading a life as an artist. Self-invention became

reality. Therefore, an essential focus of this biography is on which images Lassnig drew and painted of herself, both artistically and metaphorically.

Maria Lassnig's biography is both exemplary and extraordinary for a woman of her generation—exemplary in terms of the hurdles and pitfalls that women in general, and female artists in particular, had to face in those years. She struggled her whole life against the usual stereotypes about women: in her youth, against her mother's desire that she "marry up" (preferably "a doctor," Lassnig stated smugly); in relationships with men, against the requirement of putting her own needs aside to nurture and care for her partner's ego; in the art business, against having to play the role of the sweet and pretty girl; as a university teacher, against having to play the "mother figure"; and as an old woman, against the image of "odd old lady" and the "grande dame."

Even though she herself wanted to be an artist, not a *female* artist, her life story is extraordinary because she was finally, despite it all, able to assert herself as an artist and a woman due to her outstanding talent, her persistence, and her single-mindedness.

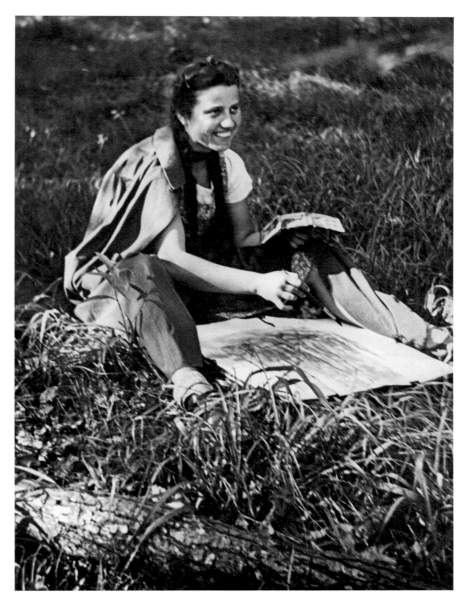

Maria Lassnig painting with watercolors, 1942

Translator's Notes

German catches flak for being a "harsh" language with long block sentences and U-boat verbs that submerge at start and resurface at the end. Chapter by chapter, page by page, from 2019 to 2020, I ferried Natalie Lettner's Maria Lassnig biography, sentence by sentence from German into English—but I didn't translate it word for word. Sadly, German word order and rhythm were sacrificed to attain sentence cadence in English; long, multiclausal, noun-loving German sentences were broken into shorter and simpler verb-driven English, and I had to hold myself back on the flavoring particles. Lost in translation was Lettner's use of the historical present, where one writes about the past as if it were now. Sentences in German are longer on average than their English equivalents. German's propensity for compound nouns explains why this English translation has 7,804 more words, but the original German book has 61,784 more characters. The German word for translate—übersetzen, "to bring across"—conjures up the image of a river crossing. This translation was a veritable transoceanic crossing that has landed Lassnig's official biography firmly on the shores of the English-speaking world.

Lassnig's connection to New York was as strong as her Austrian accent—American English was selected for this translation as that was what Maria spoke. As a Californian, Austro-Germanophile expatriate living in Vienna, my experience as a translator, my knowledge of Austrian dialects, and my hankering for weird words were why I was chosen for the formidable task of translating Lettner's elegant and intricate prose and capturing Lassnig's spirit, her Carinthian voice, her sharp—sometimes unintentional—humor: her *Schmäh*.

Lassnig lamented she was less adept with words than paints, but she was a mighty wordsmith whose playful and philosophical use of language was as creative as her art. She coined the most important term in the Lassnig cosmos, Body Awareness, as if it were easier to find the right word in English; the German translation Körperbewusstsein came later. Lassnig's use of "awareness"—*Bewusstsein*—is not how we use it today in the sense of "consciousness." She refined and reformulated her terminology to avoid being misunderstood and to distinguish different aspects of Body Awareness: Body Feelings and Body Sensations. Let's leave it to Lettner to fully explain the nuances. Grappling with Lassnig's unique art-philosophical vocabulary was the most demanding test of your translator.

Translated at face value, *Vorstellungsbilder* is "imagined pictures," but Lassnig did not mean fixed images in the artist's head. I reworded the translation of *Vorstellungsbilder* as "Imagination Pictures" to better capture what Lassnig meant, the process of how her images formed in a series from a *Gestrüpp*, a thicket of imagination, as illustrated in her Awareness Pictures on the subject of "dog" [p. 246].

Weaving art and wordplay together, Lassnig's inventive use of both English and German seems to have influenced her art in a feedback loop that in-

spired the titles of her works, such as *Sprachgitter* (*Language Mesh*), which sounds like a synonym for *Beißkorb*, "bite basket," or dog muzzle, a speech screen (see her self-portrait on p. 158), but this mandoline-portcullis doesn't cover her mouth; it slices through her throat. Likewise, *Sprechzwang* (*Forced Speech*) describes what the painting depicts; not language but communication burdens her. The English translation of these titles might seem fragmented to some German speakers, who may think, "Why can't you just say it all in one word?" The defining feature and glory of German is its capitalized compound nouns, which allow you to press whatever ideas you want together into one word and make it as long as you desire; for example: *Eierlegendewollmilchsau*—the egg-laying-wool-milk-pig, figuratively translatable as the Swiss Army knife of such and such. If German can't say it all in one word, then it tries to say it all in one sentence. German seems peculiar to everyone but German speakers. To describe the Cubist-Impressionistic heads she painted, Lassnig took the word *Kopf*—head—and abstractified it into *Kopfheit*—Headness. Lassnig told people she was painting *Headnesses*—nothing odd about that.

Maria Lassnig left behind a handpicked and trusted foundation team to curate her art and cultivate her legacy after she was gone. A hypersensitive artist deserves a highly sensitive biographer. What unites both artist and author is their intense curiosity—both Lassnig and Lettner are deep see-ers, keen observers. "It's stressful when you see so much," Lettner says, and with the intellectual appetite of a humpback whale she swallows her topic whole, first gorging, then filtering. The more extensive her research, the greater her time pressure to write. Fortunately for public libraries, Lettner's apartment is her library, as this bibliophile is a defiler of books who scrawls all over the margins. In her writing breaks, Lettner switches from her desk to her puzzle table, and while solving puzzles she pieced together the mosaic of Lassnig's life. Even if some pieces are invariably missing, Lettner has written a portrait of Lassnig that is worthy of the portraitist herself. Lassnig's contradictions, quirks, and character are revealed with a piercing honesty that autobiography couldn't achieve. Lettner tells the history of twentieth-century painting and brushes up our art knowledge in broad strokes, while taking us on Lassnig's artistic journey from a Carinthian backwoods to Vienna, Paris, New York, Berlin, and back.

Lettner loves movies like *The Magnificent Seven, Hatari!,* and *The Adventures of Robin Hood*, where teams work together with camaraderie toward a common goal. The Maria Lassnig Foundation, Hauser & Wirth Publishers, and Petzel assembled this translation and editing team to do Lassnig's English biography justice. An epic editorial battle over word choice, the historical present, punctuation, capitalization, and orthography ensued among four stubborn sticklers, including yours truly, translator Jeff Crowder; historian Gregory Weeks; managing editor Jennifer Magee; and copyeditor Georgia Bellas.

Prior to this editing saga, Natalie Lettner and I parsed every word together out loud. The German edition of the biography had one glaring mistake: the word "basketball glove" was printed instead of "baseball glove" in the description of *Self-Portrait as Native American Girl* [p. 21]. This prompted Lettner to warn me that "the better a manuscript is written, the more a proofreader becomes lax, glosses over the sentences, and the mistakes remain within." In this regard, Maria Lassnig Foundation Curator Johanna Ortner's deep reading and eye for details contributed significantly to the quality of this book. She and I debated wording and Lassnigisms, like whether it should be a splotch, blotch, or patch for *Farbfleckenbilder* and *Fleckenmalerei.* Over and over again, Johanna worked with her colleagues at the Maria Lassnig Foundation—Hans Werner Poschauko, Marlene Hans, and Peter Pakesch—to remove all of my splotches and blotches and replace them with patch, only to have me edit out their patch and put splotch and blotch back in. I wanted to avoid readers imagining some patch that is sewn on, and for me, splotch and blotch had more onomatopoeia to them—or *Wortmalerei,* "painting with words," as the German word conveys. Johanna and the foundation's team finally clued me in on the nomenclature of the art world, and I surrendered to the foundation's will: color-patch paintings (*Farbfleckenbilder*) and patch painting (*Fleckenmalerei*).

A nitpickers' tug o' war over commas, hyphens, apostrophes, and other editing minutiae played out. We universally underestimated the scope of this project, but we overdid it for Lassnig. Jenny's coordination and encouragement were essential for keeping up morale and momentum and keeping this megaproject on track. From the beginning of 2020 until the end of 2021, Maria Lassnig's official English biography was scrutinized through Greg's spectacles, passed through Johanna's curatorial filter, received X-ray proofreading and cosmetic surgery from Georgia's fine editorial scalpel, and passed Jenny's discerning judgment. Toiling away alone, in pairs, and as an editing team, Jenny, Georgia, Greg, Jeff, and Johanna kept at this editing behemoth, reading, rereading, and re-rereading, dedicated to making this translation of Natalie Lettner's biography of Maria Lassnig gleam, and a joy for you to read. Editing is a creative contribution, and I thank the entire team for refining and polishing my translation.

A notable Austrian phenomenon is a form of inverted schadenfreude, a dismissiveness begrudging the success of compatriots—like Falco, Arnold Schwarzenegger, Wolfgang Puck, and Maria Lassnig—who have made it big in America. In her last 20 years, Lassnig gained considerable international fame. May this translation further Lassnig's reputation and guarantee Maria's ascension into the pantheon of artists.

JGGJJ did it for NL & ML & you the reader,
Jeff Crowder

The past is nebulous, a big mush, a dough to cut shapes out of. But where do you cut first? It doesn't matter. There is little left of what they shared, grandfather, my mother—I did not retain everything they knew.[1]

1 Childhood and Youth in Carinthia

1919–40

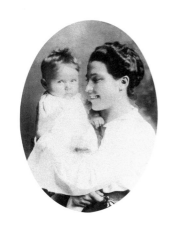

Maria Lassnig with her mother, 1920

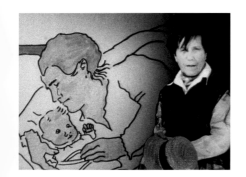

Film still, *Maria Lassnig Kantate (The Ballad of Maria Lassnig)*, 1992

"Did you know that goats have square pupils?" Alois Knafl, the son of the mayor, didn't know this, even though he himself had grown up on a farm.[2] For the first time in many decades, Lassnig had returned to her birthplace in Carinthia, to Kappel am Krappfeld, twenty-five kilometers northeast of Klagenfurt. The occasion: in 1985, the now-sixty-five-year-old artist finally received her first major retrospective in Vienna, Düsseldorf, Nuremberg, and Klagenfurt. She wrote her own resumé for the exhibition and catalog—reason enough to explore her own roots. She contacted the community in Kappel and asked for a guided tour to the places of her childhood, a task delegated by Alois Knafl Sr., mayor and big farmer, to his then-thirty-year-old son, Alois Knafl Jr. This dedicated teacher was open to contemporary art. His most important memory of Lassnig? When he showed the artist his family's stable at the end of the tour, she stared "forever" into the eyes of a goat, "at least fifteen minutes," and she drew his attention to the shape of the animal's pupils. Indeed, goats as well as sheep have horizontal, almost rectangular pupils, which allow them a wide field of vision, an advantage as a flight animal. This fascinated Lassnig. The young teacher, in turn, was not only impressed by Lassnig's extraordinary powers of observation but also—like so many others—by her intense, almost staring gaze, with which she seemed to grasp, even X-ray, her environment. From the time she was a child, she had observed everything very closely, so much so that some people reproached her, saying she stares so "strange and slow."

When a few years later, Knafl Jr. suggested naming the school after Lassnig or honoring her in another way, he met with little interest in the local council. It was hard to imagine that a woman from Kappel, of all places, could have made an international career, and in New York to boot. Things look different today; Kappel is now proud to be the cradle of the famous artist. They like to show the farmhouse where she was born, but the circumstances of her birth were anything but idyllic.

Day laborers and aristocrats

Lassnig was born on September 8, 1919, as an illegitimate child. Her mother, Mathilde Gregorz, was herself illegitimately born, as was her father, Anton Hubinger. Although illegitimate children were considered a disgrace, they were the norm. At times, the number of illegitimate children in Kappel even exceeded that of legitimate children. Servants, maids, farmhands, and day laborers, as well as many farmer sons and daughters, could not afford to marry.

In December 1890, a good two years after Mathilde Gregorz was born, the Kappel Town Council issued a notice to deal with the high proportion of illegitimate children. It says in stilted Austrian bureaucratese: "The flagrant public nuisance of unmarried persons cohabitating in sin is prohibited in the community by the morality police." In the case of a violation, a fine was imposed. Repeat offenders were also considered: "By noncompliance, this punishment will be repeated until the dissolution of the immoral cohabitation."[3] These empty threats did not change social inequality or the family and inheritance structures of peasants and did little to improve the undesirable situation in the end.

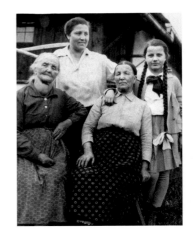

Four generations (from right to left): Maria Lassnig, her grandmother, her mother, and her great-grandmother, ca. 1930

Lassnig's grandmother, Maria Gregorz, let herself get "knocked up by a tall, jaunty mountain farmer," as the artist noted in her journal in 1998, who then "married a wealthier woman of course."[4] This grandfather, Josef Winter, still played an important role in her memories. He was paralyzed in both legs from the middle of his life. He made himself a wheelchair out of wood, with which he allegedly travelled up to fifteen kilometers to St. Veit an der Glan to visit another former lover. Lassnig admired not only the charm he exerted on women but also his technical and practical talent, which she desired for herself. She made some portrait sketches of this grandfather—mostly with a pipe in his mouth. He allegedly said crazy things; for example, a tale about an old farmer and his wife in the neighborhood who had beaten each other to death, a horror story that burned itself into his granddaughter's mind.

During her visits to her grandfather, she also met her great-grandmother, Agatha Winter, an old woman in a headscarf and a faded smock. Of all the family members, the artist is said to have most closely resembled this great-grandmother, "a big square-built woman with bright eyes and strong cheekbones."[5] Lassnig attributed "square-built" to herself: "I was more of a square child; as tall as I was wide."[6] Even as an adult woman, she would have this Square Body Sensation and capture it in a series of abstract images and drawings.

Grandfather Josef Winter and Maria Lassnig

When little Maria met her great-grandmother, the old woman could only walk out of her room with the help of her cane to the sunny bench along the wall of the house. Earlier however, so they said, Agatha Winter had run a tight ship: "She reprimanded her lanky husband every time he tried to even drink a swig of liquor. Her mercilessness was feared by all."[7] However, when she saw her great-granddaughter, she was deeply touched, her whole body began to shake, her jaw clattered, her eyes watered. Lassnig saw a parallel to her own emotionality. "With the songs *Silent Night*

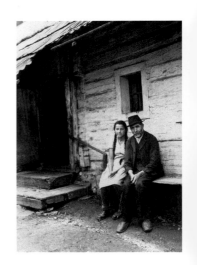

Quadratisches
Körpergefühl (Square
Body Sensation),
1960, painted over
at a later date

and *Holy God We Praise Thy Name*, I feel like my great-grandmother. I'm physically shaken by how it touches me, and before my tears roll, I make quite a face."[8] Agatha Winter could even read and write—also an indication that the Winter family was socially higher than the Gregorz family.

Grandmother Gregorz, with whom Lassnig spent the first six years of her life, was illiterate, and when she had to sign something, she made a little cross under what she could not read. She was a penniless maid or day laborer who first lived in a one-room hovel in the Boden district. Belonging to this hovel was a so-called bathhouse—a kind of wooden shed constructed out of blocks and covered with a board roof that jutted out. Kappel am Krappfeld, a community which then had approximately 2,000 inhabitants, shouldn't be thought of as a compact and cohesive village but as a group of forty-one hamlets, some of them far apart, some consisting of only a few houses, and others of up to forty. One of these hamlets is Garzern, with seven houses, and in one of those, Lassnig was born. Another hamlet was Boden, about an hour's walk from Garzern. There, Mathilde Gregorz, Lassnig's mother, had grown up in the poorest conditions as an illegitimate child. Then, Maria Gregorz married the widower Valentin Rassinger, "who had a mob of children," and one of these children was still a baby. Gregorz raised it and "loved it more than her own child, my mother" and, as Lassnig captured in her journal, "even more than me."[9]

Little is known about the youth and the career of her mother. She must have been a self-confident girl, at least that's how Lassnig portrays her, which is much different from Lassnig's own experience as a child. Mathilde told her daughter that she had often been involved in brawls and had to defend her helpless boy cousin, the "snotty-nosed Loise," against many attackers. A photo from 1916 showing the then-twenty-eight-year-old Mathilde in a hunting outfit is labeled: "Thilde poaching." The photo suggests how little it suited Mathilde to be reduced to the housewife and mother role. It is no coincidence that Lassnig titled one of her drawings *Meine Mutter war eine Indianerin* (*My Mother was an Indian*, 1978) and painted herself as a Native American girl in 1973.[10] Nevertheless, she always felt her mother was much stronger and more resilient than herself. "My mother was very different. Even as a child she punched all the boys who harassed her. I took it all, swallowed it, and carried it all around on my shoulders."[11] She described her mother as a beauty: "She had long raven-black hair and thick black eyebrows, beautiful straight teeth, well-proportioned features, and red cheeks."[12] Her mother yearned for literature, would have liked to have become a writer. She wrote short stories and countless poems, often in dialect—poor writing in Lassnig's opinion. She made her living doing various things. Lassnig mentioned that her mother had been a maid to a count in Styria. On another occasion she mentioned that she had worked in Klagenfurt. Upon the occasion of little Maria's baptism, Mathilde Gregorz is listed as an accountant in the parish chronicle records. Lassnig notes in a further journal entry that Mathilde had worked in the Treibach chemical factory, not far away from Kappel am Krappfeld. The factory was founded by the inventor, researcher, and entrepreneur Carl Auer von Welsbach in 1907. In 2008 when Auer von Welsbach's 150th birthday was celebrated, Lassnig wrote down a few keywords: "Light bulb (Osram), incandescent mantle, cigarette lighter. Carl Auer Welsbach, Treibach factory—my mother must have known them all. Radioactivity. Because she often spoke about Auer von Welsbach and Meiselding because she worked there."[13]

Where and how her mother met her father, Lassnig did not exactly know. Anton Hubinger was also an illegitimate child, but his father's side came from quite different social circumstances. He was the son of Maria Hubinger and Count Viktor Sternberg-Rudelsdorf, who did not, however, recognize him as a legitimate descendant.[14] The Sternberg-Rudelsdorfs were a noble family, originally from Moravia. Anyhow, Anton won her over with music, Mathilde told her daughter, because he could play any instrument. Mathilde got pregnant. "I'm happy my mother didn't abort me," writes Lassnig later. "She probably did try. The

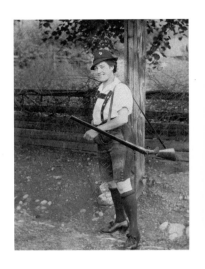

"Thilde poaching," Maria Lassnig's mother, Mathilde, Kapfenberg, 1916

way they used to do it in the countryside: jumping from a high table and drinking a lot of strong coffee in vain. Who knows what this did to the baby?"[15]

Mathilde was thirty-one years old when she gave birth to her daughter in Kappel, far from being a young mother in those times. One week after birth, baby Maria was baptized and named Maria Eleonora—Maria after her grandmother and Eleonora after her godmother.

The baby's father, Anton Hubinger, had no intention of marrying Mathilde. The marriage would not have gone well anyway, Grandmother said, since both were too feisty and prone to angry outbursts that would have been explosive. Lassnig remembered how her grandmother was all too convinced of this. However, her mother told little Maria a different story. When Anton visited the mother and newborn baby, he was supposedly disappointed that he had not sired a son. In addition, he shook his head and looked down upon his allegedly not-so-pretty little daughter and sarcastically remarked, "She'll improve."[16] Her mother often told this story, consciously or unconsciously blaming her daughter for Anton not marrying her. Little Maria internalized this view, and, even as an octogenarian, she was still convinced she was responsible for her father abandoning her mother. "He probably didn't marry her, because I was a girl, and his buddies mocked him as a 'chick maker' when I was born."[17] It hit Lassnig hard that girls were valued less in the countryside. "As a girl in Carinthia, you are not celebrated like the ancestral farm boys. It's always been: when a boy is born, we drink a schnapps, and when it's a girl, we drink water or nothing at all."[18] It can only be speculated

Meine Mutter war eine Indianerin (My Mother was an Indian), 1978

how much Lassnig's perception of men was marked by this early male rejection, even if merely experienced through the stories of her mother. Still, it stands out how often in her love life the subjective feeling of abandonment, or not being wanted, is repeated. The fact remains that this father is a void in her own life narrative. She rarely mentions him and never lets the public know his name.

She attached great importance, however, to his noble ancestry and thus to her own, too. Time and again she came back to it. She once said that the Sternberg-Rudelsdorfs had been intellectually active and literarily interested for generations, and she derived her own artistic talent from them.[19] Even as late as 2001, when composing sketches for an autobiography that was never written, she mused: "The farmer's genes, aren't they still fighting the aristocratic genes? That's too prissy. Let's not be arrogant. But isn't it a fact that the square-built farmer's genes were donned with a lace bonnet from the duchess? Or was it rather that the magnanimity of the duke was doused in the farmer's stinginess?"[20]

Lassnig did not meet her biological father until she was twenty-two. Hubinger lived in Judenburg, Styria, at that time. When she first met him, she was surprised by his appearance. He looked like "a blond Mongol."[21] And she wrote, "That he had a pretty face, I only saw a few times later: a thick round head on a petite body. His face always twitched nervously."[22] She noticed the sharp, almost piercing look of her father, which reminded her of her own ability to observe people and see through them. One of his less positive qualities was the paranoia she inherited: "Although he gave generous gifts to friends, such as typewriters, radios, and mopeds, he was convinced that everyone wanted to exploit him,"[23] a conviction that was not foreign to Lassnig in her later years. She admired his technical skill, which she completely lacked. "My father liked to patch together cars and motorcycles out of discarded parts. He drove such a car himself. Unfortunately, I didn't inherit his talent, only a fear of machines and machine noise."[24] The fact that she often felt torn between several possibilities and wanted to try everything at the same time led her back to the very different qualities of her parents. "My feeling torn began in the egg cell: Should I become blonde or brunette? Or my mother's color? Always torn between *two possibilities*, in life and in art."[25] She was brunette after all, and in art she never let herself be deterred from doing all sorts of things in parallel.

After their first meeting, father and daughter continued to see each other occasionally. She captured his distinctive face in several portrait drawings, one titled *My Daddy* (*Mein Daddy*) with a shaky heart drawn around it. He wrote her several letters in which he called her "Dear daughter" or "Sweet lass" and signed them with "Your deeply caring bad dad" or "Your loving Toni-father."[26] He was very proud of her artistic success and was happy to receive her catalogs. He congratulated her on her birthdays, TV appearances, and good reviews of her exhibi-

Selbstporträt als Indianergirl
(*Self-Portrait as Native American Girl*), 1973

tions. In a letter he sent to her when she lived in Paris, he asked her how she felt about the 1968 Movement and was astonished that he did not really know which worldview she adhered to. After moving to New York, she sent him photos and sketches to show him how she lived now.[27]

Maria Lassnig, 1929

But the relationship remained ambivalent. Not only was it hard for her to forgive him for how he had abandoned her as a child, but there was also a further incident that left her feeling deeply slighted. Hubinger believed in astrology and had a horoscope made for Lassnig. On the basis of this, he imparted to her that although she would become a very good artist, she would not become a great artist—a message that outraged and tormented her until the end of her life. In 2007 she wrote in her journal, "My dad said: You will fail before the finish. *Nein, ich werde nicht scheitern. Non, je ne vais pas échouer.* No, I will not fail (be wrecked)." She confidently rejected her father's judgment and intended to add a Russian and Spanish translation to the French and English—perhaps inspiration for an animated film that never came to be. But then she resigned, "Yes, I will fail. *Oui, je vais échouer. Ich werd' vielleicht scheitern.* (I will perhaps fail.)"[28] At least she toned it down in German with a "perhaps."

Lassnig once even painted her father as a motorcyclist, casually leaning on his motorcycle, in boots and a leather jacket, with a cap and rider's goggles on his head. On the ground in front of him lies the adult naked Lassnig; the front tire of his motorcycle almost touching her, as if her father is about to run her over. Next to her, her mother, also naked, squats with a sad, averted look. The title of the painting: *Large Family Portrait (Großes Familienbild)*. Lassnig had such a photo of her father in a leather jacket and cap, without the female figures of course. "The Scoundrel" was written on the back by her mother. Lassnig defended his decision to leave the family though. "He wasn't made to be a husband. I think that's right. If you aren't born for it, you shouldn't marry."[29] She probably meant this as much for herself as she meant it for her father. When Hubinger was dying in September 1970, he asked the nurse in the retirement home to inform his daughter about his condition. The nurse sent Lassnig several postcards and once wrote, "Perhaps you could come? He expects he will pass away soon, and he finds it very difficult to be so alone in his last hours. ... I pity him. He was one of the most intelligent men here. I send his greetings to you, from your Toni father."[30] Lassnig wrote back that she herself was sick and could not come. Hubinger left her a modest sum of inheritance money.

"Mariele" at the age of 14, 1933

Little Maria wasn't only abandoned by her biological father but also by her mother. What exactly Mathilde Gregorz did in the five to six years after Lassnig's birth still remains unknown. Maybe she was working again in the Treibach factory, but she supposedly went to Klagenfurt. Lassnig mentioned several times that her mother worked in the city. Wherever Mathilde went, she left little Maria in Kappel with Maria Gregorz, the grandmother the girl was named after. Grandmother soon moved from Kappel to Obermühlbach, some twenty kilometers away, not far from St. Veit an der Glan. Obermühlbach was where little Maria would spend future summers—a place with many positive associations for her, especially her grandmother's intensely fragrant herbal chamber. Even as an old woman, Lassnig remembered her first sensuous perception of the world, how her barefoot soles sensed the summer-dry ground and the warm sand of the dusty country path sprang up between her toes. Left and right, the high dry grass, at least as high as she was then: "I can still remember the grasses so well, and how the chicory smelled, you could tear its head off and throw it into the air. Or the dandelions with their seed stars you blew into the air."[31]

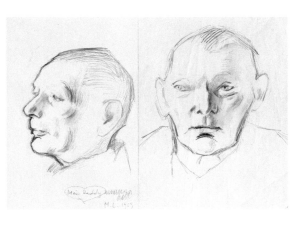

Mein Daddy
(*My Daddy*), 1969

She told of little kittens she tried to catch, of hay piles on the barn floor under which she hid herself, and of bendy birch branches from which she hung and swung by her knees and admired the world upside down. When the artist described such things in a radio show about her life story, the journalist seemed to think she had a harmonious childhood. This, Lassnig vehemently rejected.

Despite these experiences in the countryside, which appealed to all her senses, she felt altogether uncared for, unloved, and completely left to herself, virtually neglected. The grandmother, "a poor little lady," was a hard-working woman, a maidservant, who had to get up at the crack of dawn and toil until sunset. Of course, this left her little time to raise a child or give it loving care. When the child screamed, her grandmother put a pillow corner soaked with poppy seeds and alcohol in her mouth, a commonly used method for calming children down at that time. Loving words were few; there were hardly any words at all: "I grew up without language."[32] Grandmother kept silent, so it is not surprising that little Maria developed into a quiet child. In retrospect, she felt she had not received any upbringing at all. She had to teach herself everything, an early childhood conditioning that would accompany her throughout her life. "And who taught me to walk? Certainly not my father. My mother was working in the city. My grandmother, she took no pleasure in me to

begin with, and was always working in the field, so I even had to learn to walk on my own,"[33] just like everything else later. A memory on the same theme: "The little child was never held by the hand, so it often fell on the unhewn stone steps. Then it screamed, nothing came after the first shrill sound, the cry stifled in its mouth but after four seconds erupted, screaming, its chubby hands burned like fire."[34] As a consolation, the child was told to punch the stone to punish it, "which I thought was stupid even then, but I punched the stone anyway, which hurt me a second time."[35] After she learned to walk, Maria would follow her grandmother, who toiled in the area's vast cornfields, and there the little girl found her toys. "The corn cobs were dolls that had blonde hair."[36] These anecdotes are among the many childhood memories that Lassnig began to chronicle around the time of her eightieth birthday, an attempt to write her autobiography.

The artist interpreted one of these experiences as the beginning of her interest in perceptual theory. One December 5, as usual, an acquaintance disguised as Saint Nicholas came to visit. The little girl, between three and five years old, was told to stroke the kind-hearted old man's face. The child was completely confused when she didn't touch soft skin but grabbed a hard papier-mâché mask. Saint Nicholas spoke like a human, moved like a human, but he did not feel like a human being. "The child was astonished for the first time that reality can be something 'different,' and throughout her life retained this memory of her first philosophical realization."[37]

The little girl was often ill. One traumatic experience happened after a game of tag. Maria drank from the icy fountain in front of the house and caught severe pneumonia. They were afraid she might die. Lassnig remembered how they put a candle in her hand and everyone around her prayed the rosary. But the internal image of her feelings of being neglected is epitomized by a scene that her mother would later tell her over and over again. When Mathilde came back again from Klagenfurt on a visit to the countryside, she found little Maria all alone, as if dumped and forgotten, in a cart in a field—that was the moment, according to Lassnig many decades

"The Scoundrel," Anton Hubinger, 1918

later, in which her mother decided to conduct her life in a more orderly fashion and strive for a middle-class existence. As much as this may be a family myth, in 1922, Mathilde did indeed marry the master baker Jakob Lassnig in Klagenfurt, who was twenty years her senior. Three years later, she brought little Maria, who was then at the school age of six, to Klagenfurt. The baker adopted the girl and from then on she was no longer Maria Gregorz but rather Maria Lassnig. The artist later once recalled she would have preferred to have kept the name Gregorz, or to have taken on the name of her paternal grandfather, Sternberg. A few years before her death she planned to have a stamp made with the name Lassnig-

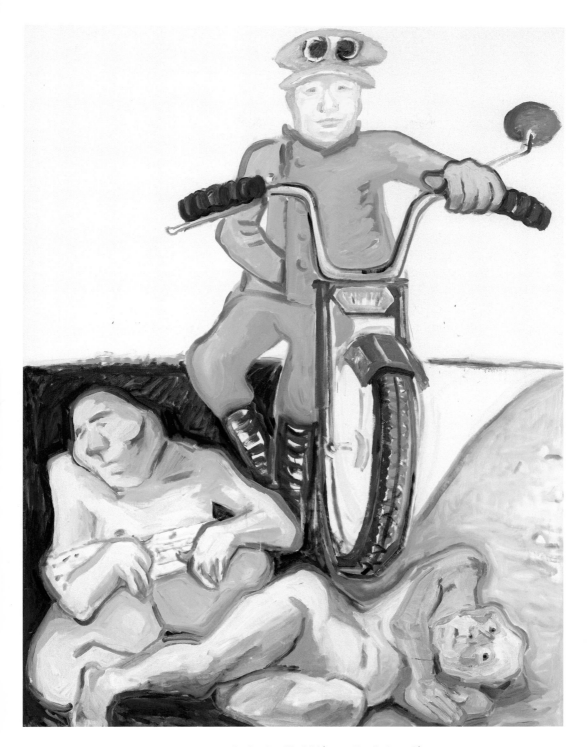

Großes Familienbild (Large Family Portrait), 2003

Sternberg.[38] Yet another time, she noted, "My pseudonym Eleonor Löwenherz was planned, but unfortunately never carried out."[39]

All in all, Lassnig had no good memories of her early childhood years. When Walter Gross, a former elementary school principal, began to work on a history of Kappel am Krappfeld in the 1990s, he sensed Lassnig's distance to the place of her childhood. In the meantime, the artist's fame had reached as far as Kappel, and Gross intended to pay tribute to her in a separate section as a famous daughter of the community. He visited her in Feistritz, about thirty kilometers from Kappel, where Lassnig now had her summer art studio. He explained his intentions and asked her "very politely" for information, but she responded snippily, "Don't bother me with Krappfeld. I don't want to hear about it. Leave me in peace. If you want to know something about me, buy the latest book from my last exhibition. It's all there." Then, he was shown the way out and treated as if he were a rascal. The section on Lassnig in Gross's history was, therefore, kept quite short. However, he was continually reprimanded for not having written more, he said in an interview.[40] On Lassnig's ninetieth birthday, a municipal delegation made an extra trip to congratulate her on behalf of the community—Lassnig did not even welcome them in. The gallery owner and collector Helmut Klewan reported having recommended to the mayor of Kappel in 2003 that he name Bahnstrasse after the artist. The mayor was enthusiastic, but Lassnig would hear nothing of it.[41]

Middle-class bakery and the Ursuline convent

After Mathilde brought her daughter to Klagenfurt in 1925, the new family lived in the center of the city at Fröhlichgasse 13, just a two-minute walk from the cathedral. A house of misfortune, and not just because it is house number 13, Lassnig's mother said. Mathilde was not happy in her marriage to a much older man. Out of desperation, she even attempted suicide, a deeply disturbing experience for young Maria. An image burned itself into her mind: Mother lying in bed with green foam running from her mouth.[42] The fear of loss Lassnig associated with this event—a fear that never left her again—she addressed in 1992 in her great life retrospective, *The Ballad of Maria Lassnig* (*Maria Lassnig Kantate*), a hybrid animated film and street ballad full of abysmal humor in which Lassnig performed in various costumes. In one scene, the seventy-three-year-old wore a short childlike sailor's outfit while the proverbial domestic sparks flew in the background's animated drawings. She sang, "My parents' house, that was a real drama, the coffee cups flew this way and that. The child screamed: Stay alive, dear mom! The child suffered a lot from these struggles. Yeah, I realized early on, marriage is no piece of cake. Early on, a bitter tear dropped into my heart."

Family Portrait (*Familienbild*) of 1947, which she created at the age of twenty-seven, suggests no idyllic family scene. The father smokes his pipe gruffly, her mother frowns bitterly, the adult daughter finds herself between and behind the two with a frightened and worried look, as if she doesn't completely belong. When little Maria finally arrived in a family, she found little security and shelter. Nonetheless, Lassnig always defended her stepfather. Although her parents did not get along well with each other, and "old father Lassnig" was quite tight-lipped, he was a good father to her within his realm of possibilities. A simple man who didn't know what to do about her artistic ambitions, he never stood in her way and he supported her financially.

One of his idiosyncrasies was that, out of shyness, he could not call family members by their actual names, Lassnig said. He compensated by devising fantasy names. "What's the *Portziuncula* doing?"[43]—"What's the Princess doing?"—he would ask, hopping around and singing moodily as he walked through the house after his afternoon nap.[44] Certainly, the neighbors and their children knew that Maria was not the baker's biological daughter, and even the adults teased her about this, saying, for example, "Do you like your father?" The child replied, "Of course I like him!" Then, "Do you want to marry him?" The child affirmed this question, too, and was laughed at.[45] Despite the frequent bad mood in the family, Maria, unlike her mother, loved the baker's wide house with its heavy barrel vaults. When the building was demolished at the end of the 1950s, she was

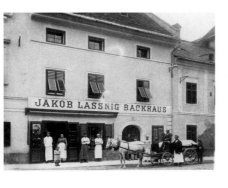

heartbroken. Even decades later, she had nightmares about it: "This afternoon (during my afternoon nap) I dreamt that I was standing in front of our Klagenfurt house, Fröhlichgasse 13, which had already been demolished twenty-five years ago, that I was standing in front of it and could not find it again. It was in a state of destruction. I cried and screamed out in pain, for I sought my mother in vain. I woke up to myself screaming."[46] The house was old, the floor uneven in parts. Downstairs was the shop and the old bakery with its two ovens, which emanated unimaginable heat. The walls were black—"a hellish room, with black cockroaches, which probably fell into the bread, but it was the best bread in town." Also fascinating for the child was the smokehouse with its black walls, which one could only cross hunched down. "It was a mysterious place, and on Krampus[47] days I hid away with my girlfriends in it." A big heavy gate led to the entrance hall, and a wide staircase into the apartment. From up there, little Maria often looked out into the courtyard and watched the journeymen bakers carry flour sacks from the storage room into the bakery. In the open corridor stood the big table where they had lunch; from there, it led into the "boys' rooms" and a

Jakob Lassnig's bakery, 1923

maid's room. Mathilde and Maria, who had once lived in a poor hovel, had arrived in the middle class. They now had employees and servants. The boys' rooms in particular remained a sort of counter-world in Lassnig's memory, "a man's world, a stinking mess, only to be entered by the child to bring them tea when they were ill."[48] Maria, now a baker's daughter, secretly had the hots for a journeyman now and then. Once she experienced a labor dispute. "Memory: workers' strikes, bakers, our worker Robert was a strikebreaker and at night the crowd of strikers at the gate demanded we hand him over. About 1926, a dangerous mood, yelling, father very upset, stones are thrown." The girl was aware of the threatening situation without knowing the political background. She was smitten by the strikebreaker's attractiveness; as the over-eighty-year-old recalled, "Robert looked like Falco[49] and strutted like superman."[50]

Initially, the six-year-old slept in a cot in her parents' bedroom. The sweet smell of yeast pastry dough rose from the bakery below. Lassnig remembered her parents' room exactly, "the Madonna over the bed, my parents' photo, my toddler photos above the plush divan, and the tablecloth table behind the marriage beds for writing in the household accounting book, and a kind of dressing table for doing your hair and all that ribbon stuff, my mother in front of it, before going to the masked ball."[51] In 1948, Lassnig drew this bedroom with her parents in a joyless marriage bed. Father, lying with his jacket and hat on in bed, holds playing cards in his hand. Mother has the covers pulled up to her chin and frowns. The tiger skin next to her bed hints at her unfulfilled sexual desires. In this bedroom, Lassnig also had one of her first spiritual experiences. "As a kid at night in my childhood bed, the experience of floating in an infinite space, no, my head itself was expanded infinitely, at the same time the feeling of being carried away and blown up, a feeling of happiness that had nothing to do with ordinary happiness."

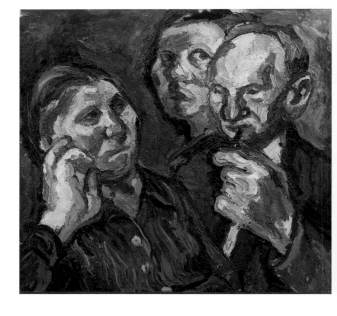

Familienbild
(Family Portrait),
1947

A state she landed in again and again but which she could not summon by willpower, to her regret. The feeling was so great, she perceived herself as chosen and special. "In those moments, I had the feeling of being brilliant, a seer, disconnected from humanity,"[52] which led to a career aspiration. "As a young girl, I told myself I wanted to become a

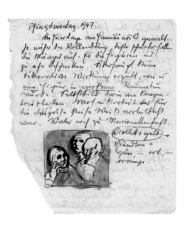

Page from Maria
Lassnig's journal, 1947

fortune-teller, and truly felt the calling."[53] Among the few moments of familial happiness were the Sunday breakfast concerts in the garden of the ritzy Hotel Sandwirth at the center of Klagenfurt. The family put on their best duds, "the good adoptive father" was "festively dressed," Mother wore a beige dress made of transparent fabric, and little Maria sported a blue dress with swinging flounces from the children's fashion store in the Fröhlichgasse. "We sat in garden chairs at the Sandwirth garden, listening to a concert and dining on beef. I hummed to the mixed melodies of operetta and classical music and imagined inventing the melody with the music, but don't remember having been reprimanded by my parents for this. These were probably the most harmonious moments in the Lassnig marriage."[54] Another happy childhood memory: Maria was overjoyed when her mother allowed her to look inside her linen closet. On the top shelf, beyond her reach, was a row of boxes, treasure chests for the little girl, containing jewelry, leather gloves, feathers, her mother's opera glasses decorated with mother-of-pearl. Sometimes her mother brought these boxes down, and Maria was allowed to take all these treasures out and even touch them, which put her in seventh heaven.[55] Her mother was her most admired, beloved, and important figure. She was a simultaneously strong and unstable woman who did not cope easily with the social conventions of marriage and the image of women then. She insinuated to little Maria that the only reason she had married the old master baker was so that she, the daughter, could grow up in orderly circumstances. Again, she blamed the child for her life situation. Lassnig took on this view of things and still described herself at over seventy years of age as a beloved but originally unwanted child, who forced her mother "into an unhappy marriage."[56]

Mathilde generally provided her daughter with ambivalent and often abysmal messages. She loved to tell her child horrifying fairy tales, which put the girl in a state of fear and terror. When little Maria then became horribly frightened, started sobbing, and could not take it anymore, she stepped in as the great comforter and allowed Maria to cuddle up to her in bed. Even worse was a wicked experiment that Mathilde subjected her daughter to for her own amusement. "She took some of my clothes, tied them into a bundle, and said to me: Go away, I do not love you anymore, look for another mom. And she repeated that until I started to cry, and she loved that look on me as my face slowly turned from joy to sadness."[57] The artist later recognized sadistic features in this, yet she defended her mother at the same time. "Yes, she herself had experienced such bad things that she somehow unleashed a certain sadism upon me."[58] Lassnig's memories of feeling abandoned by her grandmother do in fact allow conclu-

sions to be drawn about Mathilde's relationship with her own mother, for whom she also was an illegitimate and unwanted child due to the social mores at the end of the nineteenth century. Loving, physical closeness was a rarity, not only with the grandmother but also with her mother. The Swiss art historian Hanna Gagel interprets this childhood lack of physical closeness as the main motive for Lassnig later developing her Body Awareness images.[59] This quite possibly played a role, in addition to the artist's high physical sensitivity and her interest in perceptual theory.

What's unusual for the time is that Maria Lassnig remained an only child. Mathilde did not have any more children, perhaps because she was already too old for that (she was thirty-four when she married Jakob Lassnig), or perhaps because the roles of wife and mother were already too much for her. Maria made an effort to please her mother. Celebrations held for her mother, such as birthdays, Mother's Day, or name days, therefore became a challenge that placed her under great stress. Every time she had to recite a poem or make a little speech, she burst into tears. Lassnig was well aware that something was wrong with this. "Usually, you'd think, the mother should have tears in her eyes."[60] In 2001, Lassnig wrote down a film idea about her both difficult and intense relationship with her mother. Two old women are sitting on a bench, embody Lassnig. The first one says to the second, "My mother never loved me, she showed few signs of love. She only took me in her arms once. When I was recovering from an illness, she took me out of bed and carried me to the sofa, holding me in her arms, which was unusual." The other woman replies, "But she was a very good mother, who cared for you." The first insists, however, "No, she pushed me away, I always chased after her too much, I was her cutie pie, but she pushed me away." Lassnig wrote in parentheses, "Caresses and kisses were not common in the countryside, but hits were."[61] This also matches Lassnig's journal entry on birch sticks, with which her mother used to beat her.[62]

After all these childhood experiences of ambivalence and insecurity, it's no surprise that Lassnig didn't have it easy in her later relationships. She said it herself, "I am a burnt child, a child burnt a thousand times over."[63] She often pointed out that she had three fathers, too many and too few at the same time. After the death of Jakob Lassnig in 1952, Mathilde married a second time, to the retired financial clerk Paul Wicking. The now-adult Lassnig had a very good relationship with him and called him "daddy." Later, however, she will blame the once-again difficult domestic circumstances (most of which she only caught wind of from afar in Paris) for her mother's death from cancer.

Starting school in Klagenfurt was also difficult. Having now established a middle-class existence, her mother considered the convent school of the Ursulines the best choice. Lassnig was to attend this school for a total of thirteen

years. First elementary school, then eight years of Austrian secondary school, and finally another one-year training course to become an elementary school teacher, all located at the Ursulines. From the farmer's hovel to the convent school—that was a culture shock for a girl who had had little contact with city dwellers, who made a somewhat neglected impression, and who was not used to articulating herself. Lassnig remembered how everybody in class moved away from her in the beginning. Her explanation to herself was that she had a strong smell. She had come full of lice from the farm to the city, and this malady was fought in those times with odorous petroleum. In addition, she was a child who had previously had to make do without many social contacts and who had no command of urban habits. Children are known to be extremely norm-conscious and punish any conspicuous behavior with ridicule and scorn. They called her "stupid Riedi"—Riedi was a nickname for Maria. She was considered a porker, and the Klagenfurt girls found her peasant dirndl dress ridiculous and unbefitting. They mocked her for holding onto her mother's skirt and called her a "mama's girl."

*Meine Eltern
(My Parents)*, 1948

Lassnig didn't quite know what she should do to make herself more popular. She made several attempts but failed to join either of the two groups that had formed among the students; neither the "Hilde Pototschnig clique" nor the "Gerda Reinprecht clique" accepted her. The two cliques were deeply hostile but respected each other. If you didn't belong to a group, it was more or less open season on you, and Lassnig took a beating again and again from other students, no matter which side. She tried in vain to win the favor of other girls. Once she wove them paper baskets as gifts. Cruel as children are, they tore the little baskets out of her hands and ripped them up before her eyes. "What a shock for me! I was so proud of my paper baskets,"[64] Lassnig said, even up to a few years before her death. In her acceptance speech for the Carinthian State Prize in 1985, she pointed out how she felt in Klagenfurt: "Like an inhibited child, a misunderstood schoolgirl, who was laughed at, who sat on the dunce's stool, and wandered weeping along the foggy Lend Canal."[65]

Even in the 1992 retrospective film on her life, *The Ballad of Maria Lassnig*, she remembered then—with humorous distance—the pushing and punching of the other girls. The nuns did not intervene. The gentle women—as Lassnig de-

scribed them—were no match for the students; they were hopelessly overwhelmed. They themselves often had their wimples pulled. Little Maria would never have dared do such a thing. She was a very good pupil with top grades and very well behaved, as she herself later used to say with a slightly scornful smirk. Only in "diligence"—a trait that was assessed like a subject at the time—did she get a grade of C, because she was too shy to speak. Even in old age, Lassnig still attributed her low self-esteem to growing up in the countryside: "zero self-confidence!"[66] The feeling of being excluded from others reeled her in again and again throughout her life. For example, in 1998, when she had problems with the authorities because of her studio in Vienna, she immediately fell into the same old pattern, the feeling of being at the mercy of others once again. "It's no surprise that the poisonous demons of this city only produce poisonous attitudes," she wrote. "As a schoolchild, I was an individual, opposite the pack. Where to run? Nothing's changed."[67] The school was less than ten minutes away from the bakery in the Fröhlichgasse. Nevertheless, Lassnig was plagued on her way to school by "bad boys," who pulled her long braids or teased her. In 2001 she wrote in her journal, "A film idea about my youth: a chicken gets hunted from one corner to another (you only see the hunter's feet) until it runs into a knife. Laughter in the background." There weren't only "bad boys," and Lassnig experienced her first infatuation in elementary school. The six-year-old Pepperl, with the gap between his two front teeth, did it for her. He was the son of a married couple with whom the Lassnigs were friends and with whom they liked to hike Kreuzbergl (Klagenfurt's local "mountain") and dine at Schweizerhaus. While the adults were sitting at the table, the children played hide-and-seek. Once when it was Maria's turn, "I buried my head in my arms, closed my eyes, and counted to twenty." Even before the final words—"Ready or not, here I come!"—something unexpected and marvelous happened. "Pepperl did not hide, but stayed seated next to me, and I felt him gently stroking my head. That evening I joyfully told my mommy. Pepperl was a hot-tempered little child, so the tenderness was so nice."[68]

Lassnig warmly recalled Anna Plank, her elementary school teacher, a gentle person. She recommended stepping out of the way of every ant and beetle to avoid crushing them—a maxim that spoke to Lassnig's soul. Another teacher, later in high school, impressed her. "A chair is not a lifeless thing," he explained to the

(Below and right) Sequences of frames from the animated film *Chairs*, 1971

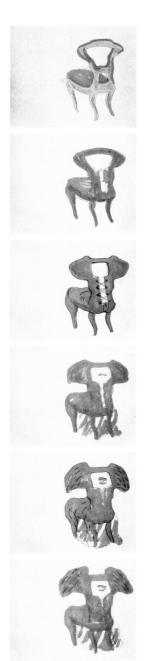

students, "but a living being, so you shouldn't treat it badly." In the 1960s and 1970s, Lassnig drew stools and chairs that are actually more reminiscent of people than lifeless pieces of furniture. In her cartoon *Chairs,* she even animated them. The teacher also said something politically weighty, as if he knew what was coming. He warned against experimenting with humans, "selective breeding" and the like.[69]

Art and fortune-telling

At home, it was easy to keep the child busy. Her mother put a pencil in the girl's hand and she began to draw, without making a peep or disturbing anyone. "My mother had her peace."[70] And in the inn her family frequented, Lassnig drew quietly there, too, sometimes on coasters or paper napkins, and even then she liked to depict the restaurant guests. "And this gave me great pleasure because people realized that I had captured them. I could draw them really well," Lassnig recounted with pride in her voice in 1995.[71] Even in bed, she often had a sketch pad with her and drew. To what extent was she already aware of her talents as a child? Lassnig's statements are contradictory, probably dependent on her mood at the time. In one interview she said her talent as a child was not clear to her at all.[72] In another conversation, she said that in her first elementary school class she was already convinced she could draw better than her teacher.[73] Once on a visit to relatives in Gurktal, all the adults agreed that she had even surpassed her uncle, who as a hunter liked to sketch deer and stags. Drawing opened up a whole new world for Lassnig as a child, which she could escape into while at the same time receiving recognition for her obvious talent. As a sixty-three-year-old, she maintained that art was better for her than any therapist. Having a "shrink" or other life coaches was quite common in her New York setting. "Painting is an elementary activity, my meditation instrument, I do not need a shrink or guru."[74]

Finally, Lassnig found a friend at school, another outsider, a girl named Annamirl, Annemarie Klopp-Vogelsang, who was from a former noble family. Although the nobility had been abolished in Austria in 1919 with the founding of the Republic, each and everyone knew exactly who was a "noble" and who was not, and the "von"[75] in the name was still used by many. Annamirl shared young Maria's passion for drawing and, as Lassnig recalled, as an "aristocratic child" had to learn how to draw. Once a week, she was sent to her aunt, Ella Milesi, in the magnificent Palais Fugger, and

Annamirl managed to convince her aunt to allow her school friend Maria to take part in her private drawing lessons. The old lady had the children copy reproductions of old masters, including the Rembrandt self-portrait from approximately 1657, which is located in Vienna's Kunsthistorisches Museum (Museum of Fine Arts). Lassnig's drawing still exists, signed R. Lassnig—with an R for Riedi—and dated 1931. She was eleven years old then. She remembered well how the nephew of the old lady, Richard Milesi—later a noted art historian, then a teenager—was appalled by the pedagogical methods his aunt ran the girls through the mill with and what kind of art she exposed them to. In those days, he was already interested in modern art. However, Lassnig thoroughly enjoyed copying artworks. While skimming through a history book during school lessons, she discovered a reproduction of Dürer's portrait of Emperor Maximilian I. Without being given the task, she copied this under her school desk. In her *Kantate*, she semi-ironically, semi-seriously declares herself to be a "new Dürer," but she didn't just copy; she also drew her first self-portraits. An outstanding drawing from 1932, when Lassnig was twelve years old, shows her with a serious face and long thick braids.

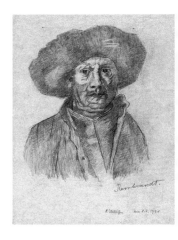

Mathilde was very worried about her odd daughter, who didn't live up to her expectations and who was incessantly drawing. Even how she drew, her mother found strange. She holds her pencil "abnormally," she criticized, "crooked, like fools do."[76] The girl's reticence disturbed her, too; she hardly ever opened her mouth. When little Maria did speak for a while longer and completed a thought, her mother said in surprise, "Wow, you're clever!"—a judgment that did not fit into her previous picture of her unusual daughter.[77] When Lassnig as an octogenarian read a biography of Herman Melville, the author of *Moby Dick*, a particular statement that Melville's father said about the seven-year-old attracted her attention: "He is mentally a bit retarded and a bit slow." She noted this sentence in her journal and added in parentheses, "That's how my mother probably thought too."[78] Another feeling that will accompany her for a lifetime: "I was always very underestimated and misunderstood. Even by my mother!"[79] Nevertheless, the mother decided to support her daughter's artistic will and came up with the money that had to be paid for private drawing lessons with Fräulein von Milesi. There was a weighty reason for this. She had asked someone for advice. A reference to the man who had curiously helped promote Lassnig could be found years later in the 1947–49 Klagenfurter address directory. In the category "Academ. Painter (Artistic painter)," not simply "Maria Laßnig" is listed there (who at that time had her studio at Heiligengeistplatz in Klagenfurt) but also Fridolin Anton Kordon-Veri, who painted landscapes of the Carinthian Lesach Valley in the 1940s. In

Rembrandt, 1931, Maria Lassnig's copy of Rembrandt Harmenszoon van Rijn's *Small Self-Portrait*, ca. 1657

Untitled self-portrait, 1932

addition, he was a photographer who inventoried art-works from 1943–45 as part of Adolf Hitler's "*Führer-auftrag Monumentalmalerei*," which cataloged paintings and furnishings in buildings endangered by Allied air raids. But Kordon-Veri was famous and even infa-mous for something different—and here his role in the early support of Lassnig comes into play. In the 1930s, he attained such fame as a psychic and demonstrator of parapsychological phenomena that numerous detailed articles were dedicated to him in the psychological and parapsychological magazines that were booming at the time. He described himself as the "first scientifically proven clairvoyant" and as a "psychometer." Critical thinkers repeatedly exposed him as a charlatan, but it was precisely this illustrious and multifaceted figure that Mathilde sought out in the early 1930s. Just like Lassnig's biological father, she had a penchant for the esoteric. She brought along a photo of her daughter, whose nature, talent, and life path she was worried about. During the session, the photo remained hidden in an envelope, and, without looking at it, Kordon-Veri put it under a crystal ball, held his hands hovering over it, and pronounced while blindfolded, "Yes, I see a very gifted child, who shouldn't have any obstacles placed in the way of her artistic education." Mathilde must have vividly portrayed this consultation to her daughter. Even at the age of sixty, Lassnig managed to convincingly bring this scene to life in the eyes of her interviewers.[80]

Decades later, in 1974 in New York, Lassnig had a fortune-telling scene in her animated film *Palmistry*. A young woman, whose biographical references soon make it clear that she is Lassnig, consults a Chinese palm reader and with great irony refutes each of his statements with reality. For example, the palm reader thinks he recognizes in her zigzag lines that she was a crazy, wild child. She replies that she was very meek and reserved. When the palm reader suggests she was dominated by her father, she replies that she had no father, or she had three fathers. After the woman contradicts all of the palm reader's statements, he says, "Very well then, it could also mean you're an artist. That'll be 20 dollars!"[81]

In her various interviews, whenever Lassnig talked about her mother's visit to s, she mixed something else in with her expectable ironic distance; you get the impression that she, too, believed a bit in the words of the fortune-teller or had at least fallen in love with the mythical character of the story, which attributed a destiny to her as an artist. In any case, her mother was impressed and paid for little Maria's private drawing lessons. Even the drawing professor

at the Ursulines, Friedrich Hackl, did not overlook the gifts of his pupil, and he also gave her private art lessons outside of school. What she did not come into contact with at all, however, were the many exciting trends in contemporary art, neither what was current nor those of the previous fifty years. More than fifteen years passed before she saw her first Monet or Cubist painting or even works of Surrealism and Dadaism, which were then red-hot. Instead, at school, religious education stood in the foreground. "Art was absolutely not a topic in the convent school. As students, we had to pray, and pray. I hated being forced. But as a child, I was quite pious."[82]

Film stills, *Palmistry*, 1974

The Wandervogel and a key artistic experience

Her most important friend during secondary school was Waltraut Paulin, whom Maria met on the first day of school. In their teenage years, the relationship between the two girls intensified, and Maria spent most of her free time with Traudl, as they all called her back then. She felt very comfortable with the Paulins, more than with her own family. They had the harmony that she so painfully missed at home. Traudl's mother was also gifted in the kitchen and taught Maria how to cook. Like Traudl, Maria also took piano lessons. Mathilde wanted to abandon her past in the farmer's hovel and make a step up with her daughter. Playing the piano was, in her opinion, a suitable rung on the way up the social ladder. When Maria missed a piano lesson, her mother beat her. Actually, she liked playing the piano even though she didn't play very well. She preferred practicing Henri Bertini's *Etudes* because she found them boring and appreciated exactly that about them. She said this is where she started to show her inclination for the abstract. Unlike Maria, Traudl aspired to a professional pianist's career. Later, she married a very likable (to Lassnig) British man and moved to England. For Maria, Traudl remained an important friend throughout her life and was one of the most unconventional people she knew. Traudl's son would later study painting with Lassnig in Vienna and paint a double portrait of his parents posing naked on a piano.[83]

What united the young girls most was their love of nature. Both found the convent school restrictive, particularly being forced to go to church on Sunday: "In order to be allowed to spend time in nature on Sundays, I nearly needed

a doctor's note. You had to apologize that you didn't go to church."[84] The Wander-vogel, one of the most successful youth movements of the time, brought just the right balance. Waltraut Paulin was already a member and recruited Lassnig, who was fourteen years old when she joined. She soon became acquainted with every peak in the Karawanken through extensive bicycle tours and hikes. With the Wandervogel, she got to know many friends, among them Hermine Schilling, and, above all, Rainer Bergmann, who was one year younger and became one of her most important lifelong friends.

The Austrian Wandervogel—ÖWV German Youth Hiking Association— was founded on the German model in 1911 and was from the outset German nationalist, xenophobic, and antisemitic in orientation. In 1913, they had already introduced a so-called "Aryan Paragraph," which denied membership to Jews. In the 1920s, there was a further shift to the right. Hiking in nature was con-sidered a countermovement to urban decadence, idleness, luxury, and excess. A farmer's way of life became the ideal, a simple healthy lifestyle without alcohol and nicotine, one that promoted sexual abstinence. The motto was: "Stay pure and mature." The organization was modeled on the military; they organized field games and met for so-called "maneuvers."

In retrospect though, Lassnig and Bergmann emphasized the unpolit-ical character of the Wandervogel, saying that political things were downright frowned upon in their group. They were especially interested in hiking, cycling, and being outdoors in general. Sometimes there were groups of fifteen teen-agers; sometimes they were only four. Bergmann, his future wife Gerlinde, Paulin, and Lassnig maintained a particularly close friendship. The four were a sworn quartet, with Bergmann as the rooster in the henhouse. Lassnig, who had been excluded so often at school, enjoyed the friendships, the conviviality, the group feeling. In those years, she gained a degree of self-esteem—although it could be shattered easily at any time. She even had a business card made. It read: "Riedi Lassnig, high school student."

On many weekends, the Klagenfurt group of the Wandervogel hiked to Moosburg, where a descendant of the former k.u.k. monarchy, Minister Karl von Stremayr, operated a farm estate where he welcomed the youths. They got a snack, sang nationalist German songs, and practiced folk dances. Part of the young people's pleasure also came from cooking in the open air and spending the night on the farm, in the hay barn or in tents, for example. Despite the motto to main-tain purity, the teenagers gained their first sexual experiences here. At Rauschele, the lake south of Wörthersee, they built a wooden hut, which was a popular destination where one could spend the night in the attic. It was self-evident they could at least cuddle and make out there. A photo series showing Lassnig in a bathing suit in a boat likely originates from summer 1942. All that is seen of

the male photographer in this picture is his foot. When the eighty-plus-year-old Lassnig looked at these photos again, she was peculiarly touched and remembered, "I am not exactly happy about being photographed because I am not sure whether the mild attempt he made to hit on me in the tent the night before is visible. In the photo, his big toe in the corner is similar to mine."[85] One can well imagine how the rather anti-Catholic, even irreligious, Wandervogel could excite and attract a student suffering under Ursuline drill. The Wandervogel offered an almost unimaginable degree of freedom, especially in contrast to the repressive monastery school and Catholic hostility toward the body. If the nuns in the school found the girls' skirts to be too short, they attached wide strips of paper to the seams. At the Wandervogel, the girls wore comfortable casual clothes, and bathing suits when they swam.

Maria Lassnig on a bike tour, 1937

Bergmann recounted that in 1938 when the Wandervogel was integrated into the Hitler Youth, he felt a sense of loss and protested out of a certain elitism. After all, they had been a select troop. Strikingly unsolicited and unrelated to the topic of the interviewer, Lassnig also emphasized in her interviews—as late as 2010—that the Wandervogel wasn't about politics, probably because she had been repeatedly questioned about having been a member of a German-nationalist association.

One thing she did not like so much about the Wandervogel: the "forced confession." One should tell the truth to one another under all circumstances, keep nothing secret, even if it was unpleasant for everyone involved. She remembered making it known to a male friend who worshiped her that someone else was also in love with her. "It was rather upsetting. This shattered him so much that he joined a movement, which worshiped the death's head, and in his yearning for death, he promptly found it."[86] Bergmann also told of a friend Lassnig was in love with who enlisted in the SS in 1938, was stationed in the Dachau concentration camp, took part in the Polish campaign in 1939, and later was killed on the Eastern Front—perhaps the same man mentioned by Lassnig.[87]

Obviously, Lassnig's friends included convinced National Socialists, and she herself had no critical attitude toward the so-called "Anschluss," the annexation of Austria by National Socialist Germany. On December 14, 1938, she, like her mother, left the church, which suggests the identification of the family with National Socialist ideas. In Carinthia, sympathy for National Socialism was particularly high. After the Night of Broken Glass Pogrom (Kristallnacht) in Novem-

ber 1938, the *Carinthian Border Call* (*Kärntner Grenzruf*), the official newspaper of the National Socialist Party, reported that Klagenfurt was the first city in the Ostmark (the Nazi term for Austria) to be "Jew-free."[88] Many years before, there had already been marches by the National Socialists in Klagenfurt, as in other Austrian cities. In 2001, when collecting scenes for her planned autobiography, Lassnig noted an incident when she was about twelve years old and playing hide-and-seek with a few friends at home. She was crouching behind the tile stove when she heard loud voices coming from the street. "There were noises as if from giants, beasts, rhythmic and dark, threatening, growling, pounding bangs in between, with every dull yell a stomping boot sound. The outcry was 'Heil, Heil,' constantly menacing, noisy men, ominous, rough outbursts short and long,

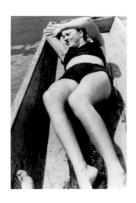

shouting, screaming, stomping, crushing, hands, fire, torch, crush, torchlight parade, a world in flames. The little girls hugged the stove, each other, were frightened, ran to the window, saw torchlight and stomping men in brown uniforms, yelling, fear only fear."[89] But then they felt relieved. One of the girls recognized a familiar face among the marchers in the torchlight procession: "That's my sister's fiancé!" And the girls were no longer afraid; what was threatening had become familiar. Later Lassnig said, "I believe I had a premonition of the coming catastrophe."[90]

Lassnig remembered Mrs. Fischbach, whose lush beauty she admired and with whom her mother had repeatedly gossiped on the street corner. Mrs. Fischbach was the Jewish owner of the children's fashion shop on the corner of Fröhlichgasse and Bahnhofstrasse, where little Maria had once gotten her blue dress with her swinging flounces. In the Fröhlichgasse there were other Jewish neighbors and business owners. As the political situation worsened in 1938, Lassnig's mother said, "Thank God they all escaped to safety in Italy." Lassnig notes, "That was how she cleared her conscience about what had happened in 1938, but we didn't know."[91] She didn't realize how contradictory this last sentence was: If you didn't know anything, you had no conscience to clear. In the remembrance year 1988, as another wave of consciousness about the country's Nazi past washed over Austria following the so-called Waldheim affair, Lassnig painted a picture with the title *1938*. It shows, from above, a kneeling figure on the ground surrounded by a rabid mob. This is obviously the image of a Jew, who was forced by National Socialists and cheering spectators to scrub the sidewalk with a toothbrush.

An almost mythical event—for her, a key experience in becoming an artist—took place in 1937. During this time, Lassnig was taking her high school exit exams and went on a trip with Bergmann. The two were returning from a jour-

1938, 1988

Childhood and Youth in Carinthia

ney to Gottschee, a then-German linguistic island in today's Slovenia around the city Kočevje. Bergmann's girlfriend Gerlinde was there visiting her grandparents. Lassnig and Bergmann decided to visit them there and to combine the whole thing into a serious bike ride, as well-trained Wandervogel cyclists do. From Klagenfurt it was almost 200 kilometers, spending the night as usual in a hay barn. On the way back, just before Ljubljana, the two took a break in an idyllic beech grove. As they were eating their snack, the light was especially good. Lassnig picked up a pencil: "Come on, I'm going to make a portrait of you," Bergmann remembered her words. "It was sheer coincidence" she started to sketch her friend. "He had a handsome silhouette."[92] Looking back, she said she had forgotten in the meantime how good at making portraits she had been as a child. Now she became aware of it again and the great joy it created. Throughout her life, creating portraits was one of the ways for her to grapple with the people who were important to her: "No one can claim to have seen someone, if they haven't drawn them." And "I want to look at people for a long time and look them audaciously in the eyes. The longer I look, the more I see who's looking out. Fortune and misfortune are captured, in dignity, timidity, hope, my eye lens follows this and I can guess it all with each pen or brush stroke."[93] She was also aware of her talent's power: "I can kill an opponent without camera or revolver. I take a good look at their face and then go and represent them on the canvas. But I can also show people how I love them or see through them."[94] Her position on the quality of this work, however, was conflicting. She spoke of "a gypsyesque painting down of a person,"[95] an activity that was a lot of fun for her but sometimes seemed too easy, not intellectual enough, too superficial. "Still, I long for friends and acquaintances and strangers because I want to explore their faces. To research a face still seems to me to be one of the most interesting occupations of humankind, especially if it happens with a pencil."[96] That's how Lassnig explored the face of her friend during their

Rainer Bergmann, presumably 1937

break under the beech trees. When she showed Bergmann the portrait, he was enthusiastic: "You have to become an artist, you should go to the Academy in Vienna." Lassnig recounted again and again that this was the clincher for why she applied to the Academy a few years later, whereas Bergmann downplayed his role. It took Lassnig a few more years after all before she actually got herself together enough to study art.[97]

Bergmann and Lassnig had a trusted relationship throughout their lives, which also allowed them to tease and make fun of each other in a loving way. Bergmann: "It was a very funny relationship!"[98] Their friendship was so stable and withstood all challenges for two reasons—sex didn't play a role, and art was not a central issue between them. With many of her artist friends, she quickly

got into competition, but it was different with Bergmann; he became a success-ful architect and never had to battle with her for the favor of gallery owners, art critics, collectors, and the like. In her journal, many years later, she would call him one of her "good spirits."[99] In fact, he appreciated her artistic work very much. He admired how she went her own way and did not subordinate herself to any artistic schools or trends.

Once, they even worked together. When Bergmann took part in the architects' competition for the Klagenfurter Landeskrankenhaus (Klagenfurt State Hospital) in the 1960s, he asked Lassnig for support. For the model he submitted, she designed the garden with its trees, shrubs, lawns, and paths. Bergmann didn't win this competition, but he won many others. The winner was the architect Ernst Hildebrand.[100] Together with his wife Heide, they were the Klagenfurt gallery dealers for Lassnig in the 1960s and 1970s, as well as some of her most important lifelong friends.

In 1937, Lassnig graduated with honors from the Ursulines. Despite Bergmann's plea and her obvious talent, she didn't think about an artistic career. She didn't know which occupation she should choose and hardly thought about it: "I was like a calf you put in a stable and it just stands there."[101] Her mother was surprised about the carefree nature of her daughter and made a habit of saying, "You're letting God take care of you, huh?" Although Mathilde wasn't happy as a wife, she envisioned for her daughter the life model and path of social advance-ment that she had chosen for herself: a "career" as a housewife, preferably the wife of a "doctor." Lassnig later said her mother had seen how lacking in indepen-dence she was and because of that, marriage seemed the only way to guarantee she was provided for; "She also arranged a dowry for me, with beautiful linen and what not." A potential husband was not on the scene then, so Mother had another idea. Lassnig, like her friend Gerlinde, should attend the teacher training center of the Ursulines and complete the one-year education to become an ele-mentary school teacher. Lassnig followed her mother's wish. However, she did not marry a doctor, and she later repurposed the linen sheets from her dowry as canvases for painting.

Elementary school teacher in the remote Metnitz Valley

After her one-year crash course in teachers' education, she was placed as a primary school teacher in a valley not too distant from Krappfeld and Klagen-furt but absolutely remote, the Metnitz Valley (Metnitztal).[102] Similar to Kappel am Krappfeld, the community of Metnitz consists of many small villages, twenty-two altogether, including Feistritz. The locals speak of "The Feistritz," not of a place where all the houses crowd around a church tower but of an area. In this wooded area, which was only settled in the eleventh century, the farms are often far apart.

Maria Lassnig with skis, ca. 1940

In order to get from one part to the other, hills must be negotiated, gullies crossed, and, at least today, long country roads driven. At that time, in 1939, when Lassnig taught there, there was no road leading to Feistritz, only footpaths. Enthroned at the top of a hill was the church with the vicarage next to it. In this vicarage, on the upper floor, was a twenty-five-square-meter room where class was taught. It was a one-class school, that is, Lassnig had to teach all eight grades, which constituted elementary school at that time; that meant all ages six to fourteen, simultaneously. She herself did not live in the vicarage but in a hamlet called Grades, about an hour's walk away. In order to arrive on time to start class, she had to get up at five. In winter this meant trotting up a steep and narrow pass through the snow. The young, athletic teacher pulled her skis on a rope behind her all the way up to the school and thus shortened her way home with the descent. The daily ascent and teaching—both very strenuous work for a highly sensitive person—consumed her strength nevertheless, and after a few months she became ill. The suspicion of pleurisy was not confirmed; instead a painful inflammation of the intercostal nerve was diagnosed, which often occurs as a result of shingles, a stress-related disease. The associated feeling of burning needles in her chest or back area would repeatedly afflict Lassnig throughout her life.

After Austria was annexed by Germany, the schools were redesigned according to the new system. The Hitler salute was obligatory for all students, and for the teachers of course. The curriculum was adapted to the totalitarian and racist ideology. Teachers had to drill into the children the three pillars for the preservation of the German people: "racial purity," "keeping the blood healthy," and "sufficiently strong offspring."[103] The objectives of elementary school were the "joyful affirmation of the National Socialist worldview" as well as the "preparation for the Hitler Youth and BDM"[104] and "participation in ethnic life."[105] In the primer *Kinderwelt* (*Children's World*), it says: "Hail our heroes! The soldiers are coming! How stalwartly they march! The music is playing too. All the people stop. We salute the Wehrmacht flag. They march to the Monument of Dead Heroes. It should always remind us of the fallen soldiers. They were brave warriors, who gave their blood and lives for Germany. They died so that Germany can live. We honor our dead heroes!"[106] Today it's hard to determine to what extent Lassnig conveyed this content to her students; it was definitely part of her duty to do just that. What separated her from the principles of Nazi pedagogy, however, was her

rejection of corporal punishment. Her former students remembered this very clearly. Unlike many other teachers, Lassnig never used the yardstick as a means of punishment.

She still had her long braids, which she pinned up into a bun. "Ms. Lassnig was a sight to be seen, a real phenomenon!" recalled Antonia Schönfelder, a former student. That their elementary school teacher had become one of the most important Austrian artists was first learned by many of her former students when Lassnig purchased a summer studio in Feistritz at the end of 1985. The now-retired forestry worker Valentin Wurzer, another former pupil, said that only today does he realize the value of his A+ in drawing—after all, the grade was awarded by someone who later became a famous artist. She must have seen something, but he couldn't have known that at the time and therefore didn't take her advice seriously to invest more time in drawing. "Frau Lassnig wanted to persuade me to abandon my dream job of carpenter and to become a painter," said Wurzer, who finally became neither a carpenter nor a painter but rather a forestry worker. Schönfelder remembered that with the help of the teacher, who painted so realistically, "that it looked like a photograph"; you could draw almost anything, "even a skier," which particularly impressed the pupil. Unfortunately, none of these drawings remain. At that time, the children still had hardly any journals but scribbled with a pencil on a slate.[107] Lassnig, on the other hand, kept a sketchbook in which she drew portraits of her pupils after the lessons, often under the great linden tree that still stands today between the rectory and the church: "Those were such clever and beautiful children."[108] Once again, Bergmann was enthusiastic about the drawings and reaffirmed his conviction that she had to become an artist.

During vacation, the bee he had put in her bonnet finally left her no peace and she decided to apply to the Academy in Vienna. Together with a teacher friend, who also taught in an elementary school in the area, they set forth. The two young women swung themselves onto their bicycles, Lassnig's drawings of her pupils on her bike rack. They slept in hay barns; Lassnig's Wandervogel experience had trained her for this. They cycled "over hill and dale" and reached Vienna within two days.[109] At the Academy, Lassnig showed her

Maria Lassnig as an elementary school teacher in the Metnitz Valley, 1939–40

portfolio of portraits to a professor. "And the professor said, you must come to the entrance exam, and I trembled and cried and said I will surely fail, pass out, and have to be taken out on a stretcher. But actually, everything went very well. And from then on, I knew: there's nothing else but painting."[110]

Schooling was almost as important during the Second World War as military service, and teachers were urgently needed. Lassnig therefore turned to Georg Graber, the provincial school inspector of Carinthia, and showed him her sketchbook with the drawings, "and he said: Yes, you must go."[111] This put the permit in Lassnig's pocket, and nothing more stood in the way of her departure to Vienna.

Thirty years later when Lassnig was hard-pressed for money in New York and wanted to earn some cash through teaching, she needed confirmation that she had already worked as a teacher. She wrote her gallerist and friend Ernst Hildebrand and asked him to submit the appropriate documents to the Provincial School Board: "If possible, the confirmation certificate should not include a year (because otherwise they may quickly assume I was a Nazi)—just a stamp and perhaps do it in English: We testify that ML has been teaching for 2 years in O. and Gr. with visible success. The school inspector. Yes, it should also show what I taught: Elementary Class for 6–14 year-old children. Hope that's enough."[112]

"That must have been a terrible time.
Was that how you perceived it then
or did you just devote yourself
to studying and not notice
what was going on around you?"

"Not very much, I have to say.
I was always a late bloomer."[1]

2 Student in National Socialist Vienna

1940-45

Maria Lassnig, early 1940s

Lassnig didn't talk much about the Nazi era or her own role in those years. Her later friends in New York, most of them Jewish women, wondered in retrospect why they had never asked her any questions.[2] They themselves didn't know why. Maybe out of shyness. Maybe because, despite all the allegations in the 1970s, Austria had still somehow managed to convince itself and the world that it had been the first victim of Nazi aggression and was virtually uninvolved in the mass crimes of the Nazi regime. Maybe also because Lassnig had never left any doubt about her antifascist sentiments after 1945. One-and-a-half years after her death, there was some media excitement when a study showed that she had received scholarships and prizes while studying at the Academy of Fine Arts during the Nazi years.[3] The extent to which the artist had subsequently stylized herself into a victim and claimed "resistance" in which she had not participated was discussed. This chapter addresses these questions as well as how the young painter and ambitious student searched for her own artistic language and made important discoveries for herself, despite the aesthetic of the time having been in lockstep with the Nazis.

Dirndl dress, Rembrandt, and home front

In the autumn of 1940, Lassnig moved to her Aunt Nessie's, into a small sublet bedroom at Siebenbrunnengasse 6 in Vienna's fifth district, and began to study at the Academy of Fine Arts.[4] When she began attending Wilhelm Dachauer's class, he was already sixty years old. Like her, Dachauer came from the countryside, Ried im Innkreis in Upper Austria. His paintings mainly focused on his home province, the Innviertel.[5,6] Lassnig's frequently repeated reasoning as to why she was placed in Dachauer's class is convincing: "Probably because my drawings had a rustic farm quality to them—and on top of that I wore a Dirndl dress and had braids."[7]

Dachauer painted symbol-rich images, which strangely glorified country life. *Earth and Farmer* (*Erde und Bauer*) from 1923, one of his best-known works, depicts a nude woman ecstatically writhing on the soil, who almost seems to roll out onto the beholder. She symbolizes the earth. Kneeling powerfully over her, the darkly tanned farmer has his legs spread and his arms raised. His shirt is open to the waist, exposing his broad, bare chest. He is about to throw himself on the woman's body—essentially a rape scene. Many of Dachauer's paintings from this period have a kitschy pornographic quality. When the Academy of Fine Arts recruited him in 1927, the decision to do so was criticized. For instance, Clemens

Holzmeister, a convinced Austrian patriot who would especially thrive during Austro-fascism, found both Dachauer's German-nationalist political attitude and his traditionalist understanding of art problematic, and protested, albeit unsuccessfully, against his appointment. Dachauer was a convinced antisemite and National Socialist who welcomed the German Wehrmacht's invasion of Austria on March 12, 1938.[8] He did not have to reorient himself politically or artistically. His idealization of the farmer and his naturalistic old-master's style corresponded to the aesthetic notions of the new rulers.

On March 21, 1938, a victory celebration took place in the auditorium of the Academy, and a congratulatory telegram was sent to Adolf Hitler: "The Academy of Fine Arts in Vienna, the oldest on German soil, festively convened to celebrate the *Anschluss* [Austria's annexation]. We thank the great master-builder of the German Reich for our salvation from deepest distress. Out of loyalty to our leader, we commit ourselves to fanaticism in German art. The provisional leadership: Andri, Dachauer, Popp."[9] Dachauer, Alexander Popp, and Ferdinand Andri, who was later also Lassnig's professor, thus took over the interim management of the Academy, and the day after the invasion they immediately "cleansed" the faculty of the last remaining Jewish, "Jewish-miscegenated," and politically undesirable university professors.[10] Of course, these expulsions also enabled them to get rid of annoying competitors and to increase their own career opportunities, but Dachauer was already a professor and had no further career advances to make. Thus, in 1939, when he painted a monumental full-length portrait of Hitler for the ceremonial room of Vienna's City Hall, he acted out of conviction, just as when he offered lectures on "Depicting Farm Life and German Myth."[11] As the air raids and reports of looming defeat increased in 1944, he created *And from the Victims of War rises the New Europe* (*Und aus den Opfern des Kreiges entsteht das neue Europa*), a heroic painting conceived for the Reich Chancellery in Berlin. After liberation in 1945, Dachauer was removed from his teaching post. Still, in 1946, he had already been rehabilitated—"de-Nazified"—in the classic Austrian style.[12] After his death in 1951, he received a memorial grave in Vienna's Central Cemetery.

This is the political environment that professor Lassnig found when she arrived in the winter semester of 1940–41, and she soon became one of his favorite students. She was highly gifted. What plagued others came easily to her. The struggle to find the right color and the appropriate form, which would regularly accompany her later work, was still foreign to her at that time. She was immediately up to the job, whether it was portraits, nude studies, or rural scenes. In old age, she still proudly recalled how her classmates had told her, "Maria, you don't even know how good you are."[13] Dachauer demanded

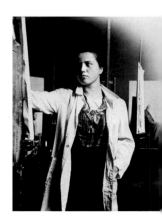

Maria Lassnig at the Academy of Fine Arts, Vienna, summer 1941

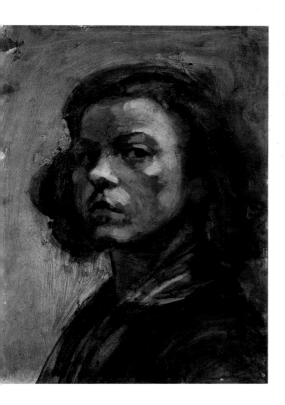

exact drawing according to nature. You weren't allowed to use an eraser. What went wrong was thrown away. Heimo Kuchling, an art theorist and later an important friend of Lassnig's, was convinced: "Maria Lassnig definitely learned something from Dachauer: Seeing."[14] When she had completed one of her first self-portraits at the Academy, the professor said enthusiastically that she painted like Rembrandt—of course the student felt flattered. At the time, Rembrandt was regarded as the heroic artist type, along with Dürer, and although Dutch, he was reframed as an "essentially German" painter—and therefore an ideal figure for Nazi cinema. The film *Rembrandt* with Ewald Balser in the title role was filmed on original location in occupied Holland and premiered in 1942. The film aimed to place Nazi art in the tradition of the old masters, and implicitly drew parallels between Rembrandt and Hitler; just as Rembrandt was misunderstood, the small minds and complainers on the Eastern and home fronts had misunderstood Hitler, whose tremendous accomplishments could only be appreciated for their full importance with historical distance.[15] The film showed the artist as a genius and a sufferer, whose financial ruin was blamed on his Jewish moneylenders and backers. Historically this is outrageous nonsense, of course. The climax of the film was the final scene: Rembrandt, the impoverished old man, ascends from his gloomy old cellar with a candle, climbing a spiral staircase to his loft. There, he approaches a dust-covered painting, wipes it off, and illuminates it with his candle. One can see it's the *Night Watch*, later to become his most famous painting. Despite all the misery, Rembrandt can draw a positive conclusion at the end of his fateful life: "I did not live in vain." Lassnig also saw the film, and, to a certain extent, the conception of an artist's life propagated in the film may well have even influenced her. In 1989 she referred to this final scene and noted it in a drawing: "Unfortunately, I lived in vain, and so did Rembrandt."[16] There is much irony in this on the one hand. On the other, it also expresses her own pessimism as well as her eternal suffering from having received too little recognition (from her point of view).

Back at the Academy, however, she definitely found no lack of approval. This is reflected in the numerous study grants she received. In 1943, she was awarded the Reich District Scholarship for Carinthia two times, with 600 and

375 Reichsmarks, respectively; in addition, she received an 800-Reichsmark study grant from the Reich Governor in Carinthia; and in 1944, again was awarded the Reich District Scholarship for Carinthia with a one-time sum of 375 Reichsmarks. After earning her diploma in February 1945 (a few months before the end of the war), the Academy awarded her the National Scholarship, endowing her with 500 Reichsmarks for further artistic education. The former purchasing power of a Reichsmark corresponds to three dollars today. In 1942, she participated in the large 250th anniversary exhibition of the Academy of Fine Arts with seven graphics—only a few other students were allowed to present so many works. The jubilee event was a propaganda spectacle in which big Nazis received honorary membership in the Academy; among them were District Leaders and Reich Governors Arthur Seyss-Inquart and Baldur von Schirach. Lassnig was only in her fifth semester at the time and showed, among other things, a nude study, sunflowers, a landscape, head studies, and a bacchanal scene from classical mythology.[17]

In addition to such traditional tasks, Dachauer also had his master class produce ideologically charged Nazi content. An example of such an exercise was the topic *Homeland and Front* (*Heimat und Front*)—a sketch found in a portfolio of drawings that Lassnig created at the Academy. She depicted a man and a woman according to their roles in Nazi ideology—the man, a brave soldier; the woman, a German mother staring seriously into the future—both with a highly elevated, determined chin, which Lassnig noted on her sketch: "chin position." The task may very well have been to pay special attention to this. So she conformed, and her achievements fulfilled the required aesthetic and thematic norms. But here she had reached the limits of her artistic development and would soon become aware of this.

Absolute color vision instead of "brown sauce"

In addition to the master class for painting, Lassnig also attended the so-called supporting subjects such as "Perspective" with Herbert Boeckl, "Theory of Color" with Eduard Haschek, and "Chemistry of Color" with Albert Magnaghi. These last two lectures, which she completed in her second year of study, especially illustrate how her interest had already turned to color. Dachauer demanded tone-in-tone painting in muted colors. "I've always painted brownish with this professor,"[18] she said. Lassnig stated this even more ambiguously and ironically in another interview: "My color experiences at the Academy were limited to brown sauce."[19] From this time on, the color brown would only play a minor role in her art. When she was well over eighty years old, she wrote in her journal, "Could it be that I am afraid of using brown because of our past?"[20]

As an aesthetic guideline, Dachauer recommended the rustic farmer paintings by long-dead artists Hans Thoma and Wilhelm Leibl or historical paintings by Franz Defregger. A contemporary role model was the Nazi painter Sepp Hilz, who, among other things, became known for his *Peasant Venus* (*Bäuerliche Venus*) from 1939, a cheesy oil painting of a young farmer's wife undressing in her bed chamber: "He made a big exhibition for Hitler, with lots of women in beautiful traditional Dirndl dresses."[21] Anything that betrayed even the slightest signs of Classical Modernism was frowned upon by Dachauer: "Egger-Lienz was already pushing the limit. Yes, that was already a bit too risky, you know, too expressive."[22] The deep contempt in Lassnig's voice was unmistakable. The fact that Dachauer also rejected the East-Tyrolean artist Albin Egger-Lienz (who died in 1926), despite the fact that many Nazi art theorists used him for their Blood-and-Soil cult, speaks volumes about his understanding of art.

Lassnig later criticized her own artistic taste from back then: "In the beginning, I liked everything," she laughed. "My God, I came from the Ursuline convent, where there were no pictures to be seen—not a trace of art education!"[23] And: "Before this I was too stupid and childlike."[24] But even if she had possessed the corresponding interest at that time, there were few possibilities for her in the years before Nazi rule to look into the trends of contemporary art. In the provincial and arch-conservative Klagenfurt of the 1930s, hardly anyone was prepared to engage themselves with the currents of international contemporary art. Even the Carinthian Colorists, who later became famous, seldom had the chance to show their work in Carinthia. That became even more difficult after 1938. During her studies, Lassnig would only have had a few opportunities to receive even the most rudimentary impulses of the modern era. Perhaps she attended the *Young Art in the German Reich* exhibition, which the Vienna Künstlerhaus (House of Artists) displayed in 1943 on the initiative of Reich Governor Baldur von Schirach, showing almost six hundred works by more than one hundred and fifty artists. The exhibition was denounced as "liberal smut" and "as a moderate form of decadent art," among other things, and closed prematurely.[25]

That von Schirach supported this exhibition was not at all an act of resistance to the Nazi regime but an expression of inner-party aesthetic differences. The exhibited works were also far from reflecting the international art discourse of the time. If anything, they showed weak influences of French Impressionism, an art movement that had reached its peak seventy years earlier—apparently this was reason enough to provoke great protests. Hitler described the show as "sabotage, with the goal of culturally opposing the Führer."[26] The same year, 1943, Lassnig may have visited the exhibition *German Drawings from the Turn of the Century* at the Albertina Museum, which had also been commissioned by von Schirach. There she would have seen drawings by Gustav Klimt, Egon

Schiele, Käthe Kollwitz, Lovis Corinth, and Alfred Kubin. In an interview, she mentioned her class once traveled to Munich to see an art exhibition: "If you don't know something, then you don't know what you are missing. But then we saw it: Woooah 'Look at all of this' and then I started doing such things myself."[27] There she seemed to have discovered something, which inspired her to adopt a new style of painting and didn't conform solely to the dreary Nazi aesthetic. Which exhibition this could have been, and in what year, can't be determined. The Academy made repeated excursions to Munich to show the students the official exhibition of Nazi art, the *Great German Art Exhibition in the House of German Art*, which took place in Munich every year between 1937 and 1944. It is very likely that Lassnig was also on one of these excursions. The most inspiring show for her would certainly have been the propaganda exhibition *Degenerate Art (Entartete Kunst)*, which defamed modern artworks. But it's extremely unlikely that Lassnig saw this. The exhibition took place in Munich in 1937 and in Salzburg and Vienna in 1939—years before Lassnig studied at the Academy. In 1937 she was a student of the Ursulines, and in 1939 she was an elementary school teacher in the remote Metnitz Valley.

Besides a few impulses beyond the official Nazi aesthetic, the young artist felt a need for something different, something new—especially color: "I had to develop my color vision on my own."[28] She turned away from the naturalistic tone-in-tone painting, put herself above the real colors of the objects, and experimented with pure colors, white, red, or yellow. But soon this didn't satisfy her. "Just painting in elementary colors, that wasn't enough for me, for example just yellow like Van Gogh ... That was Van Gogh's great accomplishment of course, but for me it was a great achievement to see the colors absolutely."[29] First, she stared at a tiny dot of color and focused only on it—with blinders on, she said. She called this method "vertical color vision" because she looked at the color at a right angle without letting her eyes wander: "I first had to learn that it depends on me how a color looks; there is no such thing as *the* color. I got to know relativity through colors. I looked at a miniscule dot—as long as I needed to analyze it. At first you can see the color normally, red as red, blue as blue."[30] But the longer she fixated on this dot of color, the more it started to change. Gray appeared first. Suddenly the color turned into its opposite, its complementary color. Red became green. Yellow became purple. Lassnig was thrilled. She described this process as "a glowing into or re-melting of color into colored gray, to an almost glowed-out gray, and back to color."[31] On another occasion, she explained this process once more: "I stared at a dot of color for so long, until the color changed so that I could create it, you know?"[32] Lassnig later described this intense examination of color as her first intellectual experience.[33] In retrospect, she felt she had discovered basic principles of Classical Modernity quite independently at that time, without

having been confronted with the relevant works: "I dissected the color without first actually knowing of Cézanne or the modern painters who already existed, and some told me you paint like Kokoschka, but I didn't know who Kokoschka was because these people were all scorned by the Academy. They couldn't even be found in the library."[34] Under the Nazi regime, the Austrian Expressionist Oskar Kokoschka was the epitome of a "degenerate" artist, his works were removed from the museums and partly destroyed. The propaganda exhibition *Degenerate Art* presented eight of his works as particularly detestable examples.

Regardless of whether Lassnig took on a few impulses from the outside or whether she found her way to a new style of painting through her own exploration and research, her professor found even the slightest hint of modernity an abomination and didn't know what to do with her experiments. Her "painting like Kokoschka" must have been a thorn in his side, and decades later she recalled him saying, "You paint like a degenerate, Lassnig, you're corrupting my students!"[35] They fell into artistic conflict. Nevertheless, Dachauer defended her when she got into a personal dispute with a classmate who threatened her with a student tribunal. The classmate was a German female auxiliary volunteer who Lassnig claimed was envious of her artistic success: "She was wearing make-up. Was all done up. I mocked her for this. So, then she sued me in a student court."[36] Lassnig rarely told this story and told it in a somewhat contradictory way. She appears to have confronted her fellow student with the Nazi motto: "A German woman does not wear make-up." There is nothing in the Academy's archive. Lassnig's stories are the only source.[37]

She came back to this a few times when she was addressed about her years of study during National Socialism. The news magazine *Profil* asked Lassnig, "What goes through your mind when the remembrance year is celebrated? You were an art student in National Socialist Vienna."[38] Lassnig replied: "I also got a sense of it, even though I was still very childlike back then. Once I was even dragged before a student tribunal because I had made fun of a colleague who was active as a Wehrmacht helper." What's noticeable here is that Lassnig answered the question about the Nazi period with a story that portrayed her as a victim of the system. She also mentioned that she was "still very childlike" back then, which translates as politically naïve and unreflective, but this is just a side note from her. Lassnig suggested vaguely, but never explicitly expressed, that she was uncritical and unreflective toward the Nazi regime or had adopted a too apolitical stance perhaps—in short, she just went along with it. In her surviving journals, we find neither an indication that she dealt with the racist persecution of Jews nor do we find any mention of antisemitic or other statements committed to National Socialist ideology. Later she mentioned that her Aunt Nessie, with whom she lived in Siebenbrunnengasse, had made her aware of the synagogue just a few

houses over, which had been destroyed during the November Pogrom in 1938 (the so-called *Reichskristallnacht*).³⁹ Lassnig then asked in horror why the synagogue had burned—an indication of the artist's naive and unworldly perspective at that time. She described herself as a late bloomer. On another occasion, when asked how it was in the Academy during the Nazi era, she said, "We were not confronted with politics, I have to say, honestly say, you know?" Shortly after, she hesitantly answered the question of what it was like after 1945: "By then I'd already discovered what National Socialism was all about ... I'd already seen it as ... I'd felt it as oppression in a way, I must honestly say, because of the threat of a student tribunal."⁴⁰ Unlike a lot of Austrians, after 1945 she quickly realized how criminal the Nazi regime was.

Whatever Lassnig may have said to her fellow student, it seemed to not have been a political conflict but rather a personal one. Still, it was enough to get her into trouble. She was terrified in any case and was afraid of getting caught up in the mills of Nazi despotism, whereas her classmate adversary could count on political support because she was a Wehrmacht helper. Nothing happened to Lassnig, however—probably because Dachauer protected her despite their increasing artistic differences. When these became insurmountable, Dachauer asked her to leave his master class: "It would be better if you go"⁴¹—that's how Lassnig remembered it. However, her letters to her mother from autumn/winter 1943–44 suggest instead that Lassnig herself had decided to switch to another professor to get new artistic impulses.⁴²

In many of Lassnig's 2014 obituaries, it was said that she had been forced to drop out of her studies at the Academy because her painting style was classified as degenerate.⁴³ When a book on the history of the Academy of Fine Arts under National Socialism appeared in 2015 and documented, among other things, that Lassnig instead had continued to study and even received some scholarships, it caused quite a stir.⁴⁴ The artist was deceased and was now being accused of having stylized herself as a victim. However, Lassnig had never claimed in any known source to have been expelled from the Academy. Perhaps it suited the desires of some journalists to reinterpret Lassnig's departure from Dachauer's class as a resistance story. Some were probably grateful to be able to free the artist from all ambiguities by conjuring up a story that she had been thrown out of a National Socialist educational institution. This corresponded far more with the cliché image of a great avant-garde artist—especially one who had been misjudged by the National Socialists. Lassnig herself, however, repeatedly pointed out that she had received a lot of recognition from the Academy and that Dachauer had greatly appreciated her. As an interviewer said, "But nevertheless you were expelled from your master class." Lassnig answered relativistically: "Yes, indeed, although my professor, Wilhelm Dachauer, loved me."⁴⁵ Lassnig thus left

his painting class but by no means the Academy. Dachauer's artistic ideas were retrogressive yet still within the framework of Nazi aesthetics. Even if a student like Lassnig did not follow his guidelines, it was far from intolerable for the Academy as a whole. As the scholarships prove, Lassnig did not principally offend anyone. She was a well-adapted, ambitious, and gifted student who did not want to interest herself in politics but had reached a point where her artistic needs and aspirations were no longer compatible with those of her professor. The fact that she did not let herself be deterred shows how seriously she took painting. She therefore switched from Dachauer's class to Ferdinand Andri's; this, too, Lassnig stated repeatedly and made no effort to conceal—"And then I went to professor Andri, where I could do what I wanted."[46] An obituary in *Die ZEIT* misinterpreted this as an event that had taken place only after 1945: "After the Nazi craze, she completed her studies with Ferdinand Andri and Herbert Boeckl."[47] In reality though, Lassnig switched to Andri in the winter of 1943 and at the same time attended the evening nude drawing class with Boeckl. She studied for another two semesters and graduated in December 1944. In January 1945, she received her diploma as an academic painter—which wasn't "after the end of the Nazi craze" but during it. These misinterpretations, especially in the obituaries, shouldn't be blamed on Lassnig. What she can be blamed for is her uncritical and well-adapted attitude toward the Nazi regime, which she quickly reconsidered after 1945, however. But she didn't sufficiently counter well-meaning journalists or make a clear effort to correct false claims.

Summer 1943: between the "national-political" exhibition and Carinthian Modernism

Ferdinand Andri led the master school of mural painting and frescoes, a genre of special concern to him, which he wished to revive. Lassnig also tried her hand at fresco painting. She spent the summer of 1943 in Carinthia and was hired by the Carinthian artist Switbert Lobisser. She was to assist him in his work on a fresco in the Kohldorfer Strasse in Klagenfurt, Lobisser's last work before his death. The painter was considered to be the "ideal figure of a German artist, what the Führer wanted," said Friedrich Rainer, the former Reich Governor of Carinthia.[48] After Anton Kolig's frescoes in the Carinthian government building were destroyed in 1938, Lobisser decorated the hall with a monumental series of paintings: *Carinthia's Return Home to the Reich (Heimkehr Kärntens ins Reich)*. His giant *Memorial to the SA Stormtroopers (Mahnmal der SA)* in Lamprechts-hausen near Salzburg glorified the 1934 uprising of the—at the time illegal—National Socialists.

The fresco, which Lassnig collaborated on, shows a rather unpolitical and kitschy family scene with clearly assigned gender roles: a breastfeeding mother is

surrounded by girls with flowers, while father and son valiantly go out to chop wood. Later on, Lassnig found this collaboration with a prototypical Nazi artist embarrassing. She said that Lobisser didn't let her contribute anything of her own; he only let her paint the aprons. When Lobisser died shortly after their joint work on October 1, 1943, she visited him at his death bed and drew two sketches of his dead visage in her journal.

In order to be able to assist Lobisser in Carinthia in the summer, she needed an exemption from the Academy "for a cultural work assignment in the Nazi district of Carinthia" in July 1943, as stated in a letter to the Academy to the head of the Reich Cultural Chamber in Carinthia. The Reich Labor Service was part of the Nazi education system, and participation in it was required in order to be eligible for higher education at all. Women had to work primarily in agriculture, in offices, and in armaments production. In their non-study periods, both male and female students also had to perform such tasks. While Lassnig had worked as a harvester on farms in the preceding years (among other places in Rechnitz, Burgenland, in 1941), she was able to fulfill her labor service duty as a specialist in the summer of 1943. She was not only to assist Lobisser but also to participate in a "national-political exhibition."[49] Incidentally, her application was also strongly supported by Dachauer, her not-yet-ex-professor. Even though he no longer wanted her in his class, he still stood behind her, promoting her liberation from non-artistic labor.

In the same summer, Lassnig took a trip that was much more important for her artistic development than her work in a national-political exhibition or her work assisting Lobisser: She visited Franz Wiegele, an important pioneer of Modernism in Carinthia. The then-fifty-six-year-old artist had retreated to his birthplace in Nötsch in the Gail Valley in southern Carinthia. No other place outside urban centers was of comparable significance for Austrian Modernism, especially in the interwar period. Not only Wiegele but also Sebastian Isepp was born in Nötsch, and both Kolig and Anton Mahringer had their studios there. Art history thus speaks of the painters of the Nötsch Circle, even if they did not form a closed group of artists. Although they worked in the most remote Carinthian province, the Nötsch artists had been in close contact with Schiele and later with Kokoschka, Boeckl, Clemens Holzmeister, and many others. What bound the four Nötsch painters together, in addition to their personal friendships, was their interest in painting as an art of color—and that is precisely what so-called Carinthian Colorism was all about—and this attracted the young Lassnig. Wiegele stood for moderate Modernism. During his stay in Paris, he was more interested in the Impressionists, or in Van Gogh and Cézanne, and less interested in the then-super-trendy Cubism of Pablo Picasso and Georges Braque. The Old Masters in the Louvre attracted Wiegele even more. It was completely different

when Lassnig traveled to Paris for the first time with the help of a scholarship in 1951, together with Arnulf Rainer, her great love at the time. Rainer and Lassnig didn't set foot in the Louvre. The two of them lusted for Modernism, for the most current and contemporary—for everything they had been completely cut off from during the Nazi era. However, during the Nazi years, Wiegele's art might have been the most modern that Lassnig encountered. From the middle of the 1920s, Wiegele had cozied up to nationalist ideals in his art, but after the seizure of power by the National Socialists, he returned to a more expressive style in strong colors. Precise observation was very important to Wiegele. He maintained the principle that "a blade of grass casts a different light at ten o'clock than at eleven o'clock."[50]

The Nazi cultural politicians generally rejected Wiegele. Andri, the professor who admitted Lassnig to his class in the autumn of 1943, had already done everything in the inter-war period to prevent Wiegele's appointment at the Academy. Wiegele had then himself decided against a professorship because he only saw stagnation at the Academy: "and it's state-sanctioned too! I cannot and do not want to participate in this at all."[51] The only work of art the Nazis ever commissioned Wiegele to create was a mother-child painting, which he never

Maria Lassnig, as an assistant of Switbert Lobisser,
in front of a fresco at Kohldorfer Strasse 37, Klagenfurt, 1943

completed. And he sympathized with the Gail Valley's Slovene population and spoke Slovenian demonstratively and publicly.[52]

In the summer of 1943, Lassnig decided to visit this fascinating artist. She set off with her fellow student Rudolf Wohlmuth, who worshipped her back then. Wiegele was not in Nötsch at that moment but in his hunting cabin in Kesselwald, about twenty kilometers away. He had an art studio set up there as well, amid stag antlers and stuffed wood grouse on the walls. Lassnig showed him an oil painting depicting a peasant girl. Wiegele must have been impressed by this colorful painting because Lassnig later wrote on the back: "Highly praised by Wiegele in 1943." She also showed him a self-portrait. Lassnig recalled Wiegele then saying, "I give this girl credit."[53] He did not comment on the work of her fellow student, however. Lassnig was impressed by the solitary artist, and after her return to Vienna, she wrote him a letter that illustrated her intense search for her own artistic identity. She enclosed photos of her work, including a female nude and another self-portrait. She requested comments and feedback from Wiegele. Self-confident and self-critical at the same time, she wrote, "I am not ashamed of the many defects in the tone, in the body's boundaries, and in the unity." The interest she would pursue her whole life in various forms is already hinted at here: "I still can't manage to remove the person from the clutches of the contingencies of their environment and mood, like one removes a nut from its shell, to find out the reason, the purpose of their feelings." She ended her letter by reminiscing about the hunting cabin: "The memory of your wonderful place in the Kesselwald, so close to God, is one of our favorites."[54] Just a year later, Wiegele invited her to visit him again for an artistic exchange: "Would it be fun for you, to draw with me, for example, the beautiful old subject of the Three Graces. These ladies shouldn't be dull as dishwater, but look like real dishes! Can you do that?"[55]

Wiegele also asked Lassnig to bring her own linen to Kesselwald because he had to do the laundry himself. It is unknown whether Lassnig took him up on his offer. Just five months later, on December 17, 1944, Wiegele was killed at his home in Nötsch by an Allied bombing raid. In retrospect, Lassnig described

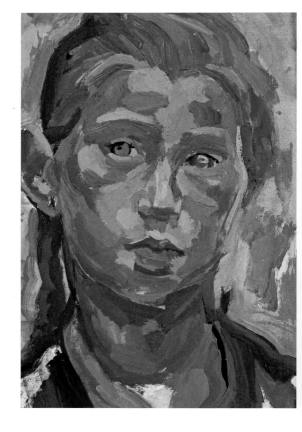

Bauernmädchen (Farm Girl), 1943

Wiegele as the Cézanne of Carinthia, in contrast to Kolig, whom she character-ized as the Carinthian Van Gogh.[56] Kolig was another important representative of the Carinthian Colorists. Lassnig wouldn't get to know him until 1946. She later visited him in Nötsch and had an artistic exchange with him, too. Kolig wrote her several letters, calling her "Dear adoring disciple" and signing with "Father Kolig" or "Painting Father." He advised her to be free and independent of role models: "With worn-out shoes you dance neither beautifully nor well, which is the same for me, and if you make your shoes yourself, as I did for myself, I am happy to provide you with my experience, my insights, my knowledge."[57]

When Lassnig was later asked whether she felt influenced by Carinthian Colorism, she always confirmed this. She traced the important role of color in her work back to her Carinthian origins: "Yes, I think it arises from this place be-cause the border to the south is there, and you see more colors, too, probably due to the greater sunlight."[58] Sunlight was an important working condition for her throughout her life. As an eighty-year-old she noted, "I need the sun as a trigger for the pure colors. In the natural environment, every color is refracted, meaning the colors are mixed with each other. The less the sun shines on the world, the harder it is to identify individual colors amongst the mix."[59]

She later became famous for her very special way of combining colors, but as a student she felt she had not yet found her own colors: "I see myself taking paint from others' pots, and detest it so much. I'd kill myself on the spot, were it not for the hope that it is my hand and my heart that makes the difference."[60] She was aware of how subject to external influences she still was, sometimes even copying someone or using certain elements of another artist—the most natural thing in the world when you're learning but unacceptable to Lassnig, a highly gifted artist who desperately wanted to find what was hers.

Lassnig may have received the tip to visit Wiegele from Boeckl, who had gotten to know Wiegele back in the 1920s. Boeckl, whose nude drawing classes Lassnig attended, was one of the few at the Academy to whom she owed creative impulses. She didn't, however, see his important works until after 1945. He did not display any of these during the Nazi period, she recalled: "His painting was quite extraordinary during the war and would probably have been considered degenerate, so he hid himself away with his painting."[61] Some of his works quite possibly corresponded with what the National Socialists labeled as "degenerate" or "the decadent art of decline." He was not persecuted as a "degenerate" artist but was the least displayed of all artists employed at the Academy. At the 250th Anniversary Exhibition in 1942, he participated with merely an oil painting and a pastel—while Lassnig, the student, exhibited seven works. Unlike other profes-sors, Boeckl's fiftieth birthday was not publicly celebrated.

He was one of the few within the Academy who identified with principles of Modernism, albeit from a Catholic perspective. His painting in the 1920s was expressive, plastic, and corporeal. Color played a central role. During the Austro-fascist corporate state, which elevated political Catholicism to a state ideology, his career reached its climax. In 1934, he received the Grand Austrian State Prize and became a professor at the Academy in 1935. In the Nazi era, Boeckl was one of those artists who was tolerated, but the Nazis regretted that he did not recognize the "greatness of the time" and did not contribute enough to the "movement."[62] Boeckl was also a member of the National Socialist German Workers' Party (NSDAP). In his 1944 Nazi file, it is noted about him that "the National Socialist world view … is not expressed as much as one would expect from a party comrade."[63] It may have been true in his case what everyone else later claimed for themselves: he became a member, not out of conviction but out of opportunism, in order to continue teaching at the Academy. He said in 1946 that for career and economic reasons, and as the father of nine children, he came to terms with the Nazi regime "out of pure self-preservation instinct."[64] Artistically, however, he did not adapt. In order to avoid conflicts in content and aesthetic form, and perhaps also due to pressure from the outside, he stepped down in 1939 from teaching his master class at the Academy. He took on the daily evening nude drawing class that was obligatory for all students. Here he was less exposed than in the master class. After the end of Nazi rule, Boeckl became rector of the Academy but had to resign the following year when his NSDAP membership, which he had concealed, became known, whereas his nightly nude drawing class, which he ran until 1965, gained legendary status, especially after 1945. Countless artists who became famous in the post-war era went through his school: Ernst Fuchs, who was then only fifteen years old and had just returned from exile, Arik Brauer, Josef Mikl, Wolfgang Hollegha, Adolf Frohner, Alfred Hrdlicka, and many others.

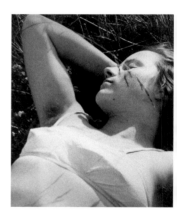

Maria Lassnig, ca. 1943

Boeckl was an impressive and charismatic personality who had a great impact on young people. "Draw shape!" was his constant emphatic plea. He'd walk between the students and sometimes sat down next to the very talented ones. Time and again, he sat down with Lassnig, took the pencil out of her hand, and drew into her sketch or even erased something. Boeckl only did this with works that had potential, and when he drew something into them, the students were not upset but rather the opposite; they were happy for the recognition. Boeckl's credo was a painter does not copy the world but transforms it. In 1943, Lassnig noted in her journal, "Boeckl once said: We are here to master the chaos of the world—how right he was!"[65] Boeckl could become very emotional in his

speeches. He spoke of a divine ray that strikes the artist: "The ray burns him, and from the immense elevation the artist plunges into nothingness, into despair."[66] Parallels to these statements can be found if one compares Lassnig's journal entries and notes from that time. Her journal also showed how self-critical she was with what she had achieved after having painted a lot in this intense summer of 1943. She spoke of four steps through which she perceived her pictures: "First I imagine them, consciously, mostly unconsciously, but I'm only hanging onto old ideals." Then the practical implementation followed: "Then I saw it becoming and cursed my hands, which had so little connection with my eyes." Now a somewhat more optimistic, almost euphoric moment: "... after some time, I am able to admit there are good parts, and I forget the real nature of it, and worship with enthusiasm what I created." This short flare of self-praise is followed by the scathing verdict: "And now I only want to kindle hell-fire with it. It's crap."[67] A few weeks later she wrote of moments when something succeeded: "May these blessed moments last longer." And: "There are still short flashes, but it must be one long day."[68] She was hard on herself and wanted to bring about something better. She compelled herself to do so by remembering clever quotes, such as Schopenhauer's inspiration: "I feel like the alchemists who, when they were only looking for gold, discovered gunpowder, medicine and similar things."[69] Even though she hadn't (yet) found what she was looking for, she discovered other useful things. Soon, however, she would create a work that she would still be proud of at the end of her life.

The *Green Self-Portrait* from 1944: "It's all very fleshy"

In autumn 1943, Lassnig continued her studies with Andri. Like Dachauer, Andri was also a National Socialist and antisemite. He was a leading member of Athenaia, a fraternity of art academics. The Athenaia strictly rejected the founding of the Austrian First Republic as a "movement led by Social Democrats, Communists and mainly Jews."[70] In the interwar period, the fraternity became a pioneer of National Socialism, so it was not surprising that in 1933 Andri had already joined the NSDAP, which was then illegal in Austria. Long before 1938, he actively supported National Socialist students: "Professor Andri performed at his academic teaching post in his school in such a way that only Volk-conscious Germans were well received and the school grew to become a power source for the NSDAP,"[71] Nazi files praisefully state. Politically, Andri is therefore no less National Socialist than Dachauer. Artistically, however, he differs. Although his work is also dominated by peasant-farming motifs, his painting style does not seek to be of the old master and naturalistic kind like that of Dachauer. Andri's style is influenced by Art Nouveau and the Vienna Secession, which he was president of from 1905 to 1909: colorful, ornamental, and decorative. Unlike

Selbstporträt (Self-Portrait), 1944

Student in National Socialist Vienna

Dachauer, Andri was once part of the artistic avant-garde in Vienna. Lassnig's experiments with an expressive, coloristic manner of painting were therefore in better hands with him.

The names of modern artists who were considered degenerate during the Nazi era started to appear in Lassnig's journals as of 1944, presumably tips from Wiegele or Boeckl. She read Van Gogh's letters to Anthon van Rappard and identified with his hypersensitivity: "Understandable that the 'great sensitive' perished at the hands of the abnormal idiocy in his surroundings." But then she also wrote critically: "My enthusiasm for Van Gogh has changed. At first I admired his work without liking it. Now I like it without admiring it. From his letters it can be seen that he had adopted his technique from the Japanese (strongly decorative), and his fondness for the peasant-farmers and the simple life from Millet."[72] She resonated with disappointment about the fact that even the great Van Gogh assimilated impulses from others, such as the French painter Jean-François Millet, one of the leading representatives of the Barbizon school, or that he was influenced by Japanese woodcuts, which experienced a boom in France at the end of the nineteenth century. Lassnig clung enthusiastically to a romantic ideal of the artist to which she never quite said goodbye. According to her conviction then and perhaps also later, a really great artist invents everything herself. That could be one of the reasons that she insisted on having had no information about Classical Modernity during her Academy time and virtually developed its principles on her own. That might have been true for her first years with Dachauer, but later she kept writing down names of so-called "degenerate" artists. For example, she read the aphorisms of Franz Marc and absorbed the theories of Wassily Kandinsky about how pure composition evolved out of realistic painting and ultimately became abstract painting.[73] Fascinated, Lassnig wrote down keywords: "Quantitative reduction results in qualitative magnification, therefore: a minimum of figurativeness results in the strongest realness." Some years later, she temporarily considered abstraction to be the only adequate way to approach reality. She hadn't yet gone this far in 1944: "Do not omit (= abstract) too much too soon. The discovered or invented fullness must first be there." This idea was also to be found decades later with Lassnig. Abstraction for the sake of abstraction—this artistic fad never interested her. For her, abstraction was always closely linked to perceived reality. She even quoted Cézanne: "One has to see nature like nobody before us has ever seen it." And she took note, "Cézanne does not start with a completely coherent figurative object or body, but with color patches and their modulation."[74] Last but not least in her journal, she mentioned the names of ostracized contemporaries like Kokoschka and, in Lassnig's spelling, "Pikasso." She seemed to be doing a little bit of mythmaking in later interviews when she described herself as completely cut off from Classical Modernism.

After all, she had studied with Boeckl, who admired Van Gogh and Cézanne as great role models, and she saw the works of Wiegele and maybe other Nötsch Circle members. Furthermore, she read texts from Van Gogh, Cézanne, Marc, and Kandinsky, but it was certainly not easy to access this information at the time or even to see the artists' works or reproductions. It was not even remotely possible to catch wind of anything about contemporary developments, such as in France, Switzerland, or the USA. One thing was certain: Lassnig was hungry for something new, modern, and contemporary, for impulses beyond the narrow guidelines of Nazi aesthetics.

She devoured whatever she could find on theories or texts by artists. In her own work she was searching and trying out a lot of things. This got her reproached by Andri, and the memory of this gnawed at her frequently her entire life. He said, "You have no continuity," and what he meant was, she did not build upon her very promising results but always tried something new, "which was foolish and unprofitable."

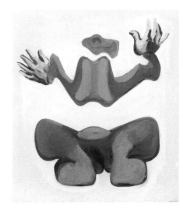

"Maybe my old professor Andri was right," Lassnig wrote fifty years later. "It still seems to be true of me that whenever something new is successful, I always make a giant sidestep to the next thing because I dread getting caught up in the stagnation of repetition, but at some point, months later, I reconnect with the first achievement."[75] In fact, there are many artists who, once they have found a recipe for success, stick to it and more or less always do the same thing and fare well in reviews and with the public. That would never be Lassnig's thing. She remained someone who searched, evolved constantly, and experienced repetition as crippling and boring. She revisited certain questions and topics throughout her long artistic life, but she always found new answers and approaches.

Selbstporträt als Prophet (Self-Portrait as Prophet), 1967

With Andri she painted a self-portrait, which she was still proud of at the end of her life.[76] She knew she had found something new in this self-portrait and had made an important step in her artistic development. It got her away from the naturalistic painting she found so easy, sometimes all too easy. She called it her *Green Self-Portrait (Das grüne Selbstporträt)* because among the colors she used for her facial skin were green shades—a true discovery for the young artist; first, that it was possible to paint like this and second, and more importantly, that it was also more fitting and correct for her. She noted, "Self-portrait May 44. Do not continue painting until that which is at hand is checked for the truth of its origin. Abstraction was the only way forward—in form and color—perhaps content came to light through this alone."[77] This painting truly represented a quantum leap for Lassnig, and it was not surprising that she sometimes called it her first

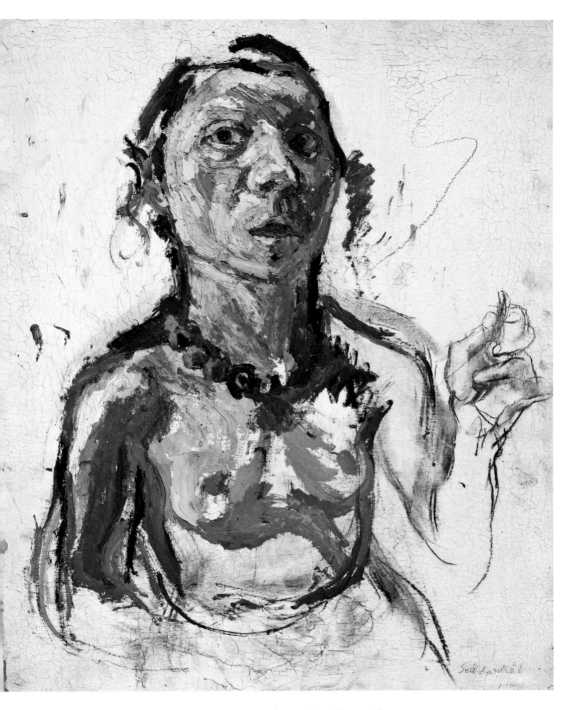

Selbstporträt expressiv (*Expressive Self-Portrait*), 1945

self-portrait. It gave her the feeling of having found her own way of expressing herself, and more than sixty-five years later, she still raved about this self-portrait when she showed it to a journalist: "Nice, isn't it? All the blotches ... I looked at a single dot until something glowed in me. It's all very fleshy."[78]

A masterpiece, which was tough to top. Later, she had the feeling she couldn't progress, that she could only use the new imagery in details but not in the larger whole: "The intensity, which I often only achieve in one little spot, I try to expand to the big picture, or else I stop. Is it possible to become whole? I have many impressions, which appear so strong in my eye. I'm so shaken by form or color that it *must* become something new, purely from what is seen. But these are only fragments."[79] What Lassnig considered a disadvantage or defect here, she later turned into a method; she portrayed only in fragments what she felt. In many of her self-portraits from the 1960s onward, she simply painted the elements of her body, which she perceived at the moment she was painting. In her *Self-Portrait as Prophet* (*Selbstporträt als Prophet*) from 1967, three unconnected body parts are visible, which do not result in a unified whole. More about this later. In 1946, she referred back to her groundbreaking self-portrait: "How far along I already was with the *Green Self-Portrait* from 1944, which is so hard to achieve again."[80] Easter 1955, a good ten years later, she noted, "You run like a trained mouse through all the tunnels until you find the carrot in the last hole. Have I ever found the carrot? Yes, with the self-portrait from 1944. Cézanne-like results, without even having known of Cézanne. Then, too much relaxation, distraction."[81] She gained the important experience that learning steps she had already made did not guarantee her future performance. It was always about preserving, transforming, and developing new achievements.

In December 1944, Lassnig completed her studies. She received her diploma in January 1945. Shortly thereafter, the Academy was closed due to the events of the war. In the winter semester of 1947, she applied to the Academy again, this time in the class of Albert Gütersloh, who supported her admission. Her main goal was to have a warm place in an art studio and a nude model. The Academy rejected her application on the grounds that Lassnig had already graduated as an academic painter. Admission should be made available to still untrained artists. Nevertheless, she continued for a few months at the Academy in Vienna. In 1954, Lassnig applied again, was accepted, and studied six semesters with Gütersloh.

Lassnig spent the last months of the war in Klagenfurt. When the city was bombed, the house in back of Fröhlich Street collapsed. When asked by a journalist whether she had felt afraid, Lassnig said she had had a scare but no fear of death: "My stepfather was worried because I always ran into the street to look at the planes flying over."[82] The bombing inspired one of her most expressive

self-portraits from those years. She was on her way from Vienna to Klagenfurt when the train line was bombed, and she then walked the rest of the way back. When she arrived home, she painted this self-portrait in an adrenaline rush[83]—perhaps the first time she presented herself as an artist at work with a piece of charcoal in her hand with which she had just sketched out her own contours.

Wehrmacht soldiers, forced laborers, and liberators

Lassnig was often in love—too often, she felt in retrospect. She thought she wasted too much time she should have instead spent focusing on her work. She really fell quite quickly head over heels in love. In autumn 1941, H. W. appeared—he, too, an artist, whose gushing love poems she transferred to her journal.[84] Before Christmas in 1941, he wrote, for example: "Always only you, oh sweetheart, you are in me, the only yearning, painful joy! If only I could find peace, fulfill my quest, my faith, the taming fantasy, my dearest you—H. W. 12/21/1941." Like almost all her friends and classmates, H. W. was drafted. He was stationed in the Mödling barracks as a private first class in the Reserve Panzer Division 4. The initial lightness of these love stories evaporated quickly. Fear, doubt, and self-blame followed. Critically and shrewdly she judged herself: "My relationship to men is quite destructive: even the most beautiful castle in the sky that invites me to linger is destroyed by my doubts. The curlicue ornamentation falls off, columns and arcades collapse, and lightning strikes the simple hut."[85]

Untitled portrait of Louis Popelin, ca. 1945

Here she showed what characterized her many love relationships—they worked best as pie-in-the-sky fantasies, dreams of an unreachable, not-too-well-defined lover.

She suddenly developed such a crush for her teenage friend Bergmann, who meanwhile had had to interrupt his architecture studies because he was drafted into the Wehrmacht. He wrote her some letters from the front—not much about the war but about his own artistic endeavors, his drawings and sketches with which he tried to capture nature. Lassnig copied them page by page into her own journal and added, "Feel the closest connection to you." And, "Nothing but a crush?" And a short while after, "I can only cry when I think of you."[86]

Increasingly she became aware of the devastating consequences of Nazi wartime

policy. In the last pages of her journal at the time, there are numerous field-post numbers of former fellow students and friends, of Rudolf Wohlmuth, with whom she visited Wiegele, of Bergmann, of H. W., and quite a few others. Many of her friends had already died. She noted: "War = curse of the oldest breach of conscience, atoned for personally and as a people. We are *all* to blame for this war."[87] A remarkable observation in 1944, which many Austrians even decades later were not capable of making. In January 1944, she wrote her mother, "I get angry when I read about the hoopla that is made out of the dead, even this is propaganda! First they force men into war and then they award them the Iron Cross as 'volunteer dead heroes.'" She appealed to her mother to speak less frivolously of sacrificing herself for the "Volk."[88]

Louis Popelin (second from left in back) in front of the Lindwurm in Klagenfurt, before June 1945

During her Klagenfurt summer of 1943, Lassnig met Louis Popelin, a twenty-one-year-old student who wanted to become an interior designer and was passionately interested in art and literature. Decades later in interviews she referred to Popelin as a "relocated person." When asked what that meant, she said, "The students were, I do not know, they were brought together and had to come to Germany to perform forced labor. They were forced laborers, weren't they?"[89] In a 2006–07 journal entry, she referred to him as a "displaced person," using the term introduced by the Allies for the more than eleven million people who were deported by the Nazi regime, most of them forced laborers, including prisoners of war and civilians. In occupied France under the Vichy regime, which had collaborated with the Nazis, they tried at first to recruit volunteer civilian workers to work in the German Reich, but the war-related growth in labor demand meant that entire age groups were obliged to work. A total of nearly two million French civilians and prisoners of war had to work in the German Reich. In Carinthia between 1943 and 1945, around 15,000 French civilian workers were deployed, including Popelin. He worked on the "hated protection of buildings,"[90] and his job was to spray the walls of houses with water hoses in order to reduce the risk of fire during an air raid. He was quartered in a former Slovenian-owned hotel that the National Socialists had expropriated.[91] The Nazi regime's treatment of Western and Eastern European forced laborers differed considerably. Although contact between the native population and the foreign workers was undesirable, Popelin was sometimes able to move freely around the city and have dinner with the Lassnig family, for example, which he did regularly and with pleasure—a drawing by Lassnig testifies to this: "A handsome fellow with a beret, rather dark." Bergmann recalled Lassnig showing him a photo of Popelin.[92]

She had graduated from the Ursulines in French and could finally test her language skills with a native speaker. It was also the language in which the texts of revered artists such as Van Gogh and Cézanne were written, which she studied eagerly at the time. Her journal entries were also sometimes formulated in French, especially if they were about Popelin. She even wrote poetry in the foreign language, not without adding self-critically in French, "I fear this poem sounds more German than French and lacks rhythm."[93] The two fell in love. Popelin also wrote poems for her: "Winter has spring days for me, a young woman with round arms lets words of love blossom in my soul."[94] He compared her blue eyes with the Austrian mountains. Lassnig captured Popelin in several portraits and drawings, and even in a double portrait of them both.

Louis Popelin in front of a double portrait, ca. 1944

When Lassnig was later questioned by journalists about the Nazi period, she recounted not only the student tribunal at the Academy but also this forbidden love story: "You were not allowed to talk to them."[95] And: "That was very dangerous, you see? I could have been imprisoned if they had discovered that."[96] Lassnig reported of a neighbor who had had a relationship with a French forced laborer and was arrested. "In our case, it was just friendship, not a relationship—probably I was therefore not imprisoned for miscegenation or anything like that—but it was dangerous. But I was not aware of the danger."[97] It may not have been a relationship, yet the love story became an important sensual experience for Lassnig, who noted, of course in French, "Totally new ideas, upon the fingertips and upon the skin and so on, a new being, which one becomes through the touch of another."[98] She read Gerhart Hauptmann's *Book of Passion* (*Buch der Leidenschaft*) and found her own feelings mirrored in it: "It contains the tragedy I have known for a long time, and this sweetness I have only recently been able to sense."[99] When Popelin forged plans for the future, it was not acceptable for her: "He spoke of the past and the future, which I rejected, because only 'now,' the present moment itself, can be recognized."[100] Nevertheless, the two had a project for the future; before Popelin returned to Paris after the end of the war, they got engaged. Popelin planned to get Lassnig to France as soon as possible. He arranged a marriage license and a visa, not an easy task in post-war Europe. In France, a low opinion was held of people who were involved with the former enemy, the Third Reich. Even Popelin's parents, who lived in a small town in Normandy, were against the marriage. Without Popelin's knowledge, they wrote to Jakob and Mathilde Lassnig that they did not believe in such an intercultural marriage and asked them to talk their daughter out of it. Mathilde, however, desired nothing greater than to get her daughter hitched and advocated for this marriage. Popelin and she got on well—he called

her "Mommy" and they were in regular correspondence. While Popelin tried to arrange everything, Lassnig wrote him sporadic love letters. Doubts began to arise in her. She felt love was preventing her from art and simultaneously no longer felt this love anymore. "Inexplicably a pane of glass was pushed between the eyes and the things, or was it between the eyes and the heart?" she noted skeptically in her journal. "Try to force your eyes to see, because love does not answer. It is hermetically sealed, set aside somewhere."[101] The absence of pain she experienced as a lack of energy, as a form of depression. "Boredom, joylessness, loneliness, if only I had friends."[102] One paragraph later she considered enemies to be the better elixir of life: "If only I were stone, I would like to torture someone to death. I must conjure up enemies." The thoughts of Popelin and Paris—both of which had seemed very tempting to her before—didn't raise her spirits. When she tried to look forward to the Louvre, she felt no enthusiasm.

Shortly afterward she wrote: "Surely, I'm still too deep in the heavy humus of my earthly love, and without being directly reminded, the snares of the experience keep me trapped. They are snares I put myself in, just for fun, for recreation, my feet are now stuck deep inside, I almost want to say in a morass, in a warm swamp, annoying me, and my hands do not even find the smallest branch above me to save myself. I want to go back to the quiet, well-known ground of an unfulfilled distant love, the heavenly one, which alone can lead me into painter's

Die Küchenschürze (The Kitchen Apron), 1992

Student in National Socialist Vienna

heaven."[103] Throughout her life, Lassnig felt this profound ambivalence toward real love—especially the opposition between art and love—and she always chose art, as in this case.

Despite being granted a marriage license from the French state, despite convinced parents-in-law, despite an already furnished apartment, and despite the prospect of getting to know the French avant-garde, she did not marry Pope-lin. Year after year until 1949, he hoped she would decide to come to him in Paris. Lassnig, meanwhile, had already fallen in love with at least four other men. She was well aware of her cruelty: "His parents approved against their will that he could marry me ... but I did not go. And they even bought him furniture for the marriage. And I did not go. Terrible!"[104] She would retell this story much later in numerous interviews, but to justify her decision, she would—rather surprisingly—refer to French cuisine as the reason why she had not had the courage to take this step: "I was just scared of cooking, really ... French cuisine requires that you cook very well, and here I'd come with my Carinthian dumplings!"[105] Almost absurd how Lassnig later harped on cooking when it came to the subject of Popelin. However, it also expressed the great mixture of biting humor, seemingly naïve unworldliness, and feminist consciousness that distinguished her—a mixture that showed itself in perfect balance in her 1992 *Kantate*, her life review in animated form.

Also in the 1990s, she painted a series of paintings that dealt with the missed opportunities at that time and the role models connected with these. *Self-Portrait with Saucepan (Selbstporträt mit Kochtopf)* shows Lassnig with a pot on her head, which blocks her view of the world. In another painting, *The Kitchen Apron (Die Küchenschürze)*,[106] she is forced into a threatening apparatus that forces her to bend over in an uncomfortable and humiliating way. Housewife attire restricted a woman in her freedom of movement, in her freedom as an artist. Most of the men in the 1940s, 1950s, and 1960s—probably many of them in the following decades, too—expected their wife to be in charge of the household, regardless of whether she had previously worked or not. Cooking represented the larger housewife role here, which Lassnig simply could not imagine for herself. Whether Popelin, who admired her as an artist and regularly sent her expensive paints from Paris, really would have expected her to get all housewifey, we do not know. Lassnig certainly feared that. Add to this what a journal entry in French, presumably from 1945, made clear: "I have a great ability to adapt to the point of self-denial—and that is what leads me to flee from this intimate relationship, which is more beautiful and funny than profound and productive. Can you guarantee that my life will be happy with you?"[107] Well, who can do that? For Lassnig, a love relationship was definitely linked with the fear of losing herself. Even months before, she noted: "It is recognized, testified, and established that eros

flees the eternally alert, aspiring, truth-seeking soul."[108] And she would rather be alert, aspiring, and truth seeking than dissolve into a symbiosis—which she also tended to do when she let herself fall in love, then head over heels, as she wrote, to the point of giving herself up. So she decided against marriage—and not for the last time. She rejected all further marriage proposals in her life.

At the age of nearly eighty, she returned to these "missed" opportunities for a bourgeois marriage and family life and took stock of this in a series of paintings, not coincidentally titled *Illusion of the Missed Marriages* (*Illusion von den versäumten Heiraten*) and *Illusion of the Missed Motherhood* (*Illusion von der versäumten Mutterschaft*). Although Lassnig felt the yearning for the security of a family and marriage, she also knew that this longing couldn't have been fulfilled: "The picture is titled the illusion, you see? I know it wouldn't have worked out, even with Louis, with the Frenchman."[109] Like all the images in the series, *Illusion of the Missed Motherhood* is a self-portrait. A greenish, naked Lassnig squats there with her knees drawn up and her thighs spread open. As with a birth, the indication of a grotesquely deformed baby protrudes from her loins. She reaches out with her fingers, as if she wants to stuff the baby back into herself the next moment. She wouldn't have dared to undertake the role of mother: "I know for a fact that I would have been a bad mother. Now, of course, at my grandmotherly age, I would be a very nice grandmother."[110] And: "But children and painting: that would have been impossible, especially because I always want to do everything perfectly."[111]

Portrait des Sergeanten (Frank Philips) [*Portrait of the Sergeant (Frank Philips)*], 1945

Sometimes she thought about what the children with this or that man would have looked like. Asked whether such thoughts made her sad, she answered, "Well, at weak times yes, in strong times no."[112] At the age of eighty-five, she would have found it thrilling to introduce children to the world and its words: "When you have children, you have to explain every word to them, which is good for your use of language: Granny, what does 'gay' mean?"[113]

Illusion of the Missed Marriages I (*Illusion von den versäumten Heiraten I*) shows an elderly Lassnig with glasses, a bare torso, and a baby in her arms. She isn't breast-feeding the child; it is just lying there, while Lassnig gazes upward with her mouth open, perhaps yearning. The baby is actually a grown man who needs to be mothered. It is not Popelin whom she cradles like a baby on her lap but Sergeant Frank Philips, one of the British soldiers who invaded Klagenfurt on May 8, 1945, and freed the city from Nazi rule. Another love story, another marriage proposal. Fifty years later, this potential missed

marriage was also considered an illusion—yet her thoughts kept revolving around him, as journal entries made clear, from her years in France in the 1960s to old age. Like most of the men she fell in love with, she portrayed Philips several times. Another image from the series, *Illusion of the Missed Marriages II* (*Illusion von den versäumten Heiraten II*) from 1998, shows Lassnig lifting up a casually stretched man, who is smoking. She almost seems to collapse under his weight. Men are exhausting. With much irony and humor, she not only confronted her own yearnings, which she considered illusory but also the needy men she felt she had to nurture, nourish, and care for like babies.

Even though at the age of eighty she knew it was about illusions, she would never be so hard-nosed as to deny her yearnings: "I am moved to tears when a child caresses me or a cat snuggles with me, and I'm so sorry

Untitled self-portrait with Frank Philips, ca. 1945

for every kiss I did not give."[114] Although she made fun of herself and the men in the illusion paintings, she also saw these works as a kind of homage to her former marriage candidates. "As I often spend 'idle hours,'" she laughed, "thinking about how it could have been different, maybe I also have a bad conscience towards those men who would have wanted to marry me and I did not want to and so on. To make it up to them afterward, you know?"[115] Another time she said she did not mourn the men who spurned her but the ones she gave walking papers. These are the ones she especially loved without their knowing: "My real sadness is for them."[116]

Lassnig remained friends with Popel in her entire life. When she traveled to Paris on a scholarship in the early 1950s, she contacted him, and when she lived in Paris in the 1960s, they strolled together through the famous Parisian antique markets. He came to her exhibition opening at the Centre Pompidou in 1995, as well as to Nantes in 1999, where the two almost octogenarians giggled and held hands like teenagers.[117]

Illusion von den versäumten Heiraten I (Illusion of the Missed Marriages I), 1997

Student in National Socialist Vienna

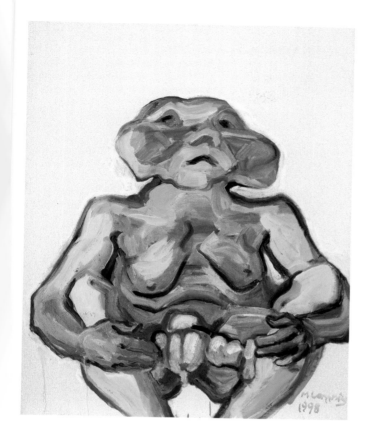

Illusion von der versäumten Mutterschaft
(*Illusion of the Missed Motherhood*), 1998

Lassnig never married. Art always came first. How ambivalent the situation was for her though is illustrated by a letter to her mother: "Concerning my extreme complexity, which tortures me and which will never let me take the simple path (that of the good marriage)—beyond this I am always guided by a wise instinct, of which I still do not know whether it leads me to the highest peaks of art, into a good marriage or whether it lets me stay with you. Whatever happens, I want to make you a famous mother."[118]

I was a twinkling young star back then.
Everyone was in love, and they just dropped by.[1]

3 A Carinthian Provincial Star

1945–50

Change of scenery: Austria had been liberated, and the young art scene felt a radical desire to break out. Lassnig returned to provincial Klagenfurt, which in the years following 1945 attracted a number of innovative artists, writers, and critical spirits. Soon after the end of the war, Lassnig rented her first studio in the center of Klagenfurt, at the corner of Klostergasse / Heiligengeistplatz, in an old, unrenovated Art Nouveau building. It was anything but cozy; friends described it as a miserable ruin.[2] Still, it had an irresistible attraction. Within a short time, it became a salon for all those who were enthusiastic about Modernism and strove to differentiate their conception of art from the National Socialist one, which was still all too prevalent in most people's hearts and minds.

Avant-garde hotspot: Lassnig's first studio

When Bergmann returned to Klagenfurt after three and a half years in Russian captivity and visited his old childhood friend, he was astonished; her art studio was "overrun," as he put it. Lassnig was surrounded by fans and admirers. "Many men fell for her"[3]—this is important to contrast with the image Lassnig had of herself as the all-too-often abandoned one. Back then, she was, in reality, the only hen at a rooster party and broke many a heart: "She cast everyone and everything under her spell."[4] Lassnig herself admitted, "All sorts of men wanted to marry me. I felt a little wooed."[5] But even then, she quickly had a reason to relativize. It was because of the post-war circumstances. Everyone was hungry, and Lassnig's stepfather, Jakob Lassnig, was the master baker who made sure the bread basket was always full in her studio. Lassnig thought that's why everyone came. These really were the years of food rationing, and newspapers reported daily on the population's poor nutritional status. Only slowly could the supply be increased from 1,200 to 1,800 calories per day. Visiting a chic café was unthinkable for the young artists; nobody would have had the money for it.

As much as hunger may have driven them into Lassnig's studio, she herself was still the main attraction. In her interviews, she made a habit of reluctantly adding, "I suppose they liked me, too."

Her ambivalence toward the esteem she was held in was typical for her, both privately and

Maria Lassnig
in her studio at
Heiligengeistplatz,
Klagenfurt, ca. 1949

professionally. Whenever she felt acknowledged, respected, or loved, she found or invented a reason to weaken or not trust the feeling. She considered herself rather unattractive and in her many self-portraits tried to reinforce this self-conception: "I usually make myself look uglier." The Ugly Duckling was her favorite fairy tale: "I think if a person is born ugly, she can later become very beautiful." When Lassnig talked about this, echoes of her early childhood trauma could be heard: her biological father's rejection of her for not being a son but "only" a daughter. She associated this trauma not just with her gender but also with her appearance. Even when she was more than eighty years old, Lassnig was still convinced she had always been an ugly duckling: "I was not a pretty kid. I was wider than I was long, such a small ball, nothing special, bland. Maybe I am still like this sometimes ... or even most of the time." She maintained she wasn't very vain and did not make any effort to priss herself up: "Alas, that's probably why no man would stick with me."[6] As ironic as this sounds, Lassnig seemed to adhere to this dubious claim. All too often in her interviews she talked about men leaving her because she was not pretty enough, even though she rationally had to have known that was nonsense. The photos in this book belie her negative self-image, and most men found Lassnig beautiful, smart, and interesting. Still, because of her high sensitivity and her early childhood deficits, she was also a difficult, extremely needy, and at the same time dismissive partner, who was hard to please. Then, there were the all-too-prevalent conservative images of women that she often neither lived up to nor aspired to as an independent artist with a strong will of her own. This unsurprisingly led to difficult situations. Especially in the post-war decades, many men were not used to facing conflicts with women but rather evaded this by ending the relationship. But Lassnig also broke enough men's hearts herself.

None of those involved could remember any other woman being present in Lassnig's studio except for Lassnig's cousin Lioba, presumably a niece of her stepfather who worked as a shop assistant in Jakob Lassnig's bakery and, from time to time, sat as a model for the artist. One of the guests in her studio was her former teacher Boeckl, who continued to teach his famous evening nude drawing course at the Academy of Fine Arts. During his visits to Klagenfurt, he also dropped by. After Lassnig had seen his major retrospective in Vienna, she noted: "Boeckl has gotten so close to me. I would have never thought this possible! Now he's so close he's smothering me. Strangely, it is not his most recent paintings, which would correspond more to my last ones, but rather his older paintings, the *Sicilian Landscape*, the *1. Ulrichsberg*, which superimpose themselves on me. The lush, heavy, densely packed colors. Yes, yes, they are superimposed on me."[7] Lassnig referred to works that had been created twenty years prior. In 1924, Boeckl painted *The Great Sicilian Landscape* and *The Little Sicilian Landscape*, both

of which depict sun-drenched scenes. He often painted the area around Maria Saal and Ulrichsberg, too; one of the earliest examples is from 1927. In her search for her own language of imagery, Lassnig felt threatened by Boeckl's earlier work. She was convinced she had to free herself from the influence of others. She did not want to be distracted and felt she had neglected her own starting point, which had occupied her so intensely during her years at the Academy: "I know the causes of my weaknesses. I am cramped and pushed, the sinking and drilling around a *single first* dot of color is fleetingly ignored, the starting point frivolously blurred away."[8] Already at this point, she was trying to capture the perception of a single, brief moment—a topic which occupied her time and again: "What twitches up in quick flashes of good and great thoughts in the brain apparently gets lost. If only I had a pencil at hand to capture it."[9]

Over and over, she reflected on color and the role of subjective perception: "There is no point in time where the color 'works on its own'?"[10] And: "The colors don't exist; they only have an effect through my assumption." When she came across particularly intense impressions of color, she noted these down as painting ideas: "Green cat on a red sofa, red carnations against milky glass."[11] Often, she had no money for canvases and instead painted on empty flour sacks she got from her stepfather's bakery. Once she even painted on a baker's apron, and the back of the painting still had the apron's sewn-on pocket.

Not just Boeckl but also his friend Arnold "Nolde" Clementschitsch impressed Lassnig. Clementschitsch, like Boeckl, belonged to the established guard of the Carinthian Colorists and had already made a name for himself in the late 1910s with his classy street scenes and portraits. During the Nazi era, he had painted, on the one hand, a series of Hitler paintings for reasons of opportunism and, on the other hand, expressive nudes that by no means corresponded to the idealistic body image of Nazi aesthetics—a typically ambivalent attitude for many artists of the time. After 1945, he resumed where he had left off before 1938.

The young artists were especially fascinated by his Bohemian lifestyle, which he had also cultivated during the Nazi era. For them, he was a vagabond between worlds who—usually traveling with a backpack—moved from one artist friend or family member to another between Villach, Klagenfurt, and Vienna, between Italy, France, and Dalmatia. And he was very fond of alcohol. The poet Michael Guttenbrunner, also a guest at Lassnig's, described him as a "real and true original," as the "freest of all" who led "the life of a vagrant, swapping day with night." He made a habit of staying "where night and intoxication and weariness left him," at whatever tavern, station, or friend's art studio.[12] Lassnig was proud that Clementschitsch had once described her as being philosophically talented. Encouragement from more established elders was important for her since she was often dissatisfied with herself: "I'm too faint-hearted. Clementschitsch

says that's the result of wanting too much and not yet knowing what you want. He's right, I'm just bull-headed, with too soft of a heart in my head!"[13] To encourage herself, she jotted down quotes from famous artists who were also marked by internal struggle and self-doubt: "Derain: I risked my life with every single painting." And "Matisse: The start of each and every painting still terrifies me to this day."[14] She implored herself, "Please, no flood of wanting! Making due with less is what distinguishes an artist."[15]

Despite this youthful heroism, she didn't lack the wit and self-irony she was so well known for in later years. On the cover of a small-format journal from 1945–46, she wrote as a kind of title, "The Pegasus of Painting." The illustrative sketch next to it doesn't show a noble, winged horse flying into the high hallows of art but a piglet with wings. Upside down and below this is a portrait sketch that shows how excellently she had mastered this genre. In this page's limited space, Lassnig described the poles she had moved between her entire life: giftedness, artistic quest, and self-irony.

The most memorable public appearances in Lassnig's studio were provided by "the boys"—for example, Max Hölzer, who belonged to her inner circle. The artist recalled: "Besides Jené, Hölzer was the only real Surrealist in Austria. We immediately allied ourselves against the present."[16] During his visits, he made

Journal cover, 1945–46

a habit of pulling a hand-scribbled piece of paper out of his pocket and presented his latest lines to the exclusive audience. For example: "I would like to pet a tree, which is a room where I live and which gets smaller and smaller until it disappears under my hand. I want to see a sky whose skin comes off like a ripe fruit, carrying the sensation of pollution across the room."[17] He was a master of recitation and could speak until the early hours of the morning in surrealistic hermetic word cascades. Lassnig was thrilled.

This is how Lassnig and her friends—with more than a twenty-five-year delay—learned about Surrealism. Hölzer was a close friend of Edgar Jené, who at the same time was promoting Surrealism and organized exhibitions and readings in Vienna. Together through a Klagenfurt publishing house, they issued *Surrealist Publications* (*Surrealistische Publikationen*), with the promising and self-confident subtitle *The First Manifestation of the Avant-garde in the*

Intellectual and Social Fields. For the magazine, Hölzer translated texts by André Breton, including excerpts from his Surrealist manifestos. The magazine only appeared twice, but it offered *the* possibility to read Surrealist texts in German and was therefore very influential. Hölzer and Jené were friends with Paul Celan, who contributed a few poems and provided about a third of the translations from both French and Romanian into German. Hölzer and Jené would later establish contact for Lassnig and Arnulf Rainer to Celan in Paris, who in turn would introduce the two to the Pope of Surrealism, Breton. Hölzer also translated Breton's famous novel *Nadja* for the most prestigious postwar publishing house in the German-speaking world, Suhrkamp Verlag.

Professionally, Hölzer was a judge at the regional court in Klagenfurt. As the investigating judge, he got Guttenbrunner released from the mental hospital, where the poet had been incarcerated for brawling with a British-occupation soldier. Guttenbrunner, later a good friend of Thomas Bernhard, was also one of the most frequent visitors to Lassnig's studio. He played a crucial role in the great scandal that flared up around one of her paintings.

Michael Guttenbrunner: love story and scandal

Guttenbrunner and Lassnig had a lot in common—they almost even had the same birthday. Guttenbrunner was born one day before her, on September 7, 1919, only a few kilometers away from Kappel am Krappfeld, in Treibach-Althofen. However, Lassnig didn't get to know him until after the war during the first group exhibition, which was presented at Klagenfurt's Landhaus in March 1946 and which Lassnig also took part in. "That's where I saw Michael Guttenbrunner," the artist recalled later. "Totally excited, with small prancing steps, he walked up and down in front of my paintings and commented on them like an actor. Clementschitsch was also there. I liked this."[18] Enraptured, she described the encounter as "The Guttenbrunner experience."[19]

Often Lassnig and Guttenbrunner talked about their almost simultaneous twin-like birth in immediate geographical proximity. They also shared the experience of growing up without a biological father. When Guttenbrunner was two years old, his father was hit by a train while working. Like Lassnig, he also had a stepfather. At the same time, there were big differences: Guttenbrunner had eight siblings, and they were a working-class family of convinced Social Democrats. In the late 1930s, Guttenbrunner discovered his passion for Karl Kraus and trained his sense of language and his precision in expression using old versions of *The Torch* (Kraus's legendary magazine, *Der Fackel*).

During the Second World War, he was a soldier in Yugoslavia, Crete, and on the Eastern Front. The military drill weighed upon him; he suffered from "the torture of marching in lockstep and the torment of standing still," as he

put it in a poem.[20] Time and again, he was taken into custody for lack of discipline, rebellion, defiant speech, insulting superiors, taking unauthorized extended leave, physical roughness, growing his hair too long, and once for theft. In a court-martial verdict, it was said that Guttenbrunner corresponded to the "unpleasant type of smug, arrogant intellectual."[21] The events of the war, especially on the Eastern Front, traumatized him for the rest of his life. He spoke of an "inconceivable climax of cruelty" and "boundless military violence."[22] He was convicted in late autumn 1944 and, as punishment, transferred to the notorious SS Special Unit Dirlewanger, which committed the most heinous war crimes and, among other actions, brutally put down the Polish Home Army's Warsaw Uprising in August 1944.[23]

At the end of the war, Guttenbrunner suffered a nervous breakdown. He had always been hotheaded; now he was even more inclined to uncontrolled outbursts of rage and violence, which could well be directed at people close to him. Between June 1945 and March 1946, he was interned in the Klagenfurt mental hospital after having attacked a British officer.

Throughout his life, Guttenbrunner came into conflict with authorities, not just with the Wehrmacht under the Nazi regime. In 1946, he published an anthology of poems against war from Gryphius to Kraus. Already during the war, he had written Expressionist poems describing landscapes strewn with corpses. In 1947, he published these in his first book of poems, *Black Rods* (*Schwarze Ruten*), with the Kleinmayr publishing house in Klagenfurt. Kleinmayr was a beacon of enlightenment and anti-fascism in narrow-minded post-war Austria. Kleinmayr's central role for the Klagenfurt avant-garde after 1945 should not be underestimated. Ferdinand and Edith Kleinmayr offered Guttenbrunner, Hölzer, and many other young authors a first opportunity to publish, such as the then-unknown Christine Lavant. In addition, Edith Kleinmayr founded a gallery on Klagenfurt's Alter Platz (Old Square), where young artists could exhibit their works. Kleinmayr was "a noble, generous lady," recalled Rainer.[24] Lassnig had her first solo exhibition there in 1949; Rainer in 1951.

Despite his working-class origins, the highly intelligent Guttenbrunner managed to comprehensively educate himself. He learned French and even ancient Greek in order to read his beloved ancient philosophers and poets in their original languages. In his letters to Lassnig, he also repeatedly quoted in ancient Greek script and language. His passions included—in addition to literature—architecture and the visual arts. When Lassnig met him, she was so impressed by his choice of words that she mistook him for a noble—her fascination for the aristocratic was unbroken. Friends called him "The Great Citator" because he possessed an inexhaustible literary knowledge and tirelessly recited passages by Kraus and other poets. He was particularly enthusiastic about writers who had

been outlawed during the Nazi era, such as Theodor Kramer. His future wife, Winni Guttenbrunner, described him as an "anti-celebrity." He wanted nothing to do with the literary scene and the art market. Pressing the flesh with wannabes and the cultural crowd disgusted him. Under the pseudonym Michael Strassburg (jokingly referring to a town in Carinthia), his poems appeared in Hölzer and Jené's *Surrealist Publications*. After the war, he worked as a lumberjack and finally, for a short time, in the cultural department of the provincial government of Carinthia with Johannes Lindner, another frequent guest at Lassnig's studio.

The then-just-over-fifty-year-old Lindner was not only a cultural director but also considered the founder of modern poetry in Carinthia. His poetry book *God, Earth, and Man* had already appeared in 1920 and set slightly modernist accents against the widespread Carinthian countryside kitsch.

After 1945, he was one of the few who encouraged the young Carinthian avant-garde to break new ground in fine arts and literature—an ideal mentor for the maladapted Guttenbrunner. Once, Lindner showed understanding for a long night of debauchery, saying merely: "Guttenbrunner, go into the woods!"[25] Still, he could not keep the uncompromising poet in office very long because Guttenbrunner had made it his passionate goal to prevent former National Socialists from receiving state subsidies. When a Karl Truppe exhibition took place in Klagenfurt's Künstlerhaus in 1950, there was hardly anyone who protested—besides Guttenbrunner. Truppe, highly esteemed by Hitler, Goebbels, and other high-ranking Nazi functionaries, was able to continue his career after 1945 without difficulty, and even to great acclaim. Guttenbrunner wrote a devastating review.[26]

How Nazis continued to succeed after 1945 made his blood boil. In a poem, he formulated: "Villains inherit *The Fatherland* from villains. The Nazi spirit has come back home to roost and still hasn't had its fill of shame."[27] The young Ingeborg Bachmann, also a Carinthian, then in Vienna, recommended Guttenbrunner, whom she greatly esteemed, to leave the province and come to the more anonymous capital, but it was not until 1954 that he took her advice. He described the political and cultural atmosphere in Klagenfurt as "a landscape steamrolled, burned, and, murderously cleansed by dictatorship and war," the people as "bedraggled, bewildered, and in many circles, a remorseless audience."[28]

Lassnig felt attracted to the eloquent, argumentative, and stubborn Guttenbrunner. For her, he was the "rising poet star,"[29] her counterpart in the field of literature, so to speak. For him, Lassnig was an artist who was "ahead of the curve," a "sensational new experience."[30] He wrote to her, "I do not doubt you understand me, that you feel we resonate." Guttenbrunner, used to only being involved with older women, was pleased to finally have found an ally of the same age: "Because I have long lacked a young, like-minded companion. In you, I

see my generation materializing towards me. We encounter each other on good, intellectually fulfilling paths and having been deprived of a partner of the same age, I am compensated now with the fairest friend. Blessings upon you, dear Fräulein!"[31] The two went on long walks together and fell in love. Guttenbrunner wrote innumerable multipage letters, usually every day, sometimes even several times a day, in well-arranged, beautiful, but sometimes emotionally erratic handwriting. He suffered from mood swings.

Lassnig had her first sexual experiences with Guttenbrunner. He saw it as his task to familiarize her with desire and her body, which he thought she did not yet know: "Love, desire, and lust, however, are the key to heaven and hell alike: love shall lift us aloft! If love won't carry us, we will crush it and leave its rubble to the dogs."[32] While Guttenbrunner wrote powerfully eloquent letters to her, the young artist painted outstanding portraits of him, which communicated both his sensitivity and his passionate temperament. "My paintings are supposed to fill your rooms, beloved, that seems to me to be their most thrilling purpose. You, you, if only I could take a piece of your face out of its strict context and carry it with me as fleshy reality!" She was deeply in love and admired him, and as she painted him, she simultaneously thought about representability and other questions that she continued to pursue in her art many decades later, such as the problem of how much a part already contained the whole: "If your face were covered up to the level of your forehead, mouth, or eye, it would have all the charm concentrated in it. Just looking at your sublime childlike temple is alone enough to make me marvel until it fades. That's how it would be for me with every part of your face, which as a whole makes me go pale with lustful surprise." At the same time, she suggested that feeling overwhelmed by love and sexuality could become an obstacle to art for her: "It is impossible to paint a face, to paint anything at all: How can one even presume to paint? How does one get the idea to do art when nature is already so perfect?"[33]

She also painted several nudes of him. A particularly expressive nude in white, red, and blue-green shades brings the strong body of her boyfriend very close to the painting's front edge. One leg lies on the floor, the other spreads at an angle. While his face is in shadow, his body is brightly lit. Lassnig painted his penis in intensely bright red, which forms a strong contrast to his white thighs and black pubic hair. Soon she had the opportunity to present this remarkable painting to a wide audience in a large exhibition at the Kärntner Kunstverein (Carinthian Art Association). Not surprisingly, feelings ran high, stirring up a scandal.

The exhibition took place in the summer of 1947. The Kunstverein's Art Nouveau building was still being used by the British occupation authorities, so they switched to the venerable coat-of-arms room of the Landhaus (the seat of the provincial parliament), whose colorful walls, as one reviewer said, distracted

a little from the exhibited works. The Kunstverein strove to show all of Carinthia's artistic directions. To the right of the entrance hung the traditionalists and conservatives, to the left, the modernists and "youthful revolutionaries."[34] Lassnig, of course, belonged to the latter. She exhibited three works: the painting of Guttenbrunner, another nude, and a group portrait. There was significant outrage. For centuries it had been a matter of course that men painted naked women, usually connected with biblical or mythological themes, such as sinful Eve or divine Venus, for example. Now a young woman had dared to paint a nude of a

Guttenbrunner als Akt / Aktstudie M. G. (Guttenbrunner Nude / Nude Study M. G.), 1946

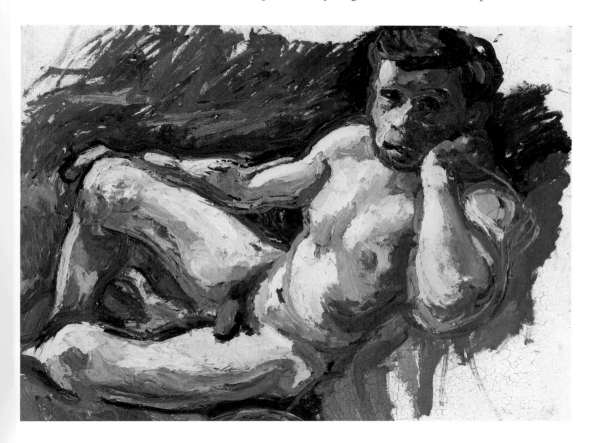

well-known man made of flesh and blood. And she had the gall to focus on his primary sexual characteristics, with the bright red strengthening the associations of passion, erection, and blood.

The work was hotly debated and stirred emotions, especially in the daily press. Even if the language of the journalists might sound stilted to us today and is a bit tiresome to read, it is worth engaging oneself in it for a moment. It becomes clear how intensely the regional press dealt first with art in general and second with the young Lassnig. The then-already octogenarian artist August Veiter

wrote a review for the *Volkszeitung*, a newspaper published by the Carinthian Conservative Party. He did not get much out of Modernism and as early as 1931, together with other artists, signed an open letter against the frescoes of Kolig in the Carinthian provincial parliament, arguing that the work was "in its very nature, un-German."[35] He now tried to put Lassnig in her place and diminish her with a perfidious argument by denying that her nudes had any innovative character: "Such exercises had been done decades ago in the painting classes of art schools without ever having claimed to have discovered new art paths." The editors, however, didn't think this was discrediting enough, so they added in parentheses: "Yes, this male nude leaves the artistic sphere, and borders on pornography. The 'official' promotion of this aberrant work, which the choice of model proves, does not mitigate this judgment. The Editor."[36] Everybody understood the allusion; putting "official" funding in quotation marks referred to Guttenbrunner's having worked in the Cultural Office of the Carinthian provincial government.

The Social Democratic newspaper *Neue Zeit*, however, was full of appreciation for the young artist: "In two nude paintings and a group painting, all stridently naturalistic, Maria Lassnig reveals her strong figurative talent, which is something rare in Carinthia."[37] The third daily newspaper permitted by the Allies was the *Volkswille* (*The People's Will*), published by the Carinthian Communists. This reviewer dealt with Lassnig extensively and described her as a "real artist." He was already reacting to the conservative criticism: "Maria Lassnig, strongly condemned and strongly praised, the latter not always in balance with the former, may find gracious support here, after being ignorantly and maliciously disparaged (which failed, however, as was to be expected, given the mouth trying to debase her)." The reviewer praised Lassnig's power, eros, and perception of form and picked her out from among many other good artists in the exhibition: "The rung upon which Maria Lassnig currently stands allows her to rightly look down upon several dozen average artists, whose achievements can already be addressed as distinctive." At the end of the article, he returned to Veiter and criticized his accusation of pornography as an outrageously shameless allegation.[38]

Even Guttenbrunner, the model in this "offensive" painting, could not resist writing an angry response to Veiter's article. He accused Veiter of praising "a headless pack of embarrassing white-washing amateurs with total disregard for artistic aspiration" and at the same time "sullying all those who dare with their painting style to prove that they are *not* the still well-behaved ones of today—who grew up as Catholic altar boys and have recently made an effort, to become the most *non-degenerate* painters to enter the 'House of German Art' in this world, and to make it into heaven in the afterlife."[39] Guttenbrunner was alluding to the Nazi regime's two 1937 propaganda shows organized in parallel in the touring

exhibition *Degenerate Art* and the *Great German Art Exhibition* in the House of German Art in Munich.

That the scandal also had to do with the fact that Lassnig was a woman was perfectly clear to Guttenbrunner. As late as 2004, he recalled, "She moved outside of what was legal, beyond the boundaries of that time, which, for her gender, were especially narrow."[40]

Even though the positive voices ultimately predominated in this intense media debate, most of the Klagenfurt populace didn't know what to make of Lassnig's artworks and shared the conservative press' outrage. Lassnig's work did not correspond at all to the still very strong public perception of a *gesundes Volksempfinden* (healthy national attitude) toward art, and her artworks triggered deep aggression—a welcome opportunity for some citizens of Klagenfurt, who were suspicious of any modernity at all in art, to make themselves heard and get on their high horse. In the exhibition, someone smeared over the name of the artist, and she was accosted on the street. These violent personal attacks weighed upon Lassnig so much that she fled to Vienna for a few months. At the same time, however, the scandal provided her with a lot of attention and made her, as she said later, into a "provincial star," albeit a controversial one.[41]

Incompatibilities: art and love

The relationship between Lassnig and Guttenbrunner was an emotional roller coaster. They broke up several times and got back together again and again. Lassnig viewed the great similarities between herself and the poet critically: "We only love each other, Michael, inasmuch as we can fall in love with our own reflections!"[42] And she was never without self-doubt: "We overestimate each other. I see you as so great. I cannot see beyond you. But in this radiant light we project upon each other, each of us sees oneself in his and her own imperfection."[43] She experienced not only the symbiotic closeness between lovers but also the strangeness: "You stranger, why do I concern you? Why do you concern me? And yet, I laugh when you laugh and weep when you weep."[44] Over and over again, her self-confidence broke down: "And the jubilance of finally having a boyfriend mixes with the lament that I am only a naive child to you."[45] This feeling of not being wholly accepted by men, especially the men who loved her, would burden her through her entire life. Two things coalesced here: on the one hand, Lassnig's fear of being treated as naive and stupid was rooted in her family and school experiences when she felt excluded as the "dumb Riedi"; on the other hand, a paternalistic or jovial masculine attitude toward women was engrained in the gender relations of that time, especially when it came to intellectual issues.

Once, at the beginning of the relationship, the two were still addressing each other in the German formal "Sie." Guttenbrunner wrote, "In you a wild

woman appears to be coupled with a pious child, one of those rare children who is born knowing, but immaculate, who looks upon us like one of Raphael's angels. Artistry is rooted in the conflict between these two natures."[46] Here, his romantic ideal of an artist became as clear as his image of women. The childish little woman, who could also be a passionate beast, was one of the then-most widespread male fantasies. And yet, Guttenbrunner captured certain aspects of Lassnig's multifaceted personality; many friends and acquaintances, and even she herself, were repeatedly surprised, even into her old age, by her childish naiveté and unworldliness, which stood in apparent contradiction to her willpower, seriousness, and intelligence.

Nevertheless, Guttenbrunner acknowledged her intellectual abilities. Fascinated and intimidated at the same time, he wrote: "Your unusually strong responsiveness, the responsiveness of your senses and intellect, which is an indispensable condition for your artistry, and a main incentive for me to get close to you, scares me away again and again, calling my resolution into question."[47] Strong women can overwhelm men, yet still attract them. He also never left any doubt about how highly he esteemed her artistic achievements: "How you painted today appealed very much to me. I'm amazed and surprised—not surprised that you do what you do, but surprised that it's done at all." He was enthusiastic about her innovative avant-garde power. "You really are a human being with your own deeply profound demonic possession, and I am genuinely flattered to be personally close to you, the painter, and to be able to glimpse your intellectual and artistic spheres more often than any other human being."[48] He supported her not only in words but also in deeds. In his function at the Cultural Office of the Carinthian provincial government, he ensured that she received scholarships and work material such as brushes, paints, and canvases, and arranged provincial government purchases of her artworks. Once he offered her 1,500 schillings and apologized that the empty coffers did not allow higher remuneration; she should consider what painting she was willing to part with at this price.[49]

Lassnig's journal entries from these years illustrate how little she trusted love, how little she trusted anyone at all: "I would be quick to jump at the throat of anyone who disturbs my circle—which also means being on guard against the cowardly betrayal of my mother, father, dearest boyfriend, waiting in ambush."[50] Above all, she had the feeling that every love was ultimately a burden: "Love is there, so that the trees grow into the sky. Or is it the ballast, which after being voluntarily or forcefully dropped, then allows the balloon to rise aloft?"[51] Living a love without losing herself seemed impossible: "Facing the problem that troubles me every day, and torments me some nights—Michael and I—or 'we'—my hand almost resists writing 'we.' Michael *or* me?"[52] Togetherness seemed unlivable to her.

Guttenbrunner and Lassnig finally came to the conclusion that a love relationship and sex distracted from artistic work and were in contradiction to it. In a letter, he described how he experienced his lady-love at work: "You worked in the morning: you fought, suffered, and you died a little bit with every brushstroke you made, and I watched this perishing or crumbling of your sensual nature." Then he described his own struggle for expression and his failure; he spoke of a "time of infertility" and a "wordless void." Although desire and love could indeed have a positive influence on one's work, Guttenbrunner said, you come quickly to the point where you regret you have not devoted the lost time to your own work. "Do you recognize, beloved, the thorn that tortures me? Although I am of demonic libidinousness and of the most brittle delicacy of intellect, almost an ingenious weakling! Acknowledge I may still be your companion, with respect to your work and your purpose, which is the very completion of your work, which is endangered by this very companion, who, however, will never grow tired, and counterbalances this danger through his utmost vigilance, and sincerity, and summons up all his good powers of mind and soul."[53] She noted, after one of the many break-ups, "If only I could coolly and calculatingly arrange my life so it is reduced to the absolute essential—in the manner of Cézanne, who admitted visiting the brothel once a week and otherwise wasted no thoughts on anything other than painting."[54]

Lassnig, who was able to capture human faces with a brush or pencil, to probe into them and expose their character, had the idea of assigning faces to abstract concepts as well—of course with her own sense of humor: "The enjoyment of life to the point of immorality has a pure and beautiful face. Virtue has a face full of pimples. Love has an evil, cramped face, distorted by pain. Frivolity has a beautiful, pleasing and charming face."[55] She dreamt of an ideal—sex without problems, without emotional confusion and injury. Lassnig's proto-feminist program: "The woman question will only be completely answered when there are brothels for women, too."[56] She remembered a conversation with a friend of her mother's. She let the elderly lady know that physical and intellectual love were completely separate things for her. The lady was appalled: "Are you evil, Maria?" Lassnig, in turn, was astonished that her views were considered immoral,[57] a good example of how her unworldliness and naiveté overlapped with her avant-gardism and her need for independence.

Although Lassnig often felt overwhelmed by Guttenbrunner's verbal and linguistic powers, she appreciated the intellectual exchange with him. He quoted Plato in his letters, recommended not only his beloved Karl Kraus but also Ernst Jünger, Friedrich Nietzsche, and Henri Bergson. Fascinated by Bergson's theories, Lassnig translated whole passages from his *Introduction to Metaphysics* into her journal: "By intuition is meant the kind of *intellectual sympathy* by which one

places oneself within an object in order to coincide with what is unique in it and consequently inexpressible. Analysis, on the contrary, is the operation that reduces the object to elements already known, that is, to elements common both to it and other objects."[58] Already apparent here is Lassnig's interest in the phenomena she would explore again and again in her later work: the relationship between intuition and analysis, the relationship between inside and outside, as well as perceptual issues.

She also copied into her journal passages from Nietzsche with which she identified, such as: "In order to become beautiful, a woman must not desire to be considered pretty. That is to say, in ninety-nine out of a hundred cases where she could please, she must scorn and put aside all thoughts of pleasing. Only then can she ever reap the delight of him whose soul's portal is wide enough to admit the great."[59] In her reading, she found reflected her current life situation as well as her struggle for art. She read Kierkegaard's *Diary of a Seducer* and found parallels to her relationship with Guttenbrunner—even when she was more than eighty years old and leafing through it again: "Did I read it in Kierkegaard or discover it on my own? In the time, when I was discovered and persecuted by the poet M. G., did the *Diary of a Seducer* help me?—Sure, because it was a mirror of what happened."[60] In his text, Kierkegaard rejects love as an end in itself. Johannes, the protagonist, does not court Cordelia to spend his life in love with her but to practice seduction as an artistic project and thereby advance in his aesthetic goals. If even sixty years later this reminded Lassnig of her relationship to Guttenbrunner, it can be concluded that she in some ways perceived herself as his puppet, as part of his poetic existence, while her own needs and life goals drifted out of focus. Lassnig was absolutely determined to break up with Guttenbrunner again: "The Michael chapter is over! Too much form, too little content! The power over my own world and art were almost lost beneath his avalanche of words."[61] Shortly thereafter, they became a couple again.

Guttenbrunner also felt at her mercy. He called her his Armide, like the Muslim sorceress from Torquato Tasso's *Jerusalem Delivered*. Armide used her magical powers to force the Christian crusader Rinaldo to make love to her and kept him trapped on her island. Guttenbrunner recommended Stendhal's *The Charterhouse of Parma* and Prévost's *Manon Lescaut* to Lassnig as the only fitting love stories in literary history. Stendhal's novel tells of the impossibility of love, and in Prévost the heroine is unfaithful to her lover and ruins him financially. Guttenbrunner sought both the demoness in Lassnig and the archetypal mother. And as much as he admired her self-will, it was also a thorn in his side: "That was her way of wanting and having to assert herself that escaped my understanding."[62] Guttenbrunner himself was plagued by "deep sadness and sinking into foolish self-absorption," which could turn into self-hatred: "*Dulcissima Ma-*

ria! More than by anything else, which is uncertain and terrible, I am ceaselessly troubled by the thought of you and the cheerless, tormented knowledge of having merely even saddened and tortured you, and of not returning your love with love, but rather with disgusting, sick, and malicious beastliness offered in horrific amounts I hate myself."[63]

Friends from that time reported he had often been lost in despair, had uncontrollable outbursts of anger, and had once thrown objects at Lassnig out of heartache.[64] He tended, not without reason, toward attacks of jealousy, dramatic gestures, and Actionist reactions, which finally went too far for Lassnig: "He was a very attractive man, but somehow he frightened me, too—he, the soldier, who had faced all these dangers and indescribable horrors; he, who also had been required to kill." She described him as "hardened, but also heavily traumatized" and herself as "completely inexperienced and naive."[65] The final breakup came. Guttenbrunner could not accept this at first, kept going to Lassnig's mother and kissing up to her. Lassnig, in turn, avoided further confrontations and sent him messages via her mother. Together, the two went to Nötsch to visit Kolig one last time. Lassnig insisted on separate rooms. When she locked her door in the evening, Guttenbrunner wrote a love poem and pushed it through the crack beneath the door. But this was not enough. Beforehand, he lit the note on fire with a match. It is hard to imagine how shocked Lassnig must have been when the burning sheet of paper appeared under her door.[66] But he finally respected Lassnig's decision. In her journal, she summarized the relationship: "On the grave of my love, the grass is already growing. Small encounters ripple only slightly on the surface of my heart and at the same time allow me to look back in tears and horror at the ship on which I had almost been shipwrecked."[67]

In 1948, Lassnig met the budding boy Arnulf Rainer, and Guttenbrunner also found a new girlfriend, a former partisan. Their friendship redeveloped, and soon the two couples were taking trips together as a party of four. Over the following decades, the relationship between Lassnig and Guttenbrunner remained friendly. Time and again, he sent her letters, poems, and other texts. In 1975, he visited her exhibition in the Ariadne Gallery in Vienna, where her drawings from the late 1940s were being shown: "I enter, and what do my eyes see? What's this? I ask myself. Realizing in a flash as I walk through the exhibition of your old Klagenfurt drawings, I am transfixed with amazement and tantalized by the recognition of your uniquely great achievement. Permit me to finally *see* them, and please understand I didn't recognize their value even then, Your Michael."[68] When Lassnig returned from New York at the age of sixty and became a professor in Vienna, the two again saw each other more frequently. The fact that the artist was now becoming more successful and famous, however, went against the grain of Guttenbrunner, the "anti-celebrity." Lassnig, who had spent her past ten

years in New York, couldn't handle his rabid anti-Americanism. Guttenbrunner died in Vienna in 2004.

Erotic still lifes and her first solo exhibition

It was difficult in those years to clearly determine the sequential order of Lassnig's relationships with men, probably because a clear order only existed to a certain extent. Quite a few overlaps can be presumed. Lassnig did not really approve much of such simultaneity in art or love: "Painting two pictures at the same time is just as unappetizing—and as chaotic—as having two lovers at once," she said even when she was eighty.[69] Nevertheless, one could suppose she spoke from personal experience. Another time she noted: "Ten lovers at a time, ten paintings at a time. You can only compare them, without going into depth."[70] Lassnig equated loving with painting, but the latter would always prove to be far more constant and reliable in her life. Both were difficult to bring to perfection, she said. "We experience our past friendships as we do our artworks: you nostalgically bear in mind the great goals you wanted to achieve, and that patience ran out just a moment too soon to perfect them."[71]

One of the many men who had a crush on Lassnig at that time was Arnold Daidalos Wande, a young painter she had met at the Academy in 1940. He was seventeen then and had started studying at the same time, but then—like most able-bodied young men—he was drafted into military service. He was seriously wounded in Russia, and Lassnig didn't see him until after 1945. Wande was born in Braunschweig, Germany, but spent a lot of time in Carinthia, his mother's home province. In the post-war years, he was one of the regular guests in Lassnig's studio. The two came closer to each other. Lassnig lovingly called him "Wandelein" (little Wande) and portrayed him several times—for example, in *Wande in the Studio / Interior with A. W. (Wande im Atelier / Interieur mit A. W.)* from 1948. She loved it when he puttered around her studio and arranged the objects into a still life. She felt at one with the world in such moments. She returned many times to this feeling several decades later. As was so common with her, it expressed itself as a physical state, a sense of well-being in the rear of her head, nape of her neck, and her back, which she sometimes described as "sweet paralysis"[72]: "It is different from orgasm, better, gentler, more lasting."[73] She had already had this feeling as a little girl when someone braided her hair. Later, she was overcome by this feeling in the presence of certain people. She described this phenomenon in a note from 1992 and remembered how Wande had moved the objects back and forth: "That's when I noticed the same feeling of happiness in the back of my head when he moved his hands in a certain graceful way."[74] As idyllic as this painting of the interior appears at first, there is also a dissonance here; small and almost

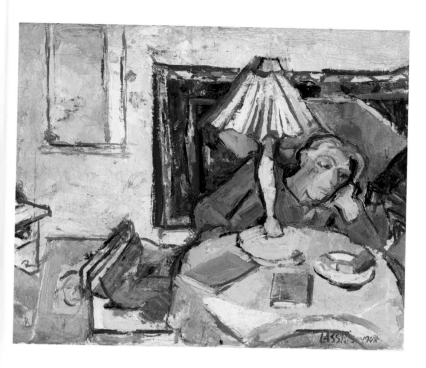

Wande im Atelier / Interieur mit A. W. (Wande in the Studio / Interior with A. W.), 1948

hidden lies a self-portrait of her on the floor—"her Self" at bottom, which could be walked all over.

Soon two easels were standing in front of the studio window at Heiligengeistplatz in Klagenfurt: one for Lassnig and one for Wande. Her childhood friend Bergmann thought he recalled there having been one easel for Lassnig and one for Rainer in the studio.[75] Rainer did not rule this out completely, but he did not remember it. He considered it unlikely, since at that time he only drew and did not paint, so he did not use an easel but worked at the table.[76] What speaks for Wande—rather than Rainer—is that Lassnig portrayed him painting several times at his easel. It's not surprising Bergmann confused the two when looking back more than sixty years in hindsight. For Lassnig it was no different. She labeled a painting from 1949 with "Cubist Portrait of Rainer," but "Wande" is written on the stretcher frame. Maybe she didn't know anymore whom she had portrayed there, highly abstracted, fragmented into Cubist surfaces, or perhaps she just reused an old stretcher frame.

Wande finally went back to Germany, but the contact did not fizzle out. Even in the 1950s, when Lassnig was living in Vienna, the love story flared up again when Wande dropped by. In the 1960s, he even visited her in Paris. She mentioned him decades later in her journals as one of her potential marriage candidates: "A closer contact, a bond with a human being, any human being; my fear always stood in the way of us being too similar. Even A. W., who really is the opposite of me in all my character traits, was too close to me in his messiness for me to marry him (would we have had depraved children?)."[77] At about the same time, in 1983, she dedicated the painting *Superman* (*Supermann*) to him, in which she portrayed herself surrealistically as a glass pitcher whose handles were turned into arms that held up the naked Wande, who had conspicuously colorful genitalia. The painting speaks volumes; Lassnig never had the feeling of being supported or uplifted by men, but rather she always had the role of strengthening and

pepping them up. Many years after Wande's death, she believed she had seen him in Vienna's Schönbrunn Palace: "The resurrection in the palace gardens: coming towards me, the same gait, the same haircut, the same proud nose, the slick gait, bounce in his step, blond. He was the dead A. W."[78] In 2003, when she listed off important historical data in retrospect, such as the fall of the Berlin Wall in 1989, she wrote in brackets: "Wande dies."[79] Wande was seriously ill at the time and died in Cologne just six months later. A poem, also from 1989, was not about the men who left her, but rather those she left:

> I love the ones I left
> when in the morning light's steaming fog
> I look back on the hill ridges that rise softly from the whitewash
> of oblivion.
> They torture me now with their distant dignity in dream.
> The blindness of youth torments me to death,
> perhaps the dead will then greet me again in love.[80]

In 1949, Lassnig got her first solo exhibition at the Kleinmayr Gallery in Klagenfurt.[81] She was then twenty-nine years old. A photograph from her studio shows a number of the works exhibited there. Although she had already been experimenting with late-Cubist and Surrealistic approaches in those years, she preferred to exclusively show her Expressionist paintings, which were in the tradition of her great role models: Boeckl, Kolig, Clementschitsch, and Wiegele, who died in 1944. However, she was already aware of her independence. In 1946 she wrote: "How far you've come is seen in how the radiance of the greats we worshiped no longer dazzles us. I feel at the same level with Wiegele and Boeckl."[82]

Nevertheless, she remained her toughest critic. When she was working on her *Family Portrait (Familienbild)* in 1947, an impressive analysis of her family relationship, she had a lot to object to: "The closer I am to finishing, the more noticeable the flaws are: the figures are too trimmed." She found the least fault in

Arnold Wande and
Maria Lassnig, 1947

her self-portrait: "My self-portrait is the most focused of the three, a mosaic work, for which the tough, stiff white was advantageous. Father is puppet-like. Violet + yellow → basic tone + green, – red, – orange."[83] Ultimately, she must have been happy with the family portrait, otherwise she would not have presented it in the exhibition with the not-for-sale works, which also included the portrait of her mother and her self-portraits.

She now had an advocate, one who classified her work art-historically and art-critically: the influential

Supermann (Superman), 1983

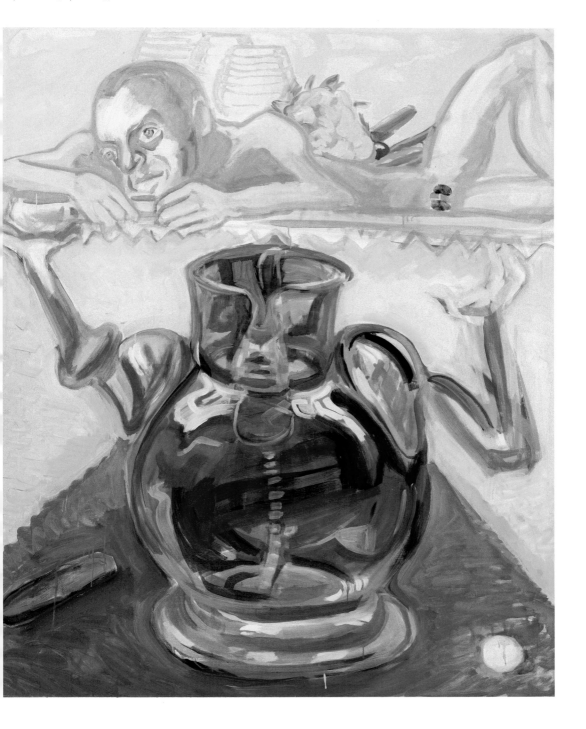

art theorist Heimo Kuchling, a former schoolmate of Guttenbrunner. Kuchling became an important lifelong friend and adviser. He wrote the text for the exhibition, and many more followed. He was also the one to whom she showed paintings before displaying them to the public. He was one of the very few whom she trusted professionally. "Maria only accepted criticism from a few people," remembered Rainer. "One of them was Heimo Kuchling."[84]

Kuchling's daughter knew why: "My father was one of the first to recognize the high quality of Maria Lassnig's paintings. That was probably also a reason for her confidence in his judgment."[85] Kuchling was indeed enthusiastic about Lassnig's work from the very first moment when he saw it in the group exhibition of the Carinthian Art Association: "There, the Carinthian artists presented themselves after the war, and of all the younger artists who were exhibited, the works of Maria Lassnig were the most remarkable." Kuchling had total confidence in her: "Maria Lassnig can do a formidable lot. She can do everything. She can do it perfectly."[86] Decades later when she felt overwhelmed by teaching as a professor at the College of Applied Arts, she contacted Kuchling and asked for his assistance. Kuchling had his own theory of art, which went back to Gustaf Britsch, an early twentieth-century art historian, at whose school in Starnberg Arnold Clementschitsch, among others, had been trained. According to Britsch, art is a mental process, a function of the mind, independent of origin, nation, and age of the artist.

At this exhibition, Lassnig sold her very first painting to a private collector, a still life. She got 600 schillings for it. Perhaps it was one of those paintings where Wande pleased her by arranging the objects on the table. Apropos Wande: One of Lassnig's most remarkable portraits of him was also displayed in the exhibition and provoked quite different reactions in reviews. Kuchling in the catalog's text: "Wande's portrait is no longer just optics and psychology; outline, color, and germs of shape are already putting the picture plane in visual tension. The painting is not bound by the model; an iconic image is at its basis."[87] The *Volkszeitung*, or Christian-Social People's Daily, did not review it so positively. You generally had to look at her pictures for a long time to see their value, the newspaper said. She did indeed grasp the psychological nature of the person, they wrote: "Which, however, leads to bizarre curlicues in a poster-like portrait of A. W."[88] Whereas the *Volkswille*, the communist newspaper, was enthusiastic about the painting: "For example, if we admire the bold structure, the strong and audaciously abstract composition in 'Portrait A. W.,' it is not only for its purely decorative appeal, but mainly because we are confronted by the psyche of the represented person, his differentiated nature."[89]

On the whole, the Klagenfurt reviewers responded favorably; even the Austrian People's Party-aligned newspaper, the *Volkszeitung*, considered her a

"very talented young artist."[90] However, it was telling how much they made her gender a topic and how surprised they were that a woman could and wanted to paint like this. In the Socialist *Neue Zeit*, it said: "The uncompromising nature of this painter seems quite masculine."[91] The conservative *Volkszeitung* confirmed "a striking intellectual involvement for a woman."[92] Both quotes made it clear which prejudices female artists and women in general at that time struggled against. This wouldn't change that fast, as Lassnig's later experiences showed.

Porträt A. W. (Arnold Wande) [Portrait A. W. (Arnold Wande)], 1948

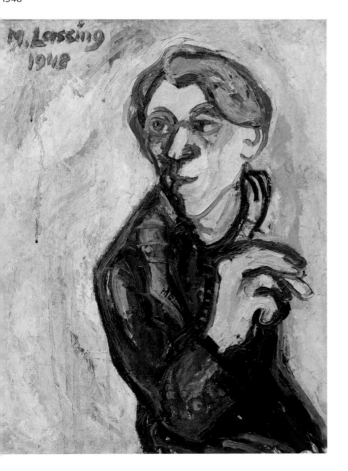

Well, after the war we were exposed to everything, Cubism and so on. I also did Cubist and then Surrealist stuff. You had to shake a lot off, the whole great tradition, starting with Rembrandt or the Egyptians, up to now, you had to shake everything off! That was hard.[1]

4 Paris, Contemporary Art, and Arnulf Rainer

1951

Two photos: They show the same studio and the same artist, surrounded by her then-current paintings. Still, the difference could not be greater. 1949: A young woman with permed curly hair in the midst of her expressive portraits of people and animals, many of which she displayed in her first solo exhibition in Klagenfurt's Kleinmayr Gallery. 1951: The same young woman in the same studio with short hair and darkly painted lips. She looks French now and wears men's wide corduroy pants. Her latest Art Informel abstract works hang on and lean against the wall behind her. About two years lie between these two photos—a period in which both Lassnig's art, and she herself, had radically changed. With breathtaking speed, the young artist had experimented since 1945 with currents of Modernity that were unfamiliar to her—from Expressionism to Late Cubism and Surrealism to the most current Art Informel. Looking back, Lassnig characterized these years as an "adventurous time, rich in experiments, deviations, experiences," which were "necessary to later be sure about what you'd really found."[2]

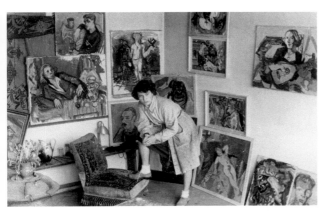

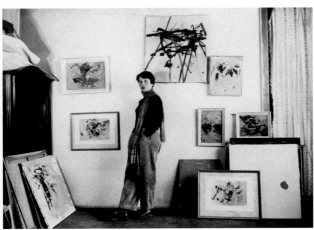

Hippie, mop top, mythical creature: Arnulf Rainer

Rainer must have been an impressive figure at the age of nineteen. Young men just didn't look that way back then. Hardly anyone had hair as long as he had, and many still regarded the strict military haircut of the Nazi era as the only acceptable men's hairstyle. For Lassnig, Rainer was the first Austrian hippie—long before this term existed: "It impressed me that he never washed and let his hair grow into a broad thicket that matched his drawings so well. Then, in turn, he shaved his head bald like a convict, consciously leaving little islands of hair here and there, which also went very well with his drawings."[3] Just a few years later, the painter Ernst Fuchs described Rainer's hairstyle as "a frizzy mountain of ringlets," a "mop top," a "giant permed paintbrush."[4]

Guttenbrunner was also fascinated by the eccentric young man: "I had never seen anyone like him." His large

head was covered in "half a sheep's worth of wool." He seemed to move conspicuously: "His head was trapped in the armpit of someone larger, who walked invisibly beside him and squeezed him. His eyes also seemed to be fixated. He barely rotated or rolled them. It was as if he could only peer out of the corners of his eyes." Guttenbrunner seemed to resonate with leftover jealousy when he described his successor. "A half-animal makes himself known with perpetual transformation. Every year a new surprise. That was too much, and it was annoying too. Besides this: he was threatening, a mocking mythical creature. I, too, have often felt affected, but every time I wanted to beat Rainer up, Boeckl intervened with raised arms and broke it up."[5] And yet, Guttenbrunner was also quite taken with Rainer: "With a big roll of paper under his arm, he visited me, and didn't say a word. This roll contained a drawing about four meters long that he rolled out onto the floor of my room, and showed me a pitch-black pencil drawing, ground to greasy shininess. One saw the weaving of microbes and infusoria, rosaries in between, braided out of intestines and algae, with drowned girls floating in them, mixed with numbered food cans and other industrial and wartime waste."[6] Guttenbrunner described one of the surrealistically inspired monumental graphic works that Rainer had created at the time.

But first things first. Lassnig got to know Rainer when he was still attending school in Villach, probably in April 1948.[7] He was in the Hitler Youth under the Nazi regime and his parents put him in a National Socialist elite school in Traiskirchen, Lower Austria—the National Political Education Institute—"the stupid NAPOLA," as Rainer later said.[8] In such schools, ideological and political indoctrination played an even greater role than in the general education system. The students wore uniforms, and military drill was part of the daily schedule; most

Arnulf Rainer while drawing, ca. 1949

teachers were members of the SS. Rainer suffered from constant peer pressure and the school's paramilitary structure: "I wanted to talk to myself, to contemplate the incomprehensible, autistic philosophies, and transcendences of that kind. But there were constant roll calls, marches, boring speeches, and so on." He repeatedly managed to sneak away from the group events. Yet, there were only a few places where one could not be discovered quickly: "The only place you could develop your philosophy was sitting on the toilet."[9] Watercolor painting and drawing provided a world of escape that Rainer withdrew into. He attended school from 1940 to 1944, then couldn't stand it anymore, especially because his favorite drawing professor was no longer there. That professor had supported and encouraged Rainer but then was replaced by another teacher. The new one

demanded precise, naturalistic drawing in the Biedermeier style—something that Rainer even as a junior high school student was not interested in. He explained to his parents that he wanted to become an artist. His request did not fall on deaf ears, and his parents took him out of the school. However, art schools were closed due to the war. The Rainers sent their son to high school in Baden, just a few kilometers from the family home in Vöslau.

At the beginning of April 1945, the Red Army was preparing to liberate Vienna and Lower Austria. Rainer was afraid of being drafted into the so-called Volkssturm, which enlisted old men, youth, and children in a last-ditch attempt by the Nazi dictatorship to oppose the approaching Soviets. And he was afraid of the Red Army, too, so his parents sent him to his Carinthian relatives. Since the trains were strictly checked by the Wehrmacht in order to catch deserters, Rainer opted to ride his bicycle and pedaled across Mount Semmering to Carinthia—almost the reverse tour that Lassnig had taken on her way to Vienna when she applied at the Academy five years earlier. After two long exhausting days, Rainer finally reached St. Georgen am Längsee, where his grandfather owned a large farm about twenty kilometers north of Klagenfurt. Here, of all places, away from all that was urban, he made his first contact with Modern Art. Close to the farm, the St. Georgen Monastery had been confiscated by the Nazi regime and transformed into a giant military hospital. There, the fifteen-year-old discovered art books left by a nurse who was married to a painter. With enthusiasm, he plunged himself into the volumes and for the first time became acquainted with classic Modernist works, which were banned under the Nazi regime. Van Gogh was a revelation in particular: "What Francis of Assisi is for the Franciscan, that's what Van Gogh was for me. I realized then that painting is devotion and religion, not fabrication."[10]

On May 8, 1945, the Second World War in Europe ended and British troops marched into Carinthia. In the autumn, Rainer moved to his aunt's in Hörtendorf near Klagenfurt to complete his high school education. From 1947 onward, he attended the provincial vocational school in Villach—at the request of his father, who would have liked his son to become an architect. He now lived as a boarder with a family in Villach. His desire to become an artist had not diminished, and he longed to interact with other artists. Summer vacations he always spent at his grandfather's farm in St. Georgen, and he just so happened to meet the painter Arnold Wande, who was in the area. This is how he heard the name Maria Lassnig for the first time. Rainer became curious and tried to get in contact with the artist. The summer holidays were over and he was living in Villach again. Fortunately, his landlady was interested in art and was well connected in the Klagenfurt cultural scene of the time. Lassnig was a well-known personality after having exhibited the Guttenbrunner nude, which had provoked a scandal.

Rainer's landlady arranged a meeting: "The elderly lady seems to have told Maria marvelous stories about me and made her curious."[11] He was allowed to visit the artist in her studio at Heiligengeistplatz in Klagenfurt, where he showed her his drawings.

Rainer was thrilled about Lassnig's seriousness and uncompromising attitude. For him, she was the first real artist he had met. A fierce and difficult love affair ensued between the twenty-eight-year-old and the man ten years her younger—a relationship that lasted for about four to five years and which Lassnig spent her whole life trying to come to terms with. Rainer recalled: "She was very pretty and of course I was in love with her, and I had never known any woman before."[12] And: "She was ten years older, probably seduced me, from what I can reconstruct today. I was completely inexperienced; I did not have any idea how to do it at all."[13] Lassnig's journal entries were unusually positive during those years. On one occasion she wrote: "Everything you see up close, everything you can live in makes you happy; living in the middle of the medium of love, work, a dream, makes you happy. From the outskirts of longing, doubt, and discontent, slowly to the warmest place of love, where only smiles remain—that's life!"[14]

Lassnig and Rainer in her studio at Heiligengeistplatz, Klagenfurt, 1949

Rainer was very much in love, but he soon found Lassnig difficult. When asked what was so difficult about her, he still answered with fervor more than sixty years later: "Because she always had reservations, first these misgivings, then those qualms! This was not right for her, and that made her feel slighted—there was always something." When asked which things Lassnig had misgivings about, Rainer said: "With everything! For everything that came up, one couldn't say, 'Let's go for a walk.'—That was totally impossible." Why not? "Someone will see us." This is just one of the examples that Rainer cited from memory. "I was completely inexperienced and naive and totally bewildered. I said, for God's sake, if women are like that, then I prefer to flee! If that's how it is, I'd rather avoid women." In a nearly resigned voice, the then eighty-six-year-old recalled: "Everything was so complicated, everything so complicated!" In all things, Rainer felt that Lassnig had always seen the problems and not the positive: "Also in the relationship, I couldn't get down on my knees enough. It was never enough for her." Lassnig, on the other hand, felt she was not pretty enough. Rainer: "Yes, that's her paranoia, that's a naive thought. ... Because she was so difficult, wasn't she?"[15] Despite all the problems that soon became apparent, they remained a cou-

ple for several years. First of all, the cold headwind of the Klagenfurt community blowing against them united the two. They were "outcasts, well known throughout the town in a not-so-positive way."[16] Rainer can still feel how much small-town disfavor weighed upon the highly sensitive Lassnig: "She fought a lot. In such a small town they're always talking, criticizing, and gossiping."[17] Time and again there were unpleasant encounters on Klagenfurt streets with "old Nazis,"[18] as Lassnig once said, and with young men in traditional Carinthian outfits for whom the artist couple and their art was a thorn in their side. "The Carinthian guys threatened to beat us up and said our art is cultureless."[19]

The two felt isolated and sought contact with other artists. Kuchling and Guttenbrunner advised them to visit Werner Berg. Berg came from the German Wuppertal and had lived as a painter and farmer since 1930 at the Rutarhof, a remote mountain farm near the border to Slovenia. His subjects were the peasant countryside and the rural Slovene-Carinthian population, which he captured in a flat style in color-intensive paintings and black-and-white woodcuts. Guttenbrunner and Kuchling were among his close friends and supporters, and Kuchling became his son-in-law in 1951. Lassnig and Rainer visited the then-forty-five-year-old artist at his farm. Afterward, Lassnig wrote him a thank-you letter: "Your high art is created out of odd encounters and deep interpretations of daily activities. While everyone all around lost their head or hadn't found it yet; here a rare example of art emerged out of inner necessity." Rainer added: "Let me see a role model in you—of an artist, whose life and work and character are one."[20] Lassnig later visited Berg several times, and they both gave each other a work of art. Through Berg, Lassnig also met the poet Christine Lavant, whose poetry and prose she would later read with great enthusiasm.

As much as Rainer and Lassnig were impressed by the artist's charisma during their first visit and expressed this in their letter, Berg's work was not so inspiring for them; as Rainer recalled: "It was far too conservative for us. We looked at it politely."[21] The two wanted something new, beyond the moderate modernity of the established Carinthian art scene. There was so much still unknown out there in the big wide world that they were curious about.

On a quest: the time of -isms

Today, in the age of the World Wide Web, where one mouse-click is enough to travel virtually around the globe, it is hard to imagine how difficult it was in Austria in the 1940s and 1950s to get international news and content. It can't be stressed enough how important and major the liberators' contribution was to cultural and exhibition policy. After 1945, Austria was divided into four occupation zones. Carinthia and Styria belonged to the British zone. During de-Nazification, the British Council in Klagenfurt not only focused on

educating Austrians about democracy but also on cultural policy. The same was true for the other Western occupying powers. In particular, the French Cultural Institute in Innsbruck held numerous readings, theatrical performances, and even large-scale exhibitions on French art—it was a magnet for artists from all over Austria. Lassnig also traveled twice to Tyrol to finally get to know French art. What she saw there, from Cézanne to Picasso, overwhelmed her: "A wonderful world has arrived here."[22] Above all, she remembered an exhibition in which she first saw originals by Georges Braque, who together with Picasso had founded Cubism, which had its peak between 1906 and 1914 in France. Now, about forty years later, Lassnig was experimenting with its stylistic devices. Her fascination for Cézanne, who was considered a precursor and pioneer

of Cubism, also played a role here. Cézanne said in 1904: "All natural forms can be reduced to spheres, cones, and cylinders. One must begin with these simple basic elements, and then one will be able to make everything that one wants."[23]

Lesender / Kubistisches Portrait Rainer (Reader / Cubist Portrait of Rainer), 1948–49

Inspired by what she saw in Innsbruck, Lassnig began to dissect landscapes and figures into color planes and forms. She painted Cubist girls reading and Cubist portraits of Rainer, such as *The Objective Chance / Portrait A. Rainer* (*Der objektive Zufall / Portrait A. Rainer*). The colorful portrait breaks Rainer's face, clothing, and background into fragments, into spatial and geometric forms, yet the young artist is recognizable with his curly hair and his intense staring gaze. The title *Objective Chance* already pointed to another "-ism" that Lassnig approached in those years: Surrealism. Its founder, André Breton, coined the term "objective chance" and meant a clash of things that was at the same time surprising and necessary because it was inherent to the human subconscious.[24] This sounds paradoxical, but exactly such thought games produced great fascination in both Lassnig and Rainer.

How much the two influenced each other and who shaped whom more is today difficult to assess. There are a variety of claims. When asked if Lassnig and he were discussing or even criticizing their respective stylistic experiments, Rainer, in hindsight, said that they didn't talk each other into anything, but that they showed mutual respect. Rainer preferred to speak of stimulation rather than influences: "We mutually stimulated each other artistically, one has to say that as well. And we certainly competed with each other."[25] Lassnig once characterized herself as a "well-meaning nurse," as a nanny to Rainer and his artistic coming-out.[26] He did not contradict this and described himself as an "artist baby"[27]: "I called her Maria and she called me her little squirt. That says a lot already!"[28] Rainer candidly admitted: "I was a beginner; she had pretty much found herself artistically." Rainer was impressed by Lassnig's approach to colors and admired

her Expressionist paintings: "If you look at her paintings from then, they seem like the usual Realism to us. They have nothing that is too expressive or caricature-like, but they were viewed as such back then."[29] As Carinthian Colorism and late Cubism played a lesser role in Rainer's own artistic quest, he felt less inspired by Lassnig in his specific work than in his attitude and self-image: "She was my first encounter with a real artist." He was surprised to discover what big challenges must be faced when trying to establish an artist's existence: "I saw how tremendously difficult it is; I hadn't known that at all! How hard it is to have a studio, to pay for everything, how much you have to struggle. How futile it is! And how isolated you are."[30]

Der objektive Zufall / Portrait A. Rainer (The Objective Chance / Portrait A. Rainer), 1949

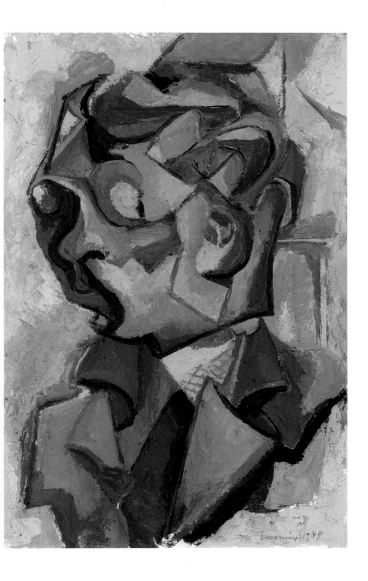

Der aktive Ekel (Active Nausea), 1951

Rainer also found access to philosophy through Lassnig, a topic that was becoming increasingly important to him. At the time, Lassnig was enthusiastic about Kierkegaard and shared her books with Rainer. He tried to work his way through this "heavy stuff."[31] Again and again, Lassnig was looking for an art theory that suited her experience as an artist. Rainer recalled intense discussions about the *Theory of Fine Art* by Gustaf Britsch.[32] Britsch was not interested in historical, sociopolitical, or manually technical aspects of art but rather tried to explore what was typical of art—independent of time and place. He saw art as a mental achievement in which what was seen was not translated into terms but directly into images, without the detour via language. For Britsch, all artistic thinking was based on distinguishing between what was "meant" and "un-meant." The "meant" was the one color-patch among all visual impressions that the artist had selected and transferred to canvas or paper. The "un-meant" was the surrounding chaos the artist ignored at that moment. Lassnig was fascinated because this theory was also about how a perception is translated onto a canvas—one of her lifelong topics. However, she would soon say goodbye to connecting art exclusively with the sense of sight like Britsch did. For her, perception could also be something quite different; perception could be experienced even more directly through her body than her eyes. At that time, however, she was impressed by Britsch's theory, and Rainer was impressed that Lassnig was dealing with theoretical and philosophical questions in the first place. They both enthusiastically read Sigmund Freud. Lassnig: "It feels good to read Freud. While reading I was shaken by horror and

disgust when I found myself in his writings, yet my joy was twice as great when I was forced to realize my state wasn't that bad."[33] She jotted down long reading lists, cutting across world literature from Flaubert, Dostoevsky, and Stevenson to Kipling, Saint-Exupéry, and Maupassant to Zweig, Wedekind, and Musil. She wrote: "Proust, Sartre, Thomas Mann, my greatest experiences of recent times."[34] In 1951, she titled a drawing *Active Nausea* (*Der aktive Ekel*), alluding to Sartre's famous novel *Nausea*.

Rainer also owed much of his inspiration to the cultural activities of the liberators. Driven by a tremendous curiosity, whenever he had time he visited the reading room of the British Council or the small French Cultural Center in the Kärntner Kunsthaus (Carinthian Art House)—a paradise for a young artist: international art magazines and catalogs lay there, which you were allowed to leaf through and study as long as you wanted. Rainer's most important discovery at the time was Surrealist art. He came to the conclusion: "Everything that was modern was Surrealist, in contrast to the Carinthian school."[35] At that time, he didn't know that Surrealism's best days were already long behind it. The trip to Paris with Lassnig opened his eyes. But in the meantime, Surrealism was a fascinating frontier for him, and he was determined to enter and explore it in numerous drawings.

Lassnig gradually got into Surrealism, too. Previously, she had only known it from literature, especially via Max Hölzer, who recited Surrealist texts in her studio. Now, Rainer showed her catalogs of Surrealist visual art. In 1948, she had seen the first Venice Art Biennale to take place since 1942. In those days,

Sex-Selbstporträt (Sex Self-Portrait), 1949

Klagenfurt to Venice was a feasible but strenuous day trip. There she first saw Max Ernst and other Surrealists in the original. Her use of Surrealist methods in her own works she attributed to Rainer's influence: "His mutilated figures made a strong impression on me and, to the horror of my friends, I began making similar drawings."[36] Rainer was pleased and proud that Lassnig was interested in his perspective: "I do not want to say that she was influenced, but that she took on this way of thinking in her work." All in all, he was humble in retrospect: "It's not about my influence. It's about the influence of the Surrealists. But perhaps she was motivated by me to deal with Surrealism. I wouldn't dare to claim that I directly influenced her painting."[37] Later, in the mid-1950s, he told Lassnig she shouldn't have let him distract her so much from her own artistic path, that her detour into Surrealism had hurt

her career. Lassnig saw it differently: "For me, the Surrealist drawings were an act of liberation."[38] On another occasion, however, she herself thought that Surrealism had been an unnecessary detour for her, that she had not needed it to find her own way.[39] Nevertheless, Surrealism made Lassnig's stroke freer and more like calligraphy, and her Surrealist drawings, which were still figurative at first, gradually developed into more and more abstract forms. "That came in stages: Surrealism, automatism. The Surrealism was still figurative, and the automatism was simply scribbling around, like doodling while on the telephone, just a great freedom!"[40]

Surrealism was an important step on the way to arriving at her artistic life topic: Body Awareness. Decades later, she included her Surrealist work from 1948–49 as some of her earliest Body Awareness drawings. At that time, she had already noted her first thoughts about Body Sensation, simple observations she made when she put her arm on the table:

Selbstporträt als Ohr (Self-Portrait as an Ear), 1949

"Determined concentration enables anyone to realize that pressure applied to parts of the body causes images to take shape in the head, images that might not come directly from the unconscious, but which are freely invented forms that can be further elaborated."[41]

Now she drew her first Surrealist self-portraits, where she no longer presented herself as she saw herself but how she felt—for example, all puckered up sourly in *Self-Portrait as a Lemon* (*Selbstporträt, als Zitrone*) from 1949. Between the sliced lemon halves you can see a tightened-up face, the way one puckers up when one has eaten something sour. At the same time, Lassnig—as the title suggests—becomes a lemon herself, not just the lemon but also the table on which the lemon lies, connected with her body. Lassnig described it this way: "If the eye coalesces with a lemon lying on the table, then you choose the lemon. The best you can do is just let the table edge crop your body and cover it with wood grain!"[42] Here, she combines Body Awareness with Surrealist methods, which also combine seemingly unrelated things.

Another drawing from the same year Lassnig labeled *Sex Self-Portrait* (*Sex-Selbstporträt*)—a provocative title for the late 1940s. You see a collage of net-stockinged legs and hairy legs, genitals, body curves, painted lips, table surfaces, and abstract shapes. In *Self-Portrait as an Ear* (*Selbstporträt als Ohr*), also from 1949, she in turn put her extreme sensitivity to sound and noise at the center of her body perceptions. In this drawing, the outside world, or the noise, dissolves the boundaries of the body—the outside penetrates the inside. The ear

*Tartüffe Rainer
(Tartuffe Rainer),
1949*

and the objects can no longer be separated from each other.

All of these drawings, which Lassnig referred to as Introspective Experiences (Introspektive Erlebnisse), show no complete body but fragments into which she dismantled her body perceptions. For her, this didn't mean less realism, but even more: "The Introspective Experiences became even more Surreal, the more real and clear the perceptions were. Reality consisted of recognizing the individual body sensations and their connectedness." Then, the important sentence: "False reality, the reality of the naive realist, means very little."[43] "Introspective," that is, "looking inward," was a term she later rejected since it was not about an inner view, not something that could be perceived with the eyes and the sense of sight. One thing is clear here; Lassnig did not pick up ideas from Surrealism in order to simply copy them but rather to use them for her very own interest, for what she later called Body Awareness images.

How much Lassnig experimented with various artistic approaches at that time is illustrated by her first solo exhibition in Vienna. It took place in 1950 in the French bookstore Kosmos in the Vienna Wollzeile street, where Ernst Fuchs had already exhibited that same year. Whereas in the previous year at the Kleinmayr Gallery in Klagenfurt she had exclusively displayed her most color-intensive, expressive paintings, she now presented the whole palette of her stylistic endeavors: expressive works in the tradition of Carinthian Colorism, Cubist paintings, and Surrealist drawings—for some visitors a too confusing variety. Five years had passed since the end of National Socialist rule. During these five years, Lassnig had caught up a lot on and worked her way through many directions and positions of Modern Art. Kuchling, her friend and adviser, once again wrote a text describing her as an "earnest seeker—the best that can be said about a young artistic force."[44]

Albert Paris Gütersloh, known for his rousing art-exhibition speeches, opened the show. The sixty-plus-year-old Gütersloh was not only president of the Vienna Art Club but at the same time a well-respected doyen and art patron, as well as *the* authority figure of the young Viennese art scene of the time. In

1938, he lost his professorship at the Academy. In 1940, he was banned from work and was therefore considered one of the few from the older generation who was politically spotless. In his opening speech, he said: "Maria Lassnig has the obvious academic ability. She can draw the hand correctly, so that it can draw a correct head correctly. Why doesn't she stay on the golden, stable ground of her learned artistry? Why does she act as if she can't do anything according to the rules of academic art?" Gütersloh's posing of this rhetorical question illustrated what the general public expected at that time and how little they could handle modern art in post-war Vienna. In Lassnig's paintings, Gütersloh continued, "reality is still present, but in a strange collapse, like after an earthquake." With earthquake he meant, without expressing it explicitly, on the one hand, the shocks of the modern world; on the other hand, National Socialism. Finally, Gütersloh added, contemporary art must be doubtful because the present and future are doubtful, dubious, and uncertain: "That's why we shouldn't take our standards from the museums, where these standards stand around like walking canes or umbrellas, while the corresponding coats have disappeared."[45] Despite this celebrity spokesman and the well-attended opening, the exhibition generated less resonance than Lassnig had hoped for. There were certainly positive reviews that counted Lassnig among the "most promising forces in Austrian painting," and they considered her a "credible talent," describing her work as "full of an unruly, spellbinding power."[46] A Klagenfurt newspaper headline: "Maria Lassnig succeeds in Vienna."[47] But that was not enough for her. Her exhibitions in Klagenfurt had been the talk of the town, and for the first time she experienced how difficult it was to gain recognition in the capital.

Lassnig was even less satisfied with the reviews for a subsequent group exhibition. It was the legendary first and only exhibition of the so-called Dog Pack (*Hundsgruppe*) in March 1951 in Vienna. This artists' group name goes back to a famous antique mosaic from Pompeii showing a black dog baring its teeth with the inscription "Cave Canem," that is, "beware of the dog." The name was the program: it was about an aggressive, provocative, radical demarcation of the boundary line to—what the group considered—all-too-tame Austrian contemporary art. Gerhard Rühm, who, together with Hans Kann, presented the joint composition *Noise Symphony* (*Geräuschsymphonie*) at the opening, described the group as "the extreme left with a provocative profile."[48] In addition to Lassnig and Rainer, there were seven other artists, among them Fuchs and Arik Brauer.[49] Only by personal invitation did one have access to the exhibition itself, both at the opening and on the following days.

On the invitation, Lassnig's name was written once correctly and once as "Lassnigg." This was not a misprint but intentional, Rainer remembers, because Lassnig experimented with her name back then. He himself signed his work

TRRRR, a series of letters that musically imitated the growl of a dog—corresponding to the name of the group.

His protest attitude was also made clear in the titles, such as *ha—oh (I spit on you)* [*ha—ach (ich bespucke euch)*] or *My Hatred is Inextinguishable (Mein Haß ist unauslöschlich)* or simply *I Say No! (Ich sage Nein!)*. Many myths grew especially out of his provocative performance at the art opening—the so-called "insulting the audience"—and a variety of different memories exist around this event. One thing is certain: Fuchs had started with an opening speech when Rainer, outraged by its conservative harmlessness, intervened. He was said to have suddenly appeared, like the crocodile in a puppet show, behind one of the exhibition walls, standing on a ladder with a hammer and a saw in his hands, waving them around. Shaking violently with excitement and a bright red head, he shouted: "And this I want to add, too. We shit on you! You are all assholes! You with your rotting concept of what culture is! I spit on you." At least this is how Wolfgang Kudrnofsky, one of the other participating artists, remembered the evening. With his aggressive performance, Kudrnofsky said, Rainer was actually the only one who complied with the motto "Cave Canem."[50] The audience consisted of fellow artists from the Vienna Art Club, press representatives, and old court councilors (*Hofrat*) from the Society for Science and Art, on whose premises (Vienna's Museumstrasse 5) the event took place.

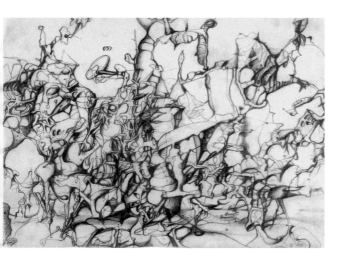

Exkremente des Kolibri (Excrement of a Hummingbird), 1951

When Rainer was asked what Lassnig thought of his provocations, whether she had admired or criticized them, he said: "She supported it, but she didn't admire it."[51] Lassnig contributed four of her Surrealist drawings to the exhibition, among them her *Excrement of a Hummingbird (Exkremente des Kolibri)*, a highly abstracted organic formation.

There were mixed reviews. The *Wiener Tageszeitung*, a Viennese daily newspaper, described the participating artists as "extremists who have now turned their backs on the Art Club as a watered-down club full of lightweights."[52] While Otto Breicha, one of the most important cultural journalists of the period, regarded Lassnig's and Rainer's Surrealist works in retrospect as the most radical of the Dog Pack, the reviewer from Vienna's daily newspaper *Der Kurier* saw it quite differently. He could not see anything original in their work. While he granted a certain talent to the artists Fuchs and Brauer, later to be known as Fantastic Realists,

he completely rejected Lassnig's and Rainer's talent and quoted the titles of two drawings: "The less gifted try to touch up their harmless drawings with titles like *Excrement of a Hummingbird* and *bü-häll*."[53] Even the review in the Austrian *Presse* newspaper was anything but jubilant.[54] Although Lassnig's art was not greeted with great enthusiasm in Vienna, she would finally move back there again. Before that, however, a mind-expanding journey was on the agenda.

Meeting the Pope of Surrealism André Breton in Paris

"France was the dreamland for me. Paris, the city of art!"[55] Lassnig was burning to learn more about French art and culture. When relationship difficulties stacked up—"when I had had enough of Rainer"[56]—she looked for distance and distraction. A trip to Paris would have been just the thing, but first of all, it was unaffordable, and secondly, almost impossible during the Allied Occupation without an invitation from France. Fortunately, Lassnig had good contacts with the small French cultural center in Klagenfurt thanks to her former fiancé Louis Popelin, whom she contacted again on this occasion. The French cultural society had already supported her exhibition in the Kosmos bookstore. Then, when she applied for a stay in Paris, she received a two-month art scholarship on top of this—and her joy could not have been greater. In the meantime, she had reconciled with Rainer. Although the scholarship was only enough for one person, she decided to take him with her and allocate the money for two or three shorter trips. Lassnig's statements about this are contradictory. The first stay took place sometime between mid-April and late May 1951, soon after the Dog Pack exhibition, another stay probably in September 1951, and the third in February 1952.[57]

Lassnig and Rainer boarded the train to Paris, and with this, their art adventure began. In the Bohemian district of Saint-Germain-des-Prés, they found a cheap hotel room, "a dive," as Rainer recalled.[58] Going to bistros was far too expensive and out of the question. In order to fill their stomachs, they both bought starchy foods at the market and prepared them on a Bunsen burner in their hotel room. Most of the time, they ate semolina pudding or rice. The cramped room offered little space, and when the two wanted to work, they had to do it in bed—sometimes even under the blanket because the unheated room was bitter cold at this time of the year. "You couldn't paint at all, you could only draw. Of course, the bedding was also dirty because of all the carbon and graphite dust."[59] The circumstances were anything but idyllic, and the conflicts between the couple stacked up again. Rainer would even leave Paris before Lassnig.

Lassnig's language skills, which she owed to her eight years at the Ursuline High School and to Popelin, proved to be a great advantage. Rainer recalled, "Since she spoke good French in contrast to me, I naturally depended on her a bit."[60] So it was her job to make telephone calls, arrange meetings, and to

translate everything as well. One of the first visits was to the poet Paul Celan, whose address they got from Hölzer and Jené. Celan lived in a hotel, as did many artists, writers, and intellectuals.

He was very happy about the visit because despite all the distance he placed between himself and Austria due to the Nazi enthusiasm of his former compatriots, he still felt connected to Austrian culture—at least that's how his friend Hölzer described it in a letter to Guttenbrunner in 1952: "Celan, very tender, with a great longing for Austria, especially for the forests, and the East."[61]

He lived from teaching and translating and was about to translate into German *A Short History of Decay* by aphorist and philosopher Emil Cioran, who was still little-known in the German-speaking world. Originally from Romania, Cioran was characterized by radical pessimism. After his enthusiasm for National-al Socialist Germany and antisemitism in the 1930s, Cioran's basic thesis was that any ideology, religion, or political action was an illusion and would only accelerate the collapse of the world. It is not known whether Celan, himself a victim of the Nazi regime, knew of Cioran's political past.[62] In any case, Celan told his Austrian visitors about this translation work, and Rainer was especially affected by this and attracted to Cioran's pessimistic theories. This soon motivated him to paint his gloomy black paintings: "This shaped me and my art for the coming decades."[63]

Mostly, however, Celan gave the artist-couple advice about Paris, recommending artists' cafés such as the Flore, which at the time was not crowded with tourists yet, and listing other important addresses. However, the two were not very enthusiastic about the barely affordable cafés: "Artists, or people who thought they were artists, sat there for days or at least half a day, thinking they were producing culture with their discussions or arguments."[64] It was Celan who arranged the meeting with the man who was the main reason why Lassnig and Rainer had come to Paris in the first place: André Breton. In order to understand how great their curiosity for Breton was, one has to realize how revolutionary his approach was for Austrian artists after 1945. Breton was the leading figure in French Surrealism, an artistic movement in film, literature, philosophy, and art that emerged in the aftermath of the First World War. When Breton wrote his First Surrealist Manifesto in 1924, five-year-old Maria was still lying neglected in a wheelbarrow in Kappel am Krappfeld. While this artistic movement was at its peak, her drawing teachers had her copying Rembrandt and Dürer. And at the time of her studies at the Academy, Surrealism, like all Avant-Garde movements, was considered degenerate. The Surrealists did not want to revolutionize just art but also society and life as a whole. All areas of human existence should be included, all human relationships, eroticism, fantasy, and dreams. Surrealism was less a style than a way of life. At the center of the criticism were the hypocrisy

of bourgeois society, double standards, and the dominance of logic and reason, which, according to the Surrealists, had led to the First World War.

They both now sat across from the founder of this art and life revolution, the "Jesus of Surrealism," as Rainer put it. Breton held court in a café, surrounded by ten to twenty of his followers. He was used to being visited and adored by artists from abroad: "At that time, all the Surrealists who had fire or ambition came to Paris and sought the blessing of Breton. For him, that was not a burden, but a self-elevating matter of course, and at the same time a ritual."[65] Breton must have been a charismatic phenomenon indeed. With his big head and serious face, he reminded many of a majestic lion and radiated tremendous authority. In the 1920s, when he gathered with his friends and colleagues on the terrace of Café Flore, and everyone practiced together in "automatic writing," the mood was creative, avant-garde, and grandiose. This vibe was lost by the early 1950s—lost at least to Lassnig and Rainer. Breton, now a fifty-five-year-old, was deeply disappointed about the failed Trotskyist revolution in France for which he had hoped. "In the evening, they are always huddled and crammed together like chickens in the café," remembered Rainer, who was also disturbed by the sectarianism: "Pure Trotskyist doctrine ruled the group, and if anyone had a different opinion, the person was excluded. In our view, that was a bit ludicrous."[66] Lassnig and Rainer hadn't anticipated this: "We were naïve enough to believe that Surrealism was still in its heyday."[67] But Surrealism "wasn't cooking anymore."[68] Still, they got into conversation with Breton and others. They met Julien Gracq, Benjamin Péret, and Toyen, the most famous twentieth-century female Czech painter, who had joined the Surrealists in Paris back in the late 1920s. Lassnig and Rainer showed their drawings to the group and gained their recognition. It was decided to publish a portfolio: Gracq would write about Rainer's drawings and Péret on Lassnig's work. Lassnig's planned portfolio was supposed to have the title *The Garden of Passions* (*Der Garten der Leidenschaften*), and Péret wrote, among other things: "The body corral of wild hordes provokes unexpected copulation. On the barely born day, Maria Lassnig's world will surrender to loveplay."[69] Lassnig was thrilled about the text and had it printed decades later in her exhibition catalogs, although the portfolio never came to fruition.

Breton was overjoyed with Lassnig's and Rainer's artistic achievements and invited them to his home apartment. The two of them found this visit particularly disappointing. As a greeting, Breton kissed the young female artist's hand. Lassnig and Rainer could not believe how settled, how bourgeois, how downright stuffy the former revolutionary had become. There was nothing left of the 1920s spirit of shocking the bourgeoisie. In 1928, Breton proclaimed in his *Second Surrealist Manifesto*, "The most basic Surrealist action is to go out into the streets with revolvers in hand and blindly shoot as much as you can into the

crowd."[70] Now, he sat comfortably in his living room and smoked a pipe while his daughter, "dressed conservatively," stood at the ironing board, diligently doing housework—a sight that permanently puzzled Rainer in particular.[71]

Anyhow, Breton possessed impressive artworks: "I was surprised because I had never seen such a wonderful art collection on the walls before,"[72] Rainer said. But the encounter did not become the consciousness-expanding key experience they both had hoped for. As so often in life, it's not what you long for, it's the unexpected that actually knocks your socks off.

"Vehement confrontations"—real contemporary art

When Lassnig and Rainer once again strolled through the galleries of their neighborhood, they discovered something sensational. In a side street of boulevard Saint-Germain, on rue Dragon, there was the Nina Dausset Gallery, which housed the latest avant-garde art of the time. The exhibition *Véhémences confrontées* took place here from March 8 to 31, 1951.[73] The show's subtitle was "Extreme Tendencies in Non-Figurative Art." The titling alone made it clear: it's "cooking" here; innovation is taking place here, quite unlike worn-out Surrealism. The small but groundbreaking exhibition was curated by influential French art critic Michel Tapié. For the first time, American and European abstract artists were exhibited together—the highly sought-after American Abstract Expressionists and the European Informel, although this term was not yet common at the time. Only after Tapié used it for another exhibition in November of the same year was the term established for the new art movement.[74] Although the Informel (Informal Art) was rooted in Surrealism, it distanced itself greatly from it. Sociopolitically, it was a reaction to the catastrophes of the twentieth century, to National Socialism, the Holocaust, and Stalinism. The horrendous reality could no longer be overcome with Figurative Art and Realism but with an abstraction that was not based on geometrical forms but on the unformed, on gestures and inner expression. Everything figurative was considered politically infected or at least in danger of becoming ideologically instrumentalized. Artists took a big step back from the observable outside world. Abstraction in general, whether American Abstract Expressionism or European Art Informel, was now considered the language of the Western Free World, deliberately propagated in opposition to the aesthetics of National Socialism and Socialist Realism.

When Lassnig and Rainer entered the Nina Dausset Gallery, the exhibition had already been taken down for a while; only a few works of the exhibited artists were still on the walls. However, there was a large poster-leaflet that was both a poster and an exhibition catalog that showed a work by each exhibited artist.[75] Today, it is hard to imagine what a tremendous impression the French exhibition made on the young artist couple from provincial Austria. It featured

Körpergehäuse (Body Housing), 1951

Jackson Pollock's monumental drip paintings, huge oil canvases that he did not produce on an easel but on the floor as he danced with tubes, paintbrushes, and spatulas across the canvas, rhythmically and gesturally distributing paint. And there were the famous Woman paintings of Willem de Kooning, who, like Pollock, worked in New York and who had just celebrated making his international breakthrough at the Venice Biennale. His female figures, between figuration and abstraction, were buxom, deformed bodies with demonic grimaces, which shocked prudish 1950s America. Lassnig and Rainer also saw the work of Georges Mathieu, who did not apply paint with a brush but instead hurled it at the canvas. Later, he would no longer do this in a quiet studio but in public and in theater halls in front of two thousand spectators. With eight hundred tubes of paint, he would complete a four-by-twelve-meter painting within half an hour. In 1959, Mathieu had a spectacular performance at the Theater am Fleischmarkt in Vienna.

Pollock, de Kooning, and Mathieu were still counted as the stars of those years. However, the two artists who impressed Lassnig and Rainer most were far less well-known: action painter Jean-Paul Riopelle from Canada and French painter Camille Bryen. When Lassnig and Rainer coincidentally met Riopelle at

the exhibition, they were overjoyed. As always, when they moved through the galleries, they also had their own portfolios with them and showed them not only to Nina Dausset, the young gallery owner, but also to Riopelle: "We didn't have any originals with us, just photostats," Rainer reported. "In those days I drew on transparent paper and then made copies. I'd learned how to do that in the structural engineering course, and I kept increasing the quality and thickness of the material I used. I ended up using translucent tracing cloth." Although Riopelle had abandoned Surrealism by the end of the 1940s, he was able to make something out of the Surrealist drawings of Lassnig and Rainer. "When Riopelle saw what we were doing, he looked after us,"[76] said Rainer. The artist not only invited them both to his art studio, he also introduced them to Karel Appel and Mathieu, as well as to Hans Hartung and Wols. The latter two had fled from Germany into French exile during National Socialism and already felt like they were Parisians.

Lassnig was especially interested in getting to know Bryen, whose exhibition work she found convincing. This was easy because Bryen's art studio was just across from the Dausset Gallery: "Bryen impressed me greatly, as he was very close to the surface and the paint. I've always had a penchant for the painterly aspect of painting."[77] Bryen's works blurred the lines between Surrealism and the Informel, which also may be the reason that Lassnig appreciated Bryen so much. In the exhibition at Dausset's gallery, he presented his works with the label "meta-morphique," which can mean both "between the form" and "after the form." About half a year later, Lassnig labeled her own work with the buzzword "metamorphic painting." Bryen was witty, jocular, bubbling over with great verve and was prone to erupt in loud shrill laughter. One often met him with Wols or Mathieu in venues such as the Tabou on rue Dauphine, where Juliette Greco performed, or in the first American bar in Paris, Bar Vert, on rue Jacob, where intellectuals like Jean Paul Sartre, Raymond Queneau, Jacques Prévert, and Antonin Artaud met, or even in La Rhumerie on the boulevard Saint-Germain.[78]

Lassnig and Rainer networked their way from one art studio to the next and got to know almost the entire French Informel scene. Lassnig thought, however, she had been far too shy about entering into an intense exchange with the individual artists.[79] Another painter whom Lassnig especially valued alongside Bryen was Jean Fautrier. Fautrier made his breakthrough in 1945 with his *Otages*, a series of hostage paintings depicting abstracted heads on a sculptural background of plaster and paper—his attempt to artistically process the atrocities of the war and the Nazis. Fautrier's thick application of paint fascinated Lassnig and was something she had never seen in Austria. However, Lassnig's and Rainer's greatest longing was not to just meet artists but also to exhibit their own artworks in Paris. They conversed with many gallerists, Dausset among others, who initially seemed very interested. Still, despite the good contacts with Riopelle,

Bryen, and the other artists, nothing came of these high-flying plans—at least not then. Lassnig and Rainer underestimated how difficult it was to gain a foothold in Paris. A good decade later, by the way, Lassnig met Riopelle again when she moved to Paris for eight years. Together with his partner Joan Mitchell he would count among her best friends.

Back in Austria, Lassnig and Rainer, quite euphoric from their experiences in Paris, began to do Informal Art themselves: "Yet I didn't just simply take it on, but immediately translated it into my own Body Awareness language."[80] Rainer summed it up similarly: "We both benefited from the fact that we increasingly dissolved our Surrealisms and found shades and nuances between the Surrealist and the Informal. In doing so, we prided ourselves in finding our own way, which was not French."[81] This means that even though Lassnig experimented with the Informel, she didn't make it an end in itself or do it because it was the latest craze, but rather she used these new methods to get closer to her life topic, Body Awareness.

Lassnig and Rainer not only changed their own ways of working but also became ambassadors of Informal Art in Austria. Dausset's stimulating exhibition inspired them to try something similar with Austrian artists. They conceived of an exhibition in which the most varied Austrian positions of abstraction confronted each other. The two succeeded in finding an attractive location for this extraordinarily innovative project—the Künstlerhaus in Klagenfurt. They also managed to win over the most important artists. In November of 1951, the same year as the exhibit that had inspired them, they opened the exhibit *Unfigurative Painting (Unfigurative Malerei)*, the first major survey of Austrian nonfigurative art ever. Works were on display by Friedrich Aduatz, Hans Bischoffshausen, Josef Mikl, Wolfgang Hollegha, and Johanna Schidlo. Following the Parisian model, the exhibition was accompanied by a large poster-leaflet, which simultaneously served as a poster and catalog.

Lassnig played with her name again. This time she didn't call herself "Lassnigg," as she did with the Dog Pack, but "Lassing." A handwritten note on the draft of the catalog showed she also considered calling herself "Salassing."[82] For the exhibition, she authored a manifesto, which stated, among other things: "Unfigurative art is not an absence, not a turning away from the world, but far more a concentrated accumulation of all its possibilities and contradictions." And: "Aesthetic color associations begone!"[83]

While Lassnig presented her works—inspired by Bryen—under the moniker "metamorphic painting," Rainer summarized his work as "optical dissolution, atomic painting, blind painting, expression élémentaire" and called himself TRR again, this time with two R's fewer. What's more, under the Dadaistic-looking female nickname Katharina Zuzzlu, he exhibited the so-called

"Nada painting," or "Nothing painting." These were the most radical works of the exhibition because they consisted of empty picture frames. In the catalog, TRR wrote: "This beautiful child of nature receives all our adoration. Her Nada painting, growing out of naturalism, has already earned her many honorary prizes. Her latest non-figurative works represent the culmination of her development, which we all envy. (Congratulations, Katharina)."[84] Lassnig recalled, "I exhibited my patch paintings, and he caused a scandal with his empty picture frames."[85] The exhibition was not positively received in Carinthia or any other part of Austria. Some of the professors at the Academy of Fine Arts in Vienna explicitly opposed it. Lassnig summed up the outrage: "The first Informal exhibition that Rainer and I organized in Carinthia caused quite a stir. No landscape, no more people in the paintings—the stir reached threatening proportions among the ignorant."[86]

For the second time in this eventful year of 1951, it was Rainer who was perceived as particularly provocative; first, for his "insulting the audience" at the Dog Pack art opening, and second, for his negating or overcoming of painting at their jointly curated exhibition, with which he actually became the most radical modern art representative. Lassnig was no longer the new young star but rather Rainer, despite how hostile much of the public and the art scene were to him. In the autumn of the same year, Rainer had his first solo exhibition at the Kleinmayr Gallery, where Lassnig had held her first solo show two years earlier. In his invitation to the art opening, he claimed to be "a member in several foreign art groups (la groupe des surréalistes, Paris)." Furthermore, it stated that his works were "in private and public collections in Brazil, Germany, France, Italy, Austria, Switzerland, USA, etc."[87] He was twenty-two years old then. Without any doubt, Rainer was much more talented in self-marketing than Lassnig. The artist who called herself "Little Miss Zero-Self-Confidence"[88] was growing increasingly upset by Rainer's cockiness. It was becoming progressively difficult for her to deal with the competition.

I'm everything, but only halfway. I get there, almost. Hoping with all my power to conquer Vienna, just because I don't want to conquer it.[1]

5 The 1950s in Vienna: A Man's World

1951–60

In 1960, at the end of the decade, Lassnig drew herself a mustache. Naturally it was a joke but with a bitter aftertaste, a commentary on how hard it had been for her to assert herself as a female artist in a male-dominated scene for the past ten years. If you wanted to make art in the 1950s, it was better to be born a man—this insight is symbolically expressed by Lassnig with two black strokes above her lips. Two years earlier she had written in her journal: "I shit on this world and the next. Before I die, I want to have time to destroy everything I did and destroy my stuff in all museums."[2]

The beginning of this decade initially held great hopes for Lassnig. In 1951 alone, her growing accomplishments ranged from the Dog Pack exhibition in Vienna to the overwhelming experiences in Paris to the *Unfigurative Painting* exhibition in Klagenfurt. In the same year, she also undertook a weighty step: she moved back to Vienna six years after she had returned to Carinthia at the end of her studies. There were many years where she had lived for weeks and some-

Maria Lassnig with a mustache, cover photo on the leaflet for her exhibition at Galerie St. Stephan, 1960

times months at various addresses in Vienna to prepare exhibitions, among other things.[3] She lived with Rainer in Ernst Fuchs's old and—as Lassnig emphasized—drafty art studio in Haasgasse 10 in the second district, where he generously allowed them to stay. They probably didn't know that the first Vienna city kibbutz was located here in 1933. In 1952, Lassnig moved into her own attic apartment at Bräuhausgasse (Brewery Street) 49 in the fifth district, not too far from the Naschmarkt.[4] Because of this address, her friends nicknamed her "little brewery horse."

The studio consisted of a large, bright room with gray-lacquered panels directly under the roof and a sloping window facing north. Lassnig appreciated these lighting conditions: "My paintings need light, so they can shine."[5] She couldn't work without natural sunlight. She also bemoaned the lighting situation in the few Viennese galleries that existed in the 1950s. In 1955, the year of the Austrian State Treaty when Austria's sovereignty was returned ten years after the end of the Second World War, she wrote, "Painting in Austria is so bad because the galleries are so dark."[6] However, the light was ideal in her studio. Only in winter when it was snowing did it get dark, because the snow remained on the sloping windows. In this attic apartment—"a very poor studio"[7]—she lived under the simplest conditions: "I

starved and froze there."[8] In summer, however, the room's low ceiling made it suffocatingly hot. A narrow couch was enough for Lassnig to get some shuteye. The only water came from the old staircase washbasins—*Bassena*. The toilet, as was common then, was also in the main public hallway. There was no heating. A charred aluminum pot was her only crockery, which dated back to her old Wandervogel hiking club days, and her childhood friend Bergmann immediately recognized it when he visited her.

With a shudder, more than sixty years later, he remembered how Spartanically his old friend had nourished herself back then; most of the time, the old pot was only filled with a little rice or potatoes.[9] Lassnig herself also liked to share anecdotes about her diet: because she had no fridge, she used to put perishable food on the sill between the windows. Sometimes when she had meat, it developed maggots. Looking back on this, she almost gleefully told how she had held the rotten meat over her gas stove until the worms fell out. In her eyes, it was then perfectly fine again.[10] She had little money to go shopping. Sometimes Lassnig was able to pay for food with her artworks—to her great relief. For example, on the back of a painting there was the following note: "An oval landscape by Ms. Lassnig in exchange for potatoes and preserving sugar for a whole month. Delivered to Bräuhausgasse in September."[11] She lived under these conditions for ten years. In her journal, she noted, "I felt justified by what Boeckl said: 'The more vital you are, the harder and more ascetically you have to live.'"[12]

Despite the barren conditions, she always clung to this studio. She didn't give it up, even when she lived in Paris and New York, but instead left it for Bergmann's sons to live in when they were studying in Vienna. During the summer months, which Lassnig always spent in Austria, she herself moved back to the Bräuhausgasse for intermittent stays in Vienna.

The Vienna Art Club, the Strohkoffer, and Lassnig's "dumpling paintings"

The 1950s Vienna cultural scene often has a whiff of the romantic—even the infamous, the exclusive, and the creative. But that's only a small part of the truth. Nowadays, it's hard to see how difficult it was for women then who didn't opt for the traditional role of the housewife, spouse, and mother. Combining work, life, and love was impossible for the most part, and that was also the case for Lassnig. But it is not just the situation of female artists in the 1950s that is hard to imagine today but also the resentment-laden, dull, and narrow-minded atmosphere in Austria and its capital, Vienna, back then. National Socialism had virtually extinguished the cultural and artistic Viennese avant-garde and intelligentsia. Even many years after the liberation, Nazi words like "filth and trash," "healthy national attitude" (*gesundes Volksempfinden*), and "degenerate" were still in

many people's mouths, especially when speaking about contemporary art. Members of a League Against Degenerate Art appeared reliably and vociferously at exhibition openings. As late as 1962, a demonstration of angry mothers against American Western movies took place in Vienna; they threatened young long-haired men with scissors.[13]

Only a tiny minority was eager to follow international trends. Slowly and in closed circles, an avant-garde art and cultural scene once again emerged. The desire and hunger for something new, after the notion of having reached a zero hour, was enormous. If you were in this scene, you actually had the feeling of being part of something very special. Ernst Fuchs was twenty years old in 1950 and belonged to this new wave of the avant-garde. He recalled: "There was this explosive spirit of wanting to break out, this longing to be outside oneself, beside oneself, to get out of hand in a wild high spirit."[14] Oswald Wiener, who classified the periods of his life in wave troughs and peaks, expressed similarly that the 1950s were "undoubtedly a peak" for him.[15] Or as filmmaker Ferry Radax put it: "With nothing but our imagination we created our world out of nothing."[16] The artist Maria Biljan-Bilger recalled the beginnings of the Art Club: "It was as if we all suddenly put aside the heaviness and began to blossom. It was really a great collective desire."[17] Lassnig was also determined to participate in this creative spirit of optimism and conquer the Viennese art scene. But she imagined it would be easier. Forty years later she summed up the 1950s; first, the positive: "I was a real avant-gardist." Then, the negative: "But my bad luck was that nobody acknowledged me at the time."[18]

In post-1945 Vienna, there were no serious, internationally recognized institutions of contemporary art. There were no galleries, no museum of contemporary art, no noteworthy art magazines, no art market. This made Vienna different from other European capitals, and it is not surprising that the art scene was on the one hand more provincial than in other cities, and that on the other hand, the artists felt particularly radical and avant-garde by setting themselves apart from the anti-modern art context. Wiener aptly described the mood of his generation: "I had the impression that all the others experienced this mood and spirit the way I did. That they were aware of the educational resources and the opportunities to blossom and unfold. These were all pretty talented people who faced the same problem, namely, that it was impossible to have a career in any reasonable sense of the word. Making money was absolutely unthinkable."[19] Wiener was a member of the Vienna Group (*Wiener Gruppe*), a loose association of authors who were intensely involved with language philosophy and language criticism. The architect and writer Friedrich Achleitner, also a member, described the morbidity of the 1950s scene: "For example, there was the slanguage word '*g'fäud*.' Every third sentence was 'Man, that's *g'fäud*.' It's actually a Surrealist term

with the mixed meaning of 'rotten' and 'to have missed the target.' '*G'fäud*' means something is wrong or slightly morbid. What '*g'fäud*' was could be seen everywhere. We deliberately searched for it, for example, in our endless strolls through Vienna and to the outskirts of the city."[20]

The reservoir for all those visual artists, literary figures, musicians, architects, and art educators who saw themselves as the avant-garde was for a short but decisive time the Vienna Art Club, founded in 1947 and around which today many myths, self-heroization, and fiercely contradictory anecdotes are tangled.[21] One thing was certain: men had all the say in this institution as well. Female artists like Lassnig, Biljan-Bilger, and Johanna Schidlo were members but fulfilled different roles than their male counterparts. Lassnig recalled having been perceived primarily as "decoration" and a "nice girl" rather than as an artist to be taken seriously.[22] Biljan-Bilger also had ambivalent memories and described obstacles for women, which we describe today as the glass ceiling: "I was always welcomed, loved, and presented as long as it was in an intimate circle. The moment a position, a role, was offered, I was instantly blocked."[23] The president of the Art Club was Albert Paris Gütersloh and one of the interim deputies was the Austrian sculptor Fritz Wotruba, who had returned from exile in Switzerland. Rainer described the Vienna Art Club as "the only artists' association that was free of Nazis after the war,"[24] while the Künstlerhaus was regarded as a citadel for National Socialists.[25] Even if there were remnants in the Art Club both from the time of National Socialism and Austrofascism, they tried more than anywhere else to clearly disassociate themselves from this.[26] For example, Gütersloh, who gave one of his famous speeches at the opening of the Art Club's inaugural exhibition in 1948, said, "We declare war on narrow-minded nationalism and the even more narrow-minded provincialism, not because we do not love our people and our country, but we declare this fight in the foreground to hit something deep in the background: the narrow-minded spirit, which so happily and unfortunately so successfully camouflages itself as love for the homeland, as loyalty to the soil." Gütersloh turned against all longings for old yesteryears and insisted upon innovation, exclaiming at the end of his speech: "The accent is on tomorrow!"[27]

However, opinions differed greatly about what this "tomorrow" should look like. After all, the Art Club was a "bunch of arch-individualists going in different directions,"[28] according to Otto Breicha. There was even a fight at the founding meeting, where Herbert Boeckl left before joining at all. There were also conflicts between young and old, quarrels, and petty jealousies. Rainer, who certainly would have liked to exhibit in the Art Club, was met with little love and enthusiasm and was considered a "charlatan and merely a provocateur."[29] Not least because of this, the previously mentioned Dog Pack, to which Rainer and Lassnig belonged, split off and organized its own exhibition at which Rainer

insulted the audience in a legendary way. Unlike Rainer, Lassnig was a member of the Art Club and exhibited there in 1952. She was also present in one of the successor organizations, a group that met after the end of 1954 in the Adebar in the Annagasse in downtown Vienna and called itself Exile. The name alluded to the isolated situation of the avant-garde in narrow-minded post-war Austria.[30]

A central agenda of the Art Club was to make it possible to hold an exhibition because there were hardly any opportunities for young artists to present their work. While the Art Club used other showrooms in its first phase, in December 1951 it finally opened its own gallery and clubhouse, the legendary Strohkoffer (Straw Suitcase). The premises were located in the basement under today's Loos Bar in the Kärntner Durchgang 10, a side street of the Kärntnerstrasse in the city center. Via a narrow spiral staircase, you came down into the small room, where there were a few tables, stools, and a piano. As there was hardly any money, they decided on cheap wall decorations made of reed mats from Lake Neusiedl, which inspired Wotruba to name the new club Strohkoffer. During the day, the Strohkoffer served as an art club gallery and in the evenings as a venue and clubhouse with a packed program. Every few days there were events. Famous Austrian authors like H. C. Artmann, Gerhard Rühm, and Friederike Mayröcker held public readings here. Joe Zawinul and Friedrich Gulda played the piano with four hands, and even international visitors such as Jean Cocteau, Benjamin Britten, and Orson Welles appeared here. A Stravinsky evening was organized; Hans Kann, Gerhard Lampersberg, and Rühm presented avant-garde music; and there were lectures on jazz, modern art, and contemporary poetry. During Carnival, the Art Club organized a costume party with the theme "Little Straw-Suitcase's bridal day."[31] At an earlier Art Club ball, Lassnig performed in pink pajamas and Rainer "partially cross-dressed as a girl": "We were crazy enough to attract attention among the crazies."[32] The mood was, at least for outsiders, wild, permissive, infamous. The evening events were hopelessly overcrowded, people crammed together like so many "sardines in a can"[33] that sometimes even numbered tickets were issued. They drank a lot of alcohol. The place was loud and smoky. They boogied and jitterbugged in the few free square meters. If you were hungry, you bought a pair of frankfurters or a "Bur-

Amorph (Amorphous), 1951

enheidl with Kremser,"[34] an Austrian sausage with sweet-hot mustard, from the "Little Sacher,"[35] as the sausage stand around the corner was affectionately called.

The writer Hans Weigel, who at the time promoted numerous young authors, reminisced about the pub: "The Strohkoffer was the most beautiful café in Vienna with all the advantages, and without the disadvantages, without the local ladies at the next table talking about food or clothes. It was the most ideal club you could imagine because it didn't have the rigid principles of a club."[36]

In January 1952, the Art Club Gallery opened its program with the first solo exhibition by Friedensreich Hundertwasser, followed by Johann Fruhmann, Maria Biljan-Bilger, and Josef Mikl.[37] Although men dominated the Art Club, women also had the opportunity to exhibit. According to Biljan-Bilger, Lassnig was the second woman to have an individual exhibition dedicated to her.[38] As in her first Vienna exhibition in the Kosmos bookstore, Lassnig showed her most diverse groups of works side by side: Surrealist-Automatism, as well as Tachisme and her latest works, which she called Static Meditations (Statische Meditationen) and Mute Forms (Stumme Formen). Again, both critics and the audience were bewildered. She was well aware of the problem, but it seemed justified to her to display several approaches at the same time because it was all about the same thing: Body Awareness, even if she had not yet found that term for herself. Even at the age of ninety, she mentioned that she always liked to show everything at the same time: "I was never very smart and clever at exhibiting. I always crashed into the art galleries with everything I had. You can't do that. You first have to put out all the red neckties, then the green ones two years later."[39] The latter was an envious allusion to Rainer, her eternal competitor, whom she accused of being a "necktie painter" because he often worked in cycles.[40] She noted in her journal in 1955: "Producing in cycles and series has ruined contemporary art."[41]

Lassnig had meanwhile, at least for the time being, said goodbye to Tachisme, which is a term often used synonymously with Informel. Derived from the French word *tache*, for patch, it also denotes a gestural-abstract art style, which spread from France through Europe in the 1950s. The term was coined by a critic, who actually meant it contemptuously, but as so often happens in art history—Gothic, Baroque, and Impressionism are other examples—the initially negatively associated word soon prevailed as a neutral term for the style. When Lassnig talked about Tachisme at the beginning of the 1950s, she meant her "color-patch paintings," where she slung paint at canvas or paper. "I didn't want to 'shape' any more, but hurled paint. I felt like a paint-flinging machine."[42] However, even though Tachisme quickly became fashionable in Vienna after she and Rainer brought it with them from Paris, Lassnig soon no longer liked the paint-slinging of Georges Mathieu. In his public appearances, he covered huge canvases with paint in no time. Mathieu focused on speed in order to release the

Statische Meditation III
(Static Meditation III),
1951–52

unconscious. Lassnig now wanted the opposite: "The Static Meditations were anti-speed paintings [as opposed to the popular, fast, and vigorous Tachisme]: I sat as a virtual resting point in the middle of rather small paintings, and went with the brush as far as my hand could reach, around the edge of myself."[43] Here it is clear how much these works have to do with her body, its borders, its interior, its exterior, which she separated from each other with the brush. The same applied to the Mute Forms. The extraordinary thing about these paintings was that she worked with blue-black on a white background: "I have renounced color, which is a big sacrifice for me."[44] Elsewhere she said, "That was quite exciting for people. They thought the painting wasn't finished."[45] The Static Meditations and Mute Forms are usually counted among Lassnig's Informal Art works, although the term is misleading. They do show parallels to the Informel, in form but not in content. Whereas the Informel relied on gestures, unbridledness, and action, Lassnig held herself back and concentrated on the inside. Due to the lack of alternatives and probably also to be somehow classifiable, she nevertheless used the terms Informel and Tachisme now and again for her abstract works throughout the 1950s.

The exhibition was accompanied by a small leaflet catalog with her own short text. Here it said, among other things: "Find the great form, which includes the multiplicity of all possible forms, walking along the boundaries of the hailstorms of the pen's furrowed fields in order to chronicle the smallest fluctuations on the infinite periphery, which the center makes."[46]

She didn't yet dare to speak explicitly about her body, which she later did in retrospect when she referred to these paintings: "In the leaflet for the Art Club Gallery exhibition in Vienna in 1952, I already tried to formulate that the brushstrokes in the Static Meditations are virtually drawn along my border, that the round forms show the body as something closed, as enclosed as possible."[47]

When Lassnig spoke of Static Meditations, she didn't mean anything spiritual or esoteric inspired by the Far East. Often, she spoke of her circles and conglomerations as having been snipped from the umbilical cord and called them "dumplings." With this term, she brought meditation back into prosaic Austrian daily life. The woman artist became a dumpling: such an antiheroic

and unmelodramatic approach was unusual in the Viennese art scene of the 1950s and incomprehensible to many. Some of the work from 1951 she called her Baby Carriage Form (Kinderwagenform). Like all her titles, this one also came about as an afterthought, when she realized what the captured body sensations reminded *her* of. She was now in her thirties, and the relationship with Rainer was already in crisis mode. With the title of this painting it was quite possible that she was both consciously and unconsciously, both ironically and seriously alluding to her ticking biological clock.

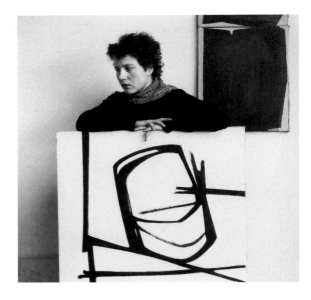

Maria Lassnig in her studio, Bräuhausgasse, Vienna, 1952

At the Art Club exhibition in 1952, Lassnig highlighted her intellectual character with quotations from Hölderlin, Parmenides, and Heidegger. The reviewer from the *Presse* newspaper had no sympathy for this and criticized the general tendency of young artists to fiddle around with too much theory: "They only theorize and brush up their weaknesses with quotes and big words. They have to talk big because their paintings are not paintings, just exercises and proof of theory."[48] Klaus Demus, whom Lassnig greatly appreciated, also found too much theory in her current work. Since he saw "art's zero point" had been reached, he called upon her to make a turnaround as he considered her "one of the very strong artistic talents."[49] Lassnig took this seriously.

Rivalries and lovesickness

In retrospect, Lassnig described the near decade she lived in Vienna from 1951 to 1960 as the "hard years."[50] By this she meant not only her financial circumstances but, above all, the difficulties of being perceived as an artist. The competition with Rainer played an important role, and this she found increasingly irritating. Rainer felt very differently about it. He found the constellation a stimulus, which drove him to better achievements. "We entered into a kind of artistic competition: who is the more modern? Or the more progressive? I do not know what expression we used then. It was definitely a challenge, but fruitful for both sides as well."[51] Lassnig didn't believe she could keep up with Rainer's talent for self-promotion and feared he might overshadow her. In numerous interviews, even decades later, she brought it up again: "I've always been connected with Rainer, as if I were his student. That was a terrible blow for me."[52] Or: "In those days I was always considered an imitator of Rainer. And that, of course, upset me

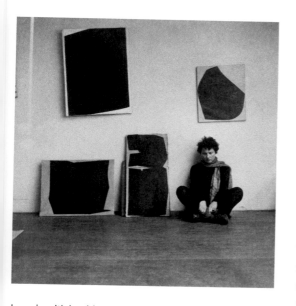

Lassnig with her Mute Forms, 1952

greatly."[53] Or as she wrote: "The fact that I was a friend of a strong personality (subordinate) made me a weak personality in the eyes of my Viennese friends, and I suffered a lot from this."[54] Rainer, however, didn't remember such things: "That is her complex."[55] The relationship between the two suffered from these circumstances. He had the impression he couldn't please her: "I had the feeling that she was becoming stranger and weirder, perhaps even more demanding."[56] He found it particularly preposterous when she reproached one of his distant ancestors: "The most paranoid thing I experienced from her was that in the nineteenth century a certain Sigmund Rainer got a great-grandmother of hers pregnant and didn't marry her." She used to reproach him, half in jest, half in earnest, and then added, "There, you see how the Rainers are."[57] Rainer did not find this particularly funny.

She, in turn, found that his achievements were recognized and hers weren't. Especially traumatic for her was his success with blind painting. More than a decade later, after she had already been living in New York for a while, she brought it up in a letter to her gallery owner. She was outraged to find out that Rainer's "blind paintings"—works that the artist had created in the early 1950s with his eyes closed—were well received. "I was very sad about it: There is only one witness (a German painter named Wande) who knows that I had already painted blindfolded in 1946–47 to better sense the Introspective Experiences. Rainer exploited this and made blind painting out of it."[58] On the one hand, Lassnig's remarks may seem whiny at first, a little paranoid and like a child screaming for attention. On the other hand, her experiences coincided with those of many female artists from those years. Women who developed a certain new way of working, a new motif, an interesting way of rendering something were barely noticed. But when their male colleagues, or often enough their husbands or life partners, did exactly the same thing, the men were celebrated for it.

Rainer, of course, saw the story of blind painting differently. He didn't remember that Lassnig had ever experimented with it and, in retrospect, could not recognize in her works of that time any of the familiar features of working blind. He was quite sure that he did not copy Lassnig: "I do not know if Lassnig did that, I do not want to say that she didn't do it. But I do not know of any such work from her because blind drawings have very specific characteristics. I do not know of even one from her."[59] Whether Rainer, without his being aware of it,

owed impulses to Lassnig that led him to blind drawing or whether he developed these completely independently can't be clarified. That he experimented with it at that time seems obvious since he was very interested in Surrealist methods. Blind painting or drawing was invented neither by Rainer nor Lassnig. As early as the 1920s, the Surrealists had already experimented with it. For them, it wasn't about getting at inner perceptions and excluding the outside world as it was for Lassnig. For them, it was about liberating the unconscious, the world of dreams, the sexual, and the irrational with the help of working blindly. The tradition went back even further. Caspar David Friedrich wanted to free himself from external influences in 1830. Although he didn't work blindfolded, he recommended: "Close your physical eye, so that you first see your painting with your mind's eye, then bring into the light what you saw in the dark, so that it reacts to the beholder from the outside in."[60]

The love relationship with Rainer neared its end in the summer of 1953. There were still a few ups and downs—Rainer accompanied Lassnig to Frankfurt, where she was preparing her first exhibition in Germany, which opened in the Zimmergalerie Franck in February 1954.[61] The two of them tried to stay friends, which was especially difficult for Lassnig, as she felt deeply slighted. She wondered why the relationship had failed but dismissed this question at the same time: "No more thinking about the problems and what was to blame: the money, the greed, the stinginess, the intolerance, the lovelessness—my age or my naiveté? Or the hunger for fame."[62] Especially the last point shows how difficult the artistic competition was for Lassnig. Then she came to the conclusion again that love relationships were generally not for her: "An insight I had already ten years ago: permanently playing the role of man tamer (of a certain man), is not worth the effort, not even if he's the largest predator." And: "Better to send him packing, and give the mind free rein again."[63]

Nevertheless, she was heartbroken: "I let myself go, and go, and go. I let myself down into unhappiness. May I and the world collapse."[64] In spite of all her longings, her conviction that art and love were mutually exclusive solidified: "If you make concessions in life, art goes downhill. If you take on too much in life, you cannot do art anymore. I wanted a perfect love. No wonder art does not accept my infidelity."[65] In the meantime, she knew she tended to lose herself in love relationships and surrender to the other—the typical psychological profile of a woman who lacked feelings of security in her early childhood, whose desire for love was insatiable, and who never learned to develop trust in human bonds.

The social circumstances played at least as important a role: it didn't fit the image of women in the 1950s and 1960s that an artist's mistress would want to be an artist herself and might even rate her own talent higher than that of her partner. Women artists were not deemed capable of innovation, an independent

style, or even the ability to found their own school. This didn't just apply to the Austrian art scene. The American artist Helen Frankenthaler had to experience how her works from the early 1950s were classified by critics as merely preliminary to the works of Morris Louis, one of the most important representatives of color field painting. Louis was considered more innovative than Frankenthaler, and she was treated as if she were his artistic midwife. Lassnig felt similarly when she mockingly looked back at herself in the 1950s as the "well-meaning nurse," as the nanny for Arnulf Rainer.[66]

Many female artists of this generation internalized the contempt associated with a term like "women's art" in a male-dominated art world. They rejected this pigeonhole because they feared—not entirely wrongly—that they would be ghettoized and not appear in the "official" art discourse. It was considered a com-

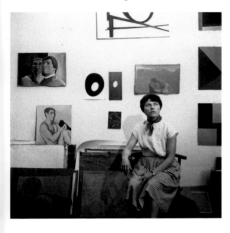

Maria Lassnig with some of her work, including *Memory of Buddy Frieberger* [p. 134], ca. 1954

pliment when a critic or a male artist colleague would pat a woman artist on the shoulder and say she painted like a man. Hans Hofmann, one of the most influential artists in the United States between the 1930s and 1960s, expressed such sentiments about works by Lee Krasner, the wife of Jackson Pollock: "This is so good that you would not know it was done by a woman."[67] Comparable statements were also made about Lassnig, even in reviews that were meant to be positive.[68] Lassnig found it discriminatory to be referred to as a *Künstlerin*, "female artist," and not as a *Künstler*, an "artist." Feminists in the German-speaking world would later insist on using the feminine form *Künstlerin* in order to become visible, but artists of Lassnig's generation preferred not to be perceived as women at all as only disrespect and contempt were associated with their gender.

Even in the mid-1950s, Lassnig had feminist thoughts: "Women aren't dumb. But they are dumbed down, and by giving in, they are ignored." Lassnig's humorous wit was already gaining force at that time and was later brought to bear in her explicitly feminist films: "The heads of women are so weightless and unsteady because at their feet they have neither the foundation ballast nor the broad base of real shoes."[69]

Throughout her entire life, Lassnig attached great importance to comfortable shoes and even wore sneakers with elegant dresses. In her relationship with Rainer, however, she did not feel that she was standing on an equal footing with both feet on the ground. At the end of 1954, she found in her journal a metaphor for the perceived imbalance. She said she pulled a metaphorical wagon together with Rainer: "I was reined in behind him, I couldn't see and wasn't allowed to go where I wanted (only ever had his butt for a view.)"[70]

What percentage of this can the then quite young Rainer be accused of? What was owed to the patriarchal circumstances of the time, and what was explained by Lassnig's own deficits? This can no longer be ascertained from today's perspective. One has to assume a mixture of all these aspects. Oswald Wiener, with whom Lassnig had a love affair in the mid-1950s, was quite self-critical in retrospect: "Male chauvinism was endemic to Vienna and probably still is." And he added, "I do not know if there was anyone at all who would have been willing to say in the 1950s and 1960s: Lassnig, she's a painter. I can't think of anybody who'd have said that."[71] Although this is an exaggeration; Lassnig was certainly considered a serious artist. Even if exaggerated, Wiener's comment expressed the mile-wide difference in perception of female and male artists. An important— but not the only—reason for this: women often appeared less bold and self-confident in public. Rainer especially pursued a much more forceful career strategy than Lassnig. Her longtime adviser and friend Heimo Kuchling also shared this view: "Arnulf Rainer created a brand for himself. She had no brand. She was not branded."[72]

Wiener saw it similarly: "She had no strategy whatsoever; she always responded ad hoc on a case-by-case basis."[73] Rainer was always well informed about what was happening in the art world and knew how to react to it. Lassnig, on the other hand, retreated into her own, sometimes almost autistic world and was much more awkward in how she appeared to those outside. As was the case for so many women, she had been taught much less than her male artist colleagues about how to deal with competitors and how to use them as an incentive to make yourself more productive. She swore to herself: "Avoid all those who want to compete with me in the slightest"[74]—a tactic that was understandable but less promising of success. What would be referred to today as networking was a nightmare for her: "A very distinct sense of being handicapped, at the mere thought of having to connect with 'important' people."[75]

After the breakup, she tried again to focus more on the most important thing in her life. "God, give me reason and insight and give me back the strength, which I so much wasted. The self is lost, given away, but still the belief in my progress in art remains, an almost childlike faith"[76] was a mantra that ran in variations through all her journals.

As much as Lassnig tried to avoid love affairs, she fell in love again and again. She met Padhi Frieberger in the Strohkoffer. He was thirteen years younger than she was, an artist, jazz musician, and anarchist, an original and outsider to the Viennese art scene who danced rock 'n' roll superbly—not least with Maria Lassnig. She was enthusiastic about his dance style: "I have never seen the same intensity and ecstasy in dance since then. He danced once until he fainted."[77] In 1951, Frieberger began to make staged photos and montages out of postcards—a

good ten years before mail-art collages came into vogue in the early 1960s. Frieberger was always aware of his outsiderness. He was not concerned with what would remain in the arts; he did most of his works for himself.

In his photos, he documented his social environment and his life. In total, he photographed nearly 2,700 people, including Lassnig. As for his art, she noted, "His memory albums terrified me. That's where he stored every tram ticket, every visible proof of his being here and there, where he most certainly would have loved to glue or dry his friends for storage."[78] What connected the two was their Spartan lifestyle and their love of nature and animals. One of Frieberger's greatest passions was pigeon breeding, and once he even brought a pigeon that had fallen from its nest to Lassnig's studio[79]—reason enough for Lassnig to capture Frieberger with his pigeon in her drawings and paintings. She also told her mother about it: "There are little pigeon craps everywhere. She already eats out of my hand and has her fixed flight routes. There's a lot of life in the studio and that's good."[80]

Lassnig with Frieberger's pigeon, Bräuhausgasse, Vienna, ca. 1954

How long the relationship lasted is unknown. Rainer said it was only a few weeks; Wiener spoke of an even shorter period, just a few days.[81] It sounded different in Frieberger's short biography, which stated he lived in a "life and artist community with Maria Lassnig" as of 1953.[82] Lassnig referred and wrote to him as "Buddy" or "Bady." He was one of the men who did not immediately elude her, and she couldn't handle this either. She began to see him as an obstacle: "The closer the person at your side, the more ideal an obstacle he is to be overcome. The closer he is, the better you can get through him (water barrier—water source), beyond him."[83]

In her journal, she let two voices speak. The first one called him "Dear Sweet Bady" and added, "Just to hear your voice once more and my soul would be healthy." The second voice countered, however: "He is no longer sweet because he stays longer than you want." The first voice made a plea for Frieberger again, while the second voice advised caution: "Can you trust him fully? No!" And: "Is it worth the effort? The resources will run out soon. Remember, you can't endure a marriage." The first voice: "Oh, marriage, we're not talking about marriage. But love." An ode to his body follows: "The heat of his neck, the comforting hollow of his hand, the pure unbroken ray of his eyes, his passionate voice, to have to go without the glowing aura of his body? No. Life is short." The second voice remained skeptical and made it clear how exactly Lassnig knew she was incapable of a relationship: "Big words, how much do you care about reality? Wouldn't you prefer just a reminiscence? Reality is too crude for you, too undifferentiated."[84] When men became too clingy, Lassnig quickly felt smothered. The double por-

trait she created of herself and Frieberger shows this with all its ambivalence: he touches her lovingly, yet this same chubby hand seems to choke her.

The giant hands she gave him in the dove-catcher image also have something brutal about them. And indeed, Frieberger was a man who couldn't accept it when a woman separated from him, and he reacted with aggression against his lover and himself. He slapped her in the face, broke her apartment door down, and threatened to kill himself. Desperately, she wrote to her mother and asked her to come to Vienna: "I can't get rid of him without a scandal or murder or suicide. He wanted to jump out of the window in front of me. I can't go to the police—he would do something terrible. I don't know what to do. He has realized I'm afraid and now dares to do anything."[85]

Lassnig in her studio, Bräuhausgasse, Vienna, ca. 1954

In the fall of 1954, Lassnig finally managed to break away from Frieberger but despite the inconceivable incidents not without pain: "My heart hurts in a very corny way, dear Bady, where are you? All paintings are dearly paid for."[86] The motive for the separation was not his violence but art. She had to get rid of him in order to be able to work in a concentrated manner and—last but not least—not to feel weak because that was what every love did to her: "Terrible relapse into letting myself go after love. On the edge of the abyss. Oh, holy insight, the short time I left you, will it be possible to make amends? Where do I start? This body and mind-destroying love. Hard to get the blood pumping evenly again. To

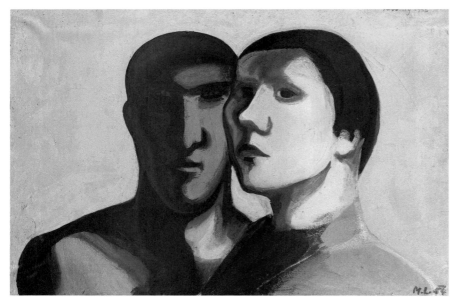

Erinnerung an Buddy Frieberger (Memory of Buddy Frieberger), 1954–55

get it pumping up into my head, that's where my focus must be, otherwise I'm weak."[87] When she thought she had overcome the deepest heartbreak, she swore to herself not to let any more happiness near her.[88] A double-bind situation: on the one hand, she longed for a satisfying love relationship; on the other hand, she saw it as a danger to her art. A lifelong dilemma for Lassnig. She was now thirty-five, and on her birthday she made a laconic note in her journal: "The tragedy of aging has not yet set in."[89] Despite everything, Lassnig remained friendly with Frieberger, and many years later, he sent one of his collages to her in New York. Toward the end of her time in New York, when she was sixty, she wrote the following poem in retrospect about her love for various "flighty airheads":

> Later, twixt waves of ennui and excitement,
> one would gladly recover time lost and misspent,
> squandered in pursuit of youth's entertainment.
> Unable to brush off the lightheaded boors,
> one had to push through love on all fours.[90]

Intensive reading, Headnesses, and love again

She was not well. She felt she was losing her grip. Sometimes she even feared she was going crazy: "Kafka in the morning, house plans at noon, worries about the future, strong nervous irritability, headache, fear of madness. Undermined health. Meaningless start in art."[91] When she felt bad, literature helped her. She loved difficult texts that she had to work through, which created resistance. In the autumn of 1954, she read Kafka almost daily for several intense weeks, including his *Fragments from Notebooks and Loose Pages* and *The Zürau Aphorisms*, and she transferred the most important quotes into her journal. For example: "Life is a perpetual distraction that does not even allow one to reflect upon what it distracts from."[92] Kafka's aphorism must have appeared to her as if it had been coined from her own difficult love stories, which she believed had held her back again and again from art. She could also identify well with this one: "I have a strong hammer, but I cannot use it because its shaft glows hot."[93] Five years earlier, in 1949, she had approached Kafka with great timidity but read his biography with fascination: "I do not dare to boast about Kafka. But for now, how Brod portrays his life story makes me absolutely enthusiastic."[94]

Soon after Kafka, she introduced herself to another classic of Modernism, *Ulysses* by James Joyce: "Annoying reading at first."[95] But she continued to read and was increasingly thrilled: "The simultaneity of letting it happen, letting it run, letting it drain, and observing, this most exact and complete letting it be observed is admirable. Fragments of thought, scraps of conversation."[96] A few weeks later she wrote: "My reverence is growing and growing."[97]

In addition, she loved philosophical and theoretical texts. Since her early twenties, she had read Plato, Kant, and Kierkegaard. Above all, the theme of perception left her no peace, as she wanted to trace her own perceptions, which she then tried to transfer to paintings or drawings. Like so many of her generation, she devoured Sartre; for example, *The Imaginary*, which dealt with the distinction between sensory perception and the imagination.[98] Here, she read that one perceived only one side of an armchair at any one time because perception requires observation. Imagination, however, is total, Sartre said, because when we imagine a chair, we imagine it from all angles at the same time. This completeness of the chair, however, is based again on our knowledge, that is, on previous impressions and observations. Sartre distinguished between mental imagery that uses previously accumulated knowledge and physical imagery that creates an absent object imaginarily. Sartre pointed out that there is an imaginary world beyond the perceptual world: the imaginary, which can't be seen, heard, smelled, touched, or tasted, and which is not at the mercy of the influences of the physical real world.

Lassnig didn't read Sartre to deepen herself in Existentialism but to gain inspiration for her work on canvas. Perhaps it was no coincidence she always focused on chairs. They were even the subject of her 1971 film *Chairs* in which she animated wingbacks and other seating furniture, showing their externally perceptible sides and virtually turning them inside out into living bodies that melded with the sitter. In all her theoretical reading, she was more concerned with impulses than with systematically grasping the complex intellectual constructs of the respective philosopher. She often picked individual phrases and terms out of context, which made her sparks fly and opened an associative space for her own thoughts, her life situation, and above all, her art.

Die Eltern im Bett / Mutti und Vati (The Parents in Bed / Mommy and Daddy), 1955

Lassnig was fascinated not only by the linguistically and intellectually potent men she read but also by the men she met in everyday life. If such a man crossed her path, all self-promises and good intentions were not forgotten but started to wobble. Again she fell in love, and again with a much younger man, the then just twenty-year-old Oswald Wiener. Wiener had been active in the Viennese art and culture scene since he was sixteen years old. First and foremost, he made music and played trumpet in jazz bands. Starting in 1954, he was the youngest member of the Vienna Group, a loose association of authors who were intensely involved with language philosophy and language criticism. Apart from Wiener, the other members were Friedrich Achleitner, H. C. Artmann, Konrad Bayer, and Gerhard Rühm. Women authors—such as Friederike Mayröcker and

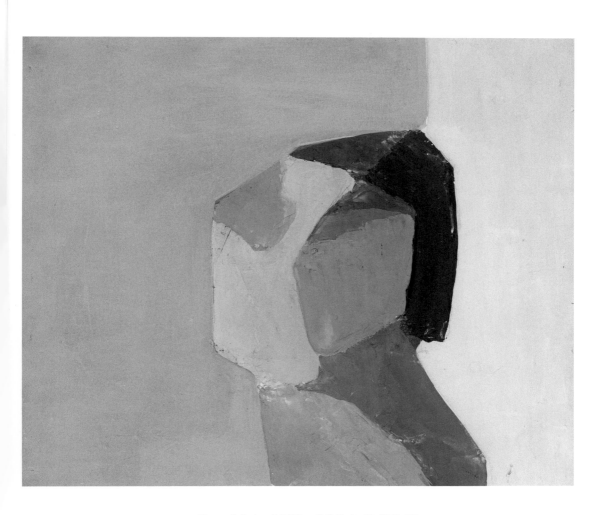

Blaues Selbstporträt (Blue Self-Portrait), 1955–56

Elfriede Gerstl—were more on the periphery of this scene. This group of artists, as well, was mainly a boy group.

Lassnig and Wiener had been acquainted for quite some time, and they became a couple in May 1955. At least that's what Lassnig's journal entries suggest. Wiener himself thought the relationship had begun earlier. Anyway, she picked him up by simply staying at the table with him. Wiener remembered: "I barely knew her, but it was already very late. I had no intentions or anything! I said I'm going to eat a Burenwurst [an Austrian kielbasa] and then she just came along." The two of them ambled over to a sausage stand at Naschmarkt, or "Nosh Market," Vienna's famous food bazaar. "And then she shyly said somehow, 'You know, I have my studio over there. Don't you want to come along?'"[99] Thus began a love affair that lasted for about three and a half years and later led to a life-long friendship. This relationship was in many ways reminiscent of the one with Rainer: Wiener's much younger age, his role as an avant-gardist, his provocative appearance. However, there was at least one decisive difference: Wiener was not a visual artist; Lassnig did not have to compete with him when it came to exhibitions, gallerists, and critics.

Wiener was convinced of her exceptional talent: "From the beginning, as early as the 1950s, I expected her to become a famous artist. I always believed that." He experienced her as an intense, almost obsessive worker: "From the moment she got up until sunset, she sat in front of the easel in the sweltering summer heat. It was quite a cheap studio under the roof, both of us soaked in sweat. I read Spinoza, half sitting, half lying, ten hours straight, and she sat for ten hours in front of the easel. Not exchanging a word." When she worked, asceticism reigned: "Only the minimal enjoyment of life was possible as a reward when she was on an artistic roll. If she had the feeling she had improved on the painting that day, then she was ready to eat a sausage sandwich. Literally." Lassnig also described her almost masochistic approach to work: "Good work is only possible if the comforting feeling 'I'm going to get it together' becomes a panic-like 'Everything that I've done so far is crap.' 'I will not be able to do it,' is a good start."[100]

Throughout the 1950s, Lassnig wrestled with Informal Art. She was not interested in abstraction as an end in itself. Even in 1950, she wrote: "Everything abstract and Cubist can only grow out of the Expressionist if it wants to be interesting."[101] Decades later, she was still convinced: "No jolt without content: language or color without content don't jolt me."[102] She tried to use, transform, and overcome the methods of Informal Art. In the mid-1950s, she felt she had reached a dead end: "When my 'Informal Art' time was in danger of degenerating into sterile abstraction, I had a great desire to paint juicy realism, nudes, portraits."[103] But even the portrait painting, which had always come with such ease to her, became a challenge: "The person in the portrait is an obstacle, you

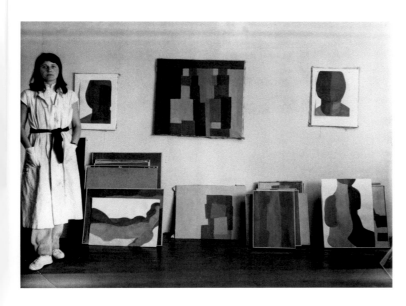

Maria Lassnig with her Headnesses, 1956

want to throw them at the ground a couple of times, mill them through, so that their brutal physicality vanishes. It is so insurmountable."[104] In order to overcome the physicality of the person portrayed, she began to compose them out of color planes and three-dimensional spatial parts. She refrained from rendering eyes, noses, and mouths, the "physiognomically important stuff," as she put it, and almost architectonically constructed the portraits out of "cheek shields, forehead shields, neck cylinders."[105] Soft brushes were only of limited use for this purpose. Therefore, she now applied paint with a palette knife on the canvas. She called these paintings Headnesses (Kopfheiten). Even though Lassnig did not appreciate it if one found the influence of another artist in her work, it can be surmised that the Headnesses were created with inspiration from Fritz Wotruba, who composed his sculptures from cubic forms. Wotruba was highly present in the Viennese art scene in the 1950s. He was an associate professor of sculpture at the Academy of Fine Arts and from 1953, artistic director of the Würthle Gallery in Weihburggasse 9 in Vienna's city center—one of the few galleries for Modern Art. Since there was not yet a Museum of Modernism in Vienna in the 1950s, it was an urgent concern for Wotruba to show both international and (the then-largely forgotten) Austrian Classical Modern Art, such as Pablo Picasso, Oskar Schlemmer, Gustav Klimt, Egon Schiele, and Oskar Kokoschka. However, this strategy gave the gallery the reputation of showing only established artists. When Lassnig got the opportunity to exhibit at Würthle, Wiener did not consider this a good idea: "I think I advised against it because the Würthle Gallery seemed too conservative for me." The motivation for the exhibition came from Lassnig's

old friend Kuchling, whom Wotruba had won as a curator for the gallery. Despite
Wiener's concerns, Lassnig chose to do the show, as she had not had too many
opportunities to present her work at that time. She showed her Headnesses as
well as full-length portraits of sitting and standing figures, which were mainly
composed of colored planes, and abstract landscapes.

The exhibition was well received by the critics. The conservative critic
from the *Presse* newspaper was glad she had distanced herself from abstraction,
which he never thought much of, and mentioned Lassnig's "subtle sense of color."
But he did not discover much innovation: "Didn't Cézanne already paint all this in
a much more valid and meaningful way in the end? Nonetheless, one cannot deny
that Maria Lassnig is honestly on her way."[106] Other reviews in the *Wiener Zeitung*
and *Neues Österreich* emphasized the sculptural character of the paintings: "First
glancing at the Würthle Gallery exhibition, you believe you see the paintings of
a sculptor."[107] The reviews remained ambivalent. In hindsight, after ten years,
Otto Breicha very positively assessed these works, which anticipated the figu-
rative turn in 1960s art, "as real avant-garde and as an opening up of fresh and
meaningful possibilities."[108] He explicitly mentioned Lassnig's portrait of Padhi
Frieberger, *Pigeon Catcher* (*Taubenfänger*, 1955).

Many decades later, the American artist, curator, and critic Robert Storr
detected Lassnig's wit and humor in the Headnessess: she created portraits and
self-portraits as if she were making fun of the archaic and so-called primitives
celebrated by Modernism.[109] Wiener, whom Lassnig also portrayed in her Head-
ness series, could in retrospect recognize her very specific interest in these

works. Even though the Headnesses were in their form reminiscent of Wotruba, for Wiener they were about something completely different: "These Wotrubesque faces anticipated her Face-Sensation pictures. They absolutely go together." He referred to works that Lassnig produced in Berlin during an intellectual exchange with him at the end of the 1970s. The focus of these works was also on questions of perceptual theory, some of which she had already dealt with in the 1950s.

At about the same time, Lassnig worked intensely on abstract land-scapes—tortuous attempts as Wiener recalled: "The whole mood was actually something hardly bearable. Because one noticed there was a lot of grim fighting for something, but it could not be said what was being fought over." Hardly any of these pictures are still preserved today. Maybe Lassnig destroyed them out of dissatisfaction. One of the few that survived was the aforementioned painting that she sold to her grocer for potatoes and sugar.[110] In her journal, she wrote: "Every artistic achievement is about shinnying-up the Maypole and eternally sliding-down again."[111] And: "I suffer from a lack of experience, that is, a lack of images in the imagination, *just like everyone else* of my time. Nevertheless, I try to put in the center and take as an outline what is at the moment the most important thing in my emotional world: a certain person, a landscape."[112]

Because of her dogged, in his eyes downright fanatical, way of work-ing, Wiener often found the relationship with Lassnig exhausting and boring. He was interested in her work, but he missed the exchanges with her about it: "With the landscapes, I would have liked to have known what it was all about. But since she could not tell me what she sought, I could only see it from the outside. How she sat in front of the same-old painting for ten hours a day. She ground the colors herself, always going back and forth between grinding paint for the current day and then sitting in front of the easel. And very short-spoken, tight-lipped. But I realized that she was often suffering. That somehow what she wanted wasn't working out. But I didn't know *what* she wanted." Lassnig, in turn, expected Wiener to get involved in her work, to give her suggestions, and—most of all—write something about it: "She repeatedly asked me to write something about her. But I wasn't able to because she didn't or couldn't give me any information." And: "Of course, I often looked closely at the paintings that slowly emerged there and tried to figure them out on my own because she could say nothing about them. Nothing!"[113]

Hitchhiking in the South

In April 1956, Lassnig noted: "Never ever really wanted to travel. The de-sire to see imagined and read-about landscapes in reality only fleetingly touched me. My self-sufficiency needs to be taught a lesson, since depth is gained by expanding the field of experience."[114] Soon after she embarked on a great journey,

presumably in the summer of 1956 or 1957, when she and Wiener decided to travel for about two months through Italy and Greece to visit the sites of antiquity. They didn't have the money for this, so they hitchhiked mostly. By way of Padua, Bologna, and Le Marche they went to Bari and from there with the ferry to Greece. Along the way, the ship made a short stop in Ithaca, the island of Odysseus. It was six o'clock in the evening, at which time the sun was already setting—an unforgettable impression of colors, Wiener recalled. In Athens, the two stayed at a youth hostel on the city's local hill, Lykabettus; from there they could see the Acropolis and the port of Piraeus. Lassnig sent a postcard to her parents in Klagenfurt: "Dear Momma and Poppa! We've been in Athens for four days and we climb the Acropolis every day because you can't get enough of its beauty." She told very lovingly how Wiener had taken so many hardships off her hands, from carrying the backpack to communicating in Greek. The blistering hot climate bothered her, but "the heat is bearable when there are so many beautiful things to see."[115]

Soon they continued on to the Peloponnesus, again by hitchhiking: "In Greece, there were only trucks. It was an adventure to make it even fifty kilometers, standing in the blazing sun all day long. And then occasionally a truck passes by,"[116] Wiener wrote. The two slept under the stars: "These are really great experiences when you wake up at dawn, four in the morning because a sheep is licking your face." Wiener also remembered the burning heat: "It was almost drug-like, this heat, and probably also the lack of nutrition." Sometimes they stole tomatoes from the fields to at least have something to eat. Wiener absolutely wanted to go to Sparta. "There was only a sand hill! There was nothing left of it. Getting there was a chore. Maria didn't know why she had to go to Sparta!" Tiryns and Mycenae were more worth it. Wiener had the general impression that the journey corresponded more to his interests than hers, as he was then devouring ancient Greek literature with great enthusiasm: "During the trip, I wondered what was in it for her. Other than light and colors, which when the sun is not too bright, are incredible at certain times of the day." Moreover, for him the journey was so overwhelming that he didn't have much energy for romance: "And Maria wasn't all too important there; I was like a dreamer."

The two had originally planned to travel to Turkey, too. That didn't happen. First, the little money they had was long gone, and second, they had seen and experienced enough. Lassnig wrote: "I had completely had my fill, Greece alone made too many impressions!" On the return journey a stop in Pompeii near Naples was still planned. They only had enough money for the entrance fee for one person, so Wiener stayed outside: "It was clear that it was more important that she saw that! I did not feel at a loss. I offered it to her rather voluntarily." In

1959, Lassnig undertook, with the help of scholarships, extensive study trips to Paris, Rome, Oslo, and Stockholm—this time alone.[117]

This relationship also failed. Wiener liked to be around people. He enjoyed going out, sitting with others to talk, learning something new, relaxing, whereas: "She was a recluse. She didn't really go out to meet friends. In fact, everything was calculated: I go there because he and he and she and she are coming. He or she may be able to do something for me. Just chatting and drinking didn't interest her." Lassnig had phases where she didn't go out at all: "Live as withdrawn as an old witch today. Nobody knows where and how I live, what I'm doing in there at all. The Viennese will soon resent me for this."[118] The trendy bars, from the Strohkoffer to the Domcafé to Café Glory, were all too loud and hectic for her, overstimulating. She noted in her journal: "I can never sleep after being among company. The lack of freedom, that I can't say what I want (this having to hold myself back actually makes me really say something wrong), and yet you always have to speak, the many simultaneous impressions, and at the same time you should be calm and relaxed, loquacious and cheerful—this causes tension in my head."[119] Feeling overwhelmed among company is one of the classic symptoms of hypersensitivity. Sometimes she got herself to go out and even enjoyed it a bit: "When I particularly dread them all, it works out fine nonetheless." But at a price: "But then I dread myself afterwards."[120] Or even more clearly: "I always feel very dirtied after having been amongst company."[121] If she had been with people, she often couldn't work for days: "How can one be heavy, that is a good artist, and at the same time be light, that is a good social butterfly?"[122]

Asked whether her shying away from the public had led to a conflict between the two, Wiener said: "No, we just didn't have an intensely intimate relationship. That was not possible. She had something strange. I can't express it otherwise. The English word *alien* describes it pretty well. There was something, something puzzling, and you wondered if there was anything there at all. She seemed empty to me in some respects."[123] Lassnig's notes from that time are full of despair, lovesickness, a longing for closeness, and often passion. There was obviously a great contradiction between what happened inside her and what she managed to communicate outwardly to her love partners. Wiener: "Art *per se* was and is the most important thing for her in her life. There was nothing beyond this. That was something she suffered from. Her body disturbed her art, to put it quite drastically. She would have preferred to be bodiless, I believe."[124] Over and over again she was overtaken by her fear of symbiosis, which made her seem autistic to her love partners. One time she noted: "Love is a fight against being drenched by the other."[125]

Wiener couldn't remember the end of the relationship: "It must have petered out just as suddenly as it began."[126] Rainer described his separation from

her similarly. The difference from Lassnig's own perception could not have been greater in both cases: "On Jan. 26, Ossi broke up with me for good. Fourteen days of only crying fits. Only smoking. Now the most painful condition continues permanently. How long will that go on? Can't the heart break completely? Art is no comfort."[127] A little later, Lassnig learned that Wiener was getting married. He accepted a job in data processing at Olivetti and withdrew, at least for a few

years, from the Viennese art and culture scene: "The fact that I went to Olivetti then certainly had to do with Maria. I saw it all as overheated. I wanted to get out of it. I wanted to lead a normal life, with family, children, and a business job."

Almost sixty years later, Wiener said he just could not fulfill the role that Lassnig needed: "What she was missing was the caretaker, the caretaker in the sense of a manager, who says: Listen, you have the talent and I'll help you make it now. If only she had found such a person! But that's probably very rare."[128] If Lassnig had been a man, she would certainly have had a better chance of finding a "caretaker" for herself. Many an artist's wife in the 1950s and 1960s was ready to put herself at the service of her husband and his genius—to defend his back, to comfort him in the event of failures, to provide him with a safe home that would protect him from the wild storms of the outside world. Lassnig didn't have that kind of person in her life. But the question also arose as to whether a man without selfish interests would have been attractive to her at all.

After Wiener's marriage to Lore Heuermann, there was a man named Max in Lassnig's life—not an artist, not an intellectual, a "simple man," as Lassnig said in her journal. But even this antithesis to her previous men didn't work out: "This rawness and vulgarity of mind. This brutal slamming if he does not believe he's honored enough." Again, she quarreled with herself, downright begged to get rid of the desire for love: "God help me not to hang my heart on anyone else anymore." But what she swore to herself stood yet again in stark contrast to her old yearnings: "My life as a recluse will never stop. Life can end soon. I beg for it. Fame is no substitute for love."[129]

"Mario" Lassnig and the St. Stephen's boys

While Lassnig and Wiener later became friends again in the 1970s, in relation to Rainer she basically felt slighted her entire life. The main reason for this was the rivalry she experienced so strongly with him. Until her death, she barely managed to acknowledge Rainer as having greater success, even temporarily. This was not least due to her experiences with the St. Stephen's Gallery in the 1950s, which she experienced as extremely stressful, if not traumatic.

The St. Stephen's Gallery in the Grünangergasse, founded in 1954, was an astonishing, perhaps typically Austrian phenomenon. Under the auspices of the Catholic Church, of all things, the gallery quickly became the most important address for the avant-garde in Vienna,[130] not because the church at that time was even remotely liberal and open to contemporary art, but because one of its representatives, the legendary Monsignor Otto Mauer, got the idea into his head. Mauer was a preacher in St. Stephen's cathedral, secretary of the Catholic Mission, and the Vienna Academics' chaplain. He became a powerful string-puller in the contemporary art scene. Inside the Church, Mauer met with great opposition to his exhibition policy, so the gallery was no longer allowed to call itself St. Stephen's Gallery from 1964 onward. Since then it has been called Gallery Next to St. Stephen's (Galerie nächst St. Stephan).

Mauer was not a liberal but was convinced that the divine could be found in contemporary abstract art. For him, every serious work of art was Christian art. He believed that world history had reached its final phase and that in the face of Nazi atrocities, Stalinism, and the atomic bomb, the apocalypse would soon come and heavenly salvation would take its course. Christian art accordingly had to follow new paths; the hitherto customary realism, as manifested in small cheesy pictures of saints, would not do justice to the present. From 1956, Mauer focused primarily on young Austrian artists, namely Arnulf Rainer, Josef Mikl, Markus Prachensky, and Wolfgang Hollegha. Three of them, Rainer, Mikl, and Hollegha, were twenty-five years old at the opening of the gallery; Prachensky was only twenty-two.

Akt (Nude), 1959

In 1956, Alfred Schmeller published a much-noticed article, "Born in '29," which must have eaten at Lassnig. Schmeller argued that strikingly many of the then-current Austrian artists were born in 1929—such as Rainer, Mikl, Hollegha, and Anton Lehmden—or shortly before or after, such as Prachensky, Hundertwasser, Fuchs, Brauer, and many others: "This generation gradually emerged after the war. It belonged to 'Modern Art,' which emerged in the sudden silence after the noise and alarm of war. This generation opened a door; it functioned like a valve."[131] Lassnig did not appear in this article, nor did any other woman. She had been born in 1919,

ten years earlier. From the older generation, Schmeller mentioned Wotruba and Boeckl, whom he called a "considerable source of friction" for the younger artists. Lassnig didn't belong to this generation either. She was twenty-five years younger than Boeckl and twelve years younger than Wotruba. As was so often the case, she was caught between two stools; she didn't fit into either group. Considering this, it was understandable that Lassnig responded irritably in later decades if someone mentioned her age. She felt she had been too late—a feeling rooted, at least in part, in the 1950s because those years were so difficult for her. Even though she was ten years older, she thought of those born in 1929 as her generation from which her fellow artists, her competitors, and even her lovers all came. Therefore, she wanted to be perceived at least as an equal to them.

However, Mikl, Rainer, Hollegha, and Prachensky soon formed a sworn community and regarded the St. Stephen's Gallery as their power base and hardly let anyone else in. Mauer was their patron, promoter, and advertising drummer boy. He exhibited the works of the four St. Stephen's boys, as they were nicknamed, not only constantly in his own gallery but also organized exhibitions in the Vienna Secession, in Germany, and in Switzerland. Other artists were rarely tolerated. Arts and culture professionals who were not visual artists had a bit easier time in using the gallery for themselves. The Vienna Group gave readings, and avant-garde filmmakers such as Peter Kubelka, Ferry Radax, and Kurt Kren hosted film screenings. In all of these groups and cliques of the Viennese scene, women generally had little to say. Although the groups saw themselves as avant-garde, progressive, sometimes even revolutionary, their patriarchal structures were no different from conservative old-boys' clubs. "As a woman, she was always marginalized," recalled Oswald Oberhuber, himself an artist, born in 1931. Oberhuber arranged exhibitions at the St. Stephen's Gallery in the 1960s—including for Lassnig—and it was he who took over management of the gallery after Mauer's death in 1973: "At that time, Mikl, Rainer, and Prachensky were the country's big shots, and she was just swept along."[132] Oberhuber was simultaneously convinced of the quality of Lassnig's work: "She felt undervalued, although she was always at the forefront."[133]

When asked in retrospect about her relationship with the St. Stephen's Gallery and the St. Stephen's Boys, Lassnig was very mocking: "Yes, yes, those were the heroes."[134] And: "You only had access when you were a friend of theirs or slept with them."[135] She was only allowed to exhibit when the wives or girlfriends of the four also got to exhibit their works. In 1956, she noted this shrewdly in her journal: "The artists' wives are merely the wrens under the eagles' wings."[136] With "artists' wives," Lassnig meant, among others, Kiki Kogelnik, who was only twenty-one at the time and who was briefly engaged to Rainer. Lassnig said Mauer only made room for male artists. Women were only included as an

act of grace: "Unless you were an extraordinarily beautiful girl like Kiki Kogelnik. She, of course, was very, very pampered by Monsignor Mauer."[137] Rainer partly confirmed Lassnig's perceptions of the time: "At the St. Stephen's Gallery she was underestimated by Otto Mauer. Mauer failed to acknowledge her. He acknowledged her, but he didn't appreciate her enough." When asked why Kogelnik had an easier time of it in the gallery, he said: "She was personally more charming and sociable. Being sociable is also something that counts." Lassnig was quite different, he said: "She was always difficult, not so easy to deal with and not coquettish, not at all, which was the case with Kiki."[138] Many decades later Kogelnik remained a source of friction for Lassnig. Eventually, Lassnig was invited to participate in an exhibition with the men. Mikl personally asked her to do so: "But I didn't want to. That was actually my fault, that I didn't want to, because I was so angry at Rainer."[139] Then, in 1958, she exhibited there for the first time, as part of the so-called Christmas exhibition in which the gallery opened itself up a little for other artists.

Finally, in 1960, she was invited to have her own solo exhibition. This idea was not Mauer's but Werner Hofmann's, who, born in 1928, also belonged to that aforementioned generation. He was a very successful, internationally renowned art historian and writer at a very young age. He had just published two Fischer paperbacks on modern art, which had quickly become bestsellers.[140] In 1962, he became the founding director of the Museum of the 20th Century—the first museum in Vienna dedicated to Modernism. So it wasn't just anyone who had tried to convince Mauer to dedicate an exhibition to Lassnig. The story goes, he only succeeded with a trick; Hofmann was said to have initially stated that he was doing a group exhibition but eventually just did a Lassnig solo show.[141]

Tachistisches Knödelselbstportrait (Tachist Dumpling Self-Portrait), 1960

She exhibited some older abstract works but mostly her latest paintings and watercolors. She was painting abstractly again but now, as she emphasized to journalists, no longer "compressed" as in the Static Meditations from the early 1950s, but on the contrary, the brushstrokes spread out across the entire canvas in "predominantly red, white, and yellowish; flesh, blood, and slime colors," as a critic wrote.[142] She herself spoke of a phase of expansion and again described these images as Tachistic. The work was, as almost always, about her body perceptions, such as *Square Body Sensation* (*Quadratisches Körpergefühl*). Having just realized that he had been outwitted by Hofmann, Mauer nevertheless held the opening address; Mauer was known for his melodramatically

religious and very impressive speeches. In a prior briefing, Lassnig had explained to him what her paintings were about, namely, her innermost self, her physical sense of her body: "Monsignor Mauer said: 'I beg you, stop it, I do not want to know at all where you got it from.'"[143] Lassnig had the feeling that she was not being taken seriously at all. Again and again she came back to this episode: "And when I said these dumplings, which I made back then, that those are me, my body, then he just laughed, of course. Everyone laughed, you see?"[144] More than a year after the opening of the exhibition, she wrote, "Monsignor Mauer believes people who say something with more conviction over those who say something with less conviction."[145] In 1979, she was still contemplating Mauer's lack of understanding. "The question is: should we artists ever explain the origins and sources from which we start? I have always encountered a terrible disillusionment with the audience. Mauer, who could wax transcendentally about art, told me: I do not want to know how it came about."[146]

It's no surprise Lassnig's references to the body, especially the female body, didn't suit a representative of the Catholic Church, which is known for its hostility to the body. It certainly wasn't what Mauer wanted with abstract art, which in his eyes visualized the transcendental. In his opening speech, he described Lassnig's work as "cosmic painting." After she insisted that it was something physical, he added that her painting ranged from "the lowest bodily to the highest spiritual." Quite telling again was that he attributed the lowest to the bodily—his discomfort with this must have been unmistakable.[147]

"Mario Lassnig," journal, August 1959

The exhibition opened on March 17, 1960. A leaflet with Lassnig's manifest-like *Painting Formulas* (*Malrezepte*) and a few illustrations appeared. In addition, Hofmann wrote the text for the leaflet—another indication of how much the renowned art historian regarded Lassnig. However, one of the most notable contributions to the leaflet was the photo on the title page. It showed Lassnig in her Bräuhausgasse studio, surrounded by her paintings. As mentioned at the beginning of this chapter, she had painted a mustache on her face with two black strokes. She had already sketched the idea in her journal half a year earlier. She wrote above this sketch: "Mario Lassnig"—her comment on what your sex had better be if you wanted to succeed in the St. Stephen's Gallery or the Viennese scene in general. The critic from the conservative *Presse* newspaper did not find this funny. He spoke of an "infantile mustache à la Dalí." Nevertheless, he ventured to make a soft plea. Like many young artists, Lassnig was without an anchor because all previous positions had proved deceptive. And he called for viewers "to behold the works of Maria Lassnig with the openness that they doubtlessly deserve."[148]

In the *Wochenpresse*, a detailed favorable review appeared. The title was "Maria with a mustache." Lassnig had done the right thing after all. She had made a statement that attracted attention. The critics pointed out that her watercolors were already finding buyers, and the respected Galerie 59 in Aschaffenburg had acquired "all of Lassnig's production" for sales in Europe. The journalist observed how little Lassnig trusted these initial successes: "She is also distrustful of the goodwill that she finally receives from the St. Stephen's Gallery. Out of all this praise she hears: 'relatively good for a woman.'"[149]

Lassnig attached great importance to the approval of Schmeller, a critic from the *Kurier* newspaper. He also talked about the topic of women. He was full of praise for the exhibition and rejected Mauer's transcendental notion: "Please, in these watercolors I see nothing cosmic, no primordial steam, no day of creation. I took the liberty to view these paintings in a quite figurative, concrete way." He discovered the body in Lassnig's works: "Depicted are femininities. The pictures are perspectives on nudes. Skin, scent, and the freshly-bathed transformed into water colors." But as positive as his review was meant to be, so revealing was its conclusion: "Her painting is actually very masculine in its naturalness. In this respect, the mustache drawn on the photo of the lady painter is justified."[150] This was the highest praise that a woman artist could attain in the 1950s and 1960s: to paint like a man.

painting formulas
one must be hungry, have inhibitions, be able to forget all images.
the picture is secondary (don't look at it while painting!)
discard style! you'll exploit yourself soon enough.
you have to try to unite *duration* and *extension*
with *movement* and *vehemence*.
the rhythm of painting should be like gasps of breath,
when life chokes us (1951).
the pure gesture will ultimately produce focal points,
points of concentration.
you can also begin with them, lose them, and relocate them.
for this, you need plenty of turpentine, many canvases,
a 6-cm-wide brush.[151]

I always saw my life as provisional
(I never have closets, only suitcases),
so I only have time for the most important things.
No time for formalities.
No time for common courtesies.
No time for primer coat.
No time for perfection!
No time for explanations.[1]

6 Paris Encore

1960–68

"At that time, I only knew one thing: my situation could only improve if I left. It didn't matter where to."[2] She was forty-one when she moved to Paris in mid-November 1960. Her reasons for this departure were many. She once said she had left Vienna in protest, citing both artistic and private motives: "The Vienna Actionists had already started back then. All that machismo got on my nerves. Also, as a woman, I was deeply disappointed because I was constantly being cheated on. Vienna was too confining. There were four men at the St. Stephen's Gallery, and there was no room for me. I just didn't want to be here anymore."[3]

Otto Breicha, critic, publisher, and big shot in the Austrian art and literary scene of the 1960s and later a curator and museum director, diagnosed Lassnig's departures as escapist behavior. Still, he shared her perspective that she had been underappreciated in Vienna. "ML was there from the beginning and is nevertheless gladly overlooked," he wrote in 1968 while looking back at the 1950s. "What Austrian postwar painting owes to her remains in the shadow of spectacular colleagues."[4] Lassnig confidently and wittily noted to herself: "If you write the art history of the postwar years 1950–60 in Austria, you will name it America and not Columbus."[5] In this scenario, she saw herself as an unthanked Columbus (whom she considered to be the actual discoverer) whose name was only granted to one country, whereas the St. Stephen's boys represented Amerigo Vespucci, who ventured out later and for whom the entire continent in her view was unjustly named. If you look at *Modern Art in Austria* (*Moderne Kunst in Öster- reich*), published in 1965, you have to agree with Lassnig: she wasn't mentioned in more than three lines and otherwise only in the chapter, "The angry young men."[6]

But Breicha thought Lassnig also had run away from success in Vienna, which she had so dearly longed for. It was indeed striking how often the artist left an environment as soon as she began to get established in it. In Klagenfurt, she was a "provincial star" and then she set off for Vienna. In Vienna, she finally attained the recognition that was so hard for her to receive in the environment of the St. Stephen's Gallery—and then she went to Paris. In Paris, she was increasingly invited to interesting exhibitions and received excellent reviews—and then she moved to New York. A certain fear of success—a now often diagnosed career obstacle, especially for women—might have actually plagued her. Fritz Wotruba also told her she was not taking advantage of the opportunities offered to her. It was difficult for her to savor success, to take it seriously, or even to accept it as such. For example, she never spoke about receiving the Theodor Körner Prize for Art, which she was awarded in 1955 by "a young, rosy red" Bruno Kreisky, who was then state secretary and later became Austrian federal chancellor.[7]

Fear of success, however, does not suffice as the only motive for her restlessness. As an artist, Lassnig chose "the uncomfortable way of experimenting" and "always having to start again from the beginning," as Breicha observed. And:

"ML has a pretty strong instinct for what's current, before its time has come."[8] Lassnig viewed herself similarly: "I am so far ahead that it seems unprogressive or I don't even get noticed."[9] And: "The motto of my life: too early and too late. Or too early is too late."[10] That there was no great applause from the masses was not surprising of course. Lassnig knew in the end, "without admitting, of course," wrote Breicha, "that she had no place in the establishment where many of her prominent painter colleagues were stuck upside down."[11] Breicha especially meant the St. Stephen's boys. Neither Josef Mikl, who in the 1960s many considered the most important Austrian artist, nor Markus Prachensky nor Wolfgang Hollegha nor Arnulf Rainer ever left Austria for a longer period, whereas Maria Lassnig dared to embark onto the international scene.

The "art brew-kettle" of Paris

In interviews from the 1980s and 1990s, Lassnig was repeatedly asked why she had gone to Paris of all places. Paris was no longer the navel of the art world; it had already been displaced by New York, a view that was justified in retrospect but by no means shared by artists in Europe at the beginning of the 1960s. If you wanted to be contemporary, you had to have been in Paris for at least a short time. In 1960, hardly anyone had the idea of going to New York instead.[12] Hans Staudacher raved about the city on the Seine; Arik Brauer and Friedensreich Hundertwasser both absolutely wanted to go there; Arnulf Rainer inquired about studio possibilities; Markus Prachensky spent several months there now and again; Hans Bischoffshausen fulfilled a long-cherished dream with his move to the French capital in 1959. Paris was for Lassnig, too, a bubbling pot, or as she put it, the "center of the art brew-kettle."[13] Once, she responded rather gruffly to the frequently asked question of why she had chosen Paris: "Paris was the art metropolis, a place where art happened."[14] As an example, she mentioned Ileana Sonnabend, who in 1962 launched her gallery on the Quai de Grands Augustins and was to become one of the most influential gallerists in Europe. Before this, Sonnabend had been one of the leading art dealers for the contemporary art scene in New York, together with her first husband, Leo Castelli, from whom she was now divorced. Now, she had her own gallery in Paris, bringing artists like Robert Rauschenberg, Andy Warhol, Roy Lichtenstein, and other Pop Artists to Europe.

Paris was exciting for Lassnig, lively and avant-garde—Vienna couldn't compare. This was conveyed in her numerous articles, which she published in Austrian daily newspapers in order to earn a little money. She turned out to be a well-informed art connoisseur. In her Parisian Art Letters (*Pariser Kunstbriefe*), she described the vibrant contemporary art scene on the Left Bank of the Seine, the Rive Gauche. She roamed from gallery to gallery, listed her personal high-

lights, and described in depth how much American Pop Art was spreading in Paris and how, in addition to the hitherto dominant abstraction, the figurative had also begun to reassert itself. She discussed the question that is still being debated to this day, whether Pop Art—with its huge Coca-Cola bottles, comic figures, and pinups—criticizes or glorifies commerce, commodity fetishism, and consumer culture. She cleverly concluded: "Quite simple: it does both at the same time!"[15]

She introduced Austrians to the Portuguese-French artist Maria Vieira da Silva, who was, by the way, the first woman ever to receive the Grand Prix National des Arts in 1966. In addition, Lassnig drew attention to the latest craze in Paris—the wrapped motorcycles and chairs by "packaging artist" Christo. Although Christo later designated all, including his early works, as a joint effort by him and his wife Jeanne-Claude, he acted back then as the sole male creative genius, in keeping with the spirit of the times. About a year before Lassnig saw Christo's and Jeanne-Claude's motorcycles and chairs in the Paris gallery, the two had caused a sensation with their first monumental work. They had reacted to the construction of the Berlin Wall in 1961 with their own Iron Curtain project. Without a permit, Christo and Jeanne-Claude had blocked a side street of the rue de Seine with high-piled oil barrels—to the great indignation of many Parisians. In later years, the two would cover entire coastlines, park paths, the Pont-Neuf, and the German Reichstag in Berlin, too.

During her walkabout in the rue de Seine, Lassnig stumbled upon a film shooting with the "divine Jeanne Moreau ... in a checkered skirt and black sweater." It can hardly get more glamorous and contemporary than this, and Lassnig confidently and proudly communicated that in every line to the Austrian readers of her Art Letters. She created a multifaceted kaleidoscope of a vibrant, diverse, and controversial art scene that was anything but sleepy in the early 1960s.

She also reported to her compatriots back home about the large art history exhibitions. She raved about the great Kandinsky exhibition at the Musée d'Art Moderne. Kandinsky's path into abstraction could be clearly traced, wrote Lassnig, in "how the contours of the mountain ridges and spruce trees become independent, how the lines and dots on the painting's surface take on a life of their own and become the main focus."

She honored meanwhile the sixty-plus-year-old Max Ernst as a master of classical Surrealism. Ernst had returned to Paris in 1953 from exile in New York, and in 1954 won the Venice Biennale's Grand Prize, after which the orthodox Surrealists, who had long since become a sectarian group, ostracized him from their circle. Lassnig described Ernst's latest lithographic works, *The Dogs Are Thirsty* (*Les chiens ont soif*), which she noted with mild disrespect, "look more like

chickens." Anyone who bothers to google Ernst's prints will find that Lassnig is not entirely wrong.[16]

In 1964, on Surrealism's fortieth anniversary, a large exhibition took place in which nothing at all happened to shock the bourgeoisie, no revolver shots, no stink bombs: "The panic has given way to a solemn mood, in which one finds the pictures of Ernst, Chirico, Dalí; with the devotion of a museum visitor, one sees the surreal 'objects' in glass cases." Lassnig might well have been recalling the museum-like impression that André Breton had left with her and Rainer more than ten years before. She paid tribute to the "great female Surrealists Tanning and Toyen," who were also represented in the exhibition. In general, it stood out that she liked to discuss women artists—as a matter of course—without making a point of their gender.[17] Finally, she enthusiastically presented an Ingres exhibition in the Petit Palais and, even more enthusiastically, a Vermeer exhibition in the Orangerie: "You've never seen such a thing, you'll probably never see it again: twelve Vermeers at once!" And: "Every painting has its own guard!" The exhibition offered her occasion for a brief patriotic detour: "Not every country in the world has the fortune of possessing a Vermeer van Delft (Vienna's Kunsthistorisches Museum has one of the most beautiful.)."[18] In her 1976 animated film *Art Education*, Lassnig treated Vermeer less respectfully by making fun of the relationship between the vain male artist's ego and his female model.

Lassnig mostly wrote these Art Letters to bolster her very meager budget. All the same, the articles convey how she perceived the cultural scene of the time and how proud she was of participating in it. She immersed herself ever more deeply in the Parisian scene and realized slowly but surely how the French way of life was changing her. At the age of eighty, upon the occasion of her great retrospective in Nantes, she came back to this: "I was very impressed by the lifestyle and manner of behaving. I became more sophisticated, so to speak."[19] She found herself provincial in comparison to the Parisians: "How smooth, tasteful, and courteous everyone is, and what luxury is now on display again in Paris. One should have money, but it is also nice just to look at everything!"[20] She enjoyed the language and even wrote some of her journal entries in French. At times, she appeared to write a French and a German journal in parallel; sometimes verbatim translations from one language to the other can be found, as if, at the time, she had already thought of publishing her often aphoristic texts. (That didn't actually happen until 2000.) She considered visiting a seminar on French literature at the Sorbonne. She devoured Marcel Proust's *In Search of Lost Time* as well as the absurd dramas of Eugène Ionesco and Michel de Ghelderode. Soon she herself had ideas for plays: "Would now be an ideal co-worker for an *écrivain* [a writer]."[21] To be able to write like a writer, to have the power of language and the stamina, remained a yearning that flared up throughout her life. She even

read Samuel Beckett's *Malone Dies* in the original French.[22] Beckett's novel has no real plot: Malone is dying in his own room at home, thinking about himself and the world and telling himself invented stories. The slowness and uneventfulness of the novel surprised and delighted Lassnig. She wrote that it was as if someone "in the middle of a burning city tenaciously keeps standing on both feet, for days and nights, with his eyes closed, only touching the surface of his shirt button, over and over."[23] The spirit conveyed in the novel mirrored her completely, as she regularly felt overwhelmed by the hustle and bustle of everyday social life. Malone still occupied her decades later: "As in Beckett's *Malone Dies*, am I 'like a monkey scratching its fleas with the key that opens its cage?' To break out of my cage, I'd probably need a new life."[24] Presumably via Jean-Paul Riopelle and Joan Mitchell, she got to know Beckett and discussed his novels with him for an entire dinner. Beckett drank a lot, Lassnig remembered.[25]

She saw old acquaintances again, not least Louis Popelin, the former forced laborer from France to whom she had once been engaged. She wrote him a letter informing him of her move to Paris. Popelin had been living in Rouen for ten years and was married, yet in his answer, he confessed he still loved her. Lassnig's mother, who would have liked to have seen them both married in 1946, was still in contact with Popelin. He wrote her in broken German and called her "Mommy." In December 1960, she wrote him about her daughter, who had been living in Paris for about three weeks at the time: "She has everything, just no husband and no child. What do you say about that? Now I've come to terms with it a bit, but for years I've always been very annoyed about it because she had so many opportunities, which she never took, all because of her stupid painting, which to top it all off is now so crazy!!!"[26] She asked Popelin to assist Lassnig in setting up her new apartment. In fact, he brought furniture to her, "lots of luxury items," lent her money, and otherwise supported her in every respect.[27] Lassnig found a kind of family connection with his friends Madeleine and Rémi Dela-touche. As an interior designer and furniture specialist, Popelin regularly visited Paris for professional reasons, and soon Lassnig's favorite pastime was strolling from stand to stand at the famous Parisian antique markets, admiring the cabi-nets, chests of drawers, tables, and chairs: "He always told me if something was a fake piece of furniture or if it was hunky-dory. But I didn't become a furniture collector as I did not have any money for that."[28] On his fortieth birthday, April 9, 1962, Lassnig gave him a painting. She wrote in her journal: "Read a long time ago in Ernst Jünger: His head is more immoral than his body. I believe this applies to all of us who are cautious (see Louis and other married men)."[29]

Paul Celan—"the world in concentrate"

Even before Lassnig bought her studio on rue Bagnolet at the end of February 1961, she had already contacted Paul Celan, whom she had met in Paris in 1951. Celan was born in Czernowitz in 1920, so he was about the same age as Lassnig. What undoubtedly connected the two was their extraordinarily high sensitivity. Celan suffered from the outrageous and unfounded plagiarism reproaches made by Yvan Goll's widow, Claire.[30] His severe depression forced him into several hospital stays, and after years of close work together, he called things off with his publisher Bermann Fischer. Although Celan had fits of not doing so well in those years, he managed to encourage Lassnig when she was in danger of falling into despair: "'You'll do it,' he said. Because he saw how hard it was. 'You'll do it!' He believed in me."[31] He spoke in Austrian colloquial language. This Austrian, or more precisely soft-singing Carinthian, was another characteristic that Celan appreciated about Lassnig. Many years later she herself said: "And now I have just learned that he was very close to Bachmann and that it was quite a tragic love story. And I often thought, because I am also a Carinthian like Bachmann ... probably that's why he liked to be with me, because I reminded him of Bachmann."[32] Lassnig also liked his voice and telephoning with him. She also loved to hear him sing—"so Rrrrussian" as she once wrote in a letter to Celan. She also wondered if the Parisian environment was really ideal for Celan: "I was also thinking that you might be better off staying in Germany for a longer period, because in Paris you are like an island and that is not good for the long term, but that is certainly not so easy, and it would be sad if you were not here."[33]

She must have been aware that Celan, who had lost his parents in the Shoah, could not and did not want to live in any former Nazi-perpetrator country, neither in Germany nor in Austria. In a letter to Heide Hildebrand, her gallerist and friend in Klagenfurt, she wrote: "You know, his parents were gassed, so he is afraid that the Nazis will come back. Could that really happen? Unfortunately, stupidity is hereditary."[34] To Celan, she wrote: "You have given me so much that is good, with your books, your poems, your presence, your thoughts, your voice on the phone, that I could feed on all this for years. You are something very precious to me, and when I walked through the streets next to you, I thought: You are walking next to the world in concentrate." Then she castigated herself and her poverty of language, calling her own words "wild sprouts" and "random forms from a speechless world." All the more important were her personal encounters with the poet. Afterward, she found herself "reeling with excitement," as she wrote to Celan, and was completely overwhelmed: "I am then totally kaput."[35]

When Celan's poetry book *No One's Rose* came out in 1963, she let him know: "I talked to various friends about your new book. I love it very much!"[36] Her entire life, poetry had comforted her; she read Celan again and again but also

Pablo Neruda, Durs Grünbein, Ingeborg Bachmann, and Friederike Mayröcker. In December 1966, she reported about a Celan poetry reading for *Kärntner Tageszeitung*, the Carinthian daily newspaper. Celan read in his usual solemn manner—and in German—the poems of Nelly Sachs, his "sister in spirit," who had received the Nobel Prize for Literature that same year. The entire German-speaking Parisian cultural community had come to this event. "Paul Celan chose the most striking and most poetic verses and addressed his listeners in the most effective way. Nelly Sachs's poems, which let the stones talk and the painful worldly experience of the Jewish people speak, are of a moving beauty,"[37] Lassnig wrote. Celan occasionally gave her several pounds of books. This was how he dealt with the multitude of reading copies he received from his publisher—he passed them on unread to friends. Once, he took her out for Christmas. Lassnig said to him, "You look like dear little Jesus," making him laugh heartily—which she determined was rare for Celan.[38]

With Celan's wife, Gisèle Lestrange, Lassnig also got along well. A sketch and graphic artist, Lestrange taught her how to make drypoint etchings. Lassnig visited the two in Paris and at their farmhouse in Moisville, Normandy. She described Celan and his wife as her favorite people in Paris.[39] In her journal, she wrote: "It is very nice when someone opens their house up so wide to you (like Celan), hopefully I won't screw this up."[40] She knew exactly how difficult she could be, how often she suddenly jeopardized her friendships because of trifles and broke everything off. Besides, she had fallen a bit in love with Celan and made it her goal not to show it. Almost obsessively in those years, she swooned after a handsome neighbor boy, who was a minor, the little Martinot. She dedicated three poems written in French to him, which she titled *Poèmes platoniques*, and included them nearly forty years later in her book of journal excerpts published by Dumont. In the poems, she called him "my divine child" and spoke of a "disgraceful love in her heart."[41] In general, she had the feeling of constantly falling in love: "My ease of falling in love and out of love arouses my astonishment and my amusement. A man smiles amiably at me and I'm already in the heavenly high jubilant frenzy of joy (the way it is supposed to go for young girls, I did not feel that way then)—and suddenly I love everything about him, I'm already dreaming all day about our one meeting." It's clear to her that these are illusions: "Would that remain for a long time? Hardly! Big black eyes, an incredible pug nose, certainly a cock of the walk for all lady painters." And she was aware of how ephemeral her infatuation was: "But, half an hour before, I had a crush on Celan just as much. Exhausted by today's emotional swings."[42]

Still, above all, Celan was important to her as a language artist. The two shared a similar approach. Celan was accused of incomprehensibility in his late poems, and Lassnig similarly felt misunderstood. His phrase—"My alleged ab-

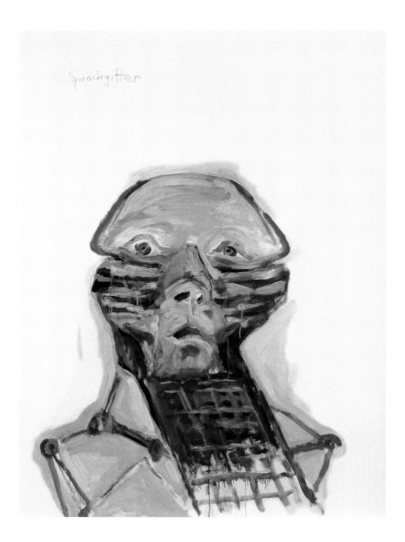

straction and real ambiguity are moments of realism for me"[43]—resonated with
Lassnig. In the course of her artistic life, she, too, always found true reality in
abstraction. She was perceived by Celan to be a serious artist, and he was the
epitome of a poet for her—"the greatest, that is, the most concentrated."[44] In 1992,
as she turned away from the then-popular "expanded concept of art," she referred
to Celan in an interview: "I believe, as Paul Celan said, that art does not need
expansion but narrowing."[45]

 Lassnig often tried to meet Celan, seeking conversation with him, but
was forced to realize that his condition was getting worse and worse: "The last
time I met him, it was rather tragic. He was already very disturbed. We sat there
in a coffee house and suddenly he started to sing loudly, in the coffee house, in

*Sprachgitter
(Language Mesh),
1999*

Russian. I was a little frightened, because the French are always so finicky about what is *comme il faut*, socially acceptable."[46]

Later when she was in New York and learned of Celan's death, she was deeply distraught. His body was retrieved on May 1, 1970, ten kilometers from Paris down the Seine, after he had flung himself into the river from Mirabeau Bridge. In 1997, Lassnig drew an homage to all suicide victims—and intentionally gave the sheet a French title, *Hommage à tous les suicidés*.[47] Even for herself, suicide was—at least in fantasy—an option. In 1999, she paid tribute to Celan with her painting *Language Mesh* (*Sprachgitter*), named after his eponymous poem and volume of poetry from 1959. Celan explained the title of his poem: it's about "the difficulty of speaking (to one another)" and at the same time about the structure of this difficulty, "which chimes in as well."[48] In Lassnig's painting, a self-portrait, a guillotine-like mesh or grid cuts under her chin into her neck and seems to separate her head from her body—a brutal image of how stressful interpersonal communication could be for Lassnig.

High ceilings, large paintings

In order for Lassnig to be able to afford a studio in Paris, her mother had to sell part of the garden of the family's house on Adolf-Tschabuschnigg-Strasse.[49] But before this, the artist lived briefly at various friends' homes and in hotels: first in the rue Vaugirard just around the corner from the Jardin du Luxembourg, then in a small hotel in Montmartre, followed by the rue Gay-Lussac in the Latin Quarter and the rue Saint-Sulpice in Saint-Germain-des-Prés. Finally, however, she found a large apartment located in a charming old building at rue Bagnolet 149 in the 20th district, in the northeast of Paris, a fifteen-minute walk from the famous Père Lachaise Cemetery, where Molière, Proust, Wilde, Chopin, Rossini, Delacroix, Ingres, and many other icons of European culture are buried. Not too far away is the Bois de Vincennes, one of the big forests in the city, where Lassnig took long walks. The 20th *arrondissement* is a working-class district, where high numbers of immigrants lived in the early 20th century and where relatively cheap flats existed by Parisian standards. As in her Vienna attic, there was no bathroom, and the toilet was in the hallway. From the third floor, Lassnig looked out with great joy upon a maple from one window, while from the other windows she had a view of chestnut trees, which took away a little bit of light but delighted her in May with magnificent flower blossoms.

Her new home had three rooms, but she had the walls between two rooms ripped out to create a seven-by-four-meter studio. Soon, the high, wide rooms began to affect her work. She got in the mood for larger formats and used two-meter-by-two-meter canvases. For the first time, the dimensions corresponded one-to-one with her body—"my size, because I project a print of my

complete size onto the canvas, so to speak."[50] As with the Static Meditations, she painted on a white background but no longer in black like in the early 1950s but in bright basic colors: contours in green, light red, and blue with a broad brush. Here, it is less about the circling and balling together of Body Sensations, as in the Static Meditations, and more about feelings of tension and stretching as well as of individual pressure points at which the lines cross or the paint densifies: "Two meters wide, from one corner of the picture to the other, the shoulders stretch, the middle of the body narrows into an hourglass or stretches from one door to the other. Between the ears, there is room for the universe or for the battlefield of erased attempts."[51] To correct what had already been paint-ed, she used turpentine-soaked paint rags—and old panties were her mate-rial of choice. In many photos of her Parisian studio, you can see a slew of turpentine bottles on the floor.

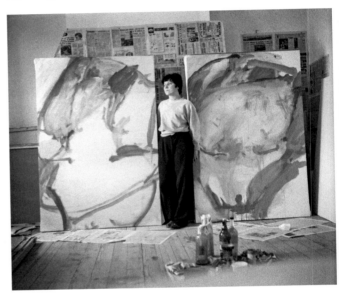

Lassnig with her Line Paintings in her studio, rue de Bagnolet 149, Paris, 1961

Lassnig referred to these works as Line Pictures (Strichbilder), or affectionately as "stickmen."[52] Al-most forty years later, she considered them to be her purest Body Aware-ness works: "I mean, the real body art was the lines, the stretching lines, and that's not an abstraction, but a real sensation which I really just por-trayed as sober, as cool, as I sensed them ... the outstretched, the crum-pled up, and so on."[53] And: "Basically, these are my most beautiful paint-ings."[54] These Line Pictures are, as Lassnig made clear with this term, in between drawing and painting. She wrote in her journal in French: "It's easier to draw than to paint, and it's better to make a good drawing-painting than a bad paint-ing-painting."[55] She criticized the traditional distinction between graphic arts and painting: "Because my oil paintings are graphic (some of them at least) and my graphic art is painterly."[56] She did not always finish her paintings. "Of course: Better an interesting unfinished painting than a less interesting finished one!"[57]

Hardly anything was as difficult for Lassnig as self-marketing, which remained a horror for her: "I spend my life completely in a dream. Instead of pre-senting myself to the galleries, I stay at home and paint or don't."[58] In her journal, we find numerous, at first hopeful, then increasingly annoyed and frustrated en-

tries about Denise Breteau, a Parisian gallery owner, who again and again raised her hopes for a solo exhibition. Breteau, who exhibited among others Nancy Spero, visited Lassnig six times in total—the first time when Lassnig was still living in a hotel in Montmartre. Lassnig showed her the expansive watercolors and paintings in shades of red and pink, similar to those she had recently presented at the St. Stephen's Gallery. Breteau was interested, made suggestions, said that Lassnig had to liberate herself even more. The next visit took place in the Latin Quarter and the one after that in the studio on rue de Bagnolet. There Lassnig

"M.L. resting on the laurels she dreamt of," journal, spring 1960

showed her latest large-format Line Pictures. Breteau was extremely pleased: "Great astonishment and enthusiasm, especially for one painting. Almost a promise for a solo exhibition soon."[59] Breteau haunted her in the night; Lassnig dreamt of the gallery owner as a charming devil. When Lassnig returned to Paris from Carinthia after the summer of late September 1961, she visited the gallery owner again but without the success she had hoped for: "After my first jaunt in Paris (Breteau), I just wanted to hide in a corner of the apartment and not come back out again."[60] The only effective antidote to depression was to create even better art, and she continued to work intensely. The gallerist came by and said, "Very nice, very good. But please make me a series of thirty such paintings." That, however, Lassnig couldn't and wouldn't do: "If I have made a few paintings, then that doesn't interest me anymore and I have to do something new."[61] And: "I would rather contradict myself—before I repeat myself."[62]

Lassnig's disappointment was great, and her distrust of the world once again assumed boundless proportions: "If someone gave me a gift and I held it in my hands, I would neither believe in the gift nor my hands."[63] She read in an article that among certain African ethnic groups there were professional admirers, mostly older people, who came to the house and praised and admired everything in detail. As a reward, they were invited for a meal and received a small gift. She wrote: "I don't think it's that stupid, because people need admirers."[64] It also didn't strike her as insincere. Even if it was just a convention, she felt you would believe the admirers nevertheless. "M.L. resting on the laurels she dreamt of" showed how much she longed for success, while making a little fun of herself, too.[65] She captured this in a journal sketch before her departure to Paris. At the end of 1961, she had been living in Paris for a year. She wrote resignedly: "No recognition, neither here, nor there. What am I talking about? Haven't even started to create something revolutionary yet!"[66]

"Lassnig is good. Get her while you can!"—
Hans Bischoffshausen and the Hildebrand Gallery

As enthusiastically as Lassnig reported about Paris in her Art Letters, it was very difficult to gain a foothold there. In depressive moments, she had the feeling she was being hindered in her art by the city, becoming more sluggish and even more conservative. While this may have been her self-perception, it was by no means true: Lassnig's work in Paris was even more innovative than before and she found her own distinct language in her painting. Sometimes she knew this very well: "A painting, a master shot, ho ho!"[67] Often, however, she was disappointed again the very next day: "I almost never have happy moments in which the paintings paint themselves, and if they do, then I'm suspicious of them and all too often destroy them; therefore, I will never produce a great oeuvre."[68]

Lassnig looked forward to visits from old friends because she was often quite lonely. Wieland Schmied, at that time an art critic at the *FAZ* (the major German newspaper) and later museum director of the Kestner-Gesellschaft in Hannover (one of the largest art associations in Europe), stopped by. Werner Hofmann, director of the Museum des 20. Jahrhunderts / 20er Haus (the contemporary art museum in Vienna), visited her, as did Rainer Bergmann, Max Hölzer, Arnold Wande (who was still in love with her), and her fellow artist Arik Brauer, about whom she reported in a letter to her mother: "He is the most amiable, kindest, funniest of all, without envy or jealousy, he is like a Wandervogel. He skis, climbs mountains, and he's an Israelite!"[69] Lassnig seemed to emphasize the latter point because even fifteen years after the end of the Second World War, her mother in some letters gave free rein to her antisemitism.[70] How insular social circles in the French capital can be is still experienced by expats in Paris to this day. The competition was enormous precisely because the city attracted so many foreign artists. Nevertheless, there was also a form of solidarity. "The painters greet each other like warriors. They appreciate each other's smallest victories," Lassnig noted in 1961.[71] Occasionally, she met Friedensreich Hundertwasser, who had owned a farm in Normandy since 1957. He was frequently in Paris and had achieved his artistic breakthrough. "But Hundertwasser, who only lived on wheat grain in Paris, has become the most famous artist, but he is still not rich," she wrote to her mother, who worried endlessly about her daughter in a foreign land.[72]

"Paris is tough," recalled Helene Bischoffshausen, who had been living in Paris since 1959 with her husband, the Carinthian artist Hans Bischoffshausen, and their two children.[73] Hans Bischoffshausen had long dreamt of living in this city. After receiving the Graz Joanneum Art Prize (*Joanneums-Kunstpreis*) in 1959, he could finally risk the move to Paris with his family. For Lassnig, the Bischoffshausens became a first important contact point in Paris. They lived in difficult conditions in a former factory hall on rue de Glacière in the 13th district, near

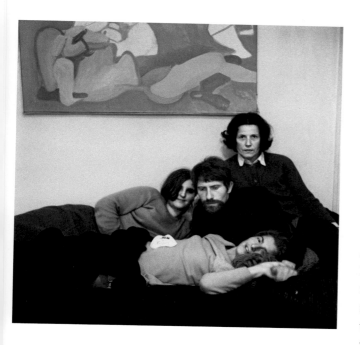

Maria Lassnig (back right), Bärbl Zechner (back left), Heide Hildebrand (front), and a friend in Paris, 1968

boulevard Auguste-Blanqui. Hans Bischoffshausen used plaster, boards, and cardboard to build a living studio for himself and his family in the factory hall. Soon after, other artists also settled there and in the surrounding factory halls. Helene Bischoffshausen had imagined life in Paris differently: "I bought a pair of stilettos and an elegant red velvet skirt, thinking of the cosmopolitan city of Paris, and landed in this hole. We lived with rats and fleas. Our neighbors were homeless bums, black Africans, illegals, homosexuals, moneyless artists. In the morning, before the children were up, I cleaned the communal toilet for all of us. The walls were splattered with shit up to the very top. It took me a long time to somehow learn to cope with that."[74] Hans Bischoffshausen sometimes signed his letters ironically with "Baron de la Glacière."[75] Despite these circumstances, the Bischoffshausens often had visitors, including Lassnig. Helene Bischoffshausen wrote: "The friends liked to come to us, because it was hard for them in Paris."[76] After three years, this artists' quarter was demolished, and all the residents were evicted. Miraculously, the Bischoffshausens received a cheap, new, and large apartment nearby from the municipality, which—unlike Lassnig's studio—even had a bathroom with a bathtub. Reason enough for Lassnig to visit the family once a week to take a bath there. Helene Bischoffshausen remembered: "The children were always happy to see her. She always brought a tartlet. We had a Jour fixe every week."[77]

Hans Bischoffshausen was one of the most important Austrian avant-garde artists of the time. He was best known for his abstract images in white on white, which were characterized by a plastic surface structure. He regularly visited Lassnig at her studio. She wrote: "I spent a boozy night with Bischoffshausen and friends and noted his abstractionism was canceled out by his delight for dirty words. He looked at my paintings around five in the morning and deeply insulted me."[78] Whatever Bischoffshausen might have said about Lassnig's paintings, he certainly thought highly of her. When he took part in the Salon des Surindépendants in Paris in 1963, he invited ten colleagues and he chose Lassnig among them. He also supplied her with the contact to Heide and Ernst Hildebrand, who were just about to establish an avant-garde gallery in Klagenfurt. The

small gallery, initially in a cellar in Wulfengasse, quickly developed into one of the most important addresses for contemporary European art in Austria. Heide Hildebrand asked Bischoffshausen to recommend some artists. Several times he drew attention to Lassnig: "Lassnig is good. Get her while you can!"[79]

Heide Hildebrand didn't have to be told twice and shortly thereafter wrote a letter to the artist that began "Dear Fräulein Lassnig"—Lassnig was already over forty years old, but the title "Fräulein" for an unmarried woman was then still common, even in avant-garde artistic circles. "In the last few days, I have considered the final program for this year and decided I would like to do an exhibition with you." The conditions follow, and the letter ends with a polite question about the Parisian weather and a somewhat brash request: "Please answer me as soon as possible. It is not easy to organize such a thing if you have to wait half a month for each answer."[80]

Lassnig answered nine days later, pointing out that spring had long since arrived in Paris. She followed this up with an invitation to her Paris studio, and soon Ernst and Heide Hildebrand strolled with Lassnig through the Père Lachaise cemetery and delighted in the Parisian galleries, not least in the locales of Montmartre. When, in December 1961, the Hildebrands produced a Christmas exhibition with numerous artists under the title *Mishmash* (*Mischmasch*), a work of Lassnig's was on display. However, three years passed before a first solo exhibition was scheduled—not because Heide Hildebrand did not want to exhibit her earlier but because Lassnig made a fuss. The relationship between the two women was quite friendly but also complicated. Lassnig called the very young gallery owner "my dear child" and spelled her name wrong every time. Often, she reversed the syllables of the first and last name and wrote—half deliberately, half unintentionally—Hilde Heidebrandt or even "Dear Heidebrandt!" In 1962 she wrote, "I don't think it is good if I exhibit this summer: I have to recover in Klagenfurt and do nothing. It would also be quite a financial sacrifice for me to make the catalog. You wouldn't understand."[81] The exhibition in the Landesmuseum of Carinthia in 1961 cost Lassnig[82]—like every exhibition—a lot of nerves: "If you don't believe me, ask my mother, who you believe more, what distress last summer's exhibition brought to our house."[83] The correspondence between the two made it abundantly clear that Lassnig was not making it easy for the gallery. Nevertheless, her relationship with the Hildebrands was becoming ever closer. The artist was very fond of their daughter and also had an important friendship with Ernst Hildebrand, who, as a well-paid architect and art connoisseur, took care of the financial base of the gallery. In addition, he took care of many artists—including Lassnig—through his friendship and material support. Since the Hildebrands knew exactly how poor Lassnig's nutrition was, they now and

again sent her packages of energy-rich delicacies, such as biscuits, honey, nuts, and dried figs.

When the exhibition in the Hildebrand Gallery finally took place in July 1964, Lassnig was, as usual, extremely nervous and complained of psychosomatic symptoms to her family in Klagenfurt. Her stepfather had died twelve years earlier in 1952, and her mother had remarried in 1954 to Paul Wicking, a retired finance official. Lassnig got along very well with her new stepfather, who, like her mother, regularly wrote to her in Paris. When she mentioned that the upcoming exhibition in Klagenfurt was giving her heart pain, Wicking answered: "I beg you please, go to the doctor as soon as possible. There's no joking around with the heart!! Get a doctor's note, send it to lady Hildebrand, and cancel this stupid, cellar exhibition!!!"[84] Her mother added: "Because of Hildebrand you will hardly be able to cancel on such short notice before the exhibition, but it was senseless from the very beginning to show your large paintings in that cellar hole, which doesn't do them justice."[85]

The transport of finished paintings from Paris to Klagenfurt or Vienna regularly presented Lassnig with great challenges. She wrote to Heide Hildebrand: "Will you come to Paris before the start of the season, and maybe you could take smaller paintings with you by car? I'm going to schlep myself to death with all these canvas rolls this summer." Because of these problems, Lassnig would have preferred not to exhibit in Austria before autumn so that she could paint works in Carinthia during the summer. Lassnig wrote Hildebrand countless letters with detailed instructions, requests for changes, accusations, and complaints.

The exhibition expenses were also a source of great concern for her: stretcher frames, invitation cards, catalogs, and posters. "Absolutely do not buy the expensive glossy paper," she wrote to Hildebrand, and later when the catalog was finished, she said: "Instead of the cheapest, you chose the most expensive, and did not say a word about the price! This will financially ruin me!"[86] About the posters: "Gluing is getting expensive again, isn't it?" And: "You know very well that I have to live all year in Paris from one or two purchases. (A Parisian worker earns more in a month.) Unfortunately, that's the bitter truth."[87]

Still, everything went well, and Lassnig herself was amazed at how the gallery worked together with her: "The extraordinary, that is, unexpectedly good cooperation with you during my exhibition also remains a positive memory." The two women were now on friendly terms. The mood was so good that Lassnig even visited the Hildebrands during the summer at their holiday home in Stara Baška on the island of Krk in today's Croatia—from then on, a highlight of each summer. The Hildebrands had a romantic old house there to which they invited artist friends, including Oswald Oberhuber, Bruno Gironcoli, and last but not least, Lassnig. She wrote: "One needs to cordon off this heroic landscape with

barbed wire because otherwise it will sooner or later be occupied by a film company." Then she added: "Do you know *Big Sur* by Henry Miller; do we want something like that in Stara Baška?"[88] In *Big Sur and the Oranges of Hieronymus Bosch* from 1957, Miller described a colony of writers, mystics, artists, and worn-out city dwellers who had retreated far away from civilization into the grandiose Californian coastal landscape of Big Sur. In the prudish America of those years, this colony had the reputation of being a hotbed of sexual debauchery.

First successes in Paris and Yves Klein

Soon after arriving in Paris, Lassnig contacted Jean-Paul Riopelle, the Franco-Canadian artist whose acquaintance she had already made in Nina Dausset's gallery in 1951. Riopelle was one of the most successful painters in Paris at the time, and in 1959, he participated in documenta II. In 1962, he won the UNESCO Prize at the Venice Biennale. Riopelle was an attractive man and popular with the ladies. Lassnig got to know numerous American artists through him. She regularly invited them to her studio and spoiled them with Austrian dinners, such as paprika chicken with rice and apple strudel for dessert. Her friends included Hugh Weiss, Kimber Smith, Charles Semser, Shirley Jaffe, and especially Joan Mitchell, Riopelle's girlfriend at the time. In Mitchell's New York years of the 1940s, she had been active in the macho world of Abstract Expressionists. She had boozed with Jackson Pollock, Willem de Kooning, Franz Kline, and others in the infamous Cedar Tavern in Greenwich Village and was considered one of the boys. This equal treatment came to an end as soon as they had to recognize her as an artist. Mitchell was well aware she had to overcome obstacles that her male counterparts didn't. In later years, when asked what the hardest part of her career had been, she said, "Well … I'm a girl, a woman, a female."[89] Mitchell was undoubtedly one of the first women to bring Lassnig into touch with feminist ideas—not much was going on in Paris in those days in that regard despite Simone de Beauvoir.

Mitchell had the gift of synesthesia. She perceived everything in colors: sounds, persons, feelings, and even the letters of the alphabet.[90] Green, for example, belonged to the letter A. Even as a child, she felt these connections. This resonated with Lassnig, who would later talk about Body Sensation colors, torture, smell, thought, and cancer-anxiety colors. Mitchell's color experiments also had something very physical about them, as if they wanted to explore all bodily fluids and flesh tones. It was therefore not surprising that Lassnig and Mitchell understood each other artistically. They hung out with each other in their respective studios, and when Riopelle and Mitchell moved from Paris to the countryside in 1968, to Vétheuil near Giverny, Lassnig also visited them there. Later, there was

a dispute between the two strong-willed women that led to their breakup—a pattern that repeated itself in many of Lassnig's friendships with women.

It was even harder to make friends with French artists than it was with expatriate Parisians. Her few French friends included the painter Marcel Pouget, a representative of the New Figurative Painting, and his wife, Alphea, a Swedish dancer. Lassnig also tried to refresh her old contacts with the Surrealists and went to their meetings. She felt excluded, however, from the intellectual debates, which she considered aloof and snobbish: "I did not speak French well enough to be able to participate."[91] Here, she got to know Jean Schuster, the editor-in-chief of the magazine *Surréalisme même*, and, most importantly, José Pierre, an art critic and writer, who became an important friend and supporter. Nevertheless, Lassnig had the feeling he did not take her completely seriously: "José Pierre valued me as a painter, but not as an intellectual."[92] Over and over again in her life—probably not without justification—Lassnig was given the impression that men underestimated her intellectually. In spite of this, Pierre was important to her. He wrote several texts for her exhibitions, which she published decades later in her catalogs. Pierre also arranged contact with the Creuze Gallery, which in May 1962 hosted a large group exhibition titled *Donner à voir* in which Lassnig, among others, participated. It was probably at this exhibition that an important incident with Yves Klein took place, which Lassnig still proudly spoke of into her old age.

Klein was famous for his monochrome works in bright ultramarine blue, a color he patented in 1960 under the name of IKB, International Klein Blue. Lassnig was particularly impressed by his Anthropométries, life-size paintings created by the artist during "happenings," where he smeared the nude bodies of female models in blue paint and then used them as human brushes to produce life-size imprints on canvas. Many years later when Lassnig was asked in an interview whether she considered this misogynistic, she said that she had not thought about that at the time as she had had completely different questions and problems.[93]

Klein's Anthropométries were so interesting to her because she also considered her new life-size Body Awareness works as imprints on canvas. The relationship between body and canvas would often preoccupy her, especially in her series Inside and Outside the Canvas (Innerhalb und außerhalb der Leinwand) in the 1980s.

Presumably at the opening of *Donner à voir*, Lassnig had recognized Klein as he sauntered through the gallery.[94] He passed her paintings, paused, and asked around the room, "Who's this? Who made this?" Lassnig was too shy to make herself known, but she was delighted that the famous Yves Klein found her paintings remarkable enough to inquire who their creator was. Very likely one of her male artist colleagues would have been better able to use this situation to his

advantage. But even fifteen years earlier, Lassnig had written: "I do not want to gain publicity by having had the luck of meeting a powerful personality; I would like to seize my fortune myself, when it is cut and dried enough."[95]

She knew, however, that she was not actually accelerating her career this way: "It has always been very slow in coming because I am not the type of person who creeps under the armpit of others."[96] The large exhibition was designed by a total of six French curators.[97] Most famous among them was the art critic Pierre Restany, the intellectual head of the New Realists, which included Klein. Restany had coined the term Nouveau Réalisme two years earlier, the name under which he also presented his part of the exhibition at the Creuze Gallery. The artists of this group differed significantly at first glance. The common goal was to take away the sublime from art and anchor it in ordinary reality. Many of the artists therefore used everyday objects. Arman found his materials in trash cans and wastebaskets, or he smashed violins and double basses. César welded scrap iron into sculptures. Raymond Hains and Jacques de la Villeglé were well known for their torn posters in which they made visible the different layers of glued-together advertising bills, thus creating abstract images and criticizing consumer culture at the same time. Niki de Saint-Phalle was represented with her famous Shooting Paintings, plaster reliefs with built-in paint bags, which she shot at during the vernissage.

In the Creuze Gallery, Lassnig displayed works similar to those at the St. Stephen's Gallery in 1960—paintings and watercolors in which the paint spread over the entire canvas, especially in red and pink shades. While the works were not monochrome like many of Klein's, they explored a color in all its shades. It was quite possible that Klein had noticed them for this reason. They were included in the group that the art critic, poet, and gallerist Jean-Jacques Lévêque presented under the title *Proposals for a Garden (Propositions pour un jardin)*. The other exhibited artists in this group also worked abstractly, including Jean Messagier, Émile Compard, the Japanese painter Key Sato, the American Abstract Expressionist John Levee, and the Dutch artist Corneille, co-founder of Cobra, an artist group founded in 1948. Lassnig was therefore not presented in the group of superstars—that is, together with Yves Klein and Co.—but also not in the context of complete nobodies. By the way, Klein suffered his second heart attack on the evening of the vernissage. Only three weeks later he was dead.

In November of 1962, Lassnig again exhibited a number of works with Lévêque. In his gallery Le Soleil dans la tête, an old bookstore in Saint-Germain-des-Prés, he presented *Young Austrian Painting (Jeune peinture autrichienne)*; alongside Lassnig were Hans Bischoffshausen, Paul Meissner, Josef Mikl, Markus Prachensky, Arnulf Rainer, and Hans Staudacher. As so often, Lassnig was the only woman in the group.[98] In the small catalog, there was one artwork from

*Große Knödelkonfig-
uration (Big Dumpling
Figuration)*, 1961–62

each artist; from Lassnig, one of her monumental new Line Pictures: *Big Dump-ling Figuration* (*Große Knödelkonfiguration*). In the catalog, the year of creation is listed as 1962, but Lassnig wrote the date "1960" on the painting, an unlikely date, since she only began to work in this format after she had lived in the rue de Bagnolet, which was from 1961 on. Her information about a work's time of origin was frequently inconsistent. She often dated her paintings after the fact, as this wasn't so important to her, and her memory was sometimes mistaken.

Brigitte Bardot and Napoleon—the New Figuration

In 1964, the Paris art world experienced a shock. For the first time ever at the Venice Biennale, an American artist won the International Grand Prize in painting.[99] Since World War II, painters living in France had almost exclusively been awarded the prize: Georges Braque in 1948, Henri Matisse in 1950, Raoul Dufy in 1952, Max Ernst in 1954 (although German, he had lived in Paris for decades—and this was only interrupted by his exile in New York), Jacques Villon in 1956, Jean Fautrier in 1960, and Alfred Manessier in 1962. Now, however, the prestigious prize went to the thirty-eight-year-old Robert Rauschenberg, one of

the pioneers of Pop Art, who from a Euro-
pean standpoint was virtually considered
the epitome of an American.

He was famous for his so-called
Combines in which he mixed sculpture
and painting. He combined things like car
tires, ladders, taxidermied animals, a torn-
off poster photo of the just-murdered
American President John F. Kennedy, and
an advertisement for security locks. With
him, the oil paint didn't just land on the
canvas but also on the nose of a stuffed
goat. Rauschenberg departed from tradi-
tional panel painting and at the same time
brought themes of everyday life and poli-
tics into exhibition halls. Now his art had

*Napoleon und Brigitte
Bardot (Napoleon and
Brigitte Bardot), 1961*

been honored with Venice's highest prize. It was a close decision, and the French
press was foaming at the mouth. They sensed the downfall of Western Civiliza-
tion, spoke of cultural colonization, and in general felt the strong presence of the
Americans in Venice as a humiliation of the so-called École de Paris, the school
of French painting; the French had just assumed they would always be the pio-
neers. What was really surprising about the Venice Biennale was not so much
Rauschenberg's win but rather the outrage about it. A conflict between abstract
and the New Figurative Art, which was more related to the outside world, had
long since become apparent, even in Paris. Pierre Restany, the theorist of the New
Realists, was therefore one of those who was pleased Rauschenberg had won
the award. The shift in power from Paris to New York had now become obvious
to everyone, as much as Paris had tried not to miss the bus. Only two weeks
after Rauschenberg had won in Venice, a groundbreaking exhibition took place
in Paris. Gérald Gassiot-Talabot, one of the most respected French art critics,
curated the first major show on Figurative Art in the Paris Museum of Modern
Art: effectively the official end of abstraction's hegemony. The exhibition bore
the telling title *Everyday Mythologies*—both everyday life and the outside world,
as well as narrative, now played a role in art again.[100] Also appearing in the same
year was Alain Jouffroy's *Une Révolution du regard—A Revolution of the Gaze*—the
most influential publication about the New Figuration.

Lassnig's Parisian Art Letters also showed this change in trend. As early
as 1963, she reported on American Pop Art, which "already has a small follow-
ing here,"[101] and also on the New French Figuration, which tried in vain—in the
end—to halt the triumph of the Americans: "There are painters who see the world

Frühstück mit Ei (Breakfast with Egg), 1964

around them again, assess it, make fun of it, or deplore it, whatever they do—a new preference for the *subject* becomes obvious and with shock or amusement widens the audience's bridge to art (may this optimistic prognosis be fulfilled)."[102] The accompanying conflicts were not lost on Lassnig: "The New Figuration, which is now in the air, bitterly hated by the Abstractionists, even more bitterly by those who were 'always' figurative, bears a lot of fruit."[103] Lassnig not only provided insight into the all-too-common envy in the art business but also into the squabbling between the different trends. These conflicts played out between New York and Paris—within New York between Abstract Expressionists and Pop Art, and within Paris between the abstract and the figurative, between painting and object art. Although there had always been artists who worked figuratively—in France, for example, Pablo Picasso and in Austria, the Vienna School of Fantastic Realism—for a long time it seemed certain that abstraction was the future. It was regarded as *the* method of the avant-garde, as the universal language of art, and one believed this historical clock could not be turned back. This only made the shock strike deeper now. Many artists working in the abstract felt that Modernism and its ideals were being betrayed.

This wasn't the case for Lassnig. She wrote in an article that the "visible world" had slowly but surely penetrated her works, too.[104] The titles of her works told this story. Her first large Line Pictures from 1961 included titles such as *Tension Figuration (Spannungsfiguration)*, *Body Sensation Figuration (Körpergefühlsfiguration)*, and *Big Dumpling Figuration (Große Knödelkonfiguration)*—heavily abstracted Body Sensation artworks, which, however, were based on something concrete, namely her own body. She titled others *Fat Green (Dicke Grüne)* and

Harlequin Self-Portrait (Harlekin-Selbstporträt). Eventually, Lassnig would no longer put a single figure, that is, herself, on the canvas but several, standing in relation to each other: "A figure in a painting does not yet tell a story, two figures form a story, many figures make it theater."[105] In one of these paintings, for example, she had two French icons meet: the French sex symbol Brigitte Bardot and Napoleon, the national hero par excellence. Napoleon with his two-cornered hat and his uniform looks a bit ridiculous, like a figure from the *commedia dell'arte*. Nevertheless, he seems to be doing some harm to Bardot, who is cowering on the ground. Violence, national chauvinism, and gender conflicts were the subject of many of these new works, which Lassnig called Narrative Line Pictures. Painted between 1962 and 1963, they bore titles such as *Menace of Woman (Bedrohung der Frau)*, *Recumbent and Dismembered Female (Liegende und Zerstückelte)*, *Death and the Devil (Tod und Teufel)*, *Evil and Good (Böse und Gut)*, *The Grumpy Hero (Der mürrische Held)*, *War Children (Kriegskinder)*, and *The Dictator (Der Diktator)*.

Political and social issues also played a role for Lassnig. She was experiencing a productive time and wrote to Heide Hildebrand: "My paintings often amaze me, too, a good thing, isn't it?"[106] One of those amazing paintings is *Breakfast with Egg (Frühstück mit Ei)* from 1964, which Lassnig presented in numerous exhibitions and Otto Breicha described as the "pamphlet version" of Édouard Manet's *Luncheon on the Grass*. In fact, Lassnig's French title was *Déjeuner sur l'herbe*—like Manet's famous painting. While Manet

Der mürrische Held
(The Grumpy Hero),
1962–63

showed a nude woman among dressed men at a picnic in 1863 and thus created a scandal, Lassnig avoided any eroticism. Her breakfast-eaters are mutant characters—violence is in the air. A small deformed creature in pink, perhaps Lassnig herself, crouches shyly on a checkered picnic blanket with a boiled egg in the eggcup in front of her. By the way, the work was later acquired by the famous pianist Alfred Brendel. When he learned there was a counterpart titled *Breakfast with Ear (Frühstück mit Ohr)* from 1967, he wanted to swap it for his painting because the ear fit him better as a musician.[107]

As the title suggests, this time an ear lies on a blood-red picnic blanket, surrounded by monsters that are reminiscent of food processors. Lassnig later said that this ear alluded to the noise from which she had always suffered so extremely. For a whole season beginning autumn 2005, this painting adorned the iron fire curtain in front of the Vienna State Opera's stage, part of an annual

tradition since 1998 in which the curtain has been covered with work by a contemporary artist.[108]

However, Lassnig had an ambivalent relationship to the titles of her works. She swore to herself: "Romanticization of titles should finally be dropped."[109] The titles occurred to her, usually as an afterthought, when the work was finished. It was a burden to her to have to think them up because she felt she was leading the beholders of her art in the wrong direction: "They suggest something which sometimes doesn't fit at all!" She deeply scorned collectors who only bought her paintings because of the title. At the same time, she knew that most people found a title helpful, and she did, too: "It annoys you always that you have to do it, but otherwise you don't recognize the paintings yourself."[110]

Once, when Lassnig was asked which of the New Figurative painters she found the most inspiring, she named two: Gérard Tisserand and Eduardo Arroyo.[111] In the group exhibition that Lassnig curated herself for the Hildebrand Gallery in 1967, she showed Arroyo as well as Tisserand, among others. Following the current trend, Lassnig came up with the exhibition title herself: *Figures and Histories (Figures et Histoires).*[112] Additionally, in 1969, she hosted a joint exhibition with Tisserand at the Hildebrands.[113]

In an article about the exhibition, Lassnig wrote with her typical sense of humor that Tisserand would succeed in epicurean France since he painted roast chicken, spaghetti eaters, and so forth. But there was certainly a twist "because these juicy roasts are, if you look more closely, female nudes with their legs amputated like chickens, wickedly painted between peas and vegetables."[114] Arroyo, the second artist Lassnig had mentioned as inspiring, put Napoleon in a series of paintings. She described him as a "gifted revolutionary, who dares to portray the idol Napoleon in the most human scenes," such as in *"Napoleon, qui fait l'amour*, naked with boots and spurs."[115]

In the run-up to the exhibition *Figures and Histories*, there was a little scandal. One of the other artists presented in the exhibition was Jean-Claude Silbermann, a French Surrealist with whom Lassnig was friends. However, when he learned that Monsignor Otto Mauer would be speaking at the opening of the exhibition—Heide Hildebrand's idea—he was consumed by a fit of rage, as Lassnig reported to the gallery owner: "Yesterday, Silbermann called to ask me if it was a joke or whether a priest would really open the exhibition." Lassnig tried to explain to him that Austria was not France and that Mauer was seriously committed to contemporary art, but: "All intellectuals are anarchists here and a priest is a red flag for them."[116] Silbermann heavily reproached Hildebrand, wrote a telegram, and wanted to withdraw all his artworks. Finally, Lassnig managed to calm the artist down, and the exhibition was carried out as planned.

Lassnig didn't see the choice between figuration and abstraction as a conflict. Her seemingly abstract paintings were not without an object but precisely represented her Body Sensations. But the conflict was forced upon her from the outside. As a result, she was disappointed that the renowned gallery owner Jean Fournier perceived her paintings as purely abstract: "Those who were accustomed to the abstract only saw the abstract side of my paintings. Fournier loved the brightness of the colors, but he didn't want to see what they represent."[117] This, however, had less to do

The safety curtain at Vienna State Opera, season 2005–06, displaying *Frühstück mit Ohr* (*Breakfast with Ear*) from 1967

with Lassnig's work than it did with Fournier's preferences, as the New Figuratives didn't interest him at all. Surprisingly though, Pierre Alechinsky didn't respond to Lassnig's content either: "And Alechinsky, the New Figurative artist? He spoke enthusiastically of my painting style, the switch between the speeding up and slowing down of the brush, just as if he were one of the gestural painters! Strange!"[118] Alechinsky was a member of the international avant-garde group Cobra, which was characterized by an expressive gestural style in often bright colors. The group had disbanded in 1951, but its former members still exerted an important influence. Lassnig also wrote in her Art Letters about the successes of the former Cobra artists. She especially appreciated the Danish painter Asger Jorn, who also lived in Paris at the time: "Asger Jorn is a miracle! A man for whom there is no difference between what he thinks and what he does."[119] At the time, Jorn was part of the Situationist International, a left-wing artists' association that wanted to combine art and life and was considered an important source of inspiration for the '68 Movement in West Germany. All this was rather remote from Lassnig and yet she came a little closer to the prevailing zeitgeist: "The painter as a medium of his time? For a long time, I have rejected this: now even I agree."[120] Above all, she was excited about Jorn's painting and described it enthusiastically: "His pictures show visions of macabre humor, tragic and bizarre witch dances, water-headed monsters, masks, and amphibian people. Full of lyrical delicacy sometimes, of dramatic colorism another time, they are frequently imitated, and have a great affinity with Ensor."[121] Jorn heard that Lassnig had written about him and visited her afterward in her studio. She wrote: "When Asger Jorn one day stood in my doorway in Paris to say thank you for the article in which I had praised him in an Austrian newspaper, he must have been very disappointed to find such an intellectually voiceless creature, yet from then on, he sent me his *Situationniste* magazine"[122]—a good example of Lassnig's shy-

ness and low self-esteem. Incidentally, monsters and beasts soon appeared in her works, yet they were very different from Jorn's.

Her mother's death

Lassnig was forty-five years old when her mother died of liver cancer on September 18, 1964—just three months after the diagnosis. Lassnig's world collapsed; she couldn't cope with the loss. Even in old age, she called her mother's death the most terrible experience of her life. Her mother was her "only attachment figure in this world."[123]

The relationship between mother and daughter was intense and often difficult—"Didn't make her happy," as Oswald Wiener once put it.[124] Lassnig's early childhood experiences were lacking in physical affection, and even in her seventies she dreamt of physical closeness to her mother, which she had longed for her entire life: "Another dream about my mother. I sit up and hold her naked in my arms. The feeling of her body that she never gave me."[125] Sometimes she thought she had never even been loved by her mother: "It makes my loneliness even bigger. That I never experienced real love for me, and never will, not even from my parents!"[126]

In many ways it was like mother, like daughter. Lassnig ended a letter to her mother with the words: "Your daughter, your spitting image, your grateful Maria."[127] She also attributed some of her difficult traits to her maternal heritage, writing, "The apple does not fall far from the tree: which is obvious from our paranoia and constant feeling of subjugation."[128] However, her mother seemed to her a lot stronger than herself. When Lassnig was feeling good about her mother, she lovingly called her "Mama-heart," "Mommykins," or even "Shakey-Mum" because her hands would shake so hard she could barely hold a pen and had to type her letters.

Daughter and mother quarreled a lot; there were alienations, misunderstandings, and slights; and at the same time there was a great need for closeness from both sides. In a letter on Mother's Day in the 1940s, Lassnig wrote of how much she longed for them to live side by side "in speaking or mute harmony."[129] The reality was often different. When Lassnig returned to Paris after one of her summer holidays in Carinthia, her mother wrote to her: "You were so totally distant this summer. I really had no time with you. I was only in your way all the time, and you just wanted to be alone, and then on the last day you complained so much about Klagenfurt ... It is so sad we are living past one another like this. One yearns the whole year for one human being. The only one to whom one really completely belongs, and is always coldly snubbed by her, eats the insult, so silently scared away, and so alone!!!!!! Can you understand that? No, I don't think so." Her mother said she fortunately had her husband, "the father," as she

put it, but he was not as important as her own child, "the only creature of my flesh and blood."[130]

Paul Wicking, her second stepfather, also often wrote to Lassnig. He called her "dear Miedele" or "Mizzimoizele." He usually wrote on the back of the sheet that her mother had already written on. His letters were humorous and full of wordplay. Once he ended with an allusion to the partially aristocratic origins of Lassnig's biological father: "Now, I'll finish for today and send you a thousand kissies, your bloody-nosed dad." Below, he scribbled, "not your blue-blooded."[131] When a portrait Lassnig painted of him was presented at a group exhibition in Graz and Klagenfurt, he wrote: "So, on Monday, the 20th, I carried myself under my arm as instructed, and proceeded with heavy footsteps to where they will hang me!! And today, I suddenly learn that I will be hung in Graz first and then in Klagenfurt!! So maybe I can see myself hanging in Graz first!!?? What you experience in a seventy-year-old life!"[132] However, when his portrait was not shown in the Künstlerhaus in Klagenfurt, he took up the topic once again: "I have just come back from the Künstlerhaus, where I again took myself under my arm and carried myself home! They didn't hang me for a lack of space!!—so I'm just hanging at home behind the stove again."[133] Wicking knew his stepdaughter's fears very well and assured her that another work, a portrait of the neighbors,[134] was very well positioned in the exhibition—"diagonally opposite the three Boeckl paintings"—and had already been positively mentioned in a newspaper. Lassnig got along well with her stepfather and

Letztes Bild meiner Mutter im Liegestuhl (Last Picture of My Mother on a Chaise Lounge), 1964

for his 70th birthday, she sent him drawings she had done in Paris and a record from her favorite chansonnier, Georges Brassens. Wicking was proud of his step-daughter: "With all your artistic talent, you leave all these painting blunderers here in your dust!!"[135]

Lassnig's mother worried endlessly about her daughter in the distant city when she didn't receive a letter from her for a while: "You cannot imagine how tortured I am, the uncertainty. My God, what have you done to me with your Paris!! And what do you have from it, only disadvantages and abandonment, neither individual nor practical gain."[136] Accusations were a part of the mutual way of dealing with each other: "It's mainly me, who suffers from your provisional existence in Austria because I have to take care of and arrange everything."[137] Mathilde Wicking wasn't completely wrong with her complaint, since she had largely taken over the management of her daughter's affairs in Austria.

She took care of the subletting of the Vienna studio in the Bräuhausgasse and the running costs; she arranged accommodation for her daughter in Vienna when Bräuhausgasse was not free; she forwarded letters and carried paintings to exhibition venues. She handled all the financial transactions because transfers to and from France in the 1960s were associated with enormous costs. She ensured that her daughter wrote pending thank-you and congratulation letters. She regularly sent her packages of bacon, salami, chocolate, nuts, *Kärntner Reindling* (Carinthian cinnamon-raisin Bundt cake), medicines, her own tinctures that she mixed, clothes, and belly warmers. She regularly put five-hundred-schilling notes in her

letters. She supported her daughter as much as she could and was proud her daughter had become an artist.

Lassnig knew how much she owed her mother: "But my heart really melts away when I think of what I would be without you, dear Mommykins. I think I'd lose my whole strength and lightheartedness without you. I would never have become an artist without your kind help and your understanding."[138] At the same time, her mother was a strong and dominant woman with whom it was not easy to live, especially as an adult in her mid-forties, and sometimes Lassnig reacted defiantly and reproachfully like a pubescent teenager. When her mother sent her newspaper articles about the Austrian art scene, Lassnig accused her of putting her under massive pressure. Her mother replied: "That you are always so dissatisfied with me upsets me very deeply, as I do everything I can possibly imagine for your own good. I only send the newspaper clippings so that you have everything worth knowing about your dear-

Mathilde and Paul Wicking, 1959

est homeland and are kept up to speed about all that's happening in terms of art here. (Can't do you right.) Then you call me a sadist." She followed this up with a side blow to Lassnig's biological father: "As long as you live, I will only have your well-being and your happiness in mind. But you are very strongly afflicted with the rebellious blood of the Sternbergs."[139]

Still, her mother was devoted to helping and even tried to network for her daughter because she knew exactly how difficult a task this was for Lassnig: "It's a pity you let yourself go forgotten here. Should I write to bigwigs like Wedenig, Köstner, Truppe, etc. about commissioning portraits? I think it would work. Or you do it yourself before Christmas? You have to live, money is necessary for that. Since there's no succeeding in Paris, I'm worried about you."[140] Mathilde Wicking referred to "bigwigs" such as the Social Democratic politician (SPÖ) and long-standing Carinthian governor Ferdinand Wedenig and Joseph

Köstner, bishop of the Gurk-Klagenfurt diocese. Lassnig got stressed out. Her great timidity and the combination of pride and inferiority complex—often two sides of a coin—made it impossible for her to propose portraits to VIPs. Her mother replied: "You do not have to worry about Köstner and Wedenig, I'm just asking you, but I'm very annoyed that you don't trust yourself enough and will never make it. You're good and should have more self-confidence. The world only belongs to the courageous! Keep doing what you're doing and you'll someday starve!"[141] Repeatedly, her mother gave her well-intentioned but unsolicited advice on how to make money.

Toward the end of June 1964, her mother wrote a worrisome letter full of accusations because she had long been awaiting her daughter in Klagenfurt, but Lassnig was still stuck in Paris. Mathilde Wicking knew meanwhile that she herself was seriously, maybe even terminally, ill. Only a slight hint could be found at the end of the letter: "Come home soon and don't get so annoyed about everything. My whole life was also very, very hard ... but everything comes to an end someday. ... Greetings from your old trembling mother."[142] Lassnig first learned about her mother's condition in Klagenfurt when she was in the middle of preparing for the exhibition at Heide Hildebrand's. She had a violent psychosomatic reaction, especially heart pain. In the summer, she produced a gouache titled *Last Picture of My Mother on a Chaise Lounge* (*Letztes Bild meiner Mutter im Liegestuhl*).

Maria Lassnig in front of her *Leberselbstporträt* (*Liver Self-Portrait* Galerie nächst St. Stephan, 1970 (photo: Barbara Pflaum)

Her mother is lying on a deck chair in the garden, and Lassnig rendered her deformed self in the foreground. Her contours dissolve into the surroundings; her eyes are dilated with fright.

After her mother died on September 18, 1964, Lassnig fell into severe depression. In a kind of empathic over-identification, she now began to suffer from liver ailments, even when the doctors assured her that her liver was healthy. The topic of her liver preoccupied her time and again. She even painted a self-portrait of her liver. In 1966, she wrote Heide Hildebrand: "I'm sure now: I have cirrhosis of the liver. It is not my stomach, so I'm hopelessly lost! Hurray!"[143] When she gave a talk at a symposium on health at the documenta X in 1997, one of her central points was: "Doctors should take the liver seriously and would be better off prescribing liver diets more often than not."[144] She also felt she would die and wrote in her journal: "My love is as hot as my tears. Will they disturb you, dearest mother, in the grave? Shakey-Mum, will the umbilical cord soon pull me after you? But you don't want that, do you? I have to pick myself up, I must!"[145] At the end of September, she returned to Paris. She experienced the death of her mother as an epochal turning point: "Era after the death of my mother"[146] was a wording she used several times in her journals. She worried about her stepfather and asked Heide Hildebrand to stop by to check up on him. But then there was a conflict. She made major accusations against him, only referring to him as Mr. Wicking, and instructed Hildebrand not to let him into the house on Tschabuschnigg street anymore.[147] What exactly happened can't be reconstructed. Later, a New York friend reported that Lassnig blamed her stepfather for her mother's death because Mathilde was supposedly unhappy with him. Allegedly, he was a womanizer.[148] These were all rumors, and Mathilde was certainly a woman for whom relationships with men were difficult, a legacy she appeared to pass on to her daughter. Lassnig wrote desperately in her journal: "Every death is a murder. Mommy was murdered." She found her stepfather callous toward her mourning and felt betrayed by him as he claimed some of the inheritance and part of the house for himself. In agitated handwriting she wrote, "It's like being rushed to death now: attacks from all sides. How can my heart endure!"[149] She felt abandoned, misunderstood by everyone, offended. She was convinced that no one could match her grief appropriately, not even the otherwise always available, good-natured, and patient Louis Popelin. Even he seemed callous to her now. This is a phenomenon described in particular by many highly sen-

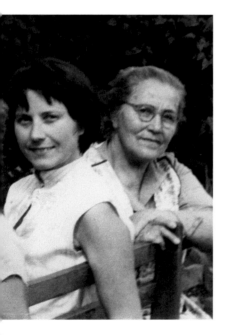

Maria Lassnig with her mother in Klagenfurt in the 1960s

sitive persons but not exclusive to them: in a time of of mourning they feel even more isolated and misunderstood than they usually do in their everyday lives. Everything became too much and unbearable for Lassnig. Every critical or perceived mean word, every insensitivity of the other, became an affront, even the behavior of the bricklayers, who were supposed to repair something at the house in Klagenfurt. The whole world seemed to have conspired against her. Her feelings of abandonment reached a new climax: "My loneliness is so great that I feel a sense of gratitude to the tap that gives me

Beweinung (Lamentation), 1964

water."[150] Her high sensitivity increased to the unendurable: "The noise of a passing car could kill me, it hurts me so much."[151] Her mourning entailed symptoms we'd call burnout today. "My injured heart can't seem to heal itself. If I die now, then it's really from a broken heart. *Muttilein*, what have you done to me?"[152]

Eventually, the death of her mother also became a reality shock. She now had to deal with the things of everyday life that her mother had taken care of until now. "Era after my Mother's Death: The second half of my life, if that is granted to me, I will seemingly have to spend learning what I had contempt for earlier: treating my fellow humans properly, behaving diplomatically, business, administrative thinking, and planning ahead. That means I have to deal with reality, which didn't exist at all for me (apart from the sea and clouds and trees)! What slave-galley drudgery and personal violation are ahead of me!?"[153]

Her mother had been her only reliable anchor in the world besides art. Now she only had art. And it was art that helped her deal with the traumatic experience. Lassnig began to express her deep sorrow in her haunting, magnificent Mourning Pictures (Beweinungsbilder). One of the paintings shows her mother from above inside a coffin with crossed arms between which a pale amphibian or embryo-like shape floats: Lassnig herself. One part of the background is deep black like death and cemetery earth; the other part is as blue as the sky. Like the hand of God, Lassnig's artist-hand protrudes down from above into the composition and paints the picture.[154] In another painting, *Mother and Daughter (Mutter und Tochter)*, her dead mother rests at the center of a white cloth, the daughter cuddling with her and grass already growing from the corpse. There is hustle and bustle all around this oasis of tranquility; an arm with a watch protrudes from under the white cloth, which is spattered with blood at this point. *Beam in the Eye / Mourning Hands (Balken im Auge / Trauernde Hände)*, in contrast, shows Lassnig apart from her dead mother. The daughter is cowering on the floor, and only the color of her deathly pale hands creates a symbiotic connection to the deceased. A wooden beam cuts through one of her eyes, perhaps a board from

Mutter und Tochter (Mother and Daughter), 1966–67

her mother's coffin. Roses grow out of the dead body in this painting and in *Mother's Grave / Dead Mother (Mutters Grab / Tote Mutter)* from 1965. In yet another Mourning Picture, there are hyacinths. The body of the dead mother transforms into fertile, flowering earth. Thirty years later, when addressed in an interview about these expressive paintings, Lassnig was amazed she had been in a condition to paint this: "The fact that I still had the distance to do that."[155] In retrospect, Lassnig recognized she had not only overcome her grief in these paintings but had also progressed artistically. She succeeded in combining realistic portraiture with the Body Awareness caused by the pain of her mother's death: "The mother really looks like my mother. And I look like me with my big nose and so on. Half of it is a body likeness and half of it is a Body Sensation. They melded together well."[156]

In the next decade, her mother appeared time and again in her art, like a kind of superego. In the monumental *Self-Portrait with Stick (Selbstporträt mit Stab)* from 1971, Lassnig sits on a chair in the foreground. Her naked torso is pierced by a staff, which she grips at the same time with her hands, like an Amazon

Selbstporträt mit Stab (Self-Portrait with Stick), 1971

Paris Encore

grasps her spear. A painting hangs behind her upon which, with a few lines, her mother's portrait is sketched. From this painting, her mother's gray-green, zombie-like hands protrude out to rest on Lassnig's shoulders, protecting and menacing at the same time. Lassnig's award-winning animation film *Selfportrait* from the same year shows a self-portrait that is constantly transforming as the artist narrates, "Then my mother died and I became her. She was so strong." At a certain point Lassnig's head breaks apart on the longitudinal axis, like a lost mold during bronze casting, and the mother comes out of it. In 2004, she noted another film idea: "Filmspot: ML sits in front of her mother's portrait and says: Haha, you're still here, almost more than when you were alive. You're alive, how beautiful and good!"[157]

As much as art helped her to overcome her deepest depression, her grief still remained. She dreamt of her mother again and again, even decades later, such as in 1989: "Dream: people dressed in mourning surround the coffin of my mother. When my heart almost bursts with pain, she wakes and pets a black cat on her chest. I woke up and sobbed to myself, Mum, Mummy, like a little girl. In this way, the dead demand their right to be remembered."[158] In 2004, when Lassnig was eighty-five years old and her mother's death was forty years past, she wrote a poem:

> Where is my mother?
> In panels
> carved from oak
> which is called German
> In the linoleum frayed
> and buckling from the slats
> this is her ghost
> The kitchen apron
> starched and crossed
> strength of character
> dark pots and the
> flour sieve and the tub
> where her dough rose
> only I know this
> and she is there
> where is she then
> if everything goes to
> waste with me
> falling into rubble?[159]

Sentimental paintings from Paris:
monsters, beasts, and science fiction

"The police doctor says I'm too thin," Lassnig wrote to the Hildebrands after returning to Paris in autumn. Her long absences regularly led to the loss of her residence permit: "I had to pay the police a lot again because I had been away too long."[160] This time she also had to present a health certificate. No matter where Lassnig had her main residence, whether in Vienna, Paris, or New York, in the summer months she always recharged in Carinthia from the hustle and bustle of the big city. She enjoyed nature and visited her friends, including Gerlinde and Rainer Bergmann. She usually dropped in on them when she cycled home from the beach at Wörthersee. The Bergmanns' children marveled at what they considered a crazy aunt, especially when she wore her avant-garde pointy bra made of wire, which she had brought fresh from Paris.[161] For a few weeks, Lassnig spent most of her time in the Bergmanns' cabin on the Turracher alpine plateau in order to withdraw completely. Gerlinde Bergmann was one of the good spirits who regularly took care of the house on Tschabuschnigg street after Lassnig's mother's death when the artist was not there. Rainer Bergmann, now a well-paid architect, supported Lassnig by buying her paintings. This is how the large group portrait of the Bergmann family came about, a triptych for which the family members modeled individually. As was so often the case, Lassnig's attitude was ambivalent even about this large group portrait. When it was shown in the autumn exhibition of the Carinthian Art Association in 1967 and subsequently depicted in several newspapers, Lassnig scribbled "for money" on a newspaper clipping to state that this was not her true art. In an interview, she said, "Painting portraits is my holiday activity. My 'real' painting is indeed very far away from reality. Portrait painting demands the painter be completely impersonal and that she depersonalize herself. But I enjoy it during vacation."[162]

Maria Lassnig in front of her triptych *Familie Architekt Bergmann* (*Family Architect Bergmann*), 1967

Lassnig's "real" paintings were her *Sentimental Paintings from Paris* (*Sentimentale Bilder aus Paris*). Anyone who expected romantic views of the city on the Seine was disappointed, although curiously enough, she spoke of a new Romanticism: "Now it is the environment, the events, in the positive as well as in the negative, which affect me more, hence the Romantic line. I am nearing the great myths, probably also because of the death of my mother the previous year." And: "My criticism of the world has resulted in more humor."[163] In the 1960s, however, hardly anyone

Selbstporträt als Tier (Self-Portrait as Animal), 1963

would have come up with the idea of describing Lassnig's images as "sentimental" because they showed violet and pink monsters with deformed heads and faces. Otto Breicha commented: "Maria Lassnig's sentimental paintings are rather uncomfortable."[164]

The beasts and monsters are much more figurative than the Line Pictures, but for Lassnig there is no conflict between the two. The lines have transformed into planes and three-dimensional forms: "In the case of the monsters, I not only combined the pressure points with lines but also filled the form with paint. There's a nose again, a mouth and so on, just no hair. The color is completely monotone. Actually, this is a throwback to the traditional, to the perception of reality, which is remembered: how a person appears, how I appear. The starting point was Body Sensations, but now memory has been added to it." The artist recognized that memories of the visible world could also be stored in Body Sensations. Sometimes the gap between the mouth and the nose disappeared because the two couldn't be separated in body perception: "That's why they look like monsters, because you do not sense how you really are."[165] The interplay between Body Sensation and memory, between inside and outside view, yields monstrosity. This combination of the visible world and Body Sensation shaped many of her future paintings. In a postcard to Heide Hildebrand, Lassnig compared her current monsters with her former Surrealist self-portraits from 1949.[166] Once again, it's clear how much Lassnig continued to be concerned with the same ideas but used new means to explore them. The monsters often have their eyes shut. Later in the 1990s, Lassnig reflected: "The closed-eye feeling, the eyelid feeling, one senses that the cheeks reach from one corner of the room to the other, that the chin is not there or reaches down to the belly, the nose is a burning opening. ... The spatial feeling of the facial parts shifts the proportions, what comes out is a monster, the monster in us. Even angels have monsters in them, we are all monsters."[167]

Often, something animalistic gets mixed into Lassnig's features; she painted herself with a glaring red head, a pig's snout, and a cigarette in the corner of her mouth in one self-portrait. Another self-portrait from 1965 is titled *L'Autrichienne*. Lassnig played with the phonetic double meaning of the title in French: literally "the Austrian" but also *l'autre chienne*, "the other she-dog." Consequently, another title for this painting is *Self-Portrait as a Dog (Hundeselbstportrait)*, and Lassnig not only gave herself a dog snout but a dog collar as well.

In Lassnig's work, not only did animal and human merge but also man and machine. She called these images Sciencefiction, a title she first used for a surrealistic painting from 1950.[168] From then on, she produced sci-fi works every decade up into the 1990s. The paintings depicted robots, cyborgs, and hybrid figures where machine parts penetrated the body or replaced body parts. In a

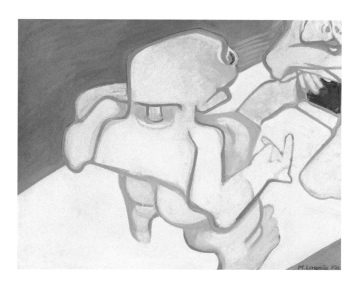

Gynäkologie
(Gynecology), 1963

letter, she once referred to these as "Martians"[169]; one of the paintings from 1963 is called *Mars Child* (*Marskind*). She was extremely skeptical of the technoid, the mechanical, and the automated, especially when it came to art: "I want to be as independent as possible from machines and complicated tools. Pencil and brush are primal-state tools. Painting is the primal state of art."[170]

How threatening machines were to Lassnig was penetratingly emphasized in *Gynecology* (*Gynäkologie*). The woman in the gynecologist's chair is pushed into the top corner. She mainly consists of a blood-red vaginal body opening, which oddly enough is square, in accordance with the overly technical view of medicine. The woman holds her hand half-protectively in front of it, but in vain. It's no coincidence that the gynecologist calls to mind a rapist; he's a muscly robot who will soon enter the woman with his cold fingers. Lassnig's superb painting captures a situation that is familiar to many women: the feeling of being at the mercy of medicine and its associated male gaze upon the female body. There were hardly any female gynecologists in the 1960s.

Lassnig soon had many opportunities to show these fascinatingly intense paintings, starting with her first solo exhibition at the Hildebrand Gallery in Klagenfurt in July 1964, where for the first time she presented her monsters in addition to her Narrative Line Pictures. Soon after, Gallery Next to St. Stephen's opened their autumn season with Lassnig. In the *Kurier* newspaper, Breicha called her "one of the finest painters in Austria."[171] In spring 1965, Lassnig exhibited her works in the Case d'Art Gallery in Saint-Germain-des-Prés. The catalog texts were written by José Pierre, Otto Breicha, and Guido Marinelli.[172] In 1966, Heide Hildebrand moved her gallery to a new location in Klagenfurt and celebrated the new start with the large exhibition *Confrontation* (*Konfrontation*).

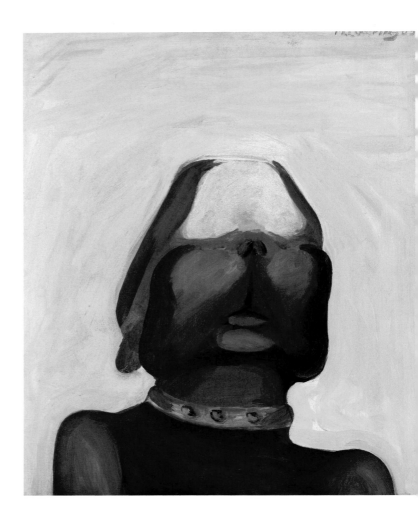

Among the more than eighty exhibited artists were not only Maria Lassnig and Hans Bischoffshausen but also international celebrities such as Lucio Fontana, Yves Klein, and Piero Manzoni. In 1966, the Würthle Gallery in Vienna showed her works under the title *Sentimental Paintings from Paris*. In the same year, Lassnig exhibited her works at the Sothmann Gallery in Amsterdam, and in 1967 she showed them at the Le Ranelagh Gallery in Paris, where José Pierre again contributed a text. It stated, among other things: "Maria Lassnig keeps a strange diary: her paintings. In them she confides her dreams, her friendships, her thoughts, and sometimes, not without a little bias, her own face. ... Her painting reveals an absolute certainty; and hers is better than most other ways of painting."[173] Even the renowned Parisian gallery Lahumière showed a drawing of hers in a graphics exhibition.

Selbstporträt ("L'Autrichienne") / Hundeselbstporträt / La femme chienne [Self-Portrait ("L'Autrichienne") / Self-Portrait as a Dog / The Dog Woman], 1965

Many positive reviews were published about Lassnig's exhibitions. She collected these and translated excerpts into German to make them available to Austrian journalists.[174] Even the influential curator and critic Gérald Gassiot-Talabot praised Lassnig's paintings in the cultural magazine *Les Annales*.[175] Kristian Sotriffer ranked her among the big names, Picasso and Miró.[176]

Both in 1967 and 1968, Lassnig exhibited in the Salon de Mai, an annual group exhibition that was founded in 1943 under German occupation as an act of resistance against National Socialism. From the 1950s onward, the Salon de Mai was the most important annual exhibition of contemporary art in Paris. A selection from the 1967 exhibition went on to Havana, Cuba, where it was presented at Salon de Mayo (but in July). Lassnig's *Mother and Daughter* (*Mutter und Tochter*) was exhibited with the title *Source and End of Problems* (*Source et fin de problèmes*) alongside the works of Picasso, Joan Miró, Alexander Calder, Asger Jorn, and Antonin Saura. Anyone who was invited to the Salon de Mai had made it into the temple of serious artists, and it's not surprising this made Lassnig very proud. She wrote to Heide Hildebrand: "You know, if you make it into this salon, you've made it!"[177] Nevertheless, she planned to leave Paris. Otto Breicha's thesis about her fleeing from success seemed to be confirmed once again. Despite the increasing recognition, she did not feel that she had received sufficient praise, as the following remarks, made on several occasions, make clear: "In Paris, Informel had developed into Tachism, in which all Moderns have indulged. But I had already begun with Body Sensations in 1951 and did not find there was much interest in it."[178] As hard as her beginnings in Paris had been, her work did not go unnoticed and Tachism did not dominate throughout the 1960s. But on another occasion, she said her works were dismissed as "German Expressionism" and "German Expressionism was only understood by the French twenty years later."[179] Then again, she was well aware that she wasn't being completely ignored. "After some time, they also knew me in Paris," she admitted, but: "Paris got too small for me. Everything was focused on a few star artists."[180] Or: "In Paris, I didn't get my break ... although I exhibited a few times. And it might have gotten even better and better, but then I just left. I *did* exhibit in the Salon de Mai, you know? And I did attract attention. But it wasn't enough to keep me there."[181] Lassnig laughed at this last remark, as if she herself knew exactly how she ticked. At the time, she was well on her way to arriving in the best circles of the Parisian art scene—high time for her to break away and start all over again.

ah, the artists, captives of their styles,
see the world with peevish eyes and
wish desperately to sit on the green twig of super-success;
spurn style, change it every week,
change your norms every week,
change your hair-color, your wig every day,
change your vocabulary,
your preconceived opinions about your neighbor and
about politics,
change them every day,
change your way of life every week, change your jobs,
and beat the changes
our time has in store for us.[1]

7 New York: Feminism, Animation, and "American" Painting

1968–80

By this time, Lassnig was forty-nine. At this age, most people are too lazy, comfortable, and anxious to jump into cold water and dare to undertake such a radical new beginning. Not Lassnig. Her inner restlessness and lack of contentment—in spite of her many accomplishments—forced her in 1968 to again break out into the unknown. As much as she dreamt of resting on her laurels, it didn't suit her, and she couldn't manage to do so. Above and beyond that, there were many good reasons for her to leave Europe. Her mother was no longer alive, and Paris was no longer the capital of art: "Of course it would have been possible to stay in Paris, but all Paris was Pop—that meant: influenced by America—so why not go straight to the source."[2] In addition, Lassnig's American friends in France had assured her that women artists had an easier time of it in the United States than in Europe, an attractive prospect after all her experiences with the old boys' clubs in Vienna and Paris. She admired American women because they seemed much more independent and self-confident to her than Parisian women. You could already tell from their voices: "In France, the women always fluted around with a pointed mouth and a very high-pitched voice, like little birds, right?" American women were completely different. When Lassnig heard a young woman on the phone, whom she would later meet in person, she was surprised: "I thought a bear was growling." She had an explanation for this: "The women there are completely different. Growing up so differently in the Wild West, they've become more independent."[3]

And Lassnig mentioned another reason for her departure. She was distraught when student riots broke out in Paris in the spring of 1968. The burning trash cans and cars in the streets scared her deeply, reminding her of the bombings at the end of the Second World War. For her, this was unnecessary outrage from spoiled bourgeois boys and girls: "I saw how the young people, these wannabe revolutionaries, let loose their fury on the poor young policemen. I pitied them. I didn't understand why they were fighting. For me, it was like this: everything's going so well for them with their silver spoons. What do they need to get upset about? That's what I thought, and went back home."[4] Politics was alien to her as always: when she was told about the much-vaunted "Hot Quarter of an Hour" in Vienna, she couldn't believe what she was hearing. She knew the participants after all, and one of them very well: Oswald Wiener.

The Actionist campaign *Art and Revolution* (*Kunst und Revolution*) on June 7, 1968, at the University of Vienna didn't emerge out of a student mass movement, as in Paris, but from a small group of artists: Oswald Wiener, Peter Weibel, Otto Muehl, and Günter Brus. The Actionist campaign consisted of lectures, inflammatory speech, and performances in front of approximately three hundred only mildly interested students and ended with public urination, defecation, and masturbation. Brus sang the Austrian national anthem and cut

himself bloody. Austria had its scandal. The tabloid press described the Actionist campaign as "Swinishness at the University," and this title has remained in the collective memory of conservative Austria to this day. Lassnig found it all rather ridiculous. However, the completely disproportionate response of established society made clear how hard it had been hit. Brus and Wiener were sentenced to six months in jail. Both fled to Berlin, where at the end of the 1970s Lassnig would again enter into an intense artistic and intellectual exchange with Wiener.

Maria Lassnig, Neue Galerie Graz, 1970

But first she went to New York. Here, in addition to painting, she took a completely new second path and started to make films. Here she discovered the women's movement for herself and actively participated in it. And here she developed her painting, which had gone relatively unnoticed on the New York scene. The work she did flew largely under the public radar and gave the artist the feeling New York had hardly inspired her painting, unlike Paris before: "In France, I was still developing. And in New York, I was already quite finished, so I didn't need any input."[5] Nevertheless, she took on American influences, especially realism, and called upon them off and on in parts of her later work.

In the 1970s, Lassnig slowly but surely became part of Austrian art history. In 1970, Wilfried Skreiner, the director of the Neue Galerie in Graz, was the first museum director outside Carinthia to have a Lassnig exhibition. On display were oil paintings, drawings, and silkscreen prints. Vienna's Museum of the Twentieth Century (in 1971) and the Neue Galerie (in 1975) showed exhibitions on the beginnings of the Informel in which Maria Lassnig, Arnulf Rainer, and Oswald Oberhuber were presented as *the* avant-garde forces who had brought Informal Art to Austria. In 1973, Innsbruck's Taxispalais presented Lassnig's films and their accompanying drawings. In 1975, the Ariadne Gallery in Vienna showed early drawings from 1948 to 1950. And in 1977, Lassnig was granted her first retrospective, not focusing on her paintings but on her graphic work in the renowned Vienna Albertina. The exhibition was also shown in Klagenfurt and Innsbruck in the same year. "Maria Lassnig was always avant-garde, was always at the forefront, but she wasn't always applauded for it," wrote Walter Koschatzky, then-director of the Albertina. "But I believed it was high time to make her achievement clear in the big picture of Austrian art, to respect it and thus to evaluate it as a historical fact."[6] That meant that in the 1970s, Lassnig had finally started to arrive in the Austrian art canon. In the United States, she had not yet made her breakthrough as a painter, and, despite several exhibitions, she was

almost exclusively perceived as a filmmaker. Nonetheless, her New York years, together with her time in Paris, formed the basis for her later international career.

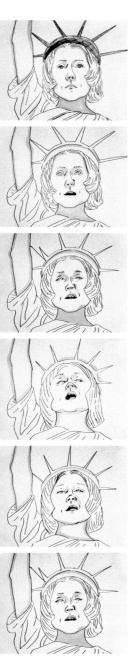

Sequence of frames from the animated film *Selfportrait*, 1971

The Lady Liberty of Austria

Arriving in classic fashion, Lassnig passed the Statue of Liberty by ship. Soon Lassnig would impersonate this icon of the United States herself, as Lady Liberty in one of her marvelous animation films, a self-ironic picture of her yearnings narrated by her in laconically spoken Austrian English, where she reminds the viewer that Austria was not yet ready for her: "I wanted to be the Liberty of Austria, but there I got a bad cold. Atchoo! It was too early."[7]

Contrary to her fears, she had a pleasant and unexpectedly beautiful experience on the weeklong transatlantic ship passage on the *Amsterdam*: "almost magical because all the people looked like millionaires (but they were just well-dressed cheapskates)."[8] Then, the thrilling entrance into the harbor: "I stood at the railing, looked down and held a big sign with *Maria* on it in my hands, so that my friends, who were supposed to pick me up, would know that I was there. Everyone saw that and began to sing: 'Maria, Maria! I have just met a girl named Maria!'"[9] the hit from *West Side Story*—what an entrance. According to a second version, which Lassnig also told, it was not her holding the sign but rather acquaintances who were waiting for her at the pier in New York: Helen Morris and Luise Menzer, two aunts of Rainer Bergmann's wife Gerlinde, who had already been living for a while in the US.

They were the first port of call for the Austrian, a first anchor in the big foreign city. She stayed with them for a few weeks at a small, pretty family home in Ridgefield, New Jersey. However, her extreme sensitivity to heat and odor weighed upon her: "As if I were dumped in a hot steam boiler that stinks of gasoline like a gas chamber," Lassnig wrote in her first letter from New York to the Hildebrands, "That's why I was always nauseous. You both know how I can't take the smell of exhaust fumes." Not only the traffic smog bothered her but also a nearby factory's air pollution, which the wind blew over the hill during certain weather. Lassnig's general first impression of New York was "unexpectedly terrible": "This is where comfort [*Gemütlichkeit*] really ends." She still believed she had liver disease: "Do not know if I can stay here, whether my liver will last." And: "I actually wanted to go back the second day."[10]

But the charms of the metropolis didn't escape Lassnig. She was thrilled about both Manhattan and its skyscrapers: "worth seeing inside and out." She sent the Hildebrands a picture postcard of Rockefeller Cen-

ter with the huge Christmas tree in front of it, the epitome of romantic, festive New York. She experienced her first New York winter, where due to the snow masses and ice storms, everything stopped for a few days, from public transport to the schools: "A great commotion, but it looked *so* pretty."[11] As much as she liked Manhattan, she was hardly able to find an address there with affordable rent—under 100 dollars. She ended up in Queens, Richmond Hill, not far from Kennedy Airport. The airport soon turned out to be a new source of nuisance for the highly sensitive Lassnig. This time it was not the stench but the noise. She felt "it's a little like living in Annabichl," the Klagenfurt neighborhood near the airport back home. In 1968, the air traffic of Carinthia's provincial capital could hardly have rivaled that at Kennedy Airport. But unlike Annabichl, she wrote, from here it is not far to the ocean to look back across to Europe. She needed about three-quarters of an hour on the subway to reach Manhattan, where she encountered African Americans for the first time: "In Brooklyn, only blacks enter the subway. I like to see them, but they are rather indifferent to whites, because now *Black is beautiful* is the new motto, the more black, the more beautiful, which is almost true."[12]

Like so many continental Europeans, she had to adjust to some practical matters that were different in the US, such as windows that you push up rather than open to the side. Because she was afraid one of these could someday fall on her head, she called it a guillotine window. Something as simple as cleaning the windows was a great challenge. "When I arrived in New York, I had the feeling I was on the moon because everything was different, you know?" Lassnig reported with laughter decades later. "I've bent up all the keys because you do not

Subway, 1977–87, Edition Hundertmark

unlock to the left, but to the right, lots of stuff like that!"[13] And almost every European in New York knew the overheated rooms: "I'm always dressed like it's summer at home, and nearly suffocate at night,"[14] she wrote at the end of November 1968, because the windows would stick and not open.

Much was fabulous otherwise, such as her unusually spacious and luxurious bathroom. Now she didn't have to visit friends to enjoy a full bath, like she did in Paris at the Bischoffshausens. For the first few weeks, she enthusiastically drew herself a bath three times a day. And for the first time in her life, she owned a refrigerator. However, she didn't tell this to her American friends: "Otherwise, they'd think Austria is the most uncivilized boondocks, and no American would

come to Austria."[15] And what a refrigerator it was, not a small one like what was common in Europe but the classic man-sized American model: "In the summer I can live inside it."[16] Lassnig not only used it for food but also for clay, out of which she made sculptures. In New York, she started experimenting with sculpture again, a genre she rarely talked about, and which for a long time the public didn't even know she worked in. She made her first clay sculpture, a woman's head, around 1945 in Klagenfurt.[17] Gerda Fassel, an Austrian sculptor, once said to Lassnig that her drawings were practically screaming to become sculptures. In Paris 1966-67,[18] Lassnig painted *Proposal for a Sculpture* (*Vorschlag für eine Plastik*), a painting that, decades later, thrilled the Austrian artist Eva Schlegel precisely because of its indecision between the genres: "And that's the great thing about the picture: it's painted, it's about painting. The figures are drawn, drawn with a brush, in red. And it's about the proposal for a sculpture, for a three-dimensional element. It's also very ironic: there's one of those cartoon figures that looks like it is sitting in front of a grilled chicken."[19] Lassnig not only painted sculptures but also produced them out of clay, bronze, and aluminum off and on throughout her life, including fascinating figures like the *Sex Goddess* (*Sexgöttin*) of 1979 and *Creature* (*Kreatur*) in 1981–82. However, she was not really convinced this genre suited her; she thought her hands were too tender for it.[20]

In addition to the fridge, a television was one of the great modern comforts in New York, and it was also the first one Lassnig ever owned. She was overwhelmed by how many American channels there were, spent days in front of the tube, and watched seven movies in a row until she got "red eyes like a rabbit." She had loved films in Paris, too, but there she went to the movies. Now,

she enjoyed not having to be among people. She tried to reduce her quota to three films a day. Time and again, however, she spoke of her television excesses: "I often stay up watching TV until midnight, and then I'm too tired to work."[21]

Sexgöttin (Sex Goddess), 1979

In *The Ballad of Maria Lassnig* from 1992, her short autobiographical film, she ironically addressed her television addiction by letting the TV appear as a substitute for a love partner. One of her favorite series in New York was ABC's *The Odd Couple*, produced between 1970 and 1975 with Tony Randall and Jack Klugman in the main roles. The protagonists of the sitcom were two friends who were opposites and, for financial reasons, shared an apartment in Manhattan: Oscar, a divorced sports reporter, was a poorly dressed slob. Felix, a photographer, was a hypochondriac and neat freak. Regular conflicts with a lot of humorous potential—even with canned laughter— were inevitable.[22] Lassnig could easily identify with both Oscar's casual dress style and Felix's hypersensitivity.

Her hypersensitivity didn't remain hidden for long from her new American friends. Over and over again, she heard she was a *sissy*. She learned that in English this didn't refer to the former Austrian Empress Sissi but rather to a sniveling whiner: "You're a sissy. They played some song, and that was when I got homesick and started to cry."[23] In retrospect, Lassnig said she got into the habit of being a little bit less sensitive in New York: "For those with an introverted nature 'transplanting' is always good, and it was good for the all too sensitive plant that is me."[24]

To make her first contacts in New York, Lassnig reached out to Austrian friends who were already living there. They readily supported her: "Everyone knows how difficult it is for a beginner in NY. They smile knowingly and do help with their advice."[25] Among others, she met the then-thirty-four-year-old architect Hans Hollein, who gave her courage and assured her that he, too, had found it difficult at first to find his way. Particularly important for Lassnig was Kiki Kogelnik, also a Carinthian artist, whom she had met in the 1950s in the St. Stephen's Gallery scene. After Kogelnik fell in love with the American Expressionist Sam Francis in Paris, they moved to New York together. Later, she married radiologist George Schwarz, with whom she spent several months in London in 1966. At that time, she also visited Lassnig in Paris. Lassnig wrote: "That was very nice. She admired my most recent paintings and invited me to London."[26] Nothing came of it then, but in New York, Lassnig contacted her again. Kogelnik invited Lassnig to her New York parties, introduced her to people, and supported her as best she could. Lassnig noted: "I see Kiki frequently. She's very nice, and her husband is *really* friendly too."[27] He was a doctor and was always ready to

examine the uninsured artist for free. She didn't, however, let him talk her out of her self-diagnosed liver problems: "George, Kiki's husband, doesn't think I have a damaged liver, but *I* know it, which means drinking's over for a long time now."[28]

Marriage insured that Kogelnik had a large social circle and no financial worries. In New York, she had begun to say goodbye to gestural painting, which she had practiced during her St. Stephen's Gallery time, and drew closer to Pop Art. Now, she asked her friends to lie down on the floor, and she produced bright-colored vinyl foil cut-outs and hangings of their outlines, which she placed over hangers and presented on garment rails. In the art scene, she was considered The Love Goddess, and Pop Art stars such as Andy Warhol and Roy Lichtenstein attended her parties.

Lassnig's relationship with this much younger artist was ambivalent. In Vienna, she had been convinced that the supposedly prettier Kogelnik had it a lot easier than her in the St. Stephen's Gallery. When Kogelnik told her in Paris that the New York art world was a hard patch, Lassnig responded with surprise. "She doesn't seem to have an easy time with the New York galleries," she wrote to the Hildebrands, "despite her sex appeal" and "although she does exactly what's fashionable." She added: "She does it very well, too."[29] Now Lassnig herself was in New York and was very grateful to Kogelnik for her help and contacts, but

Fernsehkind (TV Child), 1987

competition was still in the room. She said to friends: "I do paint better than Kiki Kogelnik, don't you think?"[30] Kogelnik regularly visited Lassnig in her studio. When Lassnig was working arduously on various still lifes, Kogelnik made a harmless remark about an apple that seemed superfluous to her. Lassnig was so annoyed that she told the Hildebrands about it.[31] On one occasion, she initially didn't find a summer tenant for her New York studio, although she was already very homesick for Austria. She dreaded the sweltering heat of the New York summer, but then she remembered that a Kiki Kogelnik exhibition was planned in Vienna, saying, "This year's probably going to be a Kiki hype in Vienna. It's better if I stay here anyway."[32]

Rainer Bergmann shared an anecdote from the 1980s when Lassnig had her Carinthian studio in Feistritz. An unknown lady and her daughter stopped in a car in front of her house and got out while Lassnig was lying on a deck chair in her garden. The lady said to her daughter: "Look, this is the studio of the famous artist Kiki Kogelnik." Lassnig allegedly jumped up in outrage and shouted loudly, "Maria Lassnig, would you please!"[33] In general, she had difficulties with other female artists and was liable to act even more competitively toward them than toward her male colleagues. A major exception to this was her time with the Women/Artist/Filmmakers, an interest group she had founded with nine other women experimental filmmakers in New York in 1974.

As difficult as it was for Lassnig to settle in during the first few months, she eventually felt fully at home in New York. As early as January 1969, she wrote to the Hildebrands: "Isn't it a good sign that I don't write? Too much to do."[34] In retrospect, she saw it this way: "I acclimated myself after a few months, and then New York was *the* life for me, really! The freedom and looseness above all. It was no longer a pain to be here."[35] Once, she even talked about the healing effect New York had on her. In her first spring, she enjoyed Central Park, watched the hippies picnicking, and found the city wonderful.

Lassnig had learned French in school but hardly any English. In the long Carinthian summer before her departure to New York, she borrowed entire years of *Time* and *Life* from the Bergmanns, her Klagenfurt friends, and worked her way through the magazines with a dictionary, slowly expanding her vocabulary.[36] Even if she didn't speak English that well at first, it didn't matter so much in cosmopolitan New York, which was totally different from Paris, where a slight accent was enough for you to never count as an insider. "New York was somehow easier because of the language. Although I didn't speak English very well," Lassnig laughingly admitted, "but nobody there speaks very good English, as everybody is a foreigner."[37]

Lassnig's Body Awareness and the New York art scene

Lassnig's apartment in Queens was painted "bleak pink": "*Exactly* like my pink paintings, but they still stand out from the wall."[38] She continued where she had left off in Paris: her monsters, her deformed self-portraits, her Body Sensation paintings. She coined the term Body Awareness, especially to get away from the term "feeling," which was too often misinterpreted as something emotional, sentimental, and typically feminine. Sometimes she even wrote this term retrospectively on old paintings and drawings from the 1940s to make it clear that it was already about that for her then.

When she was not painting, bathing, or watching TV, she made the long trip to Manhattan, full of curiosity to explore the New York art world: "The galleries are much more numerous and better. But so far I have not found *one* that is on my wavelength."[39] Of course, that was her goal: to find a gallery that suited her and was ready to exhibit her paintings. She increasingly lost the desire to participate in the group exhibitions on Austrian painting that were currently being planned for Great Britain, the Netherlands, and other European countries: "I'd prefer not to take part in general household exhibitions anymore because it doesn't matter whether you're there or not," she wrote resignedly to Heide Hildebrand. "Nobody pays attention to these Austrian concoctions anyway."[40] Lassnig didn't want to be perceived as an Austrian artist (which for her was a synonym for provincial and peripheral) but as an internationally important painter. Still, she would have to wait a long time for that.

Selfportrait in NYC, 1969

To get closer to this goal, she introduced herself to New York's galleries, even though she still loathed promoting her own work. Therefore, she often only sent color slides to the galleries. Which—and how many—art dealers Lassnig showed her paintings to is unknown. One of her favorite galleries was the Allan Stone Gallery on 86th Street on the Upper East Side, which was founded in 1960 and had a diverse portfolio, from Abstract Expressionists to French Nouveaux Réalistes to Pop Artists. The owner, Allan Stone, also promoted less-classifiable artists, such as Joseph Cornell, who created small curio-cabinet boxes containing his memorabilia, and Robert Arneson, a Californian ceramic artist. Stone was also an obsessive collector himself, not only of contemporary American and non-European art but also of Bugatti au-

tomobiles, of which he was said to have owned about thirty. Inspired by Orson Welles's most famous movie character, the charismatic media man and real devil of a fellow in *Citizen Kane,* they called him Citizen Stone. Rosalind Schneider, a filmmaker and later a friend of Lassnig, remembered what an "incredible macho" Stone was. When she showed her work to him, he supposedly said, "This is good work, but why aren't you at home taking care of your children?"[41] If Lassnig had introduced herself to Stone, it wouldn't have been surprising if he had rejected her work. Another gallery owner whom Lassnig mentioned as interesting and to whom she may have presented her paintings was Allan Frumkin on 57th Street. He sold classics such as Munch, Miró, and Beckmann but also exhibited current figurative painting by Leon Golub, Jack Beal, Joan Brown, and Joan Semmel.

It didn't matter to whom Lassnig presented herself, she didn't initially find a gallery ready to represent her. Later, she would repeatedly describe her failure. The Americans couldn't get into her Body Awareness and described her paintings as *weird* and *strange*, as uncanny, bizarre, and morbid; in short, they were not positive enough. Because Lassnig encountered such a lack of understanding for her work, she tried to explain what she meant with it. She explained the difference from realistic representation in which, for example, she painted an arm as seen from the outside. With Body Awareness, she could depict it "as a wire, string, sausage or not at all," depending on how she perceived it at that moment, as in her *Self-Portrait with Wire Arms* (*Selbstporträt mit Drahtarmen*) from 1968. When she sat on her couch and rested on one arm, she first felt her shoulder blade and the palm of her hand. "I feel the pressure points of my buttocks on the couch, my stomach, because it is full like a sack. My head is sunken in the cardboard of my shoulder blades, my brain-case is open at the back,"[42] she wrote in 1970. She often closed her eyes and ears so as not to be disturbed by external perceptions while painting.

As in Paris, however, she also let herself be inspired by experiences, events, and encounters in her surroundings. The United States at the end of the 1960s was not only the land of the Civil Rights Movement, the Nixon Era, and the Vietnam War but also the Apollo space missions. On July 20, 1969, Neil Armstrong uttered his legendary phrase: "That's one small step for man, one giant leap for mankind," reason enough for Lassnig to paint a *Self-Portrait as Astronaut* (*Selbstporträt als Astronautin*), an even bigger step for *womankind*, so to speak. The little illusionistic gag at the top right—where the painting appears to come off the canvas like wallpaper that is peeling—seems like an ironic commentary. The self-portrait combines realistic elements, such as the view from

Maria Lassnig in front of her *Selbstporträt als Astronautin* (*Self-Portrait as Astronaut*) from 1968/69, Galerie nächst St. Stephan, 1970 (photo: Barbara Pflaum)

above of her arms and legs, with inner perceptions of the face, back of the head, and back, a way of working that she had used in Paris, especially in some Lamentation Paintings, which she perfected in New York after the death of her mother.

For example, in the *Pentecost Self-Portrait* (*Pfingstselbstporträt*), which also shows a view from above, her realistically painted left hand with a wristwatch rests on a wavy linen cloth or blank canvas. The white fabric of her shirt merges directly into the canvas or sheet without any delineation of boundary. At the bottom of the painting, to the right, you can see a foot and a bent leg. Propped up on her hands, the painter squats on the floor. Almost everything else that can be seen in this painting eludes an outside view. As with her Parisian monsters, there is also a sculptural, deformed shape in pink-violet, suggesting the buttocks, back, upper arms, and the lower part of the face with nose and mouth. The buttocks and back are depicted from behind and the face from the front. The body is therefore to be seen from all possible views and modes of representation at the same time: from the front, from behind, from the side, from above, from the inside, from the outside, realistically and abstractly. Creating such a painting was a complex process, as the artist still underscored as a ninety-year-old. A Body Sensation is not fixed but changes from one second to the next: "This is a very complicated thing that you can't explain in five minutes!"[43]

Perhaps it is not surprising that many—even in the United States of the 1970s—were struggling to appreciate the innovative, unusual, and avant-garde in

Maria Lassnig's Body Awareness paintings. They didn't match any of the trends that were currently in vogue in American contemporary painting. Apart from this, painting was rather out at the time. Otto Breicha once praised Lassnig as an "old-fashioned painter" who "affords herself the superfluous luxury of brush painting and emotional life" and doesn't care about affiliating with a trend.[44] The fashions of the time were minimal art, conceptual art, land art, performance, and even video.

Land Art, which was cutting edge then, didn't turn Lassnig on. At the end of the 1960s, a number of artists began to use previously uncustomary materials such as earth and stone in their art. The Land Artists left their studios and galleries and museum rooms to transform and conquer the landscapes in the vast expanses of the American West, just like the pioneers did, only with artistic means. In 1970 in Utah's Great Salt Lake, Robert Smithson built his famous *Spiral Jetty*, which mainly gains effect in aerial photographs and is one of Land Art's best-known works to date. Lassnig was unimpressed and described the Land Artists as "dirt pilers" and their art as "so temporary." When Heide Hildebrand expressed her fear that galleries were now superfluous and they could close down, Lassnig replied that she shouldn't worry: "No gallery in New York is calling it quits because of this."[45]

All in all, the current tendencies posed a challenge for an artist whose main interest was painting. If you painted in the US in the 1960s, then it was Pop Art that succeeded, a trend that Lassnig didn't shy away from. In Paris, she had followed this direction with great curiosity. Next, she learned the technique that became the epitome of Pop Art, especially through Andy Warhol and his famous Campbell's soup cans and Marilyn Monroe portraits: silk-screening. Three times a week, she attended an evening class at the Pratt Graphics Center in Brooklyn, and soon she set up a small silk-screening workshop at home. However, she did not like the technical effort it required: "I now know why I always hated printmaking; it takes so much time and effort. In the same amount of time, I can make dozens of new and original hand drawings." The vapors of the silkscreen inks were hard for her to take: "My liver's having a relapse because of the toxic acetone I inhale. Victim of the profession."[46] Despite these complaints, she produced a whole series of large-format screen prints, which were characterized by bright colors and associations to Pop Art. Her subjects differed significantly from this, however: while Pop Art put on canvas unmistakably identifiable subjects gleaned from the consumer world, comics, mass media, and billboards, Lassnig let her body merge with objects, like a razor, an anchor, or a chair, into an anything-but-realistic figure. In an early example, she combined the city map of Queens with a self-portrait, which could also be a portrait of her dead mother with arms crossed in a coffin. Soon Lassnig would exhibit a series of silkscreen

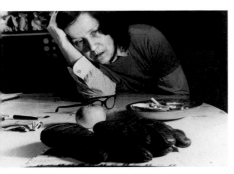

prints together with oil paintings and drawings in the Neue Galerie in Graz, Gallery Next to St. Stephen's in Vienna, Hildebrand Gallery in Klagenfurt, and the Austrian Institute in New York.[47] She wrote Otto Mauer that the transport costs from Graz to Vienna were too high for her. Still, he begged Lassnig not to cancel the exhibition: "The gallery can afford the transport costs. So please *don't* drop out!" Mauer, whom Lassnig often felt showed little regard for her, now seemed to appreciate her a lot. The art show was a great success. Lassnig couldn't believe it: "The exhibition was very much admired, which surprised me."[48]

So while she could get something out of Pop Art, she didn't think much of the latest development, cutting-edge photorealism. In 1970 at the Whitney Museum of American Art, she saw the critically acclaimed *22 Realists* exhibition, which also presented numerous hyperrealistic works characterized by virtuoso attention to detail and illusionism, such as the mirror-like shop windows of a candy store by Richard Estes, the large-format portraits of Chuck Close, Paul Staiger's colorful American trucks, and Richard McLean's horse

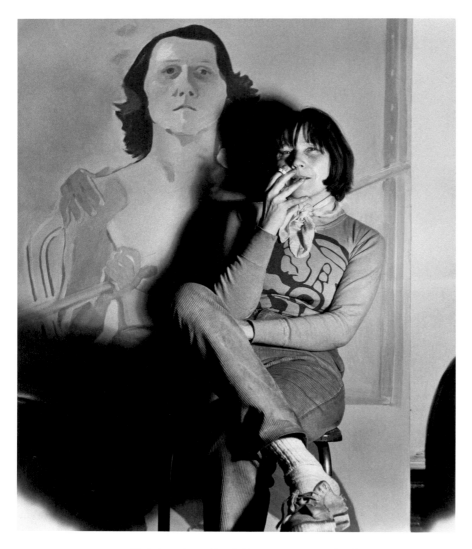

Maria Lassnig and her *Self-Portrait with Stick* (1971),
Avenue B, East Village, 1974

paintings.[49] Lassnig's judgment was devastating. She said this exhibition would
have really pleased Hitler and Stalin. And: "Not me, because I feel sorry for their
brushes."[50] Even if one does not share her judgment and does not want to com-
pare the idealizing realism of Nazi aesthetics or Socialist Realism with 1970s
Photorealism, it is understandable why the artist couldn't get into it. To this day
it is controversial whether this relatively short-lived but still popular art move-
ment should be interpreted as a reactionary longing for nostalgic images of the
"American way of life" or rather as a critical look at it. This was not the point

for Lassnig; rather, she criticized the approach to painting. She always rejected working with photographic templates. It was only in her later work that she used photographs as the basis for her work in two cycles, the Adam and Eve series, as well as the Basement Paintings (Kellerbilder). This also fundamentally distinguished her from British painter Francis Bacon, with whom she liked to be compared and whom she also greatly admired. Working with photographs was a method of alienation for Bacon, who did not aim for any realistic results. The Photorealists were quite different: in order to achieve the desired hyperrealistic effect, they usually combined several photographic images from different perspectives into a single image. In addition, they used mechanical means, such as grids or slide projections, to transfer their subject to the canvas—an approach that diametrically opposed Lassnig's interest in painting.

Painting was not something external for her that could be conveyed by machines. In 1978–79, she noted in her journal: "Through photography, the art of seeing is forgotten. One should experimentally determine who knows more after a journey; the one who ventured forth with a camera or the one with a sketchbook."[51] And in 1985: "What an impoverishment, if art is only 'media' art. Lens documentation, lens duplication, lens distortion, lens coloring."[52] And in 1996: "What's there in photography for me? This HUNDREDTH-of-a SECOND pleasure. I want to look at people for a long time, look impertinently into their eyes. The longer I look, the more I see what is looking out at me: luck and misfortune are captured there, dignity, timidity, hope. I can follow all these with my eye lens and guess everything with the touch of my pencil or brush. In a hundredth of a second that would neither be obvious to me, nor to the camera lens."[53] And in 2004, she complained, "What's wrong with art? There are two unequal sisters: painting and photography. Each has enough assets and merits to be shown on its own, but no, they have to exploit each other and mingle, so that either one or the other remains powerless, or they kill each other."[54] She felt art that serves photography is cheating. Sometimes she could get really angry about this topic:

Photo-copying—
Photo-croaking—
Photo-cunts—
Photo-smirks—
Photo-incineration—
Photo-users—
Self-defilers—
Photorealists—
Flash-fetishists—
Reality-shysters—[55]

Throughout her life she also addressed the threatening nature of cameras in her works. The drawing *Camera Cannibale* from 1998 makes the dangerous potential of the medium clear in the title: a self-portrait in which the camera sits like a gas mask on her face. Machine and head merge into a monstrous cyborg: the nose blends into the lens. The lens has become the mouth opening, from which crooked teeth peek out. In *Photography versus Painting* (*Fotografie gegen Malerei*) from 2005, photography is a monstrous cyclops that threatens and humiliates painting, which kneels before it but still holds up a standard against it: a brawny jaw baring its healthy teeth and sticking out its red tongue. Lassnig, nevertheless, liked to take pictures of herself as a lover in despair, staging herself behind a still life of leather gloves, a (farewell?) letter, and a full ashtray, or as a vamp in a velvet coat with faux fur. Lassnig soon took a camera in her hands to shoot her own animated films.

Finally a loft!

Lassnig was still searching for an art studio in Manhattan. She saw Queens as a temporary solution, a tedious, but also exciting undertaking, as she got to see a lot of different studios during her search. Above all, the large image formats of the artists impressed her and she said slightly smugly: "I see a lot of American painting that's average, which on average is really 'great,' great at least in the sense of size because the lofts are often as big as train stations." For the time being, however, she couldn't afford them: "You have to pay so much that it took my breath away. So, I gave up and will stay in my cheap luxury apartment away from the center of the world."[56]

But finally, it worked. In the fall of 1969, about a year after she arrived in New York, she moved to Manhattan's East Village, on Avenue B 95, around the corner from Tompkins Square. The rent cost 165 dollars, a pretty penny for a poor artist, even though it was hardly a good neighborhood. Gerlinde Bergmann's aunts, with whom Lassnig had stayed when she arrived from Europe, were appalled. They wouldn't set foot in this neighborhood, let alone live there. The East Village was considered a slum and dangerous in the early 1970s. While today almost all of Manhattan is one of the most expensive patches in the world, things looked different in the 1970s. The metropolis had experienced an economic and social downturn after the 1960s. Traditional New York industries, especially textile mills, were in decline. They relocated to New Jersey or even abroad. The Port of New York also became less important as it was too small for the needs of the new containerships. Unemployment rose rapidly, and traditional working-class neighborhoods such as the East Village and the Lower East Side disintegrated into no-go areas where crime and drug use were rampant.

There was hardly any investment in the city infrastructure, civil servant and teacher positions were cut back for cost reasons, and whole blocks were abandoned by their tenants and fell into disrepair. The garbage collection worked only sporadically, the trash rotted in the streets, and rats were omnipresent. The subway was considered dangerous; trains often got stuck due to poor maintenance; Times Square became a red-light district. Many white middle-class New Yorkers moved to the suburbs. In 1975, the city was bankrupt and its mayor had to apply for federal assistance, which Republican President Gerald Ford initially didn't grant. This headline became famous: "Ford to City: Drop Dead"—a populist slogan to impress small-town America, since New York was a thorn in their side anyway. In the late 1970s, the metropolis had about one million fewer inhabitants than in the 1950s and was considered a dying city.

And yet for creative types, 1970s New York was extremely attractive. This was the fertile ground on which the counterculture flourished: from feminism to the gay movement, from a lively punk scene to hip-hop, from off-off Broadway theater to a gallery scene concerned with more than commercialism. Housing was—unlike today—relatively affordable. Lassnig also liked her new address: "East Village = slum. But I feel good in the *Schlamm* [the German word for sludge]. The philistines are terrified of setting foot in it."[57] Her neighborhood was a colorful and lively area, inhabited mainly by Blacks and Puerto Ricans, and "mixed like raisins in between, the intellectuals, the hippies, and artists." The hippies she described as "long-haired fantastically dressed beings (mostly Native-American Indian style with headbands and leather fringes)." She liked them, but she also viewed them ironically and clear-sightedly. All hippies denied being hippies, she thought: "They don't work but live off of charity or rich parents. When necessary, they take on casual work. Most of them have a dark view of America's future and are of course very revolutionary."[58] A later friend and colleague, the experimental filmmaker Martha Edelheit, remembered: "Maria loved the lively streets, full of people, by day and by night. She didn't realize they were junkies. She overlooked the needles and condoms that had been discarded, the piss and the shit and the vomit, or the unconscious bodies on her landing and in the hallways."[59]

As in Paris, Lassnig wrote lively reports for Austrian daily newspapers in order to earn a little money. Proudly, she proclaimed: "I have a loft in Manhattan" and explained to the then-uninformed Austrians what that meant: "Not everyone in Europe knows what this is. Lofts are much sought after and hard-to-find abandoned warehouses that consist of one floor without dividing walls and are usually made habitable by the artists themselves and furnished with a shower and a sink."[60] Her article was well received in Austria; Heide Hildebrand made sure it got disseminated. However, Lassnig was very annoyed about

the "dreadful adulteration" of her writing by a clueless, provincial copyeditor, who changed East Village to the much nobler Greenwich Village, even in the title. When Lassnig referred to her American vocabulary as being somewhat "abstract," the editor reworded it as "meager," to Lassnig's great indignation.

Lassnig took over her loft from an architect with "good taste." The elongated room had a wide window-front on the street side, good lighting conditions for painting. Her furniture was minimalist and Spartan. What Lassnig called her "Chinese bedroom" had been designed by the architect: the bed was located in the middle, raised on a pedestal, and only separated from the rest of the huge room by rush mats. However, she rarely slept there; it was not closed off enough. Most of her furniture came from the street, as every Wednesday New Yorkers put their old furniture in front of their houses for the taking. She also found her record player that way and bought records for a few cents at the flea market. Her table consisted of a huge cable roll, for which she made "pink-checkered lunchmats," because at her new address she led a more sociable life than the one she had led in remote Queens.

Maria Lassnig in her Avenue B studio, ca. 1969

Among the people she invited were many Austrian New Yorkers, such as Kiki Kogelnik or the architect Raimund Abraham, who had been living in the US since 1964 and decades later, in 2002, designed the new Austrian Cultural Forum on 52nd Street. Another Austrian who was well established in New York at that time and whom she already knew from Vienna in the 1950s was the filmmaker Peter Kubelka. He worked in the UN Film Library and was a board member of the New York Film-Makers' Coop. In Vienna, his radically experimental films came up against great resistance, but he succeeded in New York's much larger avant-garde scene. In 1970, he co-founded the Anthology Film Archives, where he first put into practice his concept of Invisible Cinema. Lassnig knew his work, but it just didn't do it for her. When Kubelka presented his film *Arnulf Rainer* in Vienna in 1960, which consisted exclusively of light and dark single frames, noise and silence, and had no recognizable relation to Arnulf Rainer, Lassnig said, "That's not how it works." Kubelka: "Yeah, she'd already said that about *Schwechater*."[61] Even then she had reacted in a disturbed and indignant manner. Both films belonged to Kubelka's so-called metric films, avant-garde works in which he celebrated the individual still frame. The rapid sequence of exposed and unexposed single frames created rhythm and movement.

Then again, Kubelka didn't think much of Lassnig's feminist animated movies because he considered them far too conservative in their film language. Moreover, he was of the then-widespread belief that a good female artist didn't need feminism in order to make it.[62] Kubelka advised her not to get caught up in the feminist scene and politics and thereby neglect her actual art: painting; a piece of advice that gnawed at her but which she didn't follow. Nevertheless, the two appreciated each other and Kubelka visited Lassnig several times in her studio. Once, he brought sausages from his favorite Polish butcher. Other guests were also in attendance, including Maria Frankfurter, Arnulf Rainer's ex-wife, who was now married to Frank de Groote, a Belgian working for the United Nations. One of those convivial evenings in which Kubelka, Abraham, and the de Groote couple were present was described by Lassnig as a "hit": "They ate sauerkraut and Polish sausages and laughed and shouted until the walls started to bend, and holes were made in the floor and my purse, too."[63]

Kubelka also regularly updated her on the Viennese scene and told her about the latest activities of her former lovers such as Michael Guttenbrunner and Oswald Wiener. Last but not least, Lassnig repeatedly inquired about Rainer.

As early as 1968, he had been granted his first retrospective at the Museum of the Twentieth Century in Vienna. Lassnig had to wait another seventeen years for this. In a postcard to the Hildebrands, she wanted to know: "Was the Rainer exhibition any good?"[64] She still suffered from his successes, felt she was getting the short end of the stick, that her own achievements were going unrecognized. Once Rainer even visited her in New York. He remembered: "She was very nice and very friendly and very hospitable; we actually got along very well in conversation. Unfortunately, I stayed longer until it got dark. And then I wanted to ask for a taxi, and she said, at this hour no taxi will drive to this address." Nevertheless, Rainer didn't have to spend the night at Lassnig's studio: "She escorted me to the subway. It was a cakewalk for her. I wouldn't have dared to go on my own."[65] Lassnig derisively commented in a letter to Ernst Hildebrand: "Rainer-boy came here but was scared stiff and couldn't stop wetting his pants!"[66] Time and again, Lassnig had visitors from Austria. Writers like Peter Handke and Alfred Kolleritsch dropped by, as well as Barbara Frischmuth.

Lassnig soon became friends with her upstairs neighbors: Annelyn, a German from Stuttgart who worked for a magazine, and Paul, who worked for Pan Am. Lassnig called them "a hobby-painter family" because each day the man rode "with a top hat on his bike to the office." And on Sundays it was open house with artists, actors, dancers, writers, acquaintances, and friends of all kinds drop-

Maria Lassnig in the East Village, ca. 1969

ping in and painting together; they even arranged to have a model. Lassnig was invited to all these get-togethers. She liked her neighbors, and they often helped her out: "The man is as handsome as a Botticelli, and the woman gave me the order to kiss him for attaching the feet to my sofa, the sofa the previous renters had picked up off the street."

He also fastened a safety chain on the metal door to Lassnig's loft because the risk of burglary in the area was high. It was common when you went out, to leave the light and the radio on to deter potential burglars: "Every second night there is a burglar alarm. Footsteps in the hall or on the roof, me with a club behind the door. In the end, I'm so exhausted that I don't care. It's better to get knocked off than to not sleep. Everyone has a watch dog here, the park (Tompkins Square) belongs to the dogs and is full of dog shit, but is also a hippie hangout, the hippies sit around and watch their dogs copulate. I really love the hippies. A hippie family lives below me. There is always something going on down there, especially at night, and you hear everything." Lassnig's loft was burglarized twice. The first time, the only thing the burglars found worth stealing was her TV, "the biggest television in the world."[67] The second time, however, they stole Lassnig's movie camera.

She did a lot, went out, attended poetry readings, political discussions, and performances, and was thrilled with the small avant-garde theaters in the East Village. St Mark's Place was home to the famous La MaMa Experimental Theater Club, where, among others, actors and actresses such as Whoopi Goldberg, Robert De Niro, Al Pacino, Bette Midler, Harvey Keitel, and Billy Crystal had earned their spurs. Lassnig was surprised and thrilled by the quality of these off-off Broadway performances, which reminded her of the "Total Theater" of her friends from the Vienna Group. The colorfulness and variety especially fascinated the Austrian: "Musicals, then Greek tragedy, African Tribal Cult, French Letterism, and modern symbolism come together in a basket, and blow the tiny venue apart, accompanied by hot rock music."[68]

Market research, still lifes, and portraits
In New York, Lassnig suffered from a chronic lack of money again. She ate as cheaply as possible. She told the Hildebrands how she had acquired a large pack of fifty chicken hearts, "they're the cheapest," and slowly but surely ate all of them with rice.[69] When John Sailer (whom Lassnig had known since the 1950s) visited her and invited her out to a diner, he ordered hamburgers for both of them. Lassnig sat puzzled in front of her plate and asked Sailer how someone was supposed to eat something like that. Sailer was stunned: "Maria, you've surely eaten a hamburger before in New York, haven't you?" No, she couldn't afford such a thing; she only cooked oatmeal at home.[70]

Her medical care she tried in turn to limit to the summer months in Carinthia, and she paid her Klagenfurt dentist with a painting. She did everything possible to make money, like taking a typing course to supplement her livelihood by working as a typist, but this didn't suit her at all: "I'm not a machine after all. If it goes fast, I go off the rails, probably because everything automatic runs counter to me."[71] Lassnig continued to write by hand, even for the handouts she composed for her students as a professor in the 1980s.

She also temped for a market research office. "That's psychologically interesting because there we examine the opinions of Americans about shampoos and newly invented foods," Lassnig wrote in an article for an Austrian daily newspaper. "Sitting next to me are long-haired hippies; we work very hard and discuss art."[72] In addition, she unsuccessfully applied for positions as an elementary school teacher and an art lecturer at universities and colleges. With self-mockery. she reported on the various temporary jobs: "I'm a real jack-of-all-trades: on Monday, I'll paint a mural, that is a palm-tree landscape on a Puerto Rican (we always need an interpreter) photographer's wall."[73] The photographer needed wallpaper backdrops for his wedding photos and paid 150 dollars. Another time, she worked for a company that produced copies of famous oil paintings. Lassnig received a print of an Impressionist painting and was supposed to copy it. She went to great lengths, strove for perfection, and in the eyes of the company took far too long: "And then I sat crying on the toilet because they hurt me so much. I thought they would say how beautiful it is. No, it was not good enough for them; it should have simply been done quick and dirty."[74] That was the first and last copy order. "I'm piddling around and losing a lot of time."[75]

But even with her "real" paintings, she earned money from time to time. For example, in 1970 the Austrian Federal Ministry of Education and Art purchased her *Self-Portrait with Stilt-Feet* (*Selbstporträt mit Stelzfüßen*) for 25,000 schillings, while the province of Carinthia purchased two screenprints from the Hildebrand Gallery for 3,600 schillings. Works were also sold now and then to private collectors, above all in Austria. Even after Lassnig's gallery owner Heide Hildebrand separated from her husband Ernst in 1971 and ultimately gave up the business after a long period of uncertainty, Ernst Hildebrand then ran the gallery solo while continuing to work as an architect. Lassnig expressed her gratitude for various financial transfers: "Was overjoyed to receive the check and find it really great of you to be my art patron."[76]

Even in New York, Lassnig increasingly managed to sell paintings, not her Body Awareness ones but more realistic works. She rediscovered a genre with which she had already worked in the 1940s: still life. Large white tablecloths on which she arranged apples, glass jars, and household appliances dominate the paintings. She played with models from art history but also processed her every-

day experiences. In the New York supermarkets, she noticed the plastic-wrapped fruit and vegetable packs. Today, this is a matter of course for us in Austria, but at that time for the Carinthian, it was a notable and deplorable American custom. She used these keep-it-fresh packages in her still lifes. In the traditional still lifes of art history, the food and flowers arranged on tables symbolize the transience of life. In the case of shrink-wrapped fruit, this cycle of life and death seems to be suspended. The apples and peaches are just as immortal and artificial as the glass jars that Lassnig places next to them. Around the same time Lassnig made these paintings, SoHo-based American artist Janet Fish put still lifes of plastic-wrapped fruit on canvas. Coincidence, mutual influence, or a topic that was simply in the air?

Lassnig addressed this method of packaging not only in still lifes but also in self-portraits—for example, in *Self-Portrait under Plastic* (*Selbstporträt unter Plastik*) from 1972, where it is not fruit but her face that is wrapped in cellophane. Associations with isolation and loneliness are apparent, as well as shortness of breath and suffocation. Perhaps she was also ironically referring to the conserving aspect of keep-it-fresh packaging; she was over fifty after all, and, despite her youthfulness, was increasingly noticing the signs of her age. She proudly told Ernst Hildebrand that she was exhibiting this self-portrait in a small gallery. Lassnig had been a frequent visitor there, attending meetings of the women's movement and parties, such as the New Year's Eve bash in 1971: "Bring Booze."[77] The West Village Gallery, between 13th and 14th Streets, was a typical counterculture venue, self-ironically calling itself *Museum* to suggest that real museums didn't exhibit enough contemporary art. While the gallery owner wore a T-shirt with the word *Suicide* printed on it, Lassnig appeared at the New Year's Eve party with a dress that had an embryo sewn on it.

Lassnig's still-lifes enjoyed great popularity, and she managed to sell many of them. She was suspicious of this success and, above all, she hated to repeat herself. She soon wrote to Hildebrand: "I have put an end to the still lifes that I basically 'manufactured,' on an assembly line, similar to the ones you saw in Klagenfurt in the summer. If you apply even the slightest pressure in art, it is deadly! This is why I'm going back to making the *strange paintings* that the Americans don't understand."[78] In part, however, she also combined these "strange paintings"—that is, her Body Awareness works—with her still lifes; for example, in *Still Life with Self-Portrait as a Crystal Ball* (*Stillleben mit Selbstporträt als Glaskugel*) or *Still Life with Red Self-Portrait* (*Stillleben mit rotem Selbstporträt*) from 1969.

In the first case, she assimilated her self-portrait into the objects on the table and depicted herself as a UFO-like glass vessel. In the second case, she presented herself as a mixture of chair and organic being whose iron arms clamp down on the table edge. Once she even explicitly referred to the American verdict

Stillleben mit Selbstporträt als Glaskugel (Still Life with Self-Portrait as a Crystal Ball), ca. 1970–73

about her Body Awareness work and called the painting *Still-Life with Strange Self-Portrait.*

The second genre with which Lassnig earned money was, as before, portraiture. She received her first commission in New York from the couple Maria Frankfurter and Frank de Groote. Frankfurter had worked in the Gallery Next to St. Stephen's, where she met Arnulf Rainer, whom she later married. But now she was divorced from Rainer and newly married. Lassnig wrote, "She has gotten really nice because she has a fine man."[79] Lassnig once called this double portrait one of her best works.[80]

She also painted a portrait of a "great Swiss collector" and a "moody millionaire's girlfriend," an incredibly tough job in hectic New York. As Lassnig said, "The painting itself wasn't so hard. The hardest thing is to get these people to sit still. In New York everyone is tense and as fast as greased lightning, time really is money."[81] The millionaire friend mentioned above is likely to have been Inga Kelbert, a top manager in New York whom Lassnig met through Kathleen Hultgren, who worked at American Roche International. Hultgren was Lassnig's older, maternal friend with whom she went hiking. The athletic artist and outdoor enthusiast wasn't sitting in front of the television all the time, as some of her letters might suggest. She went on extensive excursions to New England—from the Hudson through the autumnal foliage to the coasts—diverse landscapes that excited Lassnig and satisfied her need for fresh air. Hultgren got her to join the Appalachian Mountain Club, which regularly arranged trips to the wider area. In addition, she commissioned Lassnig to paint a portrait of her mother: "I look at my mother's face every day and thank you. It is almost as good as a visit from her."[82]

Not only did Hultgren go hiking with Lassnig, she also looked after her studio and Lassnig's plants while the artist was in Europe. She paid bills and kept things in order. Lassnig was always worried about her loft, especially when she sublet it, which for financial reasons she made an effort to do every summer. She wrote a nervous letter to Hultgren from Klagenfurt and asked her to stop by and check up on the tenants to make sure that everything wasn't dirty and broken into tiny pieces. Hultgren answered: "I would take the time—gladly—to visit your loft. But it would be very awkward. I couldn't say 'I have come to check up on you for Maria.' They would have every reason to be very angry. You will just have to assume that all is well. If you find the loft filthy, you will just have to clean it up. And in the meantime, just hope they are keeping it in a civil fashion."[83]

Among the most impressive portraits Lassnig painted in those years—however, without commission—were the two depicting Iris Vaughan. Lassnig met the twenty-six-year-old woman at her neighbors upstairs. Although Lassnig was almost Vaughan's mother's age, Vaughan took her for much younger. Vaughan worked as a waitress, was particularly interested in classical music, and had little to do with the New York art world: a good prerequisite for an uncompetitive and cordial friendship. She saw Lassnig as a reserved, not especially gregarious person, one who preferred private two-person conversation over making herself stand out in a group: a trait that is typical of many highly sensitive people,

Selbstporträt unter Plastik (Self-Portrait under Plastic), 1972

who often have difficulties in larger groups in selecting and processing the many stimuli, noises, and chatter and therefore fatigue quickly. Vaughan was enthusiastic about Lassnig's independence. Lassnig was exactly the kind of woman who impressed her: "She was somebody who wasn't dependent upon a man to provide her identity."[84] Nevertheless, unhappy relationships with men became a persistent topic of conversation between the two women. Lassnig was already over fifty; she was getting older, but her lovers weren't. Many were just over twenty, like the young left-wing student from Boston who worked on a citrus plantation in Cuba in the summer. Before he left, he wrote her a letter, which he ended with a fiery, revolutionary "Venceremos!"—we will win![85] Other love objects were young artists from Austria or filmmakers from New York. Once Lassnig asked herself in her diary what she really wanted from these young men, "all immature youths." And: "For the 100th and 1000th time find myself in deadly heartache of unrequited love."[86] Or: "I often have heartache, pure luxury! I mustn't try to reach for a piece of reality."[87] Half a year later: "I could sing a song about the sufferings of an ascetic life, especially in New York. I was recently forced to discover that a friend I saw very often this winter is gay, which explains a lot. This is a city where at most you can find sex in the perverse way, but never love."[88] Lassnig did best when she refrained from love affairs, as she assured Ernst Hildebrand: "Dear Ernstl, I don't have private thoughts at all because I have no time for them, and that makes me quite happy."[89]

Vaughan had just gotten divorced, a good opportunity to share a glass of wine and rant about life and the world of men. Lassnig asked her friend if she would like to model for her. Vaughan came from a Catholic, restrictive family from the rural United States. Posing nude wasn't easy for her. However, she felt a great desire to dive into life right after the divorce. She accepted the challenge, and Lassnig made two great paintings. The first one showed *Girl with Wine Glass / Iris with Wine Glass (American Girl)* [*Mädchen mit Weinglas / Iris mit Weinglas (amerikanisches Mädchen)*]. Vaughan remembered Lassnig's clear instructions: hold the glass in one hand, put the other palm on your thigh, and look dreamy. At the same time, Lassnig was very attentive and didn't want Vaughan to exhaust herself. Time and again, she asked the young woman if she was cold, if she wanted to take a break, if it wasn't all too much for her. After the sessions, Vaughan got something warm to eat. Lassnig was an extraordinarily good cook, she recalled, even though Lassnig herself disagreed. Vaughan liked the second portrait of herself even better: *Iris Standing (Iris stehend)*. Here she felt she was being portrayed as a strong woman, an Amazon. She was less happy about Lassnig painting her twenty to thirty pounds heavier than she actually was, an experience shared by many of the artist's female models.

Vaughan was also present when Lassnig had her very first solo exhibition in New York in November 1970 at the Austrian Institute on 52nd Street in Midtown Manhattan, curated by John Sailer, who, a few years later in 1974, would establish the Ulysses Gallery in Vienna. Vaughan remembered the noble atmosphere of the opening, attended by numerous wealthy guests with medals on their chests or pearl necklaces. Lassnig's appearance at the vernissage must have been unusual. Vaughan recalled: "She was late getting there. We must have waited a half an hour before she came in. But when she appeared, it was almost like a vision: Her hair was in these soft curls, she had put on a little bit of make-up, and wore this lovely blue dress. Then, a friend said: 'Look at her feet!'—And she was wearing sneakers!" One had to know that Lassnig never wore dresses in everyday life: "She always looked as if she had just gotten out of bed. She was always very casual." She usually wore comfortable pants, loose shirts, and a broad, bulky wristwatch. That was more than a decade before the unisex Swatch watches conquered both male and female wrists: "In those days you never saw anybody, especially women, wearing two-inch wide wristbands with a great big watch … she was ahead of her time!"[90]

Lassnig herself was also very happy with the exhibition opening and thought it was "brilliant." She showed her "Body Awareness paintings in line and 3-dimensional figures," as the flyer of the Austrian Institute stated, including *Pentecost Self-Portrait (Pfingstselbstporträt)*. In addition, one could read: "Maria Lassnig is considered by many art critics [to be] the most important avantgarde-painter in Austria." She had to have been proud of this. Another remarkable wording in the flyer: "It is her first one-man exhibition in the USA."[91] Lassnig continued to use this wording in her short biographies for solo exhibitions. But when she showed her feminist films, she changed it to one-woman exhibitions.

Mädchen mit Weinglas / Iris mit Weinglas (amerikanisches Mädchen) [Girl with Wine Glass / Iris with Wine Glass (American Girl)], 1971

Although she enjoyed the opening, she was, as so often, extremely nervous and nothing suited her. She complained about the Austrian Cultural Institute: "Then to make things worse they put a Christmas tree (!) in the exhibition, that really took the cake, and the children of the employees played catch in the gallery and shot at the paintings!"[92]

Feminist films

When Lassnig arrived in New York, feminism was in its heyday. In 1969, an advocacy group named WAR, Women Artists in Revolution, was founded. Their goal was to make the discrimination of women in the art world more widely known and to develop counterstrategies. In 1970, Kate Millett published her book *Sexual Politics*, which sold 22,000 copies in the first month. In this feminist classic, Millett argued that sexuality, gender, and relationships weren't just private but political in nature, that they reflected hegemonic structures and reproduced power relations. Lassnig went to a reading by Millett that took place in a theater in front of hundreds of women. She was overwhelmed by the community and the solidarity of women. When Millett called out to her female audience that they were all sisters, Lassnig was deeply moved and had tears in her eyes; it was a scene that marked her and burnt itself into her consciousness, one she would refer to over and over again in later interviews.

Lassnig was captivated by the momentum and the buoyant mood of the women's movement. She regularly visited women's gatherings and was involved in feminist artist groups. She participated in rallies in front of MoMA, the Whitney Museum, and renowned galleries such as OK Harris in SoHo and Leo Castelli to protest against the fact that they exhibited almost exclusively men. She got to know Louise Bourgeois, who had been living in New York since 1938. In the 1970s, Bourgeois also still had to fight hard for recognition as a female artist: MoMA did not dedicate an exhibition to her until 1983. Nevertheless, Bourgeois was a much respected—sometimes dreaded—authority among women artists. She was by far the oldest, eight years older than Lassnig. In her basement on 20th Street, meetings were held and leaflets printed. When ORF (Austrian Broadcasting) made a documentary about Lassnig in 1994, the film crew traveled with her to New York to visit her memorable important places. This included a visit to Bourgeois, a strange reunion. The tiny Bourgeois stood at the kitchenette throughout the conversation, while Lassnig sat down in a chair. Lassnig's strong Carinthian accent met Bourgeois's equally thick French intonation of English. Lassnig tried to conjure up their common past: "We staged a protest action, do you remember? ... We were waving little flags in all colors. It was very lively!" Bourgeois agreed, of course she remembered, but: "We were pretty wild at the time. I was a negative person and I have changed a lot. That is why it is difficult

for me to reminisce." Bourgeois generally seemed a bit dismissive in her posture and gestures. After a while, though, she lightened up and said she had immediately recognized Lassnig: "Oh Maria, your face hasn't changed!"[93] Then Bourgeois claimed Lassnig was the first to combine animated film with fine arts. This was incorrect but still a nice compliment.

Still, for Lassnig, the feminist filmmakers she met at the gatherings were more important to her than fine artists. She wrote to Heide Hildebrand: "A girl friend of mine studies film; that's enticing, too."[94] In the summer in Klagenfurt, she asked the Carinthian film critic Horst Sihler how to approach filmmaking. He said: "Buy a camera and start!"[95] Lassnig followed his advice and purchased her first camera, a Bolex Single 8, at a pawnshop. Later, she acquired a Bolex Super 8, and then an old Bolex 16mm. In reality, Lassnig hated machines, and she got her first camera tips from her neighbor on Avenue B, who worked as a photographer. In the spring of 1971, she attended a course on Animation Production Techniques at the School of Visual Arts for one semester to learn the craft. The idea behind this was to make animated films for a living. She hoped to receive commissions from one of New York's major commercial animation studios, which produced commercials and feature films for movie theaters. But nothing came of this: "They only hired nephews and nieces to draw. I couldn't get in there."[96] Nevertheless, the animation course was not in vain because Lassnig soon began to shoot her witty feminist animated films. When asked why she was suddenly interested in making films, she said: "New York is a movie city; it's only natural that you make films there."[97] It's fascinating how Lassnig repeatedly thought out loud in her letters. In February 1971, she wrote to Heide Hildebrand: "But I think I'll soon repentantly return to painting again because everything mechanical makes me nervous (No wonder all photographers go nuts), and that shouldn't be the result. I haven't even had a camera in my hands yet; it's all mere fantasy. All these ideas made me worry too much. I am giving everything up now. For Austrians, American technology sounds so interesting, but it is harmful to the individual."[98]

Despite all her concerns, she experimented with the camera and produced her first short film titled *Seasons*. She painted what she called a "primitive" landscape and moved cut-out drawings on it, working with the simplest and most rudimentary equipment. She set up her workplace on her huge cable-reel table in the loft: "All kinds of holes are cut in this round, solid plate; in one of them is a pot of pencils, pens, and dry markers: my animation tools. One half of the table was used for reading, eating, and writing, and on the other half was my animation desk."[99] This consisted of two telephone books or four bricks—Lassnig mentioned both versions—which she placed on spread-out tinfoil. On the supports—that is, the books or bricks—a frosted glass plate rested. Underneath it was a light bulb. On the frosted glass, she applied markings with tape so she could

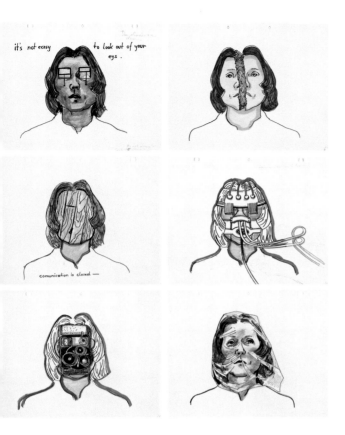

it's not easy to look out of your eyes.

comunication is closed —

place each drawing in the right place: "This is my improvised storyboard because I couldn't yet afford to buy a professional one."[100]

She learned a lot from trial and error. Although she secured the camera tripod to the ground, it often happened that just as she was filming, a truck passed by and everything got "jittery." At the beginning, she was surprised how much work a short film sequence required if, like her, you have to and want to do everything yourself: "The animated film is supposed to tell a story, that is what one is used to. But this is boring for a person who suffers from an overabundance of ideas because the composition of a three-second movement at a speed of 24 frames per second requires 36 to 72 different drawings."[101] She was indeed overflowing with creativity and filled up a whole diary with ideas. Many of them remained unrealized, yet quite a few of them came to fruition. Shortly before her 1971 summer break in Austria, she wrote: "Now I can transport my art in my pocket; a few small rolls of 8mm film (16mm too). I'm getting quite full of myself; *all* the people here love them."[102]

A particular success was *Selfportrait*, an animated film in which Lassnig's drawings of herself didn't just transform into the Statue of Liberty, Bette Davis, and Lassnig's dead mother but also into a respirator, a pineapple, and Swiss cheese. Her voiceover in a thick Carinthian accent: "With a little change I could be as beautiful as Greta Garbo, or a lion like Bette Davis!" She alludes to art history—for example, Dalí's female bodies—when her face becomes a dresser full of open drawers. In the voiceover, the artist laconically comments on her life so far, her dreams and longings: "Oh, why did I make this picture? To veil or reveal my face, to reveal my heart, the feeling?" Never cynical, Lassnig's wit resonates with pain and grief: "With humor you can overcome imperfection and pain."[103] The film shows how one is labeled as a woman: her face is stamped with "weak" and "woman." But she remains optimistic: "I didn't mind! I still love mankind!" With

a giant gesture, she hugs a group of men standing together. The film was awarded the New York State Council Prize in 1972.

Lassnig didn't just work with animation but also with live-action film. In the summer in Carinthia, she went to Gurk Cathedral, which she remembered from her childhood. For her film *Baroque Statues,* she shot close-ups of wood-carved saints. She contrasted the frozen poses, faces, beards, feet, and falling garments of these male figures with the movements of a female dancer on a summer meadow. Step by step, the—female—body frees itself from the patriarchal church traditions until it dissolves into a psychedelic rapture. As so often with Lassnig, it's not easy to date her works exactly. She didn't care that much about it at the time, and later she didn't remember what she had done when. This applied, for example, to *Iris*, another experimental live-action film. The title refers to the protagonist Iris Vaughan, her friend mentioned earlier, of whom she had already painted two portraits. Vaughan was adamant that Lassnig didn't make the film *Iris* in 1971, as it was previously dated, but in 1972.[104] Lassnig appreciated the luscious body of her friend: "I wanted to paint

Maria Lassnig seated beneath her 1972 *Porträt des Flötisten* (*Portrait of the Flutist*) at her house in Feistritz, summer 2004 (photo: Horst Stasny)

sensuality, but this time with the camera."[105] As with the saint figures, she filmed her model very close-up, so at first it was often not clear what body part you saw. Further alienation effects were provided by a heavy but flexible Mylar plate, a reflective industrial fabric that Lassnig mounted behind the couch. Throughout the shoot, she gave her friend precise instructions on how and where to move: put your arm over your head, look to the right, look up, rest crouched on your heels, and so on. Vaughan was fascinated by the intensity and seriousness of the artist during her work: "She had incredible focus! ... When she was working, she was working."[106] As a soundtrack, Lassnig added the traditional spiritual "Sometimes I Feel Like a Motherless Child," a commentary on the death of her mother, which she had still not overcome.

In Lassnig's archive, there are many other rolls of live-action film, some almost finished along with uncut footage.[107] When a scene from Francis Ford

Coppola's *The Godfather* was filmed around the corner in the East Village, she grabbed her camera and filmed along—she even captured Coppola himself playing the tuba. She almost finished editing *Alice*, featuring her Icelandic friend who appeared for a short time in the New York art world before disappearing again. As in *Iris*, it was about her feminist view of the naked female body, this time a milky-white one on which she dripped a bloodlike liquid—presumably red wine—from a jug.

Lassnig filmed her surroundings, not only her friends in New York but also those in Austria. In Klagenfurt, for example, she made a film about her childhood friend Rainer Bergmann, who as cock of the walk is indulged and fed by three women, including his wife Gerlinde. At Damtschach Palace with the Orsini-Rosenbergs, an important meeting place for artists in Carinthia since the 1960s, she shot scenes for *The Princess and the Shepherd. A Fairytale*, her longest film.[108] The bizarre fairy tale tells the story of a princess who lives alone in a castle and is wooed by numerous princes, but she rejects them all. Then, however, a flute player appears, who charms her and whisks her away to his little farmer's hut. It is no coincidence that a flute player showed up in Lassnig's New York life. The portrait that she made of him hung in her studio until her death.

In 1971, Lassnig became a member of the Millennium Film Workshop in the East Village. Founded in 1966 by Ken Jacobs, the club was a typical counterculture project. It offered film screenings, discussions, lectures, courses, and editing suites for experimental filmmakers. For the first time, Lassnig saw films by Stan Brakhage, Michael Snow, and Jonas Mekas. She attended workshop classes, including one by Bob Parent,[109] to learn more about this medium, which was so new to her. Millennium was located on 4th Street in the East Village, just a quarter of an hour from her loft on Avenue B, and she soon spent almost every night there. She had to admit: "There's so much going on. Unfortunately, I often miss the most important thing, the Women's Liberation meetings. I just can't do everything at the same time."[110] In fact, she often overdid it with her activities. She started the day with painting, then at five in the afternoon she took the bus to her typing course, which began at six. She then went to a rhetoric course at the same school, after which she arrived at the Millennium Film Workshop at about nine in the evening, where she continued to work on her films: "Recently, I roll ever faster like an avalanche, and am very often close to having a heart attack."[111] Elsewhere she wrote: "I am smoking a lot right now and probably look like World War I, that's probably because I want to drive the devil out with Beelzebub (if only I could say that in American)."[112]

At Millennium, she also had the first opportunity to show her own films. Once a week, there were open screenings and everyone could present what they wanted, followed by discussion: "It is very inspiring there, and my films have

already inspired others."[113] Also at Millennium, she met Silvianna Goldsmith, who became one of her best friends. Goldsmith was ten years her junior, a committed, combative feminist, and a founding member of WAR—Women Artists in Revolution. She was also a member of the Guerrilla Art Action Group and in 1969 participated as one of four people in the spectacular happening *Blood Bath* at MoMA, a protest against the Vietnam War. Goldsmith had a very deep voice; maybe Lassnig was referring to her when she said young American women growl like bears. At that time, Goldsmith was working on *The Transformation of Persephone*, an erotic and violent film in which she paralleled the myth of Persephone with the history of women. In all of Goldsmith's films, female sexuality played a central role. Through her, Lassnig got to know other women filmmakers, including the well-known performance artist Carolee Schneemann. Ten of these women decided to start a community of shared interest known as the Women Artist Filmmakers. They were artists who had already worked in other fields—as sculptors, painters, performance artists, dancers, or poets—and translated their respective genres into film.[114] In 1974, they officially registered as an incorporated association. They supported each other emotionally and organizationally. They met regularly and alternately in each woman's respective studio, showed their films, discussed them, and gave each other positive feedback. Schneemann recalled: "Within the feminist energies of the 1970s, [the name] Women Artist Filmmakers carried determination, distinction, and pleasurable associations of our work and daily life."[115] Olga Spiegel, another member of the group, noted: "Our generation made a breakthrough. We broke through some of the barriers, at least mentally, in that we felt the world should recognize us or we should have certain privileges just like men do. But it took a long time and we're still not there."[116] Grants were much easier to get as an incorporated association. Rosalind Schneider, a good friend of Lassnig's, was especially savvy at submitting grant applications in a way that assured their approval. The Women Artist Filmmakers received subsidies from the state of New York as well as national funding. Martha Edelheit scouted out cheap film laboratories and editing suites. Alida Walsh curated the film programs. Through division of labor, the women managed to pool their energies and show their films on many occasions and in many venues, from the Anthology Film Archives to the Global Village and Cubiculo Theater to the New York Public Library. While Susan Brockman had good connections to the Ford Foundation, Doris Chase arranged per-

Selbstporträt mit Silvia / Silvia Goldsmith und ich (Self-Portrait with Silvia / Silvia Goldsmith and Me), 1972

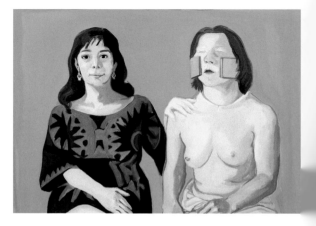

WOMEN
ARTIST
FILM
MAKERS
INC.

ROSALIND SCHNEIDER
MARTHA EDELHEIT
DORIS CHASE
CAROLEE SCHNEEMANN
SILVIANNA GOLDSMITH
NANCY KENDALL
ALIDA WALSH
SUSAN BROCKMAN
MARIA LASSNIG
OLGA SPIEGEL

*Women Artist
Filmmakers Inc.*, 1974

formances in public libraries, and yet another organized shows at universities and festivals from Woodstock to Portland to Los Angeles. The women filmmakers were also invited to give lectures, and they taught workshops on filmmaking. In 1976, Lassnig spent an exhausting week in Cincinnati, Ohio, for this purpose. In turn, she herself successfully invested time and energy in initiating a European tour for the group. She succeeded in getting the films of the Women Artist Filmmakers shown not only in prominent Austrian museums and cinemas in Vienna, Graz, Innsbruck, and Klagenfurt but also in Basel, Brussels, and Berlin. Edelheit recalled: "The amount of work she did promoting all of the films, translating, and personally reading texts at the European screenings indicates her involvement with the Women Artist Filmmakers."[117] Again and again, Lassnig and other group members premiered their films at festivals in Paris, Los Angeles, Edinburgh, and Düsseldorf.

Lassnig felt comfortable in this circle of women. Here, she could relax and let go. As difficult as it was for a highly sensitive person to deal with large groups, she was also pleased when she could thrive in a community: "Well, I've always been a loner, but when I'm with people I'm happy."[118] She was the oldest, but none of the women perceived her as older than the others. For once, she did not feel compelled to compete or argue. One of the reasons might have been that as much as she enjoyed making movies, they were not as important to her as her paintings. Lassnig herself was aware that she had it easier with friends who didn't paint. Regarding her New York environment, she said: "I actually met more filmmakers than painters. Actually, I have always made my friends in other art genres and not in my own."[119] Another reason was probably that Lassnig's films were very well received in the feminist community and she therefore did not have to envy anyone. Spiegel described Lassnig as one of the group's most successful. Indeed, her films were praised as the best.[120] For example, when the Women Artist Filmmakers showcased their work as part of the large exhibition

Women Choose Women at the New York Cultural Center in 1973, Marcia Cavell wrote a review singing the praises of Lassnig's *Selfportrait*, even though she misspelled the artist's name. She found it a pity the film was only five minutes long. "And yet in those five minutes, Ms. Lessnig [sic] manages to convey a sense of a life, a touching and witty portrait of a woman whose self-image—as with most of us—changes as she herself does."[121] If there were a competition, she would give "Lessnig" the first prize, Cavell added.

Lassnig met more and more film people, but her closest friend remained Silvianna Goldsmith. She immortalized this friendship in a double portrait. While she usually painted her girlfriends nude, she made an exception with Goldsmith, who had previously undergone a mastectomy, and allowed her to pose in a colorful, brightly patterned dress. Goldsmith was surprised at how fast Lassnig worked. She loved this painting. For her, its success lay in how differently the friends are portrayed: one, Goldsmith, realistically; the other, Lassnig, in a combination of realism and Body Awareness. Lassnig presents herself naked, with her eyes closed and her features clearly recognizable, yet with two abnormalities that deviate from the realistic image: her cheeks are covered by two square, flesh-colored shields, and her torso, though naked, forms a kind of protective cover or armor that seems more like a second skin or garment covering her actual body. Lassnig seems to be listening to what is inside herself, while Goldsmith looks directly out of the picture. When Lassnig spent a year in Berlin in 1978, she took the double portrait with her. She wrote to Goldsmith that she had worked a little bit further on it before her exhibition at Haus am Lützowplatz: "Everybody asked who is this beautiful woman?" Lassnig reported back to her friend in New York.[122] Decades later Goldsmith spoke of a "sisterhood," an "incredible bonding" between the two women. "When I think of her," she said after Lassnig's death, "I think of her as a very close relative."[123] Lassnig invited Goldsmith many times to visit her in the summer in Austria, but to no avail. Goldsmith just couldn't imagine feeling comfortable in the mountains. Once, they wanted to travel to Greece together. Everything had already been agreed upon, but then Goldsmith just couldn't follow through. After her definitive return to Vienna, whenever Lassnig went to New York, she visited her friend.

Lassnig liked the term animation better than cartoon because she preferred "to 'breathe life into things' or 'infuse them with spirit' rather than deal with gimmicks and tricks."[124] What fascinated her was how she could use film to make her drawings move. And that is what she did in most of her films, including *Chairs* (1971). Chairs and armchairs had always fascinated Lassnig: "Human beings are built like chairs. They have a backrest, a seat, feet, just like a chair."[125] And: "Because the back feels like a board, perhaps a chair-like person (or a person-like chair) emerges."[126] In 1970, she drew a whole chair series in pencil. There

are, among others, the *Playboy Chair*, *Mother Stool*, two *Lady Chairs*, and last but not least, *Self-Portrait in Chair*. All these "human" chairs seem to lead a hidden life. In her two-minute film, this life comes to the fore: the chairs stretch, breathe, dance, and even get pregnant.

She was always trying new things. For the film *Shapes*, for example, she cut out drawings of figures and filled the forms with spray technique. To the music of Bach, these sprayed stencil images move in rapid rhythm. The film is about the big existential topics: life and death, love and hate, war and peace, and of course—as in all her films—the relationship between the sexes. Lassnig's attitude toward feminism was clear: "I think if you're a reflective woman, you can't avoid feminism."[127] Her position was less clear toward feminist art, women's art, or feminine aesthetics—terms discussed and theorized about intensely in the 1970s. When the feminist Austrian artist Valie Export arranged a women's exhibition in Gallery Next to St. Stephen's in 1975, she asked Lassnig not only for an artistic contribution but also for a statement. Lassnig wrote about whether there was a special female art: "I say: yes, as long as we are put on the defensive, as long as a woman has to get rid of her personal resentments, that is, as long as she is not as free and respected as a man, there is women's art!"[128] At the same time, she hated it when her painting was pigeonholed as female: "My art is not gender specific. The term 'female art' doesn't work for me at all." This didn't bother her in another context: "In my films, however, I have thoroughly let off my feminist steam, but never in painting."[129] And: "I enjoyed trumpeting simple, long

224 — 225

pent-up truths."[130] For example, the autobiographical 1972 film *Couples* dealt with the impossibility of love relationships between men and women. A colleague from the Millennium Film Workshop had pressured her a long time with his declarations of love and attempts to seduce her. Iris Vaughan remembered: "He hounded her for months until she went out with him!"[131] Lassnig got involved in the romance, fell more and more in love, and finally even believed she had found a lasting, happy relationship. She cooked for him, got more and more domestic, and was promptly abandoned by him. Lassnig was stunned and couldn't believe that someone who had been courting her for such a long time had then suddenly, without any apparent reason, dumped her. She was desperate and had sleepless nights. Nevertheless, she dealt humorously with her lovesickness in her new animated film. Man and woman meet as deformed genitals and try to approach each other, yet like false pieces of a puzzle, they just do not fit together. You see the couple in bed, on the beach, and finally on the phone, where the man ends the relationship. Here, Lassnig inserted a piece of real film: a naked woman sits on a bed with a telephone cord choking her around the neck—a part played by Vaughan. The film ends with the ex-lover singing the final line of Casanova's song: "Who blindly loves, pays with death as a fee," a phrase that sums up how Lassnig felt in relationships. Vaughan was outraged the guy could behave so miserably to such a great woman. When Lassnig presented the film at Millen-

Art Education, 1976, single frames

nium, she almost felt sorry for him. Everyone in the cinema knew whom she meant. Lassnig had recognizably sketched her former lover with just a few lines; the film exposed him. But she achieved so much more: she spoke from the heart to a whole generation of women damaged by relationships, women who had had their fill of exactly such dialogues as those she satirized in *Couples*. Without hiding her pain, she made fun of gender relations in a way that is subversive and liberating, even to this day.

In *Art Education* (1976), Lassnig in turn focused on traditional art history from a feminist perspective. Everyone—Michelangelo, Picasso, and even her beloved Vermeer—got their fair share. Lassnig animated Vermeer's

New York: Feminism, Animation, and "American" Painting

The Art of Painting from the Kunsthistorisches Museum in Vienna. While she had praised this work to high heaven in one of her Art Letters from Paris, now she made a mockery of it. The painter is a bald man who orders his female model around until she fights back, grabs hold of the brush, and makes the beer-bellied painter the object of her "art of painting." Although Lassnig enjoyed making these films, she always wondered if she was on the right track with them: "Why make a drawing do 'gymnastics' when it is enough at rest? It regresses to something primitively infantile if you chase everything that moves and are surprised when, for example, a little stick writhes like an earthworm." But there are things you can only realize with the help of animation: "When my self-portrait slowly turns into a Greta Garbo face (suddenly becoming beautiful like her!), then that makes me happy. *But this is only possible through animation*," Lassnig wrote in 1973, trying to explain her animated films to her Austrian audience for the first time.[132] Many years later she commented on the relationship between the more hectic, machine-dependent film and lonely painting: "Probably the contrast attracted me: A painter making films is like a Buddhist monk riding a motorcycle."[133]

Sleeping with a tiger—Lassnig's "American" painting

In many letters, Lassnig complained she did not have enough time to paint because of filmmaking: "only three to four life-sized female nudes recently." She planned to put less time into filmmaking, but then she often invested even more time into her films because she had success with them. At the same time, she was on the brink of a nervous breakdown: "I am working like a dog to complete my animated film. I'm quite overworked and worn out. I chain smoke and take tranquilizers. In fact, I've been in an exceptional state of circumstances for the last few months, and sometimes there are still setbacks."[134] To her Women Artist Filmmaker colleagues and friends, it was clear: filming was not the top priority for Lassnig. Goldsmith: "She never abandoned painting, that was always her first love and passion. I think she did films as maybe a social thing. She would go to Millennium, and there were always people. She had a relationship there. And the animation that she did, you know, people liked it. And then she had our group."[135]

Her monumental *Double Self-Portrait with Camera* (*Doppelselbstporträt mit Kamera*) from 1974 shows how much of a hold filmmaking had on her. It is a sophisticated painting in which Lassnig portrays herself twice: once in a mirror as a filmmaker who self-confidently directs both her gaze and her camera at herself, as if they are weapons; a second time in the classical pose of melancholy with her elbow propped up and her chin in her hand. In the second case, her body is also depicted realistically; only her face is not viewed externally as the mirror would show it but rather in the way she felt it to be, that is, like an old accordion camera.

Doppelselbstporträt mit Kamera (Double Self-Portrait with Camera), 1974

The camera and her face merge, showing the extent to which film had started to dominate Lassnig's life.

The time of day ensured a division of labor between film and painting. She only painted in daylight; artificial light was out of the question. At night, she sat at her animation desk for hours, setting her characters in motion.

Lassnig not only faced the dilemma between film and painting but also felt a conflict between her Body Awareness and more realistic painting. When interviewers asked why she never deviated from her subject matter, Lassnig some-

Mit einem Tiger schlafen (Sleeping with a Tiger), 1975

times contradicted them: "You can't say I never deviated! People thought I couldn't paint, didn't they? That annoyed me, and then I began to paint gynormous nudes, life-size nudes quite realistically."[136] However, this format was not just a concession to public taste; it also owed itself to how she perceived and experienced both the size of her loft and the urban environment: "My paintings have become larger on their own, so to speak, because the scale of this enormous city has an effect."[137] Once she shared a serious resolution in a letter to Ernst Hildebrand: "no more two-timing painting (that is American Realism and Body Awareness at the same time). The former is at the expense of the latter, but this means I have to pass up an almost certain opportunity to exhibit my realistic paintings."[138] She didn't pass up the exhibition and instead continued to paint "American." Lassnig felt she had to paint realistically in order to be taken seriously. As much as she might have found this to be a concession, she also enjoyed it: "Realism became for me a state of emergency, to prove my abilities to the skeptics, to delight in the sensual outside world, to mourn over the oddities, and to participate in world affairs."[139]

Many of her self-portraits from these years—such as *Self-Portrait with Stick (Selbstporträt mit Stab)* from 1971 [p. 182]—were not Body Awareness images, or they only partially touched on that theme, like *Woman Laocoön* from 1976, in which the back of the head is missing and Lassnig left the arms fragmented and misaligned. In place of the male Laocoön and his sons, she placed herself—a move that has been repeatedly interpreted as feminist, as an image of the immense struggle faced by female artists and women in general. It can be seen as part of the great feminist project of investigating traditional myths for their patriarchal content and reinterpreting them against the grain, from a woman's perspective. Lassnig saw it differently: "As a painter, I don't think I have made any feminist statements except that I have persevered, which was not easy."[140] Nevertheless, a striking number of her "American" self-portraits depict self-confident, strong, or combative women. The sensational painting *Sleeping with a Tiger (Mit einem Tiger schlafen)* is interpreted by many art historians as the epitome of erotic feminist self-empowerment. Even if Lassnig didn't want to see it that way, it is undoubtedly an image of erotic fantasy, of danger, and of wild passion, which

many women can identify with. Lassnig saw it differently: "The tiger, the weakest painting of this series, is of course sexy, a sodomite joke (relatively)."[141]

Although Lassnig felt she got no inspiration whatsoever from American art at the time, there were some female painters around her who, despite their differences, also worked similarly and—like herself—received late recognition. Lassnig knew Sylvia Sleigh, who also painted portraits of friends. Sleigh's most famous painting, *At the Turkish Bath* from 1973, is a feminist reinterpretation of Ingres's eponymous 1862 *Le Bain Turc,* which shows naked women bathing in a harem. In their place, Sleigh chose to paint naked men from her circle of friends, including her husband. Lassnig also got to know Alice Neel, whose unsparing and provocative portraits are now exhibited in all major American museums. At that time, they still went mostly unnoticed—despite her 1974 retrospective at the Whitney Museum of Art. Like Lassnig, Neel painted portraits of her neighbors, friends, and colleagues in expressive, bright, often shrill colors. Lassnig also met

Invitation to the Green Mountain Gallery, 1975

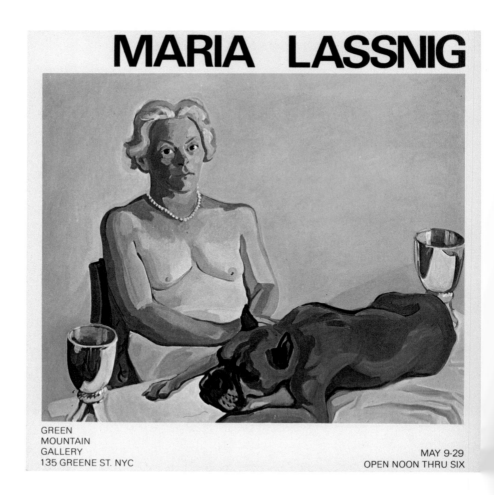

MARIA LASSNIG

GREEN
MOUNTAIN
GALLERY
135 GREENE ST. NYC

MAY 9-29
OPEN NOON THRU SIX

African American artist Faith Ringgold, who produced colorful acrylic paintings and textile works in the 1970s.

Lassnig's works are especially comparable to Joan Semmel's self-portraits of that time—at least in some respects. Semmel tirelessly tried to paint her own naked body. Unlike Lassnig, who focused on inner body perception, Semmel stayed with the outside perspective. She aimed to counter the centuries-old male gaze upon the female body with a female gaze. The two artists appreciated each other. In the 1990s, Semmel even visited Lassnig in Vienna. However, one thing was surprising: while Lassnig knew Semmel's self-portraits well, Semmel thought Lassnig was only a filmmaker. When Semmel saw Lassnig's large 2014 exhibition at MoMA PS1 in New York, she became aware of the numerous parallels with her own work. For example, both were passionately interested in color and paint. In addition, they shared an interest in the self: "It is not a narcissistic approach to the self, which, I think, many artists take when they do their self-portraits, they glamorize themselves. She doesn't glamorize herself and neither do I."[142] Lassnig made a similar remark in 1977: "Self-portrayal, a broad movement in the art of our time, is not narcissism and love of oneself, but rather the loneliness of the critic, an inability to exploit someone else, meditation, and applying a scientific scalpel to a willing object, the self. Women are particularly at the mercy of their own reclusiveness—they still are—and it became their strength."[143] Semmel thought she recognized another parallel: "It's an iconic expression of the self. The image becomes expression, not just of the self but of women, of how a woman feels rather than about how we look in a certain way."[144] Even though Lassnig might not have wanted the latter to be considered typically female, this is one of the reasons why many women appreciate her paintings so much: they don't just portray Lassnig but women in general. Instead of the usual male gaze targeting women as objects, Lassnig's portraits show how women perceive themselves as subjects. Semmel had a great deal of understanding for Lassnig not wanting to be pigeonholed as a female artist: "If you admitted you were a feminist or if you participated in the whole thing, it was negative for your career. It didn't help you! ... So that's the irony of all these women, who because of self-preservation didn't want to be seen in women's shows ... They felt it denied their professional status."[145] In her later years, Semmel has painted self-portrait nudes in which the aging of her body takes center stage. This clearly corresponds with Lassnig, who also brought her aging female body to the canvas in large format.

That Semmel knew nothing of Lassnig's painting in the 1970s is perhaps less surprising than it seems at first glance. Painter and filmmaker were two separate sides of Lassnig's personality, and they could behave antagonistically toward one another. When she exhibited both her paintings and her films at the

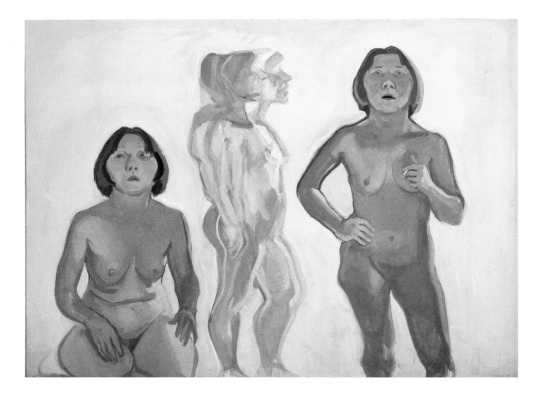

Venice Biennale in 1980, she noticed that the audience lingered longer in the film room than with the paintings: "I was jealous of my own animated films."[146]

Dreifaches Selbst-porträt / New Self (Triple Self-Portrait / New Self), 1972

Although she enjoyed her success as a filmmaker in New York in the 1970s, she wanted to finally show her paintings, and not just at the Austrian Institute. In May 1975, the time had come: she held an exhibition at the Green Mountain Gallery on Greene Street in SoHo, which specialized in figurative realistic painting. The invitation showed Lassnig's portrait of Hermine Schilling, an old Klagenfurt friend whom Lassnig knew from her Wandervogel hiking group days. The then-fifty-five-year-old woman courageously posed topless with a pearl necklace. This portrait, *The Prize Boxer (Der Preisboxerhund)*, got its title from her dog, Baron, resting in the foreground. Lassnig also exhibited her *Self-Portrait with Stick*, her *Double Self-Portrait with Camera*, the two portraits of Iris Vaughan, her *Triple Self-Portrait / New Self*, and many more, all icons of her work today. Back then, there was barely a reaction.

Two years later, in May 1977, Lassnig exhibited paintings and drawings at an address she was very proud of, the then-new Gloria Cortella Gallery: "57th Street (sort of seemed a sign of having arrived)."[147] Despite all her chronic nervousness before the vernissage, Lassnig didn't get sick as usual. Many guests came to the opening, among them Kiki Kogelnik, the German gallerist and art col-

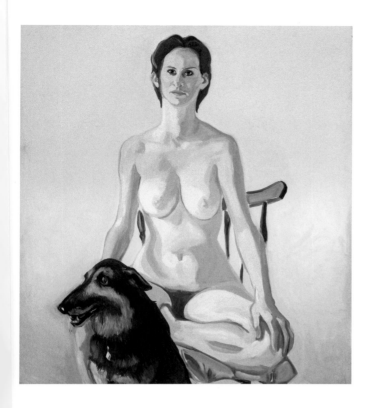

Pamela and her dog,
ca. 1975–77

lector René Block, the Women Artist Filmmakers, and many others: "The party was festive, almost lustrous, and everyone was dancing Viennese waltz. The food was not running out as I feared it might, and I had a black bartender, who looked elegant. I wore my homemade one-dollar dress."[148] Portraits and self-portraits took center stage in her work again; animals now frequently played important supporting roles. In *Learning to Fly (Fliegen lernen)*, Lassnig stretches her arms high and holds a huge bird over her head; in *Eating a Fish (Einen Fisch essen)*, she bites into a whole fish, which sticks out of both sides of her mouth; in *Owning a Dog (Einen Hund besitzen)*, she holds a German shepherd in one hand as if it were a stuffed animal; and in *Schmetterling*, a giant butterfly seems to kiss and threaten her at the same time. She said, "When I saw my butterfly painting, I thought, aha, the butterfly is the life I feel distant from and therefore it is sadly sentimental. Haha!"[149] Animals such as in *Woman Laocoön* or *Self-Portrait with a Pig (Selbstporträt mit Schwein)* fulfill a symbolic function: "I feel oppressed (serpent) or surrounded by pigs, as in these two paintings."[150] A short review in *Art/World* spoke of disturbing colors and strange relationships between animals and humans: "This is a powerful and unusual exhibition."[151] These two exhibitions made Lassnig feel recognized, and she hoped to soon make her American breakthrough with her Body Awareness images. She expressed this desire in her peculiar English: "And the world is soon ready for my strange paintings."[152]

Animals appeared in Lassnig's work again and again in many of variations. She elaborated on "animal" as a keyword: "Its similarity and strangeness, similar reflex movements, how it thinks and 'speaks,' its repulsive animality." However, her approach to animals was characterized mostly by empathy, too much empathy she thought: "Who lives oneself vicariously into the soul of a mosquito when it makes a dramatic death-dance before it dies?" And: "Question: Can a person who saves a spider in the bathtub in the morning survive in this world?"[153]

She once said she came up with the idea of the animal paintings because her roommate Pamela Klavcek had a dog and cats, and it was through them that she gained her connection to animals. This living arrangement became possible because she had moved to a new loft in 1974 and was no longer living on Avenue B. At last, she had managed to leave her studio in the East Village. The suffering caused by the extreme noise and two break-ins there had finally led her to take this step. Her previous neighbors had moved out, and the new residents—along with the trucks on Avenue B—gave her the final push. Above her was a writer: "a slob, when he walks, the whole house shakes."[154] Below her, a hard rock band: "I love the music very much, but the electric instruments are loud in this paper house."[155] Some of the windows there faced a playground with a stage for weekend concerts, which often lasted until late into the night: "It's like in the jungle. The sound penetrates the wall, the earplugs, and the paintings I've stacked in front of the window."[156] The noise had even made her consider going back to Austria: "Depends how I feel."[157] But even after her Bolex camera was stolen in the second burglary, almost two years passed before she actually found her new place. Shortly before Christmas 1974, Lassnig moved to SoHo, to Spring Street 167 on the corner of West Broadway. She was proud of the good location of her new loft on the third floor: "My address is finally acceptable, so socially acceptable that I had better not say it because I would have all the success-mad painters at my throat."[158] Right next door on West Broadway was the new second location of the Leo Castelli Gallery, which had opened in 1971. Oscar Bronner, who founded the Austrian magazines *Profil* and *Trend* in 1970 and sold both in 1974 to live as an artist in New York, lived on the floor above her.[159]

Maria Lassnig in her loft, 167 Spring Street, 1975

Although the SoHo of the 1970s was always more well-to-do than the East Village, the SoHo that today's international tourists encounter is on an entirely grander scale. Now, real estate prices have gone through the roof and the neighborhood is one of the most expensive in the world. The few artists who still live there have had their rent-stabilized lofts since the 1960s or early '70s. Today, artists and galleries have been replaced by luxury boutiques and chic restaurants. In the house on Spring Street where Lassnig found her loft in 1974, an apartment now costs 6.2 million dollars.

Lassnig's new loft in SoHo was approximately 4,300 square feet (four hundred square meters). In order to afford the much more expensive accommodations, she moved in together with fellow filmmaker Olga Spiegel. First, the

two women had to remodel everything because the premises were anything but ready for occupancy: "It was as black as hell. Finger-thick soot stuck to everything. I remember Christmas 1974, I was crying while scrubbing the floor with an oil-eating agent." Lassnig and Spiegel needed three months to complete the renovations: "Afterwards, I was so thin that my pants fell down." But finally, the black, sooty factory space transformed into a white, radiant home studio: "In the beginning, they pitied me, but later they envied me."[160]

The relationship with Spiegel, who was about twenty-five years her younger, often proved to be difficult, not least because she was raving about the Viennese School of Fantastic Realism: "Spiegel was a student of Ernst Fuchs. I mean, not really, she just worshipped him. I was nothing for her because Ernst Fuchs was everything for her."[161] Once again, Lassnig had the feeling she was being exploited, that people were copying her, stealing her ideas. When she heard organ music next door in Spiegel's room, she became suspicious: "I hear organ music through the wall, which means that she *also now* has organ music in her films like I do. That's not pleasant."[162] The two women didn't live in a shared apartment but split the large factory space into two lofts with separate bathrooms and kitchens. Spiegel was the single mother of two children, had even less money than Lassnig, and therefore had to take in another person as a subletter, Pamela Klavcek, who moved in with her dog and her cats. She was the roommate who brought animals into Lassnig's world and thus into her paintings.

This loft was where, in 1977, Lassnig was awarded the Vienna City Prize. Martha Edelheit of the Women Artist Filmmakers recalled: "There was a hilarious ceremony at her loft, which was almost bare: one cup, one saucer, a plate, a bowl, a bed, a few chairs and a table. We stood in the middle of the loft in a circle and these very uncomfortable Austrian gentlemen in their business suits crowned her with a laurel wreath and opened a bottle of champagne, with plastic glasses."[163]

As nice as SoHo was, Lassnig still had to cope with noise. However, she soon blamed the New York transportation industry for her increasingly shaky brushstroke: "The rumble of heavy trucks, the garbage collectors drove through my sleep and my nerves, a nervous brushstroke was probably the result."[164] Noise pollution remained a constant issue. Again, she considered moving. Finally, she built herself a "sleeping chamber," a sound-insulated room inside her loft: "Now I want this cage ... to be completely soundproof with a fan installed, maybe it will then be more bearable."[165]

To describe a feeling graphically
seems an impossible, romantic,
entirely super-subjective enterprise.
But I have increasingly viewed it as scientific,
like Cézanne's optical sensations,
because the decision to choose a color is as complex
and subjective
as locating and describing a feeling;
it's also not something
specifically feminine.[1]

8 Berlin: Oswald Wiener, Trees, and Theory

1978–79

Lassnig liked living in New York, but her inner restlessness led her to search for alternatives. Meanwhile, her friend Iris Vaughan had moved to San Francisco, and Lassnig asked her about the studio situation there because she was considering moving to the West Coast. Though she did not follow through on this, her anxiety remained, especially because of the extreme noise in her loft on Spring Street. Every Wednesday, she looked for a new studio: "What a nuisance. Everything just as loud and a lot more expensive."[2] It seemed all the more attractive to go to Berlin for a year. She got the idea from Oswald Wiener, who had been living in Berlin to avoid prosecution by the Austrian authorities since his 1968 *Art and Revolution* action at the University of Vienna. After their separation in the late 1950s, they initially lost track of each other, especially during Lassnig's time in Paris. Then, however, they had a friendly reunion. Hilde Absalon, a textile artist with whom Lassnig had been friends since the 1950s, played an important part in this. Absalon was about fifteen years younger than Lassnig, had studied with Albert Paris Gütersloh at the Vienna Academy of Fine Arts, and was involved in the art scene around the St. Stephen's Gallery. When Lassnig spent her summers in Austria, she almost always spent a few weeks in Vienna. She often sublet her old Vienna studio in the Bräuhausgasse during the summer and stayed with Absalon, who was close friends with Wiener.

In Berlin, together with his wife Ingrid and Michel Würthle, Wiener ran two legendary pubs for artists, Exil (Exile) and the Ax Bax, and founded the small gallery Wiener & Würthle in which Dieter Roth and Günter Brus exhib-

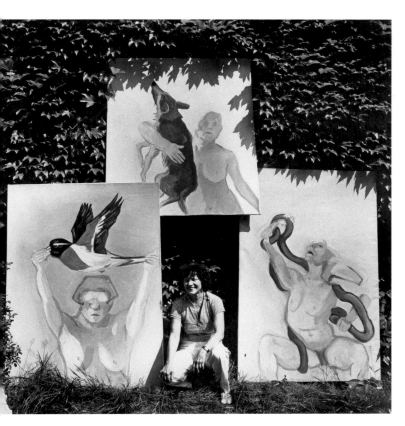

Maria Lassnig in front of her Grunewald studio in 1978 with her paintings (from left to right) *Fliegen lernen* (*Learning to Fly*), *Einen Hund besitzen* (*Owning a Dog*), and *Woman Laokoon* (*Woman Laocoön*), all from 1976

ited alongside other artists. Between Vienna, Berlin, and New York, they came up with the idea that Lassnig could also present her latest works there: "Ossi wrote that he is interested in an exhibition, either with him or another renowned gallery," Lassnig wrote to Absalon, who had been making great efforts to organize an exhibition for her.[3] In the summer of 1975, Lassnig and Absalon traveled to Berlin to check out the location and plan the exhibition. Finally, in October 1976, Lassnig displayed paintings in the Wiener & Würthle Gallery that were similar to those in her two painting exhibitions in New York: animal paintings like *Butterfly*, *Learning to Fly*, and *Owning a Dog* or portraits like *Girl with a Wine Glass* or Body Awareness paintings like *Self-Portrait as Native American Girl* of 1973, in which a baseball mitt, hanging surreally on the wall, underscores the strength and stamina of the riding Lassnig—attributes that appear more often in her self-portraits from the 1970s, such as in *The Resting Woman Warrior* (*Die Rast der Kriegerin*) from 1972.

According to Wiener, Lassnig's Berlin exhibition got zero response: "We were not a big gallery. Actually, we only had this gallery because it was a very nice space, very well located, and we could afford it. We wanted to exhibit the work of our friends, not make money, but somehow gain publicity for those artists who were not really well known back then. But that was a full-time job of course, you couldn't just do that on the side. That was why the gallery idea went by the wayside." He added: "But there was also no art scene or community of collectors. There was an intense exchange among the artists, but it was more social than theoretical." Wiener laughed: "In other words, they always got drunk together."[4] Anyhow, a long, positive article appeared in the Berlin *Tagesspiegel* by the renowned art critic, author, and feature editor Heinz Ohff. He described Lassnig as a "representative of the New Viennese School," equal to Arnulf Rainer or Christian Ludwig Attersee, and characterized her as "action-packed, wide ranging, modern and new in an old-fashioned aesthetic way, more melancholic than rebellious and of undoubtedly outstanding quality in painting and drawing skills." He admired her "poisonously bright dangerous colors" and her "peculiarly self-confident and powerful brushstrokes."[5] At the same time, the Berlin art house cinema Bali showed a series of films by Andy Warhol and the Women Artist Filmmakers under the title *Regarding New York*. Lassnig presented her *Selfportrait* and her *Baroque Statues*. She was at every showing, gave short introductions, both to her own films and to those of the other Women Artist Filmmakers, and discussed them in Q&A afterward.

During the weeks that Lassnig was in Berlin in the autumn of 1976, she painted a portrait of Ingrid and Oswald Wiener. Lassnig really wanted to do this, Oswald Wiener recalled: "We worked so hard in our restaurant and we had to get up around nine o'clock in the morning although we were only able to go to bed

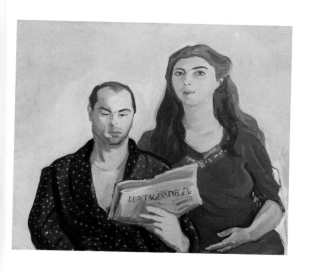

Porträt Ingrid und Os-wald Wiener (Portrait of Ingrid and Oswald Wiener), 1978

at four or five. She was absolutely tough about that. We had to pose. And that really captured the moment. I am sitting in a bathrobe reading the paper, totally wiped out, that was the mood." The double portrait still hangs at the Wieners' house to this day. It was an uncommissioned painting, for which Lassnig had still expected to be paid, yet she never mentioned that. Only years later did Wiener learn that she had hoped for some remuneration: "I hadn't realized that! I knew her as an unbelievably modest person, who got by with very little, and couldn't deal with abundance." He was just as surprised when he found out that Lassnig had been interested in a scholarship offered by the German Academic Exchange Service (DAAD) in Berlin. He had thought she was too proud to want that.

Once he knew, he tried his hardest to support her: "All the DAAD scholarship holders and also the jurors were regulars at our place. That's why it was so easy." Wieland Schmied, whom both Lassnig and Wiener had known since the 1950s, was then director of the DAAD. "I pushed him to consider Maria," recalled Wiener, but then he relativized: "A big push wasn't necessary." In 1978, Lassnig did indeed receive the scholarship and moved from New York to Berlin for almost a year.

Trees in Grunewald and goulash in "Exil"

Since 1963, the DAAD has awarded around twenty Berlin scholarships each year in the fields of fine arts, film, literature, music, dance, and performance. This program for artists, initially funded by the Ford Foundation, later by the German Foreign Service and the Berlin Senate, was supposed to support Berlin in the areas of art and culture—after the Berlin Wall was built in 1961—and thus played an important role in the Cold War. The first literary fellowship in 1963 was awarded to Ingeborg Bachmann, who wrote large parts of her novel *Malina* in Berlin and was one of Lassnig's favorite Austrian authors. Other recipients of this award included Peter Handke, Friederike Mayröcker, George Tabori, Susan Sontag, Péter Esterházy, Vladimir Sorokin, and Jeffrey Eugenides. Among the numerous fellowship holders from the applied arts were Christian Boltanski, Nam June Paik, Marina Abramović, Rachel Whiteread, and Damien Hirst. The Czech-Austrian artist František Lesák and the Italian Michelangelo Pistoletto participated in the Berlin Artists' Program at the same time as Lassnig, who found herself in good company and was very proud of her DAAD scholarship.

When she landed in Berlin in February 1978, she hoped to calm down a bit and get rid of the back pain that was plaguing her at the time. But here, too, the start wasn't so easy: "I'm quite depressed now. Berlin is rather coarse, but it will work out eventually," she wrote at the end of February to Absalon.[6] What helped her were the surroundings. She lived in her studio at Käuzchensteig 10 in Grunewald and thus—as the name of the district suggests—in the middle of the green woods, which were now magically covered in snow. Quite a contrast to her New York address in the middle of a sea of houses in SoHo. The forest edge was not far away and a short walk led to ponds and lakes. Instead of trucks and skyscrapers, she now saw birds, rabbits, and deer tracks. She spent hours peering out the window: "Why is it pleasant to watch a birch move in the wind?" This treescape was soon reflected in her art: "Now I have it with trees," she wrote in her Berlin journal. In her drawings, watercolors, and paintings, countless variations of trees showed up, which were also figures in a sense. They appeared like creatures leading a secret, hidden life: "The tall, slender pine, reminiscent of Rome's cypresses, stretches its two arms like a human," Lassnig

Ich, als Kind im Grunewald (Me, as a Child in Grunewald), 1979

noted. "Why do I just depict the tree's skeleton, and not the pine needles?"[7] In her Grunewald series, she depicted trees in which small or large figures stood, sat, or climbed. For example, she also painted herself upside down between the branches and leafy crowns. She called the picture *Me, as a Child in Grunewald (Ich, als Kind im Grunewald)*, a reference to when she was little and had loved to swing by her knees from birch tree branches and view the world upside down. Even in 2003, Lassnig retained her fascination with trees:

> The trees, these guys,
> they wave with their branches
> and sway in the wind's rush
> fearfully in blue heights,
> they swing in harmony
> holding themselves upright
> in burly pride, what keeps
> you upright, and for how long? You guys![8]

That trees were "guys" for Lassnig can also be seen in the painting *The Native American in Berlin (Der Indianer in Berlin)* in which a muscular naked man—viewed from the back and heavily foreshortened—clambers around on a bare tree, "a sex tree," she later said.[9]

Der Indianer in Berlin
The Native American
n Berlin), 1979

Although she was initially pleased with the tranquility and nature, she soon felt deserted: "I want to talk to somebody because it is rather lonely here outside on the edge of the woods, and I don't know anybody with whom I'd rather speak than you," Lassnig wrote to Silvianna Goldsmith in New York in her broken English: "It's so quiet that I, who never turns a radio on, turn it on now, because it would be too quiet otherwise—What a difference to New York—and you would not believe it: I miss it—I miss the noise, I miss Olga and the boys and Pam, and I miss the Millennium."[10]

It was a long ride to the city center, yet Lassnig regularly took the bus and tram, often to visit Oswald and Ingrid Wiener: "I love them both very much."[11]

In the Exil restaurant in Kreuzberg, she enjoyed good home cooking, which was popular throughout the Berlin artist scene. Susanne Kippenberger, journalist, author, and sister of the artist Martin Kippenberger, described the uniqueness of the restaurant in what was then the gastronomical wasteland of Berlin: "Among the diaspora, Exil was an oasis, a place of civilization. Pastries! Goulash! Real coffee! A comfy guest room designed by artists. At the stove, a lady chef, who cooked according to her fancy, with the pleasure of discovery, as she was not a trained cook. At the regulars' table, a host with a great sense of humor. Behind the counter, the prince of the bar as he referred to himself."[12] The cook was Ingrid Wiener, the host was Oswald Wiener, and the prince of the bar, the third in this party, was Michel Würthle. The ceiling painting was by Günter Brus, the wallpaper in the billiard room by Dieter Roth, the enamel sign by Richard Hamilton. For the financing of the restaurant, Joseph Beuys contributed an artist's multiple.[13] Everybody found their way here, from David Bowie to Jeanne-Claude and Christo, from Markus Lüpertz to Georg Baselitz to Max Frisch, from Peter Stein to Rainer Werner Fassbinder. Lassnig was good friends with both the Wieners, and Brus liked to drop by, but Lassnig would always leave early. Oswald Wiener noted: "She didn't drink anything. Our style was such that the place opened at six or seven in the evening, depending on the season. At that time of the day, everything was quite bright: the restaurant, white tablecloths, a quaint and cozy atmosphere. From six to eight it was pretty quiet, very soft classical music or none at all.

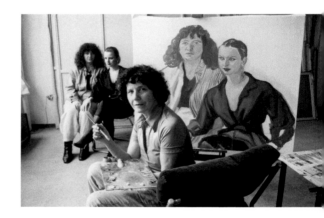

Lassnig painting a portrait of Ulrike Ottinger and Tabea Blumenschein, 1978

And then it got louder and louder until eleven, and then you had to yell to hear yourself speak. Lots of red wine all over the tablecloths. And that was then a vibe she didn't care for." Nevertheless, she got to know a lot of interesting people there. Wiener added: "All the artists came to us. There was no alternative."[14] Among them was the American artist Dorothy Iannone, who had also received a DAAD scholarship in 1976 and then stayed in Berlin afterward. There was also the avant-garde filmmaker Ulrike Ottinger and her partner Tabea Blumenschein, a writer and actress who not only participated in "happenings" but also created masks and costumes for films by Ottinger and Herbert Achternbusch. They were a dazzling couple, so much so that Lassnig captured them in a double portrait. Wiener arranged further assignments for her, like painting Eberhard Roters, the founding director of the Berlin Gallery. With these

portraits, she earned a little money in addition to her DAAD fellowship: "Berlin is very expensive. I'm sorry I didn't buy more clothes in N.Y. before I left."[15]

When her loneliness in Grunewald grew too great, Lassnig plunged into Berlin's cultural life, visiting the Berlinale, galleries, theaters, and music festivals. She loved to go to the movies, especially to art house films. In October 1978, she watched nearly an entire Godard retrospective, from *Le Petit Soldat* to *Tout va bien* about the May 1968 civil unrest in Paris, which had once so disturbed her.

Lassnig reported to the Austrians in a new Art Letter about the Meta-musik Festival in Berlin. She saw Morton Feldman's only opera *Neither*, which, she wrote, "had a great set design by Pistoletto." She described in great detail the opera *Sleeping Beauty* by her compatriot, the Austrian composer Gerhard Lampersberg. The performance took place in the impressive New National Gallery (Neue Nationalgalerie) designed by Ludwig Mies van der Rohe. Lassnig was entranced by both the building and the performance: "The mixing up of the genders, the queen's bass, the prince's soprano, and the masculinity of the charming princess are awe-inspiringly funny. The twelve-tone music of Lampersberg is difficult yet light and delightful, and to great applause."

In October 1978, Lassnig saw Lil Picard again, whom she knew from New York and about whom Silvianna Goldsmith had just completed a film. Picard was multitalented: an actress, journalist, photographer, painter, sculptor, and, last but not least, a performance artist. Born in Germany in 1899, she became a well-known cabaret artist in the golden days of 1920s Berlin, had to flee National Socialism in 1936, and emigrated to New York, where she was again active in the avant-garde as a multifaceted artist and feminist. In Berlin in 1978, the seventy-nine-year-old delivered her *Bed Performance*: "On her sick chair, thickly wrapped like a mummy in hundreds of dresses, her face made into a beautiful mask." Lassnig described the artist: "She undresses completely, almost completely, removes her make-up, and it's apparent that even without make-up she's still a great beauty." Then, a comment about Lassnig's own matters: "She wanted me to paint a portrait of her, but we will first arrive at that in New York: there is too much going on in Berlin!"[16] Whether Lassnig ever painted an oil portrait of Picard isn't known.

Indeed, Lassnig was very busy in Berlin in the autumn of 1978. She presented all the films she had shot so far and showed her paintings in an exhibition in the Haus am Lützowplatz. She had brought along many of her New York paintings, some of which she continued to work on here. In each of the five large rooms, there were about ten paintings of animals, portraits, and Body Awareness, as well as her latest Berlin drawings and watercolors, including the Grunewald series. Peter Gorsen, professor of art history at the University of Applied Arts in Vienna since 1977, wrote a catalog text, which appeared shortly thereafter in

a double volume about women in art with the German publisher Suhrkamp.[17] He tried a feminist interpretation, which, however, made the questionable assumption that woman was closer to nature: "In her self-portraits, she prefers animals—butterfly, bird, dog, and tiger—as pantheistic partners, who reunite woman with her creaturely connection to nature; these are symbols of female powerlessness and melancholy," according to Gorsen. "The nakedness of woman and nature is represented on one and the same innocent level, devoid of any symbolism of humanity's supremacy over nature."[18] As much as Lassnig appreciated Gorsen, his approach was foreign to her. In fact, her paintings celebrated a rather strange distance between woman and animal. A dog can't be carried that way, a bird can't be stretched between her hands, and the fight with the snake does not suggest a harmonious relationship. The animal paintings were well received everywhere they went, from New York to Berlin to Düsseldorf to Vienna to the Venice Biennale. Lassnig herself, however, had an ambiguous relationship to these works. She described them as "compromise paintings" and "as a sweet treat for those who can't tolerate the bitter inner world."[19] In her contribution to the Berlin catalog, she wrote almost nothing about these but explained in detail how she approached Body Awareness, which she considered her real art. A counterpoint to these more realistic, easily accessible paintings with animals were her Berlin drawings and watercolors, which came about from exchanges with Oswald Wiener about her "Imagination Pictures" and "Memory Pictures."

Ernst Mach, fig. 1 from *Analysis of Sensations*, 1922 (1991), p. 15

Fig. 1.

Sensation impressions, Body Awareness images, and theory

Lassnig had great respect for intellectually potent men "and often greatly overestimated them," as Wiener put it. Wiener, too, was exactly one of those men from whom she wanted input, and they indeed had intense discussions during Lassnig's stay in Berlin. Wiener recalled: "At that time, I was concerned with what are known as [Body] Awareness Pictures. Are these real pictures? To what extent is the word 'picture' justified? This also interested her."

Once again Lassnig plunged into scientific writings. She had always been passionate about theory that she could connect with her art in any way. In the 1940s, she had read the art theory of Britsch, as well as Plato, Kant, Nietzsche, and Bergson; in the 1950s, Sartre and Freud. In the early 1970s in New York, she had discovered the theses of Austrian philosopher Ernst Mach, especially his *Analysis of Sensations* (*Die Analyse der Empfindungen*) from 1886, in which she found many of her Body Awareness discoveries confirmed. "The ego is beyond salvation," she read in Mach, as the "ego" consists for him, like everything else, of an accumulation of sensory complexes, which are only a little more closely connected

than the so-called outside world. For Mach, the world is not composed of solid objects but of sensory complexes that are constantly changing.[20] This came close to Lassnig's experiences where the boundaries between her body and the objects around her dissolved and she had to decide which very short, concrete moment to depict: "To translate a Body Sensation into sculptural or graphic language is not easy; to limit its expansion to certain boundaries and forms is an arbitrary act which is only justified by its intensity, originality, and choice."[21] In Mach's book, she found a famous drawing that showed the view from his left eye over his mustache to his own body. Lassnig alludes to this drawing in several of her works, such as *The Anchoring* (*Die Verankerung*) from 1972. She realistically depicted herself from her belly to her toes. Her upper body, however, is wrapped around a pickaxe that is stuck in the sand. On the one hand, her body is literally anchored to the world; on the other hand, it eludes being viewed from the outside by wrapping itself around the anchor.

*Die Verankerung
(The Anchoring)*, 1972

In Berlin, she wanted to work more intensely with theories again. From a secondhand bookshop, she acquired Max Verworn's *Mechanics of Intellectual Life* from 1907 and Rudolf Carnap's *The Logical Structure of the World* from 1928 and transferred individual sentences into her journal. All terms that refer to the outside world Carnap attributed to an inner psychological basis, to subjective streams of experience, an approach that of course fascinated Lassnig. She put into a nutshell a complicated sentence from Carnap's work: "If in a bundle of world-lines the neighboring relations remain at least approximately the same during a protracted stretch of time, then the class of the corresponding world-points is called a 'visual thing.'"

But in the next section of her journal, she mocked Carnap's idiosyncratic notions of visual thing, world-lines, or volitions; these seemed absurd to her.[22] Still, she had a strong desire for theory. She tried to find philosophical approaches that mirrored her innovative way of working, which was all too often incomprehensible to her contemporaries. Perhaps her interest in theory was not so much about getting input on her own work but rather about theoretically substantiating, and thus justifying, what she did in her art. However, she resignedly wrote in 1992: "The theories, actually the studies about perception, didn't really help because they were considered to be limited by a female perspective."[23]

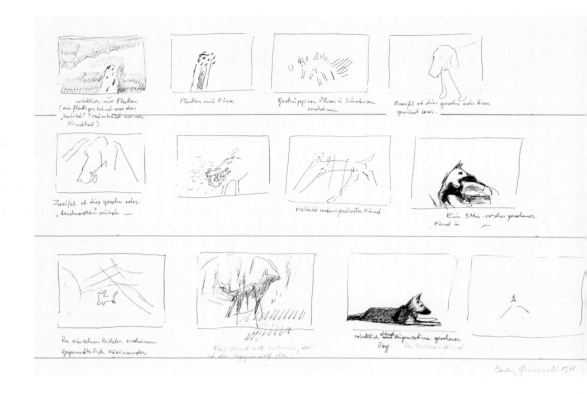

(handwritten annotations within the drawings, partly illegible German)

But in Berlin she was still full of hope. On the first page of her Berlin journal, she listed books that seemed interesting to her in the context of Body Awareness: "These are things I believe could only have come from me: Popper, Eccles, Feyerabend, Kleist as well, Johann Müller, those were recommended by me." She wrote down perceptual issues to investigate, many of which were tips from Wiener, who couldn't recall if they had talked about these readings with each other. This could have had to do with Lassnig being a bit reluctant to express her thoughts. She dreaded being perceived as naive and stupid, a trauma that traced back to her childhood at the convent school, where she had been called "dumb Riedi." Wiener recounted the following anecdote from the 1990s: After one of his lectures, everyone sat together in Café Engländer in Vienna's inner city. When Lassnig was ready to leave, she asked the waiter for the bill. Wiener then said to her: "Come on, Maria, don't be stupid. We are being treated to this!" Without Wiener noticing anything wrong, Lassnig left the restaurant deeply hurt. When they met again two months later at an exhibition opening of Lassnig's, Wiener greeted her with a kiss on the cheek. Lassnig leapt back and said, "Now you come and want to be nice to me again!" Wiener didn't know what was going on and learned only afterward that Lassnig was convinced he had said she was stupid: "She was so sensitive, so convinced that I didn't take her seriously, I hadn't

Bewusstseinsbild vom "Dog" (Awareness Picture of the "Dog"), 1978

Berlin: Oswald Wiener, Trees, and Theory

realized that at all!" Wiener assured her that this wasn't the case. "I never thought Maria was stupid. But right from the beginning, I comprehended that this was a very unique kind of intelligence that was easily and quickly overwhelmed." Her way of thinking and perceiving things was in fact unconventional and often strange in other people's eyes. This was confirmed by many of her friends. Some connections, which were crystal clear for others, were not apparent to her. She was aware of this, and it unsettled her deeply. This was why she could hardly cope with critical remarks or even mere questions. Wiener noted, "If you asked a question in return, it was already quite precarious. If one asked: 'Do you really mean that?'" He laughed: "This phrase was best avoided!"

Absalon remembered Lassnig liked to spend the evenings with her and her two sons watching murder mysteries. However, Lassnig found it difficult to follow the plot. During and after the films, Lassnig allegedly pestered her friend with questions about what had happened there and why who had done or said what. Crime-detective, whodunit thinking was completely alien to Lassnig.[24] In return, she had completely different forms of reflecting, associating, and perceiving that only few people possessed: "My paintings are significantly more clever than I am. Anticipating, penetrating, why explain anything?"[25]

Nevertheless, she tried now and then to explain to herself and others what it meant to her: "Thinking and analyzing, they are different. While painting I cannot analyze, only afterwards. But I can think. Now, when I write about what I thought while I was painting, that is a structuring process."[26] A good twenty years later, she saw parallels to quantum theory since the act of observing also changed the result in art: "Similar to quantum theory: Only through observation

Oswald Wiener im "Exil" (Oswald Wiener in "Exil"), 1979

6 Gesichtsgefühlsabdrücke (6 Face Sensation Impressions), 1979

and naming does something become real. The same is true for the real Body Sensation that I mean. Painting should not be a swindle."[27]

Between 1978 and 1980, she created a series of drawings and watercolors, which she first referred to in her journal as instructive pictures but later as Awareness Pictures, sometimes even as Retinal Pictures. Usually, she divided the paper into rectangles reminiscent of film frames or comic panels. One of her earliest attempts was titled *If You Close Your Eyes*. Below this, she wrote in her Austrian English: "If you close your eyes and concentrate on what would appear

on your retina, there are no images coming, only stripes or circles of shadows, produced by the light and shadows of the environment. If the concentration diminishes, there might come up some shapier forms."

Lassnig drew several such Awareness Pictures on the subject of "dog." On one of these sheets, she wrote, "These investigations are less artwork, more scientific work." She tried to capture what appeared in her mind's eye when she imagined a dog. In the first frame, she drew a spotted something and noted: "really only spots." As a child, she had longed for a spotted dog, so it was obvious that scraps of memory of this idle wish were the first to appear in her mind's eye. In the second frame, indistinct dog feet were added. In the third frame, a "thicket of ears and tails." Then, dog sketches appeared in which she doubted whether she had really seen them in her imagination or only remembered or evoked them. On another sheet of this kind, she once again stated firmly: "The truth is that I can't see anything with my eyes closed. At least not willfully." In one frame, she outlined a horse's head: "My image of the dog is playing tricks on me." In another frame, four shaky lines can be seen: "Disobedient image of a dog." For Wiener, the sketch with the thicket of ears and tails was particularly important: "For me, that has become a technical term. Thicket, that's a phase of imagining, which everybody knows very well, but hasn't ever been described in the literature." He used Lassnig's term to describe the beginning of imagining. When one tries to imagine an object or an animal, one has at first a few rapidly changing, quasi-visual impressions: "For this phase I borrowed the word thicket from her, because it's very fitting."[28]

On numerous Awareness Pictures, Lassnig noted: "According to instructions from Oswald Wiener." Wiener, for example, wanted to know what was going on when she imagined a face. "I asked her questions. In the beginning she said: Images? No, she doesn't see anything! She knows how the face is." He couldn't believe it at the time: "I went through the same old story. I repeated the mistakes that everyone who starts to reflect about it makes. I was very much inclined to assume that there was something visual involved in imagining." Lassnig continued to contradict him. "Then she, which struck me oddly, let herself be convinced by me. At first, she said, she didn't see anything, she knew it. But then she let herself be so influenced by me that she said: Oh yeah, that's true." Wiener regretted this very much in retrospect because he later assumed Lassnig was right with her first answer. He believed his insistence on images did her more harm than good, not in the artistic but in the theoretical field. As late as 1999, Lassnig wrote: "I only later recognized that one has to have Imagination Pictures of all the sensations that one wants to portray in order to be able to depict them. To perceive sensations, you don't have to have any Imagination Pictures. Are they only produced by the desire to represent them?"[29]

In addition to Imagination Pictures, they also discussed Memory Pictures, whereby the boundaries between the two genres became blurred. Lassnig produced a watercolor on the subject of Oswald Wiener in exile at Exil. She wrote in her Lassniggian English: "First, I remember only the wallpaper by Dieter Roth; then, the beard stubble of Oswald Wiener appeared; then, his eyes looking sharp as he speaks about Popper. I saw his suspenders, then I remember him eating and speaking about Eccles. The green lampshades and Michel washing glasses in the sink. O. Wiener is the greatest. Have only parts of a whole before my inner eye." She continued producing Memory and also Imagination Pictures on the subject of love, among other things. In the frames, you can see sex scenes, her loft on Spring Street, and a sunset.

What fascinated Wiener most were works to which he contributed nothing at all, namely her Face-Sensation Impressions: "Superficially seen, this is simply an abstract painting, quite pleasing." But there is a lot more to it, as was clear to Wiener. "She invented these things, the sensation of tension. When she spoke of it, I immediately recognized that it was a very good concept, a clever thought," he remembered enthusiastically.[30] "For me, this is a point where she really entered uncharted territory. To my knowledge, nobody before her had tried to do this."[31] He said he hadn't provided any input but only struggled in his essays for her exhibition catalogs to describe what Lassnig had done. She had always strongly wanted Wiener to comment on her work. He wrote, among other things: "Her work is at the same time a first-ever inventory and the invention of a depiction code. She has a rare talent for this and, as her further work shows, a prevailing inclination for this." In summary, he spoke of the originality and importance of Lassnig's research: "I know of no program that's more contemporary."[32]

Back in New York: *Woman Power* and a professorship in Vienna

One of Lassnig's Awareness Pictures, *The Word America … (Beim Wort Amerika …)* from 1979, shows fragments of the American flag, a big ship, the skyline of New York, and sketches of people. She wrote: "Actually, you can't do that at all: observe yourself, observe what you're currently looking at, and at the same time focus on the image the word evokes! For the word 'America' I saw almost only map pictures, star-striped or blood-stained. Letters combined with shreds of pictures: AM AM …. AM …. I won't let myself be talked into anything, therefore the lousy result. Or do I have a disturbed relationship to America?" She later crossed out the word "disturbed" and wrote in fine pencil below it the word "abstract." Whatever she thought about the US, her fellowship in Berlin was coming to an end, and it was time to return to New York.

In the meantime, a lot had changed there and Lassnig felt out of place. She had lost the loft on Spring Street in SoHo. Although she had long complained

Woman Power, 1979

about the local circumstances, including the noise off the street and from neighboring apartments, she still experienced the loss of her flat as a catastrophe. She blamed her roommate, Olga Spiegel, for not having paid the rent although Lassnig had left extra money for it. That was the reason she gave for their being thrown out. Spiegel told a different story: SoHo was getting hipper and hipper, gentrification had reached a rapid pace, and the homeowner wanted to get everyone out of the building, including the two ladies. Spiegel said that Lassnig hadn't understood what was happening because she wasn't in New York at the time. When Lassnig then appeared at the scheduled trial and the two women were each offered 2,000 dollars as compensation, Lassnig agreed to this bad deal, even though Spiegel was against it. What really happened can't be clarified today. When Lassnig felt betrayed by someone, rightly or wrongly, reconciliation was no longer possible. Lassnig lost the loft and never spoke to Spiegel again.

Untitled watercolor, New York, ca. 1979

 For the first few weeks after her return from Berlin, Silvianna Goldsmith let Lassnig stay in her 26th-floor loft on 18th Street. Goldsmith's studio loft was separate from her apartment. Lassnig soon found an apartment in public housing on First Avenue between Second and Third Streets back in the East Village, fewer than ten minutes away from her old address on Avenue B. This time, she lived on the 13th floor of a high-rise. Lassnig was so impressed by the views from her new place and Goldsmith's that in later interviews she sometimes maintained she had lived on the 30th floor. Even on the 13th floor, however, the otherwise low-built East Village offered a spectacular panorama of the distant skyscrapers of downtown and midtown Manhattan. Thrilled, Lassnig captured this in a fabulous series of watercolors. She wrote to her friend Hilde Absalon: "Dearest Hilde, wouldn't you like to come over while I'm still here? You can live with me. The view from my window alone is worth the trip. Painted a dozen watercolors that Dr. Zambo (Heike Curtze's husband, who runs the gallery with her) is ecstatic about, but I can't do much landscape, it bores me."[33]

In this letter, Lassnig was referring to the prestigious new gallery owner she had recently found, who had locations both in Vienna and Düsseldorf. In the fall of 1979, Lassnig exhibited some of her animal paintings and her Grunewald series of trees at both galleries. As was the general trend in those years, the Viennese reviews of her exhibitions were extremely positive. Although this pleased Lassnig, it also stressed her out: "Various recent newspaper articles have hyped me so much that I still have to cope with it."[34]

From her high-rise, she not only did cityscapes but also her famous painting *Woman Power*, which depicts her as a mixture of King Kong and Superwoman walking down the avenues high above miniature skyscrapers. Lassnig had an ambivalent relationship to this painting. In 1996, she said the obvious: "Yes, that is somewhat a symbol of feminism."[35] When Jörg Heiser interviewed her ten years later for the art magazine *Frieze*, she said, "Oh please, that's my least favorite of all." When Heiser—in astonishment—asked why, Lassnig answered, "This is my most expensive picture and my silliest."[36] Indeed, the painting attained a record price of more than 2.2 million schillings (approximately $200,000) in 2000. Lassnig was annoyed that paintings of this kind—once again with an appealing title—were selling so well, while others weren't. Others were much more important to her and, in contrast to *Woman Power*, were Body Awareness paintings, as she explained to Heiser.

"Woman power" was also involved when Lassnig had to make a life-changing decision: in 1979, she accepted a professorship at the University of Applied Arts in Vienna. This option had been discussed for the first time in 1976 when the Action Committee of Female Artists in Vienna wrote an open letter: "We recommend Maria Lassnig for a full professorship at an art university because we do not want a token woman, but one who is at the top of her field, and that is the case with Maria Lassnig."[37] The artists involved were Edda Seidl-Reiter, Christa Hauer, Linda Christanell, Doris Lötsch, Martha Jungwirth, Helga Philipp, Erika Ebner, Doris Reitter, and Angelika Kaufmann. Lassnig was deeply moved and shocked at the same time. In the spring of 1976, she wrote to Absalon: "I was overjoyed by the news about the professorship, but it also worried me a bit. What if it comes true? It would mean leaving America, and that's not an easy decision." She added, "Dear Hilde, please tell the artists who recommended me that I am touched and honored by their proposal and that I hope it will come true, if not for me, then for someone else."[38] It took four more years until she assumed the position in Vienna.

In 1978, she received a letter from Peter Gorsen, who asked her to apply for a professorship at the Vienna University of Applied Arts. She barely got herself to do it, got all worked up, but eventually sent her application: "That decision was horrible. I felt very bad, then I thought, try it, you can still run away if you're

not happy there—But now I almost regret having submitted the application. I already miss New York. I don't even know if I will be able to flee if I can't bear it anymore."[39] Lassnig's nerves were shot. She wavered back and forth whether she wanted the professorship or not.

Then bad news came from Vienna. The plan was not to put her in the highest salary bracket or give her retirement benefits. For Lassnig, it was clear that nothing would come of it now. "When I declined—because I would be stupid to agree to this without a pension," she wrote, "on the one hand, I was sad (because it was degrading and I was also looking forward to Vienna, and to finally having more money), but on the other hand, I suddenly had energy again to work and after a long break began a larger oil painting." Both Oswald Oberhuber, president of the Vienna University of Applied Arts since 1979, and Hans Hollein, Austrian architect and professor at the university, wanted Lassnig to be appointed. The artist Adolf Frohner visited Lassnig in New York at the time. Frohner himself had been a professor at the same university since 1972. He asked her if she would accept the position with retirement benefits, which Lassnig agreed to: "Now he doesn't respond anymore."[40] In fact, Lassnig was then sixty, at an age when other women in Austria had to retire. She wrote: "I would like to return to Austria, preferably to Carinthia and hole myself up there because when I look in the mirror, I understand why I've lost all my male friends recently. I've gotten old and wrinkly. Understandable that they do not want to have an old professor. Best I return to the grave." However, Frohner eventually responded. Federal Minister of Science and Research Hertha Firnberg, who was engaged in feminist politics, asked to have a word with Lassnig in Vienna. During her appointment with Firnberg, Lassnig sent ambivalent signals, as she herself knew perfectly well: "But I seem to have made such a depressed and insecure impression on the minister and her gentlemen. I had a bout of toothache in the Ministry just then," she wrote to Absalon, "and then I wasn't sure if I should or shouldn't."[41] Firnberg called her several times in New York, often in the middle of the night because Firnberg didn't bother to think about the time difference between New York and Vienna. Lassnig was still making a fuss: "I know that the women's group and Firnberg have good intentions—they don't realize they are almost destroying me with this offer." Her future scenarios illustrate how torn she felt: "For a moment, I thought about going back to Berlin (forever), but there were too many 'buts' (too many pubs, too little sun)."[42] Eventually, she came to the conclusion that she wanted the professorship despite all her associated fears.

Since her return from Berlin, she no longer felt at home in New York. Even in her high-rise on First Avenue, she suffered horribly again from the noise: "I wear earplugs all day long here and am still so tense that I wake up with heart palpitations."[43] And although she had hardly felt limited by the foreign language

at the beginning of her time in New York, now, after more than ten years, she had become aware of her shortcomings as a non-native speaker. The very first time she stayed the whole summer in hot and humid New York was 1979. She wrote: "Here in America, where I can't express myself well, that is, I don't have all the necessary words at hand, here my thoughts are without words! But I have thoughts!"[44] She complained that many friends had withdrawn from contact during her absence. The conflict with Spiegel made it difficult for Lassnig to continue attending meetings of the Women Artist Filmmakers. With the exception of Goldsmith, the filmmakers got on her nerves. The art scene didn't satisfy her either: "Tried once again to show my catalogs to the galleries. They are usually very impressed but say: This is European intellectualism and we can't sell that."[45] In the end, she had also gotten older. She had no pension or health insurance in New York. Just before the Berlin scholarship, she had injured her foot in a fall and had to pay $1,200 for the outpatient treatment: "I didn't know that being sick in New York is so expensive."[46]

Another of the many good reasons to dive into the next big adventure of her life—granting young people an understanding of painting.

Painting is proof of love for the world.[1]

9 Professor Lassnig
1980–89

In 1983, Lassnig painted *Chain of Tradition* (*Traditionskette*), a monumental work that made it clear where she saw herself in art history. Velázquez is the first link in the chain. Dressed in Spanish court attire, he is finishing the background in the painting. Standing on the pedestal in front of him is a bust of Munch, whose hand rests on the shoulders of van Gogh, recognizable by the straw hat and bandage he has wrapped around his head after his self-inflicted ear injury. Van Gogh in turn has put his hand protectively on the shoulder of the naked Maria Lassnig, who is kneeling on the floor in the foreground. She is not yet standing on a pedestal, but the great masters behind her give her power for her work and accept her as their successor, even if the world may not have grasped this yet. In her journal she mentioned other artist heroes whose heir she considered herself to be: "I am a female Manet-Angelo."[2] Or: "I am the Lady Picasso."[3]

In the 1980s, Lassnig's life radically changed. After spending two decades abroad, she returned to Austria in early 1980. While she had lived and worked under the most difficult conditions and had chronically lacked money, she now had a good and steady income. Up to this point, she had spent most of her time in solitude and devoted herself exclusively to her art. Now, she had to regularly stand in front of students. Just before Lassnig took up her professorship in the autumn of 1980, she was, for the first time, invited to one of the most important international exhibitions. Together with Valie Export, she represented Austria at the Venice Biennale in the summer of 1980, followed by documenta in Kassel, Germany, in 1982, and her first major retrospective in 1985, which was shown not only in Vienna but also in Düsseldorf, Nuremberg, and Klagenfurt. And there was one more thing that would give Lassnig a boost in this decade: painting, which had been declared dead many times, was experiencing a revival that was hardly considered possible.

Biennale in Venice, documenta in Kassel, and the return of painting

Living in New York, Lassnig was familiar with late-night calls from Austria; Hertha Firnberg's major feat was to prod her to recognize the benefits of a professorship. Nevertheless, Lassnig was surprised right before Christmas 1979 when once again at three o'clock in the morning, the telephone rang, and she was invited to the Venice Biennale. In the late 1970s, the women's movement had finally reached Austria, and thanks to it, Lassnig received a professorship in 1980, and in the same year, two women were sent to Venice for the first time. In earlier

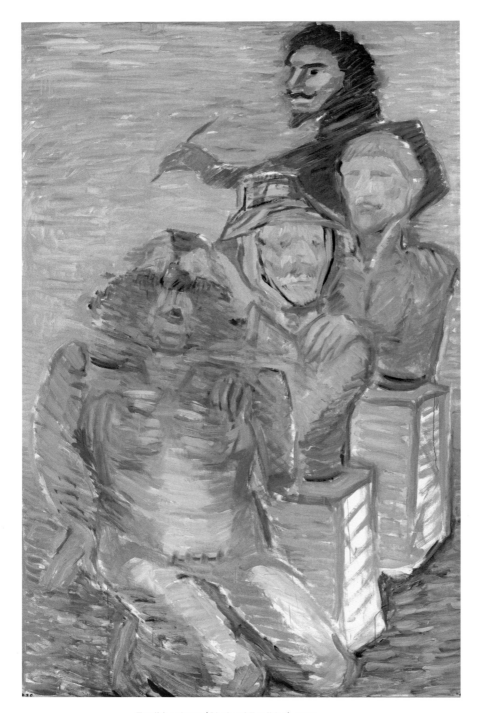

Traditionskette (Chain of Tradition), 1983

Professor Lassnig

decades, there had occasionally been women artists in the Biennale's Austrian Pavilion but only in the context of larger group exhibitions.[4] This time "only" two women would represent contemporary Austrian art: a sensation! There was criticism nonetheless. The architect and cultural journalist Jan Tabor, for example, suggested that Lassnig should have been exhibited alone and that one of the following Biennale shows be dedicated to Export: "Both artists deserve it. In this case, double isn't better; it's half as good."[5] With a few exceptions, it can be argued that it had been common practice so far to show either two or more artists together. In 1964, Herbert Boeckl and Alfred Hrdlicka represented Austria; in 1968, Josef Mikl and Roland Goeschl; in 1972, Hans Hollein and Oswald Oberhuber. Only twice before 1980 were there individual exhibitions, Gustav Klimt in 1910 and Arnulf Rainer—of all people—in 1978. In other cases, either two or more artists were presented at the same time. Now, according to the spirit of the age, two women would at last be the center of attention. Considering the decades of disregard for female artists, it would have actually been a clearer statement to simply dedicate two Biennale shows one after the other to each individual woman. Up until Renate Bertlmann participated in the 2019 Biennale, Austria had not managed to send one female artist to Venice on her own, whereas from 1980 onward, quite a few men had, as a matter of course, been given individual exhibitions, among them Walter Pichler, Franz West, Bruno Gironcoli, Hans Schabus, and Heimo Zobernig.

The two art commissioners who made the selection in 1980 were the Austrian architect Hans Hollein and the art historian Werner Hofmann, then-director of the Hamburg Kunsthalle. Both had known Lassnig personally for many years. They exhibited a kind of mini-retrospective, beginning with her surrealist drawings from the late 1940s to her latest American paintings. In addition, seven of her films could be seen in a separate room. Hofmann composed the catalog text twenty years after writing about Lassnig on the occasion of her first solo exhibition at the St. Stephen's Gallery. Even more than Peter Gorsen had in his text on Lassnig's Berlin show, Hofmann focused on the biological differences between the sexes when approaching Lassnig's work. For example, he read into her concept of Body Awareness "the core zone of female imaginative power," which has "a feeling for embryonic growth processes that man lacks."[6] He wondered whether creativity worked according to biological patterns, a question which Lassnig would have categorically denied. She had always insisted that Body Awareness was not about femininity, let alone biologically determined femininity.

Lassnig was proud to be invited, yet resonated with bitterness at the same time: "My God, I had to turn 60, so that I could finally make it to a Biennale. All the boys had made it a lot earlier. Well, I didn't open my mouth enough."[7] That

she had to share the pavilion with Valie Export was also a big nuisance for her. When she was interviewed several months before the opening, she only insinuated this: "Well, I'm pleased that women have finally made it to the Biennale, and especially Valie, who is twenty years my younger, has already got her chance. It could have come sooner for me, too."[8] In reality, however, it was difficult for Lassnig to get over her much younger colleague being allowed to exhibit with her at the same time. Above all, she considered their respective artistic approaches to be incompatible because she rejected Export's art as ostensibly political. Oswald Wiener remembered: "The whole circle in which Valie rose, Weibel, the Actionists—Maria tried to keep them at arm's length."[9]

In addition, Export's exhibition partly consisted of photographic documentations of her performances, and photos were an absolute no-no for Lassnig anyway. To Hofmann and Hollein, the main similarity these women shared was that they made their bodies the starting point of their work. The exhibition did not bring the two any closer, as Export recalled: "All I know is that she was quite grumpy at the time because my video installation was too loud for her."[10] Wiener spoke of Lassnig fighting a guerrilla war with Export: "The joint exhibition in Venice was catastrophic mood-wise."[11] Lassnig later regretted having let herself get involved in this. Other competitors were also represented in Venice: in the main pavilion of the Biennale, a whole room was dedicated to Arnulf Rainer, another to Günter Brus. Despite all her dissatisfaction, Lassnig enjoyed the Biennale and her own personal success a bit. When she returned to Vienna, she received a postcard that said: "Greetings from the Biennale! Unanimous opinion: you are the best!!!"[12] It was signed by several personalities, who unfortunately remain unknown to this day, as it has never been possible to attribute the signatures with certainty.

Lassnig's work fit into a trend that surprised Venice. Under the title *Aperto 80*, the star curators Harald Szeemann and Achille Bonito Oliva presented the large-format and colorful figurative painting of the so-called Neue Wilde (New Fauves / Neo-Expressionists). The critics spoke of the return of painting, which had been declared dead, and diagnosed a reawakened desire for narrative, myth, and the subjective and celebrated the new sensuality of art; there was finally something to look at again, and audiences sighed with relief. In reality, however, painting had never been dead. It had merely received less attention. The new "hunger for images," as it was repeatedly put, reacted to the expanded concept of art that was dominant in the 1970s and was propagated, among others, by Josef Beuys. Like the original avant-garde movements before the Second World War, Beuys wanted to combine art and life. Many artists of the 1970s tried to produce socially relevant art. In Arte Povera, cheap and everyday materials such as dirt, rags, or tree branches took the place of marble and oil paint. Concept art was no

longer interested in how something is done but understood art primarily as an idea or theory. Performances, installations, and video claimed to transcend traditional genres like painting and sculpture.

Now, however, people were once again enthusiastic about painting that took up the Expressionism of classical modernity. That painting was still remained a male domain was illustrated by the protagonists. In Italy, these were, for example, Sandro Chia, Mimmo Palladino, and Francesco Clemente. In Germany, there were, among many others, Rainer Fetting, Albert Oehlen, and Martin Kippenberger; in Austria, Hubert Schmalix, Siegfried Anzinger, and Alois Mosbacher. But even more established German artists who had been focusing on painting for a long time were getting a boost, thanks to Georg Baselitz, Jörg Immendorff, Anselm Kiefer, Markus Lüpertz, Sigmar Polke, and Gerhard Richter. After the Biennale, there were many more internationally acclaimed painting exhibitions, including a highly praised show in London, to which not a single female artist was invited.[13]

Lassnig got annoyed when she was compared to the New Fauves because that suggested she had jumped on a bandwagon, even though she had first practiced this allegedly new "fierce painting" back in the 1960s.[14] Once again, she felt confirmed that she was both too early and too late. But there were certainly artists who were willing to accept Lassnig as a role model. The Austrian New Fauves Schmalix, Mosbacher, and Anzinger emphasized how important Lassnig was for them because, despite the strongest headwinds, she had always insisted on painting. Schmalix said: "During this time, when I needed someone to hold on to, there was Maria Lassnig, who showed me that one can still paint today."[15] Schmalix, by the way, taught Lassnig's class as a guest professor during the 1986–87 academic year while Lassnig took a two-semester sabbatical. Hans Ulrich Obrist from Switzerland, later a star curator, recalled how he, as an art-loving seventeen-year-old on a visit to Vienna, canvassed the art studios of the then-young Austrian artists, from Hubert Schmalix to Herbert Brandl. When he asked if there was an Austrian equivalent to Louise Bourgeois, everyone told him unanimously: Maria Lassnig, of course.[16] Obrist then visited the artist for the first time in her studio. Many more encounters and intense collaboration on numerous projects followed in the 1990s. Among the museum directors, it was above all Wilfried Skreiner, director of the Neue Galerie in Graz, who always emphasized Lassnig's pioneering role in this new painting trend: "The painters of the 1950s avant-garde convey a continuity of painting, but they aren't the fathers. In their ranks, we find only one mother—Maria Lassnig."[17]

Lassnig recognized a definitive difference between her painting and the so-called New Fauves: "My starting point is definitely something mysterious which I try to elucidate, to unveil, to reveal, 'to realize,' to clarify. But the new

painters do it the other way around. They seek to veil a clear topic (which is reality), to mystify it through painting, to paint over it, to destroy it."[18] Indeed, the New Fauves tended to encrypt their content in private mythologies, and that was never Lassnig's agenda. When she increasingly referred to mythology, it was not to conceal anything but to make what she perceived even clearer.

Maria Lassnig at the University of Applied Arts, 1986

Documenta 7 in 1982 also focused on painting. Consequently, Lassnig was invited to exhibit five works in her own section.[19] Dutch museum director Rudi Fuchs, who continued to support Lassnig's international career into the 1990s, ran this exhibition. For him, this documenta was about liberating art from its political appropriation and giving it back its autonomy, its dignity as he put it. His exhibition was not underpinned by theoretical concepts but cultivated a poetic approach to art.

The New Fauves boom subsided quickly. Nonetheless, the new interest in painting enabled Lassnig to do some important networking for her future. In the 1980s, the path was laid for Lassnig's career to pick up speed in the following decades. That she was still curious and on the lookout as a sixty-year-old played a decisive role. Like no other artist of her generation, she reinvented herself over and over again and remained innovative. Peter Pakesch, who founded a gallery for young artists in Vienna in 1981 and frequently focused on painting, recalled that, of the well-established artists, Lassnig was one of the few who was interested in his gallery: "She was much more alert than the other Viennese of her generation because she came from New York, from a bigger world."[20]

In the late winter of 1980, Lassnig moved from New York back to Vienna to prepare for the Biennale and her master class. At first, she lived in her old studio in the Bräuhausgasse, where she had to go to the building stairwell to use the communal toilet and running water. She did not even have a telephone there. She made her various calls concerning the Biennale from a telephone booth. In the beginning, Lassnig was short on cash, but even after she got her regular salary, she could hardly get herself to stop scrimping and saving as she had in the past. She wished she could find free furniture on the street like she had in New York. She desperately asked her acquaintances how she could find a table in Vienna; they recommended Ikea.[21] Before Christmas 1980, Lassnig found an attic apartment in a fin de siècle building on Maxingstrasse 12 in Hietzing, which she expanded into a larger residential studio in the late 1980s. She spent the next

twenty-five years here until she could no longer get upstairs to the third floor and had to move to a studio with an elevator. Her windows faced a lush garden full of flowers with tall, old trees on the one side and, on the other, Schönbrunn Zoo, to which she soon received her own semi-private access through a back gate. The view from the terrace was wonderful. She was happy. She liked to hear the birds chirp but was bothered by the street noise, which for less sensitive people would have been negligible. The growling roars from the big cats in the zoo during the day and howling wolves at night were an illusion of the wild that Lassnig enjoyed. Nevertheless, she had new triple-paned windows installed to go easy on her hypersensitive ears.

White is pink, blue, or green—Lassnig's School of Seeing

In the winter semester of 1980, Lassnig began teaching her master class for design theory and experimental design, an unusual title for a painting class. It came into being because the chair was initially set up for Joseph Beuys, the superstar of the Actionists at the time, whose varied artistic activity from performance to installation was summarized as "experimental design." Beuys, however, changed his mind, and Lassnig was appointed to his position; the original, now misleading name of the class was retained. However, this title attracted some students, and although the main interest of the class was painting and, eventually, animated film as well, Lassnig's students distinguished themselves in their later careers with their diversity of media and genres. This was not Lassnig's original intention; her priority was painting. Although she personally opposed an expanded concept of art, over time she accepted that many of her students were enthusiastic about it.

In the summer before her first semester, she prepared herself carefully for the lessons and filled entire notebooks with ideas. At the same time, she was plagued by worries: the last time she had stood in front of a class was 1940 in a remote countryside primary school, and that had been painful enough. What should she tell the young people? It was not enough to share her own approach to painting. She would have to teach other contemporary viewpoints as well. Could she still find time for her own work, or would she transform into a "Sunday painter," as she feared?[22] Like everything else in her life, Lassnig took the new challenge very seriously. Many artists who teach a class at an art university take this task more casually. Some structure their courses in blocks and come for one week at the beginning and at the end of each semester. Others devote their time to their students once a month. Not Lassnig—she was in her master class every day for the first few semesters.

In the first year, about thirty candidates applied, and in the following year, there were already more than twice as many. She accepted nine students.

There were many reasons for wanting to join her class. For many young women, it was the sensational, first-time opportunity to study with a female professor and thus with a role model. Now there was finally a female painter who was teaching this male-dominated subject and, on top of that, a fascinating woman who addressed her body as a topic. Others preferred Lassnig because she had just come back from New York, the art mecca par excellence. Some had seen her impressive paintings at the Venice Biennale. However, some happened to get into her class without ever having heard her name—they simply wanted to study painting.

The first encounter with Lassnig was surprising for many. "I was really blown away: she was dressed in white, had white sneakers, and looked quite different from Viennese women," recalled Ursula Hübner, who started in Lassnig's master class in 1981.[23] Some could tell from the first moment that they had found a kindred spirit in Lassnig, like Mara Mattuschka, who began studying with Lassnig in 1982. After the entrance exam, Lassnig asked her what she intended to do. Mattuschka answered: "Paint, of course!" Lassnig said: "Okay!" Mattuschka felt she had made a pact at this moment. "I knew or felt: She is a nun, a fighter. I'm going into an arena that's brand new. That's idealism. That's all there is."[24] Mattuschka was convinced her real life had begun at that very moment. Forty years earlier, Lassnig had had similar feelings when she began studying at the Academy of Fine Arts under catastrophic political conditions but with the same desire to become a painter.

During the three-day entrance examination, the applicants had to draw portraits, paint nudes, and freely design and interpret a given topic, such as a poem by Hans Magnus Enzensberger, Ingeborg Bachmann, or Pablo Neruda. Those accepted found she ran a tight ship. To this day, Vienna has two art colleges: the venerable Academy of Fine Arts at Schillerplatz, which in the early 1980s had the bad reputation of being outdated, and the University of Applied Arts on Stubenring, which was then regarded as a haven of innovation and progress. Still, Lassnig's curriculum was precisely what many considered to be the epitome of conservative academe: a focus on drawing nudes and portraits, just as she herself had been taught at the Academy in the 1940s. She passed out photocopies of the following handwritten instructions: "I need to point out that during *the first three years of study*, you must undertake the head and nude study every day from 10:00 am to 1:00 pm to make any progress at all. Genius is diligence!" Further guidelines were followed by a final instruction: "I ask you to heed my appeal, and in the case that you don't, I must ask you to change your profession and not count on me for any support, advice, or consideration. Your master-class instructor, Maria Lassnig."[25] On another occasion, Lassnig put it in more poetic terms: "You must begin like a worker in a quarry, doing the hardest stone work, then like a

3. Übung: plastischer Automatismus (Third Exercise: Plastic Automatism), 1980s

watchmaker with precision work, and end like a bird that easily carries away its prey."[26] When a student came too late or missed class, there was an interrogation: "Where have you been? Why couldn't you catch an earlier tram? Are you sure you want to be a painter?"

For the first six months, students were only allowed to draw with pencil or charcoal, after which they painted in grayscale, and then finally with colors. For many, these strict guidelines were incomprehensible. That was not the teaching they expected from a cool New York artist. Not all of them followed Lassnig's rules. Mattuschka, for example, didn't draw but painted from the very beginning. Andreas Karner, on the other hand, wasn't interested in painting at all but only in drawing. Lassnig tolerated such deviations from some but not from others. One thing, however, she insisted upon for everyone: "First you have to learn to see."[27] That was her philosophy, as student Roland Schütz remembered: "That surprised me, as I thought I could already see." Lassnig saw herself in the tradition of Oskar Kokoschka, who had founded his international School of Seeing in Salzburg in 1953. She said, "You have to look. Once or twice is not enough. You have to look at it ten times, twenty times!"[28] She was convinced that realistic drawing had to be perfectly mastered in order to overcome it. Lassnig knew exactly how controversial this was with young people and, once again, shared a handwritten worksheet: "The study of nature (which is denounced as 'academic') is always contrasted with 'experimental' or 'free' work, but I do not see any opposites there. Studying nature can also be experimental because it's a search for 'reality.' What is real about reality for you? That is, what appears to you to be a true problem of reality that is worthy of portrayal? And what's real for you at all?"[29] Even though many resisted at first, most of them agreed she was right in retrospect. As boring as it may have seemed in the beginning to focus on the rudimentary, it developed its very own allure over time.

Lassnig didn't just demand naturalism and realism from her students though. One day, she draped a crumpled cloth landscape. She provided a handout once again in which she encouraged her students not to interpret the shadows in the sheets as coincidences but to take them seriously as forms "that have a specific volume just like a face, otherwise it will turn into coleslaw." The first part of the task was to capture the cloth landscape as realistically as possible. In the

second part, the students were given free rein to their imagination: "Strange things emerge from the folds and hills, realistic or abstract (a finger, a dead man, a TV antenna, thorns etc., a rainbow, ... a square). Surprise us! It should become a beautiful sheet of paper!"[30]

Lassnig tested all the exercises herself at home and wrote detailed instructions. For example, she assigned the task of first looking at a face very carefully, and then she tied blindfolds on the students and had them draw without looking. Another time she recommended they draw with their nondominant hand or with their backs to the sketch paper. Sometimes she provided a motto for the whole semester, such as "man and beast," a topic she herself dealt with again and again and that many students enthusiastically took up. Another task was: "Imagine being the sole survivor of a plane crash. You encounter primitive indigenous people in the jungle and can't communicate with anything other than pictures scratched in the sand. Ask them in pictures for a horse or camel to get to the next village, for food and shelter, and thank them for it. How would you draw this?"[31]

Das Rehlein / Rehlein Tschernobyl (The Fawn / Chernobyl Fawn), 1986

After only permitting pencil and charcoal and then the first painting trials in grayscale, Lassnig finally allowed her students to use colors. That this topic was important to a master of color is obvious. Color had been neglected in recent decades, she let her class know, "except for when the Actionists smear it in each other's faces." Then she made a hopeful appeal to her protégés: "Whether we enter a new renaissance of color depends on us, on you!"[32]

Since Lassnig was convinced that the more colors one uses, the greater the difficulties become, she initially only allowed a reduced palette. As Ursula Hübner recounted, "She gave us five tubes: terra pozzuoli [an ochre tone], Van Dyck brown, ultramarine blue, chrome-oxide green, and white. Some were very disappointed that they were not allowed to use the entire color palette."[33] Most, however, quickly came to understand how instructive it was to manage with less and still create an interesting composition. Limiting the choice of colors had a side effect, however; outsiders got the impression that everyone in Lassnig's class painted the same way, like her. Turquoise and pink soon popped up among the students—Lassnig's "candy colors." Madder lake, a purplish red from which

the typical Lassnig pink is created by mixing it with white, was also especially popular with her students. In addition, many—again like Lassnig—dealt with the body. She taught them that artworks become interesting when they connect things that do not seem to go together, such as rough bodies and delicate pastel tones. However, those who used colors that did not suit Lassnig experienced her displeasure. When Ursula Hübner, today herself a professor of painting, deviated from the prescribed palette and used an intense dark blue, Lassnig got angry. To others in the class, she said: "We should take dark blue away from her."[34] However, in the end, she accepted the individual interests of her students. Despite all her criticism about things that didn't suit her, she allowed for a great deal of freedom as the variety of artistic approaches illustrated.[35]

One of the most difficult and legendary tasks that nearly everyone who was there rhapsodized or complained about, depending on their perspective, was when Lassnig brought along a white tablecloth and placed a variety of white objects on it. Gerlinde Thuma recalled: "The white cube on a white background, that was still possible because you had wonderful surfaces. But the egg!" It was about capturing the colors and subtle shades, even in a white object. White is not simply white but also pink, blue, or green. In Lassnig's eyes, some ambitious students overdid it: "These aren't Easter eggs. Where do you see those colors?"[36] This was also a real challenge for Andreas Karner: "I became desperate. Nowadays, I'd be interested in that, but as a young person you have zero interest in something like that; you'd rather break the eggs and film that!"[37] Nevertheless, this exercise was one of those lessons for life: decades later, Lassnig's former students can still remember precisely how all of a sudden in white-on-white, the world of colors began to come alive.

Rainer and me: "peppercorn" and "manna"

Toward the end of Lassnig's first year of teaching, there was a scandal. The professor dismissed Birgit Jürgenssen, who had been her assistant until then. Jürgenssen was just over thirty at the time and was a self-confident, enthusiastic young artist and feminist. The two women were strong but contrary personalities, like cats and dogs. Conflicts of authority came about. Some students also suspected that Lassnig was jealous of Jürgenssen's comradery with them. Jürgenssen got on well with the young people and went on nightlong pub crawls with them through Vienna. Lassnig, in any case, was looking for an opportunity to get rid of her assistant and accused her of digging around in private papers or taking something and therefore canceled her contract. When the students heard about it, they took Jürgenssen's side and protested. In pamphlets, which they dropped from the balustrades to party guests at the great diploma ceremony in the Museum für Angewandte Kunst (Museum of Applied Arts), they demanded

that the assistant, who was "shot down in an infamous manner," be reinstated immediately.[38]

That didn't happen, and the students threatened to leave Lassnig's class. Some switched to Peter Weibel within the University of Applied Arts; others went together with Jürgenssen to the Academy of Fine Arts, where she became—and a Hollywood script couldn't make the conflict any spicier—the assistant to Arnulf Rainer, of all things. In 1981, Rainer had received a professorship at the Academy, which was a double slight for Lassnig. Finally, she had managed to gain recognition in one field before her eternal adversary did, only for him to become a professor himself a year later, and at the venerable Academy of Fine Arts, which Lassnig secretly had always ranked higher than her own University of Applied Arts. Now Lassnig's assistant and even some of her students had defected to Rainer. She was desperate and determined to step down from her professorship, give up her retirement,

Freundinnen (Girl Friends), 1982–83

and withdraw. Hübner recalled how hopeful she had been when she arrived at the Angewandte (the University of Applied Arts) in late summer of 1981 to inquire about Lassnig's master class. Having recently discovered Lassnig's uniquely colorful work, she now absolutely wanted to study with this fascinating artist. But when she entered the art classroom, she was confronted with a sad scene. A few students sat around apathetically and told her that the class probably wouldn't take place. Thankfully, everything turned out differently. After long discussions, half of the students decided to stay with Lassnig, and in the autumn, she welcomed five new students from a huge number of applicants; Hübner was one of them.

When the semester began again, Lassnig started with the passive-aggressive question: "Wouldn't you all prefer to go to Rainer, too?"[39] Sometimes Lassnig slipped in remarks about Rainer in her lessons; for example, she said he worked destructively because he painted over paintings, whereas she approached things constructively. Furthermore, she advised her female students not to get involved with younger men—pointing out that she herself had had only bad experiences with that, with Rainer, among others. Despite this, she highly respected Rainer as an artist and took his advice seriously. One example: when Robert Fleck was

planning a major exhibition on contemporary Austrian art, he invited Lassnig, among others, and she committed to participating. Later, however, Fleck received her letter of withdrawal. After some detective work, Fleck found out that Rainer had advised her not to attend because Christian Ludwig Attersee, whom both of them appreciated at that time, had not been invited. Although Fleck eventually succeeded in persuading Lassnig to take part, the anecdote illustrates how important Rainer's opinion was to Lassnig.[40] In 1984 she wrote in her journal: "We sat opposite each other at a long artists' table yesterday, and it was symbolic. The two of us are the cornerstones of Austrian art, he the peppercorn and chili pepper up Austrian art's ass, and me the moral support and manna of Austrian art, Rainer and me."[41] Later, Lassnig crossed out both "manna" and "Rainer and me." Rainer respected Lassnig just as much, also as a teacher. When some of her students attended summer courses with him, he realized they were better and more diligent than all the others.[42]

Lassnig soon found a new assistant, Ruth Labak, a young artist, art educator, and feminist, who in 1979 with Peter Gorsen as her adviser had written her final paper about Lassnig, which was a trailblazing act. Like the students, she also had to take an entrance exam and prove to Lassnig that she could paint a nude. Labak had a personality completely different from Jürgenssen, and their harmonious and productive collaboration lasted nine years until Lassnig's retirement in 1989. Labak also got along well with the students and played an important role as mediator between the master painter and her class. She cushioned the blow of many things, maintained a relaxed atmosphere, and supported Lassnig in all areas, from how to use the office telephone to organizing excursions to evaluating students. Labak accepted that Lassnig lived in her own world: "She was uniquely awkward in practical matters." Labak found the right way to deal with her and successfully avoided giving the impression of wanting to influence her in any way. Lassnig already had an almost paranoid fear of being manipulated. When Labak found a particularly good candidate during the entrance exam, she always kept it to herself: "I don't know if we should take this one." Then she could be sure of Lassnig's reaction: "Why not, he's good!"[43] Not only did Labak accept Lassnig's quirks as the peculiarities of an extraordinary artist, she also found her complex, contradictory, and intense personality exciting and therefore enjoyed every day they worked together. In the last year of Lassnig's professorship, she designed an exhibition that included a catalog presenting works by Lassnig's current and former students.[44]

Around 1982–83, Lassnig painted *Girl Friends (Freundinnen)*. She literally put herself on a pedestal, yet the bust tapers to a point at the bottom and has to be supported. Holding her up on the left is her old, loyal friend Hilde Absalon, whom she had known since the 1950s and who had supported her extensively

during her time in New York. On the right side, Ruth Labak guarantees that the bust doesn't topple from the pedestal. Concern for the unstable artist, who urgently needs their help, is written on the faces of the two women: that is how she saw her friends and that is how Lassnig saw herself. Labak hadn't known about the painting and was amazed when she first discovered it at Lassnig's grand retrospective exhibition in 1985.

Animation film studio: "Now we were cool"

Lassnig planned to set up an animated film studio in her master class. In addition to painting, she wanted her students to experiment with animation as she herself had done in New York. In order not to overload herself, she posted a new assistant position for this. She left it to her class to select a suitable candidate from among the applicants. They decided on the all-rounder artist Hubert Sielecki: a stroke of luck.[45] In 1982, the "smallest film studio in the world"[46] went into action; it took up no more than six square meters of Labak's and Sielecki's office: "In the beginning, apart from a 16mm Bolex camera, there was nothing else,"[47] Sielecki said. In the following months, he equipped the studio with the bare necessities. He built an animation table out of shelves. He begged, borrowed, or stole a single-frame monitor, control box, power panels, and so on. At first, Lassnig only wanted practice films without sound to be created here. It was not about her students becoming filmmakers but for them to expand their drawing and painting skills via motion pictures. But from the beginning, Sielecki also focused on sound. Due to the significantly higher costs, he and Lassnig had a talk. Sielecki prevailed and created his own small recording studio, for which he used a completely new technique at that time, making it possible to work with four tracks and record text, music, and sound separately. With today's computer programs, we take this for granted, but back then, it was unique for a film studio at an art university.[48] Austrian State Television's (ORF) film lab provided expensive film material for free and even developed the footage: from today's perspective, a virtually unimaginable paradise. The students brought their film reels to the ORF Center at night and picked them up again the next day.

Now the "experimental design" in the title of the master class was justified even though Lassnig continued to give absolute priority to painting. Many students were excited about the opportunity to work with film. Lassnig didn't occupy herself much with the animation studio and left the direction to Sielecki. Nevertheless, her initiative and impulses from New York were crucial for the emergence of this innovative scene of experimental filmmakers at the University of Applied Arts. The teeny-weeny studio, with its machines in a confined space reminiscent of a cockpit, developed into a creative hotspot: "The phone was ringing off the hook incessantly. At the same time the camera was in there, and the

recording studio, and a hell of a lot of business was going on around the clock. We did more than an hour of film in a year and showed it everywhere, of course. And that was pretty well known back then. It was all boiling over with incredible activity. There was a very intense group dynamic there,"[49] Sielecki said. The students noticed that they were in tune with the times: "Animated film brought momentum and a spirit of optimism," Gerlinde Thuma remembered.[50] For five years, it was the only teaching studio for animated film in all of Austria. The fact that many students combined painting and animation was also unique.

Lassnig herself was surprised by the film studio's success. During the screenings at the Angewandte, the lecture hall was packed with a thrilled audience. When there were cheers or laughter, Lassnig looked puzzledly at her student Mara Mattuschka, who would later become one of the most important Austrian experimental filmmakers, and asked: "Are the people drunk?"[51] Film festivals and TV stations took notice of Lassnig's and Sielecki's animated film studio. In 1984, the Berlin Film Festival invited the entire class to present that year's work at its International Forum of New Cinema. In 1987, sixteen students worked together on *The ABCs of a Happy Life* (*Das 1×1 des glücklichen Lebens*), a commissioned work by ORF. In 1988, the studio received the Viennale's Film Prize. Lassnig's students had been viewed as conservative in the eyes of Weibel's or Oberhuber's students, but that changed abruptly: "From then on, Lassnig's class was avant-garde and cool; something like this had never happened in Vienna before," [52] Hübner said. The theatrical parties that took place year after year in Lassnig's master class were legendary "major ragers" for the entire University of Applied Arts. The students created elaborate decorations and costumes, performed revues, and even Lassnig participated in the performances, as the Statue of Liberty, for example.

Not everyone in the painting master class made films, but many did. Originally, students were accepted for painting and could also make animation films if they wished. Later, students were also directly accepted into the animation class, which became independent over time. When Lassnig's class relocated from the main building of the Angewandte on Stubenring in 1987 to Salzgries 14 in the center of Vienna, the separation became physically evident. The painting class was on the sixth and the animation studio on the second floor. Although Lassnig appreciated that the painters also dealt with film, sometimes she insisted on a strict division; students who came to draw on the sixth floor she sent back down to the second: "You have no business here. You are in the animation class. Keep working on your animated films!" [53]

While Lassnig's painting students were pleased with the new location because there was finally more space, moving out initially brought major disadvantages for the animated film class. The room reverberated so much that sound

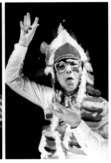

recordings were out of the question. Before the final decision was made, Lassnig visited the potential new premises with her class. A scene took place that was re-called many years later in anecdotes: Lassnig first scrutinized the classroom with her gaze, then asked one of the students to stand by the window and X-rayed him with her eyes. Nobody knew what was going on, least of all the person affected. After what felt like a quarter of an hour, Lassnig shook her head: "We won't take these rooms, there is yellow radiation here." What? From where? Nobody knew what Lassnig was talking about. "Well, from the yellow house opposite. It's re-flecting, can't you see that?" The house mentioned by Lassnig was not "opposite" at all but far away; nobody else could perceive a yellow reflection in the rooms. To everyone's relief, Lassnig finally changed her mind and the class moved to the new address. The yellow radiation was no longer spoken about.

Maria Lassnig Kantate (The Ballad of Maria Lassnig), production stills, 1992

Lassnig made her last film after she retired. Between 1991 and 1992, in a laborious 18 months together with Sielecki, she worked on her legendary *The Ballad of Maria Lassnig (Maria Lassnig Kantate)*, in which the seventy-three-year-old looked back upon her life while dressed up in a wide variety of costumes ranging from sailor to cowgirl to punk rocker. Sielecki, who produced the film, had the idea to model it on music videos. In her final New York years, Lassnig had jotted down stanzas about her life. She revised these and added new life chapters. She dreamed up costumes for each life phase and drew background scenes. Sielecki made the film with 16mm cameras, combined animation and real film in a congenial way, and played the hurdy-gurdy and flute while Lassnig sang her self-deprecating and touching autobiographical street ballad with the much-cited refrain: "I know it's art so dear that keeps me young and clear. Art made me thirsty, now fulfillment's near!" When asked why she made this film, she said she was feeling down at the time and wanted to "catapult herself out of depression."[54] One can understand Lassnig's remark quite well: the film conveys so much humor and lightness despite all the pain and sadness.

Child substitutes and *Forced Speech*

Lassnig succeeded in selecting the right people for her class: lots of individualists who nonetheless fit together well. Energy fields among the students generated a creative and productive atmosphere. When Lassnig went to Carinthia at the end of the academic year, she was relieved to finally find peace and time for herself, yet simultaneously she felt lonely and longed for her protégés: "My children, I often say, I am without a family, without a husband, without anything. Sometimes I feel like a mother among the students. If I don't teach, my breast milk hurts."[55] She used the German formal *Sie* with her students but gave many of them affectionate nicknames. Hans Werner Poschauko, her highly gifted favorite, she called her "Painting Prince." With Andreas Karner, who, like her, came from the deep Carinthian province, she used the cute and diminutive "Anderl" from the very start: "She adopted me as a country boy, as if she had motherly feelings," said Karner. And: "She wanted to be loved by us, that we would somehow become family. However, she was more than awkward in going about it."[56]

The students sensed how close Lassnig wanted to be, but at the same time they experienced her as distant. Time and again, the young people tried to do more to establish intimacy with her. The almost obsessive goal was to be invited to Lassnig's studio in Maxingstrasse. Lassnig long balked at this idea, using the argument that she did not want to show them too much of her own work so that they wouldn't become her epigones. Eventually, she gave in. Lassnig baked an apple strudel, and the visit left a lasting impression on the class. Lassnig even shared her unfinished work—a special show of trust. Everyone was thrilled to finally get to know the artist in her everyday life and working environment. They were astonished by the sparse nature of her studio, where there was nothing that could distract her from her work: "That's why she was so shy to let us in there. It really felt like she still felt our vibrations, a restlessness, even when we were gone,"[57] Gerlinde Thuma recalled. As unapproachable as Lassnig sometimes seemed, she was hungry for amorous details about her students. Many had the feeling she voyeuristically visualized these love affairs in her inner eye. At the same time, she reacted with suspicion and discouraged love affairs because she thought the energy for work would be lacking if it flowed completely into either love or lovesickness.

Among the most intense experiences the class had was an excursion to Tuscany in the spring of 1985, organized

Maria Lassnig in her studio in Vienna's Maxingstrasse (photo: Kurt-Michael Westermann)

by Labak. For one month, she rented a remote former farm near Vicchio. Lassnig visited for about ten days and then traveled to a spa in Montecatini Terme. Tuscany was about working outdoors, a new challenge for the students. Lassnig herself produced numerous watercolors there. In the evenings, they all sat together and played creative drawing games, such as the surrealist Cadavre Exquis (Exquisite Corpse), in which a folded piece of paper was passed on in turn and a common composition was created without knowing what the others had drawn before.

Toskanaengel I (Angel of Tuscany I), 1985

Lassnig loved her students, but she could also hurt them deeply. She reacted most sensitively to any critical word, yet she could hardly ascertain what she triggered in others with her own words; she was slightly autistic in this respect. "I never knew anyone so lacking in self-censorship, who said everything that came to her mind,"[58] recalled Labak. Lassnig was often perplexed by the reactions of others. Her diary was full of desperate reports that she had once again been too undiplomatic, not only to her students but also to fellow artists, friends, or gallery owners. She repeatedly offended people's sensibilities. "Maybe she suffered from that, too, and was very happy when one still loved her despite these shortcomings," Karner suspected.

Once, after seeing Karner torture himself for a week with a portrait that was not working out, Lassnig stepped up to his easel and with her thumb smudged both eyes, "spontaneously and full of anger," leaving two gray spots in their place. Karner was shocked. He experienced the worst feelings of failure and was just short of giving up. Another time, again about a portrait, she said to him: "In the time it takes you to paint a portrait, other people build an entire house!"[59] Karner took this constructively and wrote the phrase like a battle slogan on one of his works. A good decade later, long after his diploma, Lassnig's critique encouraged him to engage intensively and successfully with portraits. Through her paradoxical, sometimes very hurtful, sometimes strange reactions, she succeeded again and again in initiating something within the students and, at her best, igniting creative fireworks. In the worst case, however, some students felt so slighted that they left her class. For the students, it was always exciting to see how Lassnig entered the classroom: "Some were already trembling when she came through the door," Labak reminisced. When Lassnig was in a good mood, everything was wonderful. One way she indicated this was by placing coconut rum balls individually on the easels of her protégés—such cases were "the highlight of the week!"[60]

Sometimes Lassnig was afraid of her class, too. Her bad mood acted as a shield, as teaching placed an inordinate strain upon her. Several of her paintings attest to this, some of which she painted directly on-site in her studio at the University of Applied Arts in order to free herself from the burden by painting the stress out of herself in a virtual exorcism. *I Bear the Responsibility (Ich trage die Verantwortung)* from 1981 shows Lassnig with bent shoulders on which a heavy guy with a round belly and thick upper thighs sits—a symbol that everything literally weighed upon her shoulders, especially teaching young students art: "Performing a professorship is the worst violation that can happen to a freelance painter,"[61] she said. When she arrived in the morning, she locked herself in her office for a while first, took a deep breath, and then entered the classroom. Karner recalled: "Sometimes you got the feeling she had to force herself out of bed or the studio to teach the young oxen and cows something." [62]

She felt that stepping out in front of the class was like performing on-stage. *Forced Speech (Sprechzwang)* from 1980 illustrates how difficult it was for her to talk about art. With two fingers, she pulls her lower jaw down by the lips as if she must force herself to gag the words out, a brutal image. Lassnig also connected a film idea to this: "Somebody asks me something. I'm sitting mute and looking grumpy and profound. After a while, I slowly begin to force open my tightly pressed lips with the index fingers of both hands."[63] Her students repeatedly felt she was grumpy, especially when they dared to ask questions. Lassnig's answer to the admittedly naïve question of how one should paint hair is legendary: "Every single one!"[64] Lassnig usually reacted curtly, in amazement, or not at all. If it came to a dialogue, it went something like this: "Are there any key experiences in painting where a lightbulb goes on?" the student asked. Lassnig: "Of course there are!" Student: "Well, which ones for example? Can you name one for us?" Lassnig: "Oh, you'll

ch trage die Verant-
vortung (I Bear the
esponsibility), 1981

come up with these on your own."[65] Lassnig was right: everyone has to find their own artistic identity. Yet many felt confused by her reactions or feared they had asked something particularly stupid when she didn't respond at all. "Sometimes she came back three days later with a stack of books on the subject. Some of them had forgotten what they had asked by then,"[66] Gerlinde Thuma said. As aloof as Lassnig sometimes was, she took the young people seriously. She thought about where they currently were in their artistic development and tried, usually with some delay, to give an answer tailored to the respective person. Spontaneity wasn't her thing. While the students felt Lassnig didn't say anything, she had the opposite impression: "Beaten to a pulp by discussions with students."[67] Or: "I want to put a word-counting machine around my neck, so I know how much energy speaking requires."[68] Even in a letter to her old friend Silvianna Goldsmith, Lassnig complained, "I love my students, but they're very difficult, everything that is clear to me (color and form) must be explained over and over. They love big talks, and I don't."[69] She could barely manage to explain things comprehensibly; instead, she proclaimed everything like a prophet. "It was like a commandment from Moses,"[70] Karner smirked.

Sprechzwang (Forced Speech), 1980

Many students would have liked to have had more encouragement from her, more feedback, be it positive or critical. In the rare case Lassnig said something, it often wasn't particularly helpful. When Karner showed her a large colored chalk drawing on which he had dealt with the topic of death, Lassnig said: "But Anderl, you're a studly young guy with red cheeks, why are you doing this?"[71] Lassnig rarely gave practical tips. Sometimes she shared helpful information, explaining, for example, that if you want to continue working on an old painting, if you want to revive it, then the best solution is to smear it with oil. Or she taught that if you mixed two colors, it was good not to thoroughly mix them, otherwise the resulting tone seems dead. However, stu-

dents could not count on such advice at the beginning of their studies; Lassnig only found the advanced students worthy of these tips. She told Hübner to use large instead of small formats for her degree portfolio. Hübner was initially confused since Lassnig only gave her this advice five weeks before the final exam. Nevertheless, she took this suggestion to heart and won the grand prize.

It was not just the many questions she was supposed to answer in the classroom that stressed Lassnig out but also rhetorically more proficient fellow professors. At that time, Bazon Brock taught at the University of Applied Arts, and many loved his exciting, original, and intellectually playful lectures. She believed she couldn't keep up with this, but she didn't need to: Brock wasn't a visual artist but an art theoretician—language and the lecture were his medium. Nevertheless, she thought she had to compete with him: "My students then expected constant babble, and I demanded that they work." [72] To take some weight off her shoulders, Lassnig invited guest lecturers. These included Herbert Lachmayer,[73] for example, but above all, her old friend and companion Heimo Kuchling, whom she had known since the 1940s. Kuchling regularly gave lectures on composition and design theory or led excursions to museums. He held seminars on the drawings of Hans Holbein and provided anecdotes about Picasso, whom he had personally met. In addition, Lassnig asked him to comment on the work of her students. So it was often Kuchling and not Lassnig who gave the students feedback. There are different opinions about his role in the class. "After a while we came to the conclusion that he didn't care much about contemporary art," Thuma remembered with a laugh, adding, "After 1945, Lassnig was basically the only artist who mattered to him!"[74] And Labak said: "An elderly gentleman, whose art theory was not of the time." Some, like Karner, almost hated his conservative concept of art, which ended with Expressionism. Others, however, like Roland Schütz or Mara Mattuschka, were fascinated. His composition tips remained in Mattuschka's memory—for example, how boring it was when figures stood side by side like pharmacist's bottles, unless you wanted to consciously create that stiffness, or that one should never cut off figures at the joint, for example at the elbow, because otherwise they appear to be amputated.

The young artists could count on little support from Lassnig about how to find opportunities on the art market. First, that was not her thing at all since she could hardly do it for herself. Secondly, she thought students should first learn something before they bothered with prices, exhibition opportunities, or buyers. The danger of adventuring unequipped into the art market wilderness and getting slaughtered there was too great, Lassnig claimed. If, in her eyes, students went public too soon with their art, she let them feel her displeasure. Although she thought Hans Werner Poschauko drew like the young Michelangelo, when he was the first to get a museum exhibition at the age of twenty-four, she

told him to please wait until he was forty. Advice which he of course did not follow.[75] When Gerlinde Thuma proudly reported that she had been awarded the BAWAG Prize, Lassnig reacted impudently: "What do you need that for?" Thuma struggled to regain her composure for a moment. She had expected Lassnig to be proud and congratulate her. But then she swiftly replied: "For my sponsors!" Now it was Lassnig's turn to be puzzled and impressed: "What? Sponsors?"[76] Thuma wisely withheld from Lassnig that she meant her parents and not some rich collectors.

Some students would have expected a female professor to especially promote women; nothing could have been more foreign to Lassnig. When her students participated in the Feminale, an annual women's exhibition at the University of Applied Arts, they could count on Lassnig's criticism.

She urged the men in her class to not let themselves be excluded and just join in. When she was asked in the 1990s what especially she had tried to convey to her female students, Lassnig replied, "I think the virtue of independence: independence from men, from styles and, if possible, from sex."[77] When Thuma, a few years after her diploma, told Lassnig that she had given birth to a daughter, she first feared that Lassnig might react in an indignant manner, reproaching her with the fact that she would probably no longer be able to paint and would betray her art. The opposite was the case. Lassnig was very happy and was at a later meeting very fond of the toddler. Lassnig's messages remained contradictory, not least because she herself felt ambivalent about many things in life, especially when it came to relationships, love, sex, or children. In addition, she let her students know somewhat cryptically: "You can be pretty and still be a good painter."[78] Overall, however, she was more critical of female students than of males. When a successful gallery owner asked Lassnig if she would recommend good female students to her because she would like to promote female artists, Lassnig said: "No, the men are all better."[79] Her whole life long, Lassnig was unable to set aside her competition with female artists. When Labak asked her which female artists she admired, Lassnig couldn't come up with a single one.

Maria Lassnig and some of her former students at the opening of the exhibition *Mit eigenen Augen (With Their Own Eyes)*, 2008 (photo: Sepp Dreissinger)

Lassnig wasn't the most gifted pedagogue, but her students were well aware of what they had in her. One could learn the art of seeing from her and awareness as a principle of life, not because she explained it but because she lived

it. Her personality rubbed off on the class. As Gerlinde Thuma noted: "This forced you to work on yourself, and stand up to her as well."[80] Lassnig pushed her own limits and she required that from her students, too. She tolerated a lot as long as she sensed your full engagement. However, she did not accept split attention. When she found out that a student wasn't just studying painting but also architecture at the same time, she kicked him out of class: "There is no time for that!"[81]

As didactic examples, she sometimes shared anecdotes from her ascetic past. After saving for a long time in Paris in the 1960s, she finally decided to buy a new dress so that she wouldn't feel embarrassed at openings. But then she couldn't get herself to spend the little money she had on something as disdainful as a piece of clothing and instead came home with a big roll of canvas. Very few students were willing to take on her spartan lifestyle, but they were all fascinated by it. Art, Lassnig conveyed, is nothing simple; rather it requires an ascetic, almost religious dedication. "She infected us with her ... how should I say ... is it love for painting? That's too little. Is it zeal? Too little. It's more like an addiction, a search for something you're almost dependent on, you cling to,"[82] remembers Mara Mattuschka, who also recalled that Lassnig taught her students to rely on themselves, be independent, and not cling too tightly to the Zeitgeist. A legendary scene, which many still speak of: Lassnig once brought along a catalog from Paris of the 1960s, full of abstract works. "Take a look at this," Lassnig urged them. "Well, what do you think? Isn't that something?" The students didn't quite know what she was getting at. They flipped through the book and thought, well, yeah, it's kind of interesting. But what exactly did she want to tell them? Finally, Lassnig put on a triumphant face: "Those were the stars back then. Today, nobody knows any of them. See how ephemeral it all is!"[83] That was one of the most important messages Lassnig tried to convey: it is essential to find what is yours, independent from current fads. Art is a value in itself, so you have nothing to lose and you should not be dissuaded from your own path. Lassnig was not a good pedagogue, but she was a good teacher. Andreas Karner: "She was like a leading she-wolf who gave the direction in a pack of wolves. She was biting now and again, but she meant well. You stay with the pack because you feel it's a good pack."[84]

Lassnig's relationships with fellow professors weren't always cheery either. Oswald Oberhuber, the dean of the University of Applied Arts, supported Lassnig to the best of his ability, as did Adolf Frohner. Nevertheless, there were difficulties. On the one hand, Lassnig was the first female painting professor to penetrate this macho world full of top dogs and old bulls, and the corresponding defensive reactions were inevitable. On the other hand, she made quite a few enemies with her awkward and often all-too-blunt manner. Moreover, the cliquishness, which is almost unavoidable in such an institution, was not her

cup of tea. Some professors used the diploma exams to try to put one over on each other by competing with each other through the students. In *Samson* from 1983, Lassnig expressed how she felt about this institution of higher education. She identified with the biblical hero and gave him her own facial features. Just as Samson brought down the Temple of the Philistines to bury not only himself but also all three thousand priests under the stones, Lassnig would have liked to make this temple called the University of Applied Arts collapse when she felt poorly treated by her colleagues. In 1984, she wrote: "University of Applied Arts = Intensive Care Unit."[85]

In 1989, Lassnig's last year of teaching, the conflicts escalated during the diploma exams. Through her often thoughtless remarks, she had acquired the wrath of some people, who then fiercely opposed her. The occasion: three students, Mara Mattuschka, Andreas Karner, and

Samson, 1983

Hans Werner Poschauko, were jointly producing a film as their diploma project—*Rococo Reaches the Realm of the Huzzis*, a surrealist operetta "made of blood, tears, and semen" with magnificent black-and-white cardboard backdrops and paper costumes reminiscent of early avant-garde theater traditions of Classical Modernism. The film was based on a piece that the three of them had produced in 1987 for the Wiener Festwochen, which had gotten them invited to various theater festivals. The jury, consisting of all the professors from the Angewandte, objected: group work was not standard and could not be accepted. The conflict ended in an ugly power struggle between Lassnig and some other professors. They threatened to fail all three. Mattuschka, Poschauko, and Karner received their diplomas after all, but Lassnig suffered a nervous breakdown. She became emeritus in the same year and withdrew completely. Adolf Frohner took over her class on an interim basis for one year before the professorship was reposted.

Lassnig insisted her master class continue to be devoted to painting. Allegedly, she did everything possible to prevent Valie Export from receiving the professorship. Her preferred successor was Siegfried Anzinger, but when Christian Ludwig Attersee took over the class she was also satisfied. She wrote in her journal, "The Lassnig Class of 1990: The king is dead, long live the king!"[86] However, when she planned an exhibition at the Angewandte almost twenty years later, she also battled with Attersee. But first the background: In 2005, Lassnig met one of her former students again, Gerlinde Thuma. The idea arose for an exhibition about the Maria Lassnig master class. After the artist refused to commission a curator—"We don't need that. We can do it ourselves!"—Thuma undertook the cumbersome task of organizing and coordinating everything: "I stood between her and the students, always had to communicate her fluctuating sensitivities, sulkiness on all sides. That was a tough, tough project!" Nevertheless, everything had turned out all right so far. The Angewandte provided the Heiligenkreuzerhof as an exhibition space, and Springer publishing house created a magnificent catalog. Just as this was about to go to print, Thuma received a phone call: Lassnig nixed the exhibition. Thuma was upset, and it took a while to figure out what was going on. Lassnig had flipped through the new Study Guide of the Angewandte and discovered a painting by Attersee titled *A Night with M. L.*; Lassnig saw herself depicted with "something like three men in a bed. I've never been so insulted."[87] She felt ridiculed and was deeply outraged. If the Angewandte permitted such tastelessness in its study guide, she never wanted to have anything to do with this institution again, and therefore, she cancelled the exhibition. Thuma managed to persuade Lassnig in hours of telephone conversations not to let this beautiful project be destroyed by such external circumstances. When the exhibition finally opened, Lassnig was happy and proud. She celebrated until the wee hours of the morning; it was a deeply emotional event for everyone involved.[88]

Despite this, she looked back on her teaching with mixed feelings. When Dieter Ronte described her as one of the most influential and greatest teachers at the Angewandte, she was not pleased: "All the boys who become professors are never asked about their teaching, only the women, like me: you remain forever a kindergarten teacher."[89] In the meantime, there were not only Lassnig's "children" but already a generation of grandchildren, including Ursula Hübner's students, Christian Macketanz and Andreas Karner, who were proud to have Maria Lassnig as a virtual grandmother.[90]

Otto Muehl: Maria Lassnig as Anna O. and Valerie Solanas

Lassnig wasn't so impressed with Viennese Actionism, this "macho much-ado,"[91] but nevertheless befriended its protagonists, such as Günter Brus, Hermann Nitsch, and last but not least, Otto Muehl. Muehl founded a commune

in an old-school Viennese apartment around 1970, which then moved in 1973 to the Friedrichshof, a deserted large estate in Burgenland. Their mission included free love, joint ownership, abolition of the nuclear family, promotion of creativity, and Muehl's so-called Action Analysis combining psychoanalysis, primal therapy, and ideas by Wilhelm Reich. At certain times, as many as two hundred people were living at Friedrichshof. Many succumbed to Muehl's charismatic personality as well as his sexual and creative aura. The other side of the coin was his authoritarian nature. He was a guru who ruled his commune like a dictator, manipulated people, exercised terror and violence, and sexually exploited minors.

Lassnig as Valerie Solanas at the shooting of *Andy's Cake*, 1991 (photo: Didi Sattmann)

In the 1980s, the commune experienced a final climax when it became an attraction for the Viennese art scene (and somewhat for the international scene), and a series of films was shot there. In particular, the German artist, filmmaker, and performer Theo Altenberg, who played a leading role at the Friedrichshof, endeavored to involve as many famous people as possible in these film projects. Muehl designed the script, Terese Schulmeister was director and also a leading member of the commune, and Altenberg played the main roles.

Lassnig played in two films. In 1987, they produced *Back to Fucking Cambridge*, a grotesquely satirical episodic film with a lot of sex, the plot of which took place in turn-of-the-century Vienna. The individual scenes were held together by a framework story about the painter Richard Gerstl, played by Altenberg. Other parts were taken by over thirty people from the national and international arts and cultural scene, including Nam June Paik, Dieter Roth, Raphael Ortiz, Hermann Nitsch, Harald Szeemann, Christian Ludwig Attersee, Rudi Fuchs, Norman Rosenthal, and John Sailer.

Muehl played Sigmund Freud and Lassnig played Anna O., his most important case. The two are in Freud's office; their relationship is characterized by intimacy and latent violence. Suddenly, there is a knock on the door and two Nazis storm in: "Is this the Jew Freud's place?" Freud: "Um-hmm." One of them asks him to say "Heil Hitler!" Freud obeys. Meanwhile, the other Nazi rapes Anna O.

on the famous couch. She calls to the professor for help. He complains: "Yeah, and how?" But then Freud defends himself with mechanical stylized gestures, disarms the Nazis, and chases them away: "Even a Yid can blow his lid!" Lassnig as Anna O.: "Professor, I always told you to 'Do me!' And now it's too late! We played around all year." Freud: "That's how it goes." Anna O., very coquettish: "But the Nazis did it! Actually, I'm happy." Freud: "That's what's important, happiness." And he dances with Anna O. through the room. The deliberate comedy of this scene on the topics of Nazis and rape, despite being grotesquely overdone, leaves a lingering vapid aftertaste. Schulmeister commented on Lassnig's role and the rape scene: "That was a bit beyond her limits, but in such a way that she didn't have to fend it off."[92] Muehl had a tremendous talent for getting people to confront their boundaries, and he pushed them to the limit.

Don Juan d'Austria,
ca. 2003

Andy's Cake, the second film in which Lassnig participated, came about in the commune's final phase, as it was already heading toward dissolution. Former members of the commune accused Muehl of authoritarian behavior and sexual abuse of minors. In 1988, a lawsuit against him began. In 1991, he was sentenced to seven years in prison. The movie's topic was Andy Warhol's Factory and the New York art world. This time, Herbert Brandl, Martin Kippenberger, Ursula Krinzinger, Adolf Krischanitz, Albert Oehlen, Lóránd Hegyi, Peter Weibel, and Heimo Zobernig were among the many who took part. With great talent for grotesque wit and self-irony, Lassnig took on the role of the radical feminist author Valerie Solanas, who attempted to assassinate Warhol at gunpoint. Lassnig, who was then in her seventies, wears a black leather miniskirt that barely reaches above her pubic bone and black fishnet pantyhose with a star pattern, and she has a punker hairstyle. Before the assassination attempt, she calls Warhol (played by Altenberg) from a telephone booth several times and pressures him in a strong Austrian accent: "Andy, I want my script back!" The historical background: The real Valerie Solanas, a frequent guest at the Factory, wanted Warhol to perform her play *Up Your Ass* and left him with her only manuscript. It did not come about, and Solanas was convinced that Warhol had stolen her play. After further conflicts, Solanas fired three shots at Warhol, severely injuring him. The movie transforms the assassination attempt into a grotesquely absurd scene in which the wildly grimacing Lassnig shoots the whole place up.

Muehl was already in investigative custody during filming but not when Lassnig's scene was shot. He spurred her on to get even wilder and to completely let go of herself in this shooting rampage. Lassnig commented: "Muehl is a born

film director, full of spontaneity and ingenuity. I wasn't just allowed to, but had to play, that which I am least: aggressive. At the same time, I saw the collection of his works at the Friedrichshof, which is very impressive."[93] Lassnig wrote this when she was asked to give a statement for the 2004 Otto Muehl exhibition at the Museum of Applied Arts in Vienna. In her journal, a few years earlier, she had made a somewhat more critical comment: "To go so far beyond my limits, the way I did in the Muehl film, pressured into it, is a sort of violence against oneself and of no use for the rest of one's life except for amusement."[94] Guns, however, appear in Lassnig's work long before her role as Valerie Solanas, showing up, for example, in the *Wild West Self-Portrait* (*Wildwest Selbstporträt*) of 1983, in which she aims out of the drawing with her pistol, and in *Gunpower* from the same year, where her whole body turns into a shooting machine and a giant hand with a pistol replaces her head. Later, in 2005, Lassnig painted her famous *You or Me* (*Du oder Ich*), a self-portrait in which she puts a gun to her own temple and aims another at her viewer. Lassnig seems to have gained some forbidden excitement from fantasizing about the aggressive act of shooting.

Schulmeister, who meanwhile had begun to view Muehl very critically, yet still remaining true to her former fascination, believed that Lassnig's view of Muehl was also ambivalent: "On the one hand, she valued and somehow admired Otto's ballsy way of doing things and realized he had something she didn't have. And she surely also noticed at Friedrichshof how much Otto was appreciated by everyone."[95] On the other hand, Lassnig was shocked by the sexual abuse. Schulmeister was convinced that in later paintings such as *Child Molester* (*Kinderschänder*) and *Don Juan d'Austria*, both from around 2003, that she was thinking of Muehl without wanting to directly paint a portrait of him. In contrast to many other artists, Lassnig never visited him in prison. When Schulmeister planned a film project in 2013 in which she wanted to critically deal with the commune, Lassnig generously supported her in financing the film.[96]

The South, its myths, and watercolors
In the 1980s, Lassnig could afford to travel extensively for the first time. For her first university teaching break in February 1981, she went back to the US, to Miami, and regretted not stopping in her beloved New York. In the following years, however, she traveled mainly to the Mediterranean. Southern Europe had always attracted her. In the mid-1950s she had traveled with Oswald Wiener by car to Italy and Greece, where she discovered the glittering light of the Mediterranean Sea. In the 1960s and 1970s, she had spent a few weeks in the old stone house at the Hildebrands' place in Stara Baška on the island of Krk. But Lassnig no longer hitchhiked and did not sleep in the open air anymore but booked all-inclusive vacation packages that took care of everything. She chose, if possible,

quiet, lonely hotels on barren, rocky islands to recover from the strain of teaching. For a couple of weeks, she needed to escape the "all-too-green Carinthian landscape,"[97] where she spent the rest of the summer. She flew to Greece, the Cyclades Islands, and Crete, to Cyprus, to Turkey, to France, to Italy and also Egypt, to the Red Sea, and to the pyramids.[98] Greece was the number one dream destination among students because it was cheap to travel to with a backpack; perhaps this was another reason Lassnig went there. But it wasn't her style to be completely idle. She was unable to just do nothing and therefore unpacked her paper and watercolors. The numerous drawing sheets in cheerful colors of the Mediterranean play with the tradition of landscape watercolors but go far beyond that. Lassnig inscribed herself into nature and allowed the contours between herself and her surroundings to merge together. In *The Heat of Salamanders* (*Die Hitze der Salamander*) of 1982, she melts as a resting giantess into the scorching hot, dried-up Mediterranean summer landscape. In *Aeolus Incensed* (*Aeolus erzürnt*) from the same year, she becomes a wind god who puckers her lips to blow a storm across the peaceful landscape. She identified not only with the landscape and nature but also with the mythological figures and archaeological remains of Greek antiquity. As in her *Woman Laocoön* [p. 237] from 1976, she took on the role of famous statues, appropriated them, and occasionally satirized them. In *Female Guardians of the Sacred Site* (*Bewacherinnen des Heiligtums*) from 1983, she gave her features to a line of helmeted spear-women statues, but in one case she steps out of line and disobediently looks out of the picture, thus ironically counteracting

her military stiffness. *Female Discus Thrower at Lindos* (*Diskuswerferin auf Lindos*), also from 1983, doesn't show Lassnig as a powerful, dynamic athlete in a tense body pose like the famous antique statue of the discus thrower. Although she comes close to the original posture—with the discus in one hand and the other hand supported on the thigh—she lets all the non-heroic imperfections of an aging female body stand diametrically opposed to the classical antique male ideal of beauty. In the late summer of 1985, she metamorphosed into the *Minotaur on Crete* (*Minotaurus auf Kreta*), sitting on the seashore like a giant spirit of nature between the mountains. How much fun she had in making these watercolors can be seen in *Mediterranean Still Life* (*Mittelmeerstillleben*), which was inspired by her 1987 spa holiday on Ischia. In a rock-framed bay on the steep coast, a giant bidet floats like a luxury yacht in the blue-green sea. Such Italian ceramic bathroom fixtures are unusual in Central Europe and must have thoroughly intrigued and amused Lassnig. *The Navel of the Sea* (*Der Nabel des Meeres*) from the same year depicts a big, round tummy and navel—reminiscent of a juicy apple—sticking out of the waves.

 Lassnig didn't just do watercolor when she was in Southern Europe but also in Austria. Instead of warm earth tones and deep azure, there was a preponderance of green, of fresh grass, and of dark coniferous trees, as well as the cold grayish blue and white of the Alps, corresponding to the completely different vegetation. *When I Am Be-neath the Earth* (*Wenn i amol unter der Erden bin*) from 1985 shows Lassnig "under the earth" as part of the rolling hills, with her hand protruding like a bizarre fleshy rock formation as if she were making her last attempt to resist her ecstatic-moribund blending into the landscape. *I Am All Landscape* (*Ich bin ganz Landschaft*) from 1987 is reminiscent of a superimposed film: under the alpine mountains, a typical Body Awareness formation shows through—or the other way around. Inside and outside merge with each

other, a lifelong topic for Lassnig. In the same decade, she would deal with it in a very different way in the cycle *Inside and Outside the Canvas* (*Innerhalb und außerhalb der Leinwand*).

 Lassnig's drawings, watercolors, and gouaches from over four decades, including her travel watercolors and landscapes, were exhibited with acclaim

Bewacherinnen des Heiligtums (Female Guardians of the Sacred Site), 1983

Ich bin ganz Land-
chaft (I Am All
Landscape), 1987

in numerous solo exhibitions between 1982 and 1996.[99] However, she described her watercolor landscapes as "amateur" and even said: "That was a misstep of mine because it cost me time and wasn't my strength."[100] On another occasion, she described her watercolors a little more kindly as "chamber music in relation to the oil paintings, which are the grand orchestra." She liked to be in nature, and she couldn't be without work, so the landscapes were an "add-on."[101]

A summer studio in the countryside

Despite all the difficult childhood memories and the sometimes all too intense green that drove her to the South, Carinthia remained a place of longing. Lassnig always spent the summer in the family house on Adolf-Tschabuschnigg-Strasse in Klagenfurt. From the mid-1970s, the Dadaist action artist Viktor Rogy lived in a garden house there. Lassnig had asked Ernst Hildebrand to recommend someone to her who could take care of the house. Hildebrand knew that Rogy was looking for a place to stay; Lassnig agreed and was even looking forward to not being alone in the summer. Rogy's companion Bella Ban, also an artist, moved in as well. Uta Hildebrand, Hildebrand's second wife, recalled: "He lived so humbly there: no running water, no heating, it was the worst!"[102] She also noted that Lassnig expected Rogy to take care of the house, fix what needed to be fixed, and do small errands: "And he did in the beginning, you know, but it was never good enough for her!" Nevertheless, Rogy and Ban lived there for many years. In the mid-1980s, Lassnig wanted to use the garden house as a studio for herself and wanted Rogy out. She wrote to Ernst Hildebrand: "Since you imposed him on me, please liberate me from him!"[103] Conflict broke out and Hildebrand felt caught in the middle: "Actually we should have considered this in the first place because both were very pigheaded and quarrelsome."[104] There was a court case, which dragged on. The house was not in good condition. Since her mother's death in 1964, Lassnig had hardly changed anything: the clothes of the deceased still hung in the closets.

Since she earned enough money from her professorship and art sales, she decided to buy a house in the countryside. She asked her old childhood friend Rainer Bergmann to look for a suitable piece of real estate for her. She would have preferred a property on the Turracher Höhe near the Bergmanns' cabin, where she had spent time in the past. She hoped Bergmann would design a house for her. He remembered with a chuckle that he was not fond of the idea at all: "With an artist that'd be rather unpleasant, as you probably know!"[105] On a hiking tour

in the secluded Metnitz Valley, where Lassnig had taught more than forty-five years ago, Bergmann stumbled upon a former elementary school building in Feistritz ob Grades, which Lassnig then bought in 1985. It was not the school in the vicarage where she taught at the end of the 1930s but a 1963 building with a huge basement, rooms above, and southeast-facing windows. She could hardly believe she now had the funds to make such an investment: "Rainer, I am now famous and rich. Do you want some money, too?" Bergmann said thanks, but no thanks. He was an architect and had his own money. Her old friend Oswald Wiener, who lived with his wife Ingrid in Canada at that time, had a similar experience with Lassnig's generosity. When the couple urgently needed money to buy a cabin, he asked Lassnig for a loan of 20,000 German marks, which she granted him without hesitation. "We paid her back two years later. Then, she said she thought she'd never see the money again." Wiener laughed: "That got me riled up again!"[106]

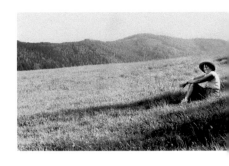

Lassnig in Feistritz, 19
(photo: Heimo Kuchli

From then on, Lassnig spent every summer in the newly acquired school. To get from Klagenfurt to her house at an elevation of 1,100 meters, she bought a moped, a Puch Supermaxi. She journaled: "The two greatest mistakes in my 'working life' are that I didn't chase after famous people and I didn't buy a car."[107] Now she had bought herself a moped and tested her driving skills along the Lend River in Klagenfurt in front of Bergmann's house, where usually only cyclists and joggers were out and about. She was sixty-seven years old, but that didn't stop her from enjoying the new means of transportation: "I must confess that motor-cycling promotes my self-confidence because I have to overcome a fear threshold; because it is new, you have the illusion of your own power to whiz by and still be close to the meadows and trees, too."[108] Of course, she soon captured this unfamiliar physical experience in paintings, too, such as *Speed Demon (Geschwin-digkeitsteufel)*, a self-portrait in which the moped handlebars grow out of her head like devil's horns. Her whizzing around was really not without danger. In July 1992, she had a bad crash and broke her arm: "Accident, drove into a street sign as if under a spell. The moment before I hit it, I was very aware."[109] She had to go to the hospital in Friesach, where she was a wearisome patient who drove doctors and nurses to despair with her impatience and irritability.[110] Afterward, she hardly rode her moped anymore but kept it until her death.

Among her new neighbors in Feistritz were some of her former elemen-tary school students, who were now over fifty years old and glad to see their old teacher again. After all, she was one of the very few who had not used the rod as a means of punishment. However, she had a difficult relationship with some of the other villagers. She was a stingy bitch, reported one female neighbor, who

traced this judgment back to the following incident: Lassnig showed the woman a rancid piece of bacon and asked her if it could be saved in any way. The neighbor advised her to throw it out. It just wasn't edible anymore. Certainly not, Lassnig protested. She absolutely had to use it.[111] Worlds collided here. For the neighbor, it was incomprehensible why a well-paid professor and famous artist would make such a fuss about a piece of bacon. Lassnig, on the other hand, who had skimped her entire life, could not drop her ascetic lifestyle despite her late prosperity. Many of her friends from Vienna had a similar experience when they visited Lassnig in Feistritz: her refrigerator was full of moldy and rotten food. As generous as Lassnig was to Bergmann and Wiener, treating herself that way was foreign to her. This also affected the property: "Feistritz, August 1, 1986, the new house. It's not me; it's the spirit of my mother who brought it all about. I want the best for that house, but I'm too stingy for big expenditures."[112]

There was another reason for her not wanting to throw out the bacon. Her respect for the animal that had to give up its life forbade her to do so. In Feistritz, she was concerned with the suffering of animals. It saddened her immensely that agriculture and forestry were increasingly restricting the living space of wildlife. The raspberries at the edge of the road disappeared because they scratched cars, the forest roads cut "terrible wounds into the forest," and nature looked as if it had been "cleaned with a vacuum cleaner."[113] The hunters were a thorn in her side: "The Austrian traditional jacket and the Dirndl dress are of no use, the village choir doesn't sing any funeral dirges for the screech owls and weasels, and the hunters simply watch as the trappers eradicate the small game."[114] In the following decade, ferrets, weasels, marten, and other small animals of the forest appeared in her works. *Machine Man with Animal (Maschinenmensch mit Tier)* from 1997 shows a car driver with a metallic armored body who is clutching a polecat instead of the steering wheel. The person behind the wheel disappears behind the machine, which has already taken possession of his body. Lassnig commented on the painting: "This expresses my discomfort about the countryside, when I see how the little animals are simply wiped out. Humans are monsters, really evil mon-

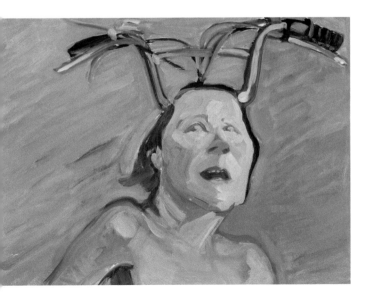

...eschwindigkeits-...ufel (Ich habe ein ...lotorrad) [Speed ...emon (I Have a ...lotorcycle)], 1987

Maschinenmensch mit Tier (Machine Man with Animal), 1997

Professor Lassnig

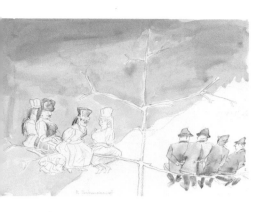

sters."[115] Naturally, with such issues, she found very little sympathy among the rural Feistritz population. Further conflicts arose from her allegations against the Catholic Church, which she accused of hypocrisy. She visited the parish church again and again, which sat enthroned at the top of Feistritz. One Sunday, when she saw all the people spiffed up in their Sunday best, she began to shout, "You think Jesus was someone in a book; you don't take it seriously! Jesus was a real person who suffered a lot! None of you understand that if you dress up so nicely for church!"[116] Her watercolor painting *Country People, The Village Community* (*Landleute, Die Dorfgemeinschaft*) fit this sentiment and is reminiscent of her Berlin series with the trees of Grunewald. Men and women in their festive outfits sit strictly separated by gender, not on pews but on the branches of a tree. When Lassnig moved to Feistritz, she had the illusion of integrating herself into the village community: "In the beginning, I had fantastic ideas, for example, that I would do gymnastics with them in my studio; there would have been enough space. I wanted to dance with them, too, because I learned folk dancing as a young girl."[117] Nothing came of all this, and soon her regular courtesy visits to the neighbors were too tiresome for her. In the mid-1990s, the idea of her portraying them was met with great skepticism at first. Although people knew Lassnig was a famous artist, they didn't know what to make of her works. However, when she made their striking features clearly recognizable with lead and color pencils against a bright yellow background, most were happy to see how well Lassnig had captured them. In 2004, she presented her cycle *Country People* (*Landleute*) at Strassburg Castle in Gurk Valley, not far from Feistritz. Many of the sitters came and were proud to find themselves in the exhibition. Lassnig said sardonically that their eyes were "bulging" because she sat next to the bishop, who was the person of highest respect in the countryside. [118]

First retrospective in 1985 and the Grand Austrian State Prize

Lassnig hit the brakes when Dieter Ronte, the director of the Museum of the Twentieth Century, began planning a long-overdue retrospective shortly after the Venice Biennale in 1980. There were good and less good reasons for Lassnig's hesitancy. Among the less good reasons was that she thought she would have to create many new works before she dared do

Krebsangst (Cancer Anxiety), 1979

a retrospective. In reality, she had more than enough, which were worth finally showing to the broader public in a grand overview exhibition. In addition, Lassnig thought she needed to settle back into Vienna and that hardly anyone knew of her after her almost twenty-year absence: "The youth don't know of me at all."[119] That's why she was all the more surprised every time someone who was not from her circle knew who she was. When her former student Ursula Hübner told Lassnig that a friend of hers, a dramatic adviser of the Burgtheater, the national theater, wanted to purchase a painting from her, Lassnig was stunned. "Why does he even know I exist?"—that's how little trust she had in her reputation in Austria.[120]

But there were also weighty reasons not to rush the retrospective. Many of her works were still spread around the world between New York, Paris, and Klagenfurt. They first had to be taken to Vienna, photographed, and documented. Wolfgang Drechsler, curator of the retrospective, began to visit Lassnig regularly in her studio. Gradually, the paintings arrived, often with three or four screens stretched over a frame: a measure taken to make storage more space-efficient

and transport cheaper.[121] Health problems also caused delays. In 1983, Lassnig underwent a tumor operation. At about the same time, in a much-quoted text, she distinguished between a wide variety of Body Sensation colors: "There are pain colors and torture colors, nerve-cord colors, discomfort and fullness colors, stretching and pressing colors, hollow and swelling colors, crushing and burning colors, death and decomposition colors, fear of cancer colors—these are colors of reality."[122] She had prophetically painted *Cancer Anxiety* (*Krebsangst*) in 1979. While she expressed a sense of threat with this title, she seems to have made fun of such fears with one of her alternative titles, *Double Self-Portrait with a Prawn*. Lassnig played with the double meaning of the German word *Krebs*, which means both crab and cancer. On the right of the painting, she depicts herself with an oversized prawn instead of a crab, which she holds in her lap like a bulky, uncuddly teddy bear. On the left, she portrays herself a second time, and as with *Gynecology* (*Gynäkologie*) from 1963 [p. 187], in front of her vagina there is a rectangular object, which is reminiscent of both a medical device and a small television: "You're left with nothing but TV,"[123] Lassnig commented. Her surgery went well, she recovered, and nothing else stood in the way of the retrospective.

For the first time in her career, a comprehensive representative catalog of her art was planned. In addition to the joy of it, she was, as always when it came to her paintings, highly nervous. She worried whether the colors would come

Lassnig in front of the 20er Haus, where her first retrospective took place in 1985

out right and gave the photographer detailed instructions. When the printer told her that her colors were too difficult, she feared the worst. But the catalog turned out gorgeous and remained one of her favorites. At just over thirty years old, curator Wolfgang Drechsler had written the best introduction published so far about Lassnig's painting; he understood how one work phase arose out of another and recognized that the diversity in her work was not a problem but a sign of quality.[124] Peter Weibel, Peter Gorsen, and Armin Wildermuth contributed further essays on individual aspects. Texts from earlier decades by Benjamin Péret, José Pierre, Otto Breicha, and Lassnig herself made this high-caliber compilation complete. With Drechsler as curator, Lassnig was generally satisfied, although the exhibition hanging gave her a lot to carp about. Drechsler, who put together a total of three exhibitions on Lassnig—including another retrospective in 1999 and a look at her recent work in 2009—recalled a repeated ritual just before the opening. At first, Lassnig always said there weren't enough works being exhibited. Drechsler then made additions according to her ideas. When

292 — 293

Lassnig saw the results, she found them terrible, and the paintings were hung as originally planned.[125]

The grand exhibition opened in January 1985 at Vienna's Museum moderner Kunst / Museum des 20. Jahrhunderts (Museum of Modern Art / Museum of the Twentieth Century) and was a sensational success. The public stormed the museum; the reviews were euphoric. *Profil* magazine described the retrospective as the most beautiful exhibition that had been displayed there for many years.[126] *Kunstforum International* spoke of a "breathtaking retrospective,"[127] the museum's "most significant exhibition in a long time." Other venues—Düsseldorf, Nuremberg, and Klagenfurt—followed. The *Süddeutsche Zeitung* rhapsodized: "There is hardly a male or female painter today with such gifted color vision as she has."[128]

Lassnig's students attended the opening and were extremely proud of their professor. They posed and took pictures in front of her paintings, of which a larger selection had never been exhibited. Then the party continued in Gmoa-Keller, a noteworthy traditional Viennese restaurant, until the wee morning hours. They danced to rock 'n' roll, the mood was boisterous, Lassnig was in her element, and for a short time she was really happy. For the closing of the exhibition, she wanted something original and asked her performance artist friend Angela Hans Scheirl to play with his band. Scheirl was one of the artists whom Lassnig had an important influence on even though he had not studied with her. He admired her as a strong personality, as an independent woman, and as a great artist: "She was my most important role model."[129] She was why he went to New York. Lassnig had gotten to know the transgender artist in the late 1970s, when she was still Angela Scheirl.[130] At their first meeting, Scheirl had one ear painted completely red—Lassnig was impressed. Scheirl assisted her a few times in the art studio and worked as a nude model in her master class: "A bit of a friendship developed then," Scheirl recalled. Lassnig was enthusiastic about Scheirl's performances, concerts, and film premieres and felt reminded of New York's 1970s off-off-Broadway scene. With her German grammar, she emphasized his transgender identity: "Liebes Hanserl" or "Liebe Hans-Angel" or "Liebe Hans." When Scheirl became professor of contextual painting at the Academy in 2006, Lassnig wrote: "Dear Hans, thank you very much for the surprising news about your professorship. How did you make it that far? I only made it to the Angewandte,"[131] another indication that Lassnig considered the Academy to be far more prestigious.

At the retrospective with the group Unfavorable Omens (Ungünstige Vorzeichen), Scheirl performed spectacularly with balancing acts on a metal framework, unusual instruments, and a pink latex cloth that produced astonish-

Innerhalb und außerhalb der Leinwand IV (Inside and Outside the Canvas IV), 1984/85

*Bildtransport
(Painting
Transport), 1986*

ing sounds.[132] At the opening, Scheirl's former experimental music group 8 or 9 performed, altogether an exceptional program for an exhibition in mid-1980s Austria.

When Lassnig took on her professorship in 1980, she was very worried she would no longer have time to paint: "But that was not the case at all. The more that's demanded from you, the more you produce."[133] Between 1984 and 1987, for example, the fascinating group of works *Inside and Outside the Canvas (Innerhalb und Außerhalb der Leinwand)* emerged. It showed Lassnig painting her pictures, carrying them around, and lying on them or inside them. The paintings had such descriptive titles as *Painting Transport (Bildtransport)* or *With the Head Through the Wall (Mit dem Kopf durch die Wand)*. It was about the relationship between Lassnig painting and the painted Lassnig, about the permeability between the artist and her work, and about the mutual penetration of painting and the world. Drechsler suspected that working on her retrospective inspired her to paint this series.[134] After all, she was intensely involved with her previous paintings, perused them, made a selection, and schlepped them around her studio. She was not only in close physical contact with her paintings but also with her earlier, self-portraited self. The Body Awareness she had felt and painted back then met her current Body Sensation when she looked at these works again. The relationship between artwork and artist can be symbiotic, as in *The Intimate Connection between Painter and Canvas (Die innige Verbindung von Maler und Leinwand)*, where Lassnig, in two versions of herself, nuzzles in and around the canvas. But the relationship can also be unpleasant, as in *Inside and Outside the Canvas IV (Innerhalb und außerhalb der Leinwand IV)*: here, the artist is stuck like a prisoner in the canvas and tries to slip it off like a dress that is too tight.

It was a productive time for Lassnig. She was not only concerned with herself and her work but increasingly with the outside world as she had been in mid-1960s Paris. Because of her interaction with her students, she perceived this external world more strongly, which in turn was reflected in her work. Like a seismograph, she responded sensitively to world events; for example, when a student engaged in political protests against the West at a runway at the Frank-

furt Airport, Lassnig translated this into a painting in which she herself squats on the edge of the runway while tanks draw near in the background.[135]

Without having ever been there, she appropriated the place and the threatening scenario, referred it to herself, and transformed it into something that she directly perceived, physically and emotionally, while visually transferring it to the canvas. This was not narcissistic but the only possible way for her to experience and master the world. The same applied to *Chernobyl Self-Portrait* (*Tschernobyl Selbstportrait*) of 1986. She took the reactor accident in the Ukraine personally, as if it had happened in her own body. Her eyes transform into huge glistening caves; her head is haloed in nuclear radiation. When she later saw a television report on the twenty-year anniversary of the accident, she felt a similar Body Sensation again: "My eyes hurt as if they had been radioactively contaminated."[136] In the 1980s, the fear of a nuclear war was omnipresent. When in 1982 the big peace demonstrations took place against the NATO Double-Track Decision, according to which Western Europe was to be upgraded with further

Maria Lassnig at her exhibition opening at Strassburg Castle in 2004

atomic missiles, Lassnig worked on a series of watercolors on the topic *Catastrophe Anxiety* (*Katastrophenangst*), in which she dealt with, among other things, her fear of earthquakes, floods, and even becoming insane. With images like *Suctioned Cow* (*Angesaugte Kuh*) of 1988, she tried to cope with her suffering from industrialized agriculture. Automated milking systems gave her the creeps just as much as the artificial insemination of cattle.

The politics of the day rarely turned up in Lassnig's art except when it had international significance, such as when Kurt Waldheim was elected Austrian federal president in 1986. Austria was in the crosshairs of international criticism and for the first time had to publicly grapple with the role of Austrians during National Socialism. At that time, she wrote to Silvianna Goldsmith: "In politics we still have Waldheim. He absolutely refuses to resign. It's terrible. I was very unhappy about what happened here, I had a real Waldheim-syndrome."[137]

After the retrospective, Lassnig was finally a famous artist in Austria. Despite all

Angesaugte Kuh (Suctioned Cow), 1988

the recognition, international fame remained lukewarm. This wasn't changed by the prestigious Austrian awards she received during this decade. In 1985, she was awarded the Carinthian State Prize and in 1988, the Grand Austrian State Prize for Fine Arts with a 200,000 schilling endowment. Both honors were given for the first time to a woman. More than twenty years passed before a female artist was once again awarded the Grand Prize: Brigitte Kowanz in 2009. Lassnig, who had always longed so much for appreciation and recognition, found it difficult to cope with such honors. The photo of the opening of the exhibition *Country People (Landleute)* at Strassburg Castle in Carinthia shows the contradictory emotions that flooded Lassnig in such moments. In her expression, childlike joy and incredulous amazement mingle, as if she couldn't believe she was really receiving such an honor. This was reflected in a combination of almost unbearable vulnerability and mistrust in her eyes, like a wounded animal that lives in fear of coming back again into the hunting party's sights.

In her acceptance speech for the Carinthian State Prize, Lassnig formulated her doubts about the current art business and its laws: "As a young painter, I always heard '*Paint, artist! Don't talk!*'—but now everything's different. Artists increasingly have to become showmen, appearing on television, possibly singing or tightrope walking in order to better convey their real art to the public." On the one hand, you don't need any art prizes, Lassnig continued, since art is the elixir of life for artists anyway. On the other hand, art is hard labor, which means the abandonment of family and therefore loneliness. Art means "fighting to the breaking point, and oh how many are broken! Is there a price that's high enough for that?"[138] In other words, no matter how much recognition she received, the satisfaction was always very brief, and the discomfort, mistrust, and insatiability returned in the next moment. In her acceptance speech for the Grand Austrian State Prize, she described a similar ambivalence: "The human soul is a strange thing. It is saddened to death if one's own achievements are not understood, then, when one is finally praised and honored, it is deeply ashamed. External recognition and inner happiness don't always go hand in hand for the artist." Lassnig then made another plea for painting, which had so often been declared dead: "Painting should not wither away. When you chose me, you chose painting, too. I thank you for that."[139]

I am the Lady Picasso
rope paintings with my Lasso
but I'm aware
Chutzpah's a bear

When I paint Mr. and Mrs. Schmidt,
I'm sure it'll be a big hit
Sure, they look more yellow,
but now, they're even better bedfellows.

I prefer to paint with fantasy,
lying down or on my knee
how I do it doesn't matter to me
'Tis all smoke and mirrors for eternity

The red monster, that's meeee
The result of my fantasyyyy![1]

10 "I am the Lady Picasso"—Lassnig as Artist of the Century

1990–2014

Maria Lassnig,
Vienna, 2008
(photo: Horst Stasny)

"Maria Lassnig is the discovery of the year—of the century"[2]: with this appraisal, the *Observer* began its enthusiastic review of Lassnig's grand 2008 exhibition at the Serpentine Gallery in London. Again and again, international media realized with astonishment that they had failed to acknowledge this painter, whose late works were as exciting as ever. In fact, only a few artists in art history succeeded in being as complex and innovative in their late works as Lassnig was. In these productive years, she created varied cycles such as Paint Flows (Malflüsse) and Re-lations (Be-Ziehungen), new Sciencefiction works, the Drastic Paintings, the Adam and Eve series, and the so-called Basement Paintings (Kellerbilder).

For a long time, Lassnig was known mainly in Austria, but her international career in the 1990s was gradually gaining momentum, with exhibitions at the Stedelijk Museum in Amsterdam, the Centre Pompidou in Paris, the Musée des Beaux-Arts in Nantes, the Kunsthalle in Bern, and Neuer Berliner Kunstverein, as well as her renewed invitation to participate in the Venice Biennale and documenta X.[3] From 2000 onward, the first Beijing Biennale and spectacular exhibitions followed, including ones in Hanover, Munich, Zurich, Hamburg, London, Cincinnati, and Cologne, finally culminating in the MoMA PS1 exhibition in New York in 2014.[4] In 2006, Lassnig dreamt of what everyone knew was a nonexistent Nobel Prize in painting: "Nobel Prize in Stockholm, ML with laurel wreath of brushes, which are like thorns."[5] Next to this journal note she drew a sketch: it is certainly no accident that the laurel wreath is reminiscent of a crown of thorns. Although Lassnig didn't receive a Nobel Prize in her last fifteen years, she did receive numerous high-profile national and international awards, such as the Oskar Kokoschka Prize, the Rubens Prize, the Roswitha Haftmann Prize, the Max Beckmann Prize, and finally, the Oscar of the art business, Venice's Golden Lion for Lifetime Achievement.

Nevertheless, she still felt underappreciated even then: "Even after death I won't be as acknowledged as I should be. That sounds haughty. But that's how it is. My art is not appreciated to the extent I deserve."[6] A subjective perception, which, in view of all her previous honors, is surprising. Nevertheless, it was not a complete misjudgment on her part. Admittedly, Lassnig was acknowledged as an extraordinary artist—far more often than she was ever prepared to take note of—from her early supporters in school to rave reviews that she received over the course of her artistic life. However, her international career took off strikingly late indeed.

The reasons for this were complex. The obstacles posed by patriarchal structures in the art world can't be underestimated. Lassnig wasn't the only fe-

male artist who had a harder time than her male counterparts, far from it. There was a system behind this that demonstrably discriminated against women. Why, for example, did the Museum of the Twentieth Century in Vienna, the so-called 20er Haus, wait until 1985 for director Dieter Ronte to host a major Lassnig retrospective? The two directors before Ronte, Werner Hofmann and Alfred Schmeller, knew the artist and her work very well and greatly appreciated her. Nevertheless, they didn't devote a large solo exhibition to her. Arnulf Rainer, ten years her junior—to once again take Lassnig's nemesis as a comparison—had already received his first retrospective there in 1968. The same applied to international museums, biennial exhibitions, and the documenta. Barbara Gross, who was tirelessly committed to female artists, opened a gallery in Munich in 1988 where she initially exhibited exclusively women, Maria Lassnig among others. That didn't go over well at all with the art scene: "At the time, they simply didn't recognize what power these women had. In the 1980s and 1990s, there was still work to be done." And: "We can only talk of equal rights when the mediocre female artist can sell her works just as well as the mediocre male artist does."[7]

Mediocrity was not Lassnig's problem and the patriarchal filter is not enough to explain her initial lack of an international breakthrough. Lassnig was eager for more recognition and yet couldn't resist paradoxically thwarting this. All her life she had a tense relationship with people who wanted to buy or sell her paintings. She regarded her works as her children, whom she had to protect, and thus reluctantly handed them away. To continue this metaphor, it was hard for her to let them out into the world and to allow them to grow up and live a life of their own beyond her control. After her death, her estate included a few hundred oil paintings, not because nobody wanted any of them but because Lassnig couldn't part with them. Friedrich Petzel, a successful gallerist in New York, recalled, "I used to call her and say we have a museum here or a museum there, or collection XYZ. What do you think of that? Might that be something for you? And then she says: Well, nope."[8] All Lassnig's art dealers shared such experiences. Gabriele Wimmer, her Viennese gallerist, was convinced that "she could have had her international career much earlier if she hadn't always subverted and blocked everything."[9]

Good souls or bad spirits: gallerists & collectors

In 1987, Lassnig painted *Ladybug and Spider* (*Marienkäferchen und Spinne*). The ladybug has a human face with Lassnig's own features. On her hunched back squats a bilious green spider, which, according to Lassnig, embodies her gallerist Heike Curtze. Once again, a painting in which, like an exorcism, the artist projected a difficult life situation straight onto the canvas in an attempt to banish it. She gave the painting a second title: *Ladybug, Fly Away!* (*Marienkäferchen*

flieg furt!), an invitation to herself to get rid of this spider, this gallerist, soon. The now-deceased Curtze, whose renowned Düsseldorf gallery still has a branch in Vienna, specialized in Austrian art and represented Arnulf Rainer, Christian Ludwig Attersee, Günter Brus, Hermann Nitsch, and from 1979, Maria Lassnig. Curtze showed Lassnig in several exhibitions and contributed to her first large retrospective in 1985, which took place in Vienna's 20er Haus. Nevertheless, Lassnig soon tore Curtze to pieces. In 1981, she commented on her relationship with galleries: "The gallery owners, art dealers rather, are looters of corpses; No, they skin you alive, and take out your intestines, without knowing who they have in front of them. Criminals!"[10]

Curtze was not the only art dealer whom Lassnig accused of exploiting her or of not representing her interests well enough. The patterns repeated themselves. Lassnig even implied that Heide Hildebrand, her Klagenfurt gallerist and close friend in the 1960s, had promoted her less than all the other artists, despite Lassnig being one of her "race horses."

When Kurt Kalb showed Lassnig's New York paintings with animals in his gallery in Vienna in 1976, she was convinced he hadn't even lifted a finger for her: "He made me furious when he said he would make himself comfortable now. Of all things, during my exhibition he starts to get comfortable. First, he lets himself be hounded by the bad boys, but with a woman like me, he can make himself comfortable. He doesn't even make an effort!"[11]

Of course, art dealers are not angels. The relationships between artists and galleries are complex, and conflicting interests can clash. Ideally, galleries are "the link to the world" on which artists depend as "highly intelligent, emotionally fragile creatures"—this is how Iwan Wirth sees it, who represented Lassnig from 2004 on in Zurich, London, and New York.[12] Some galleries did extremely good business by acquiring Lassnig's works cheaply and later—after the prices had risen—selling high. This is how the art market works, and it also harbors risks for galleries. Not all artists experience such price increases after all. Lassnig also made a lot of money through gallery sales. Nevertheless, she felt exploited: "I think I only work so that the gallery owners can send their children to school. They squeeze you dry."[13]

Above all, Lassnig worried about losing paintings. After all, if they weren't sold immediately, they often stayed in the galleries for a long time. Lassnig feared they would never give them back or had sold them long ago or wouldn't settle correctly. On the one hand, this mirrored her paranoia, which she knew she was prone to and which rose to the point of being pathological in her last decade of life. On the other hand, paintings do really disappear at galleries. Once she had a traumatic experience in this regard. In 1975, the Ariadne Gallery exhibited her early drawings (1948–50) in Vienna. The gallery went bankrupt,

litigation ensued, the gallery owner disappeared abroad, and Lassnig lost quite a few drawings. Lassnig didn't see this as an unfortunate isolated incident but as the rule: "There are only two types of galleries: those that have swindled me and those that have not swindled me yet."[14] But it was also true that Lassnig often bypassed her galleries and sold to collectors directly behind their backs.

When Lassnig found out that John Sailer of Vienna's Ulysses Gallery intended to open a branch in the famous Fuller Building on 57th Street in New York, she quickly decided to leave Curtze. Sailer presented a Lassnig exhibition in Vienna in 1988 and one in New York in 1989, which received positive reviews in, among others, the *New York Times* and *Arts Magazine*. The renowned art critic Donald Kuspit finished his six-page article with a sentence that hit Lassnig hard: "She is stuck in narcissistic plight."[15] Kuspit found her work extremely interesting but diagnosed her with a pathological relationship to her body and referred to her self-centeredness in his review title by labeling her paintings Body Ego Portraits. The charge of being narcissistic weighed upon her and she tried repeatedly, sometimes successfully, to dispel it. Gallery owner Barbara Gross was certain that men and women were held to different standards: "Maria Lassnig was accused of painting narcissistically, but the counterargument that Arnulf Rainer was also very narcissistic was simply cast aside."[16]

Maria Lassnig, Hauser & Wirth Zürich, 2007 (photo: Sepp Dreissinger)

In 2003, Sailer ensured that Lassnig was sent as Austria's representative to the first-ever Beijing Biennale. She refused at first, but when she learned that Germany was sending the art star Georg Baselitz to Beijing, her ambition was stoked. Lassnig had an exciting new experience in China. With her sharp X-ray vision, she could see through and capture every person in the shortest amount of time, yet she had difficulty distinguishing faces at first: "I investigate every face.

What do such narrow eyes say?" But soon she learned to differentiate: "But after three or four days, every Chinese person had a face which I could recognize."[17] Sailer accompanied her on the journey. They stayed in separate hotels, which immediately made Lassnig suspicious. Back in Vienna, she gossiped that Sailer had stayed at another hotel so she wouldn't see the "concubines" coming in and out of his room. For Sailer, Lassnig was the most complicated person he had ever met.[18]

Lassnig paid meticulous attention to which art dealers she worked with and often hesitated quite a while before she entered into new business relationships. A sign of her career awareness was that she only got involved with renowned galleries. In dealing with gallery owners, however, she was so uncompromising and her conditions were so unfulfillable that she often harmed herself. Gabriele Wimmer, Sailer's business partner at the Ulysses Gallery, remembers how often Lassnig prevented her from exhibiting and selling her paintings. Lassnig, on the other hand, was jealous because Wimmer had allegedly given Rainer privileged treatment. Wimmer had indeed started working for Rainer as a student at the end of the 1960s and had built up his archive for him among other things: "At that time, I managed the entire Rainer office, next to the gallery, and she always complained that I did so much for Rainer and so little for her." With all the goodwill in the world, it proved difficult to do anything for Lassnig since she delayed exhibitions regularly or canceled them, as she did with painting sales to collectors: "With Rainer it was insanely easy because he was interested in selling. With him, you could carry out exhibitions. He cooperated." Lassnig was quite different: "That's what she didn't do. Sometimes I had the feeling she was afraid of success."[19] For example, she didn't want to exhibit at the Museum der Moderne in Salzburg. The Phillips Collection in Washington—the first-ever museum of modern art in the US—would have liked to buy something. The artist showed no interest. The Drawing Center in New York wanted to acquire drawings for its collection. She rejected their offer for some unknown reason. She herself felt exactly the opposite: "Everything I want to do is thwarted, stymied. On my flight into the airy heights, I'm dragged down by the snakes of this city, by this gallery. They scheme and block my plans, my exhibitions. They will prevent my paintings from leaving the country, close the borders to them."[20]

The artist often treated Wimmer rudely and with condescension. Wimmer remembered: "She was a teacher, and she always treated me like a student. She also wrote me mean letters, sent me registered mail, when she wanted to have paintings back." Sometimes Wimmer even feared her. At exhibitions, the artist gave her precise and—as Wimmer found—nonsensical instructions: "But she immediately threatened me. She said, 'If you don't hang it the way I ask, I'll take all the paintings away from you right now.'"[21] Even if Lassnig liked to complain about her gallerist, she had a lot to thank her for. Wimmer was one of

the few women who could handle her. For the most part, it was Wimmer who organized and financed the exhibition *The Inside Out (Das Innere nach Außen)*, which Rudi Fuchs took over in 1994 for the Stedelijk Museum in Amsterdam,[22] a decisive step on the way to more international recognition. However, it was far from easy to bring this show to fruition: "She started to quarrel with Rudi Fuchs, so he called me in Vienna and said please come to Amsterdam earlier. I can't take it." While Lassnig was desperately unhappy about the exhibition at first, in hindsight—and this is a pattern—she was highly satisfied: "She loved Rudi afterwards."[23] Fuchs, on the other hand, was convinced of Lassnig's uniqueness and that her work would "certainly arrive in painters' heaven."[24]

Wimmer also helped Lassnig get in touch with New York gallery owner Friedrich Petzel, who absolutely wanted to get to know the artist whose painting he was thrilled about. Wimmer recommended he visit the grand retrospective on the occasion of her 80th birthday, which was first to be shown in Vienna in 1999 and then in Nantes. Petzel traveled to Nantes and wooed Lassnig, who let him wriggle for a long time, until she finally agreed. Wimmer was also one of those good souls who, for many years at the beginning of the summer, drove Lassnig from Vienna to Feistritz, exhausting journeys, as the gallery owner recalled: "That's where she pumped me for details about my love affairs."[25] And she went shopping for Lassnig, who didn't place any value on variation but always asked for the same: chicken schnitzel, apples or oranges, depending on the season, black bread, iceberg lettuce, butter, milk, and prunes.

Wimmer couldn't expect any gratitude for her services. In a draft letter, Lassnig called the Ulysses Gallery a "schemer gallery."[26] Sailer said Lassnig always punished those who did something for her, perhaps because any dependency on them was so hard for her to bear and an admission of weakness. She responded with aggression instead of gratitude.[27]

From 2004 on, when Lassnig was represented by the internationally successful, top-level gallery Hauser & Wirth, contact with the Ulysses Gallery faded away: "Then, Iwan Wirth came along, and we evaporated," Wimmer recalled. Only in 2012, two years before Lassnig's death, did the relationship between Wimmer and Lassnig become close again. After the artist called her former gallerist and asked for help, Wimmer rendered her a great service, which Wimmer didn't want to talk about: "I got her out of something." Now, after a twenty-five-year delay, Wimmer received her promised portrait, which Lassnig had refused to give her on the grounds that she couldn't find it or it had been stolen from her.[28]

Not only the relationship to galleries but also to collectors was extremely difficult for Lassnig: "The word 'collecting' always seemed suspicious to me. My God, you can collect beer bottles, collect beer coasters, something like that, but not art, right?"[29] Collectors were fundamentally fishy to her because she doubted

they understood anything about art, especially her art. She didn't want any old Tom, Dick, or Harry to get her paintings, even if they were willing to pay big sums for them: "I don't know why collectors have to grab everything for themselves. The collectors are all assholes to a man, or rather, asswipes."[30] She worried that her work would land in the wrong place—it was as if she had to give her children up for adoption. Her biggest fear was "some kitchen-fairy inheriting a painting and throwing it away because she has no clue. I'm really scared of that."[31] She dreamt of collectors who empathized with and understood her approach, an unrealistic request for the most part. Often a buyer liked a work for quite a different reason. And that's precisely what she couldn't take. Not only did she want to know exactly who was buying something but she also wanted to know why. Andrea Teschke, partner at the Petzel Gallery in New York, remembered: "There was a certain point at which it was thought that the collectors would have to present themselves with a curriculum vitae in order to buy something from her!"[32] Petzel responded to her needs. When a good offer was made, he wrote her a handwritten letter presenting the collector and letting her know which other artists were already in that collection and in which context her paintings would wind up.

What annoyed Lassnig most was if she suspected a collector appreciated a work only because of the title: "For example, Klewan, who has bought a lot from me, but mostly for the titles. If it was titled: *The Cheerful Austrian*, he bought it immediately! Or the *Dream of Marital Bliss*: he bought it immediately because he dreamed of marital happiness. Never saw him really fall in love with a work."[33] As justified as Lassnig's apprehensions about the mechanisms of the art market might have been, it was rather surprising that she could insinuate that one of her earliest collectors, who had acquired many of her great paintings from the 1960s, didn't love her work. Helmut Klewan met Lassnig in Vienna in 1976 when she was exhibiting her New York portraits of animals with Kurt Kalb. Klewan had a little gallery in Vienna's Dorotheergasse at the time. When he proposed an exhibition to Lassnig, she said she was not interested because she was already well-known in Austria. For Klewan, an interesting clue, which he interpreted in his own way: "In some way this drove me to open my new gallery in Munich's Maximilianstrasse a year later." And it was there that Lassnig agreed to exhibit in 1981: "In principle, she shied away from selling paintings and always hoped when she made an exhibition that the paintings would come back to her again." Klewan said this was the reason he only sold about thirty Lassnig works in thirty gallery years, among others the already mentioned 1964 painting *Breakfast with Egg (Frühstück mit Ei)* [p. 171] to Alfred Brendel. Klewan also had peculiar experiences with the artist: "Maria Lassnig could be very charming privately, a lovely radiant country girl. However, as soon as you suggested something businessy

about her art, she transformed into an unruly fury." When he went to her studio, he saw many treasures from the 1960s and 1970s: "She was hoarding all those canvases. There were wonderful paintings among them, but unfortunately, she wouldn't hand them over. She was very stingy with her oil paintings. She was reluctant to even lend them."[34]

The Austrian home-improvement retailer and passionate art lover Karlheinz Essl, who accumulated one of the largest private collections of contemporary art in Austria, was also a thorn in Lassnig's side. Whenever something of hers came on to the market, he struck—at least before 2012, before his hardware store chain ran into serious economic difficulties.[35] In the Austrian art scene, Lassnig was not alone in whining about Essl. It was a matter of good form to complain or make fun of his collecting mania rather than to be glad that someone showed so much interest in the arts, invested his fortune, and didn't hoard the works in secret chambers or in a Swiss security account as an investment but regularly exhibited them to a broad audience in his own museum. The art scene could hardly deal with this collector and art patron who was so unusual by Austrian standards. In order to prevent Essl from acquiring more, Lassnig forbade her New York gallerists to sell paintings to Austria. She was also dissatisfied with the exhibitions at the Essl Museum in Klosterneuburg, just outside Vienna. Essl didn't take this very seriously: "There has never been an exhibition that Ms. Lassnig had no complaints about. I love her."[36]

In 2006, Essl passed a 2005 exhibition from his Klosterneuburg museum on to the Museum of Modern Art in Carinthia, Lassnig's home province, where right-wing populist Jörg Haider was governor:[37] she never forgave him for this. While Essl insisted that Lassnig had consented to the exhibition in Carinthia, she said this was a gross misunderstanding: "You know Carinthians always say 'Ja'—'yes' when they first answer the phone, don't you? 'Yes, hello Kiki, yes, hello Arnulf.' When he called me about sending the exhibition to Carinthia, I probably said: 'Yeah, what's this? Yes, what's all that about?'"[38] The artist was careful to avoid being appropriated by the provincial politics of Carinthia and therefore—as long as the governor was from the FPÖ (Austria's right-wing populist Freedom Party)—she rejected any awards and the opportunity to have a Maria Lassnig Museum in a castle.[39] She said she would have had to talk with the politicians in such a case: "I then had to forgo these castles. I suffer a lot from the prevailing politics there. I don't even want to go to Carinthia anymore, but nonetheless, the fresh air there does me so good."[40] Lassnig explained the Carinthian tendency to vote FPÖ was because so few houses were bombed to pieces in Klagenfurt during the war: "That's why they think the whole war, all the Hitlerism wasn't so bad. It wasn't bad? Really, they believe that!"[41]

Lassnig once said she painted her famous *You or Me* (*Du oder Ich*) in 2005 out of anger at Essl.[42] It shows the artist holding one pistol to her temple and pointing another pistol at the observer. Of course, the extraordinary painting is much more than a little revenge anecdote. It's about the art business and being at the mercy of the observers, who interpret what they want into her paintings. It's about the inseparable combination of self-aggression and aggression toward others, about self-doubt and self-empowerment as two sides of the coin, which is the existence of artists. Mara Mattuschka philosophized: "Me or you—that can of course mean a lot! Do I have a right to be worthy? Is it true what I think? Do I exist? Is there an inner world you don't see, don't understand, can't see?"[43] The painting is a good example of how Lassnig's themes, even if they have a very personal origin—such as her anger toward Karlheinz Essl—have a universal value far beyond this for which one doesn't need to know the original reason.

Du oder Ich
(You or Me), 2005

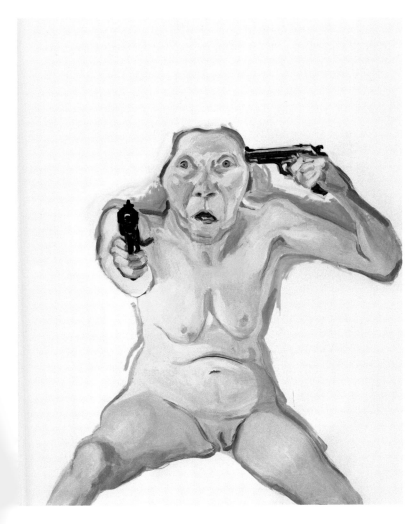

The older Lassnig got, the more the sale of paintings turned into some kind of performance. Hans Werner Poschauko, Lassnig's former student and closest confidant in those years, shared the following anecdote: When a collector wanted to make a large purchase from her to donate the paintings to the Lenbach-haus, a famous museum in Munich, Lassnig put on old sweatpants with huge moth holes and a frayed sloppy sweatshirt just before the visit. When the guests arrived and asked her politely how she was, she answered with a grave voice: "Can't you tell: bad!" While they were surveying the selection in her studio, Lassnig made the

usual fuss, didn't want to sell any-
thing, and complained she was the
poorest artist in the world. Eventu-
ally, the deal was closed. The collector
signed, bought four paintings for a
lot of money, and said quite happily:
"Ms. Lassnig, today is the most beau-
tiful day of my life!" She countered:
"And I tell you, today is the worst
day of my life! You are taking my
paintings away from me!" As soon
as the museum director and collector
were out the door, Lassnig demanded
Poschauko call them up and cancel
the whole deal. He tried to calm her
down: "Let's sleep on it first, huh?"
The mood was bad. Lassnig grumbled
to herself. Suddenly, she got up and
said she had to change her clothes.
When she came back, she hadn't just
switched from rags to normal clothes
but also from a bad to a good mood.[44]

For Lassnig, many collectors
and a significant number of pur-
chase-willing museums were unwor-

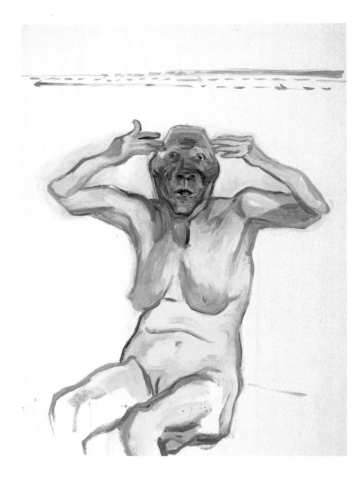

Zweifel (Doubt),
2004–05

thy of her works. For example, she didn't want to sell any more of her works to
the Museum of Contemporary Art (Museum für Gegenwartskunst) in Siegen,
where every five years the very high-profile Rubens Prize was awarded, which
Lassnig won in 2002: "They have enough. That's enough now. What do they want
to do with so many paintings?"[45]

Galleries, collectors, museums: Lassnig ultimately distrusted all these
potential promoters of her work. The fact she couldn't let go of her paintings
was unusual and surprising for many gallerists, even for Iwan Wirth, who had
successfully dealt with complicated artist personalities throughout his career.
This was a peculiarity of Lassnig's that set her apart from other difficult artists.
Of course she wanted the world to see and appreciate her work. Indeed, she
deeply craved this. But there was another side to her that actually obstructed and
boycotted the achievement of this goal. This started with showing the paintings
in the studio. Often, she had a shyness about exposing her works to the eyes
of others, which was difficult to understand. Again, the reasons were complex.

First, there was her paranoia, which was already noticeable in Paris in the 1960s: someone might steal her ideas and copy her paintings. Another more important reason lay in her insecurity and her perfectionism. She was afraid of putting a work out into the world that was not (yet) good enough: "If someone pressures me for a work of mine, I do not feel powerful, but small and unworthy, as if they overvalue me and have an incorrect and oversized image of me."[46] Petzel also observed her deep insecurity: "The unspoken sentence was always: Actually, I think, the paintings might not be good enough." He hesitated for a moment, adding, "Perhaps that's the mark of a good artist."[47]

Even when she had already sold paintings, Lassnig was often unwilling to hand them over to their rightful owners. She argued the work was not completely finished; it still needed to be improved. For example, a painting she had donated to the Kunsthalle Bern Foundation she kept in her studio for twelve years, and the museum only got it after her death. Poschauko recalled: "I heard this story a hundred thousand times. Only she never touched anything up. She always said she still had to paint the background."[48] Paranoia and perfectionism are possible explanations for her unusual behavior. After all, there was a very deep-seated reason that she rarely spelled out. In 2009, she wrote a noteworthy sentence in her journal: "Everything becomes worthless when you show it."[49] That is, Lassnig was deeply convinced that not only the "greedy" collectors and the profit-oriented gallerists but also *everyone else*, everyone except herself, trivialized her images, never grasped them in their whole dimension, nor showed them due appreciation. In 2011 she wrote: "Very weepy mood when I think of the many lost (stolen) paintings ... floating around in this filthy, thoughtless world."[50]

Art men

In 1995, Walther König published a book with portrait drawings by Lassnig with the title *Artworld Figures (Kunstfiguren)*.[51] It might as well have been called "Art Men" because out of a total of twenty-six portraited persons, there are only five women: the writers Friederike Mayröcker and Elfriede Gerstl, the curators Cathrin Pichler and Hanne Weskott, and—as the only female artist—her friend Ingrid Wiener.

Among the drawn men are artists such as Dieter Roth, Arnulf Rainer, Walter Pichler, Oswald Oberhuber, and Markus Lüpertz, writers such as Ernst Jandl, H. C. Artmann, Friedrich Achleitner, Gerhard Rühm, and Oswald Wiener, as well as—the largest group—successful museum directors and curators such as Dieter Ronte, Kasper König, Werner Hofmann, Peter Weiermeier, Rudi Fuchs, Robert Fleck, and Hans Ulrich Obrist.

Lassnig got along better with men than women; she even admitted this herself: when Agnes Husslein-Arco, the then-director of the Museum der Mod-

erne in Salzburg wanted to hold an exhibition with Lassnig, she explained she'd rather do the "real stuff" with men.[52] She also didn't want to take part in women-only exhibitions, arguing quite feministically: "Something like that might have made sense in New York in the 1970s, but this sense of unity no longer exists today. Such exhibitions are just as discriminatory as those about black, yellow, or white artists."[53] She didn't want to compete with women but rather with all successful artists of her time. In 2007, when she was invited by MOCA in Los Angeles to the high-profile exhibition *Wack! Art and the Feminist Revolution*, she initially declined. Her New York gallerist Petzel finally managed to get it into her head that *Wack!* was an important exhibition she should participate in.

Lassnig only highly regarded a few women in the art world, such as Hanne Weskott or Barbara Gross, yet they never came close to her appreciation of men because she had a good sense of where the power was. Most of all, she preferred young, dynamic men. Indeed, these were the ones who gradually got Lassnig's international career in gear. They were less biased and prejudiced than the men of earlier generations, had largely liberated themselves from the idea that women were not serious creators, and recognized, without reservations, the high value of Lassnig's work. And above all, they didn't let her strong and sometimes rather awkward personality disturb them; instead they perceived it as an interesting facet and a challenge. One of them was Peter Pakesch, who was first a gallery owner in Vienna, later a museum director in Basel and Graz. He was fascinated by how Lassnig made a habit of flirting with him and others: "The way she ensnared younger men was something very special. There was always a certain eroticism in the air ... It was like that for me, and I noticed it was similar for others. She blossomed when younger men were around her."[54] This was also Petzel's experience: "The first time we met, I did pretty much everything that you could do wrong: I treated her like an elderly lady. Then, Peter Pakesh clued me in that I should treat her like a young woman, not an old lady, not with a bunch of flowers and stuff. And somehow that worked out a lot better."[55] The young "art men" also included Wolfgang Drechsler, who curated Lassnig's first major retrospective in 1985, the gallery owner Iwan Wirth, and the curators Robert Fleck, Robert Storr and, above all, the youngest of them: Hans Ulrich Obrist, who became one of Lassnig's most important promoters.

Robert Storr, the American Curator of Painting and Sculpture at MoMA in New York between 1990 and 2002, was one of the big shots on the international art scene and became interested in Lassnig in the 1990s. She met him in 1993 when he visited her for the first time in her Vienna studio. He endeavored to promote Austrian art, for which there was little interest in the United States at the time. He still didn't manage to get Lassnig an exhibition at MoMA, where he had proposed it several times to the board and the management. The

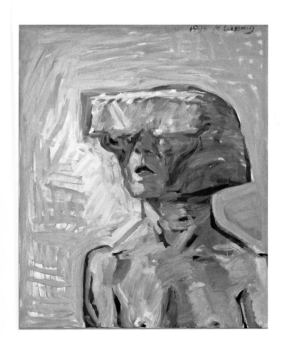

Kleines Sciencefiction-Selbstporträt (Small Science-Fiction Self-Portrait), 1995

unsparing and brutally honest self-portraits of an aging woman still seemed to be too "strange" and "weird" to those in charge. Storr didn't believe he could convey her art to Americans through Body Awareness but via science fiction instead. At the end of 1991, Lassnig used this title to exhibit her paintings in Zurich's Raymond Bollag Gallery.[56] What made Lassnig's science fiction special for Storr was its body-relatedness. He admired how she had achieved unique results in this genre since the 1960s by combining wit and horror, a topic that even young people today might connect well with.[57] In the 1995 *Small Science-Fiction Self-Portrait* (*Kleines Sciencefiction-Selbstporträt*) or even in the 1987 *Transparent Self-Portrait* (*Transparentes Selbstporträt*) [p. 350], she seemed to anticipate virtual reality technologies. Prophetically, the yet-to-be-invented headset merges cyborgishly with her head, penetrates her body, goes under her skin, and dissolves into translucent electrical nerves. It was a time when she intensely occupied herself with cutting-edge brain research and questions of perceptual theory.

In other paintings, anthropomorphic-technoid creatures emerge out of household appliances or weapons. *Kitchen Bride* (*Küchenbraut*) from 1988 is a grater that moves like a human and seems afraid of vegetables. *Vacuum Cleaner* (*Staubsauger*) from 1991 is very fleshy, a feminist critique of housewife existence.

The topics of household and war often overlap, as for example in *The Kitchen Battle* (*Der Küchenkrieg*), also from 1991, a painting ironically described by Lassnig as a "Song of Songs to Austrian Housewives."[58] The household appliances have turned into the helmet, tanks, and weapons of a robotic soldier. *Warlord III* (1996–97) again combines the kitchen topic with the horrors of war. A threatening whirlwind swirls out of a kitchen hand grinder—a grotesque version of Pandora's Box—in which the ridiculousness and nightmare of war ingeniously overlap. The Warlord series, *Mars* from 1995, and *Fury of War* (*Kriegsfurie*) and *The Grim Reaper* (*Sensenmann*) from 1991 were Lassnig's responses to the Second Gulf War and the Yugoslav Wars. For several years, she also planned an animated anti-war film, for which she collected ideas and also made drawings but never produced.

These sci-fi, war, and kitchen utensil paintings especially piqued Storr's interest. When he curated the 2004 biennale in Santa Fe, *Disparities and Deformations: Our Grotesque*, he exhibited Lassnig's *The Grim Reaper*.[59] Again, Lassnig was uncertain whether she wanted to participate in this exhibition at all since

she didn't appreciate her work being called "grotesque." However, she was well aware of Storr's status in the art world, and it seemed to her—again after additional persuasion from Petzel—inadvisable to turn down such an important "art man." They became friends, and after Storr saw her wearing a Marilyn Monroe tie on—see the cover of this book—he gave her a witty tie each time they met, such as the one emblazoned with POLICE LINE DO NOT CROSS!

(top)
Warlord III, 1996–97

(bottom)
*Sensenmann
(The Grim Reaper)*,
1991

by Ralph Marlin made out of yellow and black American police security-cordon tape. Lassnig wore it at the opening of her exhibition *The Ninth Decade* at MUMOK in Vienna in 2009—probably not by chance but rather to keep the people away from her in the hustle and bustle there. Lassnig greatly enjoyed the attention shown by such a renowned and respected representative of the art business.[60] She was completely thrilled about his essay "Ave Maria," which he wrote on the occasion of her London exhibition in 2008. He began with a quote by Willem de Kooning: "Flesh was the reason oil painting was invented."[61] This confirmation of her decades of effort tickled her pink.

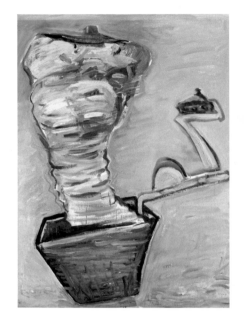

The Swiss curator Hans Ulrich Obrist was even more important than Robert Storr for Lassnig. Obrist was voted the most influential person in the international art scene by the British magazine *Art Review* in 2016. By the way, Iwan and Manuela Wirth, who promoted Lassnig in their gallery, took third place that same year.[62] Obrist had already met Lassnig in the 1980s when, as a teenager, he visited her in her art studio. She met him again in the early 1990s. At that time, Obrist was collaborating with Kasper König, one of the most important exhibition curators of his generation. When König was charged with putting together a major exhibition for the Wiener Festwochen in 1993, he decided, together with Obrist, to do a show on contemporary painting. Meanwhile, the hype surrounding *A New Spirit in Painting* (*Neue Malerei*) had long vanished, and once again, painting was declared dead. König and Obrist were all the more eager to prove the opposite with a large, quasi-countercyclical exhibition. In preparation for the project, one of the first studios they visited was Lassnig's. Obrist recalled: "I was possessed by the vi-

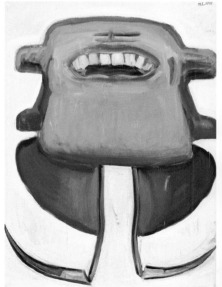

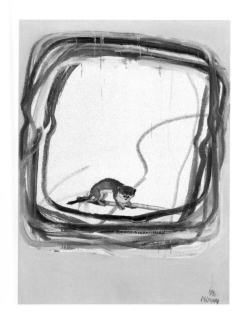

Frettchen im Spiegel (Ferret in the Mirror), 1991

sion that the world needs to know this artist! Her work is incredible!"[63]

The exhibition *The Broken Mirror. Positions in Painting (Der zerbrochene Spiegel. Positionen zur Malerei)* from 1993—initially in Vienna, then in the Deichtorhallen in Hamburg—united the celebrities of contemporary painting of the time: Agnes Martin, Leon Golub, Edward Ruscha, Gerhard Richter, Georg Baselitz, Sigmar Polke, Albert Oehlen, Per Kirkeby, Luc Tuymans, Francesco Clemente, Marlene Dumas, Arnulf Rainer, Hubert Schmalix, and many others. Lassnig exhibited three monumental works, *A Kiss for the Whole World / Tathata (Einen Kuss der ganzen Welt / Tathata)* from 1990 and *Man—War (Mann—Krieg)* and *Ferret in the Mirror (Frettchen im Spiegel)* from 1991. Once again, she experienced high anxiety at the last moment and was convinced that her paintings wouldn't get the attention they deserved. After the opening, however, she was overjoyed—not least by the fact that painting was finally being celebrated again. She wrote to Obrist: "I was quite shaken by this exhibition, firstly, that it even happened, secondly that I could be a part of it (as a painter an increasingly neglected, debased subject)."[64] Through this exhibition, Lassnig's outstanding position in painting became even more apparent to Obrist: "It was simply crystal clear to me that she was one of the greatest painters of our time, that in the entire world there were very few painters at this level. And somehow, I think that had to do with our having looked at such a sea of canvases: Suddenly, she stuck out! And then we thought how strange it was that this artist was not world-famous." Obrist compared her with Gerhard Richter and Pablo Picasso: "There are only a few artists you can get this many exhibitions out of. Every single decade deserves its own exhibition."[65]

This exhibition planted the seed for Obrist's lifelong friendship with Lassnig. From now on, his first stop on every visit to Vienna was to see her. Her legendary apple strudel was an absolute must for her special guests. Alternative eating habits were no excuse: "I had stopped eating sugar but this was always the big exception! You couldn't not eat her apple strudel. You even had to eat two or three pieces or else she'd be disappointed. It really was a ritual." And there was ritual character in the way she showed him her paintings. The paintings all stood facing the wall. Together, Obrist and Lassnig pushed them back and forth. By no means could they all be turned around. He was never allowed to see everything. She would tell him, "No, no, not this one, no way!"[66] Peter Pakesch was also one of the chosen ones whom Lassnig subjected to this ritual of showing paintings.

Pakesch noted: "That was rightly celebrated. You'd be tested on how you reacted to a painting."[67]

The whole spectacle lasted about half an hour, then it was over again. Lassnig often devalued herself during these showings, found fault with this and that, expressed doubt. Obrist was one of the few people with whom she had been in contact for decades and with whom she had not had a falling-out. A surefire reason for this was that he wasn't always there but rather a busy, rare guest. Obrist lived first in Paris, then in London: "I used to tell her about these cities and was somehow a window to the world." Besides, there was always an exciting project in which they worked together; there was no time for friction. And finally, Obrist didn't blame her for her quirks, her insecurities, and her cancellations: "Her refusing things I always saw as part of her art, just like her doubt. As extreme as her self-doubt was, she doubted others, too. She was hard on others, but she was hardest upon herself."[68]

Lassnig wearing a police-cordon necktie at her exhibition opening at MUMOK, 2009

The pen is the sister of the brush

In the year 2000, Obrist published extracts from Lassnig's journals under the title *The Pen is the Sister of the Brush*. The idea came to him in 1993 while working on the exhibition *The Broken Mirror*. The exhibition catalog contained the artist's own comments, and Obrist was especially impressed by Lassnig's text. He tried to persuade her to publish a book of her collected writings, especially from her journals: "She resisted for years. She said that it was embarrassing, that she's not a writer."[69] Obrist tirelessly insisted that her writings had literary value and were also artistically important. Seven years passed this way.

Lassnig had loved literature all her life, and as early as the 1940s, she confided in her journals how much she longed to be a writer herself: "If I lived a thousand years, I would surely become a great poet. Thus, I conclude every day with the disappointment of not having started to thread the needle."[70] This desire didn't go away and kept popping up in her last decade of life. In 1987, she stated: "My latest dream: writing. Do I still have the time and talent? No. It'll only ever be scraps of memory."[71] Ten years later, the same doubt prevailed: "I am not a wordsmith, but rather a dreamwalker between words."[72]

She reflected about the differences between painting and writing and concluded that writing just took too long for her, that painting went much faster. She remembered her first experiences of artistic awakening with "vertical color vision" in the mid-1940s and wondered whether there was anything comparable in writing: "I never looked at a word as long as I did the paint patches. Is this where literature starts? No. Mustn't the content be there? Or can a thought itself

be content enough?"[73] Above all else, she admired writers and poets. They were much more important to her than her fellow painters: "Respect, admiration, comparison: Can you paint in such a way that you say as much as a writer?"[74] She swore she'd give up her television habits in favor of reading: "I've lived in many places, but now I've got a new home: literature! And it's finally time to move away from my old home: TV."[75]

She read Ingeborg Bachmann with enthusiasm and compared how they both, the poet and the painter, artistically processed their former love affairs. She conjured up Bachmann's men "who used her, let their praises be sung by her. (I painted them a bit, my guys)."[76] When she read Bachmann, she fully identified with her: "Put a note in her grave that says: I hear you! Want to dig her out of her grave, the city of Klagenfurt."[77]

Her other favorite authors included Ilse Aichinger and, above all, Friederike Mayröcker. When Lassnig returned to Vienna in 1980, she and Mayröcker got in touch and even worked on a joint book project, which appeared in 1984 under the title *Rose Garden* (*Rosengarten*). Mayröcker wrote the texts and Lassnig contributed a limited edition drypoint etching—a rarity that is only available in antiquarian shops today. The fact that the two women got along so well was not surprising. They both lived in their own seclusive worlds, sharing a similar approach to art. For Mayröcker, her world consisted of images that she translated into language. Lassnig sometimes described her Body Awareness as sensations—Mayröcker also used the term to describe what she was trying to capture: "It's not the scenes that I remember, it's the sensations that accompany those scenes."[78] In 2010, Lassnig and Mayröcker were awarded honorary membership in the Academy of Fine Arts: up until then, only a single woman had received this honor in the two-hundred-year history of the institution.[79] In her dithyramb in honor of Mayröcker, philosopher and artist Elisabeth von Samsonow described

Maria Lassnig, Feistritz, 2008 (photo: Sepp Dreissinger)

her as "the poetic equivalent of Maria Lassnig."[80] The two women talked on the phone regularly. Lassnig also appeared in Mayröcker's writings; for example, "Maria Lassnig on the phone: 'today I felt as if I were already walking in the hereafter.'"[81]

Peter Handke, who visited Lassnig in New York in the 1970s, was also one of her favorite authors. She particularly appreciated his multivolume diaries: "If only painters could keep their eyes as open as some

writers do (Handke)."[82] Moreover, she read his "Essay on Tiredness" and was fascinated by his precise observations, which often included bodily phenomena—exactly what had concerned her throughout her life: "Tiredness, wonderful how he unearths everything undescribed so far. I wonder if he's written about hiccoughs, which are attributed to external influence."[83] Lassnig referred to a belief in the German-speaking world that hiccoughs mean someone is thinking of you.

And last but not least, she was passionate about Thomas Bernhard. She read *Extinction*, his last great novel, fell for his diction, his language, his way of thinking, and wondered what had transfixed her "because there is no pleasure in his hatred of his parents." In the 1980s, someone—she wouldn't reveal who—suggested Lassnig paint a portrait of Bernhard, but she refused "because he was not so kindly spoken of." Despite how much she admired him, she also feared him a little. After his death though, she deeply regretted not having painted him: "A sigh comes from my chest, but I can't suppress it, whenever I become aware of what I did wrong, didn't prevent, neglected, or dropped."[84] She wrote poems to the dead writer and invocations that equated to a mixture of confession, self-accusation, and love letter: "Now I know what you knew. You knew everything, I knew nothing. Your words are not words, they are handmade flowers, divine birds, and topics of intellect. We can't think the way you knew, Thomas" (dedicated to Thomas Bernhard). The conservative press considered Bernhard to be a "dirtier of the nest" because he touched on Austria's Nazi past and other dirty laundry. She felt pangs of conscience that such media scolds had deterred her from painting Bernhard's portrait, and at the same time she was convinced she wouldn't have penetrated the innermost core of his being anyway—for her, an indispensable prerequisite for a good portrait:

> You live in the stars now,
> and I could have looked at you for hours
> but didn't dare,
> I wouldn't have seen your soul,
> even less your heart
> (while painting) ...[85]

Her numerous journals, in which she made regular entries from the early 1940s onward, attest to how much Lassnig liked to write.[86] Writing in the countryside solitude of Feistritz, she filled up countless cheap school notebooks. This was particularly pleasing to her: "When I am sitting on the grass outside and just looking at the ants and so on, that's so inspiring. Yeah, and I write that down."[87]

Obrist remained determined to publish Lassnig's writings and didn't give up: "I just accepted that these doubts are part of her oeuvre."[88] Back in 1993,

Obrist had published Gerhard Richter's writings and interviews and tried to convince Lassnig she should do the same. After all, she longed for equality with the famous German artist, who was always at the top of art market rankings and whom the *Guardian* would call the "Picasso of the 21st Century" in 2004.[89] But she didn't dare place herself on the same pedestal as him then. She feared it might be a failure and how that might hurt her: "It's probably time for me agewise to publish my notes (if they're interesting enough)—but I'm not well known enough, not yet—so it might be a flop. (In Gerhard Richter's case, it was the right decision.)"[90] Meanwhile, Obrist managed to win over the renowned Dumont publishing house for the project and finally convinced Lassnig. The book was published in 2000 and was a great success. Lassnig diligently kept a journal in the following years. In 2008, she wrote, "Dearest Hans Ulrich: I hope all my journals will eventually fall into your hands."[91]

By the way, Lassnig established the connection between Obrist and Mayröcker. When Obrist saw Lassnig for the last time about half a year before her death, they spoke—as so often—about literature. Lassnig insisted that he finally meet Mayröcker. That was an urgent concern for her. Hadn't she told him that twenty-five or thirty years ago? After Lassnig's death, Obrist fulfilled her last wish and met the poet: "And now I see Friederike Mayröcker every time I'm in Vienna. That's the new ritual. Maria Lassnig brought it about."[92]

No boredom: Sensory Adventures, Re-lations, life flows as Paint Flows

Sometimes, Lassnig asked herself if it wasn't boring to always stick to the same stuff—herself and her body—and during an interview, she provoked radio host Doris Stoisser into asking her exactly this question. Stoisser: "Well, are you bored?" Lassnig: "Indeed, sometimes, yes—if I can't come up with anything new anymore!"[93] To stay inspired, she regularly had to free herself from the old: "Again, filled to the brim with nutty used-up images that have to be cleared out. It's hard work to remove all that: you must be empty and new in order to create something new."[94] The extraordinary thing about Lassnig was she managed to do just that—for example, in the early 1990s she started over with new groups of works like Lines Side by Side, Re-lations, and Paint Flows.

In order to accomplish something, she needed to be in a very specific state, which was hard for her to describe. Physical measures helped, for example: "I never wash my hands before I start to paint—and I don't bathe myself until after I've finished a good painting."[95] Since her work was often pioneering, she was convinced no one understood what she was doing: "I don't think it's possible for someone who doesn't know anything about me to recognize my paintings as Body Sensation images. They'd only see dismembered creatures or just brush-

strokes." It was all the more important for her to keep calling attention to what this was all about: "In fact, people have to accept it as Body Awareness because I say it is, but they can't see it. In the true Body Sensation paintings, they don't see it. But it's important to me that they know it."[96] For decades Lassnig had been trying to explain to journalists, curators, and their audiences what her art was all about, and she often felt misunderstood. When Lassnig exhibited at the Kestner Society (Kestnergesellschaft) in Hanover in 2002, a journalist explained to her that she felt so comfortable in the exhibition that she didn't want to leave. The artist was outraged: "The pretty journalist talked about my exhibition in Hanover as if it were a wellness-beauty hotel."[97]

Lassnig's goal was to take something invisible, but nonetheless real, and make it visible. She gave many examples: "The knee can start to tingle, the back becomes a vibrating zone, the nose becomes a hot cave, the legs become screws."[98] The colors came from these Body Sensations, even if they were not clearly identifiable and changed from day to day: "Why I painted this sharp blue or that crisp green, I don't know, but I believe that it can express the intensity of the burning skin sensation on the cheek and neck."[99] In what she considered to be her purest Body Awareness works, she had tried to completely exclude the outside world and not allow any memories since they would distort her current perceptions. Nevertheless, this outside world repeatedly penetrated into the interior; as Lassnig was thin-skinned, keeping inside and outside apart was difficult: "My heart beats so strongly that the outside world shakes, or is it an earthquake?"[100]

In the course of her artistic life, she used a variety of terms to describe what she was working on, from Introspective Experiences to Static Meditations, from Line Paintings to Body Awareness. In 1992, she tried a type of branding with acronyms: "The Sensations of the Body = Körpergefühle = KG."[101] Her wide variety of terminology and artistic results illustrate what a seeker, researcher, pioneer, and avant-gardist she was. She soon gave up the acronym KG. "Abbreviations don't help. There aren't enough words. That's the reason I draw"[102]—an important statement, for if all this were so easy to express in words or even two letters and put into a term, Lassnig's work would be superfluous. All labels ultimately seemed unsuitable to her. "Sensation"—to her sounded too much like "a mysterious, nebulous, mythological anti-fact"[103] because it was all about the factual, the real, even if this was difficult to grasp. "Feeling"—too many associate this with the "BIG" feelings like pain, love, or despair—and most horrifying of all for Lassnig, it was considered typically feminine. She also didn't paint from the gut: "There are only intestines there. I paint from the heart and from the head."[104] She always started with a very simple "small" physical feeling, a pressure point in the body, a tingling in the foot, the heat on the cheeks. She confessed, however, that other things often came up, too: "Originally, it's just Body Sensations, but you

can't prevent the spirit from coming out. Your whole heart and soul flows out of your hand onto the canvas."[105]

In 1994, journalist Andrea Schurian shot the film *Maria Lassnig: Painted Sensations (Maria Lassnig. Gemalte Gefühle)* for Austrian television. The artist let herself be filmed while painting—a rarity—since it was virtually impossible for her to work while being watched by others. Even when she painted a portrait of someone, she made scrupulously certain that the person had no view of the emerging image. So she couldn't really paint in front of the camera, but she could stage herself as a painter for the film, and she tried—almost like an actress—to re-create herself as a painter for the film, and she tried—almost like an actress—to re-create a real painting situation. The scene was nonetheless enlightening and conveyed how Lassnig's artistic process unfolded. First, she nailed a canvas directly to the wall—that was her way of working because it was important for her to be able to press firmly with the brush, and that wasn't possible with a canvas stretched on a frame. Painting was something physical for her, sometimes even strenuous.

Maria Lassnig, Maxingstrasse, Vienna, 1982 (photo: Heimo Kuchling)

Next, she stood in her stained painter's apron in front of the monumental white surface. She raised the brush, her face slightly turned away, listening inwardly, eyes closed, and slowly dragged the first thick outlines onto the canvas. Lassnig also spoke with a slow voice that sounded more sunken, broken, and quiet than usual: "Only the most important part of the face, the nasal cavity, and from there it goes downwards—the neck recess, and the drooping shoulder." Here, the artist hesitated, almost as if in a trance, she groaned, and suddenly a quick brushstroke broke fresh ground. Lassnig commented: "And there you go ... from front to back, to the end of the tailbone." When the brush reached the sacrum, it bored into the spot as if it were a particular pain or pressure point. One thinks of lumbago—a pain with which Lassnig was unfortunately familiar since her time in New York.[106]

Although this scene was staged, Lassnig gave an idea of how she approached the canvas with her entire body. She was dissatisfied with what she had painted so far. She wiped most of it off with an old pair of panties soaked in turpentine and started anew: that, too, was typical of her work process.

Not only could she not be filmed while painting, she couldn't be photographed either. Thus, all the photos are staged, too, including the famous picture of her lying on the floor where she appears to be painting a self-portrait. If you look closely, the year 1973 can be seen on the canvas. It's *Large Reclining Woman (Große Liegende)*, which Lassnig had already painted in New York. The photo, however, wasn't taken until 1982 in her Vienna studio.[107] Because of this photo,

she was often addressed about working in a reclining position. She always seemed a bit uncomfortable with this and pointed out that she had only painted while lying down a few times but usually painted while standing up because she could project her whole body onto the canvas, as the aforementioned film scene clearly illustrates.[108]

In another medium, drawing, Lassnig found it easier to take a variety of positions: "My drawings have more freedom and flexibility in them than my oil paintings. Even though a piece of paper has to be on a hard flat surface, I'm better able to place it on my knees, on my stomach in bed, on the table, in an armchair or on the floor; and I can position myself however I like, which is not as easy with a stretched canvas." That is exactly what Lassnig appreciated about drawing. It allowed her to be more spontaneous, to react immediately to inspiration: "drawing is closest to the moment."[109] And that is exactly what it was all about if you wanted to render a Body Sensation as it changed minute by minute, second by second.

Lassnig's drawings were shown in a series of solo and group exhibitions in the 1990s, including at the Centre Georges Pompidou in Paris and the Museum of Fine Arts, Bern (Kunstmuseum Bern), among others. Again, she thought about new potential titles for her Body Sensations: *Sensory Adventures*, *Phenomena of the Body*, *The Sensual Pencil,* or *Walking Along the Borders*.[110] Drawings were very important to Lassnig: "Every drawing is a triumph over the unrest of the world."[111] She even said, "Drawings have often seemed to me the most important thing, more important than oil painting."[112] However, after being invited to the world's most important large-scale exhibition of contemporary art, the documenta X in Kassel in 1997, her initial joy in participating gave way to bitter disappointment when she was told to only bring drawings.

For the first time in documenta's history, a woman was appointed artistic director: the French curator Catherine David, a circumstance that led in part to astonishingly misogynistic comments in the press and art scene. The smell of "token woman" was in the air, and they feared the exhibition would take a feminist turn. David was labeled "Madame stubbornness," "Snow White," "Holy Joan of Arc," "The Cold Brunette," "Sphinx," "Pythia," and the like—a class of attributions that none of the hitherto exclusively male directors had had to tolerate.[113]

David had seen Lassnig's exhibitions at the Centre Pompidou in 1995 and at the Kulturhaus Graz in 1996, as well as in a group show by curator Robert Fleck on Austrian contemporary art in Rouen and Caen in the same year.[114] When she invited Lassnig to attend a documenta for the second time in fifteen years, the artist was very pleased. David then visited Lassnig in her studio and chose no paintings but

Augen und Oberlippensensationen (Eye and Upper-Lip Sensations), 1995

Nebeneinander Linien II (Lines Side by Side II), 1993

instead over thirty drawings for documenta. Lassnig's face turned to stone. She couldn't say a word. Their parting was cool. Soon after, she composed a letter to David in which she apologized first for her behavior—"triggered by the bitterness of my painting being rejected." Then, she referred to the nasty comments in the German art world about David curating the documenta: "I can very well understand that because of the bad behavior of German painters, that you don't show much goodwill towards painting as a whole." Nevertheless, she asked David to reassess her decision and consider whether Lassnig's painting was worthy of documenta: "I haven't been showered with fame, and because I do not have much time left, I was hoping so much that my painting would finally find its deserved place via documenta."[115] Naturally, Lassnig wasn't entirely wrong: with her large paintings in intense colors, she could gain more attention in Kassel's Fridericianum than with her intricate drawings on a few low exhibition walls. However, Lassnig's drawings better suited David's intellectually oriented concept for documenta X, which generally refrained from large gestures, and she stuck with the original selection. Many titles—*Brainwaves, Head Meridians, Head with an Open Brain-Bowl,* or *Vertical Facial Nerves*—illustrated what the artist was working on at that time. She was interested in neuroscience and brain research and was pleased to be ahead of science as an artist in a certain way: "I find it reassuring that neurophysiology hasn't yet discovered all the secrets of the nervous system."[116] In her drawings, she explored how Body Sensations, brainwaves, and hearing, touch, and sight were related. Sometimes, the ear was in the foreground, as in *Auditus Auditor,* sometimes the sense of sight, sometimes the sense of touch and sight simultaneously, as in *Eye and Upper-Lip Sensations (Augen und Oberlippensensationen)* from 1995. Eyes and

lips are only recognizable as shadows, with radiating meridians, magnetic lines, neural pathways, or vibrations. They wrap her head in a network of invisible sensations that are thus made visible. Nevertheless, Lassnig repeatedly emphasized that Body Sensations cannot be assigned to one of the familiar senses: "Not the sense of sight, nor hearing, nor smell, nor taste, nor touch (most closely related to the latter). It isn't a mixture of these senses either. And yet it is a sense."[117] Later, she thought about calling it the "sense of recognition" or the "sense of noticing."[118]

At about the same time, lines and color tracts also appeared in the large format paintings. Her Body Awareness no longer seemed to focus on single body parts but captured all her nerve paths, bloodstreams, and meridians.

In Lines Side by Side (Nebeneinander Linien) from 1989 to 1993, Lassnig placed abstract, wide brushstrokes in the colors of yellow, blue, red, and green side by side on the canvas as the title suggests [p. 321]. Some of this is reminiscent of Lassnig's Static Meditations from her informal period at the beginning of the 1950s or of her Line Paintings from the early 1960s.

For Paint Flows, she placed the colors closer to each other and let them mix themselves on the canvas. They could run vertically, diagonally, or horizontally, as in *Paint Flow = Life Flow (Malfluss = Lebensfluss)* from 1996. Time and again, they come to a halt, knotting into dumpling-like formations, which upon closer inspection turn out to be heads. They interrupt the calm, linear flow of life, forming obstacles, stations, or climaxes. These are abstract portraits of important people from Lassnig's life. In the middle of the top color strand is the distinctive profile of Lassnig's mother; on the right is little Maria as a child with a bob. The next color strand contains her three fathers. Her biological father is easily

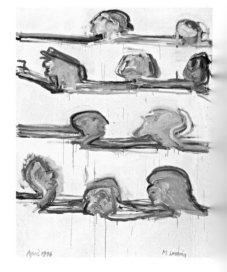

Malfluss = Lebensfluss (Paint Flow = Life Flow) 1996

identifiable with his iconic cap, which Lassnig knew from an old photograph [p. 24]; in the middle, Jakob Lassnig with his big, broad head; and on the right, Paul Wicking with glasses, her second stepfather. The two lower lifelines show some of her love-partners, "the good men and the evil men, of whom some played a smaller and others a bigger role in my life."[119] Easily recognizable are Oswald Wiener on the bottom right, Arnulf Rainer on the left, and above them, Sergeant Frank Philips and Arnold Wande with his prominent chin and distinctive head.

A related series Lassnig called Re-lations. In the first painting of this series, it becomes clear what cruel character she ascribes to relationships. "Body-Sensation piles" are penetrated by or wrapped in a dark, almost black color tract that zigzags across the canvas. It is less reminiscent of a flow

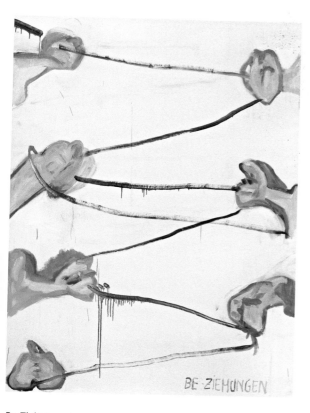

*Be-Ziehungen I
(Re-lations I)*, 1992

of life or paint, and more like a wire that seems to painfully pierce and bind the body parts and heads. Relationships don't make you happy—they are "re-lashing-ships." The German title *Be-Ziehungen,* in large letters on the canvas, is a wordplay which does not translate but for Lassnig contained the ideas of tearing, pulling, and dragging. One is lashed to another, one is bound and helplessly entangled until it physically hurts—a clever and sensual image of how Lassnig experienced love and the interpersonal.

As in the early 1950s and 1960s, Lassnig left her canvas backgrounds white—and this bothered her: "Most of the current painters seem to paint the surroundings first and then fit the people in. I paint the people first, then the surroundings, if at all. I give birth to them onto the empty canvas, into the void."[120] Lassnig saw this psychologically motivated by her life situation: "The void is happy, a happy loneliness."

Drastic Paintings: "an almost vulgar clarity"

While Lassnig was still working on Paint Flows—mainly abstract Body Sensations—she felt the urge to paint more realistically, figuratively. She put her own spin on these excessively blunt paintings and called them "drastic": "The drastic paintings are like when someone with huge clown shoes goes up the stairs to express what walking is."[121]

Her working on two completely different artistic approaches at the same time was nothing new. Back in the Nazi era at the Academy, Professor Ferdinand Andri had recommended that more continuity be brought into her painting and not to jump around so much. But following two different tracks was exactly what had always thrilled her and saved her. And she kept jumping, even now at the age of eighty—in the literal sense—back and forth.

Two blank white canvases were nailed to the wall of her studio and she didn't know what to do first: "I'd like to do both at the same time, hopping back and forth between the two canvases (channel hopping)."[122] She was born torn, Lassnig continued in her journal, and that was probably not a devastating shortcoming. She had both talents: on the one hand, the ability to work analytically

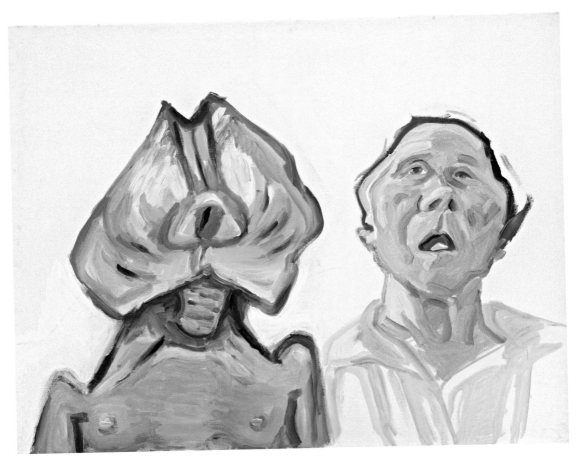

Zwei Arten zu sein (Doppelselbstporträt) [*Two Ways of Being (Double Self-Portrait)*], 2000

and abstractly; on the other hand, to present reality convincingly. That didn't have to be a contradiction, since one has two hands, two feet, and two eyes, so why not have two talents? Again and again, she felt she had to justify herself for this, especially to herself. She compared herself to Italian writer and filmmaker Pier Paolo Pasolini: after all, he was both a Catholic and a Communist at the same time, so she could be both a realist and a non-realist as well.[123] As the title of her exhibition at the Kunsthaus Zürich in 2003 proclaims, there are *Different Ways of Being* after all. In countless self-portraits, she did variations on the theme, such as in *Double Self-Portrait* in 2000, which she renamed *Two Ways of Being* for the exhibition in Zurich.

While she was convinced her Body Awareness work was difficult or even impossible for others to grasp, she considered her Drastic Paintings to be simple, straightforward, and understandable. They were characterized, as Lassnig said, by "an almost vulgar clarity."[124] These included, for example, *Illusion of the*

Missed Motherhood [p. 75], *Illusion of the Missed Marriages, The Kitchen Apron* [p. 70], and *You or Me* [p. 307].

As it was to so many things in her life, Lassnig's relationship to her Drastic Paintings was ambivalent. On the one hand, she was proud of them and knew she had created very strong images. When Hans Werner Poschauko asked her if she had founded any school, Lassnig replied, if she had done that at all, then it would be the school of Drastic Painting.[125] On the other hand, sometimes, whether in interviews or in her journal, she expressed a slight disdain for this manner of painting because it seemed all too obvious and not analytical enough to her and a concession to the insensitive audience: "Image and sensation then form something simple in which the real dominates nicely because external life dominates sensation equally nicely. That's at least what common people like to think."[126]

In 1999, Lassnig had the opportunity to present her Drastic Paintings together with many other works to a broad public in Austria and France. The retrospective took place on the occasion of her eightieth birthday and was once again curated by Wolfgang Drechsler, who had designed her first retrospective in 1985. The exhibition was a total success. Edelbert Köb, later director of the MUMOK (Museum of Modern Art) in Vienna, viewed Lassnig's career boost of the 1990s in a larger art historical context. The time of pigeonholing was over. There was a new and confusing complexity in art. As a result, individualistic and unique artists like Lassnig had a better chance of being picked up on the art business radar. Köb: "With no big categories left, no big movements to place artists in, there's only the option of seeking out original personalities."[127] That's how Lassnig was perceived in France. The exhibition moved on to Nantes in modified form, where it was shown in two locations, the Musée des Beaux-Arts and the FRAC.[128]

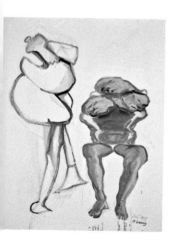

Generationswechsel (Generational Change), 1997

The exhibition in Nantes came about thanks to Hans Ulrich Obrist and Robert Fleck, who was then the France correspondent for the magazine *art.* Both acted as networkers and tried to promote Lassnig in France. Deciding what exactly she was going to show in Nantes distressed her. It was her first French retrospective after all. She sent Fleck a postcard by Ernst Voller, who was known for his humorous motifs. It depicted a huge elephant that seemed to stand with one foot on the back of a fragile boy. It's not hard to guess who Lassnig identified with: "You see how heavy the future exhibition weighs upon me. I feel I still don't have enough new work to show, and I have no time for work because of all the preparations."[129]

Her remark was all the more absurd, considering how little she had exhibited in France so far. But something completely dif-

ferent became the real problem. At the same time as the big Lassnig exhibition, Arielle Pélenc, the local curator in Nantes, was planning a show with young Austrian artists. Lassnig wrote in outrage to Fleck: "What's that supposed to mean? This must be some kind of bad joke because the newspapers, of course, as they always do, will mainly write about the youth. I think this'll go wrong. I protest!"[130] Lassnig suspected a Viennese conspiracy and wanted to cancel everything. She strongly felt the pressure of a coming generation and processed this in several paintings. In *Generational Kick* (*Generationsfußtritt*) from 1998/99, you can see how a greenish Lassnig in three forms is strangled, kicked, and pushed down by a malicious pink figure. In *Generational Change* (*Generationswechsel*) from 1997, the threat wasn't limited to the art world. Next to a bulky, hollow-bellied Lassnig stands a machinelike robotic pregnant woman who snootily turns away from her. After Fleck received Lassnig's letter, he immediately called her. He tried to smooth the waves and stop her from dropping everything on the spot. He wrote Pélenc, explained how desperate Lassnig was, and added, "I think that's perfectly understandable."[131] About two weeks later Fleck could give the all-clear. The young Austrian artists wouldn't exhibit at the same time, and he assured Lassnig that the idea hadn't come from Vienna at all. The artist was relieved: "Thank you for your understanding about the co-exhibitors, and I hope that you and Nantes aren't angry or disappointed."[132]

Kampfgeist I (*Fighting Spirit I*), 2000

In July 1999, the exhibition opened, and the French got to see seventy-plus paintings and more than eighty drawings by Lassnig. The exhibition was announced in *Le Monde* on the front page, and an enthusiastic review headed the cultural section. *Libération* and many other newspapers celebrated the artist as well.[133] Fleck wrote to Lassnig: "This was really a great success in France. I also hear this from many younger artists who discovered you on this occasion, for whom you are now the new Louise Bourgeois, if one may say so. The paintings are first class, after all. They look quite different to the eye when they are hanging in Vienna, where they are almost too familiar to be viewed without burden. I just wanted to give you my gut feeling."[134] Lassnig highly appreciated Fleck's support. He, too, was one of the younger men in the art business whom Lassnig spoiled with her apple strudel. She had high hopes when, in 2004, he became the director of Hamburg's Deichtorhallen and in 2008 of the Bundeskunsthalle in Bonn. However, when he didn't put her on the program at either venue, she was disappointed and contact abated.

During the exhibition in Nantes, she met Friedrich Petzel, who was about to gain a foothold as a gallery owner in mid-1990s New York. He had become aware of her some time ago and absolutely wanted to win her over to his gallery. When he asked her to exhibit with him in New York, she said, "But Mr. Petzel, you are too young for me. What do you want with me?" New York wouldn't make sense to her anymore, she added. She gave her address to the obstinate young man but without the postal code. Petzel didn't let up. Kasper König—highly esteemed by Lassnig—also coaxed her by saying Petzel would soon move to a larger gallery in Chelsea. Wouldn't that be something for her? And after all this, she asked him warily what of hers he wanted to exhibit in the first place. Petzel gave her the right answer: "Of course, we have to show your latest paintings."[135] That was exactly what the artist wanted to hear. In 2002, Petzel exhibited her ingenious soccer series. These large-format canvases, created between 1998 and 2001, belong to her Drastic Paintings and bear titles such as *Competition I-IV*, *Sports Ceremony / Soccer Ceremony* (*Sportzeremonie / Fußballzeremonie*), *Fighting Spirit I* (*Kampfgeist I*), or *In the Net* (*Im Netz*). Soccer, a male-dominated sport, tough and competitive, where women—at least until recently—had no place, became Lassnig's metaphor for the art business. Most of the paintings show her as a soccer player with red-striped socks and sturdy cleats, either alone or with competitors on the field, such as Arnulf Rainer. Lassnig saw herself with self-irony, which *Fighting Spirit I* shows: she takes on the role of a soccer-playing nun—the lonely, ascetic fighter—who more or less nimbly heads the ball.

In the run-up to the exhibition, of course, there were problems again. The gallery was thoroughly warned in advance, yet quite unexpectedly the transport of the paintings from Vienna to New York turned out to be a difficult hurdle for them. To minimize the risk of loss, Lassnig absolutely didn't want her work to be sent in one shipment. Andrea Teschke, who was then in charge of organizing the exhibition, contacted Lassnig's regular art forwarder in Vienna to naively ask him to pick up the paintings and was met with the response: "You've got enough time, right?" Teschke didn't know what he was getting at. Everything had been arranged. Lassnig was home. He could drive there right away. In view of this unprecedented naiveté, the forwarder scoffed: "Pff, you have no clue whatsoever!" From experience, he already knew what was coming: Lassnig furiously sent him away. She didn't want to hear anything about New York. That would be far too dangerous. There was war all over the world. When the fine art forwarder explained this to Teschke, she was shocked and feared the paintings wouldn't be delivered to New York in time. As a twenty-five-year-old intern, she couldn't have known that this ritual game took place in variations before every Lassnig exhibition, and as a participant, you had to surrender and just play along.[136] At some point, it eventually worked out.

The exhibition took place as planned. Petzel: "And it turned out to be an absolute hit!"[137] The renowned art critic Roberta Smith of the *New York Times* wrote a wonderful article: "Consider these eleven recent paintings by the Viennese artist Maria Lassnig as the tip of an iceberg that should be much better known in the United States ... [Her works] combine aspects of action painting, Viennese Actionism and feminism that Ms. Lassnig has achieved over time, through work that connected to and sometimes presaged contemporary efforts by Willem de Kooning, Konrad Klapchek, Georg Baselitz and others. Giving her work its due in the history of postwar painting would undoubtedly knock some preconceived notions pleasantly out of whack."[138]

Lassnig was surprised; she had feared New Yorkers would again perceive her paintings as *strange* and *weird* as they had in the 1970s. Whole school classes came to the gallery to see her paintings. Many visitors took her for a young artist because this group of works was so fresh, cool, and funny. The paintings sold like hotcakes to American, British, and Dutch collectors. MoMA bought some drawings. Petzel, however, had to swear an oath to Lassnig not to sell anything to Austria: "I don't need a New York gallerist to sell my paintings in Vienna!"[139] Finally, she did show some mercy though and even allowed Karlheinz Essl to purchase a soccer painting.

Lassnig was very satisfied with Petzel and Teschke, who looked after her for a fortnight. As a farewell, the artist wanted to treat the young gallery worker to dinner. Teschke, who knew her way around New York, thought of proposing a nice little restaurant in complete disregard of Lassnig's almost pathological thriftiness. Actually, Teschke should have known better as Lassnig had refused to stay in a beautiful five-star hotel at Central Park, which Petzel—of course at his expense—had booked for her, but instead she opted to stay in a run-down hotel near the gallery. She never went by taxi but by subway or on foot. In Paris, when she had her exhibition at the Centre Pompidou, she came three-quarters of an hour late to her own opening because she had taken the wrong metro. So where did this high-earning smart-spender want to take the gallery intern to show her gratitude for the great care and support? Glowingly, Lassnig divulged to Teschke that she had found something really great where you can go to lunch for just a dollar—the so-called dollar meal at McDonald's—and there was one directly across the street from her hotel. "She loved cheeseburgers! She thought that was insanely cheap, a colossal bargain!" Teschke remembered laughingly.[140]

When the gallery sold a painting and wanted to transfer the usually quite high amount, Lassnig reacted in horror: "No, for God's sake! When will Friedrich come to Austria next time? He should bring that to me in cash, in a suitcase, because otherwise they'll take it all away from me! That'll all go to the Austrian tax authorities!" The gallery, however, insisted of course on a proper transfer.[141]

Despite Lassnig's quirks, Petzel remained enthusiastic about her: "Immersing myself in the world of Maria Lassnig changed my life." For him, she was an exceptional figure in contemporary art, and he was convinced her fame would continue to rise: "She's unstoppable. I don't say this as a gallery owner."[142]

Live models instead of self-portraits:
The World Crusher, Adam, Eve, and a basement

Hans Werner Poschauko, who had countless conversations about art with Lassnig in the last years of her life, recalled how she doubted until the end whether she had ever accomplished anything worthwhile: "Isn't it just autism? Isn't it only for myself? Have I achieved anything universal at all?"[143] Throughout her life, self-doubt and insecurity made her try new things. For example, around 2000 she began to work more with live models. Before that, if she didn't depict herself, she usually painted portraits. For certain topics that occupied her, she now used models. And last but not least, it was about getting away from herself, achieving something more universal and countering the criticisms of being autistic and narcissistic—criticisms that were rarely made but still ate at her.[144] In addition, Body Awareness, which she now called the "pictures from imagination," required another form of effort: "As most of my pictures from imagination consist of me observing myself, and I sometimes get a little weary of it, I have to switch to the observation of others. Very admirable, I think."[145] This could, however, lead to intensely experienced internal conflicts: "War between optical perception and experiences from imagination! I'm lost between two canvases."[146]

Insektenforscher I (Entomologist I), 2003

One of her most important models was Wolfgang Moser. She met him through the Ulysses Gallery, where Moser had a student job. Recommended by Gabriele Wimmer, Lassnig hired him as an assistant in her studio. He assembled frames, stretched canvases, and did other errands for her. Lassnig watched him while he worked and was fascinated by his burly, beefy body. Soon, she asked him if he would model for her. Moser was honored and said yes. First, she sketched numerous drawings, then she decided to paint him as well.

At the first sitting, Moser wore blue boxer shorts with white polka dots. Lassnig began to complain: "This

blue distracts me! Don't you have normal briefs—for example, flesh-colored ones or something?" Moser knew immediately what Lassnig was really getting at but didn't dare to ask: she wanted him to undress completely. But he let her continue to nag for a while, until he finally offered to take his underwear off as well: "She was really relieved by this."[147] The first picture Lassnig painted of him was *Entomologist I (Insektenforscher I)* [p. 329] from 2003, which he particularly liked.[148] It shows Moser, who studied biology, with the subject of his master's thesis, a predator fly from Grand Canary whose mating behavior he researched. When Lassnig was painting the picture, Moser didn't yet know what she was up to. She only instructed him to extend his arm. She would then put a young lady on it. When Moser saw the result and recognized "his" oversized fly, he was delighted.

Der Weltzertrümmerer (The World Crusher), ca. 2004

In later paintings, she thought up less likable roles for him. She painted him as a *Child Molester,* as *Don Juan d'Austria* [p. 283] in a rape scene, and as *The World Crusher (Der Weltzertrümmerer).* For the latter painting, Lassnig let Moser play with her pink globe beach ball, one of Lassnig's important and beloved studio objects. Poschauko recalled Lassnig's emphasis on making sure that the ball was always well inflated: "Every now and then she played with this ball."[149] *The World Crusher* is a colossus with evil blue eyes who crushes the poor little pink world with his monstrous paws. He looks like a giant baby from a horror movie who, in a simultaneously innocent and guilty way, does something evil. With the pink ball, a children's toy, Lassnig, in her typical and unique approach, gave the brutal topic a humorous twist. Your laughter gets stuck in your throat.

Moser didn't mind the artist having portrayed him in such violent roles but still felt exploited—after all, she painted around fifteen paintings with him as a model: "When you're no longer needed, you are simply thrown away. The whole thing would be alright if you got corresponding remuneration, but that wasn't the case. To this day, I still haven't received the painting she promised me." On another occasion, she promised him sketches of the paintings. "She always had a thousand excuses. The sketches weren't there. She had them in Carinthia or they were lost. She even went so far as to claim they were stolen from her."[150]

Maria Lassnig in Maxingstrasse, early 2000s

When Lassnig had artistically used someone or something up, it or they often became worthless for her. She once said she mainly did self-portraits because she didn't want to use other people. This feeling wasn't un-

justified. Wimmer thought Lassnig "actually abused Wolfgang Moser with her painting titles."[151] Moser himself was more easygoing about this—for clearly understandable reasons: "That has nothing to do with my personality, and it doesn't really matter to me either. As a model for Maria Lassnig, I was basically an actor. If Bruno Ganz plays Hitler, that does not make him a Nazi." Lassnig also recognized no connection between Moser's character and the subjects of these paintings: "This guy certainly hasn't molested a child. He is in fact a very shy, fat, carefree man."[152] And Moser was glad and proud to have met Lassnig: "After all, I became a part of art history through her paintings. I think there are worse things that can happen to you than having been the model for a world-famous artist."

Indeed, these paintings are among Lassnig's most intriguing works from these years, which soon delighted critics and a wide audience around the world. One thing infuriated Lassnig very much though. Nobody noticed that for the first time she was working with models instead of her own body. Moser: "The fact that nobody, not even a journalist, caught on to this totally annoyed her, made her mad as hell."[153]

Moser didn't remain Lassnig's only model. Around 2001, she painted several pictures of Gildis and Adolf Merl, a collector couple living in Gurktal,

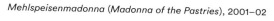

Mehlspeisenmadonna (Madonna of the Pastries), 2001–02

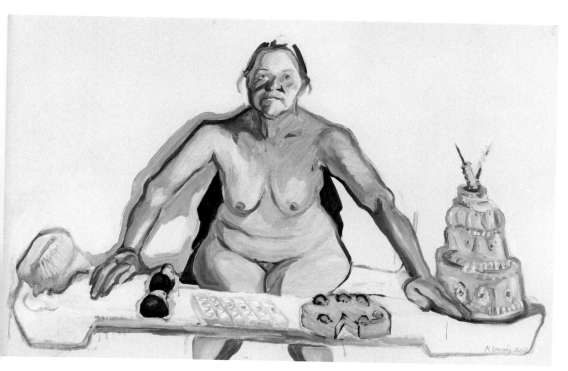

not far from Lassnig's summer studio in Feistritz. The two not only purchased the artist's paintings but also bought her groceries, picked her up from the train station, and did smaller errands. Lassnig painted Gildis Merl as a magnificent *Madonna of the Pastries* (*Mehlspeisenmadonna*) and as an equally impressive *Country Girl* (*Landmädchen*) on a motorcycle. The tensions that arise between a no longer quite so young naked woman's body, the towering pastries, and the Christian subject of the Mother of God were more than just erotically tantalizing to Lassnig. This Madonna tempts with bodily sensual pleasures.

Nudity was anything but a matter of course in the countryside. "All the people then said, for God's sake," Lassnig laughed, "my God, naked people are being painted up there."[154] That's also what the Adam and Eve series—which she painted in Feistritz, too—was about for her. She met her models, Lisa and Christoph Resch, at a parish festival at the Feistritz church, where they had been working as sacristans since 1998. The young couple was fascinated by the artist and told her about their own interests in painting. Lassnig, in turn, found the couple likable and soon asked them if they would like to model for her. An intense and exciting working relationship continued over several years. Lassnig demanded that the couple undress at least down to their underwear. Once again, she was fascinated by the implied contrast, this time between ecclesiastical office and nudity.

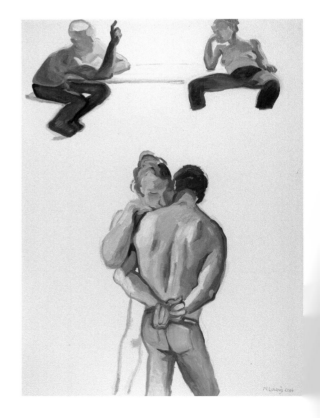

Zärtlichkeit (Tenderness), 2006

After a while, when the two had completely dropped their drawers, Lassnig was quite excited: "My two beautiful nude models suddenly stripped and I exclaimed spontaneously and enthusiastically, 'How incredibly naked you are!'"[155] As with her students, she also developed a certain voyeuristic curiosity with this couple. Lassnig enjoyed watching the two and especially admired the muscles of the young man: "You two are so beautiful!"[156] Her old yearnings for an idyllic love affair, which she had always rejected as illusion, returned again. Her paintings do not, however, depict kitschy love scenes but a contemporary couple's relationship: Adam and Eve in the twenty-first century. For Lassnig, the gender relationship remained antagonistic. Lisa Resch said, "She always wanted us to argue in the paintings; for us to enact a fight. We always wanted to accomplish that, but we

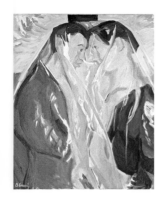

didn't succeed."[157] In fact, the two of them look friendly in most of the paintings. Lassnig captured a rift and reconciliation at the same time in *Zärtlichkeit* (*Tenderness*) from 2006. As always, she remained self-critical. When Obrist interviewed her about the Adam and Eve series, she said: "It didn't come out the way I originally wanted! What I want usually doesn't come out, but the opposite. I wanted to portray love and hate, the great emotions. They didn't come out, I think, or do you think so?" She asked Obrist doubtfully. When he nodded and said that it was by all means in there, Lassnig was almost outraged: "Well, where is it then?"[158] Her doubt remained.

Paar (*Couple*),
2005–06

Over the years, an increasingly cordial relationship between the artist and the sacristan couple developed. That Lassnig was unpredictable and not easy to deal with quickly became apparent to the young couple. This didn't stop Lisa Resch from admiring her as an artist and extraordinary woman: "That's why I was able to tolerate a lot in the relationship with her. I also went shopping for her and always wondered what I had brought back wrong this time." Lassnig once again formed a stronger bond to the young man than to his wife. He helped her with handicraft things, even made pedestals for her sculptures. After a visit, Lassnig would wistfully stand in the doorway and wave goodbye to the two of them. Before that she would ask Christoph Resch for a *neckee*, a little peck on the neck. In retrospect, the couple attached particular relationship importance to their modeling for Lassnig: "Thinking about it, Maria Lassnig also sealed our connection. A painting like that is better than a marriage contract!"[159]

Even in Feistritz, it can get very hot in summer and Lassnig invited her models to go down into the cooler basement. The two experimented with various poses, sat down in the bathtub that was stored there, hung from the gymnastic rings, and played with the "dirty, grimy, musty plastic tarps" lying around. Lassnig was thrilled and gave instructions. "Putting these building tarps on wasn't exactly pleasant,"[160] Lisa Resch recalled. A spotlight provided reflections and strong light-and-dark contrasts. The new lighting situation both fascinated and vexed Lassnig. She had so far refused to paint with artificial light since she couldn't analyze it and it was much more banal than daylight.

Adam und Eva in Unterwäsche (*Adam and Eve in Underwear*), 2004–05

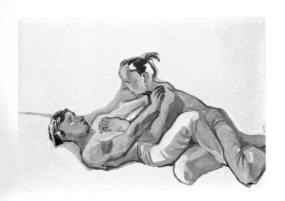

The even bigger revolution for Lassnig was, however, that she photographed the couple for these Basement Paintings with her analog Nikon camera and then worked according to these photos. For decades, she had railed against photography: "Because

photographic art is painting's greatest competitor and the greatest danger to art in general, because it seduces the best painters onto the wrong path."[161] With these aberrations, she meant artists who used photos as templates, especially Gerhard Richter.

Richter particularly grated on her, not only because he was regarded for many years as the most important contemporary artist but also because her beloved Hans Ulrich Obrist thought so highly of him. She studied Richter's writings, which were published by Obrist: "So far, however, I haven't found a sentence where he gets to the bottom of what differentiates photography from painting, and that annoys me!"[162] And yet she was now working with photographs herself, like those taken for the Adam and Eve series, but hadn't made this publicly known. Wolfgang Drechsler even suspected that Lassnig had been using photographs for a long time, such as for the animal paintings in New York, among others.[163]

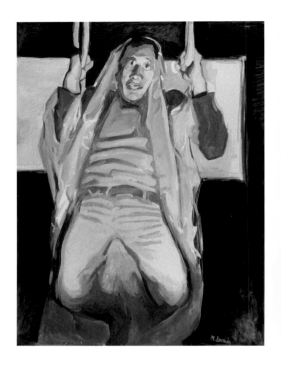

Sport ist Pflicht
(Sport is Duty),
2005–06

But now she struggled with this and bitterly reproached herself—countless diary entries over many years testify to this. For example: "Painting with the help of photography is copy, not art—is artificiality, not art, is like sculpture, which is handicraft, like the Japanese artists carving a wooden bicycle, that's great handicraft! Why doesn't anyone take this question seriously? Neither museum people nor critics do."[164] She downright had the feeling that she'd acted unethically and was harming herself with it: "I don't have my mind together, especially with painting. You have to start from scratch, with a small stroke, with a little splash of color, and find out how and why I can go on from there. It's because of this disruption that I reached for photos and included them in painting as a beginning: something *impure* came along." Once again, as so often when she became too realistic for her own taste, she had the feeling she was neglecting true art. She described the Basement Paintings as false paths and "*fabricated* images."[165] In those years, she frequently weighed the value of Body Awareness in relation to more realistic painting: "When I work on a picture from imagination, I don't have the feeling of having worked at all—but when I work from a model, I do. Maybe because the latter is like building a house: One thing after the other has to be done—an eye, a nose, etc. Whereas in the picture from imagination everything has to be done at the same moment and nevertheless remains vague for a long time."[166]

As much as Lassnig doubted the project, the triumph of her success was just as great when her paintings were exhibited at the Serpentine Gallery in London, where Obrist was curator and co-director. In the run-up to the show, the usual problems arose. Lassnig shied away from the London competition because there were, after all, a whole series of great nude painters, like Lucian Freud or Jenny Saville, who painted huge nudes of very meaty models: "I was a bit afraid to go there with my tiny nudes."[167] In addition, she wasn't sure if—as Obrist intended—she would like to exhibit her Body Awareness and her more realistic Drastic paintings at the same time. She constantly concocted new reasons why it would be better if the exhibition didn't take place. Just two weeks before the opening, she called Obrist: "Hans Ulrich, we have to cancel this exhibition because the ceilings are too low." Obrist remained cool, telling her that so many people in London were looking forward to the exhibition, she shouldn't worry, and to just trust him. Lassnig calmed down a bit but called him once again: "These ceilings, these ceilings!"[168]

The exhibition became a sensation. At the opening, Lassnig, who was nearly 90 at the time, was in top form, and everyone was amazed by the incredible energy of her paintings. Up until then, the British had hardly heard of Lassnig, and now with 80,000 visitors, many of whom waited in long lines, the exhibition was one of the gallery's best attended ever. The reviews spoke of a discovery, an artist of the century, and interpreted Maria Lassnig as a link between Francis Bacon and Lucian Freud. Being perceived as an equal in this league was balm for her soul. Obrist, who was well aware of Lassnig's persistent moaning about her lack of recognition, experienced her in a completely different way for the first time: "She was totally euphoric. I had never seen her like this before."[169] Lassnig could hardly contain her joy: "The Serpentine Gallery was a pinnacle! And initially, I didn't even want to exhibit there!"[170] Lassnig was also enthusiastic about the catalog, which contains, among others, the essay she loved so much—"Ave Maria" by Robert Storr—and a text by the artist Paul McCarthy, who greatly admired Lassnig because, according to him, she had anticipated Viennese Actionism in her painting. The exhibition then traveled to Cincinnati and finally, in a modified form in 2009, also to Vienna's MUMOK.[171]

Birthdays, a new studio, and paranoia

Lassnig's youthfulness in old age, the innovative power of her paintings, and her incredible energy inspired all those who were close to her in her last twenty years. Drechsler made a total of three major exhibitions in Vienna with her—he couldn't imagine any other Austrian artist would have had the œuvre to be able to do this: "There are very few such people in all art history."[172] Most artists repeat themselves in their later work—not Lassnig. Although she

regularly took up earlier topics and approaches, she varied them in a completely new way. For example, when she wrapped Lisa and Christoph Resch in plastic foil, this was indeed reminiscent of her self-portraits under plastic from the early 1970s [p. 214], but she gave them a very peculiar look—a mystical character, as Lassnig said—thanks to the special lighting and their constellation as a couple. When she painted a portrait of herself with animals in the early 2000s, she was, on the one hand, connecting with her American animal paintings and, on the other hand, setting completely new accents. While *Sleeping with a Tiger* (*Mit einem Tiger schlafen*) [p. 229]

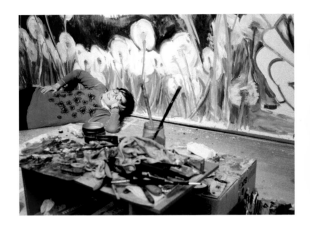

Maria Lassnig, Vienna, 2008 (photo: Peter Rigaud)

is a powerful painting of female sexuality in all its potency, the *Frog Princess* (*Froschkönigin*) from 2000 shows the same erotic needs but a much less satisfying situation. The frog, who sits on Lassnig's genitals, both wants and doesn't want to transform himself into a fairy-tale prince. At the age of eighty-eight, Lassnig wrote in her journal: "If I told the public about my sex life, people wouldn't believe it. I'm so plagued by my libido that I can't sleep and often wriggle and fidget desperately."[173] She experienced getting older as cumbersome and depressing: "Old age should proceed peacefully, smoothly, and harmoniously, in order for it to be bearable. In my case, it's the opposite: I'm always on the edge of suicide."[174]

She hated it when her age was addressed. If someone admired how much she managed to accomplish in old age, she got furious: "The Queen of Painting dreads dirt will be thrown at her on her 80th birthday."[175] When she turned ninety, similar words dawned upon her: "You're violently forced through this, this filth of a birthday. They rub it in your face."[176] This vanity of age was particularly surprising in Lassnig since she painted her aging body in an incomparable way and exposed it to the public. Poschauko remembered: "When people came to visit, I always said, 'Please don't address her age!' If someone said, 'My grandma is as old as you,' the conversation was over."[177] She also couldn't stand being called the Grande Dame of Austrian Art.

That was also why Lassnig couldn't forgive Drechsler when he called her exhibition at MUMOK in 2009 *The Ninth Decade*. It didn't matter how old she was. Why did he have to spell it out for everyone in the title? It should be about the work and not her birthday. After all, at the London show in 2008, which formed the basis for the MUMOK exhibition, her age hadn't been a concern: "But in Austria, as a woman and an artist, you immediately get the year number stamped on you. I never counted the years. I was never really young—and

now I'm not old either. I never thought I was really that old. It's only since the MUMOK exhibition that I feel old and used up."[178] This wasn't quite true. Even eight years earlier, she had felt she was constantly being addressed about her age. She noted down a movie idea: She had the number eighty-two painted on her body—on her face, on her back, on her chest. Annoyed, she removed the numbers over and over again. But that didn't help because the next person came and painted the number on her body again.[179]

The exhibition at MUMOK enjoyed tremendous popularity. Edelbert Köb, then director of the museum, commented: "I have never experienced such enthusiasm for a visual artist in Austria. This crowd of people who just wanted to touch her, exchange two words, have an autograph. It was unbelievable."[180] And: "The phenomenon of an artist having a career boost at the age of ninety is exceptional and contradicts all my experiences."[181] For Lassnig, however, the discriminatory title was at the forefront of her mind. Drechsler was shocked by her reaction: "For me, the title was such praise!"[182] There were hardly any artists who between their eightieth and ninetieth year would produce sufficient work to make such a great and magnificent exhibition possible. Moreover, she didn't object to the title before the opening of the exhibition. Even when he brought the paintings back after the show, she hadn't yet let him in on her bad mood. He only found out through others that she was so miffed with him about the title. She herself never said anything to him but broke off contact without comment after twenty-five years of very friendly collaboration. It wouldn't be Lassnig's last cessation of a friendship in her late years.

As youthful as the artist often seemed, her body and its symptoms of aging increasingly caused her difficulties. The hospital and treatment stays accumulated. Even these she transferred into radical images, such as *Hospital* (*Krankenhaus*) from 2005, which portrays emaciated, sick bodies in all their misery, or her series

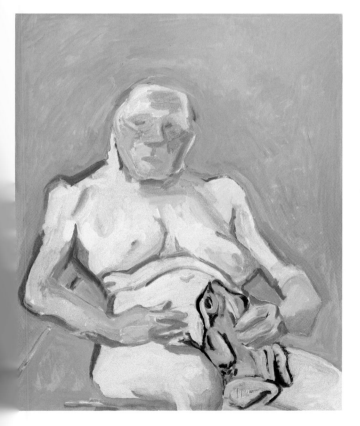

Froschkönigin
(*Frog Princess*), 2000

Krückenbild I (Crutch Painting I), 2005

of highly expressive self-portraits with crutches. In 2004, difficulty walking, along with other ailments, led Lassnig to regretfully have to say goodbye to her beloved studio in the Hietzing Maxingstrasse. She had lived there on the fifth floor without an elevator. The architect Hermann Eisenköck offered her a large, two-level studio with an elevator, directly above his office in the Gurkgasse in the fourteenth district. After hesitating for a while, Lassnig accepted the offer. However, she would never be happy in this new studio. Whereas in Hietzing she had had indirect lighting, a glass ceiling, and light from the north, now the new

lighting conditions were anything but ideal. Depending on the time of day, she could only use a certain room or corner. Working continuously became difficult, so she had to jump from canvas to canvas even more than she liked. Although she enjoyed working on two or more paintings at once, she preferred doing this of her own accord and not when the light dictated. There were further problems. The house was full of noises: creaking, rustling, and thumping. When Lassnig turned off the fluorescent lights at bedtime, they crackled for a while when she was trying to sleep. From her rooftop apartment in Hietzing, she had looked down at the trees of Schönbrunn Zoo. Now, she had the feeling she was being watched all the time from the apartments and offices opposite. These circumstances further fueled her already steadily increasing paranoia. She thought they wanted to steal both her paintings and her ideas. Similarly in the 1960s, she had suspected her French painter friends of copying her purple and her red monsters. She was convinced that everyone was just out to swipe her painting ideas—perhaps because she had been fighting so long for recognition. In the year 2000, she noted: "I have to slip away from my imitators and say good riddance. They overrun me, conceal me, devalue me."[183] When she worked on her Basement Paintings with the plastic sheets and took photos that had to be developed in the laboratory, she mistrusted the employees there in an absurd way, as Christoph Resch recalled: "They plagiarize my work while developing my photos, she claimed again and again. She couldn't be convinced otherwise."[184]

From 2006 on, Barbara Plattner, who worked in the architecture office on the floor below, regularly took care of her. It started mainly with office work, but over time she increasingly took on nursing tasks, as Lassnig was often weak and sick. The sounds in the studio regularly provoked the artist's imagination.

She thought she heard someone in the depot below her and feared they were running off with her paintings. She slept badly and asked Plattner several times to stay overnight with her—which Plattner kindly did. The year 2009 was bad. She could hardly sleep, was always shaky on her feet. One day, when she bent down to put on her slippers, she felt dizzy, then fell and broke her thigh.

Not just Lassnig but also all those around her saw this serious accident on October 5, 2009, as a turning point. Although she was recovering well physically after long hospital stays and rehab, she was no longer the same. Lassnig had all kinds of conspiracy theory explanations for

the accident. She explained to Oswald Wiener "under a pledge of secrecy" that someone had broken into her studio and pushed her.[185] She told Hans Werner Poschauko that computer rays from the architect Eisenköck were sent up from below—after all, she saw stars before her eyes when she fell.[186]

When Plattner rightfully wanted to charge the very wealthy Lassnig an adequate sum for her extensive care services, the artist ended the cooperation. That someone would want compensation for time spent with her was a great insult to Lassnig. She was often very lonely and desperately wanted care and attention. In the late 1990s and early 2000s, she painted and drew a series of self-portraits with a teddy bear in which she heartbreakingly portrayed herself as a lonely woman in need of love and tenderness. Sometimes the teddy bear looked like a baby, whom she hugged and rocked, sometimes like a substitute lover. At some point, she even went so far as to write: "I've been feeling this way for a long time: I wish people would love me more than my paintings."[187] Even though Plattner had looked after her caringly for many years, spent several nights with her, and also visited her in the rehab center in Althofen, Lassnig never spoke a word to her again. For Plattner, who continued to work in the same building on a daily basis, this grievous offense was hard to digest.

Lassnig's paranoia was often directed at the people around her, at persons who appreciated her and only wanted the best for her: "Those who know me from way back when hound me now with hatred and envy, going through this makes me sad (Sielecki, O. Wiener etc.)."[188] When Hans Angela Scheirl came to see her, she told him not to steal her books while she went to the bathroom. One of the saddest conflicts was with her old friend Hilde Absalon, who had cared for Lassnig all her life and done many major and minor chores for her during her New York and Berlin years. As a textile artist, Absalon had produced several tapestries of Lassnig's works, including one of the gouaches *Last Picture of My Mother on a Chaise Lounge* (*Letztes Bild meiner Mutter im Liegestuhl*) from 1964 [p. 176]. When Absalon planned a book about her weaving, she also wanted to photograph and include this tapestry that Lassnig had bought from her many years ago. She came to Lassnig's studio, intent on bringing the tapestry down to the courtyard for better light. Lassnig became suspicious, demanded a borrower's slip, and instructed Absalon like a schoolmaster not to damage the work in any way. Finally, she gave sundry reasons why it would actually be better not to photograph it now. For Absalon, it was inexplicable why her friend wouldn't do her this tiny favor, and they had a fierce quarrel. Absalon was so hurt that she no longer wanted anything to do with Lassnig: "Probably she couldn't help it. It was a kind of paranoia, I don't know, but I just couldn't stand her anymore." Only at Lassnig's deathbed did she see her friend again and reconcile with her. At that point, Lassnig was already very weak and could no longer speak: "She

really was very happy about my visit and kept squeezing my hand, lifting it and squeezing it again."

In retrospect, Absalon saw her friendship with Lassnig as a one-way street and drew a bitter balance: "She certainly had autistic traits. That's why she never had any real friends. She didn't care about them, just like everything else around her. You were only seen when she needed you or when it was convenient for her, but that she had to put effort into a friendship, that she might have to work at it, sometimes didn't occur to her."[189]

Mein Teddy ist
wirklicher als ich
(My Teddy Is More
Real Than Me), 2002

Until this quarrel, Absalon was one of the good souls who more or less regularly took care of Lassnig, did errands for her and kept her company. The artist had a talent for giving each individual an exclusive feeling, so that many didn't even know of one another. Peter Pakesch: "She didn't network the people she dealt with, but kept them neatly separated from each other."[190] Gabriele Wimmer told the same story: "At the end, she also tried to keep Poschauko and me apart, but we coordinated things amongst ourselves."[191] On the one hand, this had something to do with Lassnig feeling her best when she was alone with a person. On the other hand, she also entertained the fear that others might ally against her and conspire behind her back, which she wanted to prevent.

Although her paranoid phases increased, she still had good days where she could work wonderfully, visit exhibitions, or take walks. Filmmaker and photographer Sepp Dreissinger visited her regularly and, as long as possible, took her out into the countryside. He had known Lassnig since 1988, photographed her many times, and posthumously released a film and a book about her. In 2011, he celebrated Christmas with her by singing traditional non-Xmas songs like "Hoch auf dem gelben Wagen" and "Sur le pont d'Avignon" all night long.[192] In the summer, when her anxiety ran rampant in Feistritz, he used to pick her up or spend the night at her place.

Gerlinde Thuma, her former student, also frequently stopped by and took her to exhibitions. After a museum was dedicated to Arnulf Rainer in Baden near Vienna, he proposed a joint exhibition with Lassnig. She then asked Thuma to drive her there, so she could get an impression of the place. The closer they got to the museum, the more uncomfortable Lassnig felt. At the highway exit to Baden, she said, "I feel sick because of Rainer" and that she would rather not enter the museum. Thuma calmed her down. Lassnig: "I won't pay a cent to enter though!" Thuma assured her that she had already arranged for free tickets. When the two

walked into the museum, the first thing they saw in the entrance hall was a large board with the chronology of Rainer's life. Lassnig was outraged when she realized that she didn't appear in his biography. Nevertheless, she looked at the exhibition with Thuma and finally acknowledged: "He's not so bad after all."[193] The project of a joint exhibition failed nonetheless. Lassnig thought, as Rainer recalled, that he didn't ask her politely enough: "She let me be informed that my letter didn't show sufficient pleading and genuflection."[194]

Pakesch also visited Lassnig two or three times a year. When he came by for the first time after the accident—Lassnig had recovered well and was back from rehab—she staged a magnificent performance: "She was very proud she was able to open the door for me without crutches—like a little girl—as if she were a fourteen-year-old! And she showed it all, her joy and pride in not having to greet me like an old woman."[195] In 2001, Lassnig established a foundation to maintain her legacy after her death. Over the years, she had appointed different members and cycled some out.[196] Pakesch, then director of the Kunsthalle Basel and later of the Universalmuseum Joanneum in Graz, was early on one of Lassnig's foreseen members. When the foundation was established in 2015, he became the chairman.[197] In 2006, he organized an exhibition with Lassnig at the Kunsthaus Graz and in 2012 a comprehensive exhibition in the Neue Galerie Graz, curated by Günther Holler-Schuster, that formed the basis for the major shows in the Deichtorhallen in Hamburg and MoMA PS1 in New York in 2014.[198] Lassnig repeatedly expressed her concern to Pakesch that her pictures were being stolen. He suggested she have a catalog of works compiled. Pakesch succeeded in persuading her by taking her paranoia seriously: "If she had all her paintings catalogued, that would also protect her from theft because she could then prove that something belonged to her when it showed up elsewhere."[199] In 2012, Johanna Ortner began working on the catalogue raisonné.[200]

In summer 2012, the situation became critical when Lassnig almost called it quits with Pakesch. The preparations for the exhibition in Graz, which was due to open in November, were in full swing. As always, Lassnig spent the summer in Feistritz, albeit for the last time. She felt bad, certainly also because she was upset about the upcoming exhibition. Her extreme sensitivity to noise made her constantly hear things in her isolated house. At some point, she imagined that the municipality of Feistritz had quartered people in her basement. She felt in danger and called her confidants—among others, Pakesch, Dreissinger, and Hermann Eisenköck—but nobody managed to calm her down. Eisenköck made a special trip from Vienna, but she chased him away when he got there. Pakesch, who didn't want to take any chances with the exhibition, tried to talk Lassnig out of her fears. This only upset her even more because she didn't feel he was taking her seriously, but rather that he was just trying to placate her: "She almost

broke with me. Those were very delicate and touchy phone conversations."[201] Eventually Lassnig even called Obrist—as a higher authority from outside. Obrist didn't understand the situation, was worried, and alerted the police. The officers came, listened to everything, were obviously psychologically well-trained, and did just the right thing: after a while, the police returned to Lassnig and told her that the perpetrators had been caught—only then did she calm down. At the exhibition opening in the Neue Galerie Graz in November, Lassnig was feeling good again.She enjoyed being celebrated. Pakesch arranged a banquet on the museum's premises. Lassnig sat beaming next to Oswald Wiener at the grand dinner table, and her anxiety seemed to wash away.

In Maria Lassnig's last years, her most important attachment figure was Hans Werner Poschauko. After she dismissed Barbara Plattner in anger in January 2010, she called him: "Do you want to work for me?" He had been her favorite student at the Angewandte and during his studies he had stretched canvases for her. Even later, the contact never broke off and an artist friendship emerged. When Lassnig called, Poschauko knew that this time it was about more than just stretching a few canvases for her. He hesitated for a moment, discussed it with his wife, and finally agreed—a life-changing decision for the following four years. Pretty soon, Claudia Plank, Poschauko's wife, commented: "You are like Harold and Maude."[202]

At the beginning, it was mainly about work, loan contracts for exhibitions and other office duties. She often sent him shopping. Like everyone who had ever taken on this task for Lassnig, he learned all about her obsessive thriftiness. When he didn't bring the discounted jam, as ordered by her, but the quality product with real fruit, which was one euro more expensive, Lassnig reacted furiously: "I'm not paying for that! You can take it with you." Poschauko paid the

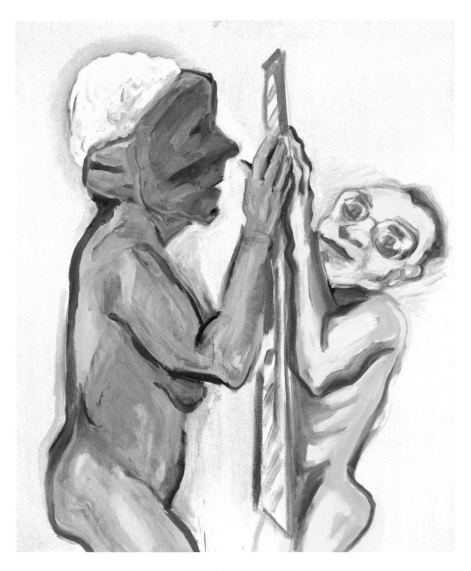

Berührung mit dem Jenseits (Touching the Afterlife), 2000

difference himself. At first, he visited her two or three times a week for three to four hours; eventually it was every day.[203]

Once a week, Bibiana Cechova, the household help, came to clean up. Lassnig waxed poetically: "Biiiibi-bibianaa, to my country Slovak culture you have brought. Let not thy sweet nose and upturned eyelashes droop into the test tube."[204] In a sketch and a painting that followed, the artist captured Cechova's muscular back. At first, Lassnig cooked her own meals, but after a few incidents with burnt pans and charred pots, Poschauko ordered Meals on Wheels over her objections. Soon she received care during the day and later 24/7. Lassnig's relationship with her nurses was catastrophic. In 2011, she wrote, "On days when I'm all alone (in the house and without a caregiver), I feel very gentle and soft. That makes me feel good."[205] She did her utmost to get rid of the nurses, although she knew she needed them. Once, at five o'clock in the morning, she waited for the nurse to go outside and then locked her out. Shortly thereafter, she fell out of bed and lay wailing on the floor. At such moments, the nurses always called Poschauko, often in the middle of the night. The fire brigade had to break a window and Poschauko fought to prevent the paramedics from delivering Lassnig to the mental hospital on the spot.

Despite all these difficult moments, the time he spent with Lassnig was precious. With him, unlike her nurses, she could spend hours and hours talking about art, philosophy, literature, and, not least, death. He helped her choose titles for her paintings, an activity that had always been a nuisance for her. They tossed around associations until the title was found.

But Lassnig even strung Poschauko along. She promised him drawings for certain jobs but never handed them over. Once she told him quite openly why she behaved this way: "If I give it to you now, then you won't come back tomorrow." She had little trust in the people closest to her. She believed they wouldn't act uncalculatingly or remain loyal if they had already been "paid."

But in the end, Poschauko found a good way of handling situations with her. He was patient, attentive, and yet strove for clear boundaries. Right at the beginning, he told her that he wouldn't stay with her overnight—since, after all, he had a family. Nonetheless, Lassnig often called him in the middle of the night and implored him to come over because she imagined someone was stealing paintings from her studio. He regularly got into a taxi at two o'clock in the morning to go see her. At one point, they even armed themselves with kitchen knives to confront the alleged thieves at the scene. After such charades, she felt better for a while.

Lassnig knew exactly what she had in Poschauko. When the two attended an exhibition in the Essl Museum in Klosterneuburg, Agnes Essl, the lady of the house, asked the artist who the young man at her side was. Lassnig replied

with a smile: "This is my angel!" Mara Mattuschka, who had been close friends with Poschauko since their studies, said: "She needed you to get from one plane of existence to another. You need some kind of angel for that." Poschauko was convinced that Lassnig deliberately chose him for this role.[206]

The Last Tango: **triumph in New York**

Lassnig predicted: "I won't be buried in the ground until I have an exhibition at MoMA"[207]—and that's exactly how it turned out. All shows during Lassnig's last years, however, could hardly have come about without Poschauko. For all three major spectacular retrospectives—2012 in Graz, 2013 in Hamburg, and 2014 in New York—Lassnig had to sign individual loan contracts. Poschauko said, "It was pandemonium to the last minute. The museums were constantly calling to ask if she had signed yet. And she just didn't want to sign. She said: Do it after my death!"[208] The New York exhibition, in particular, made her panic: she feared it'd be a flop. Once again, she boycotted what she longed the most for. Time was running out. MoMA in New York required a binding agreement, otherwise they would plan another exhibition instead. Poschauko finally resorted to the utmost pressure: "If you don't sign the contract for New York, I'll never come back." Lassnig whined and signed but demanded of him that he take full responsibility if the exhibition were to fail. While she still managed to travel to the Graz 2012 show, it was clear from the outset that she wouldn't be able to make it to New York anymore. Half a year earlier, Peter Eleey, the curator of the MoMA PS1, had sent a hanging plan with Lassnig's paintings in miniature format. She looked at the plan and said to Poschauko: "We can't do that. It's a candy-shop exhibition. Look at the colors. There is so much pink, green, and yellow. It looks like Candy Land." Poschauko responded: "But Maria, these are your paintings!" Lassnig: "Those are not my paintings!"[209] Lassnig didn't yet believe in the exhibition.

Maria Lassnig, with Peter Pakesch at her side, receiving the Golden Lion from Austrian Minister of Education, Arts, and Culture Claudia Schmied, 2013

Previously, in 2013, she had received Venice's coveted Golden Lion for Lifetime Achievement—one of the art world's most important awards. She didn't want to travel to Venice anymore, and Peter Pakesch accepted the prize on her behalf. Back in Vienna, he arranged to hand over the award in Lassnig's studio in the presence of Claudia Schmied, who was the federal minister of education,

arts, and culture at the time. Lassnig was pleased the minister took notice of her and requested to speak woman to woman with her after the official ceremony. Couldn't Schmied, by virtue of her high office, please exercise her authority and send away the nurses?

Lassnig was ambivalent toward awards throughout her life. This is why Pakesch and Poschauko had different impressions of her reaction to receiving the Golden Lion. When Pakesch officially handed her the trophy she was extremely proud,[210] whereas she told Poschauko that she didn't care about that prize one bit. The winged lion stood around for a while on the table, and at a certain point she prompted Poschauko: "When are you gonna finally store this bird away?"[211] The "bird" was only unpacked for visiting curators or museum people. When Gerlinde Thuma congratulated her on this great prize, Lassnig said it would only give thieves and burglars stupid ideas. After all, every newspaper said she owned a Golden Lion.[212]

Der Tod und das Mädchen / Der letzte Tango
(Death and the Maiden / The Last Tango), 1999

With Poschauko, she had in-depth discussions about death—a topic that had long occupied her. In 1975, at the age of fifty-six, she wrote in her journal: "Why can't death take a more divine form instead of being so beastly, so gruesomely murderous, groaning and flailing around! Why couldn't one simply dissolve into nothingness, into the clear blue sky, into a stormy cloud, or lie down on a meadow and metamorphose into grass?"[213] This fantasy dream awakens memories of Lassnig's Lamentation Paintings about the death of her mother [pp. 180–81]. Lassnig had green grass and flowers grow out of her mother's corpse and made her coffin float in the blue sky. When Lassnig thought about death, her mother was omnipresent. She remembered her "closed-door glance" just before death and she herself

now had the feeling of standing in front of this dark door: "big and black, closed, insurmountable."[214] She deeply sensed the pointlessness of death: "The older you get, the smarter, more beautiful, more perfect you become, and death (which is also a murder after all) is thus a cruel and unjust finale that unnecessarily destroys a pains-takingly constructed, gloriously radiant 'edifice' at its pinnacle."[215] Lassnig's burn-ing concern: "I will die without having discovered myself."[216]

Vom Tode gezeichnet (Drawn by Death), 2011

Death appeared in her paintings as well, "rather old-fashioned," as she said, with a skull and skeleton.[217] In *Death and the Maiden (Der Tod und das Mädchen)* from 1999, the grim reaper performs a dynamic, erotic dance with Lassnig—and the alternative title of the painting refers to this: *The Last Tango (Der letzte Tango).* In other paintings, she dealt with those who had already died and with whom she was now closer. *Touching the Afterlife (Berührung mit dem Jenseits)* [p. 344] from 2000 doesn't show Lassnig in front of a dark door but rather in front of a glass wall/mirror with her hands resting on it. On the other side, much smaller than Lassnig, stands Arnold Wan-de, who has also laid his hands on the mirror. They both reach over the edges of the mirror with their fingers so they can actually touch each other. Her mother often appeared to her in her dreams, promising to come and get her. *Drawn by Death (Vom Tode gezeichnet)* from 2011 creates an ambiguously vexing puzzle on the canvas. On the one hand, the grim reaper crops up as an artist, who uses his orange-colored brush to paint the dying Lassnig. On the other hand, he doesn't actually paint *her*, but only her outlines and the orange background. The dying Lassnig thus becomes a void, just like death itself. There's another twist here: maybe it's even a double self-portrait of Lassnig, who not only presented herself as a dying person but also as the artist turned into a skeleton who—as in reali-ty—continued to paint on as long as she could.

Shortly after her accident in 2010, she started her last self-portrait and continued working on it until late 2013. Poschauko asked her what she was hold-ing in her hand: "It looks like a bolt of lightning or a knife!" Lassnig smiled con-spiratorially and said: "No, that's a brush!" At a young age, she had become aware that the brush was also a weapon, and in her last self-portrait, she presented herself as a warrior once again.[218]

Soon she was so weak she couldn't sit upright. However, she still wanted to continue painting and asked Poschauko to help her. Actually, she was only

Selbstporträt mit Pinsel (Self-Portrait with Brush), 2010–13

able to work alone, but now she had to have her closest confidant watch her. He lifted her from her wheelchair onto her old red painting chair and held her from behind. In this way she could paint the lower parts of a large canvas, but for the upper areas Poschauko had to lift her into an almost upright position. When she couldn't manage to paint the background anymore—something that was never her passion—she asked him to do it. He refused, however, insisting she paint everything herself, but he did tie the brush to a long bamboo stick so she could reach the upper parts as well.

Lassnig worked on her last paintings until January 2014. Then she just couldn't anymore. On January 11, 2014, she wrote a final desperate letter to Obrist: "Dear Hans Ulrich Obrist! Living with art keeps you from wilting! Without art, you wilt, me especially. Not even a loud call for help could help me anymore! I'm miserably disposable, and just because I have some reddish blotches on my cheeks, nobody is seriously worried about me or my art." Below, her handwriting trails off at an angle: "Every day is the last. Every night weighs a ton around the world. Feistritz: studio + depot"—then the letter abruptly ends. At the bottom of the page, she added the date and wrote: "The kitchen tiles resounding!"[219] She could no longer paint, but she drew until the very end.

On March 9, 2014, her exhibition opened in MoMA PS1, and the New York public enthusiastically received it. Famous American artists such as Cindy Sherman and Zoe Leonard raved about the ninety-four-year-old artist and her

multifaceted work, which they had hardly known and which had never been seen to this extent before in the US. At home in Vienna, Lassnig wasn't doing well, and everyone around her felt she was only keeping herself alive because she still wanted to read the reviews no matter what. And indeed, in-depth discussions soon arose in the *New York Times*, *Wall Street Journal*, *New Yorker*, and many other media. While lying in bed reading the reviews, Lassnig smiled at Poschauko: "Hans Werner, you were right!"[220] She experienced the exhibition as the absolute culmination of her artistic life. Peter Pakesch also remembered a similar scene, about three weeks before her death. When he visited her, she had set the scene in advance by surrounding herself with all her newspaper clippings: "She sat with her wheelchair at the table and really propped herself up. I came in and she read the reviews!"[221] Even a few weeks before her death,

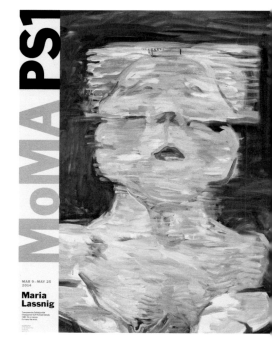

Poster for the exhibition at MoMA PS1 in 2014 featuring *Transparentes Selbstporträt (Transparent Self-Portrait)*, 1987

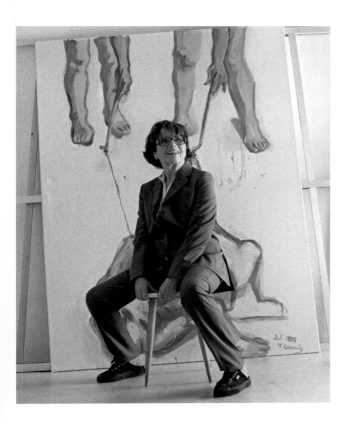

Elfie Semotan, *Maria Lassnig, Wien*, 2000, which shows Maria Lassnig
in front of her 1998 painting *Tierliebe* (*Love of Animals*)

Lassnig knew exactly how she came across to others, and she still managed to put on a convincing show.

Two weeks later, Lassnig was hospitalized but still tried to draw on a daily basis. She spent her last three days in a relaxed state of twilight. Poschauko was with her every day. Other last visitors were Sepp Dreissinger, Gabriele Wimmer, Hubert Sielecki, and the former Lassnig students Gerlinde Thuma, Sabine Groschup, and Bele Marx. On May 6, 2014, half an hour after Poschauko left her in the evening, Maria Lassnig died peacefully in her sleep.

Acknowledgments

A biography and its translation can only be achieved with the support and help of many people. First, I would like to give my special thanks to Jeff Crowder—not only for putting massive effort and all his linguistic intuition into sensitively translating and conveying my tone but also for finding the right voice for Lassnig's often very creative use of German peppered with tons of Austrianisms.

As great as a translation may be, if no one publishes it, nobody will be able to read it. My greatest thanks therefore must go to the three co-publishers of this translation: the Maria Lassnig Foundation, the Friedrich Petzel Gallery, and Hauser & Wirth Publishers. Each of them has an equal part in the project. Among many other things, they also made it possible to add a wealth of images of Maria Lassnig's great work. I can't thank Jennifer Magee from Hauser & Wirth Publishers enough for taking on the major task of managing this huge project. If it weren't for her coordinating talent we would have been lost in translation. I also have to thank Michaela Unterdörfer, publisher at Hauser & Wirth Publishers, and Ricky Lee, director of communications & publications at Petzel Gallery.

Without the active support of the Maria Lassnig Foundation, I would not have been able to write this book. The foundation gave me insider access into their extensive archive, which was just being set up at the time, with all its boxes, folders, and stacks of paper. For that I thank the foundation's chairman, Peter Pakesch. Likewise, Johanna Ortner always patiently supported me with her essential and extensive knowledge and unparalleled accuracy. With the same precision and insights, Johanna reviewed all the translated chapters and updated the bibliography and all the images.

Hans Werner Poschauko, also a member of the Maria Lassnig Foundation as well as a former student of Lassnig, accompanied me from the beginning of my writing process with his advice, his insider knowledge, and his creativity. He was my most important corrective help for the end stage of my biography project. For the translation, he supported us with various fact checks. During the writing process, I also received invaluable material and important information from discussions with foundation members Gabriele Wimmer, Hans Ulrich Obrist, and Friedrich Petzel.

Gregory Weeks, the translation editor, provided the final touch on the translation. Additionally, with his enormous knowledge of Austrian history and the correct terminology in English, he guaranteed accuracy and precision in this field, too. Thanks are also due to the copyeditor, Georgia Bellas, who polished the book in full.

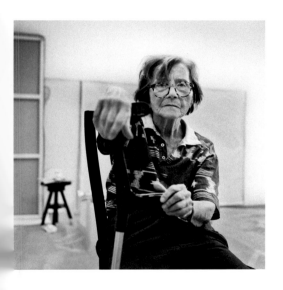

Maria Lassnig in her studio, January 28, 2013 (photo: Ronnie Niedermeyer)

I couldn't have written the original German edition without the Christian Brand-stätter Verlag publishing house, above all the-then deputy publishing house manager Elisabeth Stein-Hölzl. In 2014, she gave me the impetus to dare to tackle Maria Lassnig. I thank her for her trust, her support, and her confident serenity in all phases of this project. Big thanks also go to Nikolaus Brandstätter, the managing director, and to Ulli Steinwender for her careful, precise editing of the German version and her always encouraging support.

I also thank my interviewees and partners for helping me to understand the many facets of Maria Lassnig's complex personality. In chronological order, I thank the Knafl family in Vienna, Kappel am Krappfeld, and Klagenfurt, in particular Arnulf, Elisabeth, Alois Sr., and Alois Jr., who gave me important insights into Lassnig's place of birth and its surroundings. Arnulf Knafl also established contact for me with Walter Gross in Passering, as well as with Susanna and Robert Schelander in Kappel am Krappfeld. Likewise, I thank Elfriede Stark-Petrasch, a former neighbor in Klagenfurt and later her junior colleague. For Lassnig's youth, her lifelong friend Rainer Bergmann (d. 2021) from Klagenfurt was the most important eyewitness. Thanks also to his daughter Eva Rossbacher, who made the interview possible and shared with me her own memories of her crazy "aunt" Maria. In Feistritz, I talked to Günther Holzer, Ella Maier, and Siegfried Petautschnig, who told me of their experiences with Lassnig as a teacher in the late 1930s and her time as a neighbor in the mid-1980s.

Without Arnulf Rainer's willingness to put himself back in the not-so-easy time together with Lassnig, it would have been difficult to describe the late 1940s and 1950s, as well as their stay in Paris. Hannelore Ditz was also present at the meeting and also contributed valuable information. Oswald Wiener (d. 2021), in turn, reported with great candor on his love affair and later lifelong friendship with Lassnig and gave me important insights into his work with her in the Berlin period.

Robert Fleck helped me better understand the Austrian art scene in both 1950s Vienna and 1960 Paris. He generously provided me with his archival material on Maria Lassnig and also told of his personal experiences with the artist in the 1990s.

Christian Kircher made possible my crucial first contact with Uta and Ernst (d. 2019) Hildebrand, whose extensive archive formed a considerable source for Lassnig's time in Paris and New York and whose trust and support, especially at the beginning of my work, was fundamental. For their memories of the 1970s, Silvianna Goldsmith (d. 2019), Rosalind Schneider, Olga Spiegel, and Iris Vaughan, whom I met in New York and San Francisco, as well as Peter Kubelka in Vienna, were important sources. George Griffin provided insights into New York's avant-garde film world of the time, as did Joan Semmel into the feminist artist scene.

Lassnig's time as a professor at the Angewandte (University of Applied Arts) came to life for me mainly through the reports of her former students. Not only Hans Werner Poschauko but also Ursula Hübner, Andreas Karner, Mara Mattuschka, Gerlinde Thuma, and Roland Schütz told me about Lassnig's lessons. Her former assistants Ruth Labak and Martin Fritz also shared memories. In conversation with Ashley Hans Scheirl, I was able to understand the tremendous fascination Lassnig had for young Austrian artists at the beginning of the 1980s.

The obstacles (but also pleasures!) one had to face when doing an exhibition with the artist, especially Lassnig's ritual rehangings of paintings and constant threat of cancellations, were vividly described to me by Gabriele Wimmer, John Sailer, Wolfgang Drechsler, Hans Ulrich Obrist, Robert Fleck, Robert Storr, Peter Pakesch, Friedrich Petzel, and Andrea Teschke.

Terese Schulmeister told me about the encounters between Maria Lassnig and Otto Muehl as well as about her memories of the film shooting with Lassnig at the Friedrichshof Commune.

I would also like to thank Birgit Kassl from the Museum of the Nötscher Kreis, Eva Schober from the Archive of the Academy of Fine Arts in Vienna, Heidrun Fink from the German Literature Archive Marbach, Patrick Werkner from the University of Applied Arts, Antonia Hoerschelmann from the Albertina, and Katharina Guttenbrunner. Thomas Angerer provided me with important information on Austrian-French cultural relations after 1945. Sepp Dreissinger's book *Maria Lassnig. Gespräche und Fotos* was a major source for me, especially his interviews with those I could not talk to. My dearest thanks also go to my father, Alois Lettner, who helped me decipher the letters and diaries of the 1940s written by Lassnig in *Kurrent* (Old German cursive handwriting). Michelle Guiboud did research work, and Alexandra Varsek created the register and bibliography.

Big thanks to Cora Akdogan & Daniel Perraudin, directors of the Capitale Design Studio Wien/Berlin, who gave the book its wonderful design in both the German and the expanded English version.

I would also like to thank my friends, who have endured and supported me during these years, especially Philipp Blom, Veronica Buckley, Birgit Müller-Wieland, Werner Noska, Margit Reiter, Sandra Maria Rust, Günther Sandner, Martina Spitzer, Horst Stein, Veronika Verzetnitsch, and Benno Wand, as well as Andreas Zimmermann and Alexander Smith of the Kunsthistorisches Museum.

And finally, I thank Maria Lassnig, whom I only got to know posthumously and with whom nevertheless I had the pleasure and honor to spend a lot of great time.

— Natalie Lettner

Abbreviations

AHG = Archive of the Hildebrand Gallery
AMLF = Archive of the Maria Lassnig Foundation
AR = Arnulf Rainer
GLAM = German Literature Archive, Marbach
J = Journal
ML = Maria Lassnig
NL = Natalie Lettner

Notes
Bibliography
Index
Credits

Notes

Introduction

1 ML J, 1978, AMLF
2 The author knows the identity of this man, who cannot be named due to data protection regulations. Source: letters, AMLF
3 ML J, January 2008, AMLF
4 Grissemann 2005
5 The term corporate state refers to the one-party state that existed in Austria from 1934 to 1938.
6 ML J, November 6, 2000, AMLF
7 Obrist (ed.) 2000, p. 18
8 ML J, 2003, AMLF
9 Skreiner (ed.) 1970
10 Obrist (ed.), *Maria Lassnig: The Pen is the Sister of the Brush, Diaries 1943–1997*, 2009, p. 94. Translator's note: The translation of this quote may sound odd because it tries to capture Maria Lassnig's special way of expressing herself. Obrist translated it as "painfully rectifying a painting."
11 Werneburg 2010
12 ML J, 1998, AMLF
13 Frisch 1964, p. 58
14 ML, *Diagonal*, Ö1, May 15, 1999

1 Childhood and Youth in Carinthia

1 ML J, 2001, AMLF
2 NL, conversation with Alois Knafl Jr., Kappel am Krappfeld, August 22, 2014
3 Gross 1996, p. 101
4 ML J, July 8, 1998, AMLF
5 Ibid.
6 ML, *Von Tag zu Tag*, Ö1, November 27, 2001
7 ML J, July 8, 1998, AMLF
8 ML J, ca. 2001, AMLF
9 ML J, July 8, 1998, AMLF
10 Hofmann 1980, p. 63
11 ML J, 1978, AMLF
12 ML J, ca. 2001, AMLF
13 ML J, January 2008, AMLF
14 Count Viktor Sternberg-Rudelsdorf, Lassnig's natural grandfather, was born in 1865 in Venice as the son of Count Viktor Jaroslaw Sternberg-Rudelsdorf and Josephine Freiin von Skall and Gross-Ellguth. He was a major in an Austrian Landwehr infantry regiment and married Anna Anreiter from St. Pölten. He was killed in Galicia in 1915 during the First World War.
15 ML J, undated, AMLF
16 ML, *Menschenbilder*, Ö1, May 15, 2005
17 ML J, ca. 2001, AMLF
18 Liebs 2010
19 Murken 1990, p. 61
20 ML J, February 13, 2001, AMLF
21 ML J, January 2, 2002, AMLF
22 ML J, ca. 2001, AMLF
23 ML J, undated, AMLF
24 ML J, ca. 2001, AMLF
25 ML J, July 1998, AMLF
26 Toni is a nickname for Anton.
27 A. Hubinger, postcard to ML, 1969, AMLF
28 ML J, 2007, loose pages, AMLF
29 ML, *Im Gespräch*, Ö1, June 20, 1996
30 P. G., postcard to ML, September 11, 1970, AMLF
31 ML, Von Tag zu Tag, Ö1, November 27, 2001
32 ML, *Menschenbilder*, Ö1, May 15, 2005
33 ML J, September 10, 1994, AMLF
34 ML J, July 2000, AMLF
35 ML J, 2006, AMLF
36 ML J, July 2000, AMLF
37 ML J, 2006, AMLF
38 Hans Werner Poschauko, who assisted in caring for Lassnig in the last years of her life and became one of her most trusted friends, reports that she asked him to have such a stamp made.
39 ML J, fall 2001, AMLF
40 Interview NL with Walter Gross, September 27, 2014
41 Klewan 2015
42 ML in Kaess-Farquet, Bavarian Television, 2015
43 The German word *Portziuncula* comes from Latin. A *poriziuncula* is a small fleck in Latin. This also references a small chapel dedicated to Francis of Assisi in the Papal Basilica Saint Mary of the Angels near Assisi, Italy.
44 ML J, ca. 2001, AMLF
45 ML J, December 2008/January 2009, AMLF
46 ML J, January 1983, AMLF

47 Krampus is a devilish figure in Austrian folklore who punishes ill-behaved children on December 5.

48 ML J, ca. 2001, AMLF

49 Falco was the best-selling Austrian pop singer of all time, famous for the chart-topping song *Der Kommissar*.

50 ML J, summer 2002–03, AMLF

51 ML J, ca. 2001, AMLF

52 Ibid.

53 ML J, January 6, 2005, AMLF

54 ML J, 1997, AMLF

55 ML J, May 1992, AMLF

56 ML J, May 22, 1993, AMLF. See also Obrist (ed.) 2000, p. 162

57 ML J, November 24, 1962 (trans. from French by NL), AMLF

58 Murken 1990, p. 394

59 Gagel 2005, pp. 190–206

60 ML J, 2007, AMLF

61 ML J, 2001, AMLF

62 ML J, September 17, 2006, AMLF

63 Ernst 1980, p. 29

64 ML in Kaess-Farquet, Bavarian Television, 2015

65 ML, 1985, quoted according to Obrist (ed.) 2009, p. 91f

66 Liebs 2010

67 ML J, November 1998, AMLF

68 ML J, 2001, AMLF

69 ML J, March 20, 1966, AMLF

70 ML J, 1978/79, AMLF

71 ML, *Im Gespräch*, Ö1, June 20, 1996

72 Liebs 2010

73 ML, *Im Gespräch*, Ö1, June 20, 1996

74 ML J, 1980, quoted according to Drechsler (ed.) 1985, p. 79

75 "von" is an Austrian title of nobility preceding the surname, which was forbidden following World War I.

76 Liebs 2010

77 ML, *Menschenbilder*, Ö1, May 15, 2005

78 ML J, July 1998, AMLF

79 ML, *Menschenbilder*, Ö1, May 15, 2005

80 ML, 1986, quoted according to Grandits, Austrian Public Broadcasting, 2009

81 ML, *Palmistry*, film, 11 mins., 1974

82 Grissemann 2005

83 Interview NL with Eva Rossbacher, October 30, 2015

84 Matt (ed.) 2011, p. 226

85 ML J, spring 2000, AMLF

86 ML J, ca. 2001, AMLF

87 Interview NL with R. Bergmann, Klagenfurt, October 4, 2014

88 Baum 2002, p. 144

89 ML J, ca. 2001, AMLF

90 ML J, 1995, AMLF. While Lassnig said that 1939 was the date of this incident here, she was already twenty years old at that time. In her journal from 2001, she says that she and her friends were girls of around twelve.

91 ML J, 2001, AMLF

92 ML, *Menschenbilder*, Ö1, May 15, 2005

93 ML, quoted according to Landleute 2004, p. 30

94 ML J, 1978/79, AMLF

95 Murken 1990, p. 44

96 ML J, March 2, 2003, AMLF

97 Interview NL with R. Bergmann, October 4, 2014

98 Ibid.

99 ML J, September 19, 1943, AMLF

100 In the end, Hildebrand built portions of the hospital. In 1961, Lassnig created a draft for a wall frieze.

101 ML, *Menschenbilder*, Ö1, May 15, 2005

102 Lassnig earned her school leaving certificate (*Matura*) from the Teachers' Training Institute (*Lehrerbildungsanstalt*) in 1938. Her final paper is archived. She completed a mandatory service year, first in Oberhof (also in the local community of Metnitz) as a substitute teacher, then in Feistritz ob Grades on a full-time teaching contract.

103 Danzer 1939, p. 52

104 BDM (*Bund Deutscher Mädel*): League of German Girls, also called the Band of German Maidens, was the female version of the Hitler Youth.

105 Erziehung 1940, pp. 9–12

106 Brauner 1940, p. 68

107 Novak 2009

108 Christoph and Schedlmayer 2009

109 ML, *Im Gespräch*, Ö1, June 20, 1996

110 Liebs 2010

111 Ibid.

112 ML, letter to E. Hildebrand, New York, December 30, 1971, Archive of the Hildebrand Gallery. The two towns mentioned by Lassnig

Notes

are Oberhof and Grades. The administration in Grades was responsible for all schools, and Lassnig appears to have taught briefly in the far-off town of Oberhof.

2 Student in National Socialist Vienna

1 ML, *Von Tag zu Tag*, Ö1, November 27, 2001
2 Interview NL with Silvianna Goldsmith and Rosalind Schneider, NY, February 21, 2015
3 Pawlowsky 2015, p. 39
4 Many of the dates in previous biographical catalogs and other publications that Lassnig herself often wrote are incorrect. Lassnig usually specifies 1941 as the beginning of her studies in Vienna. According to the files at the Archive of the Academy of Fine Arts, however, Lassnig started studying in the fall semester 1940. In the fall of 1941, she moved into a sublease in Hetzgasse in Vienna's third district.
5 The Innviertel is located in the northwest quarter of Upper Austria and includes the districts of Braunau am Inn, Ried im Innkreis, and Schärding.
6 Nagl 2008, pp. 127–30
7 Christoph and Schedlmayer 2009
8 Dachauer wasn't an illegal member of the NSDAP, but before 1933 he had been a member of the National Socialist Artists and also deputy chairman of the stealth Nazi organization Association of German Painters in Austria. See database nszeit.akbild.ac.at/ and Klamper 1990, p. 17.
9 Quoted according to Klamper 1990, p. 6
10 In almost all cases, it was about the proximity of the instructors to the Austro-fascist Corporate State. See Pawlowsky 2015, pp. 40–43.
11 Nagl 2008, p. 130
12 The special commission that was convened reached the astonishing verdict that Dachauer "did not stand out either in artistic or political respects in a National Socialist sense." See Klamper 1990, p. 50.
13 ML, *Menschenbilder*, Ö1, May 15, 2005
14 H. Kuchling in Dreissinger 2015, p. 26
15 Müller 2015, pp. 61–66
16 Pencil on paper, November 3, 1990
17 In the exhibit catalog, Lassnig is recorded as having been in her fourth semester, but since she had started studying in 1940–41, she was already in her fifth semester in the winter of 1942–43.
18 Liebs 2010
19 Matt and Schurian 2011, p. 227
20 ML J, April 2003, AMLF
21 Holger Liebs, "'Nullkommajosef Selbstvertrauen' Im Gespräch Maria Lassnig," *Süddeutsche Zeitung*, May 17, 2010. The artists were Hans Thoma (1839–1924), Wilhelm Leibl (1844–1900), and Sepp Hilz (1906–1967).
22 ML, *Im Gespräch*, Ö1, June 20, 1996
23 ML, *Menschenbilder*, Ö1, May 15, 2005
24 Liebs 2010
25 Tabor 1990, p. 294; Rathkolb 1994, p. 335
26 Rathkolb 1994, p. 335
27 Liebs 2010
28 ML in Drechsler (ed.) 1985, p. 18
29 Sotriffer 1997
30 Matt (ed.) 2011, p. 227
31 ML in Drechsler (ed.) 1985, p. 18
32 Sotriffer 1997
33 ML in Weskott (ed.) 1995, p. 18
34 ML, *Diagonal*, Ö1, May 15, 1999
35 Ibid.
36 Liebs 2010
37 There is an entry in the Academy's catalog that might have something to do with this event but which could also refer to another incident: "Allegation of the student leader, 1943." Unfortunately, the corresponding file has disappeared.
38 Grissemann 2005
39 ML J, 1995, AMLF
40 ML, *Im Gespräch*, Ö1, June 20, 1996
41 ML, *Diagonal*, Ö1, May 15, 1999
42 For example: ML, letter to Mathilde Lassnig, Vienna, October 18, 1943, AMLF
43 Among others: "Malerin Maria Lassnig gestorben," *Kronen Zeitung*, May 6, 2014; Miessgang 2014; "Maria Lassnig ist tot," *Die Zeit*, May 7, 2014
44 Pawlowsky 2015, p. 39
45 Liebs 2010
46 ML, *Diagonal*, Ö1, May 15, 1999
47 Miessgang 2014
48 Quoted according to Elste and Koschat 2004, p. 297

49 File 664, June 21, 1943, University Archive of the Academy of Fine Arts Vienna. It was probably one of the exhibitions that took place as part of the Carinthian Festival Week on October 10, the anniversary celebrating the outcome of the 1920 plebiscite in southern Carinthia. At that time, the majority of the population decided that these border areas belonged to Austria and not to Yugoslavia. In autumn 1943, numerous propaganda spectacles took place to celebrate this occasion, including the exhibition *Carinthia—1,200 Years of the Reich's Borderland* in the Klagenfurt government building, the aim of which was to assert "Germanic continuity" in southern Carinthia and to suppress Slavic settlement. Maybe Lassnig worked as a student assistant on this exhibition and perhaps also on the exhibition of the Carinthian Art Association, which was the crème de la crème of Carinthian National Socialist artists present—along with some colleagues from the "Old Reich," as the press described it (*Kärntner Volkszeitung*, no. 119, October 11, 1943, p. 3).

50 F. Wiegele quoted by H. Kuchling in Dreissinger 2015, p. 26

51 Quoted according to Nierhaus 1990, p. 68

52 Rohsmann 1994, p. 461

53 ML in a conversation with Johanna Ortner, who created the catalog of her works

54 Aigner 2012, pp. 29–30

55 F. Wiegele, letter to ML, Kesselwald, July 8, 1944

56 ML, letter to C. Murken, March 25, 1988, quoted according to Murken 1990, p. 92, footnote 110

57 A. Kolig, letter to ML, June 8, 1946, AMLF

58 Sotriffer 1997

59 ML J, July 30, 2000, AMLF

60 ML J, October 15, 1943, AMLF

61 ML, *Diagonal*, Ö1, May 15, 1999

62 Elste and Koschat 2004, p. 306

63 Quoted according to Klamper 1990, p. 49

64 Boeckl to District Magistrate's Office, Magistratisches Bezirksamt, Sonderkommission SKZ 403/1.4.1946. Quoted according to Rathkolb 2009, p. 220

65 ML J, October 15, 1943, AMLF

66 Schurian 2012

67 ML J, September 9, 1943, AMLF

68 ML J, October 15, 1943, AMLF

69 Lassnig is paraphrasing an aphorism from Schopenhauer 1851.

70 Quoted according to Klamper 1990, p. 11

71 Ibid., p. 24

72 ML J, between May and December 1944, AMLF

73 Among others, she excerpts from Kandinsky 1912 and Kandinsky 1913, p. 98f.

74 ML J, between May and December 1944, AMLF

75 ML J, May 27, 1996, AMLF

76 ML, *Im Gespräch*, Ö1, 20.6.1996

77 ML J, between May and December 1944, AMLF

78 Liebs 2010

79 ML J, between May and December 1944, AMLF

80 ML J, 1946; see also Obrist (ed.) 2000, p. 22

81 ML J, Easter Sunday 1955, AMLF

82 ML, *Von Tag zu Tag*, Ö1, November 2, 2001

83 Information from H. W. Poschauko

84 Herbert Weck = Herbert Tasquil (1923–2008), who later became a professor at the University of Applied Arts and taught the master class for design theory, theory of form, and art education.

85 ML J, winter 1944; see also Obrist (ed.) 2000, p. 18

86 ML J, October 1943, AMLF

87 ML J, between May and December 1944, AMLF

88 ML, letter to Mathilde Lassnig, Vienna, January 27, 1944

89 For example: ML, *Im Gespräch*, Ö1, June 20, 1996; ML, *Menschenbilder*, Ö1, May 15, 2005; Liebs 2010

90 Louis Popelin, letter to ML, Paris, May 7, 1946, AMLF

91 Hotel Daimlinger, Völkermarkter Strasse 5, Klagenfurt

92 Interview NL with R. Bergmann, October 4, 2014

93 ML J, 1943–44, ca. November 1944 (trans. from French by NL), AMLF

94 Loose page, December 1944 (trans. from French by NL), AMLF

95 Liebs 2010

96 ML, *Im Gespräch*, Ö1, June 20, 1996

Notes

97 ML, *Menschenbilder*, Ö1, May 15, 2005

98 ML J, 1945–46, June 29, 1945 (trans. from French by NL), AMLF

99 Ibid.

100 ML J, ca. 2001, AMLF

101 ML J, 1945–46, June 10, 1945, AMLF

102 ML J, 1945–46, June 9, 1945, AMLF

103 ML J, June 30, 1945, AMLF. Lassnig later corrected the text "my earthly love" in red to "of my earthly life," probably when she went through her journals in the late 1990s and selected specific passages, some of which were published in 2000 (See Obrist, *Maria Lassnig: The Pen is the Sister of the Brush*). At that time, Lassnig made multiple corrections to the originals.

104 ML, *Menschenbilder*, Ö1, May 15, 2005

105 ML, *Im Gespräch*, Ö1, June 20, 1996

106 This painting has the additional titles *Trapped Woman (Frau in der Klemme)* and *Kitchen Apron or the Constrained (Küchenschürze oder die Eingezwängte)*.

107 ML J, 1941–47, ca. 1945, AMLF

108 ML J, between May and December 1944, AMLF

109 ML, *Menschenbilder*, Ö1, May 15, 2005

110 Ibid.

111 Schurian 2013

112 ML, *Diagonal*, Ö1, May 15, 1999

113 ML J, June 2004, AMLF

114 Schurian 2013

115 ML, *Diagonal*, Ö1, May 15, 1999

116 ML J, ca. 2001, AMLF

117 R. Fleck in a short conversation with NL, Vienna, October 7, 2015

118 ML, letter to Mathilde Lassnig, undated, placed in journal dated 1945–46, AMLF

3 A Carinthian Provincial Star

1 ML in Jobst 2012, p. 81

2 Appointments can be made to visit Lassnig's renovated Klagenfurt studio.

3 Interview NL with R. Bergmann, Klagenfurt, October 4, 2014

4 M. Guttenbrunner in Bäumer (ed.) 2014, p. 93

5 Liebs 2010

6 All quotations from: ML, *Menschenbilder*, Ö1, May 15, 2005

7 ML J, May 15, 1946, AMLF

8 Ibid.

9 ML J, June 29, 1946, AMLF

10 ML J, 1946, AMLF

11 ML J, June 28, 1946, AMLF

12 Guttenbrunner 2004, p. 330

13 ML J, May 15, 1946, AMLF

14 ML J, loose pages, 1945–48, AMLF

15 ML J, May 15, 1946, AMLF

16 Jobst 2012, p. 81

17 Jené and Hölzer 1950, p. 74

18 Jobst 2012, p. 80

19 ML J, May 15, 1946, AMLF

20 "Abend eines Rekruten," Guttenbrunner, *Schwarze Ruten*, 1947, p. 26

21 Field judgment, Court of the 5th Mountain Division, Michael Guttenbrunner, Zl. 274/42, German Wehrmacht / court files, Austrian State Archives

22 Guttenbrunner 1994, p. 32

23 Jobst 2012, pp. 39–66

24 Interview NL with A. Rainer, Vienna, May 19, 2016

25 Quoted according to Baum 2004

26 Guttenbrunner published this in *Einheit (Unity)*, a magazine for Carinthian Slovenes that only existed for a few years. He referred to Truppe's pictures of Hitler and said that Truppe had given "the crook the mask of a serious man; he outfitted the spongy tyrant as a hero, i.e., he served him better than his Gauleiter and generals." Schlapper 1995, p. 169.

27 Quoted according to Schlapper 1995, p. 166

28 Bäumer (ed.) 2014, p. 93

29 ML, *Im Gespräch*, Ö1, June 20, 1996

30 Guttenbrunner 2004, pp. 330–31

31 M. Guttenbrunner, letter to ML, undated, presumably 1946

32 M. Guttenbrunner, letter to ML, July 14, 1946

33 This and the two previous quotations: ML J, August 1946, AMLF

34 *Die Neue Zeit*, August 23, 1947, p. 6

35 Elste and Koschat 2004, p. 293

36 A. Veiter in *Volkszeitung*, August 20, 1947, p. 3

37 *Die Neue Zeit*, August 23, 1947, p. 6

38 E. W. in *Volkswille*, August 23, 1947, p. 8

39 Guttenbrunner in *Volkswille*, August 24, 1947, p. 5

40 Guttenbrunner 2004, p. 330

41 ML, *Menschenbilder*, Ö1, May 15, 2005

42 ML J, October 15, 1946, AMLF

43 ML J, May 15, 1946, AMLF

44 ML J, May 6, 1946, AMLF

45 ML J, May17, 1946, AMLF

46 M. Guttenbrunner, letter to ML, April 22, 1946, AMLF

47 M. Guttenbrunner, letter to ML, Easter Sunday 1946, AMLF

48 M. Guttenbrunner, letter to ML, February 6, 1947, AMLF

49 M. Guttenbrunner, letter to ML, November 13, 1947, AMLF

50 ML J, August 12, undated (presumably 1947), AMLF

51 ML J, June 22, undated (presumably 1947), AMLF

52 ML J, August 7, undated (presumably 1947), AMLF

53 M. Guttenbrunner, letter to ML, undated (presumably 1946/47)

54 ML J, October 15, 1946, AMLF

55 ML J, August 21, undated (presumably 1947), AMLF

56 ML J, ca. 1945–49, AMLF

57 ML J, January 21, 2002, AMLF

58 Bergson 1909, p. 4

59 ML J, loose pages, 1947, AMLF; Nietzsche quotation taken from Nietzsche 1999, p. 499

60 ML J, January 9, 2005, AMLF

61 ML J, October 22, 1946, AMLF

62 Fialik 1997, p. 251

63 M. Guttenbrunner, letter to ML, 1946

64 For example: interview NL with R. Bergmann, Klagenfurt, October 4, 2014

65 Jobst 2012, pp. 81–83

66 ML told Hans Werner Poschauko about this incident.

67 ML J, June 1948, AMLF

68 M. Guttenbrunner, letter to ML, June 1, 1975 (referring to the exhibition *Maria Lassnig. Zeichnungen 1948–1950*, Galerie Ariadne, Vienna, April 28–May 17, 1975)

69 ML J, July 30, 2000, AMLF

70 ML J, May 2, 2001, AMLF

71 ML J, 1949, emphasis in original, AMLF

72 ML J, Easter 1992, AMLF

73 ML J, September 17, 2005, AMLF

74 ML J, Easter 1992, AMLF

75 Interview NL with R. Bergmann, October 4, 2014

76 Interview NL with A. Rainer, May 19, 2016

77 ML J, 1984, AMLF

78 ML J, 2003, AMLF

79 ML J, April 17, 2003, AMLF

80 ML J, 1989, AMLF

81 In contrast to representations in almost all publications about Lassnig, her first individual exhibit took place not in 1948 but rather from March 19 to April 9, 1949, as the exhibit flyer and the reviews in newspapers prove.

82 ML J, 1946, AMLF

83 ML J, loose pages, Pentecost Monday 1947, AMLF

84 A. Rainer in Dreissinger 2015, p. 23

85 C. Shamari-Kuchling in Dreissinger 2015, p. 29

86 H. Kuchling in Dreissinger 2015, p. 26

87 Kuchling 1949

88 H. S. in *Volkszeitung*, March 22, 1949

89 E. W. in *Volkswille*, March 27, 1949, p. 4

90 H. S. in *Volkszeitung*, March 22, 1949

91 Y. in *Neue Zeit*, March 23, 1949

92 H. S. in *Volkszeitung*, March 22, 1949

4 Paris, Contemporary Art, and Arnulf Rainer

1 ML, *Menschenbilder*, Ö1, May 15, 2005

2 Quoted according to Zoe, *Kleine Zeitung, May 15, 1975*, p. 14

3 ML 1969, quoted according to Aigner, Gachnang, and Zambo (eds.) 1997, p. 66

4 Quoted according to Habarta 1996, p. 142

5 Guttenbrunner 1980, p. 20

6 Quoted according to Habarta 1996, p. 142

7 Rainer himself believes that he remembers getting to know Lassnig when he was seventeen or eighteen in 1947 or 1948. However, a postcard and a letter from him suggest that the two met in April 1948 (source: AMLF). Rainer was eighteen at the time.

8 AR, *Menschenbilder*, Ö1, June 3, 2009

9 Schwaiger 1997, p. 48

10 Ibid., p. 49 f.

11 AR in Dreissinger 2015, p. 20

12 AR in Kaess-Farquet, Bavarian Television (Germany), 2015

13 AR, *Menschenbilder*, Ö1, June 3, 2009

14 ML J, between February 28 and June 2, 1950, AMLF

15 Interview NL with AR, Vienna, May 19, 2016

16 AR 2004, p. 347

17 AR in Kaess-Farquet, Bavarian Television (Germany), 2015

18 ML J, September 24, 1999 (trans. from French by NL), AMLF

19 ML, Menschenbilder, Ö1, May 15, 2005

20 Quoted according to http://www.wernerberg. museum/biographie/1943–1952/ (accessed January 6, 2017)

21 Interview NL with AR, Vienna, May 19, 2016

22 ML 2000, Salm-Salm 2009, p. 214 (trans. from French by NL)

23 Cézanne 1957, p. 76

24 Breton 1992, p. 690

25 AR, Menschenbilder, Ö1, June 3, 2009

26 ML 1969, quoted according to Aigner, Gachnang, and Zambo (eds.) 1997, p. 66

27 AR in Dreissinger 2015, p. 20

28 AR in Kaess-Farquet, Bavarian Television (Germany), 2015

29 AR in Dreissinger 2015, p. 21

30 Interview NL with AR, Vienna, May 19, 2016

31 AR in Dreissinger 2015, p. 21

32 Britsch 1930

33 ML J, between 1945 and 1950, AMLF

34 ML J, loose pages, 1949, AMLF

35 AR 2004, p. 346

36 ML, Zeichnungen 1948–1950. Ausstellung 28.4.–17.5.1975, Galerie Ariadne, Vienna, 1975

37 Interview NL with AR, Vienna, May 19, 2016

38 Engelbach and Lassnig 2002, p. 26

39 Salm-Salm 2009, pp. 220–21

40 ML, Menschenbilder, Ö1, May 15, 2005

41 ML J, 1948, quoted according to Obrist (ed.) 2000, p. 22

42 ML 1968, p. 133

43 Ibid.

44 Kuchling 1950

45 Gütersloh 1981, p. 115 f.

46 Everything quoted according to Die Neue Zeit, June 20, 1950, p. 5. The review quotes multiple Viennese critics without naming the sources.

47 Ibid.

48 Rühm 1997, p. 17

49 The invitation to the opening names Wolfgang Kudrnofsky, Arnulf Rainer TRRRR, Anton Krejcar, Ernst Fuchs, Maria Lassnig, Daniela Rustin, Hilda Sapper, Erich Brauer (who only began calling himself Arik after his trip to Israel), and P. W. Candarin. The portfolio Cave Canem with seventeen works by the participating artists was published for the exhibition in an edition of fifty numbered copies.

50 W. Kudrnofsky, quoted according to Habarta 1996, p. 132

51 Interview NL with AR, May 19, 2016

52 Quoted according to Habarta 1996, p. 136

53 Ibid., p. 138

54 Ibid., p. 136

55 Salm-Salm 2009, p. 214 (trans. from French by NL)

56 ML, Menschenbilder, Ö1, May 15, 2005

57 Jacqueline Feldmann discusses three possible trips in 1951, 1952, and 1953. Feldmann, 24-26. In a letter dated March 28, 1951, Maria Lassnig wrote to her mother that she planned to travel to Paris in mid-April. On May 4, Mathilde Lassnig sent a letter to Maria in Paris. On May 16, Lassnig and Rainer sent a postcard to Hölzer in Paris, where they reported that the next day they would show André Breton their portfolios. The further stays can be inferred on the basis of letters from Louis Popelin to Lassnig in Rouen (dated August 25, 1951, and January 2, 1952), where Popelin refers to their planned trips. Whether Lassnig actually drove can't be inferred from the letters. A letter from Arnulf Rainer to Lassnig dated June 30, 1951, suggests that she was also in Paris during June 1951. Source: AMLF

58 Interview NL with AR, Vienna, May 19, 2016

59 AR in Dreissinger 2015, p. 22

60 Ibid.

61 Hölzer 2012, p. 15

62 Emmerich 1999, p. 101; Felstiner 1997, p. 387, footnote 6

63 AR in Dreissinger 2015, p. 22

64 Ibid.

65 Schwaiger 1997, p. 50 f.

66 AR, quoted according to Müller 2014

67 Rainer 2004, p. 349

68 Schwaiger 1997, p. 50 f.

69 Péret 1985, p. 21

70 Breton 1986, p. 56

71 Schwaiger 1997, p. 50

72 AR in Dreissinger 2015, p. 22

73 The participating artists were Camille Bryen, Giuseppe Capogrossi, Willem de Kooning, Hans Hartung, Georges Mathieu, Jackson Pollock, Jean-Paul Riopelle, Alfred Russell, and Wols (= Wolfgang Schulze).

74 The artist Antoni Tàpies had applied the term to current art for the first time in the previous year, i.e., in 1950.

75 Interview NL with AR, Vienna, May 19, 2016

76 Rainer 2004, p. 350

77 Salm-Salm 2009, p. 216 (trans. from French by NL)

78 Regarding the Paris scene, see Mathieu 1998

79 Salm-Salm 2009, p. 216; interview NL with AR, May 19, 2016: Rainer reports numerous encounters.

80 Von Tag zu Tag, Ö1, November 27, 2001

81 AR, Menschenbilder, Ö1, June 3, 2009

82 Lassnig and Rainer 1951, AMLF

83 Lassnig 1951

84 TRR 1951

85 Salm-Salm 2009, p. 217 (trans. from French by NL)

86 ML in Drechsler (ed.) 1992, p. 22

87 Quoted according to Boeckl 2000, p. 42 and footnote 28

88 Liebs 2010

5 The 1950s in Vienna: A Man's World

1 ML J, September 13, 1954

2 ML J, March 20, 1958

3 Other addresses included in the Wimbergergasse in the seventh district, the Strassäckergasse in the twenty-second district, the Gärtnergasse, the Hetzgasse, and the Streichergasse in the third district.

4 The Naschmarkt is Vienna's largest and most famous open-air market.

5 "Maria mit Bart," Die Wochenpresse, April 2, 1960

6 ML J, October 15, 1955

7 ML, Menschenbilder, Ö1, May 15, 2005

8 ML, Mittagsjournal, Ö1, January 17, 1985

9 Interview NL with R. Bergmann, Klagenfurt, October 4, 2014

10 ML, Diagonal, Ö1, May 15, 1999

11 Untitled, 1957, oil on fiberboard

12 ML J, November 26, 1955

13 Fleck 1995, p. 52

14 Fuchs 2001, p. 209

15 Interview NL with O. Wiener, Kapfenstein, February 7, 2016

16 Radax 2009

17 M. Biljan-Bilger, Was war nun der Art Club? Film, Museum of Modern Art, Vienna, 1981

18 Lecerf 1999 (trans. from French by NL)

19 Interview NL with O. Wiener, Kapfenstein, February 7, 2016

20 Achleitner 2011, p. 30 f.

21 Denk 2003; Breicha 1981

22 ML, Was war nun der Art Club? Film, Museum of Modern Art, Vienna, 1981

23 M. Biljan-Bilger, Was war nun der Art Club? Film, Museum of Modern Art, Vienna, 1981

24 AR, Menschenbilder, Ö1, June 3, 2009

25 Schmeller 1981, p. 32

26 Fleck 1996, p. 112

27 Gütersloh 1981, p. 9

28 Breicha 1981, p. 6

29 AR, Menschenbilder, Ö1, June 3, 2009

30 Rühm 1997, p. 21

31 Denk (ed.) 2003, pp. 142–47

32 ML, letter to Mathilde Lassnig, Vienna, February 18, 1950. The ball did not take place in the Strohkoffer, which opened in December 1951.

33 Die Presse, January 22, 1955, quoted according to Weibel (ed.) 1997, p. 22

34 Radax and Schweikhardt 2009, p. 39

35 Referring ironically and affectionately to Vienna's luxury Hotel Sacher nearby.

36 Hans Weigel, Was war nun der Art Club? Film, Museum of Modern Art, Vienna, 1981

37 Denk (ed.), p. 145 ff.

38 It opened on November 22, 1952.

39 Liebs 2010

40 Breicha 1997, p. 29

41 ML J, Easter Monday 1955

42 ML in Breicha (ed.) 1975, p. 20

43 Engelbach and Lassnig 2002, p. 26

44 Sotriffer 1997

45 Quoted according to Grandits, Austrian Public Broadcasting, 2009

46 Lassnig 1952

47 Engelbach and Lassnig 2002, p. 26

48 Lampe 1952, p. 4

49 Demus 1952

50 ML, *Diagonal*, Ö1, May 15, 1999

51 AR in Dreissinger 2015, p. 20

52 Matt and Schurian 2011, p. 225

53 ML, *Diagonal*, Ö1, May 15, 1999

54 ML, letter to R. Labak, NY, November 1977, quoted according to Labak 1979, p. 12

55 Interview NL with AR, Vienna, May 19, 2016

56 AR in Dreissinger 2015, p. 23

57 Interview NL with AR, Vienna, May 19, 2016

58 ML, letter to H. Hildebrand, NYC, February 26, 1969, AHG

59 Interview NL with AR, Vienna, May 19, 2016

60 Hinz (ed.) 1968, p. 94

61 The opening was on February 25, 1954. The Zimmergalerie Franck in Frankfurt was the gallery of the Informel in Germany.

62 ML J, July 13, 1953, AMLF

63 ML J, August 3, 1953, AMLF

64 ML J, August/September 1953, AMLF

65 ML J, July 1953. See also Obrist (ed.) 2000, p. 24

66 ML 1969, quoted according to Aigner, Gachnang and Zambo (eds.) 1997, p. 66

67 Hans Hofmann to Lee Krasner in the late 1930s, quoted according to Broude and Garrard (eds.) 1994, p. 13

68 See p. 149 in this book

69 ML J, May 5, 1955, AMLF

70 ML J, October 15, 1954, AMLF

71 Interview NL with O. Wiener, Kapfenstein, February 7, 2016

72 H. Kuchling in Dreissinger 2015, p. 27

73 Interview NL with O. Wiener, Kapfenstein, February 7, 2016

74 ML J, September 4, 1954, AMLF

75 ML J, September 8, 1954, AMLF

76 ML J, August 13, 1953, AMLF

77 ML, "For Buddy Frieberger," loose page, undated, AMLF

78 Ibid.

79 Ibid.: "He brought me a bedraggled pigeon that had fallen from its nest, and I drew and painted him with it. He fed it from his mouth."

80 ML, letter to Mathilde Wicking, Vienna, undated, AMLF

81 Interviews NL with O. Wiener, February 7, 2016, and AR, May 19, 2016

82 Hennig 2012, p. 150

83 ML J, September 23, 1954, AMLF

84 ML J, October 16, 1954, AMLF

85 ML, letter to Mathilde Lassnig, Vienna, May 10, 1954, AMLF

86 ML J, October 15, 1954, AMLF

87 ML J, October 18, 1954, AMLF

88 ML J, November 1, 1954, AMLF

89 ML J, September 8, 1954, AMLF

90 ML J, 1979, quoted according to Obrist, *Maria Lassnig: The Pen is the Sister of the Brush*, 2009, p. 74

91 ML J, September 20, 1954, AMLF

92 Kafka 1983, p. 242

93 Ibid., p. 252

94 ML J, 1949, AMLF

95 ML J, January 1955, AMLF

96 ML J, March 4, 1955, AMLF

97 ML J, March 29, 1955, AMLF

98 Sartre 1940

99 All quotations from Oswald Wiener from interview NL with O. Wiener, Kapfenstein, February 7, 2016

100 ML J, May 13, 1957, AMLF

101 ML J, February 28, 1950, AMLF

102 ML J, ca. 2001, AMLF

103 Drechsler (ed.) 1985, p. 35

104 ML J, September 10, 1954, AMLF

105 Drechsler (ed.) 1985, p. 35

106 Lampe 1956, p. 5

107 *Wiener Zeitung*, November 17, 1956; *Neues Österreich*, November 25, 1956

108 Breicha 1965

109 Storr 2008, p. 10

110 *Untitled*, 1957, oil on fiberboard

111 ML J, January 18, 1956, AMLF. This text is entered as January 18, 1946, in Obrist, *Maria Lassnig: The Pen is the Sister of the Brush*, but in the original journal, this entry can be found to the day exactly ten years later.

112 Ibid., AMLF

113 Quotations in this paragraph from interview NL with O. Wiener, Kapfenstein, February 7, 2016

114 ML J, April 1956, AMLF

115 ML, postcard to Paul and Mathilde Wicking, summer 1958, AMLF

116 This and all of the following quotations from Oswald Wiener from interview NL with O. Wiener, February 7, 2016

117 Her travels took her to Paris for a month in June 1959, presumably to Stockholm and

Oslo in the summer, and to the Austrian
Cultural Institute in Rome for two months
in October and November. See ML, letter
to Mathilde Wicking, Vienna, May 13, 1959,
AMLF

118 ML J, May 28, 1955, AMLF
119 ML J, January 22, 1958, AMLF
120 Ibid.
121 ML J, March 20, 1958, AMLF
122 ML J, February 18, 1958, AMLF
123 Interview NL with O. Wiener, Kapfenstein,
February 7, 2016
124 O. Wiener in Pakesch 2012, p. 33
125 ML J, loose page, undated, presumably
1950s, AMLF
126 Interview NL with O. Wiener, Kapfenstein,
February 7, 2016
127 ML J, February 12, 1959, AMLF
128 All quotations from Oswald Wiener from
interview NL with O. Wiener, Kapfenstein,
February 7, 2016
129 ML J, August 18, 1960, AMLF
130 Fleck 1982
131 Schmeller 1978, p. 25
132 O. Oberhuber, *Diagonal*, Ö1, May 15, 1999
133 Quoted according to Dusini 2009
134 ML, *Menschenbilder, Ö1, May 15, 2005*
135 Matt and Schurian 2011, p. 228
136 ML J, January 1956, AMLF
137 ML, *Im Gespräch*, Ö1, June 20, 1996
138 Interview NL with AR, Vienna, May 19, 2016
139 ML, *Menschenbilder,* Ö1, May 15, 2005
140 Hofmann 1957 and Hofmann 1958
141 For this information and many other valuable
tips, the author is grateful to Robert Fleck,
who conducted extensive interviews with
Werner Hofmann. NL interview with Robert
Fleck, Vienna, April 6, 2016
142 "Maria mit Bart," *Die Wochenpresse,*
April 2, 1960
143 ML, *Menschenbilder*, Ö1, May 15, 2005
144 ML, *Im Gespräch*, Ö1, June 20, 1996
145 ML J, June 1961, AMLF
146 ML J, 1978/79, AMLF
147 Quoted according to "Maria mit Bart,"
Die Wochenpresse, April 2, 1960
148 Lampe 1960
149 "Maria mit Bart," *Die Wochenpresse,*
April 2, 1960
150 Schmeller 1978, pp. 70–71
151 From a flyer that was reproduced
and translated in the Stedelijk Museum
Amsterdam exhibit catalog.
Bormann et al. (eds.) 2019, p. 39

6 Paris Encore

1 ML J 1960s, before May 1964
2 Lecerf-Héliot 1996 (trans. from French by NL)
3 Matt (ed.) 2011, p. 228
4 Breicha 1968, pp. 135–38
5 ML J, January 11, 1962
6 Feuerstein 1965, p. 64
7 Quoted according to Welti 1983, p. 51
8 Breicha 1968, pp. 135–38
9 ML J, January 11, 1962
10 ML J, 1960
11 Breicha 1968, pp. 135–38
12 Kiki Kogelnik was one of the few artists who
went to New York in 1961 along with her
partner at the time, the American artist Sam
Francis.
13 ML J, June 16, 1958
14 Matt and Schurian 2011, p. 228
15 ML, *Volkszeitung*, November 1966
16 ML, *Volkszeitung*, June 1963
17 ML, *Volkszeitung*, April 30, 1964
18 ML, *Volkszeitung*, November 1966
19 Lecerf 1999 (trans from French by NL)
20 ML, letter to H. Hildebrand, Paris, December
10, 1965
21 ML J, December 15, 1961
22 Beckett 1951
23 ML J, September 1961
24 ML J, March 1985. See also Obrist (ed.) 2000,
p. 93
25 Maria Lassnig told Hans Werner Poschauko
about this dinner.
26 Mathilde Wicking, letter to Louis Popelin,
Klagenfurt. December 6, 1960
27 ML, letter to Mathilde Wicking, Paris,
undated, beginning of 1961
28 Matt and Schurian 2011, p. 230
29 ML J, January 1962
30 Wiedmann (ed.) 2000
31 ML, *Menschenbilder,* Ö1, May 15, 2005
32 Ibid.
33 ML, letter to P. Celan, Germany, ca. 1961–67,
Celan 90.1.1842/6, GLAM

34 ML, letter to H. Hildebrand, Paris, December 15, 1966

35 ML, letter to P. Celan, Germany, ca. 1961–67, Celan 90.1.1842/6, GLAM

36 ML, postcard to P. Celan, Germany, end of 1963, Celan 90.1.1842/4, GLAM

37 ML, *Kärntner Tageszeitung, December 1966*

38 ML, letter to H. Hildebrand, Paris, December 31, 1966

39 ML, letter to H. Hildebrand, Paris, December 15, 1966

40 ML J, January 3, 1962

41 ML J, 1963. See also Obrist (ed.) 2000, p. 28 (trans. from French by NL)

42 ML J, January 3, 1962

43 Hugo Huppert in conversation with P. Celan, December 26, 1966, quoted according to Felstiner 1997, p. 299

44 ML, letter to H. Hildebrand, Paris, December 31, 1966

45 ML in Drechsler (ed.) 1992, p. 24

46 *Von Tag zu Tag*, Ö1, November 27, 2001

47 *Hommage à tous les suicides*, pencil on paper, 1997

48 Paul Celan, letter to Rudolf Hirsch, July 26, 1958, quoted according to Felstiner 1997, p. 147

49 On November 29, 1960, her mother, now Mathilde Wicking, transferred 130,000 schillings to Lassnig in Paris.

50 ML, *Im Gespräch*, Ö1, June 20, 1996

51 ML in Drechsler (ed.) 1985, p. 46

52 Quoted according to Murken 1990, p. 110

53 Sotriffer 1997

54 Salm-Salm 2009, p. 224 (trans. from French by NL)

55 ML J, December 30, 1961

56 ML, letter to H. Hildebrand, Paris, November 29, 1965

57 ML J, January 1, 1962

58 ML J, January 18, 1963 (trans. from French by NL)

59 ML J, January 1, 1962

60 ML J, September 27, 1961

61 Salm-Salm 2009, p. 224 (trans from French by NL)

62 ML J, 1964

63 ML J, November 27, 1961 (trans. from French by NL)

64 ML J, February 1963

65 ML J, spring 1960

66 ML J, December 14, 1961

67 ML J, February 27, 1962

68 ML J, October 1961 (trans. from French by NL)

69 ML, letter to Mathilde Wicking, Paris, April 14, 1964

70 For example, Mathilde Wicking, letter to ML, Klagenfurt, April 15, 1962

71 ML J, August 28, 1961

72 ML, letter to Mathilde Lassnig, Paris, summer 1962

73 *Helene, Stutz und die Kunst*, 2007, p. 24

74 Ibid., p. 22

75 H. Bischoffshausen, letter to the Hildebrand family, Paris, March 15, 1960, quoted according to Bischoffshausen 2009, p. 13

76 *Helene, Stutz und die Kunst*, 2007, p. 22

77 Ibid., p. 24

78 ML, letter to H. Hildebrand, Paris, January 15, 1962

79 H. Bischoffshausen, letter to E. and H. Hildebrand, Paris, January 9, 1961, quoted according to Bischoffshausen 2009, p. 59

80 H. Hildebrand, letter to ML, Klagenfurt, March 6, 1961

81 ML, letter to H. Hildebrand, Paris, January 16, 1962

82 ML, *Aquarelle*, Carinthian State Museum, August 29–September 13, 1961

83 ML, letter to H. Hildebrand, Paris, January 16, 1962

84 Paul Wicking, letter to ML, May 23, 1964

85 Mathilde Wicking, letter to ML, May 23, 1964

86 ML, letter to H. Hildebrand, Paris, June 26, 1964

87 ML, letter to H. Hildebrand, Paris, March 15, 1964

88 ML, letter to H. Hildebrand, Paris, November 23, 1964

89 Quoted according to Mitchell 2007, p. 6

90 Albers 2011, p. 5

91 Salm-Salm 2009, p. 223 (trans. from French by NL)

92 Ibid.

93 ML in Heiser 2006

94 Maria Lassnig thought she remembered this meeting with Yves Klein taking place at the renowned Salon de Mai, but that can't be. Lassnig first exhibited at a Salon de Mai in

1967 after Klein was no longer alive. Klein died of a heart attack in June 1962 at the age of only thirty-four. There are only two possible group exhibitions where Klein could have seen Lassnig's paintings: either at the *Salon des Comparaisons* in spring 1962—an exhibition at the Musée d'Art Moderne de la Ville de Paris that juxtaposed French and foreign art—or more likely at the aforementioned exhibition at the Creuze Gallery because in her letters to her mother, Lassnig described this exhibition as a "salon" curated by critics, and she also mentioned an important French artist who had praised her work, without revealing his name.

95 ML J, 1947–49, July 22, no year specified but presumably 1947

96 *Von Tag zu Tag*, Ö1, November 27, 2001

97 *Donner à voir*, Galerie Creuze (Salon Balzac), 12 rue Beaujon, Paris VIII, May 15–June 8, 1962. The curators: Michel Courtois, Jean Clarence Lambert, Jean-Jacques Lévêque, Raoul Jean Moulin, José Pierre, and Pierre Restany

98 Galerie le soleil dans la tête, Paris 6e, 10 rue de Vaugirard

99 Alexander Calder received the International Grand Prize for Sculpture in 1952, and Mark Tobey won the City of Venice Painting Prize in 1958. Since the International Awards were declared invalid, Tobey was sometimes listed as the Grand Prize Winner of 1958.

100 *Mythologies quotidiennes*, Musée d'art moderne de la Ville de Paris, July 7–October 1964

101 ML, *Volkszeitung*, June 1963

102 ML, *Volkszeitung*, spring 1964

103 ML, *Volkszeitung*, June 1963

104 ML, *Volkszeitung*, spring 1964

105 ML in Drechsler (ed.) 1985, p. 47

106 ML, postcard to H. Hildebrand, May 20, 1963

107 Fessler 2005. See also H. Klewan in Dreissinger 2015, p. 5

108 Obrist 2005

109 ML J, loose page, 1961

110 ML, *Menschenbilder*, Ö1, May 15, 2005

111 Murken 1990, p. 13 and note 51

112 *Figures et Histoires*, Galerie Heide Hildebrand, Klagenfurt, opening May 6, 1967. Lassnig selected a total of 31 works by nine

artists living in Paris: Eduardo Arroyo, Atila Biro, Breytin, Jacques Grinberg, Gabriel der Kevorkian, Michel Parré, Jean Claude Silbermann, Gérard Tisserand, and Hugh Weiss.

113 *Deux personnages: Maria Lassnig und Gérard Tisserand*, Galerie Heide Hildebrand, April 1969

114 ML, *Volkszeitung*, spring 1964

115 ML, *Volkszeitung*, February 1, 1964

116 ML, letter to H. Hildebrand, Paris, May 16, 1967

117 ML J, December 14, 1962

118 Ibid.

119 ML J, 1964 (trans. from French by NL)

120 Ibid.

121 ML, *Volkszeitung*, June 1963

122 ML J, August 25, 1994

123 ML, *Im Gespräch*, Ö1, June 20, 1996

124 Interview NL with O. Wiener, February 7, 2016

125 ML J, July 18, 1994. See Obrist (ed.) 2000, p. 168

126 ML J, 1964 (trans. from French by NL)

127 ML, letter to Mathilde Lassnig, undated, placed in journal 1945/46

128 ML J, 1946

129 ML, letter to Mathilde Lassnig, undated, placed in journal 1945/46

130 Mathilde Wicking, letter to ML, Klagenfurt, September 20, 1961

131 Paul Wicking, letter to ML, Klagenfurt, October 23, 1963

132 Paul Wicking, letter to ML, Klagenfurt, April 26, 1964

133 Paul Wicking, letter to ML, Klagenfurt, May 19, 1964

134 A double portrait of the Nessmann family, the neighbors at Adolf-Tschabuschnigg-Strasse

135 Paul Wicking, letter to ML, Klagenfurt, May 23, 1964

136 Mathilde Wicking, letter to ML, Klagenfurt, May 11, 1963

137 Mathilde Wicking, letter to ML, Klagenfurt, February 9, 1964

138 ML, letter to Mathilde Lassnig for Mother's Day, undated, between 1955 and 1958

139 Mathilde Wicking, letter to ML, Klagenfurt, Feburary 2, 1964

140 Mathilde Wicking, letter to ML, Klagenfurt, October 22, 1963

Notes

141 Mathilde Wicking, letter to ML, Klagenfurt, May 11, 1964

142 Mathilde Wicking, letter to ML, Klagenfurt, June 21, 1964

143 ML, letter to H. Hildebrand, Paris, December 31, 1966

144 ML, handwritten preparation for the health symposium in Kassel, 1997, AMLF

145 ML J, 1964

146 Ibid.

147 ML, postcard to H. Hildebrand, Paris, January 10, 1966

148 Interview NL with I. Vaughan, San Francisco, March 4, 2015

149 ML J, 1964

150 Ibid.

151 ML J, July 30, 1965

152 ML J, July 26, 1965

153 ML J, July 1965

154 *Untitled, oil on canvas, ca. 1964/65*

155 Quoted according to Schurian, Austrian Public Broadcasting, 1994

156 *Von Tag zu Tag*, Ö1, November 27, 2001

157 ML J, June 2004

158 ML J, August 26, 1989

159 ML J, spring 2004

160 ML, letter to H. Hildebrand, November 2, 1966, AHG

161 Interview NL with Eva Rossbacher, Vienna, October 30, 2015

162 ML, quoted according to *Volkszeitung*, September 24, 1967, p. 8

163 Ibid.

164 Breicha 1966, p. 13

165 Weskott (ed.) 1995, p. 80

166 ML, letter to H. Hildebrand, Paris, January 10, 1966, AHG

167 ML J, loose page, 1990s, AMLF

168 *Surreal Space (Surrealer Raum)*, *Surrealist Sciencefiction (Surrealistes Sciencefiction)*, 1950, oil on fiberboard

169 ML, letter to H. Hildebrand, April 28, 1967, AHG

170 ML 1980, quoted according to Drechsler (ed.) 1985, p. 79

171 Breicha 1964

172 *Maria Lassnig*, Galerie Case d'art, rue des Beaux Arts 3, March 30–April 12, 1965

173 Pierre 1967

174 Parisian press reviews compiled and translated by Lassnig include, among others: *Combat*, April 6, 1965; *Lettres Françaises*, April 1965; *Arts*, July 7, 1965; *Galeries des Arts*, May 1965.

175 Gassiot-Talabot 1965, pp. 54–55

176 Sotriffer 1966, p. 8

177 ML, letter to H. Hildebrand, Paris, February 26, 1967, AHG

178 ML in Drechsler (ed.) 1992, p. 24

179 ML, *Im Gespräch*, Ö1, June 20, 1996

180 Matt and Schurian 2011, p. 229

181 ML, *Im Gespräch*, Ö1, June 20, 1996

7 New York: Feminism, Animation, and "American" Painting

1 ML in Skreiner, exhibition catalog, 1970

2 ML, letter to R. Labak, NY, November 1977, quoted according to Labak 1979, p. 17

3 ML, *Im Gespräch*, Ö1, June 20, 1996

4 Matt and Schurian 2011, p. 235

5 ML 1996, quoted according to Grandits, Austrian Public Broadcasting, 2009

6 Koschatzky 1977

7 *Selfportrait*, 1971, animated film

8 ML, letter to E. and H. Hildebrand, NY, November 30, 1968, AHG

9 ML in Schurian, Austrian Public Broadcasting, 1994

10 ML, letter to E. and H. Hildebrand, NY, November 30, 1968, AHG

11 ML, letter to H. Hildebrand, NY, February 26, 1969, AHG

12 ML, letter to E. and H. Hildebrand, NY, November 30, 1968, AHG

13 ML, *Diagonal*, Ö1, May 1999

14 ML, letter to E. and H. Hildebrand, NY, November 30, 1968, AHG

15 Ibid.

16 ML, letter to H. Hildebrand, NY, January 26, 1969, AHG

17 Exhibition catalog, Galerie Ulysses, Vienna, 2002

18 *Von Tag zu Tag*, Ö1, November 27, 2001

19 E. Schlegel, *Diagonal*, Ö1, May 15, 1999

20 *Von Tag zu Tag*, Ö1, November 27, 2001; regarding the sculptures, see exhibition catalog, Galerie Ulysses, Vienna, 2002

21 ML, letter to H. Hildebrand, NY, February 26, 1969, AHG
22 The series was based on the feature film *The Odd Couple*, directed by Gene Saks and starring Jack Lemmon and Walter Matthau (Paramount 1968).
23 ML, *Im Gespräch*, Ö1, June 20, 1996
24 ML, letter to R. Labak, NY, January 17, 1978, Ruth Labak Archive
25 ML, letter to E. and H. Hildebrand, NY, November 30, 1968, AHG
26 ML, letter to H. Hildebrand, Paris, December 15, 1966, AHG
27 ML, letter to E. and H. Hildebrand, NY, November 30, 1968, AHG
28 ML, letter to H. Absalon, undated (probably Christmas 1976), AMLF
29 ML, letter to H. Hildebrand, Paris, December 15, 1966, AHG
30 Interview NL with Uta and Ernst Hildebrand, Klagenfurt, August 24, 2014
31 ML, letter to H. Hildebrand, NY, March 5, 1970, AHG
32 ML, letter to E. Hildebrand, NY, June 17, 1972, AHG
33 Interview NL with R. Bergmann, Klagenfurt, October 4, 2014
34 ML, letter to E.and H. Hildebrand, NY, January 26, 1969, AHG
35 ML, *Diagonal*, Ö1, May 15, 1999
36 Interview NL with Eva Rossbacher, Wien, October 30, 2015
37 ML 1996, quoted according to Grandits, Austrian Public Broadcasting, 2009
38 ML, letter to H. Hildebrand, NY, January 26, 1969, AHG
39 ML, letter to E. and H. Hildebrand, NY, November 30, 1968, AHG
40 ML, letter to Heide Hildebrand, November 28, 1969, AHG. Lassnig was referring to the group exhibition *Symbolic Figures* (*Symbolfiguren*, January 1970) in Innsbruck, for which Kristian Sotriffer had chosen eighteen works by Austrian artists. In addition to Lassnig's, there were works by Peter Bischof, Otto Eder, Adolf Frohner, Helmut Krumpel, and Arnulf Rainer, among others.
41 Interview NL with Silvianna Goldsmith and Rosalind Schneider, NY, February 21, 2015
42 ML in Skreiner, exhibition catalog, 1970
43 ML in Grandits, Austrian Public Broadcasting, 2009
44 Breicha 1968, p. 138
45 ML, letter to H. Hildebrand, NY, November 28, 1969, AHG
46 ML, letter to H. Hildebrand, NY, March 5, 1970, AHG
47 *Maria Lassnig*, Galerie Heide Hildebrand, October 3–31, 1970
48 ML, letter to H. Hildebrand, Vienna, October 9, 1970, AHG
49 Whitney Museum of American Art, February 10–March 29, 1970; see Monte 1970
50 ML, letter to H. Hildebrand, NY, March 5, 1970, AHG
51 ML J, 1978/79, AMLF
52 ML J, July 9, 1985; see Obrist (ed.) 2000, p. 95
53 ML, letter to H. U. Obrist, May 5, 1996, quoted according to Obrist (ed.) 2000, p. 15
54 ML J, January or February 2004, AMLF
55 ML J, September 2004, AMLF
56 ML, letter to H. Hildebrand, NY, February 26, 1969, AHG
57 ML, letter to H. Hildebrand, NY, November 28, 1969, AHG
58 ML, *Kärntner Tageszeitung*, January 9, 1970
59 Quoted according to Kozloff 2014
60 ML, *Kärntner Tageszeitung*, January 9, 1970
61 Matt (ed.) 2011, p. 215
62 Interview NL with Peter Kubelka, Vienna, October 8, 2016
63 ML, letter to H. Hildebrand, NY, March 5, 1970, AHG
64 ML, postcard to E. and H. Hildebrand, NY, November 30, 1968, AHG
65 Interview NL with AR, Vienna, May 19, 2016
66 ML, letter to E. Hildebrand, NY, December 19, 1972, AHG
67 All quotations: ML, letter to H. Hildebrand, NY, November 28, 1969, AHG
68 ML, *Kärntner Tageszeitung*, January 9, 1970
69 ML, letter to H. Hildebrand, NY, January 26, 1969, AHG
70 J. Sailer in Dreissinger 2015, p. 138
71 ML, letter to E. Hildebrand, NY, February 10, 1972, AHG
72 ML, *Kärntner Tageszeitung*, January 9, 1970
73 ML, letter to E. Hildebrand, NY, June 17, 1972, AHG

Notes

74 ML, *Im Gespräch*, Ö1, June 20, 1996

75 ML, letter to E. Hildebrand, NY, June 17, 1972, AHG

76 Ibid.

77 ML, letter to E. Hildebrand, NY, December 30, 1971, AHG

78 ML, letter to E. Hildebrand, NY, February 10, 1972, AHG

79 ML, letter to H. Hildebrand, NY, March 5, 1970, AHG

80 According to Paul Stöckl, ML Catalog of Works, AMLF

81 ML, letter to E. Hildebrand, NY, December 19, 1972, AHG

82 Kathleen Hultgren, letter to ML, NY, August 3, 1972, AMLF

83 Kathleen Hultgren, letter to ML, NY, September 23, 1970, AMLF

84 Interview NL with I. Vaughan, San Francisco, March 4, 2015

85 Tony Mastroleo, letter to ML, Cambridge, MA, July 13, 1970, AMLF

86 ML J, September 1971, AMLF

87 ML, letter to H. Hildebrand, NY, December 17, 1970, AHG

88 ML, letter to H. Hildebrand, NY, June 12, 1971, AHG

89 ML, letter to E. Hildebrand, NY, February 10, 1972, AHG

90 Interview NL with I. Vaughan, San Francisco, March 4, 2015

91 Austrian Institute, *Events and News*, New York, November 1970

92 ML, letter to H. Hildebrand, NY, December 17, 1970, AHG

93 ML in Schurian, Austrian Public Broadcasting, 1994

94 ML, letter to H. Hildebrand, NY, February 22, 1971, AHG

95 Interview NL with Uta and E. Hildebrand, Klagenfurt, August 24, 2014

96 ML, *Im Gespräch*, Ö1, June 20, 1996

97 ML J, loose page, 1990s, AMLF

98 ML, letter to H. Hildebrand, NY, February 22, 1971, AHG

99 ML in Breicha (ed.) 1973, p.45

100 Ibid.

101 Ibid., p. 46

102 ML, letter to H. Hildebrand, NY, June 12, 1971, AHG

103 Quoted according to Labak 1979, p. 15

104 Interview NL with Iris Vaughan, San Francisco, March 4, 2015. In the film, there is a puppy that is about three to four weeks old. Vaughan is 100 percent certain that her dog had puppies in April 1972. It was her idea to include one of the puppies in the film.

105 ML J, loose page, 1990s, AMLF

106 Interview NL with I. Vaughan, San Francisco, March 4, 2015

107 In 2018, this part of Lassnig's film legacy— the so-called "films in progress"—was restored and completed according to her original concepts and instructions. In 2021, the Austrian Film Museum and the Maria Lassnig Foundation published the book *Maria Lassnig. Film Works*, which provides the first comprehensive index of Lassnig's film works and includes a DVD with a selection of the "films in progress."

108 Lassnig filmed *The Princess and the Shepherd. A Fairytale* at Damtschach Palace, Hochosterwitz Castle, other locations in Carinthia, and the Mönchsberg in Salzburg with the Widrich family. Acting in the film, among others, were Markus Orsini-Rosenberg, who would later study under Lassnig, and the siblings Mechtild and Virgil Widrich, who played children.

109 Bob Parent (1923–1987) was known primarily as a photographer of New York jazz musicians. He took the photos of the Women Artist Filmmakers.

110 ML, letter to E. Hildebrand, NY, February 10, 1972, AHG

111 Ibid.

112 ML, letter to E. Hildebrand, NY, December 19, 1972, AHG

113 ML, letter to E. Hildebrand, NY, February 10, 1972, AHG

114 The ten artists were Susan Brockman, Doris Chase, Martha Edelheit, Silvianna Goldsmith, Nancy Kendall, Maria Lassnig, Carolee Schneemann, Rosalind Schneider, Olga Spiegel, and Alida Walsh.

115 Schneemann 2014

116 Interview NL with O. Spiegel, NY, February 19, 2015

117 Kozloff 2014

118 Quoted according to Grandits, Austrian Public Broadcasting, 2009

119 ML, *Im Gespräch*, Ö1, June 20, 1996

120 Interview NL with O. Spiegel, NY, February 19, 2015

121 Cavell 1973, p. 13

122 ML, letter to Silvianna Goldsmith, Berlin, October 23, 1978

123 Interview NL with Silvianna Goldsmith and Rosalind Schneider, NY, February 21, 2015

124 ML in Breicha (ed.) 1973, p. 46

125 Smolik 1995, p. 59

126 ML in Breicha (ed.) 1973, p. 51

127 Schurian 2013

128 ML in Export (ed.) 1975, p. 8

129 Mayer 2004

130 Drechsler (ed.) 1992, p. 24

131 Interview NL with I. Vaughan, San Francisco, March 4, 2015

132 ML in Breicha (ed.) 1973, p. 51

133 Matt and Schurian 2011, p. 233

134 ML, letter to E. Hildebrand, NY, April 30, 1973, AHG

135 Petzel 2014

136 ML, *Im Gespräch*, Ö1, June 20, 1996

137 ML, *Kärntner Tageszeitung*, January 9, 1970

138 ML, letter to E. Hildebrand, NY, October 6, 1973, AHG

139 ML in Albertina, exhibition catalog, 1977

140 Drechsler (ed.) 1992, p. 24

141 ML, letter to R. Labak, NY, January 17, 1978, Ruth Labak Archive

142 Interview NL with J. Semmel, NY, February 23, 2015

143 ML in Albertina, exhibition catalog, 1977

144 Interview NL with J. Semmel, NY, February 23, 2015

145 Ibid.

146 Quoted according to Grandits, Austrian Public Broadcasting, 2009

147 ML, letter to E. Hildebrand, NY, April 22, 1976, AHG

148 ML, letter to H. Absalon, NY, May 23, 1977, AMLF

149 ML, letter to R. Labak, NY, January 17, 1978, Ruth Labak Archive

150 ML, quoted according to Misar 1975, p. 16

151 "New York Exhibitions. 57th Street Review," *Art/World*, May 1977, p. 5

152 ML, letter to H. Absalon, NY, April 8, 1976, AMLF

153 ML J, 1978/79, AMLF

154 ML, letter to H. Hildebrand, NY, December 17, 1970, AHG

155 Ibid.

156 ML, letter to E. Hildebrand, NY, October 17, 1972, AHG

157 ML, letter to E. Hildebrand, NY, December 19, 1972, AHG

158 ML, letter to E. Hildebrand, NY, December 28, 1974, AHG

159 According to Oscar Bronner, he lived on the fifth floor next to Lassnig's shared apartment. Olga Spiegel was entirely convinced that she and Lassnig lived on the third floor. Lassnig also wrote in letters that Bronner lived above her. A Viennese private collector who visited Lassnig in New York confirms this.

160 ML, *Diagonal*, Ö1, May 15, 1999

161 Matt and Schurian 2011, p. 231

162 ML, letter to H. Absalon, NY, October 26, 1975, AMLF

163 Kozloff 2014

164 ML in Drechsler (ed.) 1985, p. 121

165 ML, letter to H. Absalon, NY, April 8, 1976, AMLF

8 Berlin: Oswald Wiener, Trees, and Theory

1 ML in Export, exhibition catalog, 1975

2 ML, letter to H. Absalon, NY, October 28, 1977, AMLF

3 ML, postcard to H. Absalon, Klagenfurt, June 11, 1975, AMLF

4 Interview NL with O. Wiener, Kapfenstein, February 7, 2016 (all quotations from Wiener from this interview unless otherwise noted)

5 Ohff 1976

6 ML, letter to H. Absalon, Berlin, February 28, 1978, AMLF

7 ML J, 1978, AMLF

8 ML J, summer 2002, AMLF

9 ML to Johanna Ortner while they were creating a list of her works

10 ML, letter to Silvianna Goldsmith, Berlin, March 4, 1978, AMLF

11 ML, letter to H. Absalon, Berlin, February 28, 1978, AMLF

12 Kippenberger 2012, p. 122

13 An artist's multiple is a series of art objects produced by an artist, usually a signed limited edition specifically for selling.

14 Interview NL with O. Wiener, Kapfenstein, February 7, 2016

15 ML, letter to Silvianna Goldsmith, Berlin, March 4, 1978, AMLF

16 ML, *Kleine Zeitung*, November 8, 1978, p. 16

17 Gorsen 1980, pp. 42–43

18 Gorsen 1978

19 ML J, February 10, 1981, AMLF

20 Mach 2008, pp. 11–41

21 ML in Albertina, exhibition catalog, 1977

22 ML J, 1978/79, AMLF

23 ML in Drechsler (ed.) 1992, p. 24

24 Anecdote recounted by Oswald Wiener in interview NL with O. Wiener, Kapfenstein, February 7, 2016

25 ML J, January 22, 2004, AMLF

26 ML J, 1978/79, AMLF

27 ML J, February 2002, AMLF

28 Interview NL with O. Wiener, Kapfenstein, February 7, 2016

29 ML J, February 12, 1999, AMLF

30 Interview NL with O. Wiener, Kapfenstein, February 7, 2016

31 O. Wiener in Pakesch 2012, p. 31

32 Wiener 1982, p. 100 f.

33 ML, letter to H. Absalon, NY, December 15, 1979, AMLF

34 ML quoted according to Deissen 1979, p. 26

35 ML 1996, quoted according to Grandits, Austrian Public Broadcasting, 2009

36 Heiser 2006

37 Quoted according to *Kärntner Tageszeitung*, March 13, 1976

38 ML, letter to H. Absalon, NY, April 8, 1976, AMLF

39 ML, letter to H. Absalon, Berlin, February 28, 1978, AMLF

40 ML, letter to H. Absalon, NY, November 5, 1979, AMLF

41 ML, letter to H. Absalon, NY, December 10, 1979, AMLF

42 ML, letter to H. Absalon, NY, November 11, 1979, AMLF

43 Ibid.

44 ML J, August 1979, AMLF

45 ML, letter to H. Absalon, NY, December 15, 1979, AMLF

46 Klewan 2015

9 Professor Lassnig

1 ML 1982, quoted according to Weskott 1996

2 ML J, 1980–81, AMLF

3 ML J, summer/fall 2000, AMLF

4 In 1934 and 1936, Maria Pauli-Rottler was the only woman to take part in large group exhibitions in the Austrian Pavilion. In 1950, Gerhild Diesner, Vilma Eckl, Margret Bilger, and Maria Biljan-Bilger were invited, along with 42 men. In 1954, Maria Biljan-Bilger and Johanna Schidlo took part in a large group exhibition with a total of nineteen artists.

5 Tabor 1980, p. 13

6 W. Hofmann in Hofmann and Hollein (eds.) 1980, p. 8

7 ML, *Diagonal*, Ö1, May 15, 1999

8 ML, *Mittagsjournal*, Ö1, February 1, 1980

9 Interview NL with O. Wiener, Kapfenstein, February 7, 2016

10 V. Export in Dreissinger 2015, p. 115

11 Interview NL with O. Wiener, Kapfenstein, February 7, 2016

12 Signatures unidentifiable, Postcard to Maria Lassnig. Venice, September 13, 1980. AMLF

13 *A New Spirit in Painting,* Royal Academy of Arts, London, United Kingdom, January 15–March 18, 1981. In most other exhibitions, the German artist Elvira Bach was represented. She was also counted as one of the Neue Wilde (New Fauves).

14 Welti 1983, pp. 48–50

15 H. Schmalix, quoted according to Weiermair 1987, p. 91 ff.

16 Interview NL with H. U. Obrist, Vienna, November19, 2016

17 For example: Skreiner 1985, p. 216 ff.

18 ML J, November 6, 1984, AMLF

19 At the documenta on the upper floor of the new gallery, Lassnig showed *I Bear the Responsibility (Ich trage die Verantwortung), The Conquest of the Muse (Bezwingung der Muse), The Hermitress (Einsiedlerin), Tethered (Die Angepflockte),* and *Life Cycle (Lebenszyklus).*

20 Quoted according to Schedlmayer 2014

21 Interview NL with Eva Rossbacher, Vienna, October 30, 2015. Rossbacher is Rainer Bergmann's daughter.

22 A common expression for Lassnig; for example, in Austrian Public Radio Ö1's *Mittagsjournal*, January 17, 1985

23 Quoted according to Schedlmayer 2014

24 Interview NL with M. Mattuschka, Vienna, November 5, 2016

25 ML, note, undated, AMLF

26 ML J, 1980s, quoted according to Obrist (ed.) 2000, p. 75

27 Interview NL with R. Schütz, Vienna, October 19, 2016

28 ML, quoted according to H. W. Poschauko in Dreissinger 2015, p. 106

29 ML: "Why study nature?" Loose sheet, undated, AMLF. Thanks to Gerlinde Thuma for providing me with copies of all of her exercise sheets/handouts from Maria Lassnig.

30 ML, loose sheet, undated

31 ML, document, undated, AMLF

32 ML J, loose sheet, May 1982, AMLF

33 Interview NL with U. Hübner, Vienna, October , 2016

34 Interview NL with U. Hübner, Vienna, October 7, 2016

35 See Labak 1989, Bast 2008

36 Interview NL with G. Thuma, Vienna, June 1, 2016

37 Interview NL with A. Karner, Vienna, November 4, 2016

38 http://birgitjuergenssen.com/biografie (accessed January 12, 2017)

39 Interview NL with U. Hübner, Vienna, October 7, 2016

40 Interview NL with Robert Fleck, Vienna, April 6, 2016. Regarding the exhibit: Fleck (ed.) 1985

41 ML J, October 24, 1984, AMLF

42 This was reported by Hannelore Ditz, who was part of the interview that the author conducted with Arnulf Rainer in Vienna on May 19, 2016.

43 Interview NL with R. Labak, Vienna, October 12, 2016

44 *Meisterklasse Maria Lassnig, 1980–1989* (*Master Class Maria Lassnig, 1980–1989*), April 18–May 5, 1989. See Labak (ed.) 1989

45 Hubert Sielecki was recommended to Lassnig by experimental filmmaker Ernst Schmidt Jr. with whom Lassnig was friends.

46 Sielecki 1990, p. 95.

47 Sielecki in Dreissinger 2015, p. 98

48 A four-track Tascam machine, two Uhler devices, an effect-and-echo device, and a new kind of control system from the Schmalsieg company for sound-cutting-table synchronization. See H. Sielecki in Dreissinger 2015, p. 99

49 Sielecki, *Diagonal*, Ö1, May 15, 1999

50 Interview NL with G. Thuma, Vienna, June 1, 2016

51 M. Mattuschka, quoted according to Bruckner 2008, p. 94

52 Interview NL with U. Hübner, Vienna, October 7, 2016

53 Johanna Freise, quoted according to Bruckner 2008, p. 104

54 Matt and Schurian 2011, p. 233

55 ML, quoted according to Welti 1983, p. 48

56 Interview NL with A. Karner, Vienna, November 4, 2016

57 Interview NL with G. Thuma, Vienna, June 1, 2016

58 Interview NL with R. Labak, Vienna, October 12, 2016

59 Interview NL with A. Karner, Vienna, November 4, 2016

60 Interview NL with R. Labak, Vienna, October 12, 2016

61 ML J, August 20, 1981; see Obrist (ed.) 2000, p. 79

62 Interview NL with A. Karner, Vienna, November 4, 2016

63 ML J, undated, probably late 1980s

64 Interview NL with H. W. Poschauko, Vienna, December 8, 2016

65 Interview NL with M. Mattuschka, Vienna, November 5, 2016

66 Interview NL with G. Thuma, Vienna, June 1, 2016

67 ML J, November 8, 1985, AMLF

68 ML J, April 28, 1982, AMLF

69 ML, letter to Silvianna Goldsmith, Vienna, May 10, 1981, AMLF

70 Interview NL with A. Karner, Vienna, November 4, 2016

71 Ibid.

Notes

72 ML, *Im Gespräch*, Ö1, June 20, 1996

73 Inviting Herbert Lachmayer was an idea suggested by Birgit Jürgenssen, who worked as Lassnig's assistant during her first year.

74 Interview NL with G. Thuma, Vienna, June 1, 2016

75 *Hans Werner Poschauko—Wer will mich?* Neue Galerie Studio Graz, Steirischer Herbst 87, October 22–November 15, 1987. Interview NL with H. W. Poschauko, Vienna, December 8, 2016

76 Interview NL with G. Thuma, Vienna, June 1, 2016

77 Lecerf-Héliot 1996 (trans. from French by NL)

78 Interview NL with R. Schütz, Vienna, October 19, 2016

79 Interview NL with U. Hübner, Vienna, October 7, 2016

80 Interview NL with G. Thuma, Vienna, June 1, 2016

81 Roland Schütz recounted this anecdote about another student. Interview NL with R. Schütz, Vienna, October 19, 2016

82 Mattuschka in Kaess-Farquet, Bavarian Television (Germany), 2015

83 Interview NL with R. Schütz, Vienna, October 19, 2016

84 Interview NL with A. Karner, Vienna, November 4, 2016

85 ML J, October 2, 1984, AMLF

86 ML J, 1990, AMLF

87 Quoted according to Spiegler 2009

88 Bast 2008. Interview NL with G. Thuma, Vienna, June 1, 2016

89 ML and Ronte in Bast (ed.) 2008, p. 17

90 Interview NL with U. Hübner, Vienna, October 7, 2016

91 Matt and Schurian 2011, p. 228

92 Interview NL with Terese Schulmeister, Vienna, December 13, 2016

93 ML in Noever (ed.) 2004, p. 394

94 ML J, April 17, 1998

95 Interview NL with Terese Schulmeister, Vienna, December 13, 2016

96 *Ungehorsam* (*Disobedience*), Austria, 2016

97 ML quoted according to Sternath-Schuppanz 1988, p. 31

98 Among others: the Cyclades Island of Tinos (1982), Rhodes (1983), Egypt (February 1984), Cyprus (summer 1984), Crete (late summer 1985), Ischia, Italy (1987), Crete (1988), Lanzarote (1993), Crete (1994), and Santorini (1996)

99 Selection: *Zeichnungen, Aquarelle, Gouachen 1949–1982* (*Drawings, Watercolors, Gouaches 1949–1982*), Mannheimer Kunstverein (October 24–November 21, 1982), Kunstverein Hannover (April 10–May 12, 1983), Kunstverein München (May 18–June 26, 1983), Kunstmuseum Düsseldorf (July 7–August 21, 1983), Neue Galerie, Graz (January 19–February 27, 1984), Galerie Haus am Waldsee, Berlin (1983). In 1986, the travel watercolors were seen together with paintings in the Studio d'Arte Cannaviello in Milan. The retrospective of Maria Lassnig's watercolors was in the Kärntner Landesgalerie (Carinthian State Gallery) in Klagenfurt in 1988 and in the Albertina in Vienna, as well as in the Rupertinum in Salzburg in 1989. In 1992, Ulysses Gallery in Vienna and Klewan Gallery in Munich showed Lassnig's watercolors. Additional shows: *Zeichnungen und Aquarelle 1946–1995* (*Drawings and Watercolors 1946–1995*) at the Kunstmuseum Bern (September 13–November 26, 1995), Centre Georges Pompidou, Paris (December 6, 1995–February 19, 1996), Städtisches Museum Leverkusen (March 25–June 2, 1996), Kunstmuseum Ulm (June 30–August 25, 1996), Kulturhaus Graz (September—November 1996)

100 Kaess-Farquet 2008

101 ML, *Mittagsjournal*, Ö1, March 8, 1989

102 Interview NL with E. and U. Hildebrand, Klagenfurt, August 24, 2014

103 ML, letter to E. Hildebrand, Vienna, June 27, 1984

104 Interview NL with E. and U. Hildebrand, Klagenfurt, August 24, 2014

105 Interview NL with R. Bergmann, Klagenfurt, October 4, 2014

106 Interview NL with O. Wiener, Kapfenstein, February 7, 2016

107 ML J, August 2001, AMLF

108 ML J, summer 1987, AMLF

109 ML J, July 17, 1992, AMLF

110 Interview NL with R. Bergmann, Klagenfurt, October 4, 2014

111 Ibid.

112 ML J, August 1, 1986, AMLF

113 Quoted according to Schurian, Austrian
 Public Broadcasting, 1994

114 ML in *Klagenfurt – Die Stadtzeitung mit
 amtlichen Nachrichten*, February 26, 2004

115 ML, *Diagonal*, Ö1, May 15, 1999

116 ML told H. W. Poschauko this story. Interview
 NL with H. W. Poschauko, Vienna,
 August, 25, 2016

117 ML in Dreissinger 2015, p. 38

118 Ibid., p. 39

119 ML, quoted according to R. R. in *Kärntner
 Zeitung*, August 17, 1985, p. 19

120 Interview NL with U. Hübner, Vienna,
 October 7, 2016

121 Interview NL with W. Drechsler, Vienna,
 November 4, 2016

122 ML in Drechsler 1985, p. 71

123 Quoted according to Welti 1983, p. 46

124 Drechsler 1985, pp. 9–15

125 Interview NL with W. Drechsler, Vienna,
 November 4, 2016

126 Christoph 1985, p. 66

127 Köcher 1985, p. 292 ff.

128 Weskott 1985

129 Interview NL with Ashley Hans Scheirl,
 Vienna, November 18, 2016

130 The artist later took the name Hans Angela
 Scheirl, today Ashley Hans Scheirl. See http://
 hansscheirl.jimdo.com/

131 ML, letter to H. A. Scheirl, 2006, quoted
 according to interview NL with A. H. Scheirl,
 Vienna, November 18, 2016

132 In the performance, Scheirl appeared with
 Ursula Pürrer and Susanna Heilmayr, who
 together formed the group Unfavorable
 Omens (Ungünstige Vorzeichen).

133 ML, *Im Gespräch*, Ö1, June 20, 1996

134 Drechsler 1999, p. 31

135 *The Prodigal Son* (*Der verlorene Sohn*),
 1983–84, oil on canvas

136 ML J, May 3, 1986, AMLF

137 ML, letter to Silvianna Goldsmith, Vienna,
 December 5, 1987, AMLF

138 Lassnig in Obrist (ed.) 2000, p. 91 f.

139 Quoted according to *Abendjournal*, Ö1,
 November 30, 1988

10 "I am the Lady Picasso"— Lassnig as Artist of the Century

1 ML J, summer 2000

2 Cumming 2008

3 Selection of international exhibitions, 1990s:
 1994 Stedelijk Museum, Amsterdam; 1995
 Kunstmuseum Bern and Centre Pompidou,
 Paris; 1997 daadgalerie Berlin, Neuer Berliner
 Kunstverein, and Kunsthalle Műcsarnok,
 Budapest; 1999 Musée des Beaux Arts
 and FRAC, Nantes; 1995 and 2003 Venice
 Biennale; 1997 documenta X

4 Selection of international exhibitions,
 2000–14: 2001 Kestner Gesellschaft, Hanover;
 2002 Bayerische Akademie der Schönen
 Künste, Munich, Museum für Gegenwarts-
 kunst, Siegen, and Petzel Gallery, New
 York; 2003 Kunsthaus Zürich; 2004 Städel
 Museum, Frankfurt am Main, and Hauser
 & Wirth, London; 2005 Petzel Gallery, New
 York; 2007 Hauser & Wirth, Zurich; 2008
 Serpentine Gallery, London, and Contempo-
 rary Arts Center, Cincinnati; 2009 Museum
 Ludwig, Cologne; 2010 Lenbachhaus,
 Munich, and Petzel Gallery, New York; 2012
 SBC Gallery of Contemporary Art, Montreal
 (films); 2013 Capitain Petzel Gallery, Berlin,
 and Deichtorhallen, Hamburg; 2014 MoMA
 PS1, New York

5 ML J, November/December 2006, AMLF

6 Matt and Schurian 2011, p. 227

7 Drexler 2014, p. 350 ff.

8 F. Petzel in Kaess-Farquet, Bavarian Television
 (Germany), 2015

9 G. Wimmer in Dreissinger 2015, p. 134

10 ML J, 1980/81, AMLF

11 ML, letter to H. Absalon, NY, November 29,
 1976, AMLF

12 I. Wirth in Dreissinger 2015, p. 217

13 ML quoted according to interview NL with
 H. W. Poschauko, Vienna, December 8, 2016

14 ML J, January or February 2004, AMLF

15 Russell 1989 and Kuspit 1990

16 B. Gross quoted according to Drexler 2014

17 ML J, October 2003, AMLF

18 Interview NL with J. Sailer, Vienna,
 November 4, 2016

19 Interview NL with G. Wimmer, Vienna, November 14, 2016

20 ML J, November 25, 2000, 5:00 a.m., AMLF

21 Interview NL with G. Wimmer, Vienna, November 14, 2016

22 In Amsterdam, Lassnig's single presentation was shown in the context of *Couplet I* and then continued on to Lübeck (St. Petri) and Frankfurt (Kunstverein). There were three individual presentations (Mario Merz, Maria Lassnig, and Berend Strik) and approximately sixteen minor positions according to the exhibit poster.

23 Interview NL with G. Wimmer, Vienna, November 14, 2016

24 R. Fuchs in Schurian, Austrian Public Broadcasting, 1994

25 Interview NL with G. Wimmer, Vienna, November 14, 2016

26 ML draft letter to M.W., no date, presumably 1990s, AMLF

27 Interview NL with J. Sailer, Vienna, November 14, 2016

28 Interview NL with G. Wimmer, Vienna, November 14, 2016

29 ML, *Menschenbilder*, Ö1, May 15, 2005

30 ML quoted according to interview NL with H. W. Poschauko, Vienna, December 8, 2016

31 Schurian 2013

32 Interview NL with A. Teschke, NY, February 23, 2015

33 ML, *Menschenbilder*, Ö1, May 15, 2005

34 All quotations from H. Klewan, in Dreissinger 2015, pp. 54–59

35 The Essl Museum was closed on June 30, 2016.

36 Karlheinz Essl quoted according to Dusini 2009

37 The *body.fiction.nature* exhibition took place at the Essl Museum in 2005. In 2006, it could be seen in modified form under the title *Körperbilder* (*Body Images*) in the Museum of Modern Art Carinthia (Museum Moderner Kunst Kärnten).

38 ML quoted according to Dusini 2009

39 The University of Klagenfurt decided to award Lassnig an honorary doctorate on her 80th birthday. She finally accepted this honor fourteen years later in 2013 after a political change had taken place.

40 Grissemann 2005

41 ML in Dreissinger 2015, p. 153

42 W. Moser in Dreissinger 2015, p. 166

43 M. Mattuschka in Kaess-Farquet, Bavarian Television (Germany), 2015

44 Interview NL with H. U. Obrist, Vienna, November 19, 2016

45 ML quoted according to the interview NL with A. Teschke, NY, February 23, 2015

46 ML J, April 19, 2000, AMLF

47 Interview NL with F. Petzel, NY, February 20, 2015

48 Interview NL with H. W. Poschauko, Vienna, December 8, 2016

49 ML J, ca. August 2009, AMLF

50 ML J, ca. January 2011, AMLF

51 König and Schlebrügge 1995

52 A. Husslein-Arco in Dreissinger 2015, p. 51

53 ML quoted according to Weh 1999, p. 22

54 P. Pakesch at interview NL with O. Wiener, Kapfenstein, February 7, 2016

55 Interview NL with F. Petzel, NY, February 20, 2015

56 *Maria Lassnig. Science Fiction,* Galerie Raymond Bollag, November 23, 1991–January 18, 1992

57 Interview NL with R. Storr, NY, February 19, 2015; see also Storr 2009, pp. 88–101

58 ML to Johanna Ortner, who was documenting Lassnig's works; alternative titles: *Kitchen* (*Küche*) or *The Kitchen Battle* (*Die Küchenschlacht*)

59 Storr (ed.) 2004, p. 76 f.

60 Interview NL with R. Storr, NY, February 19, 2015

61 The essay was reprinted again in German translation in 2009, W. Drechsler (ed.) 2009, p. 61

62 *Art Review* 2016, https://artreview.com/power-100/?year=2016 (accessed January 13, 2017)

63 Interview NL with H. U. Obrist, Vienna, November 19, 2016

64 ML letter to H. U. Obrist, Feistritz, summer 1993, AMLF

65 Interview NL with H. U. Obrist, Vienna, November 19, 2016

66 Ibid.

67 P. Pakesch at interview NL with O. Wiener, February 7, 2016

68 Interview NL with H. U. Obrist, Vienna, November 19, 2016

69 Ibid.

70 ML J, June 29, 1947, AMLF

71 ML J, 1987, AMLF

72 ML J, March 2000, AMLF

73 ML J, December 2008, AMLF

74 ML J, July 1985, AMLF

75 ML J, November 22, 2000, AMLF

76 ML J, June 2006, AMLF

77 ML J, March 2002, AMLF

78 Mayröcker 2012, p. 68

79 In 1953, Else Brauneis was the first and—until 2010—only woman honorary member. The Vienna-born artist became a professor at the Munich School of Applied Arts in 1923. In 1946, she was released on orders from the military government, showing her previous involvement with the National Socialist regime.

80 Samsonow 2010

81 Mayröcker 2012, p. 44

82 ML J, August 1, 1984, AMLF

83 ML J, June 2008, AMLF

84 ML J, October 31, 2010, AMLF

85 ML J, September 2006, AMLF

86 Interestingly, no diaries have emerged from her New York era in the 1970s. Maybe they were lost, but maybe she didn't write any back then either. Instead, there are journals full of film ideas, which often also have a biographical reference.

87 ML, *Diagonal*, Ö1, May 15, 1999

88 Interview NL with H. U. Obrist, Vienna, November 19, 2016

89 Harding 2004

90 ML, letter to H. U. Obrist, undated (approximately mid-1990s), AMLF

91 ML J, December 2008, AMLF

92 Interview NL with H. U. Obrist, Vienna, November 19, 2016

93 ML, *Im Gespräch*, Ö1, June 20, 1996

94 ML J, May 1, 2007, AMLF

95 ML J, August 16, 2003, AMLF

96 ML in Weskott 1995, p. 70

97 ML J, January 2002, AMLF

98 ML in *Maria Lassnig. Das Innere nach Aussen. Bilder. Schilderijen. Paintings*, 1994, p. 4

99 ML J, November 14, 1998, AMLF

100 ML J, May 3, 1984, quoted according to Obrist (ed.) 2000, p. 86

101 ML in Fundacío Antoni Tàpies (ed.), *Maria Lassnig. Werke, Tagebücher & Schriften / Works, Diaries & Writings*, 2015, p. 88 f.

102 ML in Weskott 1995, p. 11

103 ML, draft letter to Rudi Fuchs, undated, AMLF

104 ML to H. W. Poschauko, from interview NL with H. W. Poschauko, Vienna, December 8, 2016

105 ML in Schurian, Austrian Public Broadcasting, 1994

106 Ibid.

107 The author thanks Wolfgang Drechsler for this clue.

108 ML, *Im Gespräch*, Ö1, June 20, 1996

109 ML in Galerie Ulysses (ed.), *Maria Lassnig. Zeichnungen und Aquarelle*, 1992

110 ML J, 1992, AMLF

111 ML J, between 1992 and 1994, AMLF

112 Kaess-Farquet 2008

113 Quoted according to Kimpel 2002, p. 129

114 *On peut bien sur tout changer. Art autrichien 1960–1995*, Ecole d'Architecture de Normandie, Ecole Régionale des Beaux Arts, Rouen, and Abbaye aux Dames, Caen, May 20–July 30, 1995

115 ML, letter to Catherine David, Vienna, October 25, 1996 (trans. from French by NL), AMLF

116 ML in *Maria Lassnig. Das Innere nach Aussen. Bilder. Schilderijen. Paintings*, 1994, p. 4

117 ML in Fundacío Antoni Tàpies (ed.), *Maria Lassnig. Werke, Tagebücher & Schriften / Works, Diaries & Writings*, 2015, p. 88

118 ML J, summer 2002–03, loose page, AMLF

119 ML, *Menschenbilder*, Ö1, May 15, 2005

120 ML J, May 29, 2006, AMLF

121 ML J, May 19, 1999, AMLF

122 ML J, July 1998, AMLF

123 ML J, loose page, 2009, AMLF

124 ML J, summer 2005, AMLF

125 Interviews NL with H. W. Poschauko, 2014–16

126 ML J, July 8, 1998, similar to ML in Drechsler (ed.) 1999, p. 156

127 E. Köb in Dreissinger 2015, p. 169

128 *Maria Lassnig*, Museum moderner Kunst Stiftung Ludwig Vienna, 20er Haus, March 26–June 6, 1999; Musée des Beaux Arts de

Notes

Nantes, Fonds Régional d'Art Contemporain des Pays de la Loire, Nantes, July 9–September 26, 1999

129 ML, postcard to R. Fleck, undated, RFA

130 ML, letter to R. Fleck, Vienna, October 14, 1998, RFA

131 R. Fleck, letter to Arielle Pelenc, La Bouille, October 28, 1998 (trans. from French by NL), RFA

132 ML, postcard to R. Fleck, undated, RFA

133 Breerette 1999, p. 23; Lebovici 1999, p. 33

134 R. Fleck, letter to ML, La Bouille, September 24, 1999, RFA

135 Interview NL with F. Petzel, NY, February 20, 2015

136 Interview NL with A. Teschke, NY, February 23, 2015

137 Interview NL with F. Petzel, NY, February 20, 2015

138 Smith 2002

139 ML quoted from the interview NL with A. Teschke, NY, February 23, 2015

140 Interview NL with A. Teschke, NY, February 23, 2015

141 Ibid.

142 Interview NL with F. Petzel, NY, February 20, 2015

143 ML quoted from the interview NL with H. W. Poschauko, Vienna, December 8, 2016

144 For example, Kuspit 1990

145 ML J, June 2004, AMLF

146 ML J, July 25, 2002, AMLF

147 W. Moser in Dreissinger 2015, p. 163

148 There are also discrepancies in the dating here. While Moser is convinced that Lassnig made her first paintings with him in 2003 or 2004 at the earliest, and *Entomologist I* was actually the first picture, Lassnig signed *The World Crusher* with 2001. The date found on a handwritten index card is probably the correct one: 2003.

149 H. W. Poschauko in Dreissinger 2015, p. 108

150 W. Moser in Dreissinger 2015, p. 163

151 Interview NL with G. Wimmer, Vienna, November 14, 2016

152 Quoted according to Drechsler 2009, p. 33

153 W. Moser in Dreissinger 2015, p. 164

154 Kaess-Farquet 2008

155 ML J, August 12, 2005, AMLF

156 ML quoted according to L. Resch in Dreissinger 2015, p. 81

157 L. Resch in Dreissinger 2015, p. 79

158 Kaess-Farquet 2008

159 L. Resch in Dreissinger 2015, p. 81

160 L. Resch in Dreissinger 2015, p. 79

161 ML J, 2007, AMLF

162 ML, draft letter to H. U. Obrist, April 13, 2009, AMLF

163 Interview NL with W. Drechsler, Vienna, November 4, 2016

164 ML J, November 17, 2006, AMLF

165 ML J, August 18, 2008, AMLF

166 ML J, June 2004, AMLF

167 Kaess-Farquet 2008

168 Interview NL with H. U. Obrist, Vienna, November 19, 2016

169 Ibid.

170 Matt and Schurian 2011, p. 224

171 Serpentine Gallery, London, April 25–June 8, 2008; Contemporary Arts Center, Cincinnati, September 27, 2008–January 11, 2009; MUMOK, Vienna, February 13–May 17, 2009

172 Interview NL with W. Drechsler, Vienna, November 4, 2016

173 ML J, January 22, 2008, AMLF

174 ML J, January 6, 1999, AMLF

175 ML J, January 3, 1999, AMLF

176 ML in Dreissinger 2015, p. 183

177 H. W. Poschauko in Dreissinger 2015, p. 109

178 Matt and Schurian 2011, p. 225

179 ML J, Pentecost 2002, AMLF

180 E. Köb in Dreissinger 2015, p. 170

181 Ibid., p. 167

182 Interview NL with W. Drechsler, Vienna, November 4, 2016

183 ML J, May 6, 2000, AMLF

184 C. Resch in Dreissinger 2015, p. 80

185 Interview NL with O. Wiener, Kapfenstein, February 7, 2016

186 Interview NL with H. W. Poschauko, Vienna, December 8, 2016

187 ML J, May 2004, AMLF

188 ML J, July 2008, AMLF

189 H. Absalon in Dreissinger 2015, p. 159

190 Interview NL with P. Pakesch, Vienna, October 12, 2016

191 Interview NL with G. Wimmer, Vienna, November 14, 2016

192 Dreissinger 2015, p. 7

193 Interview NL with G. Thuma, Vienna, June 1, 2016

194 Interview NL with A. Rainer, Vienna, May 19, 2016

195 Interview NL with P. Pakesch, Vienna, October 12, 2016

196 Private foundation in case of death, established March 29, 2001; changes during her lifetime on July 12, 2005, and April 8, 2013

197 The board also includes Hans Werner Poschauko, Georg Geyer, Matthias Mühling, Friedrich Petzel, Gabriele Wimmer, and Iwan Wirth. Rudi Fuchs left the advisory board in 2020 at his own request. In 2021, Sebastian Egenhofer, Anita Haldemann, Antonia Hoerschelmann, Kasper König, Hans Ulrich Obrist, and Ralph Ubl are represented on the advisory board.

198 *Two or Three or Something. Maria Lassnig, Liz Larner*, Kunsthaus Graz, February 4–May 7, 2006; *Maria Lassnig. The Location of Pictures*, Neue Galerie Graz, November 17, 2012–April 28, 2013; Deichtorhallen, Hamburg, June 21–September 8, 2013

199 Interview NL with P. Pakesch, Vienna, October 12, 2016

200 Ortner started with an overview of the works in Lassnig's depot in 2012 for the Graz retrospective the same year and has been curator of the Maria Lassnig Foundation since 2015.

201 Interview NL with P. Pakesch, Vienna, October 12, 2016

202 Interview NL with H. W. Poschauko, Vienna, December 8, 2016

203 Ibid.

204 ML J, May 2010, AMLF

205 ML J, ca. May 2011, AMLF

206 Interview NL with H. W. Poschauko, Vienna, December 8, 2016

207 ML quoted according to the interview NL with A. Teschke, NY, February 23, 2015

208 Interview NL with H. W. Poschauko, Vienna, December 8, 2016

209 Ibid.

210 Interview NL with P. Pakesch, Vienna, October 12, 2016

211 Interview NL with H. W. Poschauko, Vienna, December 8, 2016

212 Interview NL with G. Thuma, Vienna, June 1, 2016

213 ML J, 1975; see also Obrist (ed.) 2000, p. 66

214 ML J, July 28, 2001, AMLF

215 ML J, November 2, 1994; see also Obrist (ed.) 2000, p. 171

216 ML J, August 12, AMLF

217 Grissemann 2005

218 Interview NL with H. W. Poschauko, Vienna, December 8, 2016

219 ML, letter to H. U. Obrist, January 11, 2014, Hans Ulrich Obrist Archive

220 Interview NL with H. W. Poschauko, Vienna, December 8, 2016

221 Interview NL with P. Pakesch, Vienna, October 12, 2016

Bibliography

Unpublished Journals

Maria Lassnig's unpublished journals, 1940–2013, AMLF.

Letters

Fleck, Robert. Letters to Maria Lassnig, 1995–99. Robert Fleck Archive, AMLF.

Guttenbrunner, Michael. Letters to Maria Lassnig, 1946–75. AMLF.

Hultgren, Kathleen. Letters to Maria Lassnig, 1970–72. AMLF.

Kolig, Anton. Letters to Maria Lassnig, 1940s. AMLF.

Lassnig, Maria. Letters to Mathilde Lassnig/Wicking, 1940–64. AMLF.

Lassnig, Maria. Letters to Paul Celan, 1961–67. German Literature Archive, Marbach, D:Celan 90.1.1842/1–6.

Lassnig, Maria. Letters to Heide and Ernst Hildebrand, 1961–84. Archive of the Hildebrand Gallery.

Lassnig, Maria. Letters to Silvianna Goldsmith, 1970s and 1980s. AMLF.

Lassnig, Maria. Letters to Hilde Absalon, 1970s–1999. AMLF.

Lassnig, Maria. Letters to Ruth Labak, 1977–79. Ruth Labak Archive.

Lassnig, Maria. Letters to Hans Ulrich Obrist, ca. 1993 to 2013. Archive of Hans Ulrich Obrist.

Lassnig, Maria. Draft letter to Catherine David, October 25, 1996. AMLF.

Lassnig, Maria. Letters to Robert Fleck, 1999. Robert Fleck Archive.

Lassnig, Maria. Letter to Hans Angela Scheirl, 2006. Ashley Hans Scheirl Archive.

Lassnig, Maria. Draft letter to Hans Ulrich Obrist, 2014. AMLF.

Lassnig, Maria. Draft letter to Rudi Fuchs, n.d. AMLF.

Lassnig/Wicking, Mathilde. Letters to Maria Lassnig, 1940–64. AMLF.

Lassnig/Wicking, Mathilde. Letters to Louis Popelin, 1945–64. AMLF.

Mastroleo, Tony. Letter to Maria Lassnig. Cambridge, Mass., July 13, 1970. AMLF.

Popelin, Louis. Letters to Maria and to Mathilde Lassnig, 1945–91. AMLF.

Rainer, Arnulf. Letters to Maria Lassnig, 1948–54. AMLF.

Signatures unidentifiable, Postcard to Maria Lassnig. Venice, September 13, 1980. AMLF.

Wiegele, Franz. Letter to Maria Lassnig. Kesselwald, July 8, 1944. AMLF.

Wicking, Paul. Letters to Maria Lassnig, 1954–64. AMLF.

Interviews with Natalie Lettner (recorded)

Bergmann, Rainer. Klagenfurt, October 4, 2014.

Drechsler, Wolfgang. Vienna, November 4, 2016.

Fleck, Robert. Vienna, April 6, 2016.

Fritz, Martin (with H. W. Poschauko, Peter Pakesch, and Johanna Ortner). Vienna, April 7, 2016.

Goldsmith, Silvianna, and Rosalind Schneider. New York, February 21, 2015.

Griffin, George. New York. February 20, 2015.

Gross, Walter. Kappel am Krappfeld, September 27, 2014.

Hildebrand, Uta and Ernst. Klagenfurt, August 24, 2014.

Hübner, Ursula. Vienna, October 7, 2016.

Karner, Andreas. Vienna, November 4, 2016.

Kubelka, Peter. Vienna, October 8, 2016.

Labak, Ruth. Vienna, October 12, 2016.

Mattuschka, Mara. Vienna, November 5, 2016.

Obrist, Hans Ulrich. Vienna, November 19, 2016.

Pakesch, Peter. Vienna, October 12, 2016.

Petzel, Friedrich. New York, February 20, 2015.

Poschauko, Hans Werner. Vienna, December 9, 2014.

Poschauko, Hans Werner. Vienna, December 8, 2016.

Rainer, Arnulf. Vienna, May 19, 2016.

Rossbacher, Eva. Vienna, October 30, 2015.

Scheirl, Ashley Hans. Vienna, November 18, 2016.

Schulmeister, Terese. Vienna, December 13, 2016.

Schütz, Roland. Vienna, October 19, 2016.

Semmel, Joan. New York, February 23, 2015.

Spiegel, Olga. New York, February 19, 2015.

Stark-Petrasch, Elfriede. Klosterneuburg, March 12, 2016.

Teschke, Andrea. New York, February 23, 2015.

Thuma, Gerlinde. Vienna, June 1, 2016.

Vaughan, Iris. San Francisco, March 4, 2015.

Wiener, Oswald (with Peter Pakesch). Kapfenstein, February 7, 2016.

Wimmer, Gabriele. Vienna, November 14, 2016.

Conversations (without recordings)

Fleck, Robert. Vienna, October 7, 2015.

Ortner, Johanna. Vienna, 2014–19.

Poschauko, Hans Werner. Vienna, 2014–17.

Sailer, John. Vienna, November 14, 2016.

Storr, Robert. New York, February 19, 2015.

Radio Shows

Abendjournal (Evening Journal). Austrian Public Radio (Ö1), November 30, 1988.

Diagonal. "The Artist Maria Lassnig." Ö1, May 15, 1999.

Im Gespräch (In Conversation). "Doris Stoisser with Maria Lassnig." Ö1, June 20, 1996.

Menschenbilder (Portraits of People). "Maria Lassnig." Ö1, May 15, 2005.

Menschenbilder. "Arnulf Rainer." Ö1, June 3, 2009.

Mittagsjournal (Noon Journal). Ö1, February 1, 1980.

Mittagsjournal. Ö1, January 17, 1985.

Mittagsjournal. Ö1, March 8, 1989.

Von Tag zu Tag (From Day to Day). "Brigitte Hofer with Maria Lassnig." Ö1, November 27, 2001.

Editions of Maria Lassnig's Films

ARGE INDEX, ed. Maria Lassnig. Animation Films (Index DVD Edition 033). Vienna: sixpackfilm, Medienwerkstatt Wien, 2009. (DVD with booklet)

Kondor, Eszter, Michael Loebenstein, Peter Pakesch, and Hans Werner Poschauko, eds.

Maria Lassnig. Film Works. Vienna: Filmmuse-umSynemaPublikationen, 2021. (Book with film index and DVD with "films in progress")

Selection of Documentary Films

Dreissinger, Sepp, and Heike Schäfer. *MARIA LASSNIG. Es ist die Kunst, jaja... (It is The Art that...),* 2015.

Grandits, Ernst. *Maria Lassnig. Farbgefühle (Maria Lassnig. Color Feelings).* Austrian Public Broadcasting (ORF), 2009.

Kaess-Farquet, Jacqueline. *The Interview. Hans Ulrich Obrist interviews Maria Lassnig.* Munich: Independent Artfilms J.K.F., 2008.

Kaess-Farquet, Jacqueline. *Maria Lassnig–Du oder ich (Maria Lassnig–You or Me).* Bavarian Television (Germany), 2015.

Schurian, Andrea. *Maria Lassnig. Gemalte Gefühle (Maria Lassnig. Painted Feelings).* Austrian Public Broadcasting (ORF), 1994.

Was war nun der Art Club? (What was the Art-Club?). MUMOK, Vienna, 1981.

Catalogs of Solo and Duo Exhibitions / Monographs

Skreiner, Wilfried, ed. *Maria Lassnig. Paintings Graphics.* Graz: Neue Galerie am Landes-museum Joanneum, 1970. Exhibition catalog, Neue Galerie am Landesmuseum Joanneum, Graz; Galerie nächst St. Stephan, Vienna; Austrian Institute, New York. (English, also published in German)

Galerie im Taxispalais, ed. *Maria Lassnig. Anima-tion.* Innsbruck: Galerie im Taxispalais, 1973. Exhibition catalog. (German)

Galerie Kalb, ed. *Maria Lassnig.* Vienna: Galerie Kalb, 1976. Exhibition catalog. (English/German)

Albertina, ed. *Maria Lassnig. Zeichnungen.* Vienna: Albertina, 1977. Exhibition catalog, Albertina, Vienna; Kunstverein für Kärnten, Klagenfurt. (German)

Berliner Künstlerprogramm des Deutschen Aka-demischen Austauschdienstes (DAAD) and Wieland Schmied, eds. *Maria Lassnig.* Berlin: Berliner Künstlerprogramm (DAAD), 1978. Exhibition catalog, Haus am Lützowplatz, Berlin. (German)

Gorsen, Peter. "Maria Lassnig, zu ihren Selbst-porträts." In Berliner Künstlerprogramm and Schmied, 1978.

Austrian Federal Ministry of Education and Art, Werner Hofmann, and Hans Hollein, eds. *Maria Lassnig. Austria. Biennale di Venezia 1980.* Vienna: Austrian Federal Ministry of Education and Art, 1980. Exhibition catalog, Austrian Pavilion, Venice Biennale. (English/Italian/German)

Galerie Klewan, ed. *Maria Lassnig. Bilder und Zeichnungen.* Munich: Galerie Klewan, 1981. Exhibition catalog. (German)

Peters, Hans Albert, and Wilfried Skreiner, eds. *Maria Lassnig. Zeichnungen Aquarelle Gouachen 1949–1982.* Düsseldorf: Edition Klaus Richter, 1982. Exhibition catalog. (German)

Wiener, Oswald. "Maria Lassnig. Untersuchungen zum Entstehen eines Bewusstseinsbildes." In Peters and Skreiner, eds., 1982, 95-101.

Drechsler, Wolfgang, ed. *Maria Lassnig.* Klagen-furt: Ritter, 1985. Exhibition catalog, Museum Moderner Kunst/Museum des 20. Jahrhun-derts, Vienna; Kunstmuseum Düsseldorf; Kunsthalle Nürnberg; Kärntner Landesgalerie, Klagenfurt. (German)

Drechsler, Wolfgang. "Außen und Innen. Zur Malerei von Maria Lassnig." In Drechsler, ed., 1985, 9–15.

Péret, Benjamin. "Der Leiberpferch der wilden Horden (1951)." In Drechsler, ed., 1985, 21.

Studio d'Arte Cannaviello, ed. *Maria Lassnig.* Milan: Studio d'Arte Cannaviello, 1986. Exhibi-tion Catalog. (English/Italian)

Walter-Buchebner-Gesellschaft, ed. *Maria Lassnig. Zeichnungen—Aquarelle—Gouachen.* Mürzzuschlag: Walter-Buchebner-Gesell-schaft, 1986. Exhibition catalog, Galerie Frei-berger, Mürzzuschlag. (German)

Galerie Thaddaeus Ropac, ed. *Maria Lassnig. Zeichnungen und Aquarelle 1957–1962. Zeich-nungen 1986/87.* Salzburg: Galerie Thaddaeus Ropac, 1987. Exhibition catalog. (German)

Reinhard Onnasch Galerie, ed. *Maria Lassnig. Innerhalb und außerhalb der Leinwand. Bilder.* Berlin: Reinhard Onnasch Galerie, 1987. Exhibi-tion catalog. (German)

Galerie Ulysses, ed. *Maria Lassnig*. Vienna: Galerie Ulysses, 1988. Exhibition catalog. (English)

Graphische Sammlung Albertina, Wien, and Kärntner Landesgalerie, Klagenfurt, eds. *Maria Lassnig. Aquarelle* (Veröffentlichung der Albertina Nr. 24). Klagenfurt: Ritter, 1988. Exhibition catalog, Kärntner Landesgalerie, Klagenfurt; Graphische Sammlung Albertina, Vienna; Salzburger Landessammlungen Rupertinum, Salzburg. (German)

Sternath-Schuppanz, Marie Luise. "'Aquarelle mag ich nicht, Landschaften liegen mir nicht.' Hinweise zu einer Bemerkung von Maria Lassnig." In Graphische Sammlung Albertina and Kärntner Landesgalerie, 1988, 31–35.

Gross, Barbara, ed. *Maria Lassnig. Werkverzeichnis der Druckgraphik 1949–1987*. Munich: Barbara Gross Galerie, 1988. (German)

Galerie Klewan, ed. *Maria Lassnig. Bilder der sechziger Jahre*. Munich: Galerie Klewan, 1989. Exhibition catalog. (German)

Kunz, Martin, ed. *Maria Lassnig. Mit dem Kopf durch die Wand. Neue Bilder*. Klagenfurt: Ritter, 1989. Exhibition catalog, Kunstmuseum Luzern, Lucerne; Neue Galerie, Graz; Kunstverein in Hamburg; Wiener Secession, Vienna. (German)

Murken, Christa. *Maria Lassnig. Ihr Leben und ihr malerisches Werk. Ihre kunstgeschichtliche Stellung in der Malerei des 20. Jahrhunderts*. Herzogenrath: Murken-Altrogge, 1990. (German)

Galerie Raymond Bollag, ed. *Maria Lassnig. "Science Fiction."* Zurich: Galerie Raymond Bollag, 1991. Exhibition catalog. (German)

Galerie und Edition Hundertmark, ed. *Maria Lassnig. Zeichnungen*. Cologne: Galerie und Edition Hundertmark, 1991. Exhibition catalog. (German)

Galerie Klewan, ed. *Maria Lassnig. Bilder, Zeichnungen, Aquarelle, Grafik 1946–1986*. Munich: Galerie Klewan, 1992. Exhibition catalog. (German)

Galerie Ulysses, ed. *Maria Lassnig. Zeichnungen und Aquarelle*. Vienna: Galerie Ulysses, 1992. Exhibition catalog. (German)

Stedelijk Museum Amsterdam, Galerie Ulysses, Vienna, eds. *Maria Lassnig. Das Innere nach Aussen. Bilder. Schilderijen. Paintings*.

Amsterdam: Stedelijk Museum, 1994. Exhibition catalog, Stedelijk Museum Amsterdam; Sankt Petri, Lübeck; Frankfurter Kunstverein, Frankfurt a. M. (English/Dutch/German)

König, Kasper, and Johannes Schlebrügge, eds., *Maria Lassnig. Kunstfiguren*. Cologne: Walther König, 1995. (German)

Weskott, Hanne, ed. *Maria Lassnig. Zeichnungen und Aquarelle 1946–1995*. Munich and New York: Prestel, 1995. Exhibition catalog, Kunstmuseum Bern; Musée national d'art moderne, Centre Georges Pompidou, Paris; Städtisches Museum Leverkusen, Schloss Morsbroich; Kunstmuseum Ulm; Kulturhaus der Stadt Graz. (German, supplement in French by Éditions du Centre Pompidou)

Weskott, Hanne. "Zeichnung und Aquarell im Werk von Maria Lassnig." In Weskott, ed., 1995, 8–33.

Neuer Berliner Kunstverein, Berliner Künstlerprogramm des DAAD, and Kunsthalle Bern, eds. *Maria Lassnig. Be-Ziehungen und Malflüsse*. Second expanded edition. Klagenfurt: Ritter, 1997. Exhibition catalog, Neuer Berliner Kunstverein, Berlin; daadgalerie, Berlin; Kunsthalle Bern. (English/German)

Udvary, Ildikó, ed. *Maria Lassnig kiállítása*. Budapest: Műcsarnok, 1997. Exhibition catalog, Műcsarnok Kunsthalle, Budapest. (Hungarian)

Drechsler, Wolfgang, ed. *Maria Lassnig*. Vienna: Ritter, 1999. Exhibition catalog, Museum moderner Kunst Stiftung Ludwig Wien, 20er Haus, Vienna; Musée des Beaux-Arts de Nantes; FRAC des Pays de la Loire, Nantes. (English/French/German)

Drechsler, Wolfgang. "Über die innige Verbindung von Maler und Malerei." In Drechsler, ed., 1999, 9–33.

Obrist, Hans Ulrich, ed. *Maria Lassnig. Die Feder ist die Schwester des Pinsels. Tagebücher 1943 bis 1997*. Cologne: DuMont, 2000. (German; see Obrist 2009 for English)

Haenlein, Carl, ed. *Maria Lassnig. Bilder 1989–2001. Kunstpreis der NORD/LB 2002*. Hanover: Kestner Gesellschaft, 2001. Exhibition catalog, Kestner Gesellschaft, Hanover. (German)

Der Bürgermeister der Stadt Siegen / FB 4 / Kultur / Museum für Gegenwartskunst / Künstlerische Leitung, ed. *Maria Lassnig*.

Körperporträts. Rubenspreis der Stadt Siegen 2002. Siegen: Museum für Gegenwartskunst, 2002. Exhibition catalog, Museum für Gegenwartskunst, Siegen. (German)

Engelbach, Barbara, and Maria Lassnig. "Vorstellungs und Empfindungsbilder. Auszüge aus Briefen im Kontext der Ausstellungsvorbereitung." In Der Bürgermeister der Stadt Siegen, ed., 2002, 24–29.

Galerie Ulysses, ed. Maria Lassnig. Eine andere Dimension. Skulpturen. Vienna: Galerie Ulysses, 2002. Exhibition catalog. (German)

Kunsthaus Zürich and Roswitha Haftmann-Stiftung, eds. Maria Lassnig. Verschiedene Arten zu sein. Zurich: Kunsthaus Zürich and Roswitha Haftmann-Stiftung, 2003. Exhibition catalog, Kunsthaus Zürich; Städel Frankfurt. (German)

Dezernat Kultur und Freizeit der Stadt Frankfurt am Main, ed. Max-Beckmann-Preis 2004 der Stadt Frankfurt am Main. Maria Lassnig. Frankfurt a. M.: Dezernat Kultur und Freizeit der Stadt Frankfurt am Main, 2004. (German)

Hauser & Wirth Zürich and Hauser & Wirth London, ed. Maria Lassnig. Paintings. Zurich and London: Hauser & Wirth, 2004. Exhibition catalog. (English)

Sammlung Essl, Klosterneuburg, ed. Maria Lassnig. Landleute. Klagenfurt: Ritter, 2004. (German)

Edition Sammlung Essl, ed. Maria Lassnig. body. fiction. nature. Klosterneuburg: Edition Sammlung Essl, 2005. Exhibition catalog, Sammlung Essl, Klosterneuburg. (German)

Höller, Silvia, ed. Maria Lassnig. Werke aus der Sammlung Essl. Innsbruck: RLB-Arts, 2005. Exhibition catalog, RLB-Kunstbrücke, Innsbruck. (German)

Madesta, Andrea, ed. Maria Lassnig. Körperbilder—body awareness painting. Cologne: Snoeck, 2006. Exhibition catalog, Museum Moderner Kunst Kärnten, Klagenfurt. (English/German)

Pakesch, Peter, ed. Zwei oder Drei oder Etwas / Two or Three or Something. Maria Lassnig, Liz Larner. Cologne: Walther König, 2006. Exhibition catalog, Kunsthaus Graz am Landesmuseum Joanneum, Graz. (English/German)

Larner, Melissa, ed. Maria Lassnig. London: Koenig Books 2008. Exhibition catalog, Serpentine Gallery. (English)

Storr, Robert. "Ave Maria." In Larner, 2008, 8–15.

Drechsler, Wolfgang, ed. Maria Lassnig. Das neunte Jahrzehnt. Cologne: Walther König, 2009. Exhibition catalog, Museum Moderner Kunst Stiftung Ludwig Wien, Vienna. (German)

Friedrich, Julia, ed. Maria Lassnig. Im Möglichkeitsspiegel. Aquarelle und Zeichnungen von 1947 bis heute / In the Mirror of Possibilities. Watercolours and Drawings from 1947 to the Present. Ostfildern: Hatje Cantz, 2009. Exhibition catalog, Museum Ludwig, Cologne. (English/German)

Obrist, Hans Ulrich, ed. Maria Lassnig. The Pen is the Sister of the Brush. Diaries 1943–1997. Translated from the German by Howard Fine with Catherine Schelbert. Zurich and London: Steidl Hauser & Wirth, 2009.

Friedel, Helmut, and Matthias Mühling, eds. Maria Lassnig. Berlin: Distanz, 2010. Exhibition catalog, Städtische Galerie im Lenbachhaus und Kunstbau, Munich. (English/German)

Lassnig, Maria. Physiognomien Lehnstuhlzeichnungen. Zwei Skizzenbücher aus dem Jahr 2009. Cologne: Walther König, 2011. (German)

Holler-Schuster, Günther, Dirk Luckow, and Peter Pakesch, eds. Maria Lassnig. Der Ort der Bilder / The Location of Pictures. Cologne: Walther König, 2012. Exhibition catalog, Neue Galerie Graz, Universalmuseum Joanneum, Graz; Deichtorhallen Hamburg. (English/German)

Eiblmayr, Silvia, Peter Pakesch, and Oswald Wiener, "Realism of What is Visible with the Eyes—Reality Perceived Through Body Awareness. A discussion between Oswald Wiener and Silvia Eiblmayr, moderated by Peter Pakesch." In Holler-Schuster, Luckow, and Pakesch, 2012, 88–98.

Verein der Freunde des Museums des Nötscher Kreises, ed. Franz Wiegele & Maria Lassnig. Begegnung im Kesselwald. Vienna: Dispositiv, 2012. Exhibition catalog, Museum des Nötscher Kreises, Nötsch. (German)

Dreissinger, Sepp. Maria Lassnig. Gespräche & Fotos. Vienna: Album, 2015. (German)

Fundacío Antoni Tàpies, ed. Maria Lassnig. Werke, Tagebücher & Schriften / Works,

Diaries & Writings. London: Koenig Books, 2015. Exhibition catalog, Fundació Antoni Tàpies, Barcelona. (English/German, also published in Spanish/Catalan)

Sammlung Klewan, ed. *Maria Lassnig 1919–2014. Francis Bacon 1909–1992.* Fanfold. Munich: Sammlung Klewan, 2015. (German)

Latham, Janine, ed. *Maria Lassnig. Woman Power: Maria Lassnig in New York 1968–1980.* New York: Petzel, 2016. Exhibition catalog, Petzel, New York. (English)

Redzisz, Kasia, and Lauren Barnes, eds. *Maria Lassnig.* London: Tate Publishing, 2016. Exhibition catalog, Tate Liverpool; Kunsten— Museum of Modern Art, Aalborg; Museum Folkwang, Essen; Zachęta—National Gallery of Art, Warsaw. (English, supplement in German by Museum Folkwang)

Ulysses KunsthandelsgesellschaftmbH, ed. *Maria Lassnig. Landleben. Countrylife.* Vienna: Galerie Ulysses, 2016. Exhibition catalog. (English/German)

Russell, John. "Maria Lassnig." *New York Times,* October 20, 1989. Reprinted in Ulysses KunsthandelsgesellschaftmbH, ed., 2016.

Drechsler, Wolfgang, ed. *Maria Lassnig. Woman Power.* Livorno: Sillabe, 2017. Exhibition catalog, Gallerie degli Uffizi, Palazzo Pitti, Florence. (English/Italian)

Haldemann, Anita, and Antonia Hoerschelmann, eds. *Maria Lassnig. Zwiegespräche. Retrospektive der Zeichnungen und Aquarelle / Dialogues. Retrospective of the Drawings and Watercolors.* Munich: Hirmer, 2017. Exhibition catalog, Albertina, Vienna; Kunstmuseum Basel. (English/German)

Obrist, Hans Ulrich, Peter Pakesch, and Denys Zacharopoulos, eds. *Maria Lassnig. The Future is Invented with Fragments from the Past.* Cologne: Walther König, 2017. Exhibition catalog, Municipal Gallery of Athens. (English, also published in Greek)

Budak, Adam, ed. *Maria Lassnig.* Prague: National Gallery, 2018. Exhibition catalog, National Gallery Prague. (English, also published in Czech)

Loers, Veit, Museion, and Lenbachhaus, eds. *Body Check. Martin Kippenberger—Maria Lassnig.* Cologne: Snoeck, 2018. Exhibition catalog, Museion, Bolzano; Städtische Galerie im Lenbachhaus und Kunstbau, Munich. (English/Italian/German)

Bormann, Beatrice von, Antonia Hoerschelmann, and Klaus Albrecht Schröder, eds. *Maria Lassnig. Ways of Being.* Munich: Hirmer, 2019. Exhibition catalog, Stedelijk Museum Amsterdam; Albertina, Vienna. (English, also published in Dutch and German)

Lentos Kunstmuseum Linz, ed. *Maria Lassnig— Arnulf Rainer. Das Frühwerk.* Cologne: Walther König, 2019. Exhibition catalog, Lentos Kunstmuseum Linz. (German)

Obrist, Hans Ulrich, Peter Pakesch, and Hans Werner Poschauko for the Maria Lassnig Foundation, eds. *Maria Lassnig. Briefe an Hans Ulrich Obrist. Mit der Kunst zusammen: da verkommt man nicht! / Letters to Hans Ulrich Obrist. Living with art stops one wilting!* Cologne: Walther König, 2020. (English/ German)

Petzel, New York, ed. *Maria Lassnig. The Paris Years 1960–68.* New York: Petzel, 2021. (English)

Additional Publications and Manuscripts

Achleitner, Friedrich. "Im Gespräch mit Thomas Eder." In Matt, ed., 2011, 27–40.

Aigner, Carl, Johannes Gachnang, and Helmut Zambo, eds. *Arnulf Rainer. Abgrundtiefe. Perspektiefe. Retrospektive 1947–1997.* Vienna: Brandstätter, 1997.

Akademie der bildenden Künste in Wien, ed. *JubiläumsAusstellung.* October 25, 1942– January 3, 1943. Vienna, 1942. Exhibition catalog.

Albers, Patricia. *Joan Mitchell: Lady Painter. A Life.* New York: Knopf, 2011.

Amann, Klaus, and Eckart Früh, eds. *Michael Guttenbrunner.* Klagenfurt: Ritter, 1995.

Art Review. "Power 100. The annual ranking of the most influential people in art." 2016. https://artreview.com/power-100?year=2016 (accessed July 10, 2020).

Art/World. "New York Exhibitions. 57th Street Review." May 1977.

Aspetsberger, Friedbert et al., eds. *Marginalisierung. Die Literatur und die neuen Medien.* Vienna: ÖBV, 1990.

Austrian Institute. *Events and News.* New York, November 1970.

B. "Wieder Neue Wege Maria Lassnigs," *Wiener Zeitung*, November 17, 1956.

Bast, Gerald, ed. *Mit eigenen Augen. KünstlerInnen aus der ehemaligen Meisterklasse Maria Lassnig / With Their Own Eyes. Former Students of Maria Lassnig*. Vienna: Birkhäuser, 2008. Exhibition catalog.

Baum, Wilhelm. *Klagenfurt. Geschichte einer Stadt am Schnittpunkt dreier Kulturen*. Klagenfurt and Vienna: KITAB, 2002.

Baum, Wilhelm. "Michael Guttenbrunner † May 13, 2004." *Kärnöl*, May 15, 2004. http://www.kaernoel.at/cgi-bin/kaernoel/comax.pl?page=page.std;job=CENTER:articles.single_article;ID=893 (accessed July 29, 2020).

Bäumer, Angelica, ed. *Michael Guttenbrunner. Über bildende Kunst und Architektur. Aus dem Nachlass*. Klagenfurt and Graz: Ritter, 2014.

Beckett, Samuel. *Malone meurt*. Paris: Les Editions de Minuit, 1951.

Bergson, Henri. *Einführung in die Metaphysik*. Jena: Diedrichs, 1909.

Boeckl, Matthias. "Von der Not, Missverständnisse hervorzurufen. Über die Funktion der Rhetorik beim frühen Rainer 1947–1955." In Brugger, ed., 2000.

Brauner, Franz. *Fibel Kinderwelt*. Graz: NS-Gauverlag Steiermark, 1940.

Breerette, Geneviève. "A Nantes, Maria Lassnig ou l'autoportrait à l'épreuve du corps." *Le Monde*, August 18, 1999, 23.

Breicha, Otto. "Vom provokanten Ernst des Grotesken." *Kurier*, September 19, 1964.

Breicha, Otto. In *Maria Lassnig*. Paris: Galerie La Case d'Art, 1965. Exhibition booklet.

Breicha, Otto. "Als Autrichienne in Paris." *Kurier*, May 3, 1966, 13.

Breicha, Otto, and Gerhard Fritsch, eds. *Protokolle '68. Wiener Jahreszeitschrift für Literatur, bildende Kunst und Musik*. Vienna and Munich: Jugend und Volk, 1968.

Breicha, Otto. "Angelegentliches über Maria Lassnig." In Breicha and Fritsch, eds., 1968, 135–38.

Breicha, Otto, ed. *Protokolle '73/1. Wiener Halbjahreszeitschrift für Literatur, bildende Kunst und Musik*. Vienna and Munich: Jugend und Volk, 1973.

Breicha, Otto, ed. *Anfänge des Informel in Österreich 1949–1953. Maria Lassnig, Oswald Oberhuber, Arnulf Rainer*. Graz: Styria, 1975. Exhibition catalog.

Breicha, Otto, ed. *Sehschlacht am Canal Grande. Alfred Schmeller. Aufsätze und Kritiken*. Vienna and Munich: Jugend und Volk, 1978.

Breicha, Otto, ed. *Arnulf Rainer. Hirndrang. Selbstkommentare und andere Texte zu Werk und Person*. Salzburg: Galerie Welz, 1980.

Breicha, Otto, ed. *Der Art Club in Österreich*. Vienna: Jugend und Volk, 1981. Exhibition catalog.

Breicha, Otto. *Anfänge des Informel in Österreich, 1949–1954: Maria Lassnig, Oswald Oberhuber, Arnulf Rainer*. Graz: Styria, 1997. Exhibition catalog.

Breicha, Otto. "Mit 20 und 30. Der junge Rainer." In Aigner, Gachnang, and Zambo, eds., 1997, 27–35.

Breton, André. *Manifestoes of Surrealism*. Ann Arbor: University of Michigan Press, 1969.

Breton, André. *Die Manifeste des Surrealismus*. Reinbek bei Hamburg: Rowohlt, 1986.

Breton, André. "L'Amour Fou" (1937) in *Ouvres complètes II*. Paris: Gallimard, 1992.

Britsch, Gustaf. *Theorie der bildenden Kunst*. Munich: Bruckmann, 1930.

Broude, Norma, and Mary D. Garrard, eds. *The Power of Feminist Art. The American Movement of the 1970s: History and Impact*. New York: Harry N. Abrams, 1994.

Bruckner, Franziska. *Animationsfilm in Österreich. Studio für experimentellen Animationsfilm in den Klassen Maria Lassnig und Christian Ludwig Attersee*. Unpublished diploma thesis. Vienna, 2008.

Brugger, Ingried, ed. *Arnulf Rainer. Gegen. Bilder*. Munich: Edition Minerva, 2000. Exhibition catalog.

Cavell, Marcia. "Women Artists as Filmmakers." *Changes*, February/March 1973, 13.

Cézanne, Paul. *Über die Kunst. Gespräche mit Gasquet und Briefe*. Hamburg: Rowohlt, 1957.

Christoph, Horst. "Den Stil verwerfen." *Profil*, Vienna, February 4, 1985, 66–67.

Christoph, Horst, and Nina Schedlmayer. "'Das mag ich nicht hören!' Malerin Maria Lassnig im großen Interview." *Profil*, Vienna, February 2, 2009.

College of Design, Architecture, and Art, ed. *Women Artist Filmmakers Inc.* Cincinnati, OH: University of Cincinnati, 1976.

Cumming, Laura. "A Stunning Body of Work." *The Observer*, London, April 27, 2008.

Danzer, Paul. "Erziehung zur Volkserhaltung." *Der Deutsche Erzieher. Reichszeitung des National-sozialistischen Lehrerbundes*, February 1, 1939.

Deissen, Eva. "Maria Lassnig. Wien neu erobern." *Kronen Zeitung*, December 30, 1979, 26.

Demus, Klaus. "Maria Lassnig." *Salzburger Nach-richten*, December 18, 1952.

Denk, Wolfgang, ed. *Mythos Art Club. Der Aufbruch nach 1945.* Krems: Kunsthalle Krems, 2003. Exhibition catalog.

Die Brücke. Kärnten, Kunst, Kultur. "Helene, Stutz und die Kunst." December 2006/January 2007, 22–24.

Die Neue Zeit. "Die große Kärntner Kunstaustel-lung." August 23, 1947, 6.

Die Neue Zeit. "Maria Laßnig [sic] in Wien erfolg-reich." June 20, 1950, 5.

Die WochenPresse. "Maria mit Bart." April 2, 1960.

Die Zeit. "Maria Lassnig ist tot." May 7, 2014. http://www.zeit.de/kultur/kunst/201405/ lassnig kuenstlerinmalereigestorben (accessed July 29, 2020).

Drechsler, Wolfgang, ed. *Ansichten. 40 österrei-chische Künstler im Gespräch*. Salzburg and Vienna: Residenz, 1992.

Drexler, Jolanda. "Die Galeristin für starke Frau-enpositionen. Barbara Gross im Gespräch." *Kunstforum* 225 (2014): 350 ff.

Dusini, Matthias. "Ich glaub' mich beißt ein Fisch ins Wadl." *Falter*, July 2009.

Elste, Alfred, and Michael Koschat. "'Gesund' und 'Kerndeutsch'.'" Kärntens bildende Kunst der NSZeit. Zwischen Kollaboration und Instrumentalisierung." In Husslein-Arco and Boeckl, eds., 2004, 289–327.

Emmerich, Wolfgang. *Paul Celan*. Reinbek bei Hamburg: Rowohlt, 1999.

Ernst, Elisabeth, and Gustav Ernst. "Gerda Fassel: Gespräch mit Maria Lassnig." *Wespennest*, no. 39, 1980.

Erziehung und Unterricht in der Volksschule. Berlin: Zentralverlag der NSDAP, 1940.

Export, Valie, ed. *Magna. Feminismus: Kunst und Kreativität. Galerie nächst St. Stephan.*

7.3.–5.4.1975. Vienna: Galerie nächst St. Stephan, 1975. Exhibition catalog.

Feldmann, Jacqueline. *Maria Lassnig (1919–2014) et Paris: vers une singularité artistique*. Master's thesis. Paris, 2016.

Felstiner, John. *Paul Celan. Eine Biographie*. Munich: C. H. Beck, 1997.

Fessler, Anne Katrin. "Ohrenschmaus oder Eier-speis." *Der Standard*, September 2, 2005.

Feuerstein, Günther et al. *Moderne Kunst in Österreich*. Vienna, Hanover, Bern: Forum, 1965.

Fialik, Maria. *Thomas Bernhard. Das Theatrale in Leben und Werk oder "Solche Menschen muss ein Mensch haben." Ein Leben rekonstruiert aus Briefen und Gesprächen. Band 2: Gespräch mit Michael Guttenbrunner und Maria Gutten-brunner-Zuckmayer*. Dissertation. Vienna, 1997.

Fleckner, Uwe, ed. *Angriff auf die Avantgarde. Kunst und Kunstpolitik im Nationalsozialismus*. Berlin: Akademie, 2007.

Fleck, Robert. *Avantgarde in Wien. Die Geschichte der Galerie nächst St. Stephan Wien 1954–1982. Kunst und Kunstbetrieb in Österreich*. Vienna: Löcker, 1982.

Fleck, Robert, ed. *Weltpunkt Wien. Un regard sur Vienne*. Vienna, Munich, Paris: Löcker, 1985. Exhibition catalog.

Fleck, Robert. "Der Wiener Aktionismus." In Smolik and Fleck, eds., 1995, 52–56.

Fleck, Robert. "Zur 'Überwindung der Malerei' in der Malerei und medialen Kunst in Österreich seit 1945." In Werkner, ed., 1996, 106–16.

Frisch, Max. *Mein Name sei Gantenbein*. Frank-furt a. M.: Suhrkamp, 1964.

Fuchs, Ernst. *Phantastisches Leben*. Berlin: Kindler, 2001.

Gagel, Hanna. *So viel Energie. Künstlerinnen in der dritten Lebensphase*. Berlin: AivivA, 2005.

Gassiot-Talabot, Gérald. "Quatre peintres parmi d'autres." *Les Annales. Revue mensuelle des lettres francaises*, no. 176 (June 1965): 54–55.

Gorsen, Peter. "Frauen und Frauenbilder in der Kunstgeschichte." In Nabakowski, Sander, and Gorsen, eds., 1980, vol. 2, 13–177.

Grissemann, Stefan. "'Der Schrecken kommt an einen heran, ganz langsam.' Interview mit Maria Lassnig." *Profil*, April 30, 2005.

Gross, Walter. *Die Gemeinde Kappel am Krapp-feld. Ein Heimatbuch*. Kappel am Krappfeld, 1996.

Gütersloh, Albert Paris. "Deswegen sollen wir unsere Maßstäbe nicht aus den Museen holen. Rede auf Maria Lassnig." In Breicha, ed., 1981, 115–16.

Gütersloh, Albert Paris. "Was denn, wenn nicht unser Bestes! Aus dem Katalog der 1. Jahres-ausstellung des Art Club in der Wiener Kunst-halle, April 1948." In Breicha, ed., 1981, 8–9.

Guttenbrunner, Michael. "Die Volkszeitung und die Kunst." *Volkswille*, August 24, 1947, 5.

Guttenbrunner, Michael. *Schwarze Ruten*. Kla-genfurt: Kleinmayr, 1947.

Guttenbrunner, Michael. "Da stand eines Tages Arnulf Rainer vor meiner Tür." In Breicha, ed., 1980.

Guttenbrunner, Michael. *Im Machtgehege II*. Aachen: Rimbaud, 1994.

Guttenbrunner, Michael. "Kärntner Kunst nach 1945. Erinnerungen eines Freundes." In Huss-lein-Arco and Boeckl, eds., 2004, 329–32.

Habarta, Gerhard. *Frühere Verhältnisse. Kunst in Vienna nach 45*. Vienna: Der Apfel, 1996.

Harding, Luke. "Picasso of the 21st century donates work to home town museum." *Guardian*, July 6, 2004.

Heiser, Jörg. "Inside out. Maria Lassnig in conver-sation." *Frieze Magazine*, November 11, 2006. https://frieze.com/article/insideout (accessed July 29, 2020).

Hennig, Alexandra. "Eine Chronologie. Padhi Frieberger und seine Zeit." In Wipplinger, ed., 2012, 150–53.

Hildebrand, Ernst, ed. *Hans Bischoffshausen. Briefe an die Familie Hildebrand 1959–1987*. Klagenfurt: Wieser, 2009.

Hinz, Sigrid, ed. *Caspar David Friedrich in Briefen und Bekenntnissen*. Berlin: Henschel, 1968.

Hochdörfer, Achim. "1000 Words. Maria Lassnig talks about her exhibition at the Serpentine Gallery." *Artforum*, Summer 2008.

Hofmann, Werner. *Zeichen und Gestalt. Die Malerei des 20. Jahrhunderts*. Frankfurt a. M.: Fischer, 1957.

Hofmann, Werner. *Die Plastik des 20. Jahrhun-derts*. Frankfurt a. M.: Fischer, 1958.

Hölzer, Max. *Letters to Michael Guttenbrunner aus zwanzig Jahren (1952–1972). Kommentiert von Frank Schablewski*. Aachen: Rimbaud, 2012.

Hördler, Stefan, ed. *Zwangsarbeit im Nationalso-zialismus*. Göttingen: Wallstein, 2016.

Husslein-Arco, Agnes, and Matthias Boeckl, eds. *Eremiten—Kosmopoliten. Moderne Malerei in Kärnten 1900–1955*. Vienna and New York: Springer, 2004. Exhibition catalog.

Husslein-Arco, ed. *Herbert Boeckl*. Vienna: Belvedere, 2009. Exhibition catalog.

Husslein-Arco, Agnes, Harald Krejci, and Clara Kaufmann. *Mehr als Zero. Hans Bischoffs-hausen und die Galerie Hildebrand*. Vienna: Belvedere, 2015.

Jené, Edgar, and Max Hölzer. *Surrealistische Pub-likationen*. Klagenfurt: Josef Haid, 1950.

Jobst, Vinzenz. *Guttenbrunner—Rebellion und Poesie*. Klagenfurt: Kitab, 2012.

Kafka, Franz. *Hochzeitungsvorbereitungen auf dem Lande und andere Prosa aus dem Nachlaß*. Frankfurt a. M.: Fischer, 1983.

Kandinsky, Wassily. "Über die Formfrage." In *Der Blaue Reiter*, 1912.

Kandinsky, Wassily. "Malerei als reine Kunst." *Der Sturm. Halbmonatsschrift für Kultur und die Künste*, no. 178/179 (September 1913).

Kärntner Tageszeitung. "Künstlerinnen fordern Kunsthochschulprofessorin." March 13, 1976.

Kimpel, Harald. *documenta. Die Überschau. Fünf Jahrzehnte Weltkunstausstellung in Stichwör-tern*. Cologne: DuMont, 2002.

Kippenberger, Susanne. *Am Tisch. Die kulinari-sche Bohème oder Die Entdeckung der Lebens-lust*. Berlin: Berlin Verlag, 2012.

Kirchmayr, Birgit, ed. *Kulturhauptstadt des Führers. Kunst und Nationalsozialismus in Oberösterreich*. Linz: Bibliothek der Provinz, 2008.

Klagenfurt—Die Stadtzeitung mit amtlichen Nachrichten. "Landleute—Landsleute. Maria Lassnig Ausstellung in der rittergallery." February 26, 2004, 30.

Klamper, Elisabeth. "Zur politischen Geschichte der Akademie der bildenden Künste 1918–1948. Eine Bestandsaufnahme." In Seiger et al., eds., 1990, 5–64.

Köcher, Helga: "Brief aus Wien. Denken ist Hin-richtung, Tun ist Herrichtung." *Kunstforum International*, vol. 77/78, 1985, 292 ff.

Koschatzky, Walter. "Vorwort." In Albertina, ed., 1977.

Kozloff, Joyce. "Maria Lassnig in New York, 1968–1980." *Hyperallergic: Sensitive to Art & Its Discontents*, November 8, 2014. https://hyperallergic.com/159289/maria-lassnig-in-new-york-1968-1980/ (accessed July 29, 2020).

Kronenzeitung. "Ikone der Kunstwelt. Malerin Maria Lassnig (94) gestorben." May 6, 2014.

Kuchling, Heimo. "Maria Lassnig." In *Ausstellung Maria Lassnig. Malerei und Grafik. Galerie Kleinmayr*. Klagenfurt: Kleinmayr, 1949. Exhibition leaflet.

Kuchling, Heimo. "Maria Lassnig." In *Ausstellung Maria Lassnig. Buchhandlung Kosmos*. Vienna, 1950. Exhibition leaflet.

Kuspit, Donald. "The Hospital of the Body. Maria Lassnig's Body Ego Portraits." *Arts Magazine*, Summer 1990. Reprinted in Ulysses KunsthandelsgesellschaftmbH, ed., 2016.

Labak, Ruth. "Zur Malerei von Maria Lassnig." Final paper. Hochschule für angewandte Kunst Wien, Vienna, 1979.

Labak, Ruth, ed. *Meisterklasse Maria Lassnig 1980–1989. Hochschule für angewandte Kunst Wien*. Vienna, 1989. Exhibition catalog.

Lampe, Jörg. "Maria Laßnig [sic] im ArtClub." *Die Presse*, December 2, 1952.

Lampe, Jörg. "Neue Wiener Ausstellungen." *Die Presse*, November 14, 1956.

Lampe, Jörg. "Maria Lassnig in der Galerie St. Stephan." *Die Presse*, March 24, 1960.

Lassnig, Maria, and Trr [Arnulf Rainer]. Leaflets for the exhibition *Unfigurative Malerei*. Klagenfurt, 1951. Four loose sheets, no specific title, AMLF.

Laßnig [sic], Maria. *Phantastische Automatik, statische Meditationen, stumme Formen, Malerei ∞ = 1*. Artclubgalerie, Vienna, 1952. Exhibition leaflet.

Lassnig, Maria. "Pariser Kunstbrief. Gibt es was Neues in Paris?" *Volkszeitung*, June 1963.

Lassnig, Maria. "Pariser Kunstbrief. Was Neues bei Picasso? Picasso und Napoleon." *Volkszeitung*, February 1, 1964.

Lassnig, Maria. "Der Surrealismus ist vierzig Jahre alt." *Volkszeitung*, April 30, 1964.

Lassnig, Maria. "Pariser Kunstbrief. Drei Abwandlungen der sichtbaren Welt." *Volkszeitung*, Spring 1964.

Lassnig, Maria. "Pariser Neuigkeiten. Von Vermeer bis Wesselmann." *Volkszeitung*, November 1966.

Lassnig, Maria. "Pariser Notizen im Dezember." *Kärntner Tageszeitung*, December 1966.

Lassnig, Maria. "Chancen des Kreativen." In Breicha and Fritsch, eds., 1968, 130–35.

Lassnig, Maria. "Maria Lassnig in New Yorker Slums." *Kärntner Tageszeitung*, January 9, 1970.

Lassnig, Maria. "Kunstsparte Animation." In Breicha, ed., 1973, 45–51.

Lassnig, Maria. "Hochzeit wird gefeiert, sonst wird die Suppe kalt!" *Kleine Zeitung*, November 8, 1978, 16.

Lassnig, Maria. Brief biography with handwritten notes for an exhibit at the Centre Georges Pompidou. Manuscript, 1995, AMLF.

Lassnig, Maria. Preparation for an interview based on correspondence with Christine Lecerf. Manuscript, September 24, 1999, AMLF.

Lassnig, Maria, and Dieter Ronte. "Gespräch." In Bast, ed., 2008, 15–17.

Lebovici, Elisabeth. "Corpus delicti." *Libération*, September 1, 1999, 33.

Lecerf, Christine. "Ne pas se laisser simplement vivre." Interview with Maria Lassing. Nantes, July 5, 1999, AMLF.

Lecerf-Héliot, Christine. Interview based on correspondence with Maria Lassnig. Manuscript, January 1996, AMLF.

Liebs, Holger. "'Nullkommajosef Selbstvertrauen.' Im Gespräch Maria Lassnig." *Süddeutsche Zeitung*, May 17, 2010.

Linthout, Ine van. *Das Buch in der nationalsozialistischen Propagandapolitik*. Berlin and Boston: De Gruyter, 2012.

Mach, Ernst. *Die Analyse der Empfindungen und das Verhältnis des Physischen zum Psychischen. Nachdruck der 9. Auflage (Jena 1922)*. Darmstadt: Wissenschaftliche Buchgesellschaft, 1991.

Mathieu, Georges. *Désormais seule en face de Dieu*. Lausanne, 1998.

Matt, Gerald A., and Austrian Parliament, eds. *Österreichs Kunst der 60erJahre. Gespräche*. Nuremberg: Verlag Für Moderne Kunst, 2011.

Matt, Gerald, and Andrea Schurian. "Maria Lassnig im Gespräch." In Matt, ed., 2011, 223–37.

Mayer, Antje. "'Ich fühle also bin ich': Ein Interview mit Maria Lassnig, der Grande Dame der österreichischen Malerei." *Kunstzeitung*, no. 11, 2004. http://www.redost.com/texte/interviews/ich-fuehle-also-bin-ich/ (accessed July 10, 2020).

Mayröcker, Friederike. *Rosengarten. Radierung von Maria Lassnig*. Pfaffenweiler: Pfaffenweiler Presse, 1984.

Mayröcker, Friederike. *ich sitze nur GRAUSAM da*. Berlin: Suhrkamp, 2012.

Miessgang, Thomas. "Maria Lassnig. Schmerzfarben, Krebsangstfarben, Wärmefarben." *Die Zeit*, May 7, 2014.

Misar, Grete. "Die 'New Yorkerin' aus Kärnten: Maria Lassnig. Dreifach beim Steirischen Herbst." *Kleine Zeitung*, September 19, 1975.

Mitchell, Joan, and Helen Molesworth. *Joan Mitchell. Leaving America. New York to Paris 1958–1964*. London: Hauser & Wirth, 2007. Exhibition catalog.

Monte, James K. *22 Realists. Whitney Museum of American Art*. New York: Georgian Press, 1970.

Müller, Hans-Joachim. "Im Schloss der Übermaler, unten die Touristen." *Die Welt*, September 26, 2014.

Müller, Jürgen. *Der sokratische Künstler. Studien zu Rembrandts Nachtwache*. Leiden: Brill, 2015.

Nabakowski, Gislind, Helke Sander, and Peter Gorsen, eds. *Frauen in der Kunst*, 2 vols. Berlin: Suhrkamp, 1980.

Nagl, Michaela. "Wilhelm Dachauer. Pathos und Idylle." In Kirchmayr, ed., 2008, 127–30.

Neues Österreich. "Wiener Herbstausstellungen." November 25, 1956.

Nierhaus, Irene. "Adoration und Selbstverherrlichung." In Seiger, ed., 1990, 65–141.

Nietzsche, Friedrich. *Menschliches, Allzumenschliches. Kritische Studienausgabe*, vol. 2. Munich: DTV, 1999.

Noever, Peter, ed. *Otto Muehl. Leben/Kunst/Werk. Aktion Utopie Malerei 1960–2004*. Cologne: Walther König, 2004.

Novak, Philipp. "Malerin Maria Lassnig—'Für uns war sie eine Erscheinung.'" *Kleine Zeitung*, March 28, 2009.

Obrist, Hans Ulrich. "Frühstück mit Ohr." Museum in Progress, 2005. http://www.mip.at/attachments/69 (accessed July 10, 2020).

Ohff, Heinz. "Realismus des Irrealen. Maria Lassnigs erste deutsche Einzelausstellung." *Berliner Tagesspiegel*, October 21, 1976.

Pawlowsky, Verena. *Die Akademie der bildenden Künste Wien im Nationalsozialismus. Lehrende, Studierende und Verwaltungspersonal*. Vienna, Cologne, Weimar: Böhlau, 2015.

Petzel, Friedrich. Interview with Martha Edelheit, Silvianna Goldsmith, and Rosalind Schneider about Maria Lassnig. Friedrich Petzel Gallery, September 12, 2014. Unpublished recording in English.

Pierre, José. "Maria Lassnig ou le somnambulisme lucide." In *Maria Lassnig*. Paris: Galerie La Case d'Art, 1965. Exhibition booklet.

Pierre, José. "Pour une raison de vivre." In *Le Ranelagh invitation*. Paris: Galerie Le Ranelagh, 1967. Exhibition invitation for *Maria Lassnig* and presentations by other artists.

R. R. "'Die Jungen kennen mich kaum.' Endlich Maria-Lassnig-Retrospektive für kommenden Herbst in Klagenfurt." *Kärntner Tageszeitung*, August 17, 1985, 19.

Radax, Ferry. "Mit nichts als Fantasie erschufen wir unsere Welt aus dem Nichts." Manuscript of an interview conducted by Josef Schweikhardt with Ferry Radax on July 29, 2009. https://www.ferryradax.at/Media/Interview_Radax_Schweikhardt.pdf (accessed July 29, 2020).

Rainer, Arnulf. "'Man musste irgendwie weg, das Denken war zu kleinkariert.' Arnulf Rainer über Kärnten. Aus einem Gespräch mit Matthias Boeckl." In Boeckl and Husslein-Arco, eds., 2004, 345–52.

Rathkolb, Oliver. "Die Wiener Note in der deutschen Kunst. Nationalsozialistische Kulturpolitik in Wien 1938–1945." In Tabor, ed., 1994, 332–35.

Rathkolb, Oliver. "Herbert Boeckl—Ein Moderner zwischen den Zeiten. Zeithistorische Anmerkungen zu den Wechselwirkungen zwischen Politik und Kunst im 20. Jahrhundert." In Husslein-Arco, ed., 2009, 215–21.

Rohsmann, Arnulf. "Duldsam und geduldet. Die Kärntner Moderne und die Diktaturen." In Tabor, ed., 1994, 452–63.

Rühm, Gerhard. "das phänomen wiener gruppe." In Weibel, ed., 1997, 17–29.

S. H. "Ausstellung Maria Lassnig." *Volkszeitung*, March 22, 1949.

Salm-Salm, Marie-Amélie zu. *Échanges artistiques francoallemands et renaissance de la peinture abstraite dans les pays germaniques après 1945*. Paris: Editions L'Harmattan, 2003.

Salm-Salm, Marie-Amélie zu. *Échanges artistiques francoallemands après 1945. Recueil d'entriens*. Paris: Editions L'Harmattan, 2009.

Samsonow, Elisabeth von. "'Dies Ganze muss selig werden' Zu Friederike Mayröckers Bedeutung in der Gegenwart." In Alexandra Strohmaier, ed. *Buchstabendelirien. Zur Literatur Friederike Mayröckers*. Bielefeld: Aisthesis, 2009.

Sartre, Jean Paul. *L'imaginaire. Psychologie phénoménologique de l'imagination*. Paris: Gallimard, 1940.

Schedlmayer, Nina. "Nachruf. Maria Lassnig war Österreichs bedeutendste Künstlerin." *Profil*, Vienna, May 10, 2014.

Schedlmayer, Nina. "Im Interview: Maler Arnulf Rainer. 'Mir steigen die Grausbirn auf.'" *Profil*, Vienna, August 16, 2014.

Schlapper, Tonči. "Michael Guttenbrunner— Biographische Erinnerungen und Anmerkungen." In Amann and Früh, eds., 1995.

Schmeller, Alfred. "Jahrgang 29." *Continuum*, Vienna, 1956. Reprinted in Breicha, ed., 1978, 24–33.

Schmeller, Alfred. "Einige Perspektiven auf Weiblichkeiten. Zu den neuen Bildern von Maria Lassnig in der Galerie St. Stephan." *Kurier*, March 28, 1960. Reprinted in Breicha, ed., 1978, 70–71.

Schmeller, Alfred. "Ein Sammelsurium." In Breicha, ed., 1981.

Schneemann, Carolee. "Maria Lassnig." *Artforum*, January 10, 2014.

Schopenhauer, Arthur. *Aphorismen zur Lebensweisheit*. Leipzig: Hayn, 1851.

Schurian, Andrea. "Ein Maler muss die Welt nicht abmalen." *Der Standard*, June 8, 2012.

Schurian, Andrea. "Die Seele ist immer da." Interview in *Der Standard*, May 31, 2013.

Schwaiger, Brigitte. "'Wie fühlen Sie sich?' Interview with Arnulf Rainer." In Aigner, Gachnang, and Zambo, eds., 1997.

Seiger, Hans et al., eds. *Im Reich der Kunst. Die Wiener Akademie der bildenden Künste und die faschistische Kulturpolitik*. Vienna: Verlag für Gesellschaftskritik, 1990.

Sielecki, Hubert. "Der österreichische Animationsfilm aus dem Studio an der Hochschule für angewandte Kunst in Wien." In Aspetsberger et al., eds., 1990.

Skreiner, Wilfried. "Behauptungen zur Neuen Malerei in Österreich." *Kunstforum International*, vol. 80, no. 3, 1985.

Smith, Roberta. "Art in Review. Maria Lassnig." *The New York Times*, November 22, 2002.

Smolik, Noemi, and Robert Fleck, eds. *Kunst in Österreich*. Cologne: Kiepenheuer & Witsch, 1995.

Smolik, Noemi. "'Der Körper stört beim Denken.' Interview with Maria Lassnig." In Smolik and Fleck, eds., 1995, 59–61.

Sotriffer, Kristian. "Schön gemalte Hässlichkeit. Maria Lassnigs 'sentimentale Bilder' bei Würthle." *Die Presse*, April 16-17, 1966, 8.

Sotriffer, Kristian. "Gespräch mit Maria Lassnig. Künstlerinnenporträts 40. Museum in Progress." Bregenz, March 1997. http://www.mip.at/attachments/191 (accessed July 29, 2020).

Spiegler, Almuth. "Macht über den eigenen Körper." *Die Presse*, February 13, 2009.

Storr, Robert, ed. *Disparities and Deformations. Our Grotesque*. Santa Fe: SITE, 2004.

Storr, Robert. "How do you solve a problem like Maria?" *Parkett* 85 (2009): 88–101.

Tabor, Jan. "Leider war's doch nur eine halbe Lösung." *Kurier*, June 1, 1980, 13.

Tabor, Jan. "Die Gaben der Ostmark. Österreichische Kunst und Künstler in der NSZeit." In Seiger et al., eds., 1990, 277–96.

Tabor, Jan, ed. *Kunst und Diktatur. Architektur, Bildhauerei und Malerei in Österreich, Deutschland, Italien und der Sowjetunion 1922–1956*. Baden: Grasl, 1994.

Trr [Arnulf Rainer]. "Gegenüberstellung." In Lassnig and Trr [Rainer], 1951.

Veiter, August. "Kunstausstellung des Kunstvereines für Kärnten im Wappensaal." *Volkszeitung*, August 20, 1947, 3.

W. "Paris künstlerischer Nährboden—Kärnten Kraftquelle." *Volkszeitung*, September 24, 1967, 8.

W. E. "Die Kunstausstellung im Wappensaal." *Volkswille*, August 23, 1947, 8.

W. E. "Ausstellung Maria Lassnig in der Kleinmayr Galerie in Klagenfurt." *Volkswille*, March 27, 1949.

Weh, Vitus H. "Ich habe Talent." *Falter*, March 26, 1999, 22.

Weibel, Peter, ed. *Die Wiener Gruppe—The Vienna Group: A Moment of Modernity*. Vienna and New York: Springer, 1997. Exhibition catalog.

Weiermair, Peter. "Zur Traditions und Herkunftsfrage." *Kunstforum International*, vol. 89, 1987.

Welti, Alfred. "Kunst, die vom Körper kommt." *Art. Das Kunstmagazin*, August 1983, 42–51.

Werkner, Patrick, ed. *Kunst in Österreich 1945–1995*. Vienna: WUV, 1996.

Werneburg, Brigitte. "'Ich brauch' den realen Körper.' Ein Interview mit Maria Lassnig." *Deutsche Bank Art Mag* 53, 2009.

Weskott, Hanne. "Das einzig Wirkliche ist das Gefühl." *Süddeutsche Zeitung*, July 26, 1985.

Weskott, Hanne. "Liebesbeweis, fälschungssicher. Die österreichische Malerin Maria Lassnig und der Kosmos des Körpers." *Die Zeit*, November 22, 1996.

Wiedmann, Barbara, ed. *Paul Celan. Die GollAffäre. Dokumente zu einer Infamie*. Frankfurt a. M.: Suhrkamp, 2000.

Wipplinger, Hans-Peter, ed. *Padhi Frieberger. Glanz und Elend der Moderne*. Nuremberg: Verlag für moderne Kunst, 2012. Exhibition catalog.

Y. "Ausstellung Maria Lassnig." *Neue Zeit*, March 23, 1949.

Zoe. "Malerin eines neuen Körperbewusstseins." *Kleine Zeitung*, May 15, 1975.

Additional Archives Consulted

Archive of the Academy of Fine Arts
Archive of the Maria Lassnig Foundation
Austrian State Archives

Index

Index

Index

Credits

All works and texts from Maria Lassnig © Maria Lassnig Foundation

Artwork photography:
pp. 15 (bottom), 272: © Hubert Sielecki; pp. 17, 21, 23, 31, 34–35, 49, 62, 73–75, 105, 107, 125, 136, 140, 144, 176, 185, 196, 199, 213, 219, 225, 240, 246, 248, 252, 275, 285, 290, 312 (top and bottom), 313, 320, 325, 349: Roland Krauss; p. 19: Ingeborg Lommatzsch; pp. 28, 145: Collection of the Museum of Modern Art Carinthia / MMKK (photo: Ferdinand Neumüller); p. 41: Werner Hanak-Lettner; p. 108: photoartpro. com; pp. 109, 321: LENTOS Kunstmuseum Linz (photo: Reinhard Haider); p. 111: Reinhard Haider; pp. 134 (bottom), 194: Auktionshaus im Kinsky; p. 147: Sammlung Lambrecht-Schadeberg / Museum für Gegenwartskunst Siegen; p. 158: Ursula Hauser Collection, Switzerland; p. 181: Graphisches Atelier Neumann, Vienna; p. 187: © The ALBERTINA Museum, Vienna – The ESSL Collection (photo: Mischa Nawrata), Vienna (Inv. EDLSB2428); p. 188: Wien Museum; p. 195: Neue Galerie Graz, Universalmuseum Joanneum; pp. 203 (top), 216: Ursula Hauser Collection, Switzerland (photo: Stefan Altenburger Photography Zürich); p. 228: © Belvedere, Vienna (photo: Johannes Stoll); p. 229: © The ALBERTINA Museum, Vienna – on loan from Oesterreichische Nationalbank (Inv. GE393DL); p. 233: Galerie Krinzinger; p. 239: Contemporary Fine Arts, Berlin (photo: Matthias Kolb); p. 251: The ESSL Collection (photo: Graphisches Atelier Neumann, Vienna); p. 265: Private Collection; p. 274: Private Collection; pp. 276, 332, 334: © Sandro E. E. Zanzinger; p. 280: Almine Rech Gallery (photo: Melissa Castro Duarte); p. 287: © The ALBERTINA Museum, Vienna (Inv. 39991); p. 291 (top): rittergallery, Klagenfurt; p. 292: © The ALBERTINA Museum, Vienna – permanent loan from Austrian private collection (Inv. GE427DL); pp. 307, 339 (top), 341: Private Collection, courtesy Hauser & Wirth Collection Services (photo: Stefan Altenburger Photography Zürich); p. 329: The ESSL Collection (photo: Franz Schachinger, Vienna); p. 331: Städtische Galerie im Lenbachhaus und Kunstbau, München; p. 333 (top): Christian Wickler; p. 337: Zabludowicz Collection (photo: Tim Bowditch); p. 343: Capitain Petzel, Berlin (photo: Jens Ziehe)

Images from the Archive of the Maria Lassnig Foundation:
p. 9: Rudolf Wohlmuth; p. 15 (top); p. 16 (top and bottom); p. 18; p. 22 (top and bottom); p. 24; p. 27; p. 29; pp. 32–33, 36, 193, 226: © Maria Lassnig Foundation / courtesy sixpackfilm; pp. 38–39; pp. 43–44; pp. 47–48; p. 57; p. 60: Rudolf Wohlmuth; pp. 68–69; p. 77; p. 80; p. 94; p. 99 (top and bottom): Willi E. Prugger; p. 100; p. 102; p. 121; pp. 128–29: Mia Williams; pp. 131, 133, 134 (top): Padhi Frieberger; p. 139; p. 148; pp. 160, 203 (bottom), 204, 208–9: Maria Lassnig; p. 163; p. 174: © museum in progress; p. 177; p. 179; p. 184: H. G. Trenkwalder; p. 223; p. 230; p. 234: Hy Shore; p. 237: Ingeborg Lommatzsch; p. 242: Ulrike Ottinger; p. 262; p. 273: © Kurt-Michael Westermann; pp. 288, 319: Heimo Kuchling; p. 291 (bottom); p. 293; p. 296; p. 330 (bottom); p. 350

Additional image credits:
pp. 178, 200: © Barbara Pflaum / Imagno / picturedesk.com; p. 192: Multimedia Collections, Universalmuseum Joanneum, Graz (photo: Stefan Amsüss); pp. 220, 299: © Horst Stasny; p. 257: Valie Export; pp. 278, 302, 315: © Sepp Dreissinger; p. 282: © Didi Sattmann / Imagno / picturedesk.com; p. 297: Museum Ludwig, Cologne, Inv. ML 10264 (photo: © Rheinisches Bildarchiv Cologne, Marion Mennicken, rba_c019089); p. 314: MUMOK / R. Schmied 2009; p. 336: Peter Rigaud c/o Shotview Syndication; p. 346: Bundesministerium für Bildung, Wissenschaft und Forschung (photo: Scharf / HBF); p. 351: Studio Semotan © Elfie Semotan; p. 353: © Ronnie Niedermeyer

Cover:
Maria Lassnig, March 2002 (photo: Bettina Flitner, Keystone / LAIF / Bettina Flitner)

Colophon

Publisher: Michaela Unterdörfer
Managing editor: Jennifer Magee
Project assistants: Maria Elena Garzoni and Courtney Meier-Neil
Editorial support, Maria Lassnig Foundation: Marlene Hans, Johanna Ortner, Hans Werner Poschauko

Book design and typography: Capitale Wien
Copyediting and proofreading: Georgia Bellas
Translation editing: Gregory Weeks
Pre-press: LUP AG, Cologne
Production coordination: Christine Stricker
Printing and binding: DZA Druckerei zu Altenburg GmbH

Cover material: Ensocoat
Paper: Magno Volume
Typefaces: Circular Pro, GT Sectra

Maria Lassnig: The Biography by Natalie Lettner, translated by Jeff Crowder
© 2022 Hauser & Wirth Publishers, Maria Lassnig Foundation, Petzel Gallery

Original German edition published in 2017 with the title
Maria Lassnig. Die Biografie by Natalie Lettner © 2017 Christian Brandstätter Verlag, Vienna

Distribution:
Europe and the UK: Buchhandlung Walther König
Ehrenstrasse 4
50672 Cologne
Tel +49 221 20 59 6-53 | Fax +49 221 20 59 6-60

All other territories: Simon & Schuster, Inc.
1230 Avenue of the Americas
New York, NY 10020
Tel : 212-698-7000

ISBN: 978-3-906915-52-4
Library of Congress Control Number: 2022930297
Printed and bound in Germany

Hauser & Wirth Publishers **Maria Lassnig Foundation** Petzel